Mastering the Nikon D600

CALGARY PUBLIC LIBRARY

DEC - 2013

Darrell Young (Digital Darrell) is an information technology engineer by trade. He's been an avid photographer since 1968 when his mother gave him a Brownie Hawkeye camera.

Darrell has used Nikon cameras and Nikkor lenses since 1980. He has an incurable case of Nikon Acquisition Syndrome (NAS) and delights in working with Nikon's newest digital cameras.

Living near Great Smoky Mountains National Park has given him a real concern for the natural environment and a deep interest in nature photography.

He loves to write, as you can see in the Resources area of the Nikonians Online community (www.Nikonians.org). He joined the community in the year 2000, and his literary contributions led to his invitation to become a Founding Member of the Nikonians Writers Guild.

Mastering the Nikon D600

Darrell Young

Darrell Young (aka Digital Darrell)

Editor: Jocelyn Howell Copyeditor: Jeanne Hansen Layout: Petra Strauch Cover Design: Helmut Kraus, www.exclam.de Printer: Sheridan Books, Inc. Printed in USA

ISBN 978-1-937538-19-4

1st Edition 2013 © 2013 Darrell Young

Rocky Nook, Inc. 802 E. Cota Street, 3rd Floor Santa Barbara, CA 93103

www.rockynook.com

Library of Congress Cataloging-in-Publication Data

Young, Darrell, 1958-Mastering the Nikon D600 / by Darrell Young. -- 1st edition. pages cm ISBN 978-1-937538-19-4 (softcover : alk. paper)

1. Nikon digital cameras. 2. Single-lens reflex cameras. 3. Photography--Digital techniques. I. Title.

TR263.N5Y683 2013

2013002606

Distributed by O'Reilly Media 1005 Gravenstein Highway North Sebastopol, CA 95472

All rights reserved. No part of the material protected by this copyright notice may be reproduced or utilized in any form, electronic or mechanical, including photocopying, recording, or by any information storage and retrieval system, without written permission of the publisher.

Many of the designations in this book used by manufacturers and sellers to distinguish their products are claimed as trademarks of their respective companies. Where those designations appear in this book, and Rocky Nook was aware of a trademark claim, the designations have been printed in caps or initial caps. All product names and services identified throughout this book are used in editorial fashion only and for the benefit of such companies with no intention of infringement of the trademark. They are not intended to convey endorsement or other affiliation with this book. Adobe Photoshop™ and Adobe Lightroom™ are registered trademarks of Adobe Systems, Inc. in the United States and other countries.

While reasonable care has been exercised in the preparation of this book, the publisher and author(s) assume no responsibility for errors or omissions, or for damages resulting from the use of the information contained herein or from the use of the discs or programs that may accompany it.

This book is printed on acid-free paper.

This book is dedicated to:

My wife of many years, Brenda; the love of my life and best friend...

My children, Autumn, David, Emily, Hannah, and Ethan, five priceless gifts . . .

My mother and father, Barbara and Vaughn, who brought me into this world and guided my early life, teaching me sound principles to live by ...

My Nikonians editor, Tom Boné, without whose assistance I could not possibly write books . . .

My friends J. Ramon Palacios and Bo Stahlbrandt, who make it possible to belong to Nikonians.org, the world's best Nikon Users' Community ...

The wonderful staff of Rocky Nook, including Gerhard Rossbach, Joan Dixon, Jocelyn Howell, and Matthias Rossmanith ...

My copy editor, Jeanne Hansen (www.hansenedits.com), whose eye for detail and knowledge of the English language made this book much nicer for its readers ...

And, finally, to Nikon, who makes the world's best cameras and lenses.

Special Thanks to:

Brad Berger of www.Berger-Bros.com (800-542-8811) for helping me obtain a Nikon D600 early in its production cycle so that I could write this book. I personally buy from and recommend Berger-Bros.com for Nikon cameras, lenses, and accessories. They offer old-time service and classes for your photographic educational needs too!

Steve Wise of www.atomos.com (503-388-3236) for allowing me to use a powerful Atomos Ninja-2 external HDMI video recorder. The revolutionary Ninja-2 is the go-to "Smart Production Weapon" for Nikon HD-SLR camera owners who want to record the highest quality, uncompressed video their camera can output.

Michael Tapes of mtapesdesign.com (321-752-9700) for providing samples of their excellent products: WhiBal for white balance ambient light (PRE) readings and accurate white balance control, and LensAlign and FocusTune for calibrating and fine-tuning autofocus in Nikon DSLRs.

Table of Contents

xiv Foreword xvi Camera Body Reference 532 Credits 534 Index

2 Basic Camera Setup

- 4 Learning about the Nikon D600
- 6 First Use of the Camera
- 7 First-Time HD-SLR Users
- 7 Five Steps for First-Time Camera Configuration
- 11 Accessing the Camera Menus
- 12 Camera Functions for Initial Configuration
- 14 Personal Camera Settings Recommendations
- 14 Things to Know When Reading This Book
- 15 Downloadable Resources Website

16 Pla	yback	Menu
--------	-------	------

- 18 Delete
- 25 Playback Folder
- 27 Hide Image
- 30 Playback Display Options
- 36 Copy Image(s)
- 43 **Image Review**
- 44 After Delete
- 45 Rotate Tall
- Slide Show 47
- 50 **DPOF Print Order**
- Author's Conclusions 53

54 **Shooting Menu**

- 57 User Settings U1 and U2
- 58 Configuring the Shooting
 - Menu
- 59 Reset Shooting Menu
- 60 Storage Folder
- 63 File Naming
- 65 Role Played by Card in Slot 2
- 67 **Image Quality**
- 75 Image Size
- 77 Image Area
- 81 JPEG Compression
- 83 NEF (RAW) Recording
- 87 White Balance
- 90 Set Picture Control
- 100 Manage Picture Control
- 108 Auto Distortion Control
- 109 Color Space
- 112 Active D-Lighting
- 115 HDR (High Dynamic Range)
- 119 Vignette Control
- 121 Long Exposure NR
- 124 High ISO NR
- 126 ISO Sensitivity Settings
- 136 Remote Control Mode
- 138 Multiple Exposure
- 141 Interval Timer Shooting
- 144 Time-Lapse Photography
- 146 Movie Settings
- 150 Author's Conclusions

152 Custom Setting Menu

- 153 Using the Camera's Help System
- 154 The User Settings and the Custom Setting Menu
- 155 Using the Custom Setting Menu
- 157 a Autofocus
- 168 b Metering/Exposure
- 176 c Timers/AE Lock
- 185 d Shooting/Display
- 204 e Bracketing/Flash
- 225 f Controls
- 243 g Movie
- 248 Modified Custom Setting Notice
- 248 Author's Conclusions

250 Setup Menu

- 253 Format Memory Card
- 255 Save User Settings
- 257 Reset User Settings
- 258 Monitor Brightness
- 259 Clean Image Sensor
- 261 Lock Mirror Up for Cleaning
- 263 Image Dust Off Ref Photo
- 266 HDMI
- 267 Flicker Reduction
- 268 Time Zone and Date
- 272 Language
- 273 Image Comment
- 275 Auto Image Rotation
- 276 Battery Info
- 277 Copyright Information
- 279 Save/Load Settings
- 282 GPS
- 287 Virtual Horizon
- 288 Non-CPU Lens Data
- 292 AF Fine-Tune
- 295 Eye-Fi Upload
- 297 Firmware Version
- 298 Author's Conclusions

300 Retouch Menu

- 303 Retouched File Numbering
- 303 Accessing the Retouch Functions – Two Methods
- 304 Playback Retouching
- 305 Using Retouch Menu Items Directly
- 305 D-Lighting
- 306 Red-Eye Correction
- 307 Trim
- 308 Monochrome
- 310 Filter Effects
- 319 Color Balance
- 321 Image Overlay
- 324 NEF (RAW) Processing
- 332 Resize
- 334 Quick Retouch
- 335 Straighten
- 337 Distortion Control
- 339 Fisheye
- 341 Color Outline
- 342 Color Sketch
- 343 Perspective Control
- 345 Miniature Effect
- 347 Selective Color
- 349 Edit Movie
- 352 Side-by-Side Comparison
- 353 Author's Conclusions

356 My Menu and Recent Settings

- 358 My Menu
- 363 Recent Settings
- 364 Author's Conclusions

366 Metering, Exposure Modes, and Histogram

367	Section 1 – Metering
369	3D Color Matrix Metering II
369	Center-Weighted Metering
371	Spot Metering
373	Section 2 – Exposure Modes
373	Programmed Auto (P) Mode
375	Shutter-Priority Auto (S)
	Mode
378	Aperture-Priority Auto (A)
	Mode
379	Manual (M) Mode
380	Settings Recommendation
	for Exposure Mode
	Selection
381	Auto Exposure (AUTO)
	Mode
382	SCENE Modes
394	U1 and U2 User Settings
395	No Flash Mode
395	Section 3 – Histogram
396	Understanding the
	Histogram

406 Author's Conclusions

408 White Balance

- 409 How Does White Balance Work?
- 410 Color Temperature
- 412 Manual White Balance Using the WB Button
- 413 Manual White Balance Using the Shooting Menu
- 415 Manual Color Temperature (K) with the WB Button
- 415 Manual Color Temperature (K) with the Shooting Menu
- 417 Measuring Ambient Light by Using PRE
- 419 Fine-Tuning White Balance
- 422 Editing the PRE White Balance Comment Field
- 423 Using the White Balance from a Previously Captured Image
- 424 Protecting a White Balance Preset
- 425 Auto White Balance
- 427 Should I Worry about White Balance If I Shoot in RAW Mode?
- 428 White Balance Tips and Tricks
- 428 Author's Conclusions

430 Autofocus, AF-Area, and **Release Modes**

- 431 Section 1 Autofocus in Viewfinder Photography
- 446 Section 2 Autofocus in Live View Photography
- 453 Section 3 Release Modes
- 459 Custom Settings for Autofocus (a1-a7)
- 459 Author's Conclusions

460 Live View Photography Mode

- 461 Using Live View Photography Mode
- 464 Live View Photography Mode Screens
- 467 Selecting a Picture Control in Live View
- 468 Changing the Monitor Brightness
- 470 Closing Notes on Live View Photography Mode
- 471 Author's Conclusions

472 Movie Live View Mode

- 473 No Tripod and Handheld Modes
- 474 Selecting Movie Live View Mode
- 474 Movie Live View Still Images
- 476 Movie Live View Screens
- 483 Preparing to Make Movies
- 501 Recording a Video with Your D600
- 504 Displaying Movies
- 507 Limitations in Movie Mode Video Capture
- 510 Author's Conclusions

512 Speedlight Flash

- 513 Light Is a Photographer's Friend!
- 514 What Is a Guide Number?
- 516 Flash Modes
- 522 Flash Compensation
- 523 Nikon Creative Lighting System (CLS)
- 529 Author's Conclusions

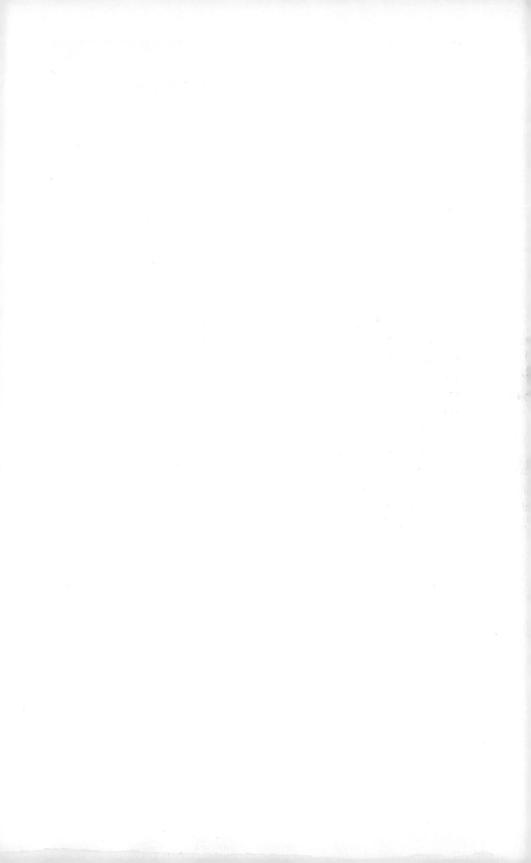

nikonians.org

Foreword

The Nikon D600 is hard to define compared to previous Nikon digital single-lens reflex (DSLR) cameras.

Nikon's announcement of the D800 (February 2012) was followed by the unveiling of the D600 a short seven months later. This new camera is smaller and lighter, and instead of being compared to the D800, it is often reviewed as a "D7000 on steroids."

The D600 is not a D800, nor is it a DX sensor equipped D7000. It is more like an upgraded combination of the two, making it a very clever merger of a semi-pro and enthusiast camera with features that surpass some recent professional models.

Imagine the dilemma faced by the author of the past eight *Mastering the Nikon*® *DSLR* series books. Nikonian Darrell Young—known to us as *Digital Darrell*—had just published the most successful (and profuse at almost 600 pages) edition of our books, on the Nikon D800/800E. It was preceded by our Nikon D7000 book (now in its fifth printing). Many of the features from both the D800 and D7000 were combined into the amazing Nikon D600. How could Darrell describe this new, powerful, hybrid digital single-lens reflex in a way that would most benefit his readers?

Working with the camera, Darrell's first step is the same as the one he recommends to all new Nikon users. He reads the user's manual as many times as it takes to understand important concepts. Once he grasps the concepts and the basic directions available through the user's manual, he takes those concepts and directions into the field. He makes sure he understands how each feature works in basic photography and how it can be applied to specialty applications such as landscapes, weddings, events, and portraits. Once satisfied that he has mastered each new feature, he then translates his experience in a simple-to-understand sequence of profusely illustrated steps, and goes on to recommend the best initial settings and shooting techniques to match.

Fortunately, Darrell's extensive knowledge and hands-on experience gained while writing *Mastering the Nikon D800* and *Mastering the Nikon D7000* put him in the enviable position to draw comparisons and highlight the remarkable advancements in Nikon's D600. In the simplest terms, he instinctively knew what was "under the hood."

Darrell spotted the best attributes almost immediately. The Nikon D600 is the perfect FX entry-level model. The camera's cost is more than reasonable when one considers inflation and devaluation, its well-sealed and robust body, and the 24 MP sensor that provides better image quality and dynamic range than the more expensive Nikon D3X. The D600 is designed for those who have wanted to

enter the FX world but have been waiting for an affordable option, making it an ideal choice for a serious or enthusiast photographer on a budget, or as a second body for the working professional. It also features a high-speed continuous shooting rate of approximately 5.5 frames per second, compared to the 4 frames per second of the D800—providing the perfect balance between resolution and speed for those who shoot both nature and sports.

Recognizing these attributes and helping owners of this camera was a natural progression for Darrell. He went back to square one with the skills he has developed in the last eight books in this series and addressed his readers with his singular point of view. He wants to help the owner of this particular camera.

In this book, Darrell has applied his time-tested and reader commended skills to the D600. The ultimate reward of much deeper knowledge of your new camera goes to you, the owner of this book. As you read the pages to follow, you will be the beneficiary of Darrell's diligence and painstaking attention to detail. By reading this book, with camera in hand, your photography is bound to improve.

This joint venture between nikonians.org and Rocky Nook has developed a strong following in the "camera instruction" genre, and Darrell's easy-to-understand writing has been a key ingredient in that trend. We are proud to include his impressive credentials and body of work in our ever growing and never-ending resources for our community, which include articles, forums, The Nikonian eZine, Nikonians Academy Workshops, the Nikonians News Blog, Nikonians podcasts, our Wiki, and eBooks. Our community now has three language versions (English, German, and French) and we continue to grow as we surpass 400,000 members on record.

Nikonians, now in its 13th year, has earned a reputation as a friendly, reliable, informative, and passionate Nikon® user's community thanks in great measure to members like our own Digital Darrell, who have taken the time to share the results of their experiences with Nikon imaging equipment.

It is a pleasure to present you with this book. Enjoy it, the Nikonians community, and your Nikons.

J. Ramón Palacios (jrp) and Bo Stahlbrandt (bgs) **Nikonians Founders** www.nikonians.org

Camera Body Reference

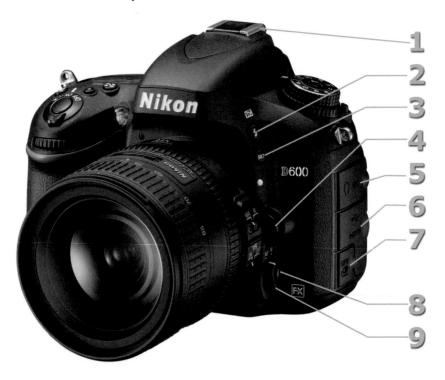

Front of Camera on Right Side (facing camera)

- 1. Accessory shoe (hotshoe)
- 2. Flash mode/compensation button (also raises flash #10)
- 3. Bracketing button (BKT)
- 4. Lens release button
- 5. Audio connector cover
- 6. HDMI/USB connector cover
- 7. Accessory terminal connector cover (GPS, etc.)
- 8. AF-mode button
- 9. Focus-mode selector

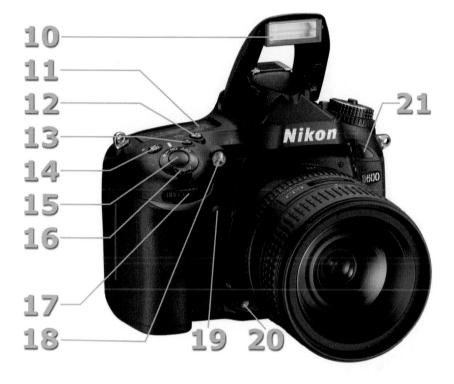

Front of Camera on Left Side (facing camera)

- 10. Built-in flash (Speedlight)
- 11. Control panel
- 12. Metering/Formatting button
- 13. Movie-record button
- 14. Exposure compensation/Reset button
- 15. Shutter-release button
- 16. Power switch
- 17. Sub-command dial
- 18. AF-assist illuminator
- 19. Depth-of-field preview button
- 20. Fn (function) button
- 21. Infrared receiver (front)

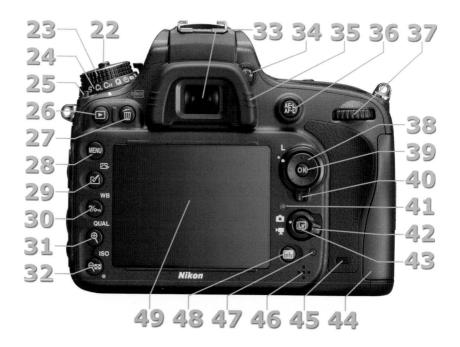

Back of Camera

- 22. Mode dial lock release
- 23. Mode dial
- 24. Release mode dial
- 25. Release mode dial lock release
- 26. Playback button
- 27. Delete/format button
- 28. MENU button
- 29. Retouch/Picture Control button
- 30. Help/Protect button (WB)
- 31. Playback zoom in button (QUAL)
- 32. Playback zoom out/thumbnails button (ISO)
- 33. Viewfinder eyepiece
- 34. Diopter adjustment control
- 35. Rubber eyecup

- 36. AE-L/AF-L button (AE/AF lock)
- 37. Main command dial
- 38. Multi selector
- 39. OK button
- 40. Focus selector lock
- 41. Ambient brightness sensor (for Monitor)
- 42. Live view selector
- 43. Lv button (Live view)
- 44. Memory card slot cover
- 45. Infrared receiver (rear)
- 46. Speaker
- 47. Memory card access lamp
- 48. Info button
- 49. Monitor

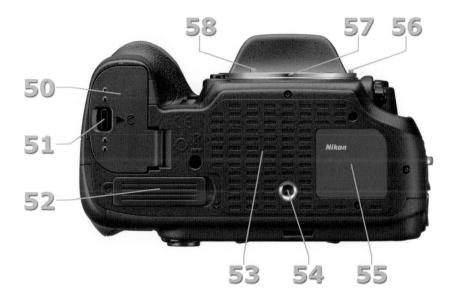

Bottom of Camera and Lens Mount (F-Mount)

- 50. Battery-chamber cover
- 51. Battery-chamber cover latch
- 52. MB-D14 contact cover
- 53. Rubber base plate
- 54. Tripod socket
- 55. Label for ID, battery voltage, and serial number
- 56. Lens lock pin (moved by Lens release button #4)
- 57. Lens mount (F-mount)
- 58. AF coupling (screwdriver)

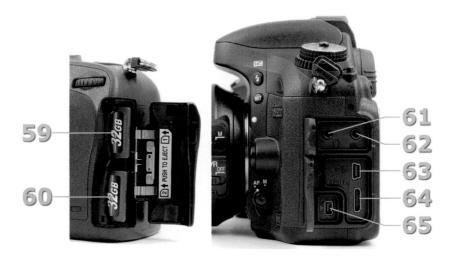

Under the Camera's Side Covers

- 59. Card Slot 1 (under #44)
- 60. Card Slot 2 (under #44)
- 61. Headphone connector (under #5)
- 62. External microphone connector (under #5)
- 63. USB connector (under #6)
- 64. HDMI mini-pin connector, type C (under #6)
- 65. Accessory terminal for GPS and other accessories (under #7)

Colors and Wording Legend

Throughout this book, you'll notice that in the numbered, step-by-step instructions there are colored terms as well as terms that are displayed in italic font.

- 1. Blue is used to refer to the camera's physical features.
- 2. Green is for functions and settings displayed on the camera's LCD screens.
- 3. Italic is for textual prompts seen on the camera's LCD screens.
- 4. Italic or bold italic is also used on select occasions for special emphasis.

Here is a sample paragraph with the colors and italic font in use:

Press the MENU button to reach the Setup Menu, and then scroll to the Format memory card option by pressing the down arrow on the Multi selector. You will see the following message: *All images on Memory card will be deleted. OK?* Select Yes and then press the OK button. **Please make sure you've transferred all your images first!**

Basic Camera Setup

Isabell and Her New Toys – Jesse Martinez (*jesse101*)

The Nikon D600 is an exciting new full-frame (FX), hybrid-digital, single-lens reflex (HD-SLR) camera in Nikon's line of advanced digital cameras. It has a newly designed imaging sensor with even more dynamic range and image quality than the top-of-the-line Nikon D3X pro camera. With a camera body design and internal operating system based on the mature and stable Nikon D7000 and many of the same internal hardware features as in the Nikon D800—including the new, very powerful EXPEED 3 microprocessor system—the Nikon D600 is the ultimate advanced-enthusiast camera. It is the first step into the FX world, where fullframe sensors and professional lenses provide commercial-level image quality.

The D600 simply has everything an enthusiast photographer will need to bring home incredibly good images, without jumping through hoops. With the D600, digital photography has reached a level of maturity that will allow you to use your camera for a long time.

The massive resolution of the 24.3 megapixel (MP) sensor and an amazing 14.2 exposure value (EV) steps of dynamic range make the D600 one of the world's best digital cameras. In fact, DxO Labs rates the Nikon D600 as the number three digital camera in the world, with an overall score of 94, just behind the Nikon D800 (score of 95) and the Nikon D800E (score of 96). This score significantly exceeds the best cameras from other brands. DxO Labs stated on their

website (www.dxomark.com) that the D600 "is also a significant improvement over the high-end professional flagship DSLRs, the Nikon D3X and the Nikon D4."

In my opinion, the image is what counts, and the Nikon D600 can deliver some of the highest-quality images out there. It's a robust camera body designed to last. With this camera we can return to the days when we seldom bought a new camera body and instead put our money into new Nikkor lenses. Wouldn't you like to have some new lenses?

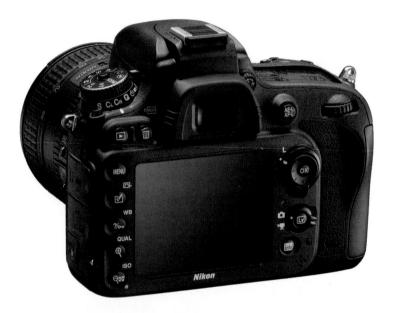

Sure, new Nikon cameras will come out, and, like me, you'll be attracted to them. However, with the D600 you won't have to buy a new camera unless you really want to. It will last for many years!

Now, let's learn how to configure and use your new D600.

Learning about the Nikon D600

The difficulty in writing a book about a powerful camera like the Nikon D600 is balancing it for multiple types of users and their various levels of knowledge and interest. With too much technical detail, the book will read like a user's manual. With too little technical detail, advanced users will get no benefit from the book.

Some users of the Nikon D600 HD-SLR camera have come over from the world of fully automated point-and-shoot cameras. On the other hand, many photographers have upgraded to the D600 from cameras like the Nikon D3200, D5100, and D7000. Then, there are professionals who bought a D600 to have a backup

for their pro-level and semipro-level cameras, like the Nikon D300S, D700, D800, D800E, D3, D3S, D3X, and D4. Others have come over from the film world, drawn by the siren call of lower cost, immediate image use, and very high quality.

In Mastering the Nikon D600 I've tried my best to balance the needs of new and experienced users. I remember my first DSLR and my confusion about how to configure the camera compared to my old film SLR: What's all this histogram, white balance, and color space stuff?

The bottom line is that the Nikon D600 is a rather complex camera, and it requires a careful study of resources like this book to really get a grasp on the large range of features and functions. According to Nikon, it's an "advanced" camera, with features not found in lesser "consumer" models. It's designed for people who really love photography and have a passion for image making that far exceeds just taking some nice pictures at a family event.

The D600 has most of the features found in cameras like the D800 and D4, which are cameras that professionals use to make a living. In fact, the Nikon D600 is becoming the camera of choice for many pros who want a backup camera or a smaller, lighter camera for pleasure use and activities like hiking, skydiving, and underwater adventures. The camera body is robust enough, with its magnesiumalloy frame, to take abuse and survive.

Following the publication of my books Mastering the Nikon D7000 and Mastering the Nikon D800, I compared the D7000, D800, and D600 side by side. I'm here to tell you that the Nikon D600 has all the critical functions found in the D800

and extends the feature set of the D7000.

The D600 has a full range of functions that allow you to shoot images and post-process them in the camera instead of on your computer. If you don't like computers but want to take digital photographs and videos, the Nikon D600 is the camera for you!

Additionally, the Nikon
D600 has a very powerful
video subsystem, allowing you to re-

I could rave for hours about all the cool features in the D600. In fact, I do go on raving about this camera for the next 12 chapters. I hope you can sense my enthusiasm for this cool new imaging machine as you read this book. There are few cameras in the world with this level of capability, and you own one!

First Use of the Camera

Surprisingly, quite a few brand-new DSLR users are buying a Nikon D600 instead of a lower-cost, entry-level model. Even new users appreciate the robust high quality of the camera.

The upcoming sections and chapters are best read with your camera in hand, ready for configuration. There are literally hundreds of things to configure on this advanced DSLR. In this chapter, I'll give new D600 users a place to start. Later, as you progress through this book, we'll look at all the buttons, switches, dials, and menu settings in detail. That will allow you to fully master the operation of your Nikon D600.

Each menu in the camera has its own chapter or section. Plus there is additional information on how to put it all together in chapters like **Metering**, **Exposure Modes**, **and Histogram**; **White Balance**; **Autofocus**, **AF-Area**, **and Release Modes**; **Live View Photography**; and **Speedlight Flash**. Since the D600 has a movie mode, we'll cover video capture in a separate chapter, **Movie Live View**.

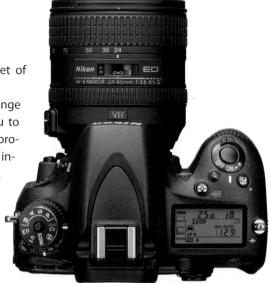

First-Time HD-SLR Users

Although the D600 is an advanced enthusiasts' camera, many brand-new HD-SLR users have purchased a D600 as their first DSLR-type camera. New users may not know how to attach and remove a lens or change the battery, and they may need help with inserting and formatting memory cards.

The majority of this book's readers, however, already know how to perform these tasks. I do not want to ask a more experienced DSLR user to read over the basics of DSLR use, so I've created a document called Initial Hardware Considerations that you can download from either of these websites:

http://www.nikonians.org/NikonD600 http://rockynook.com/NikonD600

There are also several other articles of interest to new Nikon D600 users on these webpages.

Now, let's start with the initial configuration of a brand-new Nikon D600. There are five specific steps you must complete when you first turn on the camera.

Five Steps for First-Time Camera Configuration

This section is devoted to first-time configuration of the camera. There are certain settings that must be set up immediately (covered in this section) and others that should be configured before you use the camera extensively (covered in a later section, Camera Functions for Initial Configuration).

I won't go into detail on all possible settings in this chapter. Those details are reserved for the individual chapters that cover the various menus and functions. Instead, I'll walk you through five steps for first-time configuration of the camera. In the Camera Functions for Initial Configuration section I'll refer you to the page numbers that provide the screens and menus for each function that should be configured before you use your camera for the first time. The later chapters will cover virtually all camera settings.

When you first configure an older Nikon, after inserting a battery into a justout-of-the-box camera, the word CLOCK normally flashes on the camera's upper Control panel or Information display (rear Monitor). When I first turned on my brand-new Nikon D600, I was expecting the flashing word, but it wasn't there. Instead, the Control panel was blank, except for a battery charge indicator in the upper left corner. Other than that, nothing appeared on the Control panel until I completed the five-step initial setup, then a normal Control panel display was activated.

On page 28 of the Nikon D600 User's Manual (English) it states that CLOCK will be flashing on the camera display if the camera's internal time clock has not been

set. It could be that some distributors set the clock on the camera before distribution. Mine certainly wasn't flashing. Therefore, if you do see CLOCK flashing on any of the displays, be sure to set the clock before using the camera. In fact, we will review and set the clock during the final step of our five-step initial setup.

Let's examine how to configure a new camera. You'll see the following five screens when you first turn the camera on, and they must be set up immediately.

Setting the Language - Step 1

Figure 1.1 – Setup Menu Language screen

The D600 is multilingual or multinational. As partially shown in figure 1.1, the menus can be displayed in 28 languages. Most likely the camera will already be configured to the language spoken in your area since various world distributors have the camera somewhat preconfigured. The following is a list of the display languages available in the D600, firmware version C1.00, L1.006 (Setup Menu > Firmware version):

- Arabic
- Chinese (Simplified)
- · Chinese (Traditional)
- Czech
- Danish
- Dutch
- · English
- Finnish
- French
- German

- Greek
- Hindi
- Hungarian
- Indonesian
- Italian
- Japanese
- Korean
- Norwegian
- Polish
- · Portuguese (Brazil)

- Portuguese (Portugal)
- Romanian
- Russian
- Spanish
- Swedish
- Thai
- Turkish
- Ukrainian

Here are the steps to select your language:

- 1. Refer to figure 1.1 for the Language list the camera presents on startup.
- 2. Use the circular Multi selector on the back of the camera—with arrows pointing left, right, up, and down—to scroll up or down until your language is highlighted.
- 3. Press the OK button in the center of the Multi selector to select your language.

The camera will now switch to the second screen in the setup series, the Time zone screen.

Setting the Time Zone – Step 2

This is an easy screen to use as long as you can recognize the area of the world in which you live. Use the map shown in figure 1.2 to find your area, then select it.

Here are the steps to select the correct Time zone for your location:

1. Refer to figure 1.2 for the Time zone screen. You'll see yellow arrows pointing to the left and right on either side of the small black and gray world map.

Figure 1.2 - Setup Menu Time zone screen

- 2. With the Multi selector, scroll to the left or right until your world location is highlighted in yellow. You will see either a vertical yellow strip or a tiny yellow outline with a red dot. At the bottom of the screen you will see the currently selected Time zone. Mine is set to New York, Toronto, Lima (UTC-5), as shown in figure 1.2.
- 3. Press the OK button to lock in your Time zone.

The camera will now present you with the next screen in the series, the Date format screen.

Setting the Date Format - Step 3

The English-speaking world uses various date formats. The Nikon D600 allows you to choose from the most common ones. There are three date formats you can select (figure 1.3):

- Y/M/D Year/Month/Day (2013/12/31)
- M/D/Y Month/Day/Year (12/31/2013)
- D/M/Y Day/Month/Year (31/12/2013)

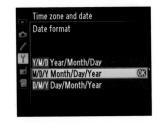

Figure 1.3 - Setup Menu Date format screen

U.S. residents usually select the M/D/Y format. However, you may prefer a different format.

Here are the steps to select the Date format you like best:

- 1. Refer to figure 1.3 for the Date format screen.
- 2. Using the Multi selector, scroll up or down to the position of the date format you prefer. M/D/Y is selected in figure 1.3.
- 3. Press the OK button to select the format.

When you have selected a Date format, the camera will switch to the Daylight saving time screen.

Setting Daylight Saving Time - Step 4

Many areas of the United States observe daylight saving time. In the springtime, many U.S. residents set their clocks forward by one hour on a specified day each year. Then in the fall they set their clocks back, leading to the clever saying, "spring forward and fall back."

You can use the Daylight saving time setting to adjust the time on your D600's clock forward or back by one hour, according to whether daylight saving time is currently in effect in your area.

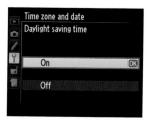

Figure 1.4 – Setup Menu Daylight saving time screen

To choose an initial Daylight saving time setting, follow these steps:

- 1. Refer to figure 1.4 for the Daylight saving time screen.
- 2. There are only two selections: On or Off. The default setting is Off. If daylight saving time is in effect in your area (spring and summer in most areas of the United States), select On. When daylight saving time ends, you will need to change this setting to Off (via the Setup Menu) to adjust the clock back by one hour.
- 3. Press the OK button to select your choice.

Now that you've made the Daylight saving time decision, the camera will move on to the last screen in the series of five setup steps, the Date and time screen.

Settings Recommendation: If you live in an area that observes daylight saving time, it's a good idea to adjust this setting whenever daylight saving time begins and ends. When you set the time forward or back on your wristwatch and clocks, you will need to adjust it on your camera as well. If you don't, your images will have metadata reflecting a time that is off by one hour for half the year. This setting allows you to adjust the camera's clock quickly by simply selecting On or Off.

Setting the Date and Time - Step 5

This screen allows you to enter the current date and time. It is in year, month, day (Y, M, D) and hour, minute, second (H, M, S) format.

Here are the steps to set the Date and time:

- 1. Refer to figure 1.5 for the Date and time screen.
- Use the Multi selector to scroll to the left or right and select the various date and time sections. Scroll up or down to set the values for

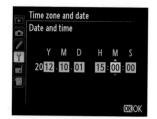

Figure 1.5 – Setup Menu Date and time screen

each one. The time values use a 24-hour clock, or military time. Use the 12- to 24-Hour Time Conversion Chart on page 270 to convert the 12-hour time you are probably using (for example, 3:00 p.m. is 15:00:00).

3. Press the OK button when you have entered the Date and time.

This completes the initial camera setup, and you are now ready to start configuring other parts of the camera in whatever order you find convenient. You'll use the menu system, as described in the next section, to access individual configuration screens. Each configuration step described in this book is accompanied by all the screen graphics you'll need and step-by-step instructions on configuration choices.

Let's look at an overview of the menu system.

Accessing the Camera Menus

To access the various configurable menus in the D600, you'll use the MENU button on the back of the camera near the top left of the Monitor, Please remember the location of this button since it will be used often in this book (figure 1.6). To avoid unnecessary repetition in the upcoming chapters, I won't mention that you need to press the MENU button to get into the camera menus.

Figure 1.6 - Press the MENU button to open the menus

There are six primary menu systems in the camera, and this book has a chapter devoted

to each one. Let's take a brief look at the opening screens of the six menus, shown in figure 1.7. You get to these six menus by pressing the MENU button and scrolling up or down with the Multi selector. A selector bar with tiny icons will appear on the left side of the Monitor when you press the MENU button. You can see the selector bar at the left of each menu in figure 1.7.

As you scroll up or down in the selector bar, you'll see each menu appear on the Monitor, with its icon highlighted in yellow on the left side of the screen, and the menu on the right. The name of the menu you are currently using will be displayed at the top of the screen.

The order of the six menus in the D600 is as follows (figure 1.7):

- Playback Menu
- · Shooting Menu
- Custom Setting Menu
- · Setup Menu
- · Retouch Menu
- · My Menu or Recent Settings

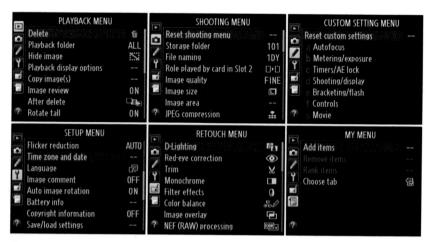

Figure 1.7 – Six primary camera menus

Notice that My Menu can be toggled with an alternate menu called Recent Settings. These two menus can't be active at the same time. My Menu is much more functional for most people, so it is shown in figure 1.7. The chapter titled My Menu and Recent Settings covers both of these options in detail so you can choose which one you want to appear most of the time on your camera. My Menu allows you to add the most-used menu items from any of the other menus to your own personal menu, and Recent Settings shows you the last 20 menu items you've changed.

Camera Functions for Initial Configuration

The following is a list of functions that you may want to configure before you take many pictures. These set up the basic parameters for camera usage. Each function is covered in great detail on the page number shown, so I did not repeat the information in this chapter. Please turn to the indicated page and fully configure the function, then return here and move on to the next function. When you are done, your camera will be ready for use.

Setup Menu

- Format memory card Page 253
- Monitor brightness Page 258
- Auto image rotation Page 275
- Copyright information Page 277

Shooting Menu

- Role played by card in Slot 2 Page 65
- Image quality Page 67
- Image size Page 75
- JPEG compression Page 81
- NEF (RAW) recording Page 83
- · White balance Page 87
- Set Picture Control Page 90
- Color space Page 109
- · Active D-Lighting Page 112
- Vignette control Page 119
- Long exposure NR Page 121
- · High ISO NR Page 124
- ISO sensitivity settings Page 126
- · Movie settings Page 146

Playback Menu

- Playback folder Page 25
- Playback display options Page 30
- Image review Page 43
- Rotate tall Page 45

Custom Setting Menu

- a1 AF-C priority selection Page 157
- a2 AF-S priority selection Page 158
- a3 Focus tracking with lock-on Page 160
- c4 Monitor off delay Page 182
- d1 Beep Page 185
- · d2 Viewfinder grid display Page 188
- d7 File number sequence Page 194
- e1 Flash sync speed Page 204
- f2 Assign Fn button Page 227
- f3 Assign preview button Page 227
- f4 Assign AE-L/AF-L button Page 227

Of course, there are hundreds more functions to configure, and you may find one function more important than another; however, these are the functions that you ought to at least give a once-over before you use the camera extensively.

Personal Camera Settings Recommendations

All through the book I offer my personal recommendations for settings and how to use them. Look for the **Settings Recommendation** paragraph at the end of most sections. These suggestions are based on my own personal shooting style and experience with Nikon cameras in various types of shooting situations. You may eventually decide to configure things differently, according to your own needs and style. However, these recommendations are good starting points while you become familiar with your camera.

Things to Know When Reading This Book

Here are a few things that you'll need to remember as you read this book. There are a lot of buttons and controls on the camera body. I have provided a **Camera Body Reference** section in the front of the book and a downloadable document titled **Camera Control Reference** that you can download from the website for this book. See the links to the downloadable resources in the next section.

What's the difference between these two resources? The **Camera Body Reference** is a place to go when you want to locate a control, including covers and doors, and the **Camera Control Reference** provides a deeper discussion of each button, dial, and switch on the camera.

I use Nikon-assigned names for the controls on the camera, as found in the Nikon D600 User's Manual. For instance, I may say something like "press the Playback zoom out/thumbnails button" to show you how to execute some function, and you'll need to know where this button is located. Use the **Camera Body Reference** in the front of the book to memorize the locations of the camera controls.

I have provided page number references to the Nikon D600 User's Manual at the beginning of most sections in case you want to refer to it for additional information about the camera settings. Using the Nikon manual is entirely optional and is not required to fully learn how to use your camera with this book. If you have no interest in using the Nikon manual, simply ignore the page number references.

Downloadable Resources Website

To keep this book small enough to carry as a reference in your camera bag, I have provided some less-used information in downloadable documents on these websites:

http://www.nikonians.org/NikonD600 http://rockynook.com/NikonD600

I will refer to these documents throughout the book when they apply to the material being discussed.

Playback Menu

Bountiful Harvest - Marcel Carey (mcpianoca)

In chapter 1 you configured your camera for picture taking your way. This chapter, and the next several chapters, will consider the camera's menu systems. The D600 has seven menus, with literally hundreds of configuration options. We'll examine each setting in each menu.

Remember, you will press the MENU button to enter the camera's menu system. The Playback Menu, which we'll consider in detail in this chapter, is first in the list of menus (figure 2.0).

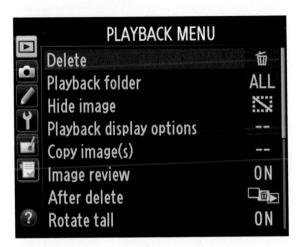

Figure 2.0 - The Playback Menu

Since this menu controls how the Monitor displays images, you'll need to learn how to use it well. You'll be taking thousands of pictures and will view most of them on the Monitor.

By now you may have quite a few pictures on your memory card. The Playback Menu has everything you need to control image playback, copying, and printing. They are as follows:

- Delete Allows you to delete all or selected images from your camera's memory card(s).
- **Playback folder** Allows you to set which image folders your camera will display, if you have multiple folders on the camera's memory card(s).
- Hide image Lets you conceal images so they won't display on the Monitor.
- *Playback display options* Controls how many informational screens the camera will display for each image.
- Copy image(s) Gives you functions to copy images between the two memory cards.
- Image review Turns the camera's postshot automatic image review on or off.
- After delete Determines which image is displayed next when you delete an
 image from a memory card.

- Rotate tall Allows you to choose whether portrait-orientation images (vertical) display in an upright position or lying on their side on the horizontal Monitor.
- Slide show Allows you to display all the images on your camera's memory card(s) in a sequential display, like the slide shows of olden days (pre-2002). No projector is required.
- DPOF print order Lets you print your images directly from a PictBridgecompatible printer without using a computer—either by using digital print order format (DPOF) directly from a memory card or by connecting a USB cable to the camera.

Now, let's examine each of these settings in detail, with full explanations on how, why, and when to configure each item.

Technical LCD Monitor Information

The D600 has a 3.2-in (8-cm) Monitor with enough resolution, size, and viewing angle to really enjoy using it for previewing images. It has VGA resolution (640×480), based on a 921,000 dot liquid crystal display (LCD). If anything you read says the LCD Monitor has 921,000 pixels of resolution—or is significantly higher than VGA—the writer is uninformed. Nikon lists the resolution as 921,000 dots, not pixels. Don't let the numbers boggle your mind. The bottom line is that this three-inch screen has amazing clarity for your image previewing needs. You can zoom for review up to 38x for Large (L) images, 28x for Medium (M) images, and 19x for Small (S) images. That's zooming in to pixel-peeping levels. Now, if you want to get technical, here's the extra geek stuff. A pixel on your camera's Monitor is a combination of three color dots-red, green, and blue (RGB). The three dots, when blended together, provide shades of color and are equal to one pixel. This means the Monitor is limited to onethird of 921,000 dots, or 307,000 pixels of real image resolution. The VGA standard has 307,200 pixels (640 × 480), so the resolution of the Monitor on your D600 is basically VGA resolution.

Delete

(User's Manual – Page 190)

The Delete function allows you to selectively delete individual images from a group of images in a single folder or multiple folders on your camera's memory card. It also allows you to clear all images in the folders without deleting the folders. This is sort of like a card format that affects only images, and not folders. However, if you have protected or hidden images, this function will not delete them.

- Selected Deletes only selected images.
- Select date Deletes all images taken on a certain date.
- All Deletes all images in the folder you currently have selected with the Playback folder function (see the next main section). If a memory card is inserted in both slots, you can select the card from which to delete images.

Selected

Figure 2.1 shows the menu screens you'll use to control the Delete function for selected images.

Notice in screen 3 of figure 2.1 that there is a list of images, each with a number in its lower-right corner. These numbers run in sequence from 1 to however many images you have in your current image folder or on the entire memory card. The number of images shown will vary according to how you have the Playback folder settings configured. (See the next section of this chapter, **Playback Folder**.)

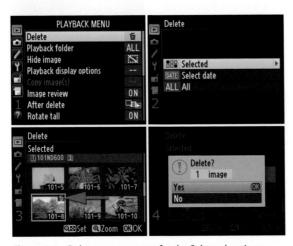

Figure 2.1 - Delete menu screens for the Selected option

If you have Playback folder set to Current (factory default), the camera will show you only the images found in your current playback folder. If you have Playback folder set to All, the D600 will display all the images it can find in all the folders on your camera's memory card.

Here are the steps to delete one or more images:

- Select Delete from the Playback Menu and scroll to the right (figure 2.1, screen 1).
- 2. Choose Selected and scroll to the right (figure 2.1, screen 2).
- 3. Locate the images for deletion with the Multi selector and then press the checkered Playback zoom out/thumbnails button. This button will mark or unmark images for deletion. It toggles a small trash can symbol on and off on the top right of the selected image (red arrow in figure 2.1, screen 3).
- 4. Select the images you want to throw away, then press the OK button. A screen will appear and ask you to confirm the deletion of the images you have selected (figure 2.1, screen 4).
- 5. To finish deleting the images, select Yes and press the OK button. To cancel, select No and press the OK button (figure 2.1, screen 4).

Note: Since the D600 has multiple card slots, many functions can affect multiple memory cards when *Playback Menu > Playback folder > All* is selected. How can you tell which memory card is being affected by the current function? Notice in figure 2.1.1 that there are two tiny SD card symbols in the top left corner (at the red arrows). Each card slot has a number: 1 or 2. If there is no memory card in one of the slots, the number for that slot will be grayed out.

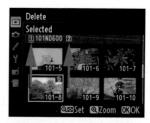

Figure 2.1.1 – Active memory card slot

As you use functions that affect displayed images, the memory card symbol will be underlined for the card that contains the image you are modifying. In figure 2.1.1, it is apparent that there two memory cards in the camera because the second card is not grayed out. The memory card in slot 1 contains the image that is currently selected, so the memory card symbol for slot 1 is underlined in yellow.

As you scroll through your images, notice that the yellow underline jumps to whichever card contains the image you are highlighting at that moment, if you have images on both memory cards. As you work through this book, pay attention to which memory card contains the picture you are working with. The one containing the currently displayed image will be underlined in yellow.

Select Date

Using the Select date method is simple. When you preview your images for deletion, you won't be shown a list of all the images, as with the Delete option. Instead, the Select date screen (figure 2.2, screen 3) will give you a list of dates with a single representative image following each date.

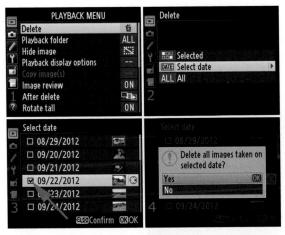

Figure 2.2 - Delete menu screens for the Select date option

Here are the steps to delete images by Select date:

- 1. Select Delete from the Playback Menu and scroll to the right (figure 2.2, screen 1).
- 2. Choose Select date and scroll to the right (figure 2.2, screen 2).
- 3. Notice that there's a check box to the left of each date (figure 2.2, screen 3). Check a box by scrolling up or down to the date of your choice with the Multi selector and then scrolling to the right until you see a tiny black symbol that represents the Multi selector. This checks the box and tells the camera to delete all images that have the checked date. If the single tiny representative image next to the date is not sufficient to help you remember which images you took on that date, you can view them. Press the checkered Playback zoom out/thumbnails button, and the D600 will switch to the images for that date. If you want to examine an image more closely, you can hold in the Playback zoom in button to temporarily zoom in on individual images. When you're satisfied that none of the images for that date are worth keeping, and while you are still examining images for a single date, press the OK button to select the date, or press the Playback zoom out/thumbnails button to return to the list of all dates.
- 4. Make sure the date you want to delete is checked as described in step 3, and press the OK button to start the image deletion process (figure 2.2, screen 3).
- 5. A final screen will ask you to confirm your deletion (figure 2.2, screen 4). This screen has a big red exclamation point and asks, *Delete all images taken on selected date?* If you scroll to Yes and press the OK button, the images will be deleted. Be careful! If you decide not to delete them, press the MENU button to cancel the operation.

All

This option is like formatting a card, except that it will not delete folders. It will delete only images, except for protected or hidden images (figure 2.3). Using this option is a quick way to format your card while maintaining your favorite folder structure.

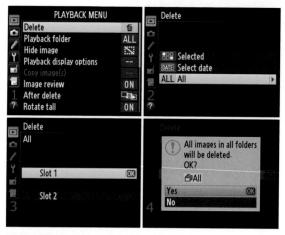

Figure 2.3 - Delete menu screens for the All option

Here are the steps to delete all images on the card (or in the current folder):

- 1. Select Delete from the Playback Menu and scroll to the right (figure 2.3, screen 1).
- 2. Choose All and scroll to the right (figure 2.3, screen 2).
- 3. Select the slot from which to delete images. Notice that both Slot 1 and Slot 2 are available (figure 2.3, screen 3). If there is a memory card missing from one of the slots, it will be grayed out and unavailable. Press the OK button to choose the slot.
- 4. Choose Yes from the next screen with the big red exclamation point and dire warning of imminent deletion (figure 2.3, screen 4). **Be very careful from this point forward!** If you have Playback folder set to ND600, the camera will delete all images in *every* folder that was created by the D600, and the warning will say, *All images will be deleted. OK?*, followed by *ND600*. If you have Playback folder set to Current, the camera will delete only the images in the folder that is currently in use, and the warning will say, *All images will be deleted. OK?*, followed by *Current*. If you have Playback folder set to All, the camera will delete all images in all folders, and the warning will say, *All images in all folders will be deleted. OK?*, followed by *All*. The camera is prepared to delete every image in every folder (created by any camera) on the selected memory card if *Playback Menu > Playback folder > All* is selected. (See the next main section for

information on the Playback folder option). When you select Yes and press the OK button, a final screen with the word Done will pop up briefly.

Being the paranoid type, I tested this thoroughly and found that the D600 really will not delete protected and hidden images, and it will keep any folders you have created. However, if you are a worrier, maybe you should transfer the images off the card before deleting any images.

Settings Recommendation: I don't use the All function often since I usually don't create special folders for each type of image. If you maintain a series of folders on your memory card(s), you may enjoy using the All function. Most of the time, I just use Selected and remove particular images. Any other time I want to clear the card, I use the Format memory card function on the Setup Menu or hold down the two buttons with the red Format label next to them. We'll discuss formatting the memory card in the chapter titled Setup Menu, under the heading Format Memory Card.

Another way I get rid of images I don't want is to view them on the Monitor by pressing the Playback button and then press the Delete button.

Protecting Images from Deletion

The Nikon D600 will allow you to protect images from accidental deletion when you use the Delete function. Using this method will not protect images from deletion when you format the memory card.

To mark an image as protected from deletion, you will use the Help/protect button, as shown in figure 2.3.1 and the upcoming steps.

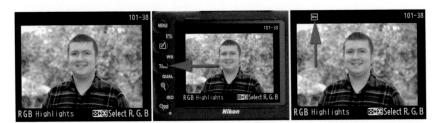

Figure 2.3.1 – Protecting images from deletion

Use the following steps to protect individual images from accidental deletion (figure 2.3.1):

- 1. Display an image on the Monitor (figure 2.3.1, first screen).
- 2. Press the Help/protect button (figure 2.3.1, middle screen, red arrow).
- 3. A small key symbol will appear in the upper left of the Monitor, signifying that this image is protected from the Delete function (figure 2.3.1, last screen, red arrow).

If you have several images protected from deletion and decide you want to remove the protection, you can follow the previous steps again, which will remove the key symbol and protected status.

You can also remove protection from all protected images at once by following these steps:

- 1. Display any image on the Monitor (in Playback mode). It does not have to be a protected image (figure 2.3.2, first screen).
- 2. Hold down both the Help/protect button and the Delete button for about two seconds (figure 2.3.2, middle screen).
- 3. A screen will appear asking you, Remove protection from all images? (figure 2.32, last screen). Press the Delete button, and after several seconds a screen will flash up briefly with the message, Marking removed from all images. At this point all deletion protection and key symbols have been removed from all images.

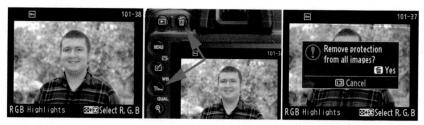

Figure 2.3.2 – Removing protection from all protected images at once

Recovering Deleted Images

If you accidentally delete an image or a group of images, or even if you format the entire memory card and then realize, with great pain, that you didn't really mean to, all is not lost. Immediately remove the card from your camera and do not use it until you can run image recovery software on the card. Deleting or formatting doesn't permanently remove the images from the card. It merely marks them as deleted and moves the references to the images to the memory card's file allocation table (FAT). The images are still there and can usually be recovered as long as you don't write any new data to the card before you try to recover them. It's wise to have a good image recovery program on your computer at all times. Sooner or later you'll have a problem with a card and will need to recover images. Many of the better brands of memory cards include recovery software, either on the card itself or on a separate CD that comes with the card. Make sure you install the software on your computer before you format the brand new memory card! My favorite image recovery software is File Recover by PC Tools (www.pctools.com/file-recover/). I've used it several times to recover lost files from damaged memory cards, and it works very well. It will also recover other standard file types, such as MP3 files, on any hard drive or memory card.

Playback Folder

(User's Manual - Page 207)

The Playback folder setting allows your camera to display images during preview and slide shows. You can have the D600 show you images only in the current image folder that was created by the D600, in the current image folder that was created by another Nikon camera, or in all the folders on the memory card.

If you regularly use your memory card in multiple cameras, as I do, and sometimes forget to transfer images, adjusting the playback folder is a good idea. I use a D600, D300S, and D7000 on a fairly regular basis. Often I grab a memory card out of one of the cameras and stick it in another one for a few shots. If I'm not careful, I'll later transfer the images from one camera and forget that the memory card has more folders created by the other camera. It's usually only after I have formatted the memory card that I remember the other images. The D600 comes to my rescue with its *Playback folder* > *All* function.

Let's look at how the Playback folder function works by first looking at the menu screens in figure 2.4. There are three selections you can choose from:

- ND600
- All
- Current

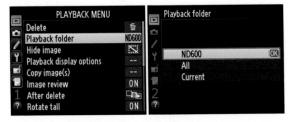

Figure 2.4 - Selecting a Playback folder source

Let's discuss each individually.

ND600

The camera will display images created by the D600 from any folder on any memory card. If there are other folders created by a different camera, they will be ignored and no images within them will be displayed.

AII

When you select All, your D600 will obligingly show you every image it can find in all folders on the memory card that were created by any Nikon camera. This

maximum flexibility setting has saved me several times when I remembered to check my camera for images before I formatted a card because I could see that I had other images on the card besides D600 images.

Each camera usually creates its own unique folders, and normally the other cameras do not report that they are there, except by showing a reduced image capacity. The D600 intelligently displays its own images and other Nikon-created images on the card.

Current

This is the most limited playback mode. Images in whatever playback folder your camera is currently using will be displayed during playback, whether the images were created by the D600 or another Nikon camera. No other images in any other folders will be displayed.

Use the following steps to select the folder(s) from which your camera will display images:

- 1. Select Playback folder from the Playback Menu and scroll to the right (figure 2.4, screen 1).
- 2. Choose ND600, All, or Current and press the OK button (figure 2.4, screen 2).

Settings Recommendation: Using anything except All makes it possible for you to lose images. If you don't have other Nikon cameras, this may not be a critical issue. However, if you have a series of older Nikon cameras around, you may switch memory cards among them.

If there's an image on any of my memory cards, I want to see it. Until I started using the All setting, I regularly formatted cards with forgotten images on them. The images can often be recovered with file recovery software, but sometimes a few of them can't. From my pain comes a strong recommendation: use All!

Playback Folder and Hidden Images

The display of images to select for hiding (see the next section) obeys the Playback Menu > Playback folder selection that we considered in this section. You can hide only the images you can see in the Hide image selection screen. If you don't have All selected for Playback Menu > Playback folder, you may not see all of the images on the card. If you regularly hide images, you may want to leave your Playback folder set to All. That way, all the images on the card will appear on the Hide image screen, and you can select any of them to hide.

Hide Image

(User's Manual - Page 208)

If you sometimes take images that would not be appropriate for others to view until you have a chance to transfer them to your computer, the Hide image setting is for you. You can hide one or many images, and when they are hidden, they cannot be viewed on the camera's Monitor in the normal way. After they are hidden, the only way the images can be viewed again in-camera is by using the Deselect all? function shown in figure 2.5, screen 2.

There are three selections in the Hide image menu:

- Select/set
- Select date
- Deselect all?

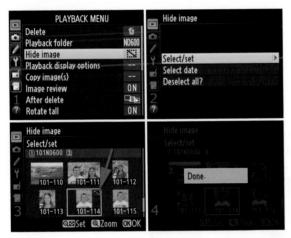

Figure 2.5 - Hide images with Select/set

Select/Set

This selection allows you to hide one or many images (figure 2.5, screen 3). Here's how to hide an image:

- 1. Select Hide image from the Playback Menu and then scroll to the right (figure 2.5, screen 1).
- 2. Choose Select/set from the list and then scroll to the right (figure 2.5, screen 2).
- 3. Scroll to the image you want to hide and press the Playback zoom out/thumbnails button to Set the image. You'll see a little dotted rectangle with a slash symbol appear in the top right corner of the image you've selected (red arrow in figure 2.5, screen 3). You can do this multiple times to select several images.
- 4. Press the OK button to hide the image(s). Done will appear on the Monitor when the hiding process is complete.

2

The number of images reported does not change when you hide images. If you have 50 images on the card and you hide 10, the camera still displays 50 as the number of images on the card. A clever person could figure out that there are hidden images by watching the number of images as they scroll through the viewable ones. If you hide all the images on the card and then try to view images, the D600 will tersely inform you, *All images are hidden*.

You can also use these steps to unhide one or many images by reversing the process described earlier. As you scroll through the images, as shown in figure 2.5, screen 3, you can deselect them with the Playback zoom out/thumbnails button and then press the OK button to unhide them.

While you are selecting or deselecting images to hide, you can use the Playback zoom in button to see a larger version of the image you currently have selected. This lets you examine the image in more detail to see if you really want to hide it.

Select Date

This function allows you to hide a series of images according to the date they were taken. You might have been shooting a nature series in the Great Smoky Mountains one day and a glamour series for a national magazine the next day. You wouldn't mind your kids seeing the nature shots, but you might not want them to see the more glamorous ones. So you simply select the date(s) you took the glamour shots and hide them.

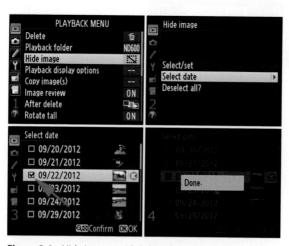

Figure 2.6 – Hide images with Select date

- 1. Select Hide image from the Playback Menu and then scroll to the right (figure 2.6, screen 1).
- 2. Choose Select date from the list and then scroll to the right (figure 2.6, screen 2).
- 3. Now you can select the date of the images you want to hide from the list of available dates by scrolling up or down with the Multi selector (figure 2.6, screen 3). When your chosen date is highlighted, scroll to the right where you see a tiny symbol that represents the Multi selector, and a check mark will appear in the box to the left of the date (red arrow in figure 2.6, screen 3). If you'd like to review the images from a certain date before hiding them, simply select the date in question and press the Playback zoom out/thumbnails button. This will display only the images from the selected date on the Monitor. You can review individual images in detail by highlighting an image and pressing the Playback zoom in button. Or you can press the Playback zoom out/thumbnails button to return to the date screen.
- 4. The images taken on this date are now selected for hiding. If you press the OK button, all the images with the selected date will be hidden immediately, and the camera will return to the main Playback Menu after displaying *Done* (figure 2.6, screen 4).

Deselect All?

This is a much simpler way to unhide the previously hidden images on the card all at once. Here are the screens and steps used to unhide (deselect) all images marked as hidden:

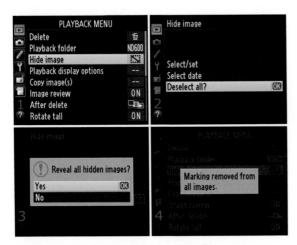

Figure 2.7 - Unhide images with Deselect all? option

- 1. Select Hide image from the Playback Menu and then scroll to the right (figure 2.7, screen 1).
- 2. Choose Deselect all? from the list and then scroll to the right or press the OK button (figure 2.7, screen 2).
- 3. At the *Reveal all hidden images?* screen, select Yes and press the OK button. An hourglass will appear for several seconds, and all hidden images on the card will then be marked as viewable (figure 2.7, screen 3).
- 4. After the images are unhidden, the Monitor will display *Marking removed from all images* (figure 2.7, screen 4).

Unhide Images Removes Protection Too

If you have images that are both hidden and protected and then you unhide them, the delete protection is removed at the same time.

Playback Display Options

(User's Manual - Page 209)

The *Playback display options* selection allows you to customize how the D600 displays several histogram and data screens for each image. You get to those screens by displaying an image on the camera's Monitor and scrolling up or down with the Multi selector.

When you want to see a lot of detailed information about each image, you can select it here. Or, if you would rather take a minimalist approach to image information, simply turn off some of the screens. The None screen is the ultimate minimalist screen because it displays nothing except the image itself with no information overlays.

If you turn off certain screens, the camera still records the information for each image, such as lens used, shutter speed, and aperture. However, with no data screens selected, you'll see only two screens when you scroll up or down. One is the main image view, and the other is a summary screen with a luminance histogram and basic shooting information. Those two screens are the basic image display screens, and they cannot be disabled.

You get to the additional screens by using the Multi selector to scroll vertically. I leave my camera set so I can scroll through my images by pressing left or right on the Multi selector. Then I can scroll through the data screens by scrolling up or down with the Multi selector.

Following are the photo information choices in the Playback display options menu:

Basic photo info

Focus point

Additional photo info

- None
- Highlights
- · RGB histogram
- Data

When you modify these selections, be sure to scroll up to Done and press the OK button to save your settings (figure 2.8, screen 3).

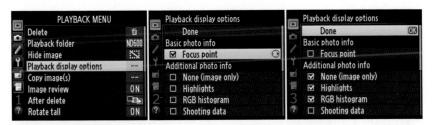

Figure 2.8 - Selecting Playback display options photo info

Use the following steps to enable or disable any of the five Playback display options screens:

- 1. Select Playback display options from the Playback Menu and scroll to the right (figure 2.8, screen 1).
- 2. Choose any of the five available screens by highlighting an option with the Multi selector and scrolling to the right to put a check mark in the box for that item (figure 2.8, screen 2).
- 3. After you have check marks in all the boxes for the screens you want to use, scroll up to Done and press the OK button (figure 2.8, screen 3).

Now, let's look at what each of these selections accomplishes (figures 2.9 to 2.12).

None (Image Only)

This setting is designed to give you a somewhat larger view of the current image, using all of the available Monitor screen space to show the image (figure 2.9, screen 2). There are no text overlays, just the image by itself. This is a good selection for when you want to more easily evaluate an image and zoom in to look at details.

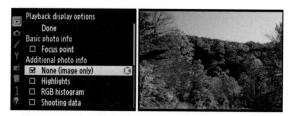

Figure 2.9 - Enabling the None (image only) display

Since only the image itself is displayed, it is easier to scroll around within it when you use the camera's two zoom buttons (Playback zoom in and out). You can zoom all the way in to 38× the normal image view. There is a tremendous level of detail buried inside each 24.3 MP image.

Focus Point

If you are curious about which autofocus (AF) point was focused on your subject during an exposure, use this mode to easily find out. If you used Single-point AF or Dynamic-area AF, you'll see a single red AF indicator where the camera was focused when you took the picture.

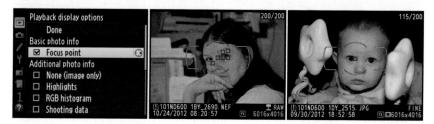

Figure 2.9.1 - Enabling the Focus point display

Focus point is a useful function for reviewing how the camera's AF system performs in different imaging situations. If you are using Auto-area AF you'll see several red focus points that provided AF in your image (figure 2.9.1, screen 2). If you were using Single-point AF, Dynamic-area AF, or 3D-Tracking, you will see only one red focus point. In figure 2.9.1, screen 3, you can see the red focus point on the corner of the baby's right eye. (We will discuss AF-area modes in detail in the chapter titled Autofocus, AF-Area, and Release Modes.)

Highlights

If you put a check mark next to the Highlights selection, as shown in figure 2.10, screen 1, you will turn on what I call the blink mode. You'll see the words RGB Highlights at the bottom left of the image (figure 2.10, screens 2 and 3).

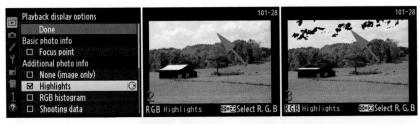

Figure 2.10 - Enabling the Highlights display (blinks white to black and repeats)

When you have Highlights enabled and you see a blinking white and black area in an image on the Monitor, it means that particular area of the image has turned completely white and lost all detail, or blown out (become too bright). Of course, there is no way to display a blinking image in a printed book, so screens 2 and 3 in figure 2.10 represent the white and black blinks, respectively. You can see the overexposed clouds at the red arrows near the tops of figure 2.10, images 2 and 3. Additionally, the letters RGB will be highlighted in yellow and will blink. You will need to use exposure compensation or manually control the camera to contain the exposure within the dynamic range of the camera's sensor.

If you examine the histogram of our example image, you will note that it is a mildly overexposed image. You can see that the histogram is cut off, or clipped, on the right side (red arrow in figure 2.10.1) or is past the right edge of the window.

Current software cannot usually recover any image data from the blown-out sections. The exposure has exceeded the range of the sensor and has become completely overexposed in the blinking area. We will discuss how to deal with

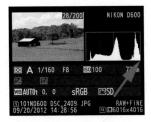

Figure 2.10.1 – Histogram is clipped on the highlight side

images that have light ranges exceeding the sensor's recording capacity in the chapter called Metering, Exposure Modes, and Histogram.

Highlights mode conveniently warns you when you have surpassed what the sensor can capture and lets you know that portions of the image are overexposed.

Note: You should learn to use the histogram on your camera! In my opinion, it is as important as the exposure meter. It will inform you when you have overor underexposed part or all of your image. If you faithfully evaluate your images with the histogram immediately after you take them, you will be able to judge when an image is correctly exposed and will come away with the best exposures vou have ever made.

In the next section we will consider how to enable and use the histogram screens on your camera.

RGB Histogram

A histogram is a digital readout that shows the range of light and color in an image. If there is too much contrast, the histogram will be cut off. We'll examine the histogram in great detail later. For now, let's take a quick look at the screen that will appear if you turn this feature on.

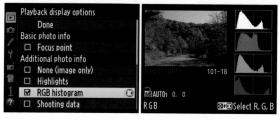

Figure 2.11 - Enabling the RGB histogram display

I like this feature because it allows me to view not just a basic luminance (brightness) histogram like some cameras, but all three color (chrominance) histograms—red, green, and blue (RGB)—and a luminance histogram on one screen (figure 2.11). The D600 stacks the four histograms on the right side of the screen, with the luminance histogram on top (white) and the RGB color histograms underneath.

It is quite useful to see each color channel in its own histogram since it is possible to overexpose, or blow out, only one color channel. The luminance histogram is usually very similar to the green channel histogram because green is the most common color.

Shooting Data

This setting will give you up to four additional image data screens to scroll through; each contains quite a bit of detail (metadata) about the image. These screens overlay a dim version of the actual picture they represent.

The data on these screens includes the following information (figure 2.12):

Shooting data, first screen (figure 2.12, screen 2)

- Light meter in use (Matrix, Spot, or Averaging), Shutter speed, and Aperture
- Exposure (shooting) mode (P, S, A, M) and ISO sensitivity
- Exposure compensation value and exposure tuning (if used)
- Focal length (e.g., 55mm)
- Lens overview (e.g., 24–85mm f/3.5–4.5)
- Focus mode (AF) and vibration reduction (VR) settings
- · Flash type (e.g., Auto, Slow sync, Red-eye reduction, Fill flash) and Commander mode (e.g., CMD)
- Flash control and compensation (e.g., M:TTL +0.7)

Shooting data, second screen (figure 2.12, screen 3)

- White balance (e.g., Color temp, fine tuning, PRE)
- Color space (sRGB, AdobeRGB)
- Picture control detail (e.g., Neutral, Standard, Vivid)
- Quick adjust settings: Base, Sharpening, Contrast, Brightness, Saturation, Hue

Shooting data, third screen (figure 2.12, screen 4)

- Noise reduction (High ISO NR and Long exposure NR)
- Active D-Lighting (Off, Low, Normal, High, Extra high, Auto)
- HDR exposure differential and smoothing settings (e.g., Auto, High)
- Vignette control settings (Off, Low, Normal, High)
- Retouch history (e.g., D-Lighting, Warm filter, Trim)
- Image Comment (you can add up to 36 characters)

Shooting data, fourth screen (figure 2.12, screen 5)

- Artist (you can add your name, up to 36 characters)
- Copyright (you can add the copyright holder, up to 54 characters)

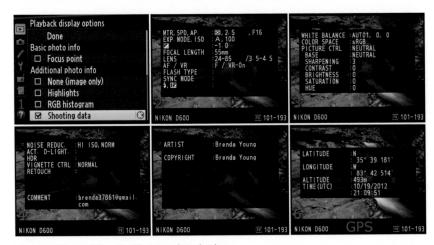

Figure 2.12 - Enabling the Shooting data display

Note: If you take a picture with a GPS unit attached and active on your D600, you'll have an additional screen available—even if you don't have any other Shooting data screens selected. Figure 2.12, screen 6, shows the GPS screen. The GPS data screen shows Latitude, Longitude, Altitude, and Time (UTC). The GPS screen is not controlled by the Playback display options setting. It will appear after the Shooting data screens if a GPS was mounted at the time you took a picture. It will not appear if no GPS was active.

Those are a lot of screens to scroll through, but they provide a great deal of information about the image. Look how far we've come from the days when

cameras wrote date information on the lower right of the image (permanently marking it) or between the frames on pro-level cameras.

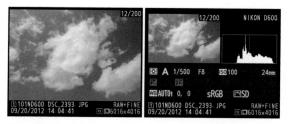

Figure 2.13 - These two display screens are always available

Including the two standard display screens shown in figure 2.13, there are eight screens just brimming with data on the D600—plus the GPS screen. You can get by with the main image display (figure 2.13, left) and one summary display (figure 2.13, right), which are always available. The summary display is a condensation of the most important shooting information. It even includes a small luminance histogram.

Settings Recommendation: I always leave the Highlights (figure 2.10) and RGB histogram (figure 2.11) displays turned on because I want to confirm that I'm not accidentally blowing out important sections of my image. The Highlights blink mode warns me when my images have overexposed areas, allowing me to adjust my exposure and reshoot the image. The RGB histogram allows me to see all the color channels in case one of them is clipped off on the light or dark sides. It also allows me to see how well I am keeping my exposure balanced for light and dark. The Shooting data screens are not very important to me because I use the summary screen (figure 2.13, screen 2) with only the most important exposure information displayed. Also, if I enable the Shooting data screens, I have to scroll through four more screens to get to my RGB histogram screen.

Copy Image(s)

(User's Manual - Page 209)

The D600 provides a means to Copy image(s) between the camera's two card slots. I'll refer to the camera's two SD/SDHC/SDXC card slots as simply the SD cards slots. If you've been shooting and decide you want a backup on the other card or want to give images to someone else, you can use this function to copy images between the two cards.

This convenient function has several steps: select a source card (if both cards have images) and the source folder; then select the images to copy; then select the folder on the destination card in which you want to place the images.

Figure 2.14 shows the screens used to Copy image(s). First you'll need to select an image source. If Select source is grayed out, there are two potential reasons, which are explained after the following steps.

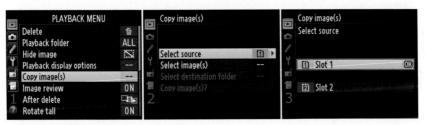

Figure 2.14 – Selecting a source for images to copy

Refer to figure 2.14 and follow these steps to select a source card:

- 1. Select Copy image(s) from the Playback Menu and scroll to the right (figure 2.14, screen 1).
- 2. Choose Select source from the list and scroll to the right (figure 2.14, screen 2).
- 3. Choose one of the card slots (Slot 1 or Slot 2).
- 4. Press the OK button to lock in your choice.

Why is Select source grayed out? - When I first opened the menu shown in figure 2.14, I found only one item available: Select image(s). The rest of the choices were grayed out. I figured out that there are two reasons Select image(s) may be the only option available. First, there might be images on only one of the cards. If only one card contains images, it has to be the source. This is the most likely scenario. Second, the SD card's write-lock switch might be in the on position. The switch is on the side, and sometimes when you insert the card into a card reader or a camera at a slight angle the switch accidentally gets moved from the off position to the on position. Remove the card and unlock it. See the sidebar titled Accidentally Insertina a Write-Locked Card for more information about what happens when a write-locked card is inserted into one of the camera's memory card slots.

The following instructions assume that you have a card in each slot and images on both cards. If you have images on only one card, you can skip this process.

When you have chosen a source, it's time to select images to copy. It's a somewhat complex process to describe but fairly easy to use.

Accidentally Inserting a Write-Locked Card

The camera cannot write to an SD card with the write lock set to on. If the locked SD card is the only one inserted into the camera, you will see the word CArd blinking on the Control panel (yes, for some reason it has an uppercase A). Also, if you press the Shutter-release button, a message will appear on the Monitor saying, Memory card is locked. Slide lock to "write" position. If there are two memory cards in the camera and one of them is locked, a blinking card slot icon will appear on the Control panel and Information display screen (press the Info button once to see the Information display screen). The blinking card symbol on the Information display screen will have a key icon in the middle, which means the card needs to be unlocked. If you don't notice the blinking card icons, it may take a while to realize that you've accidentally moved the write-lock switch to the locked position on one of the cards. The camera is smart enough to write to the other SD card when it can't access one of them, so you may be happily snapping images, thinking they are being saved to the primary SD card (Slot 1) when they are actually being sent to the secondary card (Slot 2), or vice versa. The camera will continue displaying images found on the locked SD card if it contains images and the Playback folder is set to All in the Playback Menu. The D600 can still read the card and display images from a write-locked SD card.

First, follow these steps to choose a folder:

1. Choose Select image(s) from the list and scroll to the right (figure 2.15, screen 1).

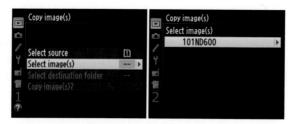

Figure 2.15 – Selecting a source folder for images to copy

2. Choose the folder that contains the images you want to copy (figure 2.15, screen 2). My camera happens to be using a folder named 101ND600. Your camera may have several folders available, or only one. After you have chosen a folder, scroll to the right.

- 3. There are three options for copying images: Deselect all, Select all images, and Select protected images (figure 2.16). Each option has a slightly different way of doing things. Choose only one option for your copy operation, follow the directions for your chosen option, then continue with step 4.
 - **Deselect all** Choose Deselect all and then scroll to the right (figure 2.16, screen 1). Deselect all opens a list of images, none of which have been selected. It sounds a little weird to select images for copying with a function named Deselect all, but this means that the camera automatically deselects all the images so you can choose which new images to copy. You'll need to scroll around with the yellow rectangle and select images one at a time. Mark (Set) an image for copying by pressing the Playback zoom out/ thumbnails button, and you'll see a small white check mark appear in the top-right corner of the image thumbnail. Figure 2.16, screen 2 (red arrow), shows only one picture selected, number 101–11. It's the only one with a check mark. Now move on to step 4.

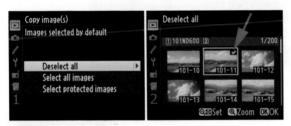

Figure 2.16 - Deselecting all images to copy

Select all images - Choose Select all images and scroll to the right (figure 2.17, screen 1). The Select all images screen will appear, with all images selected (they all have check marks, as shown in figure 2.17, screen 2). If you want to copy all of the images, move on to step 4 now. If you want to deselect a few of them before copying, scroll to an image and press the Playback zoom out/thumbnails button. This action will remove the check mark from the image thumbnail. After you've unchecked the images you don't want to copy, move on to step 4.

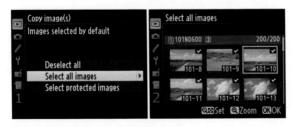

Figure 2.17 – Selecting all images to copy

Select protected images – Choose Select protected images and scroll to the right (figure 2.18, screen 1). If you have used the Help/protect (WB) button to mark images as protected, they will appear with a key symbol and a check mark in the list of images, indicating that they are already checked for copying (red arrows in figure 2.18, screen 2). If you have many images on the card and only a few are protected, it may be hard to find the protected images. Rest assured that the camera knows which ones to copy. It will display all the images but only copy the protected ones. You can see the number of protected images that will be copied in the upper-right corner of the display (4/200). This figure shows that I will copy 4 protected images out of 200 images on the card in Slot 1 (from folder 101ND600). Now move on to step 4.

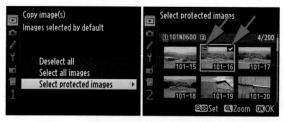

Figure 2.18 – Selecting protected images to copy

- 4. After you have selected all of the images you want to copy, press the OK button and the Monitor will display the Copy images(s) menu. Now it's time to select a destination folder into which you'll copy the images (figure 2.19).
- 5. Choose Select destination folder from the Copy image(s) menu and scroll to the right (figure 2.19). You will have two options: Select folder by number or Select folder from list (figure 2.20 and figure 2.21). Before we move on to

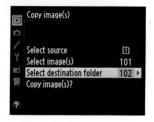

Figure 2.19 - Selecting a destination folder

step 6, let's investigate these two options. Pick an option, follow the instructions for your option, then move on to step 6. · Select folder by number - Choose Select folder by number from the Select

destination folder menu and scroll to the right (figure 2.20, screen 1). The next screen will display a folder number that can be changed to any number between 100 and 999 (figure 2.20, screens 2-4). If you select a number for a folder that already exists on the destination card, the images will be copied into that folder. If you select a folder number that does not exist on the destination card, the folder will be created and the source images will

be copied into the new folder on the destination card. Figure 2.20, screens 2-4, represent just one Select folder by number screen, and show the different conditions you may see when selecting a folder. Screen 2 (red arrow) shows that folder 101 exists and has some images in it. The folder symbol is partially full. Screen 3 (red arrow) shows that folder 102 does not exist (there is no folder symbol) and the camera will create it if selected. Screen 4 shows that folder 103 does exist, but it is empty. Now move on to step 6.

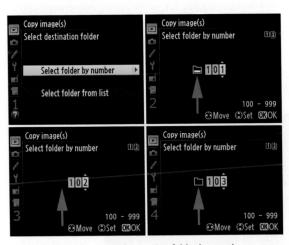

Figure 2.20 - Selecting a destination folder by number

Select folder from list – If there are no existing folders on the destination card, this option will be grayed out. Obviously you can't copy images to a folder that doesn't exist, so use the Select folder by number option to create a new folder. If this option is not grayed out, choose Select folder from list and scroll to the right (figure 2.21, screen 1). The next screen will display a list of folders. My list in figure 2.21, screen 2, has three folders in it. I chose to use the folder named 104ND600. After you have selected the destination folder, move on to step 6.

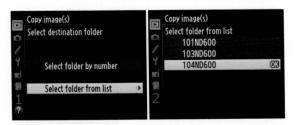

Figure 2.21 - Selecting a destination folder from a list of folders

- 6. Now it's finally time to copy some images. We've selected a source card and folder, some images, and a destination folder. Notice that you don't have to select a destination memory card. Since we've already selected a source card, the other card automatically becomes the destination. The D600 does not support copying images to the same memory card; you can copy only to the other card. All that's left is to select Copy image(s)? and press the OK button.
- 7. Figure 2.22 shows the screens for this step. After you have selected Copy image(s)?, you'll see a screen asking for verification. Mine says *Copy? 3 images* (figure 2.22, screen 2). Select Yes and press the OK button. Figure 2.22, screen 3, shows that the camera is *Copying 1/3* pictures from the source card to the destination card. Notice that the screen shows the progress of the copy action with a green progress bar. This will take several minutes to complete if you are copying a large number of images.

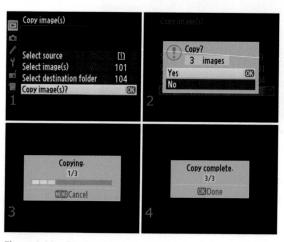

Figure 2.22 - Copying images

8. Figure 2.22, screen 4, shows the final screen in the series, signifying that the image copying process is complete. Press the OK button to return to the main menu.

There's one more screen to be aware of, in case you try to copy images into a folder where they already exist. If an identical file name already exists in the destination folder, you may or may not want to overwrite it.

The camera will warn you with the screen shown in figure 2.23, and it will display thumbnails of both images. You can choose Replace existing image, Replace all, Skip, or Cancel.

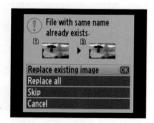

Figure 2.23 – Image overwrite warning

Image Review

(User's Manual – Page 212)

Image review does exactly what it says: it displays an image you've just taken on the Monitor. With this function turned On, you'll see each picture you take just after you take it. You can review the image for quality and usefulness.

With Image review set to Off, you won't see each picture unless you press the Playback button after you take it. This saves battery life. However, the battery is long lived because the D600 does not use a lot of power. If you prefer to review each image after you take it, then you need to set this feature to On.

There are two Image review settings, as shown in figure 2.24:

- On shows a picture on the Monitor after each shutter release
- Off causes the Monitor to stay off when you take pictures

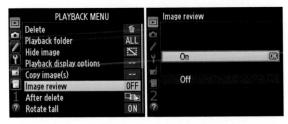

Figure 2.24 - Enabling Image review

Here are the steps to choose an Image review setting (figure 2.24):

- 1. Choose Image review from the Playback Menu and scroll to the right (figure 2.24, screen 1).
- 2. Select On or Off from the Image review screen (figure 2.24, screen 2).
- 3. Press the OK button to save the setting.

Most people turn this feature on right away. Otherwise the only way to view an image after you take it is to press the Playback button.

Note: You can control how long each image is displayed on the Monitor before it shuts off by adjusting Custom Setting Menu > c4 Monitor off delay > Image review. This custom Image review time can be adjusted to display pictures from 2 seconds to 10 minutes. We'll discuss this in more detail in the chapter titled **Custom Setting Menu.**

Settings Recommendation: Since the battery lasts a long time, I leave Image review set to On. I am an unashamed chimper (see sidebar, Are You a Chimper Too?) and always examine each image, if there's time. Photography is enjoyable, and one of the good things is the satisfaction you feel when you capture a really nice image. However, if you are shooting a sports event and blasting

through hundreds of shots per hour, there's not much time to view each image. It all boils down to how you shoot. If you aren't inclined to view your images as you take them, it may be a good idea to set Image review to Off to save battery life and time.

Are You a Chimper Too?

Chimping means reviewing images on the Monitor after each shot. I guess people think you look like a monkey if you review each image. Well, I do it anyway! Saying "Oo, Oo, Oo, Ah, Ah, Ah" really fast when you're looking at an image and are happy with it may make you sound like a monkey. That's chimping with style, and it's why the term was coined.

After Delete

(User's Manual - Page 212)

If you delete an image during playback, one of your other images will be displayed on the Monitor. The *After delete* function lets you select which image is displayed after you delete an image. The camera can display the next image or the previous image, or it can detect which direction you were scrolling—forward or backward—and let that determine which image appears after you delete another.

The three selections on the After delete menu are Show next, Show previous, and Continue as before (figure 2.25).

- Show next If you delete an image and it wasn't the last image on the memory card, the camera will display the next image on the Monitor. If you delete the last image on the card, the previous image will be displayed. Show next is the factory default behavior of the D600, since most people prefer to see the next picture.
- Show previous If you delete the first image on the memory card, the camera
 will display the next image. If you delete an image somewhere in the middle
 or at the end of the memory card, the previous image will be displayed.
- Continue as before This weird little setting shows the flexibility of computerized camera technology in all its glory. If you are scrolling to the right (the order in which the images were taken) and decide to delete an image, the camera uses the Show next method to display the next image. If you happen to be scrolling to the left (opposite from the order in which the images were taken) when you decide to delete a picture, the camera will use the Show previous method instead.

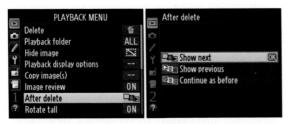

Figure 2.25 – Playback Menu – After delete

Use the following steps to choose an After delete setting (figure 2.25):

- 1. Choose After delete from the Playback Menu and scroll to the right (figure 2.25, screen 1).
- 2. Select one of the three settings from the After delete screen (figure 2.25, screen 2).
- 3. Press the OK button to lock in the setting.

Settings Recommendation: When I delete an image, I'm not overly concerned about which image shows next—most of the time. However, this functionality is handy in certain styles of shooting and when deleting rejects. For instance, some sports or wildlife shooters might like to move backwards through a long sequence of images, starting with the last image taken. They can then delete the images that are not usable in the sequence, and the camera will immediately show the previous image for review. When they reach the first image in the sequence, the entire series is clean and ready to use.

I leave my camera set to Continue as before. Why not use all the neat technology built into your camera?

Rotate Tall

(User's Manual - Page 212)

Rotate tall affects how the camera displays vertical images on the Monitor. When you shoot a portrait-oriented (vertical) image, with the camera turned sideways, the image can later be viewed as a horizontal image lying on its side or as a smaller, upright (tall) image on the camera's horizontal Monitor.

If you view the image immediately after taking it, the camera's software assumes that you are still holding the camera in the rotated position, and the image will be displayed correctly for that angle. Later, if you are reviewing the image with the camera's playback functionality and have Rotate tall set to On, the image will be displayed as an upright, vertical image that is smaller so it will fit on the horizontal Monitor. You can zoom in to see sharpness detail, if needed.

If you would rather have the camera leave the image lying on its side in a horizontal view, forcing you to turn the camera 90 degrees to view it, choose Off. The following two settings are available on the Rotate tall menu (figure 2.26):

- On When you take a vertical image, the camera will rotate it so you don't have to turn your camera to view it naturally during playback. This resizes the view of the image so a vertical image fits in the horizontal frame of the Monitor. The image will be a bit smaller than normal. When you first view the image after taking it, the camera does not rotate it, since it assumes you are still holding the camera in a vertical orientation. It also senses which end of the camera is up—if the Shutter-release button is up or down—and displays the image accordingly.
- Off Vertical images are left in a horizontal direction, lying on their side; turn the camera to view the images in the same orientation as when they were taken. This provides a slightly larger view of a portrait-oriented image.

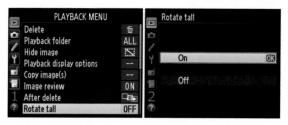

Figure 2.26 - Playback Menu - Rotate tall

Here are the steps to choose a Rotate tall setting:

- 1. Choose Rotate tall from the Playback Menu and scroll to the right (figure 2.26, screen 1).
- 2. Select On or Off from the Rotate tall screen (figure 2.26, screen 2).
- 3. Press the OK button to finish.

Settings Recommendation: I leave Rotate tall set to On so I can view a portraitoriented image in its natural, vertical orientation without turning my camera. Be sure you understand the relationship between this function and Auto image rotation, which stores orientation data with the picture. I always set Rotate tall and Setup Menu > Auto image rotation to On. Those settings let me view images in the correct orientation on my Monitor and computer screen.

Rotate Tall versus Auto Image Rotation

There is another camera function that affects how image rotation works. It's called Auto image rotation, under the Setup Menu. We'll discuss that function more deeply in the chapter titled **Setup Menu**. Auto image rotation causes the camera to record the angle at which you are holding it as part of the image metadata. Auto image rotation should be set to On so an image will report how it should be displayed on the Monitor and your computer. Rotate tall and Auto image rotation work together to display your image in the correct orientation. Rotate tall gives you the choice of how the image is viewed based on the orientation information it finds in the image metadata. Auto image rotation causes the camera to store how the image was taken so it will know whether the image has a vertical or horizontal orientation. It can then report this information to the Rotate tall function.

Slide Show

(User's Manual - Page 213)

I used to do slide shows back in the old film days. I'd set up my screen, warm up my projector, load my slides, and watch everyone fall asleep by the hundredth slide. For that reason, I hadn't been using the Slide show functionality in my previous cameras very often. However, with the D600's big 3.2-inch monitor and VGA resolution, it should be a satisfying viewing experience for one or two people.

If the monitor is not large enough, you can connect the camera to a highdefinition television (HDTV) and do a slide show for an even larger group. Connecting to an HDTV requires the separate purchase of an HDMI (type A) to mini-HDMI (type C) cable.

When you are ready for your show, you can control how long each image is displayed with the Frame interval setting. First, let's see how to start a Slide show (following the D600's menu order), and then we'll see how to change the Image type for display and Frame interval timing.

Starting a Slide Show

You can start the Slide show immediately, and it will commence with a default display time (Frame interval) of two seconds (2 s) per image, displaying the images and movies it finds on your camera's memory card(s).

Use the following steps to start a Slide show immediately:

- 1. Select Slide show from the Playback Menu and scroll to the right (figure 2.27, screen 1).
- 2. Select Start and the Slide show will begin immediately, using the default Image type (Still images and Movies) and Frame interval timing (2 s).

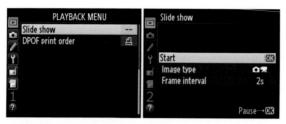

Figure 2.27 - Playback Menu - Slide show

You can easily change the way the camera chooses what Image type to display during the Slide show. The next subsection shows how.

Selecting an Image Type for a Slide Show

As you will notice in figure 2.27.1, screen 2, you can set the camera to display any Still images and movies it finds, or Still images only or Movies only.

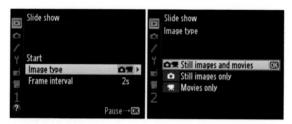

Figure 2.27.1 - Playback Menu - Slide show Image type

Use the following steps to change the Image type for display:

- 1. Select Image type from the Slide show screen (figure 2.27.1, screen 1).
- 2. Choose one of the three listed image types (figure 2.27.1, screen 2).
- 3. Press the OK button.

Finally, let's consider how to change the amount of time before the camera changes to the next image or movie in the slide show.

Changing a Slide Show's Frame Interval

If you want to allow a little more time for each Still image to display or between each Movie, you'll need to change the Frame interval (display time). Your Frame interval choices are as follows (figure 2.28):

- 1. **2** s 2 seconds
- 2. 3s 3 seconds
- 3. 5s 5 seconds
- 4. 10 s 10 seconds

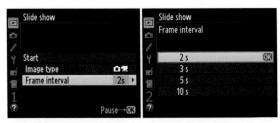

Figure 2.28 – Playback Menu – Slide show Frame interval

Use these steps to change the Slide show's Frame interval:

- 1. Choose Frame interval from the Slide show menu and scroll to the right (figure 2.28, screen 1).
- 2. Select one of the four choices between 2 s and 10 s.
- Press the OK button to lock in a new Frame interval.

To start the Slide show after you change the Frame interval, repeat the steps shown in the previous subsection, Starting a Slide Show. The Slide show will now run at the speed you chose.

Settings Recommendation: I usually set the Frame interval to 3 s. If the images are especially beautiful, I might set it to 5 s. I've found that 2 s is not quite enough, and 5 s or 10 s may be too long. I wish there were a four-second setting, but 3 s seems to work well most of the time.

There are several options that affect how the images are displayed during a slide show. None of these options are in the camera menus; they are available through the camera's controls. Your options are as follows:

- **Skip back/Skip ahead** During the slide show you can go back to the previous image for another viewing by simply pressing left on the Multi selector. You can also see the next image with no delay by pressing right on the Multi selector. This is a quick way to skip images or review previous images without stopping the slide show.
- View additional photo information While the slide show is running, you can press up or down on the Multi selector to view the additional data screens.
 - The screens you will see depends on how you have your camera's Playback display options configured for Highlights, Focus point, RGB histogram, and Shooting data (see the section called Playback Display Options earlier in this chapter). If any of these screens are available, they can be used during the slide show.
- Pause slide show During the slide show you may want to Pause, change the Frame interval,

Figure 2.29 - Playback Menu -Slide show Pause and Restart

or even Exit the show. If you press the OK button, the slide show will be suspended and you will see the Pause screen (figure 2.29).

- Restart Selecting OK or scrolling to the right with the Multi selector when this option is highlighted continues the slide show, starting with the image following the last one that was viewed.
- Frame interval Selecting OK or scrolling to the right with the Multi selector when this option is highlighted takes you to the screen that allows you to change the display time to one of four values: 2 s, 3 s, 5 s, or 10 s. After you choose the new Frame interval, select Restart to continue the slide show where you left off.
- Exit This option exits the slide show.
 - Exit to the Playback Menu If you want to quickly exit the slide show, simply press the MENU button and you'll jump directly back to the Playback Menu.
 - Exit to playback mode You can press the Playback button to stop the slide show and switch to a normal full-frame or thumbnail view of the last image seen in the slide show. This exits the show on the last image viewed.
 - Exit to shooting mode If you press the Shutter-release button halfway down, the slide show will stop. The camera is now in shooting mode, meaning that it is ready to take some pictures.

DPOF Print Order

(User's Manual - Page 202)

At first I thought it was odd that Nikon chose to put image printing functions in the Playback Menu. Then I realized that printing is a permanent form of image playback. You play (print) the images to your printer and then view them without a camera or a computer. What a concept!

DPOF print order allows you to create a print order on a memory card and plug that card into a compatible inkjet printer, or superstore kiosk printer, and print JPEG images. The function does not work with RAW images. Let's see how it works.

In-Camera Printing - Not for RAW Images

If you are a RAW shooter, the in-camera printing process won't benefit you, unless you use the Retouch Menu to create JPEGs on your memory card. Not all printers can handle printing from RAW files, so Nikon chose to limit DPOF and PictBridge printing from the D600 to JPEG files.

DPOF Printing

This function is designed to create a print order on your camera's memory card. Later this print order can be used to print directly from the memory card by inserting it into a DPOF-compatible printer. You can print to any device that supports DPOF. All you have to do is insert the memory card, select print from the printer, and wait for your pictures to print out. This is not a difficult process, and it is quite fun and satisfying.

When using DPOF you do not have to connect the camera to anything. Simply inserting a memory card that contains a digital print order on it into a DPOF compatible printer will cause the printer to detect the order and offer to fill it. Each DPOF printer's method of doing this varies, of course. However, the entire process is automated so that a new user won't have to do much more than select the number of prints and whether or not a border is required. These seven steps will allow you to create and print a digital print order on your DPOF-compatible printer.

Use the following steps to create a new DPOF print order on your memory card.

- 1. Select DPOF print order from the Playback Menu and scroll to the right (figure 2.30). You will see the screen in figure 2.31, screen 1.
- 2. If you don't have any existing digital print orders on the memory card, please skip this step and go directly to step 4. If you have an existing print order that you no longer want, you'll need to choose Deselect all? and scroll to the right (figure 2.31, screen 1). The next screen will

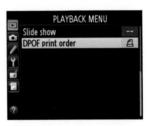

Figure 2.30 – DPOF print order

ask you, Remove print marking from all images? Yes/No. Choose Yes and press the OK button (figure 2.31, screen 2). If there are previously marked images, a message that says, Markings removed from all images will flash on the screen (figure 2.31, screen 3), and then the Playback Menu will reappear. Otherwise, no message will appear and the camera will return to the Playback Menu.

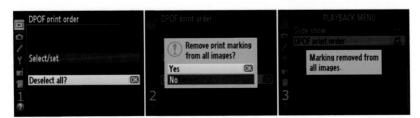

Figure 2.31 – Removing the print marking from all images

3. Since you're going to create a new print order and save it to the memory card, choose Select/set from the DPOF print order screen and then scroll to the right (figure 2.32, screen 1).

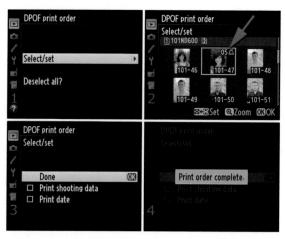

Figure 2.32 - Choosing images and number of prints

- 4. Now you'll see the Select/set thumbnail list with all the JPEG images on your memory card (figure 2.32, screen 2). Select the images you want to print with the Multi selector. After you have highlighted an image, hold down the checkered Playback zoom out/thumbnails button and scroll up with the Multi selector. Each upward or downward press of the Multi selector changes the number of prints ordered for that particular image (figure 2.32, screen 2, red arrow). You can select from 1 to 99 prints for each image you highlight. I chose five prints for the image with the red arrow, which is displayed beside a printer symbol. After you have selected which images to print and how many copies you want, press the OK button.
- 5. The next screen allows you to add shooting data or date imprints to each of the images in the print order (figure 2.32, screen 3):
 - Print shooting data This prints the shutter speed and aperture on each print in the order
 - · Print date This prints a date on each print in the order Put check marks in the boxes next to these selections by highlighting the option you want and scrolling to the right with the Multi selector. When you have completed your choices, scroll up to Done and press the OK button (figure 2.32, screen 3). Be careful with this setting because the data will be printed on the front of the image. I leave these two selections unchecked when I print.
- 6. Finally you will be presented with a screen telling you that the print order is complete (figure 2.32, screen 4).

At this point, your print order has been saved to the memory card. You'll need to remove it from the camera and insert it into the card slot of a DPOF-compatible printer or kiosk.

I have not found a way to create more than one print order on a single memory card. An existing order can be edited with the DPOF print order > Select/set function, or it can be removed with the DPOF print order > Deselect all? function. If you look at a memory card containing a print order on your computer, you'll see a new folder named MISC. It will have a file in it named AUTPRINT.MRK. That file is the digital print order.

PictBridge Printing

Another way to print images without using a computer is to attach your camera's USB cable to a PictBridge-compatible printer to print JPEG files (not RAW files). Most advanced amateur and professional users of the D600 will want to postprocess their images in computer software (like Lightroom, Aperture, Nikon Capture NX2, or Photoshop) before printing, so this functionality is not used as often as other functions. However, it can be useful for someone who would rather simply take pictures and print them at home with little or no post-processing.

Since these seldom-used functions require multiple pages to describe, involve an external device connection, and many people do not use them, I have relegated the PictBridge printing information to a detailed document called PictBridge Printing with the Nikon D600 and included it in the downloadable resources at the following websites:

http://www.nikonians.org/NikonD600 http://rockynook.com/NikonD600

Author's Conclusions

Wow! The Nikon D600 sure has a lot of playback screens and menus. I remember the old days when if you wanted to see your images, you'd have to find the old shoebox full of pictures or open an album and flip pages. Sometimes I miss photo albums. You know what? I'm going to run down to the superstore right now and buy several albums. Then I'll have some images printed and put them into the albums. Better yet, I think I'll go buy a DPOF-compatible printer so I can print my own images for the albums.

Now, let's move on to the next menu system in the camera, the Shooting Menu. This is one of the most important menus because it affects how the camera is configured to shoot pictures. Learn the Shooting Menu's settings well!

Shooting Menu

Rendezvous – Philip Rice (pjr)

The following is a list and overview of the 25 items found on the D600 Shooting Menu:

- Reset shooting menu Restores the factory default settings in the Shooting Menu for the currently selected User setting.
- **Storage folder** Selects which folder subsequent images will be stored in on the memory card(s).
- *File naming* Lets you change three characters of the image file name so it is personalized.
- Role played by card in Slot 2 Allows you to select how the camera divides image storage between Slot 1 and Slot 2.
- Image quality Selects from seven image quality types, such as JPEG fine or NEF (RAW).
- Image size Chooses whether to shoot Large (6016 × 4016, 24.2 M), Medium (4512 × 3008, 13.6 M), or Small (3008 × 2008, 6.0 M) images.
- Image area Chooses if the camera automatically selects DX mode when a DX lens is mounted (Auto DX crop) and if it will shoot in FX (36×24) or DX (24×16) mode.
- JPEG compression Selects Size priority or Optimal quality for your best JPEG images.
- NEF (RAW) recording Sets the compression type and bit depth for NEF (RAW) files.
- White balance Chooses from nine different primary White balance types, including several subtypes, and includes the ability to measure the color temperature of the ambient light (Preset manual).
- Set Picture Control Chooses from six Picture Controls that modify how the pictures look.
- Manage Picture Control Saves, loads, renames, or deletes custom Picture Controls on your camera's internal memory or card slots.
- Auto distortion control Causes the camera to look for barrel and pincushion distortion and attempts to automatically correct it. Recommended for G and D lenses only.
- **Color space** Selects the printing industry standard, Adobe RGB, or the Internet and home use standard, sRGB.
- Active D-Lighting Allows you to select from several levels of automatic contrast correction for your images. The camera itself will protect your images from a certain degree of under- or overexposure while extending the camera's dynamic range.

Nikon

- HDR (high dynamic range) Allows you to control the overall contrast in the image to provide a wider dynamic range by automatically combining—in the camera—two pictures taken at different exposures. Each image can have from 1 to 3 EV difference in exposure.
- · Vignette control Lets you automatically remove the darkening at the corners and edges of pictures taken with wide-open lens apertures.
- Long exposure NR Uses the black-frame subtraction method to significantly reduce noise in long exposures.
- High ISO NR Uses a blurring method, with selectable levels, to remove noise from images shot with high ISO sensitivity values.
- ISO sensitivity settings Allows you to select the camera's ISO sensitivity, from ISO 50 (Lo 1) to ISO 25,600 (Hi 2), or you can let the camera decide automatically.
- Remote control mode Gives you remote control of your camera so you can use a Nikon ML-L3 wireless remote to control the camera in various ways, including mirror-up shooting. This control can be used to replace a standard release cable.
- Multiple exposure Allows you to take more than one exposure in a single frame and then combine the exposures in interesting ways.
- Interval timer shooting Allows you to put your camera on a tripod and set it to make one to several exposures at customizable time intervals.
- Time-lapse photography Similar to Interval timer shooting, except more movie oriented. Allows you to make a time-lapse movie with the options selected in Shooting Menu > Movie settings. Shooting things like a time exposure of a flower opening, clouds moving across the sky, or star trails is easy with the D600.
- Movie settings Sets the Frame size, Frame rate, and Quality of the video stream in Movie mode. Also selects how the Microphone works and the Destination card slot for movies.

Each of these items can be configured and saved for later recall by using the two available User settings on the D600 Mode dial (U1 and U2).

User Settings U1 and U2

(User's Manual - Page 81)

Before you configure these Shooting Menu settings, select either U1 or U2 on the Mode dial and then make the setting modifications (figure 3.0).

Go to the Setup Menu and select Save user settings > Save to U1 (or U2) > Save settings to save your configuration for a specific style of shooting. This is optional, in case you don't want to use U1 and U2 on the Mode dial. However, it is a very convenient way to configure your camera for specific shooting situations so you can change to them auickly.

Figure 3.0 - U1 and U2 user settings

For instance, with my D600, I set user setting U1 as my high-quality setting. I shoot in NEF (RAW) Image quality with Lossless compressed and 14-bit depth in NEF (RAW) recording, Adobe RGB Color space, ISO 100, and Neutral Picture Control.

U2 is my party setting. I use JPEG fine Image quality with Size priority in JPEG compression, sRGB Color space, ISO 400 with Auto ISO sensitivity control set to On and Maximum sensitivity set to 800, and SD Picture Control.

The two user settings on the Mode dial allow you to store a lot more than just Shooting Menu items. They can also store a specific configuration for many other settings, such as the Custom settings in the Custom Setting Menu, exposure modes, flash, compensation, metering, AF-area modes, bracketing, and more. Nikon has given us a powerful and flexible way to configure our cameras for specific shooting needs.

We'll discuss the detailed configuration of these two settings in the chapter titled Metering, Exposure Modes, and Histogram under the subheading U1 and U2 User Settings. For now, just keep in mind that you can save the settings you make to the upcoming Shooting Menu items in a cumulative way within user settings U1 and U2 on the Mode dial. After you configure many aspects of your camera, you can save the changes with Setup Menu > Save user settings > U1 (or U2) > Save settings.

You can make changes to the camera's settings at any time outside of the U1 and U2 Mode dial positions with no effect on the two user settings. When you select U1 or U2 on the Mode dial, those settings outside of U1 or U2 will be overridden—but not overwritten—by your chosen user setting. In other words, if your camera is configured in a certain way for general use outside of the two user settings, and then you select U1 or U2, the user settings do not overwrite the current configuration. Instead they toggle the settings you've saved in U1

or U2. When you exit U1 or U2, the camera reverts to however it was previously configured outside of the user setting.

Basically, you can configure the camera in up to three separate ways: U1 and U2, and however you have the camera configured outside of the two user settings.

There are several Shooting Menu options that cannot be stored and saved in the user settings:

- Storage folder
- File naming
- Manage Picture Control
- Multiple exposure
- Interval timer shooting

These five Shooting Menu functions are independent of the user settings that you can save. If you modify one of these five functions, it will function the same way no matter what user setting you have selected. We will discuss how to save user settings in the chapter titled Setup Menu, under the subheading called Save User Settings.

Now, let's examine how to configure the camera's Shooting Menu settings.

Configuring the Shooting Menu

(User's Manual - Page 214)

Press the MENU button on the back of your D600 to locate the Shooting Menu, which corresponds to a green camera icon in the toolbar on the left side of the Monitor (figure 3.1).

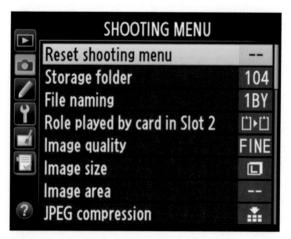

Figure 3.1 - The Shooting Menu is the camera's most often-used menu

We'll now examine each of the settings on the Shooting Menu. Have your camera in hand, and maybe even the User's Manual if you are interested in what it says about certain settings (page numbers provided). Remember that it's entirely optional to use the User's Manual. This book is a comprehensive reference, but sometimes I like to get an alternate view. The User's Manual, although somewhat dense, is still a good reference.

If you take time to think about and configure each of these settings at least once, you'll learn a lot more about your new camera. There are a lot of settings to learn about, but don't feel overwhelmed. Some of these settings can be configured and then forgotten, and you'll use other settings more often. We'll look at each setting in detail to see which ones are most important to your style of shooting.

Reset Shooting Menu

(User's Manual – Page 214)

Be careful with this selection. Reset shooting menu does what it says—it resets the Shooting Menu, only for the currently selected user setting (U1, U2, or outside the user settings), back to the factory default configuration (figure 3.2). If you have U1 selected on the Mode dial, it resets only U1, and so forth.

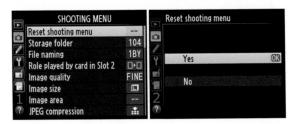

Figure 3.2 - Reset shooting menu

This is a rather simple process. Here are the steps to reset the Shooting Menu:

- 1. Select Reset shooting menu and scroll to the right (figure 3.2, screen 1).
- 2. Choose Yes or No (figure 3.2, screen 2).
- 3. Press the OK button.

Note: This function resets all Shooting Menu functions, including the five settings that cannot be saved in a User setting: Storage folder, File naming, Manage Picture Control, Multiple exposure, and Interval timer shooting. This may be a problem if you have carefully configured one of the five settings and then you answer Yes to Reset shooting menu because your settings will be lost.

Settings Recommendation: This is an easy way to start fresh with a particular User setting since it's a full reset of all the values, including the five special settings. I use this when I purchase a preowned camera and want to clear someone else's settings or if I simply want to start fresh. If you use any of the five nonsaveable settings regularly, be aware that Reset shooting menu will reset them.

Storage Folder

(User's Manual - Page 215)

Storage folder allows you to either create a new folder for storing images or select an existing folder from a list of folders. The D600 automatically creates a folder on its primary memory card called something similar to 100ND600. The folder can hold up to 999 images. You'll see the full name of the folder only when you examine the memory card in your computer—check in the digital camera images (DCIM) folder on the memory card.

When the camera senses that the current folder contains 999 images and you take another picture, the new image is written to a new folder that is a seamless continuation of the previous folder. The first three digits of the new folder name is increased by one. For example, if you are using a folder named 100ND600, the camera will automatically create a new folder called 101ND600 when you exceed 999 images in the original folder.

Manually Creating a New Storage Folder

If you want to store images in separate folders on the memory card, you might want to create a new folder, such as 200ND600. Each folder you create can hold 999 images, and you can select any folder as the default by choosing Storage folder > Select folder from list (discussed in the next subsection). This is a nice way to isolate certain types of images on a photographic outing. Maybe you'll put landscape shots in folder 300ND600 and people shots in 400ND600. You can develop your own numbering system and implement it with this function.

When you manually create folder names, you may want to leave room for the camera's automatic folder creation and naming. If you try to create a folder name that already exists, the camera doesn't give you a warning; it simply switches to the existing folder. Let's look at how to create a new folder with a number of your choice, from 100 to 999 (100ND600 to 999ND600).

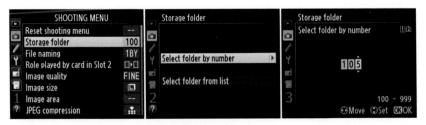

Figure 3.3 - Storage folder - Select folder by number

Here are the steps to manually create a new folder:

- 1. Select Storage folder and scroll to the right (figure 3.3, screen 1).
- 2. Choose Select folder by number and scroll to the right (figure 3.3, screen 2).
- 3. You'll now see a screen that allows you to create a new folder number from 100 to 999 (figure 3.3, screen 3). Create your number using the Multi selector, then press the OK button.

Settings Recommendation: You cannot create a folder numbered 000 to 099: I tried! Remember that the three-digit number you select will have ND600 appended to it and it will look something like 101ND600 or 301ND600 when you have finished. After you have created a new folder, the camera will automatically switch to it.

Selecting an Existing Storage Folder

What if you want to simply start using an existing folder instead of making a new one? You may have already created a series of folders and want to switch among them to store different types of images. It's easy with the following screens and steps.

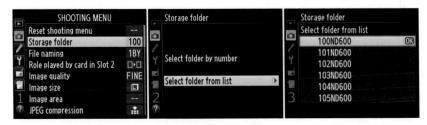

Figure 3.4 - Storage folder - Select folder from list

Use the following steps to select an existing folder:

- 1. Select Storage folder and scroll to the right (figure 3.4, screen 1).
- 2. Scroll down to Select folder from list and scroll to the right (figure 3.4, screen 2). If this selection is grayed out, there is only one folder on the memory card.

You'll need to create a new folder with the instructions found in the previous section.

- 3. You'll see the available folders displayed in a list that looks like the one shown in figure 3.4, screen 3. Select one of the folders from the list. I happen to have six folders—100ND600 to 105ND600—on my current memory card.
- 4. Press the OK button. The camera will switch back to the Shooting Menu main screen, with the new folder number displayed to the right of Storage folder.

All new images will be saved to this folder until you exceed 999 images in the folder or manually change to another folder. One note of caution: If you are using folder 999ND600 and the camera records the 999th image, or if it records image number 9999—the Shutter-release button will be disabled until you change to a different folder. Nikon warns that the camera will be slower to start up if the memory card contains "a very large number of files or folders."

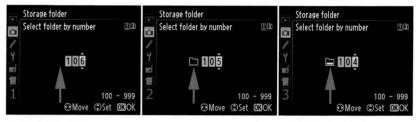

Figure 3.4.1 – Three folder conditions: Screen 1, no images (no folder); Screen 2, folder empty; Screen 3, folder partially full

Note: There is also a fourth condition—not shown in figure 3.4.1—that displays an icon of a full folder, which means there are 999 images in the folder or it contains an image numbered 9999. You cannot write any more images to a folder when it is full.

If you try to write to a folder containing an image ending with the number 9999, you could cause the camera to lock its Shutter-release button until another memory card is inserted or the current card is formatted.

Settings Recommendation: As memory cards get bigger and bigger, I can see a time when this functionality will become very important. Last year I shot around 150 GB of image files. With the newest memory cards now hitting 256 GB, I can foresee a time when the card(s) in my camera will become a months-long backup source.

I don't use the Storage folder very much, but I will in the near future. This is a good function to learn how to use!

File Naming

(User's Manual - Page 216)

File naming allows you to control the first three characters of the file name for each of your images. The default is DSC, but you can change it to any three alphanumeric characters.

The camera defaults to the following File naming for your images:

- When using sRGB Color space: DSC_1234
- When using Adobe RGB Color space: _DSC1234

You can see that depending on which Color space you are using, the camera adds an underscore to one side of the three characters (figure 3.5, screen 2).

I use this feature in a special way. Since the camera can count images in a File number sequence from 0001 to 9999, I use File naming to help me personalize my images. The camera cannot count higher than 9,999. Instead, it rolls back to 0001 for the 10,000th image.

When I first got my D600, I changed the three default characters from DSC to 1DY. The 1 tells me how many times my camera has passed 9,999 images, and DY is my initials, thereby helping me protect the copyright of my images in case they are ever stolen and misused.

Since the camera's image File number sequence counter rolls back to 0001 when you exceed 9,999 images, you need a way to keep from accidentally overwriting images from the first set of 9,999 images you took. I use this method:

 First 9,999 images 1DY 0001 through 1DY_9999 2DY 0001 through 2DY 9999 Second 9,999 images Third 9,999 images 3DY_0001 through 3DY_9999

See how simple it is? This naming method shows a range of nearly 30,000 images. Since the D600's shutter is tested to a professional level of 150,000 cycles, you will surely need to use a counting system like this one. My system works up to only 89,991 images $(9,999 \times 9)$. If you use this counting system and start your camera at 0 (0DY_0001 through 0DY_9999), you can count up to 99,990 images.

If Nikon would give us just one extra digit in the image counter, we could count in sequences of just under 100,000 images instead of 10,000 images. I suppose that many of us will have traded up to the next Nikon DSLR before we reach enough images that this really becomes a constraint. On my Nikon D2X that I've used since 2004, I've shot close to 40,000 images.

Custom setting d7 File number sequence in the D600 controls the File number sequence setting. That function works along with File naming to let you control how your image files are named. If File number sequence is set to Off, the D600 will reset the four-digit number—after the first three custom characters in File naming—to 0001 each time you format your memory card. I set File number sequence to On as soon as I got my camera so it would remember the sequence all the way up to 9,999 images. I want to know exactly how many pictures I've taken over time. We'll talk more about File number sequence in the chapter titled **Custom Setting Menu**.

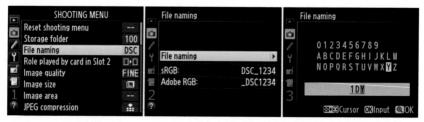

Figure 3.5 - File naming

Here are the steps to set up your custom File naming characters:

- 1. Select File naming from the Shooting Menu and scroll to the right (figure 3.5, screen 1).
- 2. Select File naming and scroll to the right (figure 3.5, screen 2).
- 3. Use the Multi selector to scroll through the numbers and letters to find the characters you want to use. Press the OK button on the D600 to select and insert a character. To correct an error, hold down the Playback zoom out/thumbnails button and use the Multi selector to scroll to the character you want to remove. Press the Delete button to delete the bad character.
- 4. Press the Playback zoom in button to save your three new custom characters. They will now be the first three characters of each image file name.

Now you've customized your camera so the file names reflect your personal needs.

Settings Recommendation: I discussed how I use the three custom characters in the beginning of this section. You may want to use all three of your initials or some other numbers or letters. Some people leave these three characters at their default. I recommend using your initials, at a minimum, so you can easily identify the images as yours. With my family of Nikon shooters it sure makes it easier! If you use my method, be sure to watch for the images to reach 9999 and rename the first character for the next sequence of 9,999 images.

(User's Manual - Page 96)

Role played by card in Slot 2 is designed to let you control the flow of images to the camera's memory cards. You can decide how and to which card(s) the camera writes image files. Slot 1 is the top card slot when you open the Memory card slot cover, and Slot 2 is on the bottom.

Here is a description of the three ways you can configure the Role played by card in Slot 2 setting:

- Overflow Have you ever gotten the dreaded Card full message? If you select Overflow, it will take a lot longer to get this message. Overflow writes all images to the card you have selected under Primary slot selection. Then when the card in Slot 1 is full, the rest of the images are sent to the card in Slot 2. The image number shown on the Control panel and in the Viewfinder will count down as you take pictures and they are written to the card in Slot 1. When the image count nears zero, the camera will switch to the card in Slot 2, and the available image count number on the Control panel will increase to however many images will fit on the second card. It is not necessary to use the same size card when using this function. The camera will merely fill up all available space on both cards as you take pictures.
- Backup This function is a backup for critical images. Every image you take is written to the memory cards in Slot 1 and Slot 2 at the same time. You have an automatic backup system when you use the Backup function. If you are a computer geek (like me), you'll recognize this as RAID 1 or drive mirroring. Since your camera is very much a computer, a function like this is great to have. Be sure that both cards are of equal capacity or that the card in Slot 2 is larger than the card in Slot 1 when you use this function. Otherwise the capacity shown on the Control panel and in the Viewfinder will be reduced. Since the camera will write a duplicate image to each card, the smallest card sets the camera's maximum storage capacity. When either card is full, the Shutterrelease button becomes disabled.
- RAW Slot 1-JPEG Slot 2 If you like to shoot NEF (RAW) files, this function can save you some time. You'll have a JPEG for immediate use and a RAW file for post-processing. When you take a picture, the camera will write the RAW file to the card in Slot 1 and a JPEG file to the card in Slot 2. There is no choice in this arrangement; RAW always goes to the primary card and JPEG always goes to the secondary card. This function works only when you have Shooting Menu > Image quality set to some form of NEF (RAW) + JPEG. If you set Image quality to just NEF (RAW) or just JPEG fine—instead of NEF (RAW) + JPEG fine, for example—the camera will write a duplicate file to both cards, like the Backup function.

SHOOTING MENU

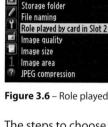

Reset shooting menu

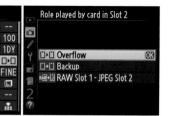

Figure 3.6 - Role played by card in Slot 2

The steps to choose the Role played by card in Slot 2 are as follows:

- 1. Select Role played by card in Slot 2 from the Shooting Menu and scroll to the right (figure 3.6, screen 1).
- 2. Choose one of the three selections discussed previously (figure 3.6, screen 2).
- 3. Press the OK button.

You can also open the Role played by card in Slot 2 screen by using a menu selection from the Information display edit screen, as shown in figure 3.6.1.

Figure 3.6.1 – Role played by card in Slot 2 from the Information display edit screen

Simply press the Info button twice to open the Information display edit screen. Select the Role played by card in Slot 2 icon (figure 3.6.1, screen 1) and press the OK button. Now, follow steps 2 and 3 that accompany figure 3.6.

Settings Recommendation: When I'm out shooting for fun or for any type of photography where maximum image capacity is of primary importance, I select Overflow. This causes the camera to fill up the primary card and then automatically switch to the secondary card for increased image storage. If I'm shooting images that I cannot afford to lose, such as at a unique event like a wedding or a baptism, I often use the Backup function for automatic backup of every image.

If I want both a RAW and JPEG file, I use the RAW Slot 1–JPEG Slot 2 function. This lets me have the best of both worlds when card capacity is not a concern, and it gives me redundancy, like Backup. In a sense, RAW Slot 1–JPEG Slot 2 backs up your images; they are just in different formats. I use each of these selections from time to time, but my favorite is Overflow.

Image Quality

(User's Manual - Page 93)

Image quality is simply the type of image your camera can create, along with the amount of image compression that modifies picture storage sizes.

You can shoot several distinct image formats with your D600. We'll examine each format in detail and discuss the pros and cons of each as we go. When we're done, you'll have a better understanding of the formats, and you can choose an appropriate one for each of your shooting styles. The camera supports the following seven Image quality types:

- · NEF (RAW) + JPEG fine
- NEF (RAW) + JPEG normal
- NEF (RAW) + JPEG basic
- NEF (RAW)
- JPEG fine
- JPEG normal
- JPEG basic

The steps to select an Image quality setting are as follows:

- 1. Select Image quality from the Shooting Menu and scroll to the right (figure 3.7, screen 1).
- 2. Choose one of the seven Image quality types. Figure 3.7, screen 2, shows JPEG fine as the selected format.
- 3. Press the OK button to select the format.

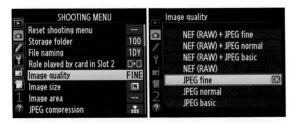

Figure 3.7 - Choosing an Image quality setting with menus

You can also use the QUAL button (Playback zoom in button) to set the Image quality (and size). The steps are as follows:

- 1. Hold down the QUAL button (figure 3.8, image 1).
- 2. Rotate the Main command dial to change the Image quality (bottom red arrow in figure 3.8, image 2). Also use the Sub-command dial (top red arrow in figure 3.8, image 2) to change the Image size.

- 3. Look at the Control panel to see the Image quality and Image Size values change. The bottom red arrow in figure 3.8, image 3, shows the quality (e.g., RAW, FINE, RAW+FINE), and the top red arrow shows the size (L, M, S).
- 4. Release the QUAL button to lock in the settings.

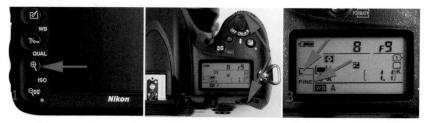

Figure 3.8 - Choosing an Image quality setting with external controls

Let's look at each of these formats and see which ones you might want to use regularly. We'll go beyond how to turn the different formats on and off and discuss why and when you might want to use a particular format. Even though the Image quality list shows seven different entries, the camera really shoots in only two formats: NEF (RAW) and JPEG.

The first three selections on the Image quality list (figure 3.7, screen 2) allow the camera to take a NEF (RAW) file and a JPEG fine, normal, or basic file at the same time. Fine, normal, and basic indicate three levels of compression that are available for the JPEG format. When you press the Shutter-release button with one of the three NEF (RAW) + JPEG Image quality modes selected, the camera creates a RAW file and a JPEG file and writes them to the memory card(s) as separate files. To understand how they work, we'll examine the NEF (RAW) and JPEG formats.

NEF (RAW) Image Quality Format

The Nikon NEF proprietary format stores raw image data directly onto the memory card. Most of the time photographers refer to a NEF file simply as a RAW file. These RAW files can easily be recognized because the file name ends with NEF. This image format is not used in day-to-day graphics work (like the JPEG format), and it's not even an image yet. Instead, it's a base storage format used to hold images until they are converted to another file format ending in something like JPG, TIF, EPS, or PNG. Other than the initial compression—as selected in Shooting Menu > NEF (RAW) recording—NEF stores all available image data and can easily be manipulated later.

NEF (RAW) Conversion Software

You must use conversion software—such as Nikon ViewNX 2, Nikon Capture NX2, Adobe Photoshop Lightroom, or Adobe Photoshop—to convert your NEFformat RAW files into other formats. You can download the latest version of the free Nikon ViewNX 2 and all sorts of Nikon imaging software from the following Nikon website:

http://support.nikonusa.com/app/answers/detail/a_id/61/~/ current-versions-of-nikon-software

The Nikon CD that comes with your camera contains Nikon ViewNX 2, which you can use immediately for RAW conversion. However, I recommend using the link to the Nikon website for downloading the latest version. Alternately, you can install Nikon ViewNX 2 from the Nikon CD and then click the Help menu, where you will find a link to check Nikon's website and update the software, if needed.

There are also several aftermarket RAW conversion software packages available. Do a Google search of "Nikon RAW conversion software" for a listing.

Before you shoot in NEF (RAW) format, it's a good idea to install your RAW conversion software of choice so you'll be able to view, adjust, and save the images to another format when you are done shooting. You may not be able to view NEF files directly on your computer unless you have RAW conversion software installed.

Viewing RAW Files as Thumbnails on Your Computer

 $Some \ operating \ systems \ provide \ a \ download able \ patch \ or \ codec \ (coder-decoder)$ that lets you see NEF files as small thumbnails in the file manager software (e.g., Windows Explorer or Mac OS X Finder).

Do a Google search on these specific words to start your search for available codecs: "download Nikon NEF RAW viewer." You will find free codecs for Windows 7, Vista, XP, and Mac OS X. However, be careful that you don't go to a website that promises the moon and delivers malware instead.

Nikon lists a free codec for Windows 7 (32 and 64 bit), Windows Vista (32 and 64 bit, Service Pack 2), and Windows XP (32 bit only, Service Pack 3) at this website:

http://nikonimglib.com/nefcodec/

Note: There were no free Windows 8 codecs available at the time of this writing, but I'm sure one will be available by the time you get this book.

There are also reliable third-party companies, such as Ardfry Imaging LLC (http://www.ardfry.com/nef-codec/), that offer various 32- and 64-bit RAW codecs for a small fee. They may even have a Windows 8 codec since they mention it on their website.

Unfortunately, there is a greater selection of codecs for Windows than for Mac. However, with so many software developers out there, things change constantly.

Nikon Software Included with Your Camera

The Nikon CD that came with your camera contains software for both Mac OS X and Windows. Nikon ViewNX 2 RAW conversion software is supplied free with the D600, but Nikon Capture NX2 requires a separate purchase. Capture NX2 has become my favorite conversion and post-processing software, along with Adobe Photoshop.

A RAW File Is Not an Image, Yet!

Now, let's talk about NEF, or RAW, quality. I use the NEF (RAW) format most of the time. I think of a RAW file like I thought of my slides and negatives a few years ago. It's my original image that must be saved and protected.

It's important that you understand something very different about NEF (RAW) files. They're not really images—yet. Basically, a RAW file is composed of blackand-white or sensor data and camera setting information markers. The RAW file is saved in a form that must be converted to another file type to be used in print or on the web.

When you take a picture in RAW format, the camera records the image data from the sensor and stores markers for how the camera's color, sharpening, contrast, saturation, and so forth are set, but it does not apply the camera setting information to the image. In your computer post-processing software, the image will appear on-screen with the settings you initially configured in your D600. However, these settings are applied temporarily for your computer viewing pleasure.

For example, if you don't like the white balance you selected at the time you took the picture, simply apply a new white balance and the image will appear as if you had used that setting when you took the picture. If you initially shot the image using the Standard Picture Control and now want to use the Vivid Picture Control, all you have to do is apply it—with Nikon ViewNX 2 or Nikon Capture NX2—before the final conversion and it will be as if you used the Vivid Picture Control when you first took the picture.

This is quite powerful! Virtually no camera settings are applied to a RAW file in a permanent way. That means you can apply completely different settings to the image in your computer software and it will appear as if you had used those settings when you first took the picture. This allows a lot of flexibility later.

NEF (RAW) is generally used by individuals who are concerned with maximum image quality and who have time to convert the images. A conversion to JPEG sets the image markers permanently, and a conversion to TIFF sets the markers

but allows you to modify the image later. Unfortunately, the TIFF format creates very large file sizes.

Here are the pros and cons of NEF (RAW) format:

NEF (RAW) positives

- Allows the manipulation of image data to achieve the highest-quality image available from the camera.
- All original details stay with the image for future processing needs.
- · No conversions, sharpening, sizing, or color rebalancing will be performed by the camera. Your images are untouched and pure!
- · You can convert NEF files to any other image formats by using your computer's much more powerful processor instead of your camera's processor.
- · You have much more control over the final look of the image since you, not the camera, make the final decisions about the appearance of the image.
- A 12-bit or 14-bit format provides maximum color information.

NEF (RAW) negatives

- Not often compatible with the publishing industry, except after conversion to another format.
- · Requires post-processing with proprietary Nikon software or third-party software.
- Larger file sizes are created, so you must have larger storage media.
- · There is no industry-standard RAW format. Each camera manufacturer has its own proprietary format. Adobe has developed a generic RAW format called digital negative (DNG) that is becoming an industry standard. You can use various types of software, such as Adobe Lightroom, to convert your RAW images to DNG if you desire.
- The industry standard for home and commercial printing is 8 bits, not 12 bits or 14 bits.

Now, let's examine the most popular format on the planet: JPEG.

JPEG Image Quality Format

As shown in figure 3.7, screen 2, the D600 has three JPEG modes. Each mode affects the final quality of the image. Let's look at each mode in detail:

- JPEG fine Compression approximately 1:4
- JPEG normal Compression approximately 1:8
- Compression approximately 1:16 JPEG basic

Each JPEG mode provides a certain level of lossy image compression, which means that it permanently throws away image data as you select higher levels of compression (fine, normal, basic). The human eye compensates for small color

changes quite well, so the JPEG compression algorithm works very well for viewing by humans. A useful thing about JPEG is that you can vary the file size of the image, via compression, without affecting the quality too much.

Here are details of the three JPEG modes:

- JPEG fine (or fine-quality JPEG) uses a 1:4 compression ratio. If you decide to shoot in JPEG, this mode will give you the best-quality JPEG your camera can produce.
- JPEG normal (or normal-quality JPEG) uses a 1:8 compression ratio. The image quality is still very acceptable in this mode. If you are shooting at a party for a 4×6-inch (10×15 cm) image size, this mode will allow you to make lots of images.
- JPEG basic (or basic-quality JPEG) uses a 1:16 compression ratio. These are still full-size files, so you can surely take a lot of pictures. If you are shooting for the web or just want to document something well, this mode provides sufficient quality.

Note: It's hard to specify an exact number of images that a particular card size will hold. My D600 reports that 151 lossless compressed NEF (RAW) images will fit on an 8 GB memory card, yet when the card is full I often have more than 300 images. With the higher compression ratio of JPEG files, it is even harder to predict exactly. The complexity within a scene has a lot to do with the final compressed file size. That's why the camera underreports the number of images it can hold. You'll find that your memory cards will usually hold many more images than the estimate presented by the camera.

The JPEG format is used by individuals who want excellent image quality but have little time for, or interest in, post-processing or converting images to another format. They want to use images immediately when they come out of the camera, with no major adjustments.

The JPEG format applies your chosen camera settings to the image when it is taken. The image comes out of the camera ready to use, as long as you have exposed it properly and have configured all the other settings appropriately.

Since JPEG is a lossy format, you cannot modify and save a JPEG file more than a time or two before compression losses ruin the image. A person who shoots a large number of images or doesn't have the time to convert RAW images will usually use JPEG. That encompasses a lot of photographers.

Nature photographers might want to use NEF (RAW) since they have more time for processing images and wringing the last drop of quality out of them, but event or journalist photographers on a deadline may not have the time for, or interest in, processing images, so they often use the JPEG format.

Here are the pros and cons of capturing JPEG images:

JPEG positives

- Allows for the maximum number of images on a memory card and computer hard drive.
- Allows for the fastest transfer from the camera memory buffer to a memory card.
- · Compatible with everything and everybody in imaging.
- Uses the printing industry standard of 8 bits.
- Produces high-quality, first-use images.
- No special software is needed to use the image right out of the camera (no post-processing).
- · Immediate use on websites with minimal processing.
- Easy transfer across the Internet and as e-mail attachments.

JPEG negatives

- · JPEG is a lossy format.
- You cannot manipulate a JPEG image more than once or twice before it degrades to an unusable state. Every time you modify and save a JPEG image, it loses more data and quality because of data compression losses.

Combined NEF + JPEG Shooting (Two Images at Once)

Some shooters use the three Image quality settings, shown in figure 3.7, screen 2, that save two images at the same time:

- · NEF (RAW) + JPEG fine
- NEF (RAW) + JPEG normal
- NEF (RAW) + JPEG basic

These settings give you the best of both worlds because the camera saves a NEF file and a JPEG file each time you press the Shutter-release button. In NEF (RAW) + JPEG fine, my camera's 8 GB single-card storage drops to about 180 images since it stores a NEF file and a JPEG file for each picture I take.

You can set Shooting Menu > Role played by card in Slot 2 to write the NEF (RAW) file to one card and the JPEG file to the other. You can use the NEF (RAW) file to store all the image data and later process it into a masterpiece, and you can use the JPEG file immediately with no adjustment.

The NEF (RAW) + JPEG modes have the same features as their stand-alone modes. In other words, a RAW file in NEF (RAW) + JPEG mode works like a RAW file in NEF (RAW) mode, and a JPEG file in NEF (RAW) + JPEG mode works like a JPEG fine, normal, or basic file without the NEF (RAW) file.

Image Compression Information

The Image quality file formats of the D600 can compress the image file into a smaller file size. We'll discuss several image compression types—like JPEG fine/normal/basic, JPEG Size priority/optimal quality, and NEF (RAW) Lossless compressed/Compressed—in later sections of this chapter. However, for now I'll mention where you can find the compression functions in the Shooting Menu.

JPEG compression is controlled by the *Shooting Menu > JPEG compression* selection, along with the JPEG fine, normal, or basic compression on the *Shooting Menu > Image quality* screen. JPEG is always a compressed format; you'll just select how much compression is applied. NEF (RAW) compression is controlled by the *Shooting Menu > NEF (RAW) recording > Type* selection. These two compression selections allow you to control the size of your JPEG and RAW files.

Pay careful attention to the various compression levels offered for the images you shoot. After you set these compression levels, all images of that format will be affected. Also, remember that image compression is specific to User settings (U1 and U2), which means you can control it separately for each of your camera's two User settings and the third non-User setting.

Image Format Recommendations

Which format do I prefer? Why, RAW, of course! But it does require a bit of commitment to shoot in this format. NEF (RAW) files are not yet images and must be converted to another format for use. Once converted, they can provide the highest quality images your camera can possibly create.

When shooting in RAW, the camera is simply an image-capturing device, and you are the image manipulator. You decide the final format, compression ratio, size, color balance, and so forth. In NEF (RAW) mode, you have the absolute best image your camera can produce. It is not modified by the camera's software and is ready for your personal touch. No camera processing allowed!

If you get nothing else from this section, remember this: by letting your camera process images in *any* way, it modifies or throws away data. There is a finite amount of data for each image that can be stored in your camera, and later in your computer. With JPEG, your camera optimizes the image according to the assumptions recorded in its memory. Data is thrown away permanently, in varying amounts.

If you want to keep *all* the image data that was recorded with your images, you must store your originals in RAW format. Otherwise you'll never again be able to access that original data to change how it looks. A RAW file is the closest thing to a film negative or transparency that your digital camera can make. That's important if you would like to modify the image later. If you are concerned with maximum quality, you should probably shoot and store your images in RAW

format. Later, when you have the urge to make another masterpiece out of the original RAW image file, you'll have all of your original data intact for the highest-quality image. (Compressed NEF loses a little data during initial compression, but Lossless compressed does not. I use Lossless compressed. These RAW compression types will be considered in an upcoming section called **NEF (RAW) Recording** under the subheading **Type**.)

If you're concerned that the RAW format may change too much over time to be readable by future generations, you might want to convert your images to TIFF or JPEG files. TIFF is best if you want to modify your files later. I often save a TIFF version of my best images in case RAW changes too much in the future. Interestingly, I can still read the NEF (RAW) format from my 2002-era Nikon D100 in Nikon ViewNX 2. Therefore, I think we are safe for a long time with our NEF (RAW) files.

Settings Recommendation: I shoot in NEF (RAW) format for my most important work and JPEG fine for the rest. Some people find that JPEG fine is sufficient for everything they shoot. Those individuals generally do not like working with files on a computer or do not have time for it. You'll use both RAW and JPEG, I'm sure. The format you use most often will be controlled by your time constraints and digital workflow.

Image Format Notes

If you have been shooting in NEF (RAW) + JPEG mode with a single memory card inserted in the camera, the D600 will display only the JPEG image on the Monitor.

Also, NEF (RAW) images are always Large images. The next section will discuss Image size, which applies only to JPEG images. There are no Large, Medium, and Small NEF images. All RAW files are the maximum size for their format (FX or DX).

Finally, you may want to investigate the Retouch menu > NEF (RAW) processing function, which allows you to create a JPEG file from a NEF (RAW) file, in-camera, with no computer involved.

Image Size

(User's Manual - Page 95)

Image size lets you shoot with your camera set to various megapixel sizes. The default Image size setting for the D600 is Large, or 24.2 M (M = megapixels, shown elsewhere as MP). In FX Image area mode, you can change this rating from 24.2 M to 13.6 M or 6.0 M (figure 3.9, screen 2), or even smaller in DX Image area mode. Image size applies only to images captured in JPEG fine, normal, or basic modes.

If you're shooting with your camera in any of the NEF (RAW) + JPEG modes, it applies only to the JPEG image in the pair. Image size does not apply to a NEF

FX mode (Image area)

Large (6016×4016; 24.2 M)
 Medium (4512×3008; 13.6 M)
 Small (3008×2008; 6.0 M)

DX Mode (Image area)

Large (3936×2624; 10.3 M)
 Medium (2944×1968; 5.8 M)
 Small (1968×1312; 2.6 M)

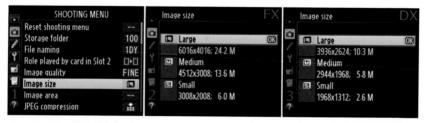

Figure 3.9 - Choosing an Image size

The steps to select an Image size are as follows:

- 1. Select Image size from the Shooting Menu and scroll to the right (figure 3.9, screen 1).
- 2. Choose one of the three Image size settings. Figure 3.9, screens 2 and 3, show Large as the selected size. You will see only one of these last two screens, according to how you have Image area configured (next section). Screen 2 shows the Image size for FX Image area, and screen 3 shows the Image size for DX Image area.
- 3. Use the Multi selector to select a size and press the OK button to choose the size.

You can also use the QUAL button to set the Image size (and quality):

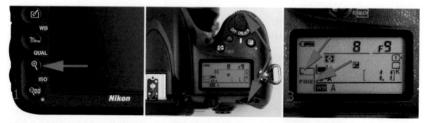

Figure 3.10 - Choosing an Image size setting with external controls

- 2. Rotate the Sub-command dial (top red arrow in figure 3.10, image 2) to change the Image size. Also, rotate the Main command dial to change the Image quality (bottom red arrow in figure 3.10, image 2).
- 3. Look at the Control panel to see the Image size and Image quality values change. The top red arrow in figure 3.10, image 3, shows the size (L, M, S), and the bottom red arrow shows the quality (RAW, FINE, RAW+FINE, etc.).
- 4. Release the QUAL button to lock in the settings.

I'm not very interested in using my 24.2 MP camera to capture smaller images. However, there are reasons to shoot at lower megapixel sizes, such as when a smaller-resolution image is all that will ever be needed or if card space is at an absolute premium.

Setting the Image quality to JPEG basic, the Image size to Small, the Image area to DX mode, and the JPEG compression to Size priority allows the camera to capture 10,300 images on an 8 GB card. The images are 2.6 MP in size $(1968 \times 1312 = 2,582,016 \text{ pixels, or about } 2.6 \text{ MP})$ and are compressed to the maximum level, but the card can hold a lot of them. If I were to journey completely around the earth and I had only one 8 GB memory card to take with me, I could use these settings to document my trip well because the camera could store more than 10,000 images on one card.

Note: As previously mentioned, Image size applies only to JPEG images. If you see Image size grayed out on your camera Monitor, you have NEF (RAW) format selected.

Settings Recommendation: You'll get the best images with the Large (24.2 M) Image size. The smaller sizes won't affect the quality of a small print, but they will seriously limit your ability to enlarge your images. I recommend leaving your camera set to Large unless you have a specific reason to shoot smaller images.

Image Area

(User's Manual - Page 89)

Image area is a convenient built-in automatic crop of the FX image to a smaller size. The FX (3:2) area is 36×24mm, and the DX (1.5x) area is 24×16mm. If you need this particular image area, you will be familiar with the industry-standard DX format. Figure 3.10.4 shows the DX format graphically.

The camera can automatically switch to DX mode when it detects that you have mounted a DX lens, or you can set the camera so it stays in the FX format unless you select DX. You will use Auto DX crop to make that decision.

- On If Auto DX crop is set to On, the camera will automatically switch formats when you mount a DX lens
- Off Setting Auto DX crop to Off means the camera will ignore the lens you
 have mounted and stay in FX format; it will usually vignette or leave dark
 edges on the images you take with most DX lenses

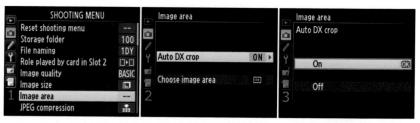

Figure 3.10.1 – Choosing Auto DX crop

Use the following steps to select Auto DX crop:

- 1. Select Image area from the Shooting Menu and scroll to the right (figure 3.10.1, screen 1).
- 2. Choose Auto DX crop and scroll to the right (figure 3.10.1, screen 2).
- 3. Select On or Off (figure 3.10.1, screen 3).
- 4. Press the OK button to save the setting.

Now, let's take a look at the two Image area sizes by examining pictures I took in both formats. These two images are of my rebuilt 1940s-era Agfa Isolette III folding rangefinder camera, with its cool new red bellows (120 roll film format).

Figure 3.10.2 – The two Image area formats

I did not vary the camera position so you can see how the change in Image area affects the size (crop) of the subject (figure 3.10.2). Note that the crop of the DX mode drops the resolution of the image from 24.2 MP to 10.3 MP.

The following is a detailed list of specifications for the two available image areas, including sensor format crop (mm), Image size, pixel count, and megapixel (M) rating:

FX (1.0x at 3:2) Image area $(36 \times 24 \text{mm})$

- Large 7360×4912 36.2 M
- Medium 5520×3680 20.3 M
- Small 3680×2456 9.0 M

DX (1.5x at 3:2) Image area $(24 \times 16 \text{mm})$

- Large 4800×3200 15.4 M
- Medium 3600×2400 8.6 M
- Small 2400×1600 3.8 M

Now, let's see how to select one of these Image area formats for those times when you need to vary the Image area crop.

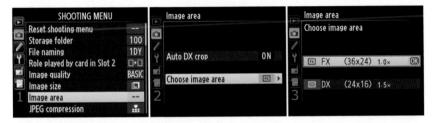

Figure 3.10.3 - Choosing an Image area format

Use the following steps to select one of the Image area formats:

- 1. Choose Image area from the Shooting Menu and scroll to the right (figure 3.10.3, screen 1).
- 2. Select Choose image area and scroll to the right (figure 3.10.3, screen 2).
- 3. Select one of the image area crops. FX is selected in figure 3.10.3, screen 3.
- 4. Press the OK button to save the Image area setting.

Using Viewfinder in DX Mode

There are two ways the Nikon D600 can show you the boundaries of the DX mode frame in the viewfinder. The first is a simple rectangle boundary frame for the exact size of the DX crop, and the second is by graying out the edges of the frame surrounding the DX crop (figure 3.10.4).

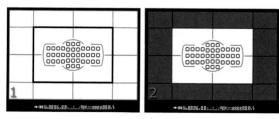

Figure 3.10.4 - DX mode shown in the FX-sized Viewfinder

Figure 3.10.4, screen 1, shows the default behavior of the Viewfinder in DX mode. A rectangular frame shows the DX area crop. Anything outside that frame is not seen in a DX image. It is a true 10.3 MP crop out of the center of the 24.2 MP FX sensor.

Figure 3.10.4, screen 2, shows an alternate way the camera can display the DX crop. You will see this grayed-out area surrounding the DX crop, instead of the rectangular outline, if you have set Custom Setting Menu > a Autofocus > a4 AF point illumination to Off. Of course, that means your AF points will never illuminate, which may be undesirable in some circumstances, such as with low ambient light pictures.

Most people simply leave a4 AF point illumination set to On and remember not to let any of their subject stray outside the DX crop rectangle. That's the way I do it. I'd rather have my camera's AF points flash when I press the Shutterrelease button halfway so I can find which AF point I am using. However, if you use DX crop often, you may want to use the grayed-out Viewfinder for DX mode shooting.

When you shoot in Live view modes, the Monitor automatically shows the entire FX or DX mode image without any frames or graying.

Note: You can assign a feature called Choose image area to a camera button, such as the Fn or Preview button. Then you can adjust the FX or DX Image area mode on the fly without using the Shooting Menu. We will consider how to make the assignment in the next chapter, Custom Setting Menu, in the sections for Custom settings f2 Assign Fn button and f3 Assign preview button.

Settings Recommendation: Being a nature shooter, I normally leave my camera set to FX, the largest image area. If I need a little extra reach, I may switch the camera to DX mode for convenience, although I could also simply crop the image later in the computer. If you shoot a lot of wildlife or sports and can use a 10.3 MP DX image, you may choose to use DX mode more often to get the extra reach without taking time to crop later.

JPEG Compression

(User's Manual - Page 94)

JPEG compression allows you to further fine-tune the compression level of your JPEG images. The JPEG format is always compressed. The Image quality settings for JPEG images include fine, normal, and basic. Each of these settings compress the file size to a certain level.

As discussed previously, a JPEG fine file has a 1:4 compression ratio, JPEG normal has a 1:8 ratio, and JPEG basic has a 1:16 ratio. A JPEG file is smaller than a RAW file.

The size of JPEG files will normally vary when the subject in one image is more complex than the subject in another image. For instance, if you take a picture of a tree with bark and lots of leaves against a bright blue sky, the JPEG compression has a lot more work to do than if you take a picture of a red balloon on a plain white background. All those little details in the picture of the tree cause lots of color contrast changes, so the JPEG file size will naturally be bigger for the complex image. In the balloon image, there is little detail in the balloon and the background, so the JPEG file size will normally be much smaller.

What if you want all your JPEG images to be the same approximate size? Or what if file size doesn't matter to you and quality is much more important? That's what the JPEG compression menu allows you to control. Let's discuss the two settings:

- Size priority This compression setting is designed to keep all your JPEG files at a certain uniform size. This size will vary according to whether you selected JPEG fine, normal, or basic in the Image quality menu. Image quality controls the regular, everyday compression level of the JPEG file, and Size priority tweaks it even more. How does it work? With Size priority enabled, the camera software has a target file size for all the JPEGs you shoot. Let's say the target size is 9.5 MB. The D600 will do its best to keep all JPEGs set to that particular file size by altering the level of compression according to content. If a JPEG file has lots of fine detail, it will require more compression than a file with less detail to maintain the same file size. By enabling this function, you are telling the camera that it has permission to throw away however much image data it takes to get each file to the 9.5 MB target. This could lower the quality of a complex landscape image much more than an image of a person standing by a blank wall. Size priority instructs the camera to sacrifice image quality—if necessary—to keep the file size consistent. Use this function only for images that will not be used for fine art purposes. Otherwise your image may not look as good as it could.
- Optimal quality This setting doesn't do anything extra to your images; the camera simply uses less compression on complex subjects. In effect, you are

telling the camera to vary the file size so the image quality will be good for any subject—complex or plain. Instead of increasing compression to make an image of a complex nature scene fit a certain file size, the camera compresses the image only to the standard compression level based on the Image quality you selected (JPEG fine, normal, or basic) to preserve image quality. Less image data is thrown away, so the image quality is higher. However, the file sizes will vary depending on the complexity of the subject.

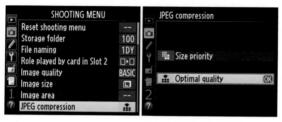

Figure 3.11 - Choosing a JPEG compression type

The steps to choose a JPEG compression type are as follows:

- 1. Select JPEG compression from the Shooting Menu and scroll to the right (figure 3.11, screen 1).
- 2. Choose Size priority or Optimal quality. Figure 3.11, screen 2, shows Optimal quality as the selected compression type.
- 3. Press the OK button.

Settings Recommendation: I normally use Optimal quality when I shoot JPEGs because the JPEG format uses lossy compression, and I don't want the potentially heavier compression of Size priority to lower the image quality even more. The only time I use Size priority is when I'm shooting what I call "party pics." When I'm at a party shooting snapshots of friends having a good time, I'm not creating fine art and will never make an enlargement greater than 8×10 inches (20×25 cm), so I don't worry about extra compression. In fact, I might welcome it to avoid storing larger-than-needed images on my computer hard drive.

Using Size priority lets the camera use maximum compression to maintain the JPEG compression ratios. Your images may not have those precise compression ratios if you use Optimal quality—especially with complex, detailed subjects.

NEF (RAW) Recording

(User's Manual - Page 94)

NEF (RAW) recording is composed of two menu choices: Type and NEF (RAW) bit depth. Type is concerned with image compression, and NEF (RAW) bit depth deals with color quality. We'll look at both of these choices and see how your photography can benefit from them.

Type

In previous sections we discussed how JPEG files have different levels of compression that vary the size of a finished image file. NEF (RAW) also has compression choices, though not as many. The nice thing about the RAW compression methods is they don't throw away massive amounts of image data like JPEG compression does. NEF (RAW) is not considered a lossy format because the file stays complete, with virtually all of the image data your camera captured.

One of the NEF (RAW) compression methods, called Compressed, is very slightly lossy. The other, Lossless compressed, keeps all the image data intact. Let's discuss how each of the available compression methods works.

Although there are two NEF (RAW) formats available, you see a single NEF (RAW) selection on the Image quality menu. After you select NEF (RAW), you need to use Shooting Menu > NEF (RAW) recording > Type to select one of the two NEF (RAW) compression types:

- NEF (RAW) Lossless compressed (20–40 percent file size reduction) The factory default for the NEF (RAW) format is Lossless compressed. According to Nikon, this compression will not affect image quality because it's a reversible compression algorithm. Since Lossless compressed shrinks the stored file size by 20 to 40 percent—with no image data loss—it's my favorite compression method. It works somewhat like a ZIP file on your computer; it compresses the file but allows you to use it later with all the data still available.
- NEF (RAW) Compressed (35–55 percent file size reduction) Before the newest generation of cameras, including the D600, the Compressed mode was known as visually lossless. The image is compressed and the file size is reduced by 35 to 55 percent, depending on the amount of detail in the image. There is a small amount of data loss involved in this compression method. Most people can't see the loss since it doesn't affect the image visually. I've never seen any loss in my images with the Compressed mode. However, I've read that some people notice slightly less highlight detail. Nikon says the Compressed mode uses nonreversible compression, with "almost no effect on image quality." However, after you've taken an image using this mode, any small amount of data loss is permanent. If this concerns you, then use the

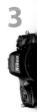

Figure 3.12 – Choosing a NEF (RAW) recording compression type

The steps to select a NEF (RAW) recording compression Type are as follows:

- 1. Select NEF (RAW) recording from the Shooting Menu and scroll to the right (figure 3.12, screen 1).
- 2. Choose Type and scroll to the right (figure 3.12, screen 2).
- 3. Select a compression method from the Type menu (figure 3.12, screen 3). I chose Lossless compressed.
- 4. Press the OK button to save your selection.

An image with a large area of blank space, such as an expanse of sky, will compress a lot more efficiently than an image of, for example, a forest with lots of detail. The camera displays a certain amount of image storage capacity in NEF (RAW) modes—about 151 images on an 8 GB card.

In the two NEF (RAW) compressed modes, the D600 does not decrease the image capacity counter by one for each picture taken. Instead, it decreases the counter approximately every two shots, depending on how well it compressed the images. When the card is full, it might contain nearly twice as many images as the camera initially reported it could hold. Your D600 deliberately underreports storage capacity when you are shooting in either of the NEF (RAW) compressed modes because it can't anticipate how well the compression will work on each image.

Settings Recommendation: I'm concerned about maximum quality along with good storage capacity, so I shoot in Lossless compressed mode all the time. It makes the most sense to me since it produces a file size close to half the size of a normal uncompressed RAW file (if you could create one with the D600, which you can't). More expensive Nikon cameras can create uncompressed RAW files,

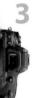

although there's no point when a Lossless compressed file retains all data and is stored on your computer hard drive at close to half the size.

I haven't used Compressed mode much since Lossless compressed became available in Nikon cameras a few years ago. Even though I can't see any image quality loss, it bothers me that it's there, if only slightly. The extra 10 or 15 percent compression is not worth the potential small data loss to me. If I were running out of card space but wanted to keep shooting RAW, I might consider changing to Compressed temporarily. Otherwise it's Lossless compressed for me!

NEF (RAW) Bit Depth

NEF (RAW) bit depth is a special feature for those of us concerned with capturing the best color in our images. The D600 has three color channels, one for red, another for green, and the last one for blue (RGB). The camera combines those color channels to form all the colors you see in your images. Let's talk about how bit depth, or the number of colors per channel, can make your pictures even better.

With the D600, you can select the bit depth stored in an image. More bit depth equals better color gradations. An image with 12 bits contains 4,096 colors per RGB channel, and an image with 14 bits contains 16,385 colors per RGB channel. In lesser DSLR cameras, the color information is limited to 12 bits. If you do not fully understand what this means, take a look at the Channel and Bit Depth **Tutorial** following this section.

The D600 has the following two bit depths available: 12 bit (4,096 colors per channel) and 14 bit (16,385 colors per channel).

Figure 3.13 - Choosing a NEF (RAW) bit depth

The steps to choose a NEF (RAW) bit depth are as follows:

- 1. Select NEF (RAW) recording from the Shooting Menu and scroll to the right (figure 3.13, screen 1).
- 2. Select NEF (RAW) bit depth and scroll to the right (figure 3.13, screen 2).
- 3. Select 12-bit or 14-bit from the NEF (RAW) bit depth menu (figure 3.13, screen 3).
- 4. Press the OK button to save your selection.

Settings Recommendation: Which bit depth setting is best? I always use 14 bit because I want all the color my camera can capture for the best possible pictures. If you read my bit depth tutorial in the next subsection, you'll understand why I feel that way. My style of shooting is nature oriented, so I am concerned with capturing every last drop of color I can.

There is one small disadvantage to using the 14-bit mode. Your file sizes will be 1.3 times larger than they would have been in 12-bit mode. There is a lot more color information being stored, after all.

Channel and Bit Depth Tutorial

What does all this talk about bits mean? Why would I set my camera to use to 14-bit depth instead of 12-bit depth? This short tutorial explains bit depth and how it affects color storage in an image.

An image from your camera is an RGB image, where each of the three colors—red, green, and blue—have separate channels. If you're shooting in 12-bit mode, your camera will record up to 4,096 colors for each channel, so there will be up to 4,096 different reds, 4,096 different greens, and 4,096 different blues. Lots of color! In fact, almost 69 billion colors $(4,096 \times 4,096 \times 4,096)$. If you set your camera to 14-bit mode, the camera can store 16,384 different colors in each channel. Wow! That's quite a lot more color—almost 4.4 trillion shades $(16,384 \times 16,384 \times 16,384)$.

Is that important? Well, it can be, since the more color information you have, the better the color in the image—if it has a lot of color. I always use the 14-bit mode. That allows for smoother color changes when a large range of color is in the image. I like that!

Of course, if you save your image as an 8-bit JPEG or TIFF, most of those colors are compressed, or thrown away. Shooting a JPEG image in-camera (as opposed to a RAW image) means that the camera converts the image in a 12- or 14-bit RGB file to an 8-bit file. An 8-bit image file can hold 256 different colors per RGB channel—more than 16 million colors ($256 \times 256 \times 256$).

There's a big difference between the number of colors a camera captures in a RAW file and the number captured in a JPEG file (16 million versus 4.4 trillion). That's why I always shoot in RAW; later I can make full use of all those extra colors—if the subject contains that many shades— to create a different look for the same image.

If you shoot in RAW and later save your image as a 16-bit TIFF file, you can store all the colors you originally captured. A 16-bit file can contain 65,536 different colors in each of the RGB channels, which is significantly more than the camera actually captures.

Many people save their files as 16-bit TIFFs when they post-process RAW files, especially if they are worried about the long-term viability of the NEF (RAW) format. TIFF gives us a known and safe industry-standard format that will fully contain all image color information from a RAW file.

It's important that you learn to use your camera's histogram so you can examine the various RGB channels at a glance.

We'll discuss the histogram in an upcoming chapter titled Metering, Exposure Modes, and Histogram. In the meantime, please look at figure 3.14, which shows the histogram screen on vour camera and its RGB channels.

We talked about this screen in the chapter titled **Playback Menu**. However, I want to tie this in here to help you understand channels better. The histogram displays the amount and brightness of color for each of the RGB channels.

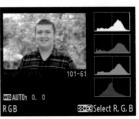

Figure 3.14 - RGB histogram screen

In figure 3.14 you can see four small histograms on the right side of the screen. The bottom three histograms represent the red, green, and blue color channels, as can easily be seen.

The white histogram on top is not an additional channel. It is called a luminance histogram, and it represents a combined, weighted histogram for the three color channels (green 59 percent, red 30 percent, and blue 11 percent). It is also known as a brightness histogram. In reality, even though all the color channels influence the luminance histogram, much of its information comes from the green channel. Notice that the luminance histogram and green channel histogram are very similar.

In digital photography we must use new technology and learn lots of new terms and acronyms. However, by investing a little time to understand these tools, we'll become better digital photographers.

White Balance

(User's Manual - Page 115)

White balance is designed to let you capture accurate colors in each of your camera's RGB color channels. Your images can reflect realistic colors if you understand how to use the White balance settings. This is an important thing to learn about digital photography. If you don't understand how White balance works, you'll have a hard time when you want consistent color across a number of images.

In this section we will look at White balance briefly and learn how to select the various White balance settings. This is such an important concept to understand that an entire chapter—titled White Balance—is devoted to this subject. Please read that chapter very carefully. It is important that you learn to control the White balance settings thoroughly. A lot of what you'll do in computer postprocessing requires a good understanding of White balance control.

Many people leave their cameras set to Auto White balance. This works fine most of the time because the camera is quite capable of rendering accurate color. However, it's hard to get exactly the same White balance in each consecutive picture when you are using Auto mode. The camera has to make a new White balance decision for each picture in Auto. This can cause the White balance to vary from picture to picture.

For many of us this isn't a problem. However, if you are shooting in a studio for a product shot, I'm sure your client will want the pictures to be the same color as the product and not vary among frames. White balance lets you control that carefully, when needed.

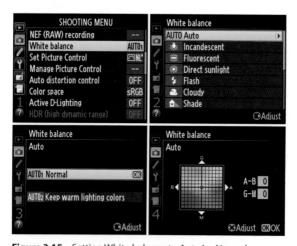

Figure 3.15 - Setting White balance to Auto1 - Normal

The steps to select a White balance setting are as follows:

- 1. Select White balance from the Shooting Menu and scroll to the right (figure 3.15, screen 1).
- 2. Choose a White balance type, such as Auto or Flash, from the menu and scroll to the right (figure 3.15, screen 2).
- 3. If you choose Auto, Fluorescent, Choose color temp., or Preset manual you will need to select from an intermediate screen, shown in figure 3.15, screen 3. Auto presents two settings: Auto1 – Normal and Auto2 – Keep warm lighting

- colors. Fluorescent presents seven different types of fluorescent lighting. Choose color temp. allows you to select a color temperature manually from a range of 2500 K (cool) to 10000 K (warm). Preset manual (PRE) shows the stored White balance memory locations d-1 through d-4 and allows you to choose one of them. If this seems a bit overwhelming, just choose Auto1 – Normal for now. The chapter titled White Balance will explain how to use all these settings.
- 4. As shown in figure 3.15, screen 4, you'll now arrive at the White balance finetuning screen. You can make an adjustment to how you want this White balance to record color by introducing a color bias toward green, yellow, blue, or magenta. You do this by moving the little black square in the middle of the color box toward the edges of the box in any direction. If you make a mistake, simply move the black square to the middle of the color box. Most people do not change this setting.
- 5. After you have finished adjusting (or not adjusting) the colors, press the OK button to save your setting. Most people press the OK button as soon as they see the fine-tuning screen so they don't change the default settings for that particular White balance.

You'll also find it convenient to change the White balance settings by using external camera controls:

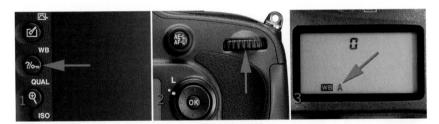

Figure 3.16 - Setting White balance with external controls

- 1. Hold down the WB button, which shares functionality with the Help/protect button (figure 3.16, image 1).
- 2. Turn the Main command dial (figure 3.16, image 2) as you watch the WB icons change on the Control panel (figure 3.16, image 3).
- 3. Release the WB button to lock in your choice.

Settings Recommendation: Until you've read the chapter titled White Balance, I suggest that you leave the camera's White balance set to Auto1 – Normal. However, please do take the time to understand this setting by reading the dedicated chapter carefully. Understanding White balance is especially important if you plan to shoot JPEGs regularly.

Set Picture Control

(User's Manual - Page 129)

Set Picture Control allows you to choose a Picture Control for a shooting session. Nikon's Picture Control system lets you control how your image appears in several ways. Each control has a specific effect on the appearance of the image. If you ever shoot film, you know that there are distinct looks to each film type. No two films produce color that looks the same.

In today's digital photography world, Picture Controls give you the ability to impart a specific look to your images. You can use Picture Controls as they are provided from the factory, or you can fine-tune Sharpening, Contrast, Brightness, Saturation, and Hue.

We'll discuss how to fine-tune a Nikon Picture Control later in this section. In the next section we'll discuss how to save a modified Picture Control under your own Custom Picture Control name. You can create up to nine Custom Picture Controls

I'll refer to Picture Controls included in the camera as Nikon Picture Controls since Nikon does too. You may also see them called Original Picture Controls in some Nikon literature. If you modify and save a Nikon Picture Control under a new name, it becomes a Custom Picture Control. I'll also use the generic name of Picture Control when I refer to any of them.

The cool thing about Picture Controls is that they are shareable. If you tweak a Nikon Picture Control and save it under a name of your choice, you can then share it with others. Compatible cameras, software, and other devices can use these controls to maintain the look you want from the time you press the Shutter-release button until you print the picture with a program like Nikon Capture NX2.

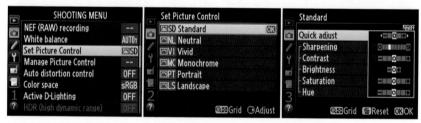

Figure 3.17 - Choosing a Picture Control with the Shooting Menu

The steps to choose a Picture Control, using the camera's Shooting Menu, are as follows:

1. Select Set Picture Control from the Shooting Menu and scroll to the right (figure 3.17, screen 1).

- 2. Choose one of the Nikon Picture Controls from the Set Picture Control screen (figure 3.17, screen 2).
- 3. At this point, you can simply press the OK button and the control you've chosen will be available for immediate use. It will show up as a two-letter name in the Shooting Menu next to Set Picture Control. You can see this in figure 3.17, screen 1, where SD is displayed to the right of Set Picture Control.
- 4. You can also modify the currently highlighted control by scrolling to the right (figure 3.17, screen 3). This will bring you to the fine-tuning screen. You can adjust the Sharpening, Contrast, Brightness, Saturation, and Hue settings by scrolling up or down to select a line and then scrolling right or left (-/+) to change the value of that line item. This is entirely optional. When you are finished, press the OK button.

You can also select a Picture Control by using a combination of the external Picture Control/Retouch button and the Set Picture Control menu that pops up when you press it (figure 3.17.1).

Figure 3.17.1 – Choosing a Picture Control with the Picture Control/Retouch button

Use the following steps to choose a Picture Control with the more direct external method:

- 1. Press the Picture Control/Retouch button (figure 3.17.1, image 1).
- 2. Select your preference from the Set Picture Control menu with the Multi selector (figure 3.17.1, screen 2).
- 3. Press the OK button to lock in your choice.

Either of these two methods work well. The more direct external method of using the Picture Control/Retouch button is preferred by most D600 owners.

Modifying an Existing Picture Control

What if you want to modify a Picture Control by changing its sharpness, contrast, brightness, saturation, or hue? Figure 3.17, screen 3, shows the settings to change any of those values.

Screens 1 and 2 of figure 3.18 show an asterisk after the Vivid Picture Control (VI* – Vivid). This asterisk appears after you have made a modification to any of the Picture Control's inner settings, such as Sharpening or Contrast. The asterisk will go away if you set the control back to its factory default configuration.

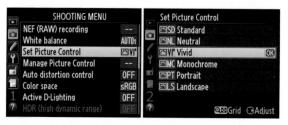

Figure 3.18 – The Vivid Picture Control has been modified

Note: You can reset a Picture Control by pressing the Delete button when you are in the Quick adjust screen shown in figure 3.17, screen 3.

Now, let's take a closer look at the Picture Control system. As shown in figure 3.17, screen 2, and figure 3.17.1, screen 2, there is a series of Picture Control selections that modify how your D600 captures an image:

- SD Standard
- NL Neutral
- VI Vivid
- MC Monochrome
- PT Portrait
- LS Landscape

Each of these settings has a different and variable combination of the following settings:

- Sharpening
- Contrast
- Brightness
- Saturation
- Hue
- Filter effects (MC only)
- Toning (MC only)

You can select one of the controls and leave the settings at the factory defaults, or you can modify the settings and completely change how the D600 captures the image (figure 3.17, screen 3). If you shoot in one of the NEF (RAW) modes, the D600 does not apply these settings to the image permanently; it stores them with the image so you can change them during post-processing in your computer. If you shoot JPEG, the camera immediately and permanently applies the settings you've chosen. Let's examine each of the Picture Controls.

Examining Picture Controls

Figure 3.19 provides a look at the differences in color saturation and shadow with the various controls. Due to limitations in printing, it may be hard to see the variations. Saturation and Contrast depth increases within these Picture Control choices, in this order: NL (low), SD (medium), VI (high).

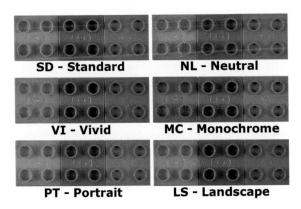

Figure 3.19 – Red, green, and blue with all six Picture Controls

The following is an overview of what Nikon says about Picture Controls and what you will see in figure 3.19 with the various controls.

- SD, or Standard, is Nikon's recommendation for getting "balanced" results. They recommend SD for most general situations. Use this Picture Control if you want a balanced image and don't want to post-process it. The control has what Nikon calls "standard image processing." It provides what I would call medium saturation, with darker shadows to add contrast. If I were shooting JPEG images in a studio or during an event, I would seriously consider using the SD control. I would compare this setting to Fuji Provia or Kodak Kodachrome 64 slide films.
- NL, or Neutral, is best for an image that will be extensively post-processed in a computer. It, too, is a balanced image setting, but it applies minimal camera processing so you'll have room to do more with the image during

post-processing. The NL control has less saturation and weaker shadows, so the image will be less contrasty. The effects of the NL and SD controls are harder to see in figure 3.19 since there's not a marked difference. However, the NL control will give you a little extra dynamic range due to more open shadows and slightly less saturated colors. If you've ever shot with Fuji NPS or Kodak Portra negative films and liked them, you'll like this control.

- VI, or Vivid, is for those of us who love Fuji Velvia slide film. This setting places emphasis on saturating primary colors for intense imagery. The contrast is higher for striking shadow contrast, and the sharpness is higher, too. If you are shooting JPEGs and want to imitate a saturated transparency film like Velvia, this mode is for you! If you look at the red block under the VI control in figure 3.19, you'll see that it's pushed into deep saturation, almost to the point of oversaturation. Plus, the greens and blues are extra strong. That means your nature shots will look saturated and contrasty. Be careful when you use the VI control on a high-contrast day, such as in direct sunshine in the summer, because you may find that your images are too high in contrast. It may be better to back off to the SD or NL control when you shoot in bright sunshine. You'll need to experiment with this to see what I mean. On a cloudy or foggy lowcontrast day, when the shadows are weak, you may find that the VI control adds pleasing saturation and contrast to the image.
- MC, or Monochrome, allows the black-and-white lovers among us to shoot in toned black-and-white. The MC control basically removes the color by desaturation. It's still an RGB color image, but the colors have become levels of gray. It does not look the same as black-and-white film, in my opinion. The blacks are not as deep, and the whites are a little muddy. To me, it seems that the MC control is fairly low contrast, and that's where the problem lies. Good blackand-white images should have bright whites and deep blacks. To get images like that from a digital camera, you'll have to manually work with the image in a graphics program like Photoshop. However, if you want to experiment with black-and-white photography, this gives you a good starting point. There are two extra settings in the MC control that allow you to experiment with Filter effects and Toning. We'll look at these settings in the upcoming section called MC Picture Control Filter Effects and Toning. The MC control creates a look that is somewhat like Kodak Plus-X Pan negative film, with blacks that are not as deep.
- PT, or Portrait, is a control that, according to Nikon, "lends a natural texture and rounded feel to the skin of portrait subjects." I've taken numerous images with the PT control and shot the same images with the NL control. The results are very similar. I'm sure that Nikon has included some software enhancements specifically for skin tones in this control, so I'd use this control

for portraits of people. The results from the PT control look a bit like smooth Kodak Portra or Fuji NPS negative films.

• LS, or Landscape, is a control that "produces vibrant landscape and cityscapes," according to Nikon. That sounds like the VI control to me. I shot a series of images using both the LS and VI controls and got similar results. Compared to the VI control, the LS control seemed to have slightly less saturation in the reds and a tiny bit more saturation in the greens. The blues stayed about the same. It seems that Nikon has created the LS control to be similar to, but not quite as drastic as, the VI control. In my test images the LS control created smoother color transitions. However, there was so little difference between the two controls that you'd have to compare the images side by side to notice. Maybe this control is meant to be more natural than the supersaturated VI control. It will certainly improve the look of your landscape images. The look of this control is somewhere between Fuji Provia and Velvia films. You get great saturation and contrast, with emphasis on the greens in natural settings.

MC Picture Control Filter Effects and Toning

The Monochrome, or MC, Picture Control has some added features that are enjoyable for those who love black-and-white photography.

As shown in figure 3.20, there are Filter effects that simulate the effect of yellow, orange, red, and green (Y, O, R, G) filters on a monochrome image. Yellow, orange, and red change the contrast of the sky in black-and-white images. Green is often used in black-and-white portrait work to change the appearance of skin tones. You don't have to go buy filters for your lenses; they're included free in your D600.

Figure 3.20 - Filter effects controls

Filter Effects

Figure 3.21 is a comparison of a color SD Picture Control and the five MC Filter effects (including off). In real-life use, the R (red) effect seems to darken the sky and emphasize clouds a bit better in nature images.

SD - Standard

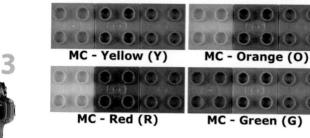

Figure 3.21 - Filter effects: SD, off, yellow, orange, red, and green

Notice how dark the blue is with the MC red Filter effect. The sky will do that too! The Filter effects can be more pronounced than if you used a glass filter attached to your lens.

MC - No Filter

Toning

As displayed in figure 3.22, there are 10 variable Toning effects: B&W (none, or standard black-and-white), Sepia, Cyanotype, Red, Yellow, Green, Blue Green, Blue, Purple Blue, and Red Purple. Each of the Toning effects is variable within itself—you can adjust the saturation of the individual tones.

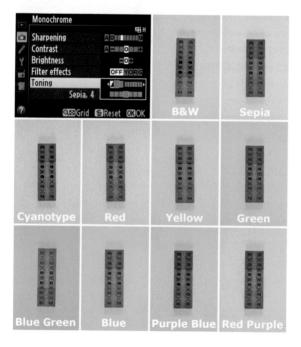

Figure 3.22 - Filter effects -Toning filters

In figure 3.22, I cranked the Toning effects all the way up to the maximum setting, which tends to oversaturate the toning color, so you could clearly see the maximum potential in the Toning settings.

You can shoot a basic black-and-white image, use filters to change how colors appear, or tone the image in experimental ways. Can you see the potential for a lot of fun with these tones?

In the first screen of figure 3.22, notice that to the right of Toning there is a row of 10 tiny rectangles and arrows on each end. The first rectangle is half black and half white. That is the normal black-and-white (B&W) selection, and it has no extra toning. Next to that you'll see a golden-brown rectangle. That is the Sepia toning effect. To the right of that is the bluish Cyanotype effect. The smaller rectangles that follow are the other colors for toning. Each color has seven saturation settings in the bar below the Toning rectangles (e.g., next to Sepia, 4 in figure 3.22). This bar allows you to select the depth of saturation for each of the colors. Sepia is set to the fourth saturation position in figure 3.22.

Use the Multi selector to move around in the Filter effects and Toning settings. Press the OK button to select one of them.

Picture Control Grid Screen

Each Picture Control has a Picture Control Grid that allows you to compare the selected control to the other Nikon Picture Controls (figure 3.23). You access the Grid by scrolling to the screen shown in figure 3.18, screen 2, then pressing the Playback zoom out/thumbnails button.

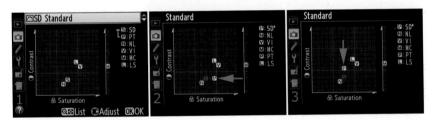

Figure 3.23 – Picture Control Grid screen

When you make a modification to the Saturation or Contrast of a particular control, you'll see the position of that control change on the Picture Control Grid. Figure 3.23, screen 1, shows a Standard Picture Control Grid in its unchanged condition, with all controls set to the factory default.

In figure 3.23, screen 2, I changed the Saturation. You can see that the S*, which represents the modified Standard setting, has moved from its starting location (screen 1) to its new location two squares to the right (screen 2, red arrow). In figure 3.23, screen 3, I changed the Contrast. The S* moved from its former location up a couple of squares to its new location (screen 3, red arrow).

The Picture Control Grid allows you to see how each control compares to the others, both before and after you make a change. When a change has been made, you'll see a black square that marks the original location of the control and a yellow square that marks the new location. The new location will have the same name as the previous location, except you'll see an asterisk after it.

Notice in figure 3.23, screen 1, that the Standard Picture Control is highlighted in a yellow bar at the top of the screen. Also notice the up and down pointers at the end of the yellow bar. This signifies that you can scroll up or down with the Multi selector and access other Picture Controls for comparison purposes. Each item in the two-character list on the right side of the screen (SD, NL, VI, MC, PT, LS) will turn yellow as that particular Picture Control is highlighted. Its symbol and full name will appear in the yellow bar at the top of the screen.

Resetting a Nikon Picture Control

If you modify the Nikon Picture Controls, you may do what I did and forget what the original settings were when you want to change them back. Worry not! Nikon has given us an easy way to reset a control.

If you press the Delete button while you have the Set Picture Control screen open (figure 3.24, screen 1, red arrow), you'll see the warning in shown in figure 3.24, screen 2: Selected Picture Control will be reset to default settings. OK? Select Yes from the menu and press the OK button to reset the control to the factory default settings.

Figure 3.24 - Reset a Picture Control

Photoshop and Black-and-White Images

The RGB color channels are intact when the D600 captures a black-and-white image, so you can use Photoshop's Channel Mixer (Image Menu > Adjustments > Channel Mixer) to manipulate the color channels and improve the blacks and whites. Or you can work with a color image and convert it to black-and-white with much higher contrast (deeper blacks and whites) than the camera will provide.

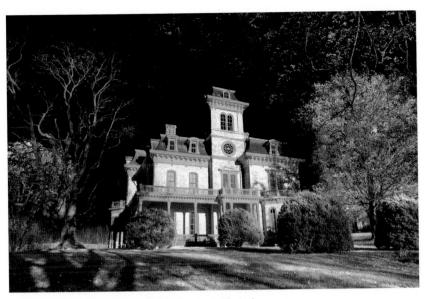

Figure 3.25 - Creating black-and-white images in Photoshop

Figure 3.25 shows an image I shot on a late fall day of a sun-drenched red brick antebellum mansion. I heavily manipulated the red channel to make the bricks turn a startling white. It is beyond the scope of this book to show you how to do this; however, I encourage you to experiment with Photoshop's Channel Mixer control for your color to black-and-white conversions and to adjust your cameracreated black-and-white images. You can create some startlingly beautiful blackand-white fine art pictures.

If you use Photoshop to play with the channels, be sure to put a check mark in the Monochrome box in the Channel Mixer window. If you don't, you'll simply add color back into your camera-created black-and-white image. This proves that a black-and-white image from the D600 is really just a color image with the colors desaturated to levels of gray. The good thing is you now have room to play with the three color channels, similar to how you use color filters when you shoot black-and-white film.

You can add or subtract contrast by moving the channel sliders until you are happy with the results. There is a lot of discussion about these techniques on the Internet. Why not join the Nikonians.org forum to learn how to best achieve beautiful black-and-white images? Look for the Nikonians Gold Membership 50 Percent Discount Coupon in the back of this book.

Manage Picture Control

(User's Manual - Page 134)

The *Manage Picture Control* section of your camera's Shooting Menu allows you to create and store Custom Picture Control settings for future use. If you modified Picture Controls when you read the Set Picture Control section, you simply created a one-off setting. If you'd like to go further and create your own named Custom Picture Controls, the D600 is happy to oblige.

There are four choices on the Manage Picture Control screen:

- Save/edit
- Rename
- Delete
- Load/save

Let's look at each of these four Picture Control management settings.

Save/Edit a Custom Picture Control

There are six screens to Save/edit a Nikon Picture Control (figure 3.26) and store the newly named Custom Picture Control for later use.

Figure 3.26 - Save/edit a Picture Control

Use the following the steps to edit, name, and save a Custom Picture Control:

- 1. Select Manage Picture Control from the Shooting Menu and scroll to the right (figure 3.26, screen 1).
- 2. Highlight Save/edit and scroll to the right (figure 3.26, screen 2).
- 3. Choose a Picture Control that you want to use as a base for your new settings, and then scroll to the right (figure 3.26, screen 3). I am modifying the Standard Picture Control and will save it under a different name.

- 4. Make your adjustments to Sharpening, Contrast, and so forth. When you are done, press the OK button (figure 3.26, screen 4).
- 5. Select one of the nine storage areas named C-1 to C-9 and scroll to the right (figure 3.26, screen 5). They are all currently marked as Unused. I can save up to nine different Custom Picture Controls for later selection (Set Picture Control).
- 6. The Rename screen works just like other screens you've used to rename things. Type in a new name by selecting characters from the list at the top of the screen and pressing the OK button to choose the highlighted character (figure 3.26, screen 6). To correct an error, hold down the Playback zoom out/ thumbnails button and use the Multi selector to move back and forth along the field that contains the new name.
- 7. Press the Playback zoom in button when you have entered the name of your Custom Picture Control. This will save the custom control to the location you selected.

Your camera is now set to your Custom Picture Control. You can switch between your Custom Picture Controls and the Nikon Picture Controls by using Set Picture Control (see the previous section, Set Picture Control). Each of your newly named Custom Picture Controls will appear in the Set Picture Control menu. Now, let's look at how to rename an existing Custom Picture Control.

Rename a Custom Picture Control

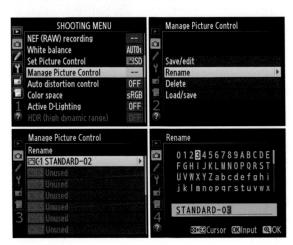

Figure 3.27 - Renaming a Picture Control

If you decide to rename an existing Custom Picture Control, you can do so with the following steps:

- 2. Select Rename from the Manage Picture Control screen and scroll to the right (figure 3.27, screen 2).
- 3. Select one of your Custom Picture Controls from the list (C-1 to C-9) and scroll to the right (figure 3.27, screen 3). I will rename STANDARD-02. This is the Custom Picture Control I created in the previous section.
- 4. Now you'll see the Rename screen (figure 3.27, screen 4). To create a different name, hold down the Playback zoom out/thumbnails button and use the Multi selector to scroll back and forth within the old name. When you have the small gray cursor positioned over a character, you can delete that character with the Delete button. To insert a new character, position the yellow cursor in the character list and press the OK button. The character that is highlighted will appear on the name line below, at the position of the gray cursor. If a character is already highlighted with the gray cursor, it will be pushed to the right. The name of your Custom Picture Control is limited to 19 characters.
- 5. Press the Playback zoom in button when you have completed the new name. I renamed my Custom Picture Control from STANDARD-02 (figure 3.27, screen 3) to STANDARD-03 (figure 3.27, screen 4).

Note: You can have more than one control with exactly the same name in your list of Custom Picture Controls. The camera does not get confused because each control has a different location (C-1 to C-9).

When you no longer need a Custom Picture Control, you can easily delete it.

Delete a Custom Picture Control

You cannot delete a Nikon Picture Control (SD, NL, VI, MC, PT, or LS). They don't even appear in the Manage Picture Control deletion list.

However, you can delete one of your Custom Picture Controls by following these steps:

- 1. Select Manage Picture Control from the Shooting Menu and scroll to the right (figure 3.28, screen 1).
- 2. Select Delete from the Manage Picture Control screen and scroll to the right (figure 3.28, screen 2). You'll find up to nine controls listed in C-1 to C-9.
- 3. Select one of the nine available Custom Picture Controls and press the OK button (figure 3.28, screen 3). I selected STANDARD-03 for deletion.
- 4. A screen with the question, *Delete Picture Control?* will appear, with the name of the selected Custom Picture Control beneath the question. Choose Yes and press the OK button to delete the Custom Picture Control from your camera (figure 3.28, screen 4). The word *Done* will flash on your Monitor briefly, and the Shooting Menu will reappear.

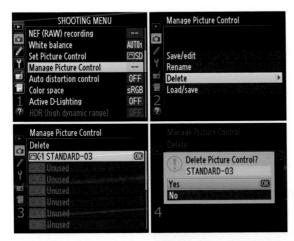

Figure 3.28 - Deleting a Picture Control

Now, let's move to the last menu selection from the Manage Picture Control screen, Load/save.

Load/Save a Custom Picture Control

There are three parts to the Load/save function. They allow you to copy Custom Picture Controls to and from the memory card or delete them from the card.

When I mention copying or deleting controls from the memory card, I'm speaking of the primary card slot on the D600. You cannot copy or delete controls from the secondary card slot. There are three selections in the Load/save menu, as shown in figure 3.29, screen 3.

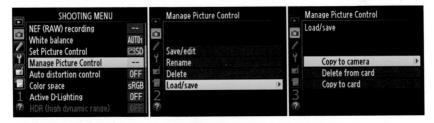

Figure 3.29 - Load/save a Picture Control

- Copy to camera Loads Custom Picture Controls from the memory card into your camera. You can store one control in each of your camera's nine memory locations (C1-C9).
- Delete from card Displays a list of any Custom Picture Controls found on the memory card. You can selectively delete them.

Let's examine each of these selections and see how to best use them.

Copy to Camera

After you've transferred a Custom Picture Control from your memory card to your camera, it will show up in the *Shooting Menu* > *Set Picture Control* screen.

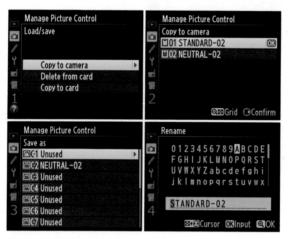

Figure 3.30 - Copy to camera

Use the following steps to copy a saved Custom Picture Control from the memory card to the camera's memory:

- 1. Figure 3.30, screen 1, continues from figure 3.29, screen 2 (Load/save on the Manage Picture Control menu). Choose Copy to camera and scroll to the right.
- 2. You'll see the list of controls that are currently on the memory card (figure 3.30, screen 2). If there are no controls on the memory card, the camera will display a screen that says, No Picture Control file found on memory card. Figure 3.30, screen 2, shows two controls: STANDARD-02 and NEUTRAL-02. Select a control from the list and press the OK button. (If you scroll to the right instead, you will be able to examine and adjust the control's settings before saving it to your camera. If you don't want to modify it, simply press the OK button.)
- You will now see the Manage Picture Control > Save as menu, which lists any Custom Picture Controls already in your camera (figure 3.30, screen 3). Select one of the Unused memory locations and press the OK button.

4. You'll now see the Rename screen, where you can change the name of the Custom Picture Control. If you don't want to change the name, simply press the Playback zoom in button, and the custom control will be added to your camera's Set Picture Control menu. It's okay to have multiple controls with exactly the same name. The camera keeps each control separate. However, I always rename them to prevent confusion, which is what we'll do next.

Copy to Camera – Renaming a Custom Picture Control

To create a different name for a Custom Picture Control, refer to figures 3.30 and 3.31.

1. Hold down the Playback zoom out/thumbnails button and use the Multi selector to scroll back and forth within the old name. When the small gray cursor highlights a character, you can delete it with the Delete button. To insert a new character, position the yellow cursor in the character list and press the OK button. The

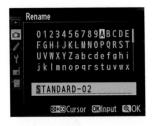

Figure 3.31 - Rename a Custom Picture Control

character that is highlighted with the yellow cursor will appear on the name line below, at the position of the gray cursor. If there is already a character highlighted by the gray cursor, it will be pushed to the right. Custom Control Picture names are limited to 19 characters.

2. Press the Playback zoom in button when you've completed the new name.

You can also create Custom Picture Controls in computer programs, such as by using the Picture Control Utility in Nikon Capture NX2, and load them into your camera using the preceding steps.

Delete from Card

After you've finished loading Custom Picture Controls onto your camera, you may be ready to delete a control or two from the memory card. You could format the memory card, but that will delete all the images and Picture Controls on the card. A less drastic method that allows you to be more selective is the Delete from card function.

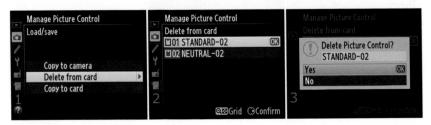

Figure 3.32 - Delete from card

- 1. Figure 3.32 continues from figure 3.29, screen 2. Choose Delete from card from the Load/save menu and scroll to the right (figure 3.32, screen 1).
- 2. Choose one of the Custom Picture Controls that you want to delete (figure 3.32, screen 2). I chose STANDARD-02. You can confirm that you are deleting the correct control by scrolling to the right, which gives you the finetuning screen with the current adjustments for that control. If you are sure that this is the control you want to delete, move on to the next step by pressing the OK button.
- 3. You will be shown the deletion screen, which asks, Delete Picture Control? Choose either Yes or No (figure 3.32, screen 3). If you choose Yes, the Picture Control will be deleted from the memory card. If you choose No, you will return to the previous screen.
- 4. Press the OK button to execute your choice.

Copy to Card

After you create up to nine Custom Picture Controls using the instructions in the previous few sections, you can use the Copy to card function to save them to a memory card. When they are on a memory card, you can share your Custom Picture Controls with friends who have compatible Nikon cameras.

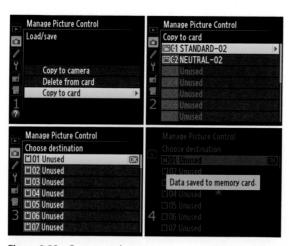

Figure 3.33 - Copy to card

Use the following steps to copy your Custom Picture Controls to a memory card:

- 1. Figure 3.33 continues where figure 3.29, screen 2, left off. Choose Copy to card from the Load/save menu and scroll to the right (figure 3.33, screen 1).
- 2. Select one of your current Custom Picture Controls from the Copy to card menu and scroll to the right (figure 3.33, screen 2).
- 3. Now you'll use the Choose destination menu to select where you want to save the custom control (figure 3.33, screen 3). You have 99 choices for where to place the control on the card. Select any Unused location.
- 4. Press the OK button, then you'll briefly see a screen that says, Data saved to memory card (figure 3.33, screen 4). Your Custom Picture Control is now ready to distribute to the world or load onto another one of your compatible Nikon cameras.

As shown in figure 3.33.1 (red arrow), you can always tell which Nikon Picture Control a Custom Picture Control was derived from because its origin is named in the upper-right corner. In this case, my new STANDARD-02 Custom Picture Control was derived from the SD Nikon Picture Control. This is useful to know in case you give your Custom Picture Control a name that does not give a clue as to which Nikon Picture Control it came from. Now you will know that your Custom Pic-

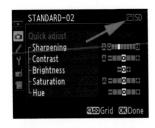

Figure 3.33.1 - Derived from where?

ture Control named Wild Colors came from the Vivid Nikon Picture Control with the Saturation turned all the way up.

Settings Recommendation: To help you understand Nikon Picture Controls even better, please download and read the following 24-page PDF document (4.79 MB) from Nikon:

http://imaging.nikon.com/products/imaging/lineup/picturecontrol/ catalog/PicCon.pdf

Please allow a few minutes for download before assuming the download is not working. This link directly downloads a PDF file with no intermediate screens. To open the file, you'll need Adobe Reader, which you can download for free from www.Adobe.com.

Although the document is a bit dated, it describes Picture Controls—with lots of pictures—to help you see the range of control you can achieve. I really enjoyed reading it because it explains Nikon Picture Controls well and even mentions software that will work with them.

If you look at the contents of your memory card with your computer after you've created and saved a new Custom Picture Control, you'll find a new folder called NIKON with a subfolder called CUSTOMPC. This folder contains any Custom Picture Controls you might have saved. Each control has a file name that ends with NCP and looks like this: PICCON01.NCP or PICCON99.NCP. You can have up to 99 Custom Picture Controls stored on one memory card.

Auto Distortion Control

(User's Manual – Page 217)

Auto distortion control is a function designed to automatically detect and remove certain lens aberrations in Nikkor type G and D lenses. Basically, if you leave this setting turned On, the camera will try to remove barrel distortion when you use a wide-angle lens and pincushion distortion when you use a telephoto lens (figure 3.34).

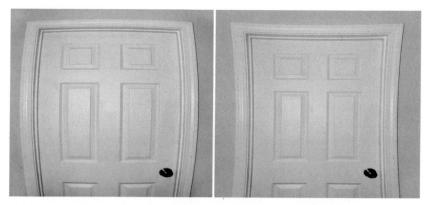

Figure 3.34 - Extreme examples of barrel (left) and pincushion (right) distortion

Barrel distortion occurs when straight lines bow outward like a barrel. Imagine a door frame with the middle bowed outward. It looks strange! Also, when you are close to an object, things centered directly in front of the lens can seem closer to the camera than things on the edges of the picture. Shooting against a flat wall can make it seem to bulge toward the camera in an odd way. Pincushion distortion is just the opposite; the edges of things seem to bow inward. If you see this problem in your images, Auto distortion control may help you overcome it.

Unfortunately, this can cause the edges of your image to be removed (cropped) as the camera adjusts the distorted areas of the image. It may also

slow the camera's image processing time as adjustments are made before the camera writes the image to the memory card.

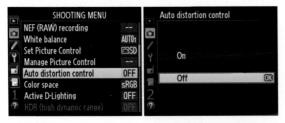

Figure 3.34.1 - Using Auto distortion control

Use the following steps to enable or disable Auto distortion control:

- 1. Select Auto distortion control from the Shooting Menu and scroll to the right (figure 3.34.1, screen 1).
- 2. Choose On or Off from the menu (figure 3.34.1, screen 2).
- 3. Press the OK button to lock in the setting.

Note: Enabling this function will seriously reduce the camera's memory buffer capacity—as much as half of its normal capacity. Therefore, you will not be able to shoot as many images in a burst. If you shoot sports or wildlife, you may find that you can't keep up with your subject because the internal buffer is full and must write images to the memory card before more pictures can be captured.

Settings Recommendation: I tend to shoot in RAW and want to adjust my images later in Photoshop so I can use its very powerful distortion tools. I therefore rarely leave this function enabled. However, if you are a JPEG shooter who is allergic to post-processing images, this function gives you another automatic choice to keep you off the computer. If you know your lens tends to have barrel or pincushion distortion, maybe you'll want to use this function.

Nikon recommends that you limit this function to Nikkor G or D lenses. However, it certainly won't hurt to try it out on non-Nikkor lenses, or even older lenses. If it doesn't work or causes a problem, you can always turn it Off.

Color Space

(User's Manual - Page 217)

Color space is an interesting and important part of digital photography. It helps your camera fit into a much broader range of imaging devices. Software, printers, monitors, and other devices recognize which Color space is attached to your image and use it, along with other color profiles, to help balance the image to the correct output colors for the device in use.

The two Color spaces available on the Nikon D600 have different gamuts, or ranges of color. They are called sRGB and Adobe RGB (figure 3.35). You can see the actual range of color the Color space gives your images in figure 3.36.

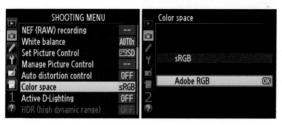

Figure 3.35 - Selecting a Color space

Here's how to select your favorite Color space:

- 1. Choose Color space from the Shooting Menu and scroll to the right (figure 3.35, screen 1).
- 2. Select the Color space that you want to use (figure 3.35, screen 2), keeping in mind that Adobe RGB has a larger color gamut. We'll learn more about that in the next section.
- 3. Press the OK button to lock in your choice.

Which Color Space Should I Choose?

Adobe RGB uses colors from a broad selection of the total color range that approximates human vision (called CIE LAB in the graphics industry), so it has a wider gamut than sRGB (figure 3.36). If you are taking images that might be printed commercially, Adobe RGB is often the best Color space to use (see sidebar, Which Color Space Is Best, Technically?).

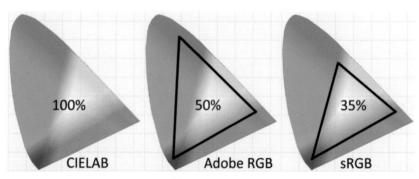

Figure 3.36 - CIE LAB, Adobe RGB, and sRGB Color spaces

After a JPEG file is created, either in a camera or on a computer, both the Adobe RGB and sRGB color gamuts are compressed into the same number of color levels. A JPEG has only 256 levels for each of its red, green, and blue (RGB) channels. However, since the Adobe RGB Color space takes its colors from a wider spectrum, you will have a better representation of reality when there are lots of colors in your image.

If you shoot in RAW format a lot, you may want to consider using Adobe RGB to store the maximum number of colors in your image files for later use, even though, for reasons we'll discuss in a moment, it really doesn't matter in RAW mode. It still is a good idea to leave your camera set to Adobe RGB.

Remember that a NEF (RAW) image file can contain 4,096 levels of color per RGB channel in 12-bit mode and 16,385 levels in 14-bit mode—instead of the limited 256 levels in an 8-bit JPEG. Using Adobe RGB makes a lot of sense when shooting in NEF (RAW) mode because of its capacity to contain more colors as a base storage medium.

There are some drawbacks to using Adobe RGB, though. The sRGB Color space is widely used in printing and display devices. Many local labs print with sRGB because so many point-and-shoot cameras use that format. If you try to print directly to some inkjet printers using the Adobe RGB Color space, the colors may not be as brilliant as with sRGB. If you aren't going to modify your images in postprocessing and plan to print them directly from your camera, you may want to use sRGB. If you shoot only JPEGs for computer display or Internet usage, it might be better to stay with sRGB for everyday shooting.

If you are a RAW shooter and regularly post-process your images, you should consider using Adobe RGB. You will have a wider gamut of colors to work with and can make your images the best they can be. Later, you can convert your carefully crafted images to print with a good color profile and get great results from inkjet printers and other printing devices. Here is a rough way to look at it:

- Many people who regularly shoot in JPEG format use sRGB
- Many people who regularly shoot in RAW format use Adobe RGB

These are not hard-and-fast rules, but many people follow them. I shoot RAW a lot, so I often use Adobe RGB.

In reality, though, it makes no difference which Color space you choose when you shoot in NEF (RAW) because the Color space can be changed after the fact in your computer. However, most people are not in the habit of changing the Color space during a RAW to JPEG conversion. Therefore, if you need the extra color range, why not leave the camera set to Adobe RGB for later convenience? Why add an extra step to your digital darkroom workflow? If you are shooting for money—such as for stock image agencies—most places expect that you'll

use Adobe RGB. It has a larger color range, so it's the quality standard for most commercial printing.

Settings Recommendation: I use Adobe RGB most of the time since I shoot a lot of nature pictures with a wide range of color. I want the most accurate color my camera can give me. Adobe RGB has a wider range of colors, so it can be more accurate when my subject has a lot of colors. However, if you are shooting JPEG snapshots, there's no need to worry about this. Leave the camera set to sRGB and have fun.

Which Color Space Is Best, Technically?

There is a large color space used by the graphics industry called CIE LAB or CIE L*a*b* (figure 3.36). This color space is designed to approximate human vision. Adobe RGB covers about 50 percent of the CIE LAB color space, and sRGB covers only about 35 percent. In other words, Adobe RGB has a wider gamut. That means Adobe RGB gives your images access to significantly higher levels of color, especially cyans (bluish tones) and greens. Another important consideration if you'll send your work to companies that use offset printing—such as book and magazine publishers—is that Adobe RGB maps very well to the four-color cyan, magenta, yellow, black (CMYK) printing process. If you are shooting commercial work, you may want to seriously consider Adobe RGB. Stock photo shooters are nearly always required to shoot in Adobe RGB.

Active D-Lighting

(User's Manual - Page 137)

Active D-Lighting (ADL) is used to help control contrast in your images. Basically, it helps preserve details in both the highlights and shadows that would otherwise be lost.

Sometimes the range of light around a subject is broader than a camera sensor can capture. The D600 is rated by DxO Labs as able to capture up to 14.2 EV steps of light under controlled conditions, but in real life the range of light can sometimes exceed what the sensor can handle. The contrast is too high!

Because the camera sometimes cannot grab the full range of light—and most people use the histogram to expose for the highlights (we'll discuss how in the chapter titled **Metering, Exposure Modes, and Histogram**)—some of the image detail will be lost in the shadows. The D600 allows you to "D-Light" the image—bring out additional shadow detail—while protecting the highlights; in other words, you can lower the contrast. ADL has these settings:

- Auto
- · Extra high
- High
- Normal
- Low
- Off

If you are familiar with Nikon Capture NX2, you may know how ADL works. You can use it to bring up lost shadow detail at the expense of adding noise in those darker areas. We'll talk about noise in an upcoming section called Long Exposure NR.

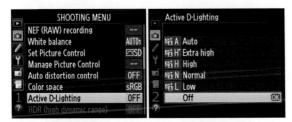

Figure 3.37 - Choosing an ADL level

Use the following steps to choose an ADL level (figures 3.37 and 3.38):

- 1. Choose Active D-Lighting from the Shooting Menu and scroll to the right (figure 3.37, screen 1).
- 2. Select one of the Active D-Lighting levels (figure 3.37, screen 2). Refer to figure 3.39 to see how the levels affect an image.
- 3. Press the OK button to save your setting.

As with some other important functions, the D600 adds access to the ADL setting through the Information display edit screen (figure 3.38, screen 1). Simply press the Info button twice, select the Active D-Lighting icon, press the OK button, then follow steps 2 and 3, described previously (screen 3.38, screen 2).

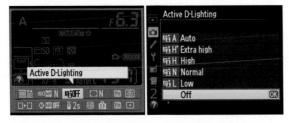

Figure 3.38 – Choosing an ADL level (alternate screens)

Basically, ADL will bring out detail in areas of your image that are hidden in shadow due to excessive image contrast. It also tends to protect the highlights from blowing out or becoming pure white with no detail.

Figure 3.39 shows a series of six images with ADL set to its various levels, including Off. I took six pictures of my favorite RGB blocks, a Nikon lens cap, and a Nikon body cap. The six images start with ADL set to Off, and they progress through Low, Normal, High, Extra high, and Auto. I used the Vivid Picture Control to maximize contrast.

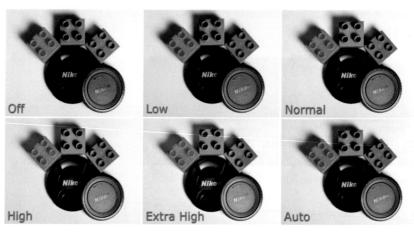

Figure 3.39 - ADL at all five levels and off

The images in figure 3.39 were taken with a point source light and deep shadows (high contrast) to show how ADL tries to pull detail out of the shadows and protect the highlights. Notice the silver Nikon logo on the lens cap. You can begin to see detail in the last few letters as the ADL level increases. In the first image, with ADL set to Off, you can see no detail past the K in Nikon. Gradually, over the next few ADL levels, the final three letters begin to appear.

The detail shown in the Auto setting looks very similar to the High setting, which tells me that the camera chose a setting close to High ADL because of the excessive contrast. Also, notice that no highlights are blown out. ADL tends to protect highlights.

Settings Recommendation: You'll need to experiment with the ADL settings to see which ones you like best. It has the effect of lowering contrast, and some people do not like low-contrast images. Also, any time you recover lost detail from shadows, there will be extra noise in the recovered areas, so be careful!

ADL can be useful to JPEG shooters, in particular. Since you really shouldn't modify a JPEG file, it's important that the image is created exactly right in the first place. When you are shooting in a contrasty setting, such as direct sunlight, some degree of ADL may help rein in the contrast.

If you set ADL much above Normal, the image will start to have an artificial look, in my opinion. Light skin tones can develop a pinkish look that seems unnatural to me. You can't see this in figure 3.39 because there are no skin tones. If you shoot some pictures of people with higher levels of ADL, you'll see what I mean.

Remember, your camera has multiple user settings, and you can set ADL for each setting (U1 and U2) in a different way and then select the most appropriate setting for a particular job. I leave it set to Off for the user setting that uses NEF (RAW) mode and On for the user setting that uses JPEG. Normally I don't go much above the Low setting, except for party JPEGs, which I set to Normal. My best JPEGs are set to Low because I worry about adding noise to the images with higher ADL levels.

Use Auto mode when you're shooting JPEGs and don't have time to fool with camera settings but you must get the shot, no matter what. Auto lets the camera decide the appropriate level of ADL according to the ambient light and contrast in the image.

Experiment with this by shooting images in high-contrast and low-contrast settings at all ADL levels. You'll see how the camera reacts, and then you can decide how you'll use this functionality.

HDR (High Dynamic Range)

(User's Manual - Page 139)

With the HDR (high dynamic range) feature, the camera combines two JPEG exposures into a single image. This feature is not available in NEF (RAW) modes. HDR combines details from an underexposed shot and an overexposed shot into one good, accurately exposed picture with a much greater dynamic range than normal. In figure 3.39.1, you can see a sample in which the two images on the left are combined, in-camera, to create the third image.

Figure 3.39.1 - HDR combination sample

HDR (high dynamic range) in the D600 is a form of simple bracketing that allows you to create an HDR image, without setting up a bracketing series using the BKT button. There are three settings under HDR (high dynamic range):

- *HDR mode* This setting has three options: On (series), On (single photo), and Off. When On (series) is selected, the camera will keep shooting its two-image HDR brackets until you set HDR mode to Off. When On (single photo) is chosen, the camera will take a single HDR bracket for one image. Off means the camera does not create an HDR image.
- Exposure differential You can choose how many stops (EVs) there will be between the two images that are later combined. The choices are 1 EV, 2 EV, 3 EV, and Auto. Use 1, 2, or 3 EV when you want to make the decision; choose Auto when you want to let the camera decide. If you control the Exposure differential, be careful to choose only what is needed or the final combined image may be under- or overexposed. If a two-image exposure bracket is insufficient, you may want to investigate the exposure bracketing system connected to the BKT button. We will discuss how to use the camera's primary bracketing system, which is capable of up to a nine-shot bracket, in the chapter titled Custom Setting Menu.
- Smoothing This allows you to choose smoothing for the boundaries between the two images. There are three choices available: Low, Normal, and High. Each subject's boundaries are different, so you may have to experiment with these settings. Higher values make a smoother combined image. Watch out for uneven shading with some subjects.

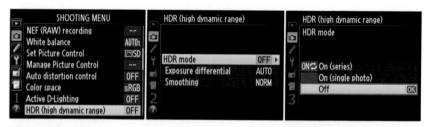

Figure 3.39.2 - Choosing an HDR mode

First, let's examine how to configure the three settings and prepare for HDR shooting. Use these steps to enable HDR mode for a single picture or a series:

- 1. Choose HDR (high dynamic range) from the Shooting Menu and scroll to the right (figure 3.39.2, screen 1).
- 2. Select HDR mode and scroll to the right (figure 3.39.2, screen 2).
- Decide if you want to make one or a series of HDR images and choose accordingly: On (series) for a series of images or On (single photo) for a single image (figure 3.39.2, screen 3).
- 4. Press the OK button to prepare the camera for shooting in HDR mode.

When the D600 is set to HDR mode, you will see HDR displayed on the Control panel and the Information display (Monitor). It will go away when HDR mode is set to Off. Now, let's look at configuring the Exposure differential setting.

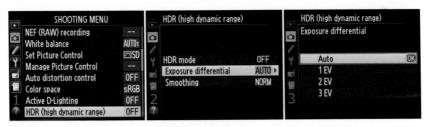

Figure 3.39.3 – Choosing an Exposure differential setting

Use the following steps to choose an Exposure differential setting:

- 1. Choose HDR (high dynamic range) from the Shooting Menu and scroll to the right (figure 3.39.3, screen 1).
- 2. Select Exposure differential and scroll to the right (figure 3.39.3, screen 2).
- 3. Choose one of the four settings, according to how much exposure variance you want between the two images that will be combined. Use Auto to let the camera decide, or choose from 1 EV to 3 EV (figure 3.39.3, screen 3). If you have a high-contrast subject, you may want to try 3 EV first to see if it works best. For low- to medium-contrast subjects, choose 1 EV or 2 EV.
- 4. Press the OK Button to lock in your choice.

Finally, let's see how to configure the Smoothing selection for the best image edge boundary control. You can choose how much the camera smooths the boundaries between the two images to make the combination look more natural. If you find that there is uneven shading with some of your subjects, choose a lower Smoothing setting.

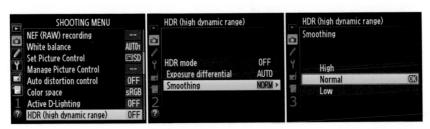

Figure 3.39.4 - Choosing a Smoothing setting

Use these steps to configure Smoothing for the HDR image combination:

1. Choose HDR (high dynamic range) from the Shooting Menu and scroll to the right (figure 3.39.4, screen 1).

- 2. Select Smoothing and scroll to the right (figure 3.39.4, screen 2).
- Select High, Normal, or Low (figure 3.39.4, screen 3). You will need to experiment and observe the differences in image boundaries when you vary this setting.
- 4. Press the OK button to choose your Smoothing level.

Now it's time to take an HDR picture. Here are some things you need to know during and after the HDR process:

- The camera will take two exposures when you press the Shutter-release button one time. It is a good idea to have the camera on a tripod or you may end up with a blurry combined image. If you do choose to handhold in low light, brace yourself and do not allow camera movement. When the light is very bright, the HDR process can be quite fast. It is much slower in low light and takes several seconds to deliver a combined image.
- HDR will be displayed on the Control panel, on the Information display, and in Live view (Monitor) as soon as you enable HDR (high dynamic range).
- HDR will start blinking on the Control panel during the initial exposures.
- HDR will display on the upper-right side of the Monitor during Live view HDR shooting. During HDR exposure and image combination, the Live view screen will not display anything.
- Job HDR will flash on the viewfinder during image combination.
- Job HDR (blinking) will be displayed on the Control panel while the images are being combined.
- The edges of the image may be cropped, so do not allow important parts of the subject to touch the edges.
- If you detect shadows around bright objects or halos around dark objects, you can reduce this effect by adjusting the amount of Smoothing. Try setting it to a lower level.
- You cannot select any form of NEF (RAW) when you're using HDR (high dynamic range); you can use only JPEG. HDR (high dynamic range) is grayed out on the Shooting Menu when you're using NEF (RAW).

Settings Recommendation: I am a big fan of bracketing and HDR. You can often find me on top of some Appalachian mountain shooting a five-bracket HDR image of the valley below. Beautiful things can be done with HDR. I do not like the shadowless HDR that some photographers shoot. To me it looks fake and seems faddish. However, HDR, when used correctly, can help create images that the camera could not normally take due to excessive light range.

If you are really into HDR or would like to be, check out the excellent second edition of *Practical HDRI*, by Jack Howard, published by Rocky Nook.

Photoshop has built-in software for HDR, or you can buy less-costly dedicated software, such as Photomatix Pro by HDRsoft.

I've been using Photomatix Pro for several years to combine my bracketed images into carefully tone-mapped HDR images. There are some limitations to in-camera HDR, which is why people who are really serious about it use the main bracketing system and combine their images in professional HDR software. However, HDR (high dynamic range) in the D600 is an easy way to knock off a few quick HDR images for those times when only HDR will do. Give it a try!

Vignette Control

(User's Manual - Page 218)

Vignette control allows you to reduce the amount of vignetting (slight darkening) that many lenses have in the corners at wide-open apertures. The angle at which light rays strike a sensor on its edges is greater than the angle at which rays go straight through the lens to the center of the sensor. Because of the increased angle, some light falloff occurs at the extreme edges of the frame, especially at wide apertures, because more of the lens element is in use. Full-frame (FX) sensors have microlenses over the pixels that help reduce vignetting, but it is still there in varying degrees with different lenses.

In recognition of this fact, Nikon has provided the Vignette control setting. It can reduce the vignetting effect to a large degree. If more vignette control is required, you can use Photoshop or Nikon Capture NX2 (or other software) to remove it. Figure 3.39.5 shows a sample of what the Nikon D600 can accomplish on its own. I shot four pictures of the sky with an AF-S Nikkor 24-85mm f/3.5-5.6G ED VR lens at f/3.5 (wide-open aperture). Each picture has more Vignette control applied, from Off to High.

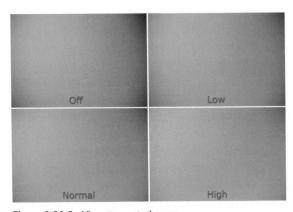

Figure 3.39.5 - Vignette control range

Let's see how to configure Vignette control for edge light falloff reduction with your lenses.

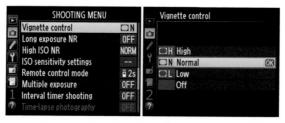

Figure 3.39.6 - Vignette control choices

Here are the steps to choose a Vignette control level:

- 1. Choose Vignette control from the Shooting Menu and scroll to the right (figure 3.39.6, screen 1).
- 2. Select a level from the list. I chose Normal in figure 3.39.6, screen 2.
- 3. Press the OK button to lock in the level.

You can also open the Vignette control screen by using a menu selection from the Information display edit screen, as shown in figure 3.39.7.

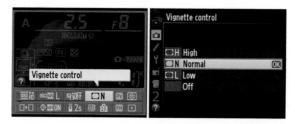

Figure 3.39.7 – Vignette control selection from the Information display edit screen

Simply press the Info button twice to open the Information display edit screen. Select the Vignette control icon (figure 3.39.7, screen 1) and press the OK button. Now, follow steps 2 and 3 for figure 3.39.6.

Note: Vignette control does not apply when you use DX lenses on your D600. It will work only with FX lenses of the G and D types, except for PC lenses. Nikon warns that you may see noise, fog, or variations in brightness "depending on the scene, shooting conditions, and type of lens." It may be a good idea to test each of your lenses and pixel peep the edges to see if you notice any problems. Vignette control does not work when you shoot movies or multiple exposures.

Settings Recommendation: The camera default is Normal, so I have been shooting most of my images with that setting. I like this control. It does help remove vignetting in the corners when I shoot with the aperture wide open.

I have not noticed any additional noise or image degradation in the corrected areas. I suggest leaving your camera set to Normal at all times unless you are shooting with a lens that has a greater tendency to vignette, in which case you can increase it to High. Even High does not seem to fully remove the vignetting when a lens is wide open, so this is not an aggressive algorithm that will leave white spots in the corners of your images. Why not shoot a few images with your lenses at wide aperture and see how Vignette control works with your lens and camera combinations?

Remember, you can remove vignetting in the computer with post-processing software if the camera's Vignette control setting does not entirely remove the problem.

Long Exposure NR

(User's Manual - Page 218)

Long exposure NR (Long Exposure Noise Reduction) is designed to combat visual noise in long exposures. Noise is that ugly, grainy look in images that are underexposed and then brightened, or when a really high ISO sensitivity setting is used. If you ever shoot film, you know how faster films have lots more grain. Noise is like that, except uglier. It's the digital equivalent of static in music. Who wants static in their images?

Nikon believes the D600 sensor may exhibit more noise than is acceptable in exposures longer than one second. The sensor can start to warm up a little when long exposures are used. This warming effect causes amp noise, in which warmer sections of the sensor start to create more noise than cooler sections.

There are two settings for Long exposure NR (figure 3.41):

• On – When you select On and an exposure is longer than one second, the camera will take two exposures with approximately the same exposure time for each. The first exposure is the normal exposure. The second one is a blackframe subtraction exposure, which is a second image that is exposed for about the same duration as the first image, but the shutter remains closed. The noise in the black-frame exposure is examined and then subtracted from the original image. It's really quite effective and beats having to blur the image to get rid of noise. I've taken exposures of about 30 seconds and have had perfectly usable results. The only drawback is that the total exposure time can be as much as doubled because two exposures are made. The black-frame exposure is not written to the memory card, so you'll have only one image, with much less noise, in the end. While the black-frame exposure is being processed, a message of Job nr will blink in any active displays. When Job nr is flashing, you cannot use the camera. If you turn the camera off while Job nr

• Off – If you select Off, Long exposure NR will be disabled in exposures longer than one second.

is flashing, it will keep the first image, but it won't do any noise reduction on

Figure 3.40 is an image I took with a 30-second exposure and Long exposure NR set to On. I left the shutter open for 30 seconds in several exposures, hoping to catch a lightning strike in a storm near my home. The camera used black-frame subtraction with the Long exposure NR setting to remove noise from my lightning strike image, without seriously blurring the image in the process. I can't see any noise, can you?

Figure 3.40 – A 30-second exposure with Long exposure NR turned On

Disclaimer: It can be a lot of fun to capture lightning images, but be sure you have a safe place to shoot from so you won't attract the lightning. I was shooting from my upstairs bedroom window. The camera was on a tripod with a wideangle lens looking out the open window. I got four or five nice lightning shots for my efforts— such as the one shown.

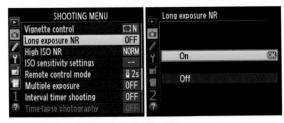

Figure 3.41 - Using Long exposure NR

Here are the steps to choose a Long exposure NR setting:

- 1. Choose Long exposure NR from the Shooting Menu and scroll to the right (figure 3.41, screen 1).
- 2. Select On or Off (figure 3.41, screen 2).
- 3. Press the OK button to save your setting.

The D600 allows you to access the Long exposure NR setting quickly by using the Information display edit screen. Press the Info button twice, select the Long exposure NR icon, and press the OK button (figure 3.42, screen 1). Then follow steps 2 and 3, as discussed previously. Figure 3.41, screen 2, is the same as figure 3.42, screen 2.

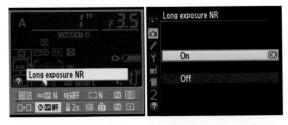

Figure 3.42 – Using Long exposure NR (alternate screens)

Settings Recommendation: I like the benefits of Long exposure NR. I shoot a lot of waterfall and stream shots where I want exposures of several seconds to really blur the water. Also, I like to take midnight shots of the sky and shots of city scenes at night. Even though it slows down the frame rate slightly and the incamera memory buffer holds fewer images, I still use it most of the time.

If I were a sports or action shooter using Continuous release mode, I might leave Long exposure NR set to Off. It's unlikely I would be using exposures longer than one second, and I would want the maximum frames per second and the ability to cram as many images into the memory buffer as possible. I wouldn't want my camera to slow down while it processes black-frame subtraction exposures.

Your style of shooting will govern whether this function is useful to you. Ask yourself one simple question: Do I often shoot exposures longer than one

second? If so, you may want to keep Long exposure NR set to On. Compare how your images look with and without it. I think you'll like Long exposure NR.

High ISO NR

(User's Manual – Page 218)

High ISO NR (High ISO Noise Reduction) lessens the effects of digital noise in your images when you use high ISO sensitivity (exposure gain) settings by using a blurring and resharpening method.

Nikon doesn't specify the exact ISO level at which High ISO NR kicks in. I suspect that a small amount of noise reduction occurs at around ISO 400–800 and gradually increases as the ISO gets higher.

The D600 has better noise control than most cameras, so it can shoot up to ISO 800 with little noise. However, no digital camera (that I know of) is completely without noise, so it's a good idea to use some noise reduction above a certain ISO sensitivity.

If High ISO NR is turned Off, the camera does not reduce noise until the ISO reaches 2500. At that point a small amount of noise reduction—less than the Low setting—kicks in, even if the setting is turned Off. At ISO 2500 and above there will always be some noise reduction.

You can control the amount of noise reduction by choosing one of the four High ISO NR settings: High, Normal, Low, or Off. Shoot some high-ISO exposures and decide for yourself which settings you are comfortable with.

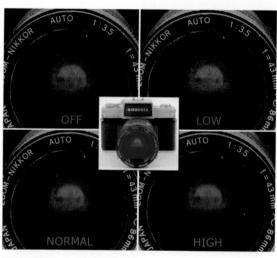

Figure 3.43 - High ISO NR - Off to High correction samples

Figure 3.43 is a sample image of my 1963 Nikkorex Zoom 35 taken at ISO 25,600 (Hi 2) with High ISO NR set to Off, Low, Normal, and High settings. The red rectangle in the little picture of the camera indicates the area that is shown in the four larger images. These images were shot with no flash of the dark subject at the camera's highest ISO sensitivity setting. It is a worst-case noise scenario.

High ISO NR works by first blurring then resharpening the image more and more as you increase the setting from Low to High. By blurring the image, the camera blends the grainy noise into the surroundings to make it less visible. Some mild resharpening is applied to restore image sharpness. This whole process tends to make the image lose detail, which is worsened with higher noise reduction levels.

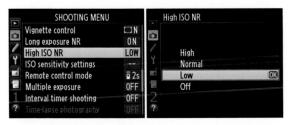

Figure 3.44 - Setting High ISO NR

Use the following steps to choose a High ISO NR setting:

- 1. Choose High ISO NR from the Shooting Menu and scroll to the right (figure 3.44, screen 1).
- 2. Select one of the noise reduction levels: High, Normal, Low, or Off (figure 3.44, screen 2).
- 3. Press the OK button to save your setting.

The D600 allows you to control the High ISO NR function by using the Information display edit screen. Press the Info button twice, select the High ISO NR icon, and press the OK button (figure 3.45, screen 1). Then follow steps 2 and 3, as described previously (figure 3.45, screen 2). Figure 3.44, screen 2, is the same as figure 3.45, screen 2.

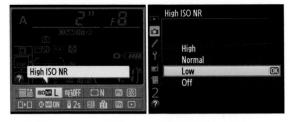

Figure 3.45 – Setting High ISO NR (alternate screens)

Settings Recommendation: I leave High ISO NR set to Low. I do want some noise reduction above ISO 800. However, since any form of noise reduction blurs the image, I don't go too far with it. I shoot RAW, so it really makes no difference because I can change everything later in the computer. If I were shooting JPEG, it would make a serious difference. Why not test a few images at high ISO sensitivity settings with High ISO NR turned On to see which setting you like? Remember that you can use a different setting for each User setting to configure your camera for different shooting styles.

Note: If you have High ISO NR turned On, your in-camera memory buffer for images shot in Continuous release mode will decrease by at least one image.

What Is Noise?

Have you ever tried to watch TV while children are playing in the same room? The louder you turn up the TV, the louder the kids get, it seems. However loud the volume of the TV, the children laughing and running around degrades the pure sound you desire. There is a high child-to-TV noise ratio that interferes with your enjoyment of the program. After a while, there is a point when you simply have to ask the kids to leave the room. Noise in a digital image is somewhat similar. You want pure, clean images when you take pictures, but digital noise interferes with the clarity. The higher you turn the camera's ISO sensitivity, the more digital noise degrades your image. The noise-to-signal ratio can damage the picture. How can you make the visual noise go away? Use High ISO NR, that's how!

ISO Sensitivity Settings

(User's Manual – Page 105)

ISO sensitivity settings is provided to give you control over the light sensitivity of the imaging sensor, including whether you manually control it or if the camera sets it automatically.

In the D600, the ISO numbers are sensitivity equivalents. To make it very simple, ISO sensitivity is the digital equivalent of film speed. The higher the ISO sensitivity, the less light is needed for the exposure. A high ISO setting allows faster shutter speeds and smaller apertures.

In figure 3.46 you can see the external camera controls used to change the ISO sensitivity on the D600. This is the fastest and easiest way to change the camera's ISO sensitivity setting, although it doesn't involve the Shooting Menu.

Figure 3.46 - Setting ISO sensitivity with external camera controls

Here are the steps you'll use to manually adjust the camera's ISO sensitivity:

- 1. Hold down the ISO button (figure 3.46, image 1).
- 2. Rotate the Main command dial counterclockwise to increase the ISO sensitivity, or turn it clockwise to decrease the ISO sensitivity (figure 3.46, image 2).
- 3. The ISO sensitivity number will display on the Control panel (figure 3.46, image 3), on the Information display (Monitor), and in the Viewfinder.

Configuring the ISO Sensitivity Settings

You can also use Shooting Menu > ISO sensitivity settings to change the camera's ISO sensitivity. Figure 3.47 shows the three screens used to select your favorite ISO sensitivity for the circumstances in which you are shooting. Figure 3.47, screen 3, shows a partial a list of ISO sensitivity settings. Only a small part of the range actually shows.

The normal ISO range for the D600 is 100 to 6400. The full expanded range, using the lowest and highest possible ISO settings, is ISO 50 (Lo 1) to ISO 25,600 (Hi 2). Select your desired ISO sensitivity from the list of available ISO sensitivity settings.

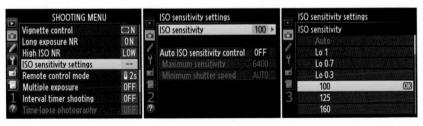

Figure 3.47 - Setting ISO sensitivity

Here are the steps to select an ISO sensitivity setting:

- 1. Choose ISO sensitivity settings from the Shooting Menu and scroll to the right (figure 3.47, screen 1).
- 2. Select ISO sensitivity from the menu and scroll to the right (figure 3.47, screen 2).

- 3. Scroll up or down in the ISO sensitivity menu to highlight the ISO value you want to use.
- 4. Press the OK button to save the setting (figure 3.47, screen 3).

The standard minimum ISO sensitivity for the D600 is ISO 100. You can adjust the camera from ISO 50–25,600 in 1/3 EV steps. Again, the normal range is ISO 100–6400, with an extended range of Lo 1 (ISO 50), Hi 1 (ISO 12,800), and Hi 2 (ISO 25,600).

The 1/3 EV step increment value is controlled by *Custom Setting Menu > b Metering/exposure > b1 ISO sensitivity step value,* which can be set to 1/3 or 1/2 EV step. We'll look at this more carefully in the upcoming chapter titled **Custom Setting Menu**.

Select your favorite ISO sensitivity setting with either the external camera controls or the ISO sensitivity settings from the Shooting Menu. Or you can simply let your camera decide which ISO to use. This brings us to two often-misunderstood features, the ISO sensitivity Auto setting and the Auto ISO sensitivity control.

ISO Sensitivity Auto Setting

You may have noticed in figure 3.47, screen 3, that there's a grayed-out Auto setting at the top of the ISO sensitivity list. This Auto setting is the default when you have the camera set to one of the automatic SCENE modes or the AUTO mode—on the Mode dial—and it allows the camera to take full control of adjusting the ISO sensitivity to help you get the picture under difficult lighting.

Don't confuse the ISO sensitivity Auto setting with the AUTO mode (it has a green camera on the Mode dial) or the Auto ISO sensitivity control that we'll discuss in the next section.

A nice feature on the D600 is that you can use the fully automatic AUTO or SCENE modes and still adjust the ISO sensitivity manually by taking it out of Auto mode and selecting a specific ISO instead (figure 3.47, screen 3). Auto will stay grayed out until you enter one of the SCENE or AUTO modes.

This feature allows new users to gradually learn how to take more control of the camera settings.

Auto ISO Sensitivity Control

There's another, more controllable, automatic setting available: the Auto ISO sensitivity control. It allows the camera to control the ISO sensitivity and shutter speed according to the light levels sensed by the camera.

Figure 3.48 - Using the Auto ISO sensitivity control

Use the following steps to enable the Auto ISO sensitivity control:

- 1. Choose ISO sensitivity settings from the Shooting Menu and scroll to the right (figure 3.48, screen 1).
- 2. Select Auto ISO sensitivity control from the menu and scroll to the right (figure 3.48, screen 2).
- 3. Choose On or Off from the menu (figure 3.48, screen 3).
- 4. Press the OK button to select the setting.

After you set the Auto ISO sensitivity control to On, you should immediately set two values, depending on how you shoot: Maximum sensitivity and Minimum shutter speed.

Maximum Sensitivity

The Maximum sensitivity setting is a safeguard. It allows the camera to adjust its own ISO sensitivity from the minimum ISO sensitivity value to the value set in Maximum sensitivity, depending on the light conditions. The camera will try to maintain the lowest ISO sensitivity it can to get the picture. However, it can rapidly rise to the Maximum sensitivity level, if needed.

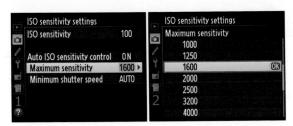

Figure 3.49 - Auto ISO sensitivity control - Maximum sensitivity

This setting overrides the normal ISO sensitivity settings. If you don't want the Maximum sensitivity to exceed a certain ISO value, simply select from the list shown in figure 3.49, screen 2, where I selected ISO 1600. The Maximum sensitivity default is ISO 6400. That's too high for my taste, since it will let the camera

Note: It's a little-known fact that you can also set a minimum ISO sensitivity, of sorts. The User's Manual describes how to set Maximum sensitivity, but it does not mention (that I've found) that you can use the normal ISO sensitivity setting to control the lowest ISO you want the camera to use. If you set the *ISO sensitivity settings > ISO sensitivity* to 400 and the *ISO sensitivity settings > Auto ISO sensitivity control > Maximum sensitivity* to 1600, the camera will use the ISO range of 400 to 1600. It will not go below ISO 400, and it will not exceed ISO 1600.

Interestingly, Custom setting b1 ISO sensitivity step value does not control the incremental ISO numbers between these primary values. I carefully set up my D600 to test this and found that it often used an intermediate value like ISO 640, 1100, 1250, 2000, or 2200 as the light dimmed. It did this whether I set Custom setting b1 to 1/3 or 1/2 EV step.

What happens when the camera reaches the Maximum sensitivity and there still isn't enough light for a good exposure? Let's find out.

Minimum Shutter Speed

Because the shutter speed helps control how sharp an image can be, depending on camera shake and subject movement, you'll need some control over the minimum shutter speed while the Auto ISO sensitivity control is set to On (figure 3.50, screen 1).

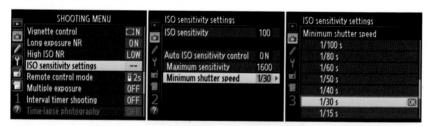

Figure 3.50 – Auto ISO sensitivity control – Minimum shutter speed

You can select the Minimum shutter speed that the camera will allow when the light diminishes. In Programmed auto (P) exposure mode (the camera controls the shutter speed and aperture) and Aperture-priority auto (A) exposure mode (the camera controls the shutter speed and you control the aperture), the camera will not go below the Minimum shutter speed unless the Maximum sensitivity setting still won't give you a good exposure.

Please carefully note what the last sentence of the previous paragraph said, or you may end up with blurry images from camera shake. The camera will drop below the Minimum shutter speed setting if it cannot get a good image in any other way.

In other words, in Programmed auto (P) or Aperture-priority auto (A) exposure modes, if you try to take pictures in low light, the camera will keep the ISO sensitivity as low as possible until the shutter speed drops to your selected Minimum shutter speed. When it hits the selected Minimum shutter speed value, the ISO sensitivity will begin to increase to your selected Maximum sensitivity value.

If there still isn't enough light for a good exposure after the camera hits the Maximum sensitivity value, it won't keep raising the ISO sensitivity. Instead, the camera will go below your selected Minimum shutter speed. Be careful because if the light gets too low, your camera can drop all the way down to a shutter speed of several seconds to get a good exposure. You better have the camera on a tripod and a static subject with a shutter speed that low.

Your Minimum shutter speed should be the lowest handheld speed you can manage, after which you'll put your camera on a tripod. Most people can handhold a camera down to about 1/60s if they are careful, and maybe as low as 1/30s if they're extra careful and brace themselves. At shutter speeds slower than that, it's blur city for your images. It's even worse with telephoto lenses because camera movement is greatly magnified with a long lens, and a Minimum shutter speed of 1/250s to 1/500s or more may be required (the maximum is 1/4000s).

Auto Minimum Shutter Speed

There is an important principle in photography called the reciprocal of focal length shutter speed rule. This simply means that you should use a tripod (no handholding) whenever the shutter speed is lower than the reciprocal of the lens focal length.

For example, if you are using a 50mm zoom position on your lens, you should not use a shutter speed slower than 1/50s without having the camera on a tripod. With a 105mm focal length, the minimum handheld shutter speed is 1/100s or 1/125s (there is no 1/105s available, so you use the closest shutter speed). If you are using a 300mm lens, you should not use a shutter speed slower than 1/300s.

The reason this rule exists is because a longer focal length tends to magnify the subject and any vibrations that are introduced when you press the Shutterrelease button. With a shutter speed slower than the reciprocal of the lens focal length, movement can be introduced just from your heartbeat, the slap of the reflex mirror when it moves, or natural hand shakiness. If you are going to handhold the camera at slower shutter speeds, you need to learn how to brace yourself properly. The best thing is to use a tripod any time you have to shoot at a speed slower than the reciprocal of the lens focal length. Otherwise you will be known for your well-exposed, blurry images.

When you use the Auto ISO sensitivity control you have an opportunity to implement the reciprocal of focal length shutter speed rule in an automatic fashion.

The Nikon D600 has added an Auto setting for Minimum shutter speed, which allows the camera to sense what focal length is currently in use and prohibit the camera from using a minimum shutter speed that would cause camera shake. Let's examine how to use it.

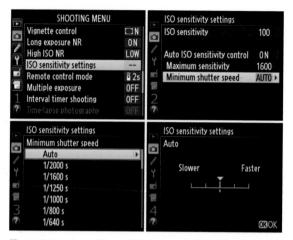

Figure 3.51 - Auto ISO sensitivity control - Auto Minimum shutter speed

Use these steps to enable Auto Minimum shutter speed (figure 3.51):

- 1. Choose ISO sensitivity settings from the Shooting Menu and scroll to the right (figure 3.51, screen 1).
- 2. Select Minimum shutter speed and scroll to the right (figure 3.51, screen 2).
- 3. Select Auto from the top of the Minimum shutter speed list and scroll to the right (figure 3.51, screen 3).
- 4. Adjust the Auto Minimum shutter speed fine-tuning scale (figure 3.51, screen 4). Each position on the scale is the equivalent of one stop (1 EV). The camera will use the reciprocal of the focal length of the mounted lens if the yellow pointer is left in the center, as seen in figure 3.51, screen 4. If you move it one notch to the right of center, the camera will switch to the reciprocal of the focal length plus one stop. If you are using a 50mm lens, the reciprocal of 50mm plus one stop is 1/100s (1/50s plus 1 EV) for the camera's minimum shutter speed. If you move the scale one notch to the left of center, the camera will use 1/25s instead (1/50s less 1 EV). Here is a list of what each position on the scale represents if you are using a 50mm lens: 1/13s, 1/25s, 1/50s, 1/100s, 1/200s. Of course, these numbers will vary with the focal length of the lens mounted on the camera.
- 5. Press the OK button to lock in the fine-tuned Auto Minimum shutter speed.

Settings Recommendation: When I use the Auto ISO sensitivity setting with my D600 I set my camera to Auto Minimum shutter speed. Why worry about having to adjust a setting just because I changed lenses? The camera is smart enough to know what to do and tries to protect me from losing sharpness from camera shake.

I generally leave the Maximum sensitivity at about ISO 1600 because the D600 generates little noise at that ISO level. However, I will go all the way up to ISO 3200 in an emergency. I rarely exceed that value.

Auto ISO Sensitivity Control from the Camera's Perspective

For fun, let's listen to the camera talk to itself while you take pictures in low light with the Auto ISO sensitivity control enabled. As we listen in on the D600 thinking, we need to know that the current Maximum sensitivity setting is ISO 1600 and the Minimum shutter speed setting is 1/30s:

"Okay, the Auto ISO sensitivity control is on! The light is dropping and my current 1/60s shutter speed at ISO 200 won't let me make a good exposure. I'll slow the shutter speed to the minimum of 1/30s, as my owner specified in my Minimum shutter speed setting. More pictures are incoming, and the light is still dropping! I can't go any lower on the shutter speed for now, since my owner has instructed me to keep the Minimum shutter speed at 1/30s unless I can't get a good picture. I'll have to start raising the ISO sensitivity. Here comes more pictures, and whew, it's getting dark! I've now raised the ISO sensitivity to my Maximum sensitivity level of ISO 1600, which is as high as I am allowed to go. I have no choice now but to go below the 1/30s Minimum shutter speed my owner has specified. I hope I'm on a tripod!"

Enabling Auto ISO Sensitivity with External Controls

In case you like to use external controls to make adjustments when possible (don't we all?), you can conveniently turn the Auto ISO sensitivity control (ISO-AUTO) on and off with the ISO button, the Sub-command dial, and the Control panel. Figure 3.52 shows the controls. You will need to configure ISO-AUTO before you use the control or the camera will use factory defaults.

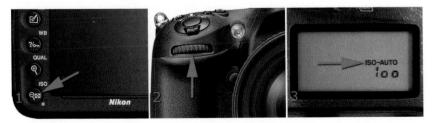

Figure 3.52 - Enabling the Auto ISO sensitivity control with external camera controls

Here are the steps to manually enable or disable ISO-AUTO:

- 1. Hold down the ISO button (figure 3.52, image 1).
- 2. Rotate the Sub-command dial to enable or disable ISO-AUTO, the Auto ISO sensitivity control (figure 3.52, image 2).
- 3. The ISO-AUTO symbol will display on the Control panel (figure 3.52, image 3).

When and Why Should You Use Auto ISO Sensitivity Control?

How much automation do you need to produce consistently excellent images? Let's explore how and when automatic, self-adjusting ISO might improve or degrade your images. What is this feature all about? When and why should you use it? Are there any compromises in image quality when you use this mode?

Normally you will set your camera to a particular ISO number, such as 200 or 400, and shoot your images. As the light dims or as the shade deepens, you might increase the ISO sensitivity to continue taking handheld images. If you absolutely must get the shot, the Auto ISO sensitivity control will work nicely. Here are a few scenarios:

- Scenario 1 Let's say you're a photojournalist and you're shooting flash pictures of the president as he disembarks from his airplane, walks into the terminal, and rides away in his limousine. Under these circumstances, you will have little time to check your ISO settings or shutter speeds and will be shooting in widely varying light conditions.
- Scenario 2 You're a wedding photographer in a church that doesn't allow flash photography. As you follow the bride and groom from the dark inner rooms of the church into the lobby, and finally up to the altar, the light conditions vary constantly. You have no time to deal with the fluctuations in light by changing your ISO.
- Scenario 3 You're at a party and you want some great pictures. You want to
 use flash, but the pop-up Speedlight may not be powerful enough to reach
 across the room at low ISO settings. You really don't want to be bothered with
 camera configuration but still want some well-exposed images. The light varies as you move around the room talking and laughing and snapping pictures.

The camera will use your normal settings, such as your ISO, shutter speed, and aperture, until the light will not allow those settings to provide an accurate exposure. Only then will the camera raise the ISO or lower the shutter speed to keep functioning within the shutter speed and aperture parameters you have set.

Look at the Auto ISO sensitivity control as a fail-safe for occasions when you must get the shot but have little time to deal with camera settings, or when you don't want to vary the shutter speed and aperture settings but still want to be assured of a well-exposed image.

Unless you are a private detective shooting handheld telephoto images from your car or a photojournalist or sports photographer who must get the shot every time regardless of maximum quality, I would not recommend leaving the Auto ISO sensitivity control set to On. Use it only when you really need to get the shot under any circumstances!

Of course, if you are unsure of how to use the correct ISO for the light level, don't be afraid to experiment with this mode. At the very worst, your images might be nosier than usual. However, it may not be a good idea to depend on this mode over the long term because noisy images are not very attractive.

Are There Any Drawbacks to Using Auto ISO Sensitivity Control?

Maybe! It really depends on how widely the light conditions vary when you are shooting. Most of the time your camera will maintain the normal range of ISO settings in the Auto ISO sensitivity control, so your images will be their normal low-noise, sharp masterpieces. However, at times the light may be so dim that the ISO will exceed the normal range of 100-800 and will start getting into the noisier settings above ISO 800.

Remember that Auto ISO sensitivity control can and will push your camera's ISO sensitivity into a range that causes noisier images when light levels drop, if you've allowed it by setting the Maximum sensitivity to a high level. Use it with this understanding and you'll do fine. ISO 6400 is the default maximum. Make sure you understand this or you might get some noisy images.

The Auto ISO sensitivity control is yet another great feature of your powerful Nikon D600. Maybe not everyone needs this fail-safe feature, but some people rely on it. I use it in circumstances when getting the shot is the most important thing and the light levels may get too low for normal ISO settings.

Even if you think you might use it only from time to time, do learn how to use it. Experiment a bit with the Auto ISO sensitivity control. It's fun and can be useful!

Auto ISO Sensitivity and Exposure Modes

Shutter-priority auto (S) and Manual (M) exposure modes allow you to control the camera in a way that overrides certain parts of the Auto ISO sensitivity control. In Manual (M) mode, the camera relinquishes all control of the shutter and aperture. It can adjust only the ISO sensitivity by itself, so it can obey the Maximum sensitivity, but the Minimum shutter speed is overridden and does not apply. In Shutter-priority auto (S) mode, the camera can control the aperture, but the shutter speed is controlled only by the photographer. The Auto ISO sensitivity control can still control the Maximum sensitivity but loses control over the Minimum shutter speed.

3

Also, it may be a good idea to enable High ISO NR—as discussed a few pages back—when you use the Auto ISO sensitivity control. This is especially true if you leave the camera set to the default Maximum sensitivity value of 6400. Otherwise you may have excessive noise when the light fades.

When you use a flash unit, the value in Minimum shutter speed is ignored. Instead, the camera uses the value found in Custom setting e1 Flash sync speed.

If Auto is selected for Minimum shutter speed, the camera will decide which shutter speed to use as a minimum based on the focal length of the lens in use, if the lens is a CPU type; otherwise, for a non-CPU lens, the camera selects 1/30s as a Minimum shutter speed.

What Is ISO?

An ISO sensitivity number, such as 200 or 3200, is a standard sensitivity for the camera sensor. Virtually everywhere in the world, all camera ISO numbers mean the same thing. Because of that fact, camera bodies and lenses can be designed to take advantage of the ISO sensitivity ranges they will have to deal with. ISO is an abbreviation for the International Organization for Standardization, a standards-setting group with representatives from several international standards organizations.

Remote Control Mode

(User's Manual - Page 85)

Remote control mode operates with your camera's Self-timer system and the Nikon ML-L3 wireless remote control. Its primary purpose is to give you a way to take hands-off images while the camera is on a tripod. This reduces camera shake and allows you to release the shutter either remotely or up close without touching the camera.

To use the Remote control mode you'll need to select one of the three modes in the Shooting Menu; mount your camera on a tripod, beanbag, or other support device; set the Release mode dial to Remote control mode (the symbol resembles a ML-L3 wireless remote); and use the button on the ML-L3 remote to fire the shutter. There are three Remote control modes available in the Shooting Menu:

- **Delayed remote** When you press the ML-L3 shutter-release button, the camera waits two seconds and then fires the shutter.
- **Quick-response remote** When you press the ML-L3 shutter-release button, the camera fires the shutter immediately.
- Remote mirror-up The first press of the ML-L3 shutter-release button raises
 the reflex mirror. You should wait for camera and tripod vibrations to subside,

then press the ML-L3 shutter-release button again to fire the shutter. This is a two-step operation that can help you create sharper images by preventing mirror slap from causing blur in your images and allowing general vibrations to cease before taking the picture.

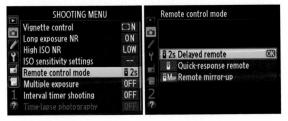

Figure 3.53 – Selecting a Remote control mode

You will use the screens shown in figure 3.53 to select one of the Remote control modes. Use the following steps to prepare the camera:

- 1. Place your camera on a tripod or other stationary supporting device.
- 2. Remove the rubber viewfinder eyepiece (DK-21 rubber eyecup) by sliding it upward.
- 3. Install the plastic DK-5 eyepiece cover where the rubber eyecup was. This prevents improper exposures by preventing light from entering the viewfinder eyepiece. The DK-5 eyepiece cover should be in the box that the camera came in, or you can buy one from a camera store. If you decide not to use the plastic eyepiece to cover the viewfinder, at least shield it with your hand or a hat during remote operations. Otherwise the exposures may not be correct, especially when there is strong light behind the camera.
- 4. Set the camera to Remote control mode by choosing the Remote control mode symbol position on the Release mode dial. Hold down the Release mode dial lock release button (figure 3.54, red arrow on left), and turn the dial to select Remote control mode (red arrow on right).
- 5. Select Remote control mode from the Shooting Menu and scroll to the right (figure 3.53, screen 1).
- 6. Choose your favorite Remote control mode from the three choices. I chose Delayed remote in figure 3.53, screen 2.
- 7. Press the OK button to confirm your choice.

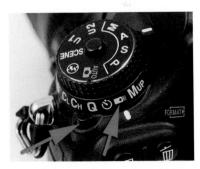

Figure 3.54 - Lock release button and Remote control mode

Settings Recommendation: I am pleased to see the Remote mirror-up mode on the D600. Most people consider this a professional feature. It allows you to take very sharp images by removing the chance of camera shake from the movement of the reflex mirror. I recommend that you learn to use this mode anytime you are shooting for maximum quality. All three of the Remote control modes have their place. Learn to use them all for maximum flexibility.

Multiple Exposure

(User's Manual - Page 160)

Multiple exposure is the process in which you take more than one exposure on a single frame, or picture. Most people do only double exposures, which is two exposures on one frame.

Multiple exposure requires you to figure the EVs carefully for each exposure segment so that in the final picture all the combined exposures equal one normal exposure. In other words, your subject's background will need two exposures at half the normal EV to equal one normal exposure.

The D600 allows you to figure out your own exposure settings and set the controls manually, or you can use Auto gain to help you with the exposure calculations.

There are really only four steps to set up a Multiple exposure session. However, there are several Shooting Menu screens to execute these four steps. The steps are as follows:

- 1. On the Shooting Menu screens, select the number of shots you want to take.
- Set Auto gain to On or Off, depending on how you want to control the exposure.
- 3. Choose whether you are shooting one image or a series of images.
- 4. Take the picture.

Use the following steps to configure one or a series of multiple exposures:

- 1. Select Multiple exposure from the Shooting Menu and scroll to the right (figure 3.55, screen 1).
- 2. Select Number of shots and scroll to the right (figure 3.55, screen 2).
- 3. Enter the number of shots you wish to take, either 2 or 3, and press the OK button (figure 3.55, screen 3).
- 4. Select Auto gain and scroll to the right (figure 3.55, screen 4).
- 5. Select On and press the OK button (figure 3.55, screen 5).

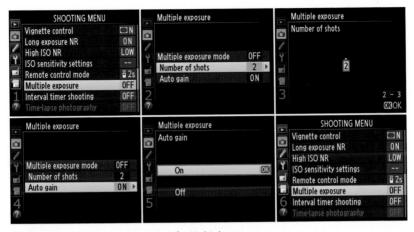

Figure 3.55 - Configuring the camera for Multiple exposures

6. This brings you back to the beginning and the Multiple exposure selection on the Shooting Menu (figure 3.55, screen 6). At this point you must reenter the Multiple exposure system and choose whether you want one Multiple exposure or a series. Figure 3.55.1 takes up where figure 3.55 leaves off. It shows the final step of choosing how many multiple exposure images you want to take in this session.

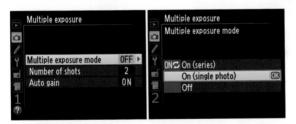

Figure 3.55.1 – Choosing one Multiple exposure or a series

- 7. Select Multiple exposure mode and scroll to the right (figure 3.55.1, screen 1).
- 8. Choose On (series) if you want to take more than one distinct Multiple exposure image or On (single photo) for just one Multiple exposure picture.
- 9. Press the OK button, and your camera is ready to take the multiple exposure.

After you've selected the Number of shots (step 2), the camera remembers the value and comes back to it for the next session. To repeat another Multiple exposure series with the same settings, you'll have to use the screens for figure 3.55.1 again and start over with step 7. That prepares the camera to do the Multiple exposure series (or single photo) in the same way as last time. The camera remembers the previous settings until you reset them by using the screens in figure 3.55.

Understanding Auto Gain

Auto gain defaults to On, so you need to understand it. Auto gain applies only if you want to make a number of exposure segments with the exact same EV for each. If you want to make two exposures, the camera will meter for a normal exposure and then divide the exposure in half for the two shots. For three shots, it will divide the exposure by 1/3, four shots by 1/4, eight shots by 1/8, and so forth.

For example, if I want a two-shot Multiple exposure, I usually want the background to get 1/2 of a normal exposure in each shot so it will be properly exposed in the final image. If I need four shots, I want the background to get only 1/4 of a normal exposure for each shot so it will be exposed correctly after the four shots are taken. Auto gain divides the exposures automatically.

It took me a little while to wrap my brain around the confusing description in the User's Manual. Whoever heard of *gain* meaning dividing something into parts? I think Nikon means that each shot gains a portion of the normal exposure so that in the end the exposure is complete and correct.

You should use Auto gain only when you don't need to control the exposure differently for each frame and can instead use an exact division of similar exposures.

Figure 3.56 - Examples of Multiple exposures

Auto gain works fine if you're not using masks, where part of the image is initially blocked off and then exposed later. When you use a mask, you want a full normal exposure for each of the uncovered (nonmasked) sections of the image, so Auto gain will not work. For masked exposures, you should use manual exposures, with Auto gain turned Off.

Settings Recommendation: Multiple exposure images can be a lot of fun to create (figure 3.56). I often shoot Multiple exposure images with two people in the frame. One person leaves after the first half of the exposure is taken, and the other person stays still. When you're finished, you'll have a normal picture of one person and the background, but the person that left halfway through the Multiple exposure will be ghosted.

It's even more fun if you have the person who leaves touch the stationary person during the first half of the Multiple exposure. Maybe you could have the moving person put a hand on the stationary person's shoulder or embrace the stationary person. If the stationary person is very careful not to move, the image will remain sharp and raise eyebrows.

You can also do this with just one person, as the second picture in figure 3.56 shows. Just make sure your subject leaves halfway through the Multiple exposure. Finally, be sure to use a tripod when you create a Multiple exposure unless you mask part of the frame. Otherwise the background will be completely blurred by camera movement between shots.

Interval Timer Shooting

(User's Manual - Page 164)

Interval timer shooting allows you to shoot a series of images over time. Make sure you have a full battery or are connected to a full-time power source, such as the Nikon EH-5b AC adapter, for images taken over long periods.

Interval timer shooting is different than Time-lapse photography (discussed in the next section) because it does not create a movie at the end of the image series. Interval timer shooting simply takes a series of images over time.

Let's examine how to configure the interval and how to start taking pictures. The screens in figure 3.57 look a little daunting, but the bottom half of screens 2-6 are just informational. They show the settings you create in the top half of each screen.

There are three steps to configure Interval timer shooting:

- 1. Choose a start time (Start Time)
- 2. Choose an interval (Interval)
- 3. Choose the number of intervals and the number of shots per interval (Select no. of times \times no. of shots)

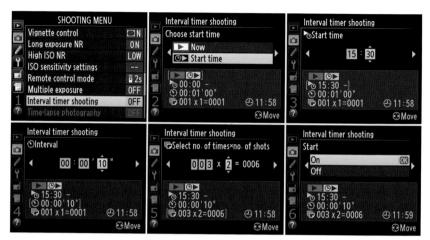

Figure 3.57 – Setting up Interval timer shooting

If you want to take a series of images starting at a particular time and shoot every 10 seconds (Interval) over a period of 30 seconds (three intervals) and make two images per interval (number of shots), you would use the following settings:

- 1. Select Interval timer shooting from the Shooting Menu and scroll to the right (figure 3.57, screen 1).
- 2. Under Choose start time (figure 3.57, screen 2) you can select Now, and the timer will start three seconds after you complete the remaining steps. If you select Now, skip step 3 and go to step 4. If you would rather start at a future time, select Start time and scroll to the right.
- 3. You will now see a Start time menu (figure 3.57, screen 3) with the time in 24-hour (military) format:

00:00

Enter the time at which you want the intervals to begin. If you want to start at 3:30 p.m., insert the following:

15:30

After you have entered the time, scroll to the right.

4. You will now see the Interval screen with hours, minutes, and seconds in the following format (figure 3.57, screen 4):

00:00'00"

The first set of zeros represents the hour, the second set represents minutes, and the third set represents seconds. Since you want to start with an Interval of 10 seconds, set the screen to look like this:

00:00'10"

Scroll to the right to get to the next screen.

5. Now you can select the number of intervals (figure 3.57, screen 5). This screen says Select no. of times × no. of shots in the following format: number of in $tervals \times number of shots = total shots.$

 $0000 \times 0 = 0000$

Set your camera so it looks like this (figure 3.57, screen 5):

 $003 \times 2 = 0006$

This means that there will be 003 intervals of 10 seconds each (set in step 4), and the camera will take 2 pictures in each interval for a total of 0006 pictures. In other words, 2 pictures will be taken every 10 seconds over a period of 30 seconds, for a total of 6 images. Now scroll to the right to get to the next screen.

6. Select On from the final screen (figure 3.57, screen 6) and press the OK button. A Timer active message will briefly appear on the Monitor. If you look at the top Control panel or rear Monitor you will see INTVL flashing. It will keep flashing as long as Interval timer shooting is in operation.

If you are shooting a timed interval during daylight hours, be sure to use the black eyepiece cap (DK-5) supplied with your camera to cover the viewfinder eyepiece. Otherwise changes in the light from behind the camera could cause the exposure to be inaccurate.

To pause the timer operation or simply check on the progress, open Interval timer shooting from the Shooting Menu and select Pause from the Start menu, as shown in figure 3.58, screen 2. You will note that Interval timer shooting is set to On in screen 1 and also that the In progress indicator (in green) is displayed in screen 2. These indicate that Interval timer shooting is currently active. You can check the interval and number of shots information on the lower half of screen 2.

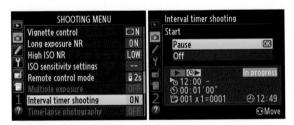

Figure 3.58 - Pause Interval timer shooting

If you want to modify the settings in the middle of the current interval, you can do so by selecting Off instead of Pause (figure 3.58, screen 2), step back through the configuration screens, then restart the Interval timer. If you want to stop Interval timer shooting ahead of schedule, simply select Off.

Note: The number of intervals remaining will be displayed on the Control panel, in the same spot where the shutter speed is normally displayed. The location that normally displays the aperture will instead show the number of shots remaining in the current interval setup.

Be sure to adjust any bracketing for the exposure, flash, or ADL before you start Interval timer shooting. Bracketing overrides the number of shots, so you may not get what you expected if any kind of bracketing is active.

Settings Recommendation: Please learn to use this function! It is complicated, but if you read this section carefully and practice using Interval timer shooting as you read, you'll learn it quickly. This type of photography allows you to shoot things like flowers gradually opening or the sun moving across the sky. Have fun with it!

Time-Lapse Photography

(User's Manual - Page 168)

Time-lapse photography is a close cousin to Interval timer shooting (discussed in the previous section). The primary difference is that Time-lapse photography is designed to create a silent movie that obeys the options selected in the final section of this chapter, **Movie Settings**.

During Time-lapse photography, the camera automatically takes pictures at intervals you select during setup and later assembles them into a time-lapse movie. Let's examine how to set up a short time-lapse sequence using Time-lapse photography.

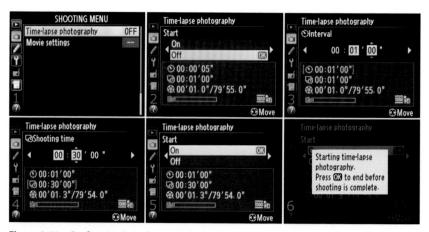

Figure 3.59 – Configuring Time-lapse photography

Here are the steps to set up a Time-lapse photography movie:

- 1. Choose Time-lapse photography from the Shooting Menu and scroll to the right (figure 3.59, screen 1).
- 2. Leave the Start choice set to Off because this is the initial configuration of the time-lapse sequence. Scroll to the right (figure 3.59, screen 2).
- 3. Set the picture Interval in minutes and seconds (figure 3.59, screen 3). You can choose from 00:00'01" (1 second) to 00:10'00" (10 minutes). The hours column is not available for adjustment in the Interval screen. Be sure the Interval you choose is longer than the slowest shutter speed.
- 4. Choose a Shooting time over which the picture Interval will be executed (figure 3.59, screen 4). You can choose from 00 : 01' 00" (1 minute) to 07 : 59' 00" (7 hours and 59 minutes). The seconds column is not available.
- 5. Make sure your camera is on a tripod and ready for shooting the time-lapse sequence, then select On from the Start menu (figure 3.59, screen 5).
- 6. Press the OK button and the final screen will appear and state, Starting timelapse photography. Press OK to end before shooting is complete (figure 3.59, screen 6).

To interrupt the sequence and stop Time-lapse photography, simply press the OK button at any time.

Note: Before you start a time-lapse sequence, check the framing and exposure by taking a picture from the position you will use to capture the time-lapse movie. It is often best to shoot in Manual (M) exposure mode with everything preset to a particular aperture, shutter speed, and ISO sensitivity. This will prevent inconsistencies in exposure during the sequence. Additionally, it is a good idea to choose a White balance setting other than Auto to keep the colors the same across all the images in the time-lapse movie.

If you have selected a long shooting time, you may want to consider connecting the camera to the optional Nikon EH-5b AC adapter for continuous power (you'll also need the EP-5B power connector).

Time-lapse photography is not available (it's grayed out) if the shutter speed is set to bulb; when you are in the middle of a bracket sequence; if the camera is connected with an HDMI cable to a device for movie recording; or when HDR, Multiple exposure, or Interval timer shooting is enabled.

The total number of frames in the movie can be calculated by dividing the shooting time by the interval. Then you can calculate the movie length by dividing the number of frames by the frame rate you selected in Shooting Menu > Movie settings > Frame size/frame rate. Remember, the Time-lapse photography system makes short movies based on the settings under Shooting Menu > Movie settings.

While you're recording the time-lapse sequence, INTVL will flash on the Control panel and the Monitor. The time remaining in hours and minutes will show where the shutter speed normally appears, just before each frame is recorded. If you want to view the time remaining before a frame is fired, simply press the Shutter-release button halfway down and it will display in the shutter speed area of the Control panel. No matter how you have *Custom Setting Menu > c Timers/AE Lock > c2 Standby timer* set, the exposure meter will not turn off during shooting.

If you want to see how things are progressing, simply press the MENU button and you can view the current sequence information on the bottom half of the screen. Unlike with Interval timer shooting, you cannot modify the settings while Time-lapse photography is running. To stop the sequence, press the OK button or turn the camera off.

When the sequence is complete, the camera will automatically assemble a short silent movie based on the frame rates you selected in *Shooting Menu > Movie settings*. You can identify the time-lapse movie by the Play button on the screen that displays the first frame of the movie sequence.

Settings Recommendation: Instead of having to manually assemble frames from Interval timer shooting into a movie, Time-lapse photography does it for us, based on normal camera movie settings. It is quite convenient for those of us who would like to experiment with interesting time-lapse sequences. Try shooting some short sequences of an event and see how easy it is!

Movie Settings

(User's Manual - Page 65)

Movie settings allow you to control how the camera records its main movies and time-lapse photography sequences. This set of functions allows you to adjust four specific things about how the Movie mode works:

- Frame size/frame rate Choose from seven frame size and frame rate combinations
- Movie quality Select from High quality and Normal
- Microphone Change the sensitivity of the internal or external microphone, or turn it off
- Destination Select which memory card (SD or CF) will receive all movies you create

First, let's examine the seven frame rates and how to select your favorite.

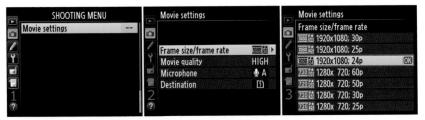

Figure 3.60 - Frame size/frame rate selection from the Shooting Menu

The following steps allow you to select a Frame size/frame rate for your next movie:

- 1. Choose Movie settings from the Shooting Menu and scroll to the right (figure 3.60, screen 1).
- 2. Select Frame size/frame rate and scroll to the right (figure 3.60, screen 2).
- 3. Choose a size and rate for your movie from the list of seven Frame size/frame rate choices (figure 3.60, screen 3).
- 4. Press the OK button to lock in the setting.

Next, let's see about selecting High or Normal quality for the movie. This affects the bit rate at which the movie is shot and determines the final quality of the movie. Table 3.1 is a list of Frame sizes/frame rates and bit rates that are controlled by Movie quality and the recording time for each.

Frame size	Frame rate	Bit rate high quality/min. sec.	Bit rate normal quality/min. sec.
1920×1080	30p	24 Mbps/20 min.	12 Mbps/29 min. 59 sec.
1920×1080	25p	24 Mbps/20 min.	12 Mbps/29 min. 59 sec.
1920×1080	24p	24 Mbps/20 min.	12 Mbps/29 min. 59 sec.
1280×720	60p	24 Mbps/20 min.	12 Mbps/29 min. 59 sec.
1280×720	50p	24 Mbps/20 min.	12 Mbps/29 min. 59 sec.
1280×720	30p	12 Mbps/29 min. 59 sec.	8 Mbps/29 min. 59 sec.
1280×720	25p	12 Mbps/29 min. 59 sec.	8 Mbps/29 min. 59 sec.

Table 3.1 - Frame size/frame rate and Movie quality bit rates and times

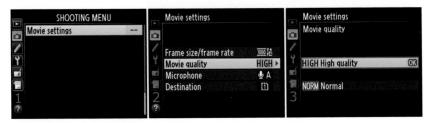

Figure 3.61 - Movie quality selection

- 1. Choose Movie settings from the Shooting Menu and scroll to the right (figure 3.61, screen 1).
- 2. Select Movie quality from the menu and scroll to the right (figure 3.61, screen 2).
- 3. Choose High quality or Normal (figure 3.61, screen 3).
- 4. Press the OK button to lock in the Movie quality.

Now, we'll look at choosing the most appropriate Microphone setting for your built-in microphone (mic), external accessory shoe mic (such as the Nikon ME-1 stereo mic), or external boom-mounted mic.

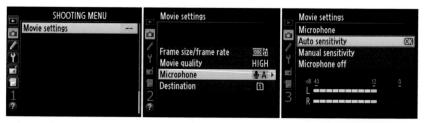

Figure 3.62 – Choosing a Microphone setting

Use the following steps to select a Microphone setting for your next movie:

- 1. Choose Movie settings from the Shooting Menu and scroll to the right (figure 3.62, screen 1).
- 2. Select Microphone from the menu and scroll to the right (figure 3.62, screen 2).
- 3. Choose Auto sensitivity, Manual sensitivity, or Microphone off (figure 3.62, screen 3). These settings are live so you can test them immediately.
- 4. Press the OK button to lock in the Microphone setting.

If you decide to use Manual sensitivity, you will need to use an extra screen that lets you choose a sound level manually.

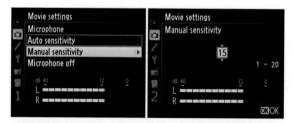

Figure 3.63 - Choosing a Microphone setting manually

Use these steps to manually choose a sound level. Follow figure 3.62, screens 1 and 2, then continue with these steps:

- 1. Choose Manual sensitivity and scroll to the right (figure 3.63, screen 1).
- 2. Select a level for the Microphone from the box by scrolling up or down with the Multi selector. You can choose from level 1 to level 20. The factory default for the Microphone is level 15 (figure 3.63, screen 2). These settings are live, so you can test them immediately.

Finally, we'll examine the Movie setting called Destination (figure 3.64). Destination lets you choose which memory card will receive and store your movies.

Just below the card slot selections you will see something like this: 02h 18m 45s. This is the total recording time the particular card will hold. If you're serious about shooting movies with your camera, you'd better buy some high-capacity cards—you'll need them!

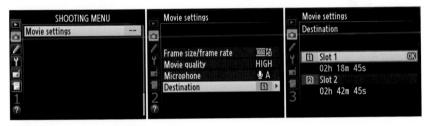

Figure 3.64 - Movie settings - Destination

Here are the steps to select a Destination for your movies:

- 1. Choose Movie settings from the Shooting Menu and scroll to the right (figure 3.64, screen 1).
- 2. Select Destination and scroll to the right (figure 3.64, screen 2).
- 3. Select Slot 1 or Slot 2. Your movies will automatically flow to the card slot you have chosen (figure 3.64, screen 3).
- 4. Press the OK button.

You can also open the Movie settings screen by using a menu selection from the Information display edit screen.

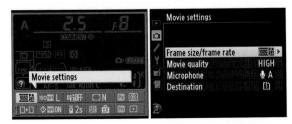

Figure 3.64.1 – Frame size/frame rate selection from the Information display edit screen

- 1. Press the Info button twice to open the Information display edit screen.
- 2. Select the Movie settings icon (figure 3.64.1, screen 1) and press the OK button.
- 3. Follow the previous instructions in this section for screen 2 and the subsequent screens.

The actual frame rate for 30 frames per second (fps) is 29.97 fps; the rate for 24 fps is 23.976 fps; and the rate for 60 fps is 59.94 fps. It is important for you to know this because if you try to interface with some devices using anything but the exact frame rate, the device will not record the video.

The maximum recording time is either 20 minutes or 29 minutes and 59 seconds. Refer to table 3.1 to see which modes allow which recording time length.

With HDMI output, you can record an endless stream of uncompressed video, with no time limits. We will discuss movies more deeply in the chapter called **Movie Live View**.

Settings Recommendation: When I shoot a movie, I normally select 1920×1080 at 24 fps because I have grown accustomed to the look of 1080p at 24 fps. You have many choices of broadcast-quality video available to you. If you want to save some card space, you may want to drop Frame size/frame rate down to 1280×720 at 30 fps. This provides extremely high-quality 720p HD video that takes up only a little more than half the space of full 1080p. To shoot video successfully, I suggest that you acquire some cards with at least 16 GB capacity—preferably 32 GB or 64 GB. Video requires a lot of space.

Video Compression Type and Audio

For the technically inclined individuals among us, the D600 uses H.264/MPEG-4 Advanced Video Coding (AVC), with MOV (Apple QuickTime) file format. The audio recording format is Linear PCM.

Author's Conclusions

Congratulations! You have fully configured one of the camera's User settings. Now, set up another one. Taking advantage of the camera's two User settings (U1 and U2) gives you a great deal of flexibility in how your camera operates. You can switch between two different camera configurations very quickly.

The upcoming information about the Custom Setting Menu will round out the major configuration of your camera for daily shooting.

Custom Setting Menu

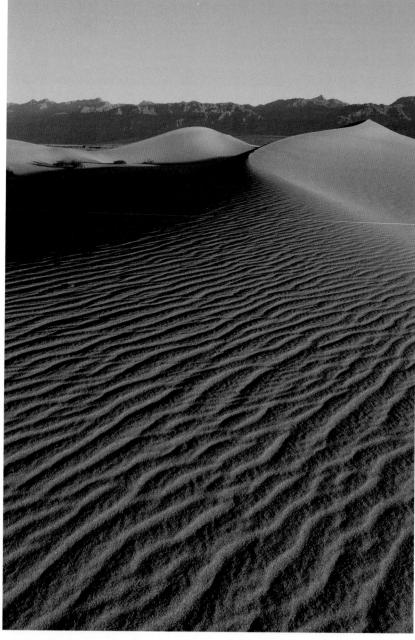

Back in the early days of photography, such as pre-1999, cameras were relatively simple affairs. They were either manual or had a few semiautomatic modes.

The professional Nikon cameras had a few tricks up their sleeves with features controlled by what were called the CSM settings. The menu used a system of hard-to-remember CS numbers. Few people could easily remember what CS 3 or CS 7 meant, so they used the small, thin manuals for initial configuration or simply ignored the settings.

How things have changed! The camera you hold in your hand has a CSM too. It turns out that the early seed planted by Nikon software engineers has grown from a few sparse CSM settings to a full-blown dictionary of Custom Setting Menu settings. It turns out that CSM stood for Custom Setting Menu and CS stood for Custom Setting. Little did we know that our basic cameras would turn into computerized machines of photographic automation. Where the 50-page manuals of yesterday fully sufficed, today's cameras come with manuals more like encyclopedia volumes.

Fortunately, that massive amount of computer automation and inherent complexity provides a camera that—even in inexperienced hands—can produce excellent pictures consistently. When an advanced photographer wants to learn how to use the various features of the camera, it can take weeks of study to fully master. But then you can do things with the camera that less-experienced users can't. A book, like this one, can compress the time it takes to complete that study by providing the real-life experience of a person who has already taken time to fully research and explain each part of your camera.

Your Nikon D600 is a truly powerful camera. It can be used as a fully automated point-and-shoot or as a master's brush for creative photography. As we progress through the literally hundreds of choices in the Custom Setting Menu, you may discover things that you never knew your camera could do. With a little effort, you can come away with a much greater understanding of how to use your new photographic tool.

The Custom Setting Menu is the core of the camera's configurability. Combined with the Shooting Menu (chapter 3) and the Setup Menu (chapter 5), you have complete control over how the D600 functions. Without further ado, let's look deeply into the 50 settings found in the Custom Setting Menu and continue our journey to mastering the Nikon D600.

Using the Camera's Help System

The D600 is complex enough that it needs a help system. Fortunately, Nikon gave us one. Whenever you have a function selected in one of the menus, you can press and hold the Help/protect button and a help screen will appear for that function.

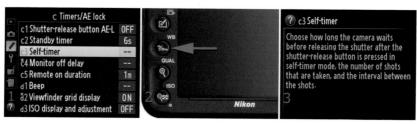

Figure 4.0 – Using the Help button to understand functions

Use the following steps to access the help system:

- 1. Highlight any function in any of the menus (figure 4.0, screen 1).
- 2. Press the Help/protect (WB) button and hold it (figure 4.0, screen 2).
- 3. A help screen will open that shows a brief description of what the function does (figure 4.0, screen 3).

When you are trying to use help in the Custom Setting Menu, be sure that you are not looking at the top of the menu; you should be inside the menu. For example, in figure 4.1, screen 1, help won't work for c Timers/AE lock. You need to select one of the items below the name of the menu, such as c3 Self-timer or d1 Beep.

Check out the useful help screens. They are excellent for when you have forgotten exactly what a function does and could use a reminder. Remember, they are available for any of the menus.

The User Settings and the Custom Setting Menu

Like the Shooting Menu, the Custom Setting Menu options are stored within the user settings (U1 and U2) on the Mode dial (figure 4.0.1). Although there is no direct connection between the Shooting Menu and the Custom Setting Menu, you can make a connection by configuring both menus under one user setting.

Maybe setting U1 will be a repository for a certain style-paired Shooting Menu and Custom Setting Menu configuration, and setting U2 will be

Figure 4.0.1 – U1 and U2 user settings

for menus that are configured in a completely different style-based way. I did this with my D600 by configuring the Shooting Menu and Custom Settings Menu for nature photography in U1 and storing events photography settings in U2.

When you think of the Shooting Menu and the Custom Setting Menu as a paired group of settings controlled by one of the user settings, you begin to see how powerful the Nikon D600 can be.

Be absolutely sure that you save your settings in U1 before going to U2 to make changes. Otherwise you'll lose your carefully configured settings in either the Shooting Menu or the Custom Setting Menu for that particular user setting. Save the user settings in the Setup Menu with the following function:

Setup Menu > Save user settings > Save to U1 (or U2) > Save settings

Note: Remember that the Shooting Menu and Custom Setting Menu configurations outside of U1 and U2—what I call non-user settings—are completely different camera configurations than the configurations in U1 and U2. As a result, there are three ways to configure your camera's Shooting Menu and Custom Setting Menu: by using U1, U2, or non-user settings.

Now, let's see how to use and configure the 50 functions of the Custom Setting Menu. You should repeat the configuration of all these functions for each user setting. This allows you to configure the camera in two completely different ways, one for U1 and another for U2. The non-user settings outside of U1 and U2 can simply be used for general everyday shooting.

Using the Custom Setting Menu

(User's Manual - Page 219)

Figure 4.1 shows the location of the Custom Setting Menu. It's the third menu down on the left-side icon bar, and its symbol looks like a small pencil.

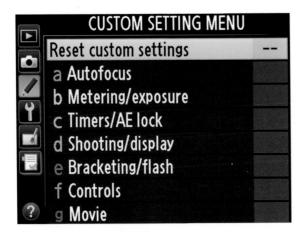

Figure 4.1 – Custom Setting Menu

Reset Custom Settings

If you ever want to start fresh with the Custom settings under a particular user setting, you can return the camera to the factory default configuration with Reset custom settings. Make sure you have the Mode dial set to the correct user setting (U1, U2, or the non-user setting outside U1 and U2) before you use the Reset custom settings function.

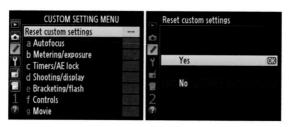

Figure 4.2 – Reset custom settings

Here are the steps to Reset custom settings that are currently active:

- 1. Select Reset custom settings from the Custom Setting Menu and scroll to the right (figure 4.2, screen 1).
- 2. Choose Yes from the menu (figure 4.2, screen 2).
- 3. Press the OK button to reset the custom settings under the current user setting to factory default settings.

This chapter is divided into seven distinct sections, one for each major division of the Custom Setting Menu. This will make it easy for you to find a particular setting in the large number of available choices.

Now, let's look at each setting, starting with those found under Custom setting a Autofocus.

a Autofocus

Custom Settings a1-a7

You'll find seven Custom settings within the a Autofocus menu:

- a1 AF-C priority selection
- · a2 AF-S priority selection
- · a3 Focus tracking with lock-on
- · a4 AF point illumination
- a5 Focus point wrap-around
- · a6 Number of focus points
- · a7 Built-in AF-assist illuminator

In this section you'll learn how to configure the autofocus system in various ways. The whole process is rather complex, yet it is important for good photography. Autofocus and related functions are important enough that I've included a chapter titled **Autofocus**, **AF-Area**, **and Release Modes**. It covers autofocus and related functions in much greater detail.

a1 AF-C Priority Selection

(User's Manual - Page 221)

The *a1 AF-C priority selection* setting is designed to let you choose how autofocus works when you use Continuous-servo autofocus (AF-C) mode. If you configure this setting incorrectly for your style of shooting, it's entirely possible that a number of your pictures will be out of focus. Why?

Notice in figure 4.3, screen 3, that there are two specific selections:

- Release (default) If the image must be taken no matter what, you'll need to set AF-C priority selection to Release. This allows the shutter to fire every time you press the Shutter-release button, even if the image is not in focus. Releasing the shutter has priority over autofocus. If you are aware of the consequences of shooting without a focus guarantee, then use this setting to make your camera take a picture every time you press the Shutter-release button. Your camera will shoot at its maximum frames per second (fps) rate since it is not hampered by the time it takes to validate that each picture is in correct focus. You'll need to decide whether taking the image is more important than having it in focus. Or you will need to use zone focusing and sufficient depth of field to cover any focus discrepancies.
- Focus This setting is designed to prevent your camera from taking a picture
 when the Focus indicator in the Viewfinder is off. If the picture is not in focus,
 the shutter will not release. It does not mean that the camera will always focus on the correct subject. It simply means that your camera must focus on

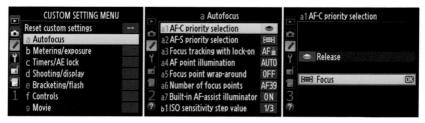

Figure 4.3 – The a1 AF-C priority selection setting

Use the following steps to select a shutter-release priority when using a 1 AF-C priority selection:

- 1. Select a Autofocus from the Custom Setting Menu and scroll to the right (figure 4.3, screen 1).
- 2. Highlight a1 AF-C priority selection and scroll to the right (figure 4.3, screen 2).
- 3. Choose Release or Focus from the menu, with full understanding that your pictures may be out of focus if you do not choose Focus (figure 4.3, screen 3).
- 4. Press the OK button to select your shutter-release priority.

Settings Recommendation: Since I'm not a sports or action shooter, I choose Focus. Even if I were an action shooter I would choose Focus, but you may not agree. Read the section called **Using Custom Settings a1 and a2** before you make your final choice.

If you are shooting action and are hampered by the camera refusing to take what it decides is an out-of-focus picture, set it to Release. Some of your images may be out of focus, but the majority may be in focus due to your understanding of how to use depth of field to cover focus errors.

a2 AF-S Priority Selection

(User's Manual – Page 221)

The a2 AF-S priority selection setting is very similar to the a1 AF-C priority selection. It allows you to choose whether the camera will take a picture with something out of focus. With this setting you set the shutter-release priority for Singleservo autofocus (AF-S) mode. If you set it incorrectly for your style of shooting, many of your pictures may be out of focus. There are two modes to choose from:

• Release - A photo can be taken at any time. This can lead to images that are out of focus unless you manually focus each time you take a picture. The

camera will release the shutter when you press the Shutter-release button, even if nothing is in focus.

• Focus (default) – The image must be in focus or the shutter will not release; the shutter won't release unless the Focus indicator in the Viewfinder is on. This is the closest thing to a guarantee that your image will be in focus when you press the Shutter-release button. However, if you are focused on the wrong part of your subject, the camera will still take the picture.

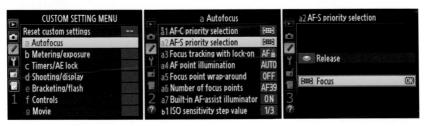

Figure 4.4 - The a2 AF-S priority selection

Use the following steps to select a shutter-release priority with a2 AF-S priority selection:

- 1. Select a Autofocus from the Custom Setting Menu and scroll to the right (figure 4.4, screen 1).
- 2. Highlight a 2 AF-S priority selection and scroll to the right (figure 4.4, screen 2).
- 3. Choose one of the two settings from the menu, with full understanding that your pictures may be out of focus if you do not choose Focus (figure 4.4, screen 3).
- 4. Press the OK button to select your shutter-release priority.

Settings Recommendation: I choose Focus priority when I use AF-S. I love pictures that are in focus, don't you? When I want to manually control focus, I just flip the switch to manual on the camera or lens.

Using Custom Settings a1 and a2

This section will help you understand why you must pay very close attention to a1 AF-C priority selection and a2 AF-S priority selection.

Focus priority simply means your camera will refuse to take a picture until it can reasonably focus on something. Release priority means the camera will take a picture when you decide to take it, whether anything is in focus or not!

You might ask yourself why there is such a setting as Release priority. Many professional photographers shoot high-speed events at high frame rates—hundreds of images—and use depth of field (or experience and luck) to compensate for less than accurate focus. They are in complete control of their camera since they

have a huge amount of practice in getting the focus right where they want it to be. There are valid reasons for these photographers to not use Focus priority.

You need to ask yourself what type of photographer you are. If you are a pro shooting hundreds of pictures of fast race cars, Focus priority may not be for you. However, for average photographers taking pictures of their kids running around the yard, deer jumping a fence, beautiful landscapes, flying birds, or a bride tossing a bouquet, Focus priority is usually the best choice. For most of us, it's better to have the camera refuse to take the picture unless it's focused on the subject.

When you shoot at a high frame rate, Focus priority may cause your camera to skip a series of out-of-focus images. It could slow your camera's frame rate so much that it will not reach the maximum 5.5 fps, in some cases. But, I have to ask, what is the point of several out-of-focus images among the in-focus pictures? Why waste the card space and then have to weed through the slightly out-offocus images?

Settings Recommendation: I set both a1 and a2 to Focus priority. I'm not a high-speed shooter, so I don't need my camera to take a picture, no matter what, if that means capturing a series of out-of-focus images. But if you shoot action regularly, you may not agree. We'll discuss this even more in the chapter titled Autofocus, AF-Area, and Release Modes.

a3 Focus Tracking with Lock-On

(User's Manual - Page 222)

The a3 Focus tracking with lock-on setting allows you to select the length of time that your camera will ignore an intruding object that blocks your subject.

Let's say you are focused on a bird flying past you. As you pan the camera with the bird's movement, the autofocus system tracks it and keeps it in focus. As the bird flies by, a road sign briefly interrupts the focus tracking as the bird moves behind it and then reemerges. It would be quite aggravating if the bright, high-contrast road sign grabbed the camera's attention and you lost tracking on the bird.

The D600 provides Focus tracking with lock-on to prevent this from happening. The lock-on portion of this function helps your camera stay focused on your subject, even if something briefly comes between the camera and the subject. Without Focus tracking with lock-on, any bright object that gets between you and your subject may draw the camera's attention and cause you to lose focus on the subject.

The camera provides a variable time-out period for the lock-on functionality. This function allows an object that stays between the camera and your subject for a predetermined length of time to attract the camera's attention. You can adjust the length of this time-out from 1 (Short) to 5 (Long).

Test the time-out length to see which setting works best for you. You might start with the factory default, 3 (Normal), and let something get between you and your subject. If you want the camera to ignore an intruding subject for a longer time, move the setting toward 5 (Long), or for less time move it toward 1 (Short). I don't suggest turning it Off unless you fully understand how it works and do not need focus tracking to lock on to your subject. You'll quickly determine how long a time period you want to use.

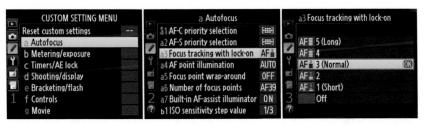

Figure 4.5 - The a3 Focus tracking with lock-on setting

Use the following steps to configure a3 Focus tracking with lock-on:

- 1. Select a Autofocus from the Custom Setting Menu and scroll to the right (figure 4.5, screen 1).
- 2. Highlight a3 Focus tracking with lock-on and scroll to the right (figure 4.5, screen 2).
- 3. Choose one of the five options or Off from the menu (figure 4.5, screen 3).
- 4. Press the OK button to select the time-out period.

With Single-point AF, the camera will start the time-out as soon as the single AF point is unable to detect the subject. With Dynamic-area AF or Auto-area AF and Focus tracking with lock-on enabled, I was amused at how adamant the camera was about staying with the current subject. I focused on a map on the wall and then covered most of the AF points with the User's Manual. As long as I allowed at least one or two AF points to remain uncovered so the camera could see the map, the focus did not switch to the User's Manual. I could imagine the D600 muttering, Hah, you can't fool me. I can still see a little edge of the map, so I'm not changing focus!

Only when I placed the User's Manual completely in front of the lens and covered all the AF points did the camera initiate the time-out for Focus tracking with lock-on. After a few seconds, the camera gave up on the map and focused on the manual instead.

Try this yourself! It's quite fun and will teach you something about the power of your camera's autofocus system. You will see how long each setting causes the time-out to last so you can choose your favorite setting.

Does Lock-On Cause Autofocus to Slow Down?

Some misunderstandings surround this technology. Since it causes autofocus to hesitate for a variable amount of time before seeking a new subject, it may make the camera seem sluggish. This prevents the camera from losing focus on the tracked subject. After the camera locks focus on a subject, it tries to stay with that subject, even if it briefly loses it. The camera ignores closer or higher contrast subjects while it follows your subject. It is not really slower, just adamant about sticking to your primary subject for a period of several seconds. This keeps the lens from racking in and out and searching for a new subject as soon as the original subject is no longer under an AF point. The camera is not really slower; it's just a lot more intelligent about subject tracking when using lock-on!

Settings Recommendation: I leave Focus tracking with lock-on enabled at all times. When I'm tracking a moving subject, I don't want my camera to be distracted by every bright object that gets between me and the subject. Nikon gives us variable time-outs so we can change how long the camera will keep seeking the original subject before it switches to a new subject. Play around with this setting until you fully understand how it works. Watch how long the camera stays locked on one subject before an intruding subject grabs its attention. This is one of those settings that people either love or hate. I find it quite useful for when I am shooting action. Try it and see what it does for you.

a4 AF Point Illumination

(User's Manual – Page 222)

The a4 AF point illumination setting helps you see the currently active AF points when you first start autofocus. You've seen the little squares that represent the AF points in the Viewfinder when they briefly appear in red and then turn black. But sometimes the Viewfinder is dark and it's difficult to see a black square.

If AF point illumination is turned Off, you'll still have the black square that represents your selected AF point. If you set AF point illumination to Auto or On, the point will flash red when you first start autofocus or select a different AF point with the Multi selector.

There are three selections on the AF point illumination screen. These selections affect how the AF points are displayed when they are active:

- Auto If the background of the Viewfinder is dark, the selected AF point will briefly flash red when you press the Shutter-release button to start autofocus. If the background is bright, you'll have no trouble seeing the black AF points, so they don't flash red when you start autofocus.
- On The selected AF point is highlighted in red when you start autofocus, regardless of the light level of the background.
- Off The selected AF point is not highlighted in red when you start autofocus. It always stays black.

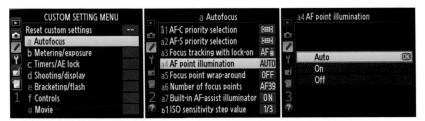

Figure 4.6 – The a4 AF point illumination setting

Use the following steps to configure a4 AF point illumination:

- 1. Select a Autofocus from the Custom Setting Menu and scroll to the right (figure 4.6, screen 1).
- 2. Highlight a4 AF point illumination and scroll to the right (figure 4.6, screen 2).
- 3. Choose one of the three options from the menu. In figure 4.6, screen 3, I selected Auto.
- 4. Press the OK button to lock in the setting.

Note: If you enable this function (set it to Auto or On) in DX mode, the Viewfinder will display a line around the DX area in the Viewfinder (figure 4.6.1, screen 1) instead of displaying a gray area (figure 4.6.1, screen 2).

Figure 4.6.1 – The a4 AF point illumination setting in DX mode

Leaving this function set to Off restores the gray area in DX mode, but it no longer flashes the AF points in red upon initial use. I wish Nikon had separated these two functions because I prefer the gray area and having the AF points flash in red, which are mutually exclusive.

Settings Recommendation: The simplest setting to use is Auto, since that lets the camera determine if there is enough light coming through the Viewfinder for you to see the AF points at the start of autofocus. If you want to force the AF points to flash each time you start autofocus or when you select different points with the Multi selector, you can set AF point illumination to On. I wouldn't leave this set to Off unless I were shooting in an evenly lit studio where the Viewfinder would have good contrast or unless I were a die-hard user of DX mode.

a5 Focus Point Wrap-Around

(User's Manual - Page 222)

The a5 Focus point wrap-around setting allows you to control how AF point scrolling on the View-finder works. When you are scrolling horizontally or vertically to select an AF point in the array of 51 points, you will eventually come to the edge of the Viewfinder area.

The Focus point wrap-around setting allows you to set whether the AF point selector simply stops when it gets to the edge of the AF point array or scrolls to the opposite side (figure 4.7). If

Figure 4.7 – The a5 Focus point wrap-around setting in action

you turn on Focus point wrap-around and scroll to the right side of the AF point array, you can continue scrolling and the AF point will jump to the left side of the array.

This setting works the same vertically. If you scroll off the top of the sensor area, the AF point selector will reappear at the bottom.

Here is a description of the two choices:

- **Wrap** This setting allows the AF point selector to scroll off the Viewfinder screen and reappear on the other side.
- No wrap (default) If you scroll across the array of AF points and come to the
 edge of the screen, the AF point selector stops there. You have to move the
 AF point in the opposite direction, toward the middle.

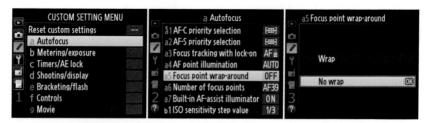

Figure 4.7.1 – The a5 Focus point wrap-around setting

Use the following steps to configure a5 Focus point wrap-around:

- 1. Select a Autofocus from the Custom Setting Menu and scroll to the right (figure 4.7.1, screen 1).
- 2. Highlight a5 Focus point wrap-around and scroll to the right (figure 4.7.1, screen 2).
- 3. Choose Wrap or No wrap from the menu. In figure 4.7.1, screen 3, I selected No wrap.
- 4. Press the OK button to lock in the setting.

Settings Recommendation: Wrapping the AF point selector from one side to the other drives me bonkers. When I reach the edge of the array, I want the selector to stop so I can scroll back the other way. However, I humbly submit that some people will simply adore having their AF point selector wrap to the other side of the Viewfinder. If that describes you, simply set it to Wrap.

a6 Number of Focus Points

(User's Manual - Page 223)

The a6 Number of focus points setting lets you choose how many AF points you want to use when you scroll manually with the Multi selector. There are two selections available: AF39 and AF11.

If you are using any of the AF-area modes besides Auto-area AF, you can unlock the Multi selector with the small switch directly below it. If the switch is pointing at L, the Multi selector is locked; if it is pointing at the white dot, it is unlocked.

When the Multi selector is unlocked, you can use it to move the AF point selector around the Viewfinder so you can select particular areas of your subject to focus on.

Since the D600 has 39 AF points (figure 4.8), it can take time to scroll to the AF point you want to use. To make it easier to scroll from one side to the other quickly, you can select 11 points (AF11) instead of 39 points (AF39), which will cause the AF point selector to jump over several points at a time. It uses the pattern shown in figure 4.8, screen 2, for 11 points.

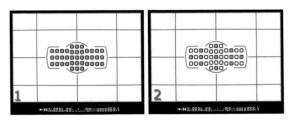

Figure 4.8 – All 39 AF points (screen 1) versus 11 AF points (screen 2)

If you are using an autofocus mode that makes use of multiple focus points, all 39 points continue being active when you select AF11. The only thing Number of focus points affects is the scrolling of the AF point selector when you look into the camera's Viewfinder. It is merely for your rapid-scrolling convenience.

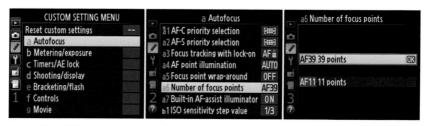

Figure 4.9 - Selecting the number of AF points

Use the following steps to change from 39 points to 11 points:

- Select a Autofocus from the Custom Setting Menu and scroll to the right (figure 4.9, screen 1).
- Highlight a6 Number of focus points and scroll to the right (figure 4.9, screen 2).
- Choose one of the two options from the menu. In figure 4.9, screen 3, I selected (AF39) 39 points.
- · Press the OK button to lock in the setting.

Settings Recommendation: I don't find it to be much trouble to scroll through 39 focus points, especially since the D600 has such a small AF point area that is based on the smaller size of a DX sensor.

I'm glad to have all those luxurious AF points so I can select my focus point accurately. However, there are times when it may be aggravating to use the 39 points setting, such as when I'm shooting a fast-moving event. It may take longer than I'd like to reselect an AF point, so I might use 11 points to speed things up.

Remember, this setting affects nothing except how the AF point selector scrolls around the Viewfinder. However, if I have the AF-area mode configured (Single-point AF, 9-point dynamic, 21-point dynamic, or 39-point dynamic), it is not affected by the Number of focus points setting. All focus points are active, depending on your configuration with the AF-mode button. We'll discuss this further in the chapter titled **Autofocus**, **AF-Area**, **and Release Modes**.

a7 Built-in AF-Assist Illuminator

(User's Manual - Page 223)

You've seen the AF-assist illuminator light on the front of the D600 (figure 4.10). It lights up when low-light conditions are sensed and when certain AF-area modes (not all) are used to help with autofocus. The *a7 Built-in AF-assist illuminator* setting allows you to control when the light comes on.

There are two choices on the a7 Built-in AF-assist illuminator menu: On and Off. It helps to know the difference between an Autofocus mode and an AF-area

mode when considering this function (refer to the chapter titled Autofocus, AF-Area, and Release Modes). The following are descriptions of how the On and Off choices affect the AF-assist illuminator.

 On (default) – If the light level is low, the AF-assist illuminator comes on to help light the subject enough for autofocus. This works only in certain modes:

Figure 4.10 - AF-assist illuminator light

- a) When Single-servo autofocus (AF-S) is selected and the center AF point is in use. The AF-assist illuminator will switch off if you move the AF point away from the center AF point position.
- b) When Auto-servo autofocus (AF-A) is selected, the subject is not moving, and the center AF point is in use. If the subject moves, the camera may automatically switch to Continuous-servo autofocus (AF-C) and turn off the AF-assist illuminator.
- c) When Auto-area AF-area mode is selected, the camera will automatically turn on the AF-assist illuminator as needed.
- d) When using Single-point AF-area mode or Dynamic-area AF-area mode (9, 21, and 39 AF points) if you are using only the center AF point.
- Off The AF-assist illuminator does not come on to help you in low-light autofocus situations. The camera may not be able to automatically focus in very low light.

Note: After writing many books on Nikon cameras, I often refer to one of my books to remember the difference between Autofocus modes and AF-area modes. That's why I added the Autofocus, AF-Area, and Release Modes chapter to the book. Read it carefully and meditate on it until you understand the differences.

An easy way to remember when the AF-assist illuminator light will shine is simply this: when you are using the center AF point, it shines most of the time; when you move off the center AF point, it stops shining. Also, any time you are in an AUTO mode, the AF-assist light will shine when needed because the camera is selecting which focus point to use. Additionally, the AF-assist light will never shine when you are in AF-C mode (continuous autofocus mode, where the camera constantly updates the autofocus and never locks focus).

Figure 4.10.1 – The a7 Built-in AF-assist illuminator setting

Use the following steps to set the Built-in AF-assist illuminator to On or Off:

- 1. Select a Autofocus from the Custom Setting Menu and scroll to the right (figure 4.10.1, screen 1).
- 2. Highlight a7 Built-in AF-assist illuminator and scroll to the right (figure 4.10.1, screen 2).
- 3. Choose On or Off from the menu. In figure 4.10.1, screen 3, I selected On.
- 4. Press the OK button to lock in the setting.

Settings Recommendation: I leave Built-in AF-assist illuminator set to On most of the time. It is activated only when the light is low enough to need it. However, there are exceptions for specific circumstances.

If you are trying to take pictures without being noticed, such as from across the room with a zoom lens or while doing street photography, you certainly don't want this extremely bright light drawing attention when you start autofocus. Or you may be shooting wildlife, such as a giant grizzly bear, and you sure don't want to call attention to yourself by shining a bright light into the bear's eyes.

Don't use this feature if you don't want others to notice you—especially if they are eight-feet tall with claws and fangs.

b Metering/Exposure

Custom Settings b1-b5

You'll find five Custom settings within the b Metering/exposure menu:

- b1 ISO sensitivity step value
- b2 EV steps for exposure cntrl
- b3 Easy exposure compensation
- b4 Center-weighted area
- · b5 Fine-tune optimal exposure

The first two Custom settings in the Metering/exposure menu (b1 and b2) affect how your camera views exposure steps in its exposure value (EV) range. Most people like to have their camera work very precisely, so they use the 1/3 step EV selection in b1 and b2. Others might not be as selective and prefer to change the sensitivity to 1/2 step.

b1 ISO Sensitivity Step Value

(User's Manual - Page 224)

The b1 ISO sensitivity step value setting allows you to change the increments the camera uses for ISO sensitivity. You can set it to use either 1/3 step EV or 1/2 step EV increments.

If you are concerned with maximum ISO control, then use the 1/3 step setting. It takes a little longer to scroll through the ISO selections if you use this setting because there are more of them to choose from, but the extra fineness allows you to control exposure better. The 1/3 step setting is the factory default.

Hold down your camera's ISO button on the back left of the camera and turn the rear Main command dial to the right. You will see the ISO sensitivity number on the Control panel, Information display, or Viewfinder change in increments. Here are the beginning steps in the pattern for 1/3 step and 1/2 step, which ranges from ISO 100 to Hi 2 (ISO 25,600):

- 1/3 step 100, 125, 160, 200, 250, 320, 400, 500, 640, 800, etc.
- 1/2 step 100, 140, 200, 280, 400, 560, 800, 1100, 1600, 2200, etc.

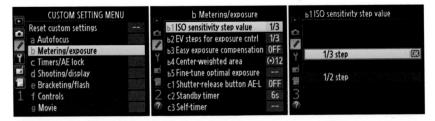

Figure 4.11 - Choosing an ISO sensitivity step value

Use the following steps to change the b1 ISO sensitivity step value:

- 1. Select b Metering/exposure from the Custom Setting Menu and scroll to the right (figure 4.11, screen 1).
- 2. Highlight b1 ISO sensitivity step value and scroll to the right (figure 4.11, screen 2).
- 3. Choose 1/3 step or 1/2 step. In figure 4.11, screen 3, I selected 1/3 step (factory default).
- 4. Press the OK button to lock in the setting.

Settings Recommendation: I like having the finest control possible of ISO sensitivity step values. I normally leave this set to the factory default of 1/3 step. This allows me to carefully fine-tune the ISO sensitivity value for precise exposures.

b2 EV Steps for Exposure Cntrl

(User's Manual - Page 224)

The b2 EV steps for exposure cntrl setting refers to the number of steps for the shutter speed and aperture exposure controls. It also encompasses the exposure bracketing system. Just as with ISO sensitivity step value, you can control the number of steps in 1/3 step or 1/2 step EVs. This applies to shutter speed, aperture, exposure and flash compensation, and bracketing. The factory default value for EV steps for exposure cntrl is 1/3 step.

EV steps for exposure cntrl means that when you manually adjust the shutter speed, aperture, exposure and flash compensation, and bracketing, they work incrementally in the following steps (starting at a random point):

1/3 step EV

- Shutter 1/100, 1/125, 1/160, 1/200, 1/250, 1/320, etc.
- Aperture f/5.6, f/6.3, f/7.1, f/8, f/9, f/10, etc.
- Compensation/bracketing 0.0, 0.3, 0.7, 1.0, 1.3, 1.7, 2.0, 2.3, 2.7, 3.0, etc.

1/2 step EV

- Shutter 1/90, 1/125, 1/180, 1/250, 1/350, 1/500, etc.
- Aperture f/5.6, f/6.7, f/8, f/9.5, f/11, f/13, etc.
- Compensation/bracketing 0.0, 0.5, 1.0, 1.5, 2.0, 2.5, 3.0, etc.

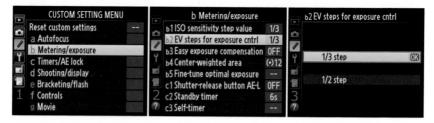

Figure 4.12 - Choosing EV steps for exposure cntrl

Use the following steps to adjust b2 EV steps for exposure cntrl:

- 1. Select b Metering/exposure from the Custom Setting Menu and scroll to the right (figure 4.12, screen 1).
- 2. Highlight b2 EV steps for exposure cntrl and scroll to the right (figure 4.12, screen 2).
- 3. Choose 1/3 step or 1/2 step from the menu (figure 4.12, screen 3).
- 4. Press the OK button to lock in the setting.

Settings Recommendation: Similar to ISO sensitivity step value, I set EV steps for exposure cntrl to 1/3 step. It's critical to control the EV steps with fine granularity for exposure and compensation. It's also best to increment the EV in small steps for use with the histogram.

b3 Easy Exposure Compensation

(User's Manual – Page 225)

The b3 Easy exposure compensation setting allows you to set the camera's exposure compensation without using the +/- Exposure compensation button. Instead, you will use a Command dial alone to add or subtract exposure.

If you set the camera to Reset On (Auto reset) or simply to On, you can use the Command dials to set exposure compensation instead of using the +/- Exposure compensation button. Off means what it says. If you use the +/- Exposure compensation button, it overrides the Easy exposure compensation settings. Each exposure mode (P, S, A, M) reacts somewhat differently to Easy exposure compensation.

In the upcoming list we'll consider how the Programmed auto (P), Shutter-priority auto (S), and Aperture-priority auto (A) exposure modes act when you use the three available settings (figure 4.13). The Manual (M) mode does not seem to be affected by b3 Easy exposure compensation, although it does work with the +/- Exposure compensation button. The Control panel, Information display, and Viewfinder will display a +/- icon to show that compensation value has been dialed in. The three settings in Easy exposure compensation are as follows:

- On (Auto reset) Use the Sub-command dial in Programmed auto (P) or Shutter-priority auto (S) modes, or the Main command dial in Aperture-priority auto (A) mode, to dial in exposure compensation without using the +/- Exposure compensation button. If you allow the meter to reset, or if you turn the camera off, the compensation value you dialed in is reset to 0. That's why it's called Auto reset. If you have already set a compensation value using the +/-Exposure compensation button, the process of dialing in exposure compensation with the Sub-command dial simply adds more compensation to what you originally put in with the +/- Exposure compensation button. When the meter resets, it returns to the compensation value you added with the +/- Exposure compensation button, not to 0.
- On This works the same way as On (Auto reset), except the compensation you dialed in does not reset. It stays in place, even if the meter or camera is turned off.
- Off Exposure compensation can be applied only with the +/– Exposure compensation button.

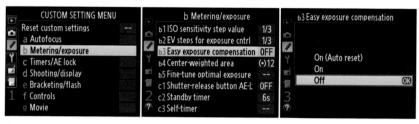

Figure 4.13 – Using Easy exposure compensation

Use the following steps to configure b3 Easy exposure compensation:

- 1. Select b Metering/exposure from the Custom Setting Menu and scroll to the right (figure 4.13, screen 1).
- 2. Highlight b3 Easy exposure compensation and scroll to the right (figure 4.13, screen 2).
- 3. Choose one of the three items from the menu. In figure 4.13, screen 3, I selected Off.
- 4. Press the OK button to lock in the setting.

Note: The granularity of the Easy exposure compensation EV is affected by whether Custom setting b2 EV steps for exposure cntrl is set to 1/3 step or 1/2 step. Also, the Command dial used to set compensation can be swapped in Custom setting f5 Customize command dials, which we will consider later in this chapter.

Settings Recommendation: I don't use this setting often, having used the +/- Exposure compensation button for too many years to change now. However, because Nikon added this feature to the camera, I'm sure many people requested it. It certainly would come in handy when you would like to quickly add compensation without searching for the +/- Exposure compensation button. Give it a try, you may like it!

b4 Center-Weighted Area

(User's Manual – Page 226)

The b4 Center-weighted area setting allows you to control the area on the Viewfinder that has the greatest weight in metering a subject when you use the Center-weighted area metering mode. Years ago cameras didn't have Matrix metering. They had averaging or partially averaging meters, or none at all.

If you prefer not to use the D600's built-in database of image scenes, otherwise known as Matrix metering, and you use only Spot metering as needed, you are most likely using the Center-weighted area meter. It is good that Nikon gives us a choice.

You have three types of meters in your camera that you select with the Metering button. We'll consider each of the metering modes in greater detail in the chapter titled Metering, Exposure Modes, and Histogram.

When you hold down the Metering button (figure 4.14, top red arrow) and turn the rear Main command dial, you'll scroll through three symbols on the Control panel on top of the camera (figure 4.14, bottom red arrow). The symbol

Figure 4.14 - Metering button and symbol

that represents the Center-weighted area meter looks like this: (·).

The Center-weighted area meter can be configured to use a central area of the Viewfinder to do most of the metering, with less attention paid to subjects outside this area, or it can be set up to simply average the entire frame.

The four size settings for the most sensitive part of the Center-weighted area meter are 8mm, 12mm, 15mm, and 20mm—or the meter can simply Average the entire frame, as shown in figure 4.14.1.

Figure 4.14.1 – Approximate Center-weighted area meter sensitivity

Figure 4.14.1 shows the approximate size of the most sensitive area in the Viewfinder for each step of the Center-weighted area meter. The pink circle in the center of the Viewfinder is the most sensitive area for metering, and it gets larger for each setting. You won't actually see anything in the Viewfinder that shows the area being used by the Center-weighted meter.

In the final image of figure 4.14.1, the entire frame is equally sensitive and averages everything seen in the Viewfinder.

The Center-weighted area meter does not move around with the currently selected AF point, as the Spot meter does. Instead, it assigns the greatest weight to the center of the Viewfinder frame, and anything outside the center circle is not as important.

Each size increase from 8mm to 20mm will increase the sensitivity of the center of the Viewfinder as more emphasis is given to a larger area in the middle.

If you select the Average (Avg) setting, the entire Viewfinder frame is used to meter the scene. The camera takes an average of the entire frame by including all light and dark areas mixed together for an averaged exposure.

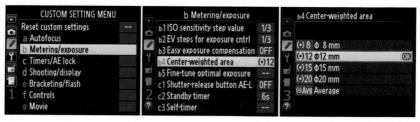

Figure 4.15 - Choosing a Center-weighted area

Use the following steps to set b4 Center-weighted area:

- 1. Select b Metering/exposure from the Custom Setting Menu and scroll to the right (figure 4.15, screen 1).
- 2. Highlight b4 Center-weighted area and scroll to the right (figure 4.15, screen 2).
- 3. Choose one of the five items from the menu. In figure 4.15, screen 3, I selected 12mm (default).
- 4. Press the OK button to lock in the setting.

Settings Recommendation: When I use the Center-weighted area meter, I generally use the 20mm setting to make the largest area in the center of the Viewfinder be the most sensitive.

I use 3D Matrix metering most of the time and have my camera's Fn button set to switch to the Spot meter temporarily when I press it. That way I can use Nikon's incredible 3D Color Matrix Metering II system, with its ability to consider brightness, color, distance, and composition when using type G and D Nikkor lenses.

Matrix metering gives me the best metering I've had with any camera! The Center-weighted area meter is still included in modern cameras for people who are used to this older-style meter. However, most people use Matrix metering these days.

b5 Fine-Tune Optimal Exposure

(User's Manual - Page 226)

The *b5 Fine-tune optimal exposure* setting allows you to fine-tune the Matrix metering, Center-weighted area metering, and Spot metering systems by +/-1 EV in 1/6 EV steps. Nikon has taken the stance that most major camera systems should allow the user to fine-tune them. The exposure system is no exception.

You can force each of the three metering systems to add or subtract from the exposure the camera would normally use to expose your subject. This stays in effect until you set the meter back to zero. It is indeed fine-tuning, since the maximum 1 EV step up or down is divided into six parts (1/6 EV). If you think your camera mildly underexposes highlights and you want it to add 1/2 step of exposure, you simply add 3/6 EV to the metering system. (Remember basic fractions: 1/2 equals 3/6.)

Fine-tune optimal exposure works like the normal compensation system, but it allows only 1 EV of compensation. As shown in figure 4.16, screen 3, an ominous-looking warning appears when you use Fine-tune optimal exposure. It lets you know that your camera will not display a compensation icon, as it does with the +/- Exposure compensation button, when you use the metering fine-tuning system. If it did display the compensation icon, it couldn't use that same icon when you use normal compensation.

Fine-tune optimal exposure applies only to the user setting (U1, U2, or nonuser setting) you are currently working with. If you are working with U1, then U2 and non-user settings are not changed. Be sure to save the user setting in the Setup Menu if you change it.

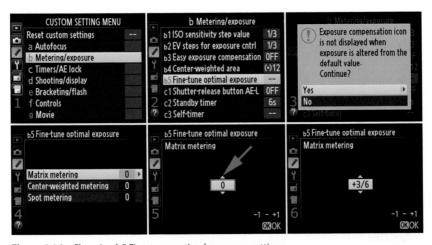

Figure 4.16 – Choosing b5 Fine-tune optimal exposure settings

Use the following steps to choose b5 Fine-tune optimal exposure settings:

- 1. Select b Metering/exposure from the Custom Setting Menu and scroll to the right (figure 4.16, screen 1).
- 2. Select b5 Fine-tune optimal exposure and scroll to the right (figure 4.16, screen 2).
- 3. Select Yes from the warning screen and scroll to the right (figure 4.16, screen 3).

- 5. Scroll up or down in 1/6 EV steps until you reach the fine-tuning value you would like to use (figure 4.16, screen 5, red arrow).
- 6. In figure 4.16, screen 6, I selected +3/6. Press the OK button to lock in the fine-tuning value for the metering system you selected in step 4.

That's all there is to it! Remember, when you have Fine-tune optimal exposure turned on, the camera will not remind you. Watch your histogram to make sure you're not regularly underexposing or overexposing images when you have fine-tuning adjustment in place. If needed, adjust the fine-tuning up or down, or turn it off. You must fine-tune each metering system separately.

Settings Recommendation: I have not needed to change the default metering level on my D600. The three metering systems seem very accurate to me!

Remember that adjusting an exposure is always an experiment. If you choose to fine-tune one of the three metering systems, you should thoroughly test it before you do an important shoot. It certainly won't hurt to play with these settings—as long as you remember to set them back to 0 if they don't perform the way you expect.

c Timers/AE Lock

Custom Settings c1-c5

You'll find five Custom settings within the c Timers/AE lock menu:

- c1 Shutter-release button AE-L
- · c2 Standby timer
- c3 Self-timer
- · c4 Monitor off delay
- · c5 Remote on duration

c1 Shutter-Release Button AE-L

(User's Manual - Page 226)

The *c1 Shutter-release button AE-L* setting allows you to lock the exposure when you press the Shutter-release button halfway down. Normally that type of exposure lock happens only when you press and hold the AE-L/AF-L button. However, when you have Shutter-release button AE-L set to On, your camera will respond as if you pressed the AE-L/AF-L button every time you start autofocus and take a picture.

This setting allows you to meter one area of the scene and then recompose to another area without losing the meter reading from the first area—as long as you hold the Shutter-release button halfway down.

Looking at this from another direction, when you have Shutter-release button AE-L set to Off, the exposure will lock only when you hold down the AE-L/ AF-L button.

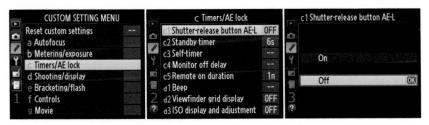

Figure 4.17 - Using Shutter-release button AE-L

Use the following steps to configure c1 Shutter-release button AE-L:

- 1. Select c Timers/AE lock from the Custom Setting Menu and scroll to the right (figure 4.17, screen 1).
- 2. Highlight c1 Shutter-release button AE-L and scroll to the right (figure 4.17, screen 2).
- 3. Choose either On or Off from the menu. In figure 4.17, screen 3, I selected On.
- 4. Press the OK button to lock in the setting.

Settings Recommendation: I use this feature only when I really need it. The rest of the time I use the AE-L/AF-L button to lock my exposure. I don't think I'd leave Shutter-release button AE-L turned on all the time since I might be holding the Shutter-release button halfway down to track a moving subject through light and dark areas.

For people who shoot sunsets or similar scenes where the sun is included in the image, this is a nice function. You can meter from an area of the sky that has the best color and then swing the camera around to include the sun in the shot. The camera will expose for the originally metered area as long as you hold the Shutter-release button halfway down. Normally you'd do this with the AE-L/ AF-L button.

c2 Standby Timer

(User's Manual – Page 227)

The c2 Standby timer function controls the amount of time that your camera's light meter stays on after you press the Shutter-release button halfway and then release it. The default value is 6 seconds.

When the light meter goes off, the various displays—like shutter speed and aperture—in the Control panel and Viewfinder go off, too. If you want your light meter to stay on longer for whatever reason, such as multiple exposures, you can adjust it to the following settings:

- 4 s 4 seconds
- 6 s 6 seconds (default)
- 10 s 10 seconds
- 30 s 30 seconds
- 1 min 1 minute
- 5 min 5 minutes
- 10 min 10 minutes
- 30 min 30 minutes
- No limit (meter stays on)

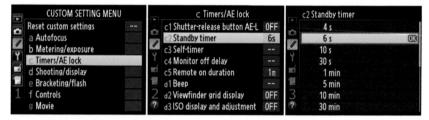

Figure 4.18 - Using Standby timer

Use the following steps to configure the c2 Standby timer setting:

- 1. Select c Timers/AE lock from the Custom Setting Menu and scroll to the right (figure 4.18, screen 1).
- 2. Highlight c2 Standby timer and scroll to the right (figure 4.18, screen 2).
- 3. Choose one of the nine options from the menu. In figure 4.18, screen 3, I selected 6 s. You can't see all the available menu selections in screen 3. Scroll down on the menu to find the No limit setting.
- 4. Press the OK button to lock in the setting.

Settings Recommendation: There are times when you want the light meter to stay on for a longer or shorter time than normal. When I'm shooting multiple exposures, I set Standby timer to No limit. However, when I'm shooting normally, I leave it at 6 s. The longer the meter stays on, the shorter the battery life, so extend the time only if you really need it.

c3 Self-Timer

(User's Manual - Page 227)

The c3 Self-timer setting is used to take pictures remotely or without touching the camera. Hands-off shooting can reduce vibrations so you have sharper pictures. The Self-timer also allows you to set your camera up on a tripod and have time to get into a group picture before the shutter fires. You can even use the Self-timer to shoot multiple shots without touching the camera.

There are three choices when you use the Self-timer:

- Self-timer delay This setting allows you to specify a delay before the shutter fires so you have time to position yourself for the shot or allow vibrations to settle down. The time delays range from 2 to 20 seconds. This setting can be used instead of a remote release, and you won't have cables to trip over.
- Number of shots Use this setting to choose how many shots will be taken for each cycle of the Self-timer. You can choose one to nine shots in a row.
- Interval between shots If you are taking more than one shot during a Selftimer cycle, this setting allows you to choose a time interval between each shot that ranges from 1/2 second to 3 seconds. The delay between shots allows vibrations from the previous shot to settle down.

Now let's look at the screens and steps used to adjust each of these settings. First, we'll look at the Self-timer delay. Here is a list of the four available settings:

- 2 s 2 seconds
- 5 s 5 seconds
- 10 s 10 seconds
- 20 s 20 seconds

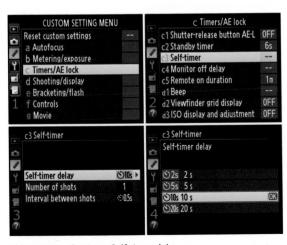

Figure 4.19 – Setting a Self-timer delay

- 1. Select c Timers/AE lock from the Custom Setting Menu and scroll to the right (figure 4.19, screen 1).
- 2. Highlight c3 Self-timer and scroll to the right (figure 4.19, screen 2).
- 3. Select Self-timer delay from the menu and scroll to the right (figure 4.19, screen 3).
- 4. Choose one of the four options from the menu (2 s to 20 s). In figure 4.19, screen 4, I selected 10 s.
- 5. Press the OK button to lock in the setting.

Next, let's look at how to configure the Number of shots for each Self-timer cycle. You can instruct the camera to take from one to nine pictures each time the Self-timer cycle completes.

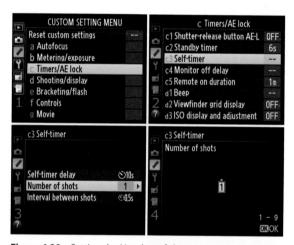

Figure 4.20 – Setting the Number of shots

Use the following steps to configure the Number of shots:

- 1. Select c Timers/AE lock from the Custom Setting Menu and scroll to the right (figure 4.20, screen 1).
- 2. Highlight c3 Self-timer and scroll to the right (figure 4.20, screen 2).
- 3. Select Number of shots from the menu and scroll to the right (figure 4.20, screen 3).
- 4. Choose the Number of shots, from 1 to 9, by scrolling up or down with the Multi selector. In figure 4.20, screen 4, I selected 1 shot.
- 5. Press the OK button to choose the setting.

Finally, let's look at how to configure the Interval between shots for each Self-timer cycle. This is simply the time delay between each shot (0.5 to 3 seconds)

when you have selected multiple images in Number of shots (1 to 9). Here is a list of the four available Interval between shots settings:

- 0.5 s 1/2 second
- 1 s 1 second
- 2 s 2 seconds
- 3 s 3 seconds

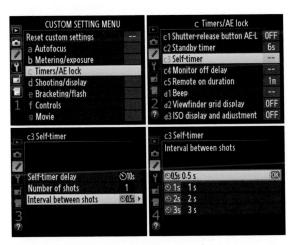

Figure 4.21 - Setting the Interval between shots

Use the following steps to configure the Interval between shots:

- 1. Select c Timers/AE lock from the Custom Setting Menu and scroll to the right (figure 4.21, screen 1).
- 2. Highlight c3 Self-timer and scroll to the right (figure 4.21, screen 2).
- 3. Select Interval between shots from the menu and scroll to the right (figure 4.21, screen 3).
- 4. Choose the Interval between shots, from 0.5 s to 3 s, by scrolling up or down with the Multi selector. In figure 4.21, screen 4, I selected 0.5 s.
- 5. Press the OK button to choose the setting.

Settings Recommendation: Often when I don't want to take time to plug in a remote release cable, I just put my camera on a tripod and set the Self-timer delay to 2 or 5 seconds. The D600 makes a hands-off exposure so I don't shake the camera or the tripod. If I must run to get into position for a group shot, I often increase the delay to at least 10 seconds so I don't look like an idiot as I trip while running for position.

I also use the settings to control how many shots the camera takes each time I use the Self-timer and how long it delays between those shots to allow

vibrations to go away. I'm sure you'll agree that the Self-timer in your D600 is one of the most flexible timers in an HD-SLR camera.

c4 Monitor Off Delay

(User's Manual - Page 228)

The *c4 Monitor off delay* setting lets you specify a time-out for the five ways you can use the LCD Monitor on the back of your camera. The Monitor will stay on until the time-out expires.

The D600 allows you to select individual display time-outs for each of the following five subfunctions:

- Playback You can manually view pictures on the Monitor with the Playback button. Select a four-second to 10-minute Monitor off delay.
- Menus The Monitor displays the in-camera menus. Select a four-second to 10-minute Monitor off delay.
- Information display Press the Info button once or twice to see the Information display on the Monitor. Select a four-second to 10-minute Monitor off delay.
- *Image review* You can see a picture on the Monitor immediately after you take it. Select a two-second to 10-minute Monitor off delay.
- Live view You can use the Monitor, instead of the Viewfinder, to view your subject. Select a five-minute or longer (up to No limit) Monitor off delay.

Here are the available Monitor off delay values:

- 2 s 2 seconds (Image review only)
- 4 s 4 seconds (all five functions)
- 10 s 10 seconds (all five functions)
- 20 s 20 seconds (all five functions)
- 1 min 1 minute (all five functions)
- 5 min 5 minutes (all five functions)
- 10 min 10 minutes (all five functions)
- 15 min 15 minutes (Live view only)
- 20 min 20 minutes (Live view only)
- 30 min 30 minutes (Live view only)
- No limit (Live view only)

There is no need to provide figures and step-by-step instructions for each of the time-out types. If you examine one of them, you will know how to use all of them. As an example, figure 4.22 shows how to select the *Monitor off delay* > *Playback time-out*.

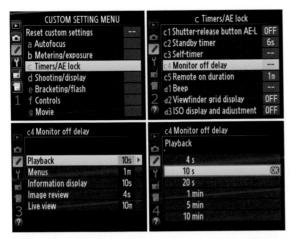

Figure 4.22 – Choosing a time-out (sample for all five delay types)

Use the following steps for each of the five delay types, with the understanding that the delay values vary, as shown in the previous list:

- 1. Select c Timers/AE lock from the Custom Setting Menu and scroll to the right (figure 4.22, screen 1).
- 2. Highlight c4 Monitor off delay and scroll to the right (figure 4.22, screen 2).
- 3. Choose one of the five display types (figure 4.22, screen 3). You can set the Monitor off delay for each type, then scroll to the right.
- 4. Figure 4.22, screen 4, shows the delay times for the Playback display, which I selected in screen 3.
- 5. Press the OK button to lock in the setting.

Settings Recommendation: I set Monitor off delay to 1 min for Playback, Information display, and Image review. I set the Menus time-out to 5 min because I like to scroll around for longer time periods as I configure various settings in the menus. I leave Live view at the default of 5 min.

If you want to conserve battery power, leave the Monitor off delay set to a low value, like 4 s to 20 s. The longer the monitor stays on, the shorter the battery life, so extend the monitor time only if you really need it. Like a computer screen, that big, luxurious VGA-resolution LCD pulls a lot of power. The Monitor and Control panel backlights are probably the biggest power drains in the entire camera. However, you don't need to be overly concerned about this. For as much image review (chimping) as I do, I can still usually shoot all day on one full battery charge.

c5 Remote on Duration

(User's Manual - Page 228)

Interestingly, the *c5* Remote on duration setting controls how long the camera will wait for you to press the shutter-release button on your Nikon ML-L3 infrared remote. It works in partnership with the *Shooting Menu > Remote control mode* we explored in the previous chapter. Recall that Remote control mode gives you three settings to choose from:

- Delayed remote Two-second delay after you press the shutter-release button on the ML-L3 wireless remote
- Quick-response remote Instant release when you press the shutter-release button on the ML-L3 wireless remote
- Remote mirror-up The first press of the shutter-release button on the ML-L3 wireless remote raises the mirror, and the second press fires the shutter

If you set Remote control mode to any of these three settings, the camera will stay in a ready state—looking for the remote signal from the ML-L3—for the time delay you set in Remote on duration. This means the camera stays ready to take a picture and leaves the exposure meter active until Remote on duration times out.

The following delay times are available for Remote on duration:

- 1 min 1 minute (default)
- 5 min 5 minutes
- 10 min 10 minutes
- 15 min 15 minutes

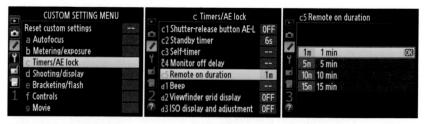

Figure 4.23 - Choosing a Remote on duration for Self-timer Remote control mode

Use the following steps to configure c5 Remote on duration:

- 1. Choose c Timers/AE lock from the Custom Setting Menu (figure 4.23, screen 1).
- 2. Select c5 Remote on duration from the menu and scroll to the right (figure 4.23, screen 2).
- 3. Select a time-out delay period from 1 min to 15 min (figure 4.23, screen 3).
- 4. Press the OK button.

Settings Recommendation: I used to leave my Remote on duration time set to 1 min (factory default). However, I have recently been leaving it set to 5 min. I wish there were a two-minute setting because 1 min is not quite enough sometimes, especially for large group portraits, and 5 min is often too long and wastes the battery. If you need this function, you'll have to decide how long is long enough.

d Shooting/Display

Custom Settings d1-d13

Within the d Shooting/display menu, you'll find 13 Custom settings:

- d1 Beep
- d2 Viewfinder grid display
- d3 ISO display and adjustment
- d4 Screen tips
- · d5 CL mode shooting speed
- d6 Max. continuous release
- d7 File number sequence
- d8 Information display
- d9 LCD illumination
- d10 Exposure delay mode
- d11 Flash warning
- d12 MB-D14 battery type
- · d13 Battery order

d1 Beep

(User's Manual - Page 228)

The d1 Beep setting allows your camera to make a beeping sound to alert you during the following functions:

- Focus lock while in Single-servo AF (AF-S) mode
- Focus lock while in Live view mode
- Countdown in Self-timer and Delayed release mode operations
- Taking a picture in Quick-response remote or Remote mirror-up modes
- · Trying to take a picture with the memory card locked

You can set the camera to beep with a high- or low-pitched tone—and you can adjust the volume—or you can turn the Beep sound Off. First let's examine how to set the Volume or disable the Beep. The Volume settings under Beep in the Custom Setting Menu are 3, 2, 1, and Off (figure 4.24, screen 4).

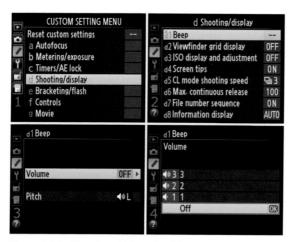

Figure 4.24 - Choosing a Volume level for Beep

Use the following steps to select one of the d1 Beep volume choices:

- 1. Select d Shooting/display from the Custom Setting Menu and scroll to the right (figure 4.24, screen 1).
- 2. Highlight d1 Beep and scroll to the right (figure 4.24, screen 2).
- 3. Select Volume from the menu and scroll to the right (figure 4.24, screen 3).
- 4. Choose one of the four options from the list (3-1 or Off). In figure 4.24, screen 4, I selected Off. You will hear a sample beep for each volume level as you choose it. The level 1 beep is rather quiet, so you may not hear it unless you hold the camera close to your ear.
- 5. Press the OK button to lock in the setting.

Next, let's consider how to change the pitch of the Beep. You have two pitch levels available: High (H) and Low (L). I compared them to my piano, and the Low (L) sound is F# just above middle C. The High (H) sound is almost three octaves higher (B just before three octaves above middle C).

(You probably don't need that much information; however, my somewhat compulsive personality requires that I give it to you. Notice that I didn't give you

the decibel level of the three Beep volume levels. Wouldn't that be excessively excessive? Of course, with my trusty Radio Shack digital sound level meter, I do have that information. If you really want it, send me an e-mail.)

When Beep is active, you'll see a little musical note displayed in the Information display (Monitor), above the battery charge symbol (figure 4.24.1, red arrow).

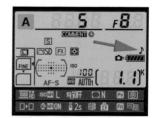

Figure 4.24.1 – Beep symbol in Information display

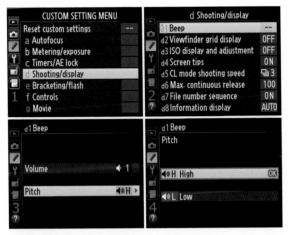

Figure 4.25 - Choosing a Pitch for the Beep

Here are the screens and steps to select a pitch for the beep:

- 1. Select d Shooting/display from the Custom Setting Menu and scroll to the right (figure 4.25, screen 1).
- 2. Highlight d1 Beep and scroll to the right (figure 4.25, screen 2).
- 3. Select Pitch from the menu and scroll to the right (figure 4.25, screen 3).
- 4. Choose one of the two options from the list (High or Low). In figure 4.25, screen 4, I selected High (default). You will hear a sample beep for each pitch as you choose it.
- 5. Press the OK button to lock in the setting.

Settings Recommendation: I don't use the Beep. If I am using my camera in a guiet area, why would I want it beeping and disturbing those around me? I can iust imagine me zooming in on that big grizzly bear, pressing the Shutter-release button, and listening to the grizzly roar his displeasure at my camera's beep. I want to live, so I turn off Beep.

You might want the reassurance of hearing a beep when autofocus has been confirmed or when the Self-timer is counting down. If so, turn it on. The AF-assist illuminator flashes during Self-timer operations, so I generally use that instead of Beep.

This is another function that people either love or hate. You can have it either way, but be careful around big wild animals when Beep is enabled. They might think you're calling them to supper, and you may be the main course.

By the way, Beep is automatically disabled when you're using the Q or Quiet shutter-release mode on the Release mode dial, regardless of how this Custom setting is configured. It also does not sound when you use Movie live view mode.

d2 Viewfinder Grid Display

(User's Manual - Page 229)

The d2 Viewfinder grid display setting causes gridlines to display in the camera's Viewfinder. You can use these lines to make sure the camera is lined up correctly with your subject.

With the D600, you have not only a Viewfinder grid display, but also Live view (Lv) gridlines—the best of both worlds! There are only two selections in d2 Viewfinder grid display: On and Off.

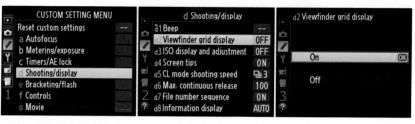

Figure 4.26 – Enabling the Viewfinder grid display

Use the following steps to enable or disable the d2 Viewfinder grid display setting:

- 1. Select d Shooting/display from the Custom Setting Menu and scroll to the right (figure 4.26, screen 1).
- 2. Highlight d2 Viewfinder grid display and scroll to the right (figure 4.26,
- 3. Choose either On or Off from the menu. In figure 4.26, screen 3, I selected On.
- 4. Press the OK button to lock in the setting.

Settings Recommendation: I use these gridlines to line up things as I shoot so I won't have tilted horizons and such. Many of us tend to tilt the camera one way or another, and gridlines help us keep it straight.

I especially enjoy shooting with gridlines enabled when I'm at the beach. Who needs tilted ocean views? When I shoot architecture, the gridlines are invaluable for making sure buildings, walls, and doors are straight. There are lots of ways to use the Viewfinder grid display.

If you set the Viewfinder grid display to On, I doubt that you'll turn it back Off. The nice thing is that you can turn the gridlines On and Off at will. You don't have to buy an expensive viewfinder replacement screen for those times when you need gridlines.

Using a Grid Display on the Live View Screen

This section pertains only to the Viewfinder grid display in the Viewfinder. However, you can also turn on gridlines when the Live view screen is active by pressing the Info button multiple times to scroll through the various display overlays. One of them is a grid display.

d3 ISO Display and Adjustment

(User's Manual - Page 229)

The d3 ISO display and adjustment setting can modify how the D600 displays the ISO sensitivity in the Control panel. Instead of displaying the frame count in the Control panel, where you normally see how many images you have left before the memory card is full, the camera can display the ISO sensitivity. The Viewfinder and Information display (Monitor) both continue to display the frame count. There are three settings:

- Show ISO sensitivity This setting displays the ISO sensitivity, instead of the frame count, on the Control panel.
 - Show ISO/Easy ISO This setting affects how you adjust the ISO sensitivity and how it displays. It works like Show ISO sensitivity, in that it replaces the frame count on the Control panel with the ISO sensitivity value. It also adds a way to change the ISO sensitivity while you take pictures. Normally you would use Shooting Menu > ISO sensitivity settings or press the ISO button and turn the Main command dial to change the ISO sensitivity. However, when you enable Show ISO/Easy ISO, the camera lets you adjust the ISO sensitivity with either the rear Main command dial or the front Sub-command dial alone (according to exposure mode), without using the ISO button. This applies only when you use the P, S, or A modes on the Mode dial. Normally, when you have the camera in P or S modes, you control the aperture (P mode) or shutter speed (S mode) with the Main command dial. The Sub-command dial does nothing. When you set the camera to Show ISO/Easy ISO, the normally unused Sub-command dial sets the ISO sensitivity when the P or S modes are set. Likewise, when the camera is set to A mode, you normally control the aperture with the Sub-command dial, and the Main command dial does nothing. When you enable Show ISO/Easy ISO in A mode, the camera lets you adjust ISO sensitivity with the unused Main command dial, and you continue to control the aperture with the Sub-command dial. For people who need to adjust ISO sensitivity quickly while shooting, this can be very convenient. M mode on the Mode dial is not affected by this setting. If you are using M mode, the camera acts as if you had selected Show ISO sensitivity and simply displays

the ISO instead of the frame count. You cannot change the ISO sensitivity with either command dial in M mode, because the command dials control the aperture and shutter speed.

• Show frame count – This is the default setting. The camera functions as normal, with the frame count showing in the Control panel and Viewfinder.

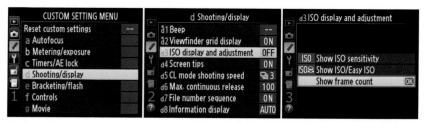

Figure 4.27 – Using ISO display and adjustment settings

Use the following steps to select a d3 ISO display and adjustment setting:

- 1. Select d Shooting/display from the Custom Setting Menu and scroll to the right (figure 4.27, screen 1).
- 2. Highlight d3 ISO display and adjustment and scroll to the right (figure 4.27, screen 2).
- 3. Choose one of the three settings from the menu. In figure 4.27, screen 3, I selected Show frame count (default).
- 4. Press the OK button to lock in the setting.

Settings Recommendation: I don't find much use for this setting. My slow and deliberate tripod-based style of nature shooting rarely requires changing ISO sensitivity from its lowest setting. However, many people need to change ISO sensitivity on the fly and may not trust the Auto ISO sensitivity control, which adjusts ISO sensitivity automatically, within bounds, to get the shot.

This feature shows how interested Nikon is in giving us very fine control of our cameras. You can use automatic methods or control everything manually. ISO display and adjustment basically gives you manual control over a feature that most people would manage with Auto ISO sensitivity control.

If you are an action shooter and find yourself in varying light levels where you want to maintain fast manual control over ISO sensitivity, you might want to use this feature.

d4 Screen Tips

(User's Manual – Page 229)

The d4 Screen tips setting allows you to enable small helpful tips on the second screen of the camera's Information display. You can access this display by

pressing the Info button twice. Pressing the Info button once brings up a summary display—you can't edit anything. Pressing it twice shows a similar screen that allows you to change several settings. It's a shortcut screen with settings that are accessed frequently, such as changing the Shooting menu bank or Custom setting bank.

Figure 4.28, screen 1, shows the screen that appears when you press the Info button once. Screen 2 appears when you press the Info button twice. The first screen is called the Information display, and I'll call the second screen the Information display edit screen to prevent confusion.

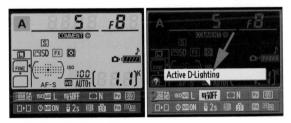

Figure 4.28 - Screen tips

Since I have Screen tips enabled on my camera, you can see the tip for changing Active D-Lighting (figure 4.28, screen 2, red arrow). If you press the OK button when you have one of the settings highlighted on the Information display edit screen (figure 4.28, screen 2), the camera will switch to a normal text menu and allow you to modify the setting.

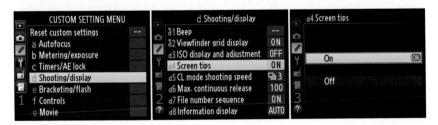

Figure 4.29 - Enabling screen tips

Use the following steps to configure d4 Screen tips:

- 1. Select d Shooting/display from the Custom Setting Menu and scroll to the right (figure 4.29, screen 1).
- 2. Highlight d4 Screen tips and scroll to the right (figure 4.29, screen 2).
- 3. Choose either On or Off from the menu. In figure 4.29, screen 3, I selected On.
- 4. Press the OK button to lock in the setting.

Settings Recommendation: This helpful setting gives you tool tips for using the Information display edit screen. I leave this set to the factory default of On. These little tips don't get in the way and may be helpful to remind you which setting you're looking at on the Information display edit screen.

d5 CL Mode Shooting Speed

(User's Manual - Page 229)

The d5 CL mode shooting speed setting controls how many frames per second (fps) the camera's shutter can fire (maximum) in Continuous low speed release mode (CL on the Release mode dial).

The CL mode is for those who would like to use a conservative fps rate. With the proper settings, the camera can record 5.5 fps in Continuous high speed release mode (CH on the Release mode dial). However, unless you are shooting race cars going 200 miles per hour and have large memory cards, you may not want a lot of pictures of the same subject a few milliseconds apart.

In that case, use the CL mode and select fewer fps than CH mode provides. You can choose from 1 to 5 fps, as shown in figure 4.30. The default is 3 fps.

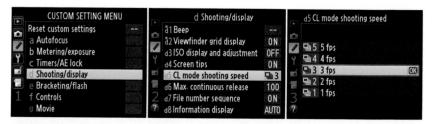

Figure 4.30 - Setting CL mode shooting speed

Use the following steps to configure d5 CL mode shooting speed:

- 1. Select d Shooting/display from the Custom Setting Menu and scroll to the right (figure 4.30, screen 1).
- 2. Highlight d5 CL mode shooting speed and scroll to the right (figure 4.30,
- 3. Choose one of the five options from the list (from 1 fps to 5 fps). In figure 4.30, screen 3, I selected 3 fps.
- 4. Press the OK button to lock in the setting.

Remember, you always have CH mode for when you want to blast off images like there's no end to your memory card or when you want to impress bystanders with that extra cool Nikon shutter clicking sound.

Settings Recommendation: I have always left my setting at the default of 3 fps since that is reasonably fast but does not waste card space. Play around with this setting and decide for yourself what speed you like. Again, remember that you have both low (CL) and high (CH) speeds for the camera's shooting rate. This function is for the low speed setting (CL) found on the Release mode dial.

d6 Max. Continuous Release

(User's Manual – Pages 230, 335)

The d6 Max. continuous release setting adjusts the maximum number of images you can shoot in a single burst. You can blast away until you have reached the number of exposures specified in figure 4.31, screen 3, which is up to 100 JPEG images.

Although you could reach 100 images in a single burst, it is improbable. Your camera is limited by the size of its buffer and the types of images you are shooting. Plus, during a burst the camera actively writes images from the buffer to one or both memory cards.

Page 335 in the User's Manual specifies the camera buffer size for each image type. Here's a summary of what it says:

- NEF (RAW) files The in-camera image buffer can hold from 16 to 27 RAW images, depending on the type of compression used and the image bit depth (Shooting Menu > NEF (RAW) recording).
- JPEG files The in-camera image buffer can hold from 57 to 100 JPEG images, depending on whether you are shooting L, M, or S image sizes; whether you are shooting fine, normal, or basic; and whether you have selected Optimal quality or Size priority compression (Shooting Menu > Image quality, Image size, and JPEG compression).

Unless you are shooting small JPEG basic files, the buffer will fill up before you reach the maximum of 100 shots specified in the Max. continuous release setting. If Shooting Menu > Long exposure NR is set to On, it further reduces the buffer capacity. Likewise, if the Shooting Menu > Auto distortion control is set to On, the memory buffer capacity could be cut in half.

However, the D600 has an ample memory buffer size for most of us, especially in JPEG mode. If you are shooting in RAW mode, it will not handle nearly the number of images as JPEG mode before running out of buffer space. Highspeed event shooting may require that you shoot in JPEG mode to keep from running out of buffer space. Using fast memory cards (for fast image writing) can help, too.

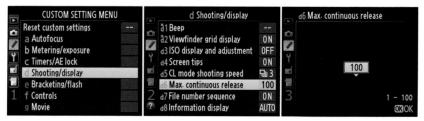

Figure 4.31 – How many images do you want to take in succession?

Use the following steps to configure d6 Max. continuous release:

- 1. Select d Shooting/display from the Custom Setting Menu and scroll to the right (figure 4.31, screen 1).
- 2. Highlight d6 Max. continuous release and scroll to the right (figure 4.31, screen 2).
- 3. Use the Multi selector to scroll up or down and set the number of images you want in each burst. In figure 4.31, screen 3, I selected 100 (default).
- 4. Press the OK button to lock in the setting.

Settings Recommendation: I want the buffer to hold as many images as it possibly can when I am blasting away in high-speed shooting modes, so I leave Max. continuous release set to 100.

However, you may want to limit the camera to a maximum burst of 10 or 20 images so the buffer will not fill up and slow the camera down. This also lets you maintain some control over your enthusiastic high-speed shooting. Do you really want dozens and dozens (and dozens) of pictures of those flying seagulls?

What Is the Memory Buffer?

Your D600 has internal memory chips, called the memory buffer, that will hold a limited number of images (up to 27 RAW, 57 Large JPEG fine, or 100 Large JPEG normal or basic; see User's Manual page 335). The memory buffer allows you to shoot several images in quick succession while the camera writes them, one at a time, to the memory card(s). The buffer holds the last few pictures you took in temporary memory until the camera can store them on the more permanent memory of a memory card. Without an internal memory buffer, it would be nearly impossible for the camera to shoot several images quickly.

d7 File Number Sequence

(User's Manual – Page 230)

The d7 File number sequence setting allows your camera to count the file numbers for each picture you take in a running sequence from 0001 to 9999. After

9999 pictures, it rolls back over to 0001, or you can cause it to reset the image number to 0001 when you format a memory card or insert a new one.

Here are the settings and an explanation of how they work:

- On The File number sequence continues even if a new folder is created, a new memory card is inserted, or the current memory card is formatted. If the file number exceeds 9999 during a shoot, the camera will create a new folder on the same memory card and start writing the new images, starting at 0001, into the new folder. Similarly, if you accumulate 999 images in the current folder, the next image captured will result in the camera creating a new folder, but the file numbering will not be reset to 0001 unless that 999th image has a file number of 9999. In other words, no matter what you do with your memory cards, or how many folders you or the camera create, the File number sequence will continue incrementing until 9999 images have been taken. Only then will the File number sequence reset to 0001.
- Off Whenever you format a memory card or insert a new one, or when you create a new folder, the number sequence starts over at 0001. If you exceed 999 images in a single folder, the camera creates a new folder and starts counting at 0001 again.
- Reset This is similar to the On setting. However, it is not a true running total to 9999 because the image number is dependent on the folder in use. The camera simply takes the last number it finds in the current folder and adds 1 to it, up to 999. If you switch to an empty folder or create a new one, the numbering starts over at 0001. Since a folder cannot hold more than 999 pictures, you will not exceed 999 as a running sequence in any one folder. Each folder has its own number series and causes the File number sequence to Reset.

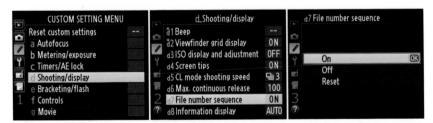

Figure 4.32 – Enabling File number sequence

Use the following steps to configure the d7 File number sequence:

- 1. Select d Shooting/display from the Custom Setting Menu and scroll to the right (figure 4.32, screen 1).
- 2. Highlight d7 File number sequence and scroll to the right (figure 4.32, screen 2).

- 3. Choose one of the three options from the list. In figure 4.32, screen 3, I selected On.
- 4. Press the OK button to lock in the setting.

Settings Recommendation: I heartily recommend that you set File number sequence to On. After much experience with Nikon DSLR cameras and many years of storing thousands of files, I've found that the fewer number of files with similar image numbers, the better. Why take a chance on accidentally overwriting the last shooting session when you transfer files to your computer just because they have the same image numbers?

Plus, I like to know how many pictures I've taken with each camera. Since I use the Shooting Menu > File naming function to add three letters to reflect the number of times my camera has rolled over 9,999 images (e.g., _1DY9999.NEF, _2DY9999.NEF, or _3DY9999.NEF), I am better able to determine how many images I've taken with the camera. I just have to be careful to change 1DY to 2DY when the File number sequence rolls over from 9999 to 0001.

d8 Information Display

(User's Manual - Page 231)

The d8 Information display setting allows your camera to automatically sense how much ambient light is in the area where you are shooting. If the ambient light is bright, the color of the Information display screen will also be bright so it can overcome the ambient light.

To open the Information display screen, press the Info button. The Information display screen shows the current shooting information. Its color and brightness will adjust according to the ambient light the camera senses through the lens.

Figure 4.33 shows the difference between the light and dark screens, which you can select by using one of the two Manual settings or allowing Auto to select a screen automatically. Figure 4.33, screen 1, is the dark on light screen, and figure 4.33, screen 2, is the light on dark screen.

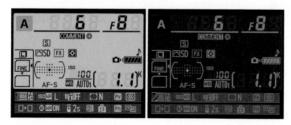

Figure 4.33 – B Dark on light (screen 1) and W Light on dark (screen 2) display screens

Try this: With your lens cap off, your camera turned on, and nothing displayed on the Monitor, press the Info button. If the ambient light is dim to bright, you'll see a light blue information screen with black characters. Now go into a dark area or put your lens cap on and cover the eyepiece with your hand. You'll see that with very little ambient light, the camera changes the Information display screen to light gray characters on a dark blue background. This assures that you won't be blinded when you need to see the shooting information when you're in a dark area. This may not impress you much, but I'm easily entertained!

As shown in figure 4.34, screen 3, there are two available selections for the Information display setting:

- Auto Through the uncapped lens or uncovered Viewfinder eyepiece, the D600 decides how much ambient light there is and changes the color and contrast of the Information display screen accordingly.
- Manual You can select the light or dark version of the Information display screen manually. If you choose Manual, you have two options: B Dark on light (light blue screen) or W Light on dark (dark blue screen) (figure 4.35, screen 4).

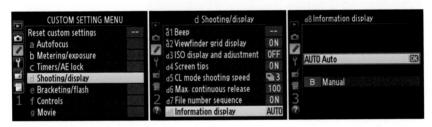

Figure 4.34 – Auto Information display

Use the following steps to configure the d8 Information display setting to Auto:

- 1. Select d Shooting/display from the Custom Setting Menu and scroll to the right (figure 4.34, screen 1).
- 2. Highlight d8 Information display and scroll to the right (figure 4.34, screen 2).
- 3. In figure 4.34, screen 3, I selected Auto. The camera will choose the light blue or dark blue screen depending on the ambient light level.
- 4. Press the OK button to lock in the setting.

If you want to manually select the screen color for the Information display screen, use the following steps:

- 1. Select d Shooting/display from the Custom Setting Menu and scroll to the right (figure 4.35, screen 1).
- 2. Highlight d8 Information display and scroll to the right (figure 4.35, screen 2).
- 3. Choose B Manual and scroll to the right (figure 4.35, screen 3).

- 4. The next screen shows the B Dark on light and W Light on dark choices. In figure 4.35, screen 4, I chose B Dark on light so the light blue screen will display when I press the Info button.
- 5. Press the OK button to lock in the setting.

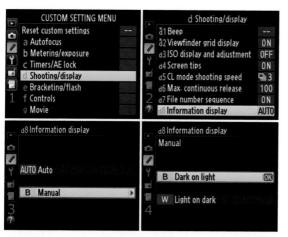

Figure 4.35 - Manual Information display

If you want to impress your friends and make your enemies jealous, show them how cool your camera is when it's smart enough to adjust the screen color to the current light conditions. I warned you that I'm easily entertained, didn't I?

Settings Recommendation: I leave my camera set to Auto because it seems to work very well at automatically selecting the proper screen for the current light conditions. If you prefer one screen over another, you can select it and it will stay that way all the time.

d9 LCD Illumination

(User's Manual - Page 231)

The d9 LCD illumination setting gives you a simple way to set how the illumination of the Control panel backlight works. When it's on, the Control panel lights up in yellowish green. Here are the two choices and how they work:

- · Off (default) If you leave LCD illumination set to Off, the backlight of the Control panel will not turn on unless you use the LCD illuminator on the ring surrounding the Shutter-release button. If you move the Power switch all the way to the right, the Control panel will light up.
- On This setting makes the Control panel illumination come on anytime the exposure meter is active. If you shoot in the dark a lot and need to refer to the Control panel often, switch this setting to On.

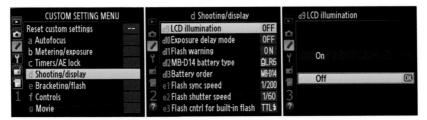

Figure 4.36 - LCD illumination

Use the following steps to configure the d9 LCD illumination setting:

- 1. Select d Shooting/display from the Custom Setting Menu and scroll to the right (figure 4.36, screen 1).
- 2. Highlight d9 LCD illumination and scroll to the right (figure 4.36, screen 2).
- 3. Choose either On or Off from the menu. In figure 4.36, screen 3, I selected Off.
- 4. Press the OK button to lock in the setting.

Settings Recommendation: This setting will affect the battery life since backlights pull a lot of power; therefore, I don't suggest using the On setting unless you really need it. You have the LCD illuminator on the ring around the Shutterrelease button to manually turn on the Control panel light when needed.

d10 Exposure Delay Mode

(User's Manual - Page 231)

The d10 Exposure delay mode setting introduces a delay of one to three seconds after the Shutter-release button is pressed—and the reflex mirror is raised before the shutter is actually released. The intention is that during the delay the camera vibrations will die down and the image will be sharper.

There are two settings in Exposure delay mode:

- On The camera first raises the reflex mirror and then waits from one to three seconds, according to your configuration choice, before firing the shutter. This allows the vibrations from the mirror movement to dissipate before the shutter fires. Of course, this won't be useful at all for shooting anything that moves. But for slow shooting of static scenes, this is great and keeps you from having to use Mirror-up (MUP), which requires two Shutter-release button presses to take a picture. Exposure delay mode has the same effect as MUP but requires only one Shutter-release button press after a delay is selected.
- Off The shutter has no delay when this setting is turned off.

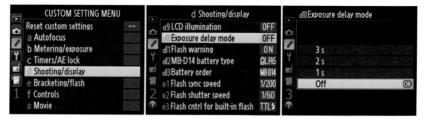

Figure 4.37 - Exposure delay mode

Use the following steps to configure d10 Exposure delay mode:

- 1. Select d Shooting/display from the Custom Setting Menu and scroll to the right (figure 4.37, screen 1).
- 2. Highlight d10 Exposure delay mode and scroll to the right (figure 4.37, screen 2).
- 3. Choose 1 s, 2 s, 3 s, or Off from the menu. In figure 4.37, screen 3, I selected Off.
- 4. Press the OK button to lock in the setting.

Settings Recommendation: Exposure delay mode is very important to me. As a nature shooter, I use it frequently for single shots. When I'm shooting handheld—or on a tripod—and want a really sharp image, I often use this mode to prevent the camera's internal reflex mirror movement from vibrating my camera and blurring my pictures. If you handhold your camera, shoot mostly static subjects, and want sharper pictures, this setting will help. On a tripod, this is a time saver compared to Mirror-up (MUP) mode, which requires two Shutter-release button presses or a 30-second time-out delay.

d11 Flash Warning

(User's Manual - Page 231)

The d11 Flash warning setting enables a blinking lightning bolt warning in the Viewfinder when the camera detects that the ambient light is too low to take a sharp picture. You should raise the camera's pop-up flash when you see the Flash warning. You won't see the warning when you use one of the camera's automatic modes because the camera will pop up the flash as needed. However, in release modes like P, S, A, or M you will see this warning often.

Figure 4.38 - Flash warning

Figure 4.38 (red arrow) shows the location of the small lightning bolt symbol in the lower right of the Viewfinder. It may be hard to see in the figure, so go into a low-light area, set your camera to P, S, A, or M mode, and press the

Shutter-release button halfway while holding the camera to your eye. If the flash is not raised, the lightning bolt symbol will flash, symbolically asking you to use the built-in Speedlight.

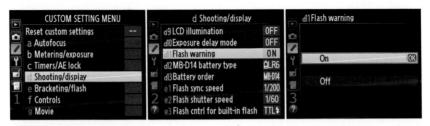

Figure 4.39 - Flash warning settings

Use the following steps to configure the d11 Flash warning setting:

- 1. Select d Shooting/display from the Custom Setting Menu and scroll to the right (figure 4.39, screen 1).
- 2. Highlight d11 Flash warning and scroll to the right (figure 4.39, screen 2).
- 3. Choose either On or Off from the menu. In figure 4.39, screen 3, I selected On (default).
- 4. Press the OK button to lock in the setting.

Settings Recommendation: Flash warning defaults to On, which I use all the time. That way, if it's too dark to make a normal exposure the camera warns me that I need to use flash. Especially for a new photographer, this function is helpful. There's no point in turning it off, unless you don't like it to flash just before you take a blurry picture.

d12 MB-D14 Battery Type

(User's Manual - Page 232)

The d12 MB-D14 battery type setting applies only when you use AA batteries in your optional MB-D14 battery pack. It does not apply when you are using Nikon EN-EL15 lithium ion battery packs because they communicate with the camera.

If you have an MB-D14 battery pack and plan to use AA batteries, you'll need to tell the camera what type of AA batteries you are using for this session. It certainly is not a good idea to mix AA battery types.

The MB-D14 can hold one EN-EL15 battery or six AA batteries. Nikon suggests that AA batteries be used only in emergencies and only in warm temperatures. The performance characteristics of AA batteries are significantly lower than the Nikon EN-EL15 lithium ion battery pack.

- · LR6 (AA alkaline)
- HR6 (AA Ni-MH) (nickel metal hydride)
- · FR6 (AA lithium)

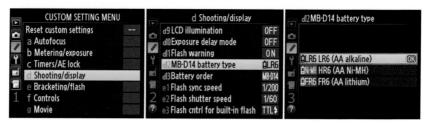

Figure 4.40 - MB-D14 battery type choices

Use the following steps to configure the d12 MB-D14 battery type setting:

- 1. Select d Shooting/display from the Custom Setting Menu and scroll to the right (figure 4.40, screen 1).
- 2. Highlight d12 MB-D14 battery type and scroll to the right (figure 4.40, screen 2).
- 3. Choose one of the three options from the list. In figure 4.40, screen 3, I selected LR6 (AA alkaline).
- 4. Press the OK button to lock in the setting.

Note: If you see that the battery symbol on the Control panel, Viewfinder, or Information display is on its last notch (figure 4.41), start thinking about replacing the old battery. If the battery symbol is blinking, replace the battery immediately because the Shutter-release button is disabled when the battery symbol is flashing.

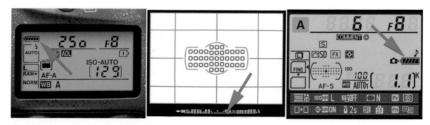

Figure 4.41 – Battery symbol locations

Settings Recommendation: Nikon does not recommend using certain AA batteries, such as LR6 (AA alkaline) and HR6 (AA Ni-MH), except in emergencies. Its primary objection to these two types of batteries is that they do not work well at

lower temperatures. In fact, at temperatures below 68 degrees F (20 degrees C), an alkaline battery starts losing its ability to deliver power and will die rather quickly. You may not get as many shots out of a set of AA batteries, so your cost of shooting may rise.

However, AA batteries are readily available and relatively low cost, so some people like to use them, especially in an emergency. If you do choose to use AA batteries, stick with FR6 (AA lithium) since that is the same type of cell used in Nikon EN-EL batteries, and they are not affected as much by low temperatures. You can also use HR6 (AA Ni-MH) batteries safely since they are not as temperature sensitive, and they provide consistent power.

d13 Battery Order

(User's Manual - Page 233)

When you are using an MB-D14 battery pack on your D600, the d13 Battery order setting lets you choose the order in which you want to use the available batteries. You can use the EN-EL 15 battery first or those in the MB-D14 battery pack first:

- Use MB-D14 batteries first (default) When the camera is turned on it starts drawing its power from the MB-D14 battery pack first. After the battery pack is exhausted, the camera automatically switches to the EN-EL15 battery inside the camera.
- Use camera battery first When you turn on the camera it uses the internal EN-EL15 battery to exhaustion before using the battery or batteries in the MB-D14 battery pack. If you select this option and remove the MB-D14 while the EN-EL15 battery in the camera is dead, you'll have to remove and recharge the camera's internal EN-EL15 battery before use.

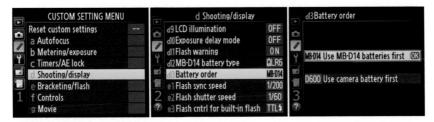

Figure 4.42 - Battery order choices

Use the following steps to configure the d13 Battery order setting:

- 1. Select d Shooting/display from the Custom Setting Menu and scroll to the right (figure 4.42, screen 1).
- 2. Highlight d13 Battery order and scroll to the right (figure 4.42, screen 2).

- Choose one of the two options from the list. In figure 4.42, screen 3, I selected Use MB-D14 batteries first.
- 4. Press the OK button to lock in the setting.

Note: If you have the camera connected to an external power source, such as the Nikon EH-5b AC adapter (requires EP-5B power connector), the camera will use the external power source no matter what you have selected in Battery order.

Settings Recommendation: Which battery do you want to draw from first? I like to use the MB-D14 batteries first and have my camera's internal EN-EL15 battery available as a backup. That way, if I remove the MB-D14, my camera won't suddenly go dead due to a depleted battery. Nikon thinks the same way, evidently, since the camera defaults to Use MB-D14 batteries first.

e Bracketing/Flash

Custom Settings e1-e7

Within the e Bracketing/flash menu, you'll find seven settings:

- · e1 Flash sync speed
- e2 Flash shutter speed
- · e3 Flash cntrl for built-in flash
- · e4 Exposure comp. for flash
- e5 Modeling flash
- e6 Auto bracketing set
- e7 Bracketing order

e1 Flash Sync Speed

(User's Manual - Page 234)

The e1 Flash sync speed setting lets you select a basic synchronization speed from 1/60 s to 1/200 s. The D600 has a more flexible Flash sync speed than many cameras.

Or, if you prefer, you can use the two Auto FP high-speed sync modes on your camera: 1/200 s (Auto FP) or 1/250 s (Auto FP). These Auto FP high-speed sync modes are available only with certain external Speedlights, not with the built-in pop-up Speedlight.

At the time of writing this book, the six Nikon Speedlights that can be used with the D600 in Auto FP high-speed sync modes are as follows:

- SB-910
- SB-800

SB-600

- SB-900
- SB-700

SB-R200

- 1/250 s (Auto FP)
- 1/200 s (Auto FP)
- 1/200 s
- 1/160 s
- 1/125 s
- 1/100 s
- 1/80 s
- 1/60 s

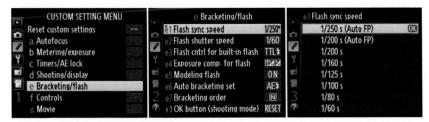

Figure 4.43 – Flash sync speed choices

Use the following steps to adjust the e1 Flash sync speed setting:

- 1. Select e Bracketing/flash from the Custom Setting Menu and scroll to the right (figure 4.43, screen 1).
- 2. Highlight e1 Flash sync speed and scroll to the right (figure 4.43, screen 2).
- 3. Choose one of the eight options from the list, from 1/60 s to 1/250 s (Auto FP). In figure 4.43, screen 3, I selected 1/250 s (Auto FP).
- 4. Press the OK button to lock in the setting.

When you're using Auto FP high-speed sync mode, the output of your flash is reduced, but it doesn't cut off the frame for exposures that use a shutter speed faster than the normal flash sync speed (X-sync). Why? Let's review.

Auto FP High-Speed Sync Review

In a normal flash situation, with shutter speeds of 1/200 second and slower, the entire shutter is fully open and the flash can fire a single burst of light to expose the subject. It works like this: There are two shutter curtains in your camera. The

first shutter curtain opens to expose the sensor to your subject, the flash fires to provide light for the correct exposure, then the second shutter curtain closes. For a very brief period of time, the entire sensor is uncovered. The flash fires during the time when the sensor is fully uncovered.

However, when your camera's shutter speed is faster than 1/200 second, the shutter curtains are never fully open for the flash to expose the entire subject in one burst of light. This is because at fast shutter speeds the first shutter curtain starts opening and the second shutter curtain quickly follows. In effect, a slit of light scans across the surface of your sensor, exposing the subject. If the flash fired normally, the width of that slit between the shutter curtains would get a flash of light, but the rest of the sensor would be blocked by the curtains. A band of the image would be correctly exposed, and everything else would be underexposed.

What happens to your external Nikon Speedlight to allow it to follow that slit of light moving across the sensor? It changes into a pulsing strobe unit instead of a normal flash unit. Have you ever danced under a strobe light? A strobe works by firing a series of light pulses. Similarly, when your camera's shutter speed is so fast that the Speedlight cannot fire a single burst of light for a correct exposure, it uses Auto FP high-speed sync mode and fires a series of light bursts as the slit between the shutter curtains travels in front of the image sensor. The Speedlight can fire hundreds of bursts per second. It looks like one flash of light, even though it is hundreds of bursts of light, one right after the other.

When the camera is in Auto FP high-speed sync mode, you'll see something like this on your Speedlight's LCD monitor: TTL FP or TTL BL FP. The FP designation tells you that the camera and the Speedlight are ready for you to use any shutter speed you'd like and still get a good exposure, even with wide-open apertures!

You can safely leave your camera set to 1/250 s (Auto FP) or 1/200 s (Auto FP) all the time since the Auto FP high-speed sync mode does not kick in until you raise the shutter speed above the maximum setting of 1/200 s. With slower shutter speeds, the flash works in normal mode and does not waste any power by pulsing the output. This pulsing of light reduces the maximum output of your flash significantly but allows you to use any shutter speed while your external Speedlight still fires. The higher the shutter speed, the lower the flash output. In effect, your camera is depending on you to have enough ambient light to offset the loss in power. I've found that even my powerful SB-900 Speedlight can provide only enough power to light a subject to about 8 ft (2.4 m) when I use a 1/4000 second shutter speed. With shutter speeds that fast, there needs to be enough ambient light to help the flash light the subject, unless you are very close to the subject.

However, now you can use wide apertures to isolate your subject in direct sunlight—which requires fast shutter speeds. The flash will adjust and provide great fill light if you use Auto FP high-speed sync mode.

Note: If your flash fires at full power in normal modes, the flash indicator will blink in the Viewfinder to let you know that all available flash power has been expended, and you need to check to see if the image is underexposed. When the camera is firing in Auto FP high-speed sync mode, you won't get a warning in the Viewfinder if the image does not have enough light. Check the histogram often when you use Auto FP high-speed sync mode.

Special Shutter Speed Setting X + Flash Sync Speed

When you use the Manual (M) or Shutter-priority auto (S) exposure modes, you can turn the shutter speed all the way down to 30 seconds, then to bulb. There is one more setting below bulb, named X + Flash sync speed. This setting allows you to set the camera to a known shutter speed and shoot away. You will see X 200 if Custom setting e1 Flash sync speed is set to 1/200 s. Whatever Flash sync speed you select will show up after the X. If you select a Flash sync speed of 1/125 s, then X 125 will show up as the next setting below bulb; a Flash sync speed of 1/60 s means that X 60 will show up below bulb, and so forth.

The shutter speed will not vary from your chosen setting. The camera will adjust the aperture and flash in Shutter-priority auto (S) mode, or you can adjust the aperture while the flash controls exposure in Manual (M) mode.

This X-Sync mode is not available in Aperture-priority auto (A) or Programmed auto (P) modes since the camera controls the shutter speed in those two settings. You'll use X + Flash sync speed primarily when you are shooting in Manual (M) or Shutter-priority auto (S) mode and want to use a known X-Sync speed.

Settings Recommendation: I leave my camera set to 1/250 s (Auto FP) all the time. The camera works just like it normally would until one of my settings increases the shutter speed to faster than 1/250 second, at which time it starts pulsing the light to match the travel of the shutter curtains. Once again, you won't be able to detect this high-frequency strobe effect since it happens so fast it seems like a single burst of light.

Remember that the flash loses significant power (or reach) at faster shutter speeds because it is forced to work so hard. Be sure you experiment with this setting to get the best results. You can use a big aperture, like f/1.8, to create a very shallow depth of field in direct sunlight since you can use very fast shutter speeds. This will allow you to make images that many other cameras simply cannot create. Learn to balance the flash and ambient light in Auto FP high-speed sync mode. All this technical talk will make sense when you see the results. It's pretty cool stuff!

(User's Manual - Page 235)

The *e2 Flash shutter speed* setting controls the minimum shutter speed your camera can use in various flash modes. You can select shutter speeds between 30 s and 1/60 s.

Let's consider each of the modes and their minimum shutter speeds:

- Front-curtain sync, Rear-curtain sync, or Red-eye reduction In Programmed auto (P) mode or Aperture-priority auto (A) mode, you can select the slowest shutter speed from 1/60 s to 30 s. Shutter-priority auto (S) mode and Manual (M) mode cause the camera to ignore Flash shutter speed, and the slowest shutter speed is 30 s.
- Slow sync, Red-eye reduction with slow sync, or Slow rear-curtain sync These three modes ignore Flash shutter speed, and the slowest shutter speed is 30 s.

The User's Manual is a bit confusing on this subject, but the mode and minimum shutter speed information in the previous list is evident after study and testing. Therefore, Custom setting e2 Flash shutter speed is only partially used by the flash modes, because the default is preset to 30 seconds in Shutter-priority auto (S) and Manual (M) modes.

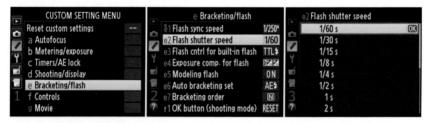

Figure 4.44 - Flash shutter speed choices

Use the following steps to set the e2 Flash shutter speed minimum:

- 1. Select e Bracketing/flash from the Custom Setting Menu and scroll to the right (figure 4.44, screen 1).
- 2. Highlight e2 Flash shutter speed and scroll to the right (figure 4.44, screen 2).
- 3. Choose one of the options from the list: 1/60 s to 30 s (scroll down to see all the available shutter speeds). In figure 4.44, screen 3, I selected 1/60 s (default).
- 4. Press the OK button to lock in the setting.

Settings Recommendation: I normally use 1/60 s. Shutter speeds slower than 1/60s can cause ghosting if the ambient light is too bright. The subject can move after the flash fires, but the open shutter and ambient light can record a blurred ghost effect. You'll have a well-exposed picture of the subject plus a ghost of the subject in the image. Use slower shutter speeds only when you are sure that you'll be in dark conditions and the flash will provide the only lighting, unless you're shooting special effects, like a blurred aftereffect following your subject to imply movement.

e3 Flash Cntrl for Built-in Flash

(User's Manual - Page 236)

The e3 Flash cntrl for built-in flash setting provides four distinct ways to control the output of the pop-up Speedlight flash. This Custom setting does not apply to flash units you attach via the Accessory shoe (hot-shoe) on top of the camera. It is only for the built-in flash. The four modes are as follows:

- TTL-TTL
- M Manual
- RPT Repeating flash
- CMD Commander mode

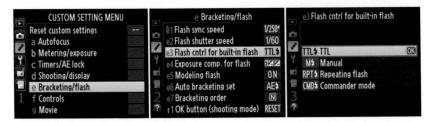

Figure 4.45 – Flash cntrl for built-in flash (TTL – TTL)

Use the following steps to choose one of the e3 Flash cntrl for built-in flash settings:

- 1. Select e Bracketing/flash from the Custom Setting Menu and scroll to the right (figure 4.45, screen 1).
- 2. Highlight e3 Flash cntrl for built-in flash and scroll to the right (figure 4.45, screen 2).
- 3. Choose one of the four options from the list. In figure 4.45, screen 3, I selected TTL - TTL. The other choices will be detailed in figures 4.46 to 4.48, which begin where figure 4.45 leaves off.
- 4. Press the OK button to lock in the setting.

Let's consider each of the four Flash cntrl for built-in flash modes.

TTL - TTL

Also known as i-TTL, this mode is the standard way to use the camera for flash pictures. TTL stands for through the lens, and it creates a very accurate and balanced flash output using a preflash method to determine the correct exposure before the main flash burst fires.

TTL (i-TTL) is compatible with the Nikon SB-910, SB-900, SB-800, SB-700, SB-600, SB-400, and SB-R200 Speedlights.

TTL – TTL is a completely automatic mode and will adjust to various distances, along with the different shutter speeds and apertures your camera can use. The TTL – TTL setting was illustrated in figure 4.45.

M - Manual

The M – Manual mode, shown in figure 4.46, allows you to manually control the output of your flash. The settings range from Full power to 1/128th power. If you've been shooting in a studio for a long time, this setting will be quite familiar to you.

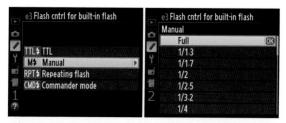

Figure 4.46 – Flash cntrl for built-in flash (M – Manual)

RPT - Repeating Flash

The RPT – Repeating flash setting turns your flash into a strobe unit so you can see the pulse (unlike Auto FP high-speed sync mode), which allows you to get creative with stroboscopic multiple flashes. As you can see in figure 4.47, screen 2, you use the Multi selector to scroll up and down to set the values, and you scroll left and right to move between Output, Times, and Frequency. Press the OK button when you have the settings configured.

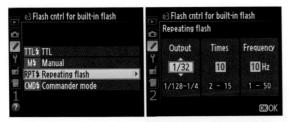

Figure 4.47 – Flash cntrl for built-in flash (RPT – Repeating flash)

Descriptions of the settings are as follows:

• Output – You can vary the power of the flash from 1/4 to 1/128 of full power. The more power the flash uses, the fewer times it can fire. The following table indicates how many times the built-in pop-up flash can fire using the various Output levels.

1/4	2 times
1/8	2–5 times
1/16	2–10 times
1/32	2–10 or 15 times
1/64	2–10, 15, 20, or 25 times
1/128	2-10, 15, 20, 25, 30, or 35 times

Table 4.1 - Times settings

- Times This setting controls the number of times the strobe will flash per second. The range is from 2 to 10 flashes in one-step increments and from 15 to 35 flashes (at 1/128 of full power) in five-step increments (the number of times shown in Output). Refer to table 4.1 to see the number of times the flash can fire. Raising the power output (going toward 1/4 of full power) will decrease the number of times the flash can fire, and lowering the power (going toward 1/128 of full power) will increase the number of times the flash can fire. As you change the Output, you'll see the maximum Times change.
- Frequency This sets how often the flash fires per second. You could also call this the Hz, or hertz, setting. The frequency range is from 1 to 50 Hz.

RPT – Repeating flash is compatible with the Nikon SB-910, SB-900, and SB-800 Speedlights only.

CMD - Commander Mode

The CMD – Commander mode allows your camera to become a commander, or controller, of an unlimited number of external Speedlight flash units that are compatible with the Nikon Creative Lighting System (CLS). It can control up to

two groups, or banks, with four available communication Channels (1–4). In figure 4.48, screen 2, you can see the Built-in flash, Group A, Group B, and Channel settings. The two columns have headers called Mode and Comp. (compensation). Use the Multi selector to move around and modify the settings.

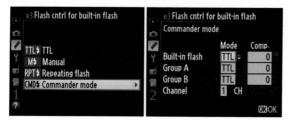

Figure 4.48 - Flash cntrl for built-in flash (CMD - Commander mode)

Descriptions of the four settings are as follows:

- Built-in flash This option lets you set the built-in pop-up flash to one of three settings. These settings do not affect any of the flash units in Group A or Group B because they are external flash units being controlled wirelessly by the Commander mode:
 - a) **TTL** Otherwise known as i-TTL mode, this is a completely automatic mode that monitors preflashes to determine the duration of the built-in flash for correct exposure. You can set Comp. to between +3.0 EV and -3.0 EV in 1/3 EV steps.
 - b) **M** This mode allows you to choose a manual flash level between 1/1 (full power) to 1/128 (1/128 of full power).
 - c) -- I call this the double-dash mode. It disables the built-in flash so it won't add light to the image. The primary light burst from the built-in flash will not fire. However, the built-in flash must fire preflashes to determine the correct exposure and to communicate with any external flash units in Group A or Group B, which are being commanded.
- Group A and Group B These are groups of an unlimited number of remote slaved Speedlights that your camera can control and fire using the Nikon CLS.
 Each group has four modes that can be applied to each flash unit in the group.
 The modes are as follows:
 - a) *TTL* This mode works like Built-in flash except it causes all flash units being controlled in each Group to use TTL (i-TTL). You can also set Comp. between +3.0 EV and -3.0 EV in 1/3 EV steps. Comp. will affect all flash units in that group. TTL is compatible with all current Nikon Speedlights.
 - b) **AA** This stands for auto aperture, and it is available only when your D600 is controlling an SB-910, SB-900, or SB-800 Speedlight flash unit in slave

mode on a bank. This is an older technology that does not use the newer i-TTL exposure technology. It is included for people who are used to the older style of exposure. You can safely ignore this mode and use TTL instead, and you'll get better exposures. If you really want to use AA mode, that's fine. It works like TTL mode with less accurate exposures. You can set Comp. to between +3.0 EV and -3.0 EV in 1/3 EV steps. Comp. will affect all flash units in that group. AA mode is compatible with the Nikon SB-910, SB-900, and SB-800 Speedlights only.

- c) **M** This mode allows you to choose a manual flash level between 1/1 (full power) and 1/128 (1/128 of full power) for each of the flash units being controlled in a group. If you like to shoot manually for ultimate control, the camera gives you a way to control multiple groups of flash units manually. M mode is compatible with all current Nikon Speedlights.
- d) -- The flash units in the group do not fire. Double-dash mode disables an entire group so you can concentrate on configuring the other group. Then you can turn the disabled group back on and configure it, too. Or you can use just one group of slaved Speedlights (Group A or Group B) and disable the other.
- Channel This is a communications channel on which your camera communicates with all grouped remote flashes. You choose one Channel to control all of your slaved flash units. You must match the Channel number for the camera to each flash unit. You have a choice of four Channel numbers: 1-4. This allows you to use your flash units near another photographer who is also controlling groups without accidentally firing the flash units on the other camera. Each photographer chooses a different channel to avoid communication conflicts.

An upcoming chapter, Speedlight Flash, is devoted to Nikon flash usage. It covers each of the flash and Commander modes in more detail.

Commander Mode Notes

When your camera controls multiple flash units in Commander mode, it is important that you understand a few points.

First, the camera communicates with the remote slaved flash groups (Group A and Group B) during the monitor preflash cycle, so the pop-up flash must be raised so it can communicate with the remote flash units.

Second, each remote flash unit has a small round photocell sensor on its side that picks up the monitor preflashes from your camera's pop-up flash. Make sure those sensors are not blocked or exposed to direct, very bright light while in use or they may not be able to see the monitor preflashes.

Third, if you want to prevent the monitor preflashes from appearing in your photographs or don't want people to squint when they fire, you can purchase

the optional SG-3IR infrared panel for the pop-up flash, which you mount on the Accessory shoe (figure 4.49, red arrow). This infrared panel makes the monitor preflashes mostly invisible to humans and imaging sensors, yet the remote flash units can still see them and react properly.

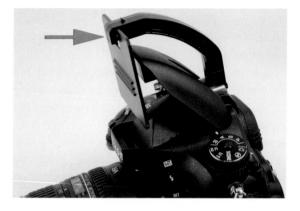

Figure 4.49 – Nikon SG-3IR infrared panel for built-in flash

Fourth, don't position any of the remote flash units more than 33 ft (10.05 m) from the camera. That's the maximum distance for which you can use the D600's pop-up flash in Commander mode.

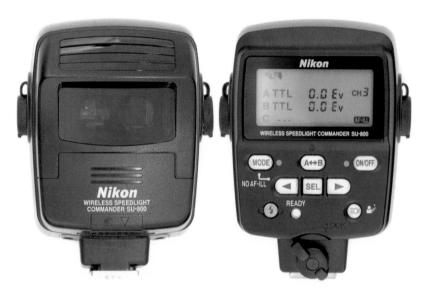

Figure 4.50 - Nikon SU-800 Wireless Speedlight Commander

If 33 ft is not enough reach, invest in the Nikon SU-800 Wireless Speedlight Commander (figure 4.50) that replaces the pop-up flash and Commander mode

combo. Mount the SU-800 onto the Accessory shoe and let it control the remote slaves up to 66 ft (20.10 m) away.

Settings Recommendation: Learn to use the Commander mode on your D600. It opens up the Nikon CLS to you. You can then use your D600 to control multiple Nikon Speedlight flash units and really get creative with your lighting arrangements for portrait work and product shots. When I'm not using Commander mode, I leave Flash cntrl for built-in flash set to TTL for fully automatic flash pictures.

e4 Exposure Comp. for Flash

(User's Manual - Page 240)

The e4 Exposure comp. for flash function originally appeared in the Nikon D4 professional camera. Interestingly, the more expensive, prolevel Nikon D800 does not have this function. Basically, it allows you to treat the subject and background differently when you use flash. You can separate the normal exposure compensation function (for the background) and the flash compensation function (for the subject). Exposure compensation can be applied to the background only, or to the background and subject (the entire frame) with flash. There are two available settings:

- Entire frame Both the flash and the exposure compensation work normally.
- Background only The nonflash exposure compensation (that you adjust with the Exposure compensation button) and the flash compensation (that you apply with the Flash compensation button) are separate. Flash compensation applies to the subject only, and nonflash exposure compensation applies to the background only.

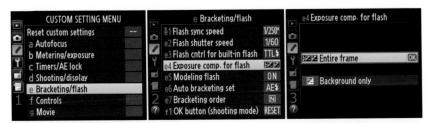

Figure 4.51 - Exposure comp. for flash

Use the following steps to choose a flash and exposure compensation combination:

- 1. Select e Bracketing/flash from the Custom Setting Menu and scroll to the right (figure 4.51, screen 1).
- 2. Highlight e4 Exposure comp. for flash and scroll to the right (figure 4.51, screen 2).

- Choose either Entire frame or Background only. If you choose Background only, the nonflash and flash compensation functions are applied separately (figure 4.51, screen 3).
- 4. Press the OK button to lock in your choice.

Settings Recommendation: I leave my D600 set to Entire frame for most shooting. If I need to change the light level relationship between the subject and the background, I set the camera to Background only and experiment until I find the best compensation for balance or to emphasize one or the other. Why not spend some time experimenting and learning how to use this new technology?

e5 Modeling Flash

(User's Manual - Page 241)

The *e5 Modeling flash* setting lets you fire a pulse of flashes to help you see how the light wraps around your subject. It works like modeling lights on studio flash units, except it pulses rapidly instead of shines. You can press the Depth-of-field preview button to see the effect if you set Modeling flash to On.

This function works with Nikon's main Speedlight flash unit group: SB-910, SB-900, SB-800, SB-700, SB-600, and SB-R200. It also works with the pop-up flash for limited periods. My SB-400 flash unit does not work with Modeling flash.

Here's what each of the settings for Modeling flash accomplishes:

- On This setting allows you to see (somewhat) how your flash will light the subject. If you have this setting turned On, you can press the Depth-of-field preview button to fire the pop-up flash, or any attached and controlled external Speedlight unit, in a series of rapid pulses. These pulses are continuous and simulate the lighting that the primary flash burst will emit. The Modeling flash can be used only for a few seconds at a time to prevent the flash unit from overheating, so look quickly.
- Off No Modeling flash will fire when you press the Depth-of-field preview button.

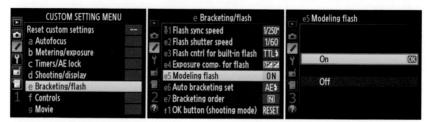

Figure 4.52 - Modeling flash settings

Use the following steps to configure the e5 Modeling flash settings:

- 1. Select e Bracketing/flash from the Custom Setting Menu and scroll to the right (figure 4.52, screen 1).
- 2. Highlight e5 Modeling flash and scroll to the right (figure 4.52, screen 2).
- 3. Choose either On or Off from the menu. In figure 4.52, screen 3, I selected On.
- 4. Press the OK button to lock in the setting.

Settings Recommendation: I often forget that I have this setting turned on and want to check the depth of field on a product shot. When I press the Depth-offield preview button, I get the modeling light instead of the depth of field. I don't find this feature to be particularly useful, and it often startles me. One of these days I'll get around to turning it off. You might like it if you do a lot of studio-style flash photography. Give it a try, but be prepared—the pulsing and the sound of the flash can be somewhat startling if you don't expect it.

e6 Auto Bracketing Set

(User's Manual – Pages 241, 153)

The e6 Auto bracketing set function lets you choose how bracketing works. You can set up bracketing for the exposure system (AE), flash, White balance, and Active D-Lighting.

The basic idea behind bracketing is to take the same picture multiple times with different exposures, White balances, or Active D-Lighting levels.

It's a way to play it safe so you get at least one excellent picture out of the series or so you can combine multiple images into one image with a higher dynamic range (HDR) or more accurate color.

Let's start by reviewing the five types of bracketing:

- AE & flash When you set up a session for bracketing, the camera will cause any type of normal picture you take to be bracketed, whether it is a standard exposure or is taken with flash.
- AE only Your bracketing settings will affect only the exposure system, not the flash.
- Flash only Your bracketing settings will affect only the flash system, not the exposure.
- WB bracketing White balance bracketing works the same as exposure and flash bracketing, except it is designed for bracketing color in mired values; that is, color temperatures are adjusted instead of bracketing light in EV step values (see sidebar, What Is Mired?). This can be used only when you are shooting in JPEG mode.

ADL bracketing – This allows bracketing Active D-Lighting in up to five separate exposures. Each consecutive exposure uses the next higher level of Active D-Lighting.

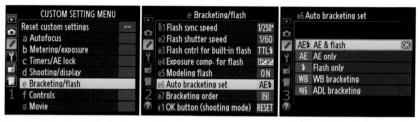

Figure 4.53 - Auto bracketing set choices

Use the following steps to select an e6 Auto bracketing set type:

- 1. Select e Bracketing/flash from the Custom Setting Menu and scroll to the right (figure 4.53, screen 1).
- 2. Highlight e6 Auto bracketing set and scroll to the right (figure 4.53, screen 2).
- 3. Choose one of the five options from the list. In figure 4.53, screen 3, I selected AE & flash.
- 4. Press the OK button to lock in the setting.

Now let's consider how to use the bracketing system.

Steps to Use AE and Flash Bracketing

The primary type of bracketing for most photographers is generally AE bracketing, which simply means auto exposure bracketing. Since AE only and Flash only bracketing work the same way, this section explains how to bracket your images when you have selected AE & flash, AE only, or Flash only bracketing. You can use AE only or Flash only when you want to bracket just AE or just Flash but not the other. If you want to bracket both at the same time, use AE & Flash.

Figure 4.53.1 – BKT button, Main and Sub-command dials, and Control panel with AE/flash bracketing symbols

- 1. Select AE & flash, AE only, or Flash only in Custom Setting Menu > e Bracketing/flash > e6 Auto bracketing set (figure 4.53, screen 3).
- 2. Press and hold the BKT button (figure 4.53.1, image 1). BKT will appear on the Control panel along with a series of characters (figure 4.53.1, image 3A-C). Do not release the BKT button.
- 3. Turn the Main command dial (figure 4.53.1, image 2, bottom arrow) to select the number of shots in the bracket. The number of shots you select will appear on the Control panel. You can see in figure 4.53.1, image 3A, that I selected 3F. You can choose from the following options:
 - 0F Bracket not set
 - 3F Three-shot bracket (exposure order set in Custom setting e7)
 - –2F Two-shot bracket (normal and underexposed)
 - +2F Two-shot bracket (normal and overexposed)
- 4. Continue holding down the BKT button and turn the Sub-command dial (figure 4.53.1, image 2, top arrow) to select the bracketed exposure increment. The EV step value will appear on the Control panel. In figure 4.53.1, image 3B, you can see that I selected 1.0. You can choose from the following increments, which are affected by the setting in Custom setting b2:
 - 0.3, 0.7, 1.0, 2.0, or 3.0 EV (with 1/3 step set in Custom setting b2)
 - 0.5, 1.0, 2.0, or 3.0 EV (with 1/2 step set in Custom setting b2)
- 5. Release the BKT button and press the Shutter-release button to shoot your bracketed pictures. If you are using Single frame (S) release mode, you will have to press the Shutter-release button two or three times (depending on the number of shots selected in step 3). If you are using one of the Continuous (CL or CH) release modes, you can simply hold down the Shutter-release button and the camera will fire the number of shots selected in step 3. Figure 4.53.1, image 3C, shows the Bracketing progress indicator. Each time the shutter fires, a part of the indicator will disappear. If you are using Single frame (S) release mode, you must be sure that you have taken all shots in the bracketed series. If part of the progress indicator remains, you have not taken all the shots in the series. In a Continuous (CL or CH) release mode all shots will fire in quick succession when you hold down the Shutter-release button.

Settings Recommendation: I normally bracket with a 1 EV or 2 EV step value (1 or 2 stops) so I can get a good spread of light values for creating high dynamic range (HDR) images. In most cases I shoot a three-image bracket, with one image overexposed and one image underexposed by 1 or 2 stops. This allows me to combine detail in the highlight and shadow areas during HDR processing.

Custom settings f2 and f3 allow you to assign Bracketing burst to either the Fn button or the Preview button. When the camera is in Single frame (S) or Quiet (Q) release modes, Bracketing burst lets the camera fire the entire bracketed series when you hold down the Fn button or Preview button and the Shutter-release button. It lets the camera override the fact that you normally have it set to shoot one frame at a time. In addition, if you have the camera set to one of the Continuous (CL or CH) release modes, it will fire the entire bracketed series over and over as long as you hold down the Shutter-release button and Fn or Preview button, instead of stopping after one bracket series.

Steps to Use WB Bracketing

WB bracketing allows you to shoot a bracketed series of images with various White balance color temperatures applied. With WB bracketing you can add amber or blue (or both) to the bracketed images to make them warmer or cooler, with lighter or darker tint levels.

WB bracketing does not work when your camera is in RAW mode. If you press the BKT button and turn the Command dials and nothing happens, the Image quality is probably set to a mode that shoots NEF (RAW) images.

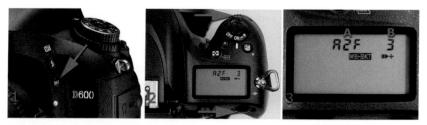

Figure 4.53.2 – BKT button, Main and Sub-command dials, and Control panel with WB bracketing symbols

Use the following steps to shoot a series of images with WB bracketing:

- 1. Select WB bracketing from Custom Setting Menu > e Bracketing/flash > e6 Auto bracketing set (figure 4.53, screen 3).
- 2. Press and hold the BKT button on the front of the camera (figure 4.53.2, image 1). WB-BKT will appear on the Control panel along with a series of characters (figure 4.53.2, image 3A–B). Do not release the BKT button.
- 3. Turn the Main command dial (figure 4.53.2, image 2, bottom arrow) to select the number of shots in the bracket. The number of shots you select will appear on the Control panel. In figure 4.53.2, image 3A, I selected A2F. You can choose from the following options:

- 0F Bracket not set
- A2F Two-shot bracket (one normal, one adds amber)
- b2F Two-shot bracket (one normal, one adds blue)
- 3F Three-shot bracket (one normal, one adds amber, one adds blue)
- 4. Now we'll set the tint level of the amber or blue color by adding more or less color depth in mired amounts. Continue holding down the BKT button and change the mired number by turning the Sub-command dial left or right, up to three maximum. The mired number will appear on the Control panel. In figure 4.53.2, image 3B, I selected 3. Choose 1, 2, or 3, where 1 is 5 mired, 2 is 10 mired, and 3 is 15 mired. If you chose a three-shot bracket (3F), the direction of the color bracketing toward amber or blue is controlled by Custom setting e7 Bracketing order. If you selected MTR > under > over in Custom setting e7, the color change direction is normal > amber > blue. If you selected Under > MTR > over in Custom setting e7, the color change direction is amber > normal > blue.
- 5. Press the Shutter-release button to take the bracketed picture series. The camera will take only one picture, then it reapplies the color filtration for each image in the bracket and saves each image as a separate file with a new file number and bracketed color value. This is different from any form of AE or Flash bracketing, (AE only, Flash only, AE & Flash) where you have to fire each individual frame of the bracket. All images in the bracket (up to three) simply appear on your memory card.

Note: White balance bracketing works differently when it comes to shooting the bracket. All you have to do is press the Shutter-release button once and the camera takes one image, makes copies, and applies the different WB bracketing values to each image. It then saves the two or three images, with their White balance settings, under different file names. You do not take multiple images in WB bracketing.

Settings Recommendation: I prefer to use RAW mode and make minor (or major) color adjustments in the post-processing stage. However, you may want to use WB bracketing when you shoot JPEGs because each time you modify and resave a JPEG image, the file is degraded. Photographers who are concerned with accurate color balance will find WB bracketing useful.

What Is Mired?

Mired changes simply modify the color of your image, in this case toward amber (reddish) or blue. In effect, it warms or cools the image. It's applied directly to the image by the camera when you shoot JPEGs, or it is saved as a marker when you shoot RAW images. You don't have to worry about mired values unless you are a color scientist. You can just determine whether you like the image the way it is or would prefer that it be warmer or cooler, and bracket accordingly. In WB bracketing the A direction warms and the b direction cools. Technically, mired is calculated by multiplying the inverse of the color temperature by 106. I'd rather let my camera calculate mired values and then judge them with my eye. Remember, if you shoot in RAW, you can modify color values during post-processing. However, WB bracketing modifications are permanently applied to JPEG files.

Steps to Use ADL Bracketing

ADL bracketing allows you to shoot a bracketed series of images with various levels of Active D-Lighting (ADL) applied. There are two types of ADL bracketing: two and three frame (represented as 2F or 3F on the Control panel) plus off (0F).

- Two-frame bracket (2F) This type of ADL bracketing fires two shots. The first is taken with no ADL, and the second is taken with whatever level of ADL you selected in *Shooting Menu > Active D-Lighting* (Low, Normal, High, Extra high, or Auto). If ADL is set to Off in the Shooting Menu, the camera will take one image with no ADL and the second image with ADL set to Auto, which means it adjusts according to what the camera thinks is the best ADL level.
- Three-frame bracket (3F) This version of ADL bracketing ignores the setting in Shooting Menu > Active D-Lighting. It captures three images: the first with no ADL (Off), the second with Normal ADL (Normal), and the third with High ADL (High).
- No bracketing (OF) If you have not selected a bracketing mode, you will see OF on the Control panel when you press the BKT button. Bracketing is currently off.

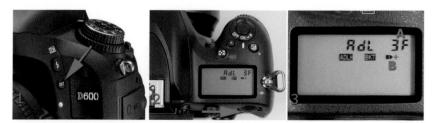

Figure 4.53.3 – BKT button, Main command dial, and Control panel with ADL bracketing symbols

Use the following steps to shoot an ADL-bracketed series of images:

- 1. Select ADL bracketing from Custom Setting Menu > e Bracketing/flash > e6 Auto bracketing set (figure 4.53, screen 3).
- 2. If you selected a two-frame (2F) bracket, set Shooting menu > Active D-Lighting to one of its ADL selections, such as Low, Normal, or High. One image will be taken with ADL off and the other at whatever setting you chose. If ADL is currently set to Off in the Shooting Menu, the camera will bracket like this: Off > Auto. For a three-frame (3F) bracket, the camera will automatically use this sequence: Off > Normal > High ADL bracketing.
- 3. Press and hold the BKT button while turning the Main command dial (figure 4.53.3, images 1 and 2) and verify that ADL- BKT appears on the Control panel. Continue rotating the Main command dial to choose one of the three settings (figure 4.53.3, image 3A):
 - 0F No bracketing selected
 - 2F Two-frame bracketing (Off > Active D-Lighting level from the Shootina Menu)
 - 3F Three-frame bracketing (Off > Normal > High)
- 4. Release the BKT button and press the Shutter-release button to take your bracketed pictures. Figure 4.53.3, image 3B, shows the Bracketing progress indicator. It will have two parts for a two-frame bracket and three parts for a three-frame bracket. Each time the shutter fires, a part of the indicator will disappear. If you are using Single frame (S) release mode, you must be sure that you have taken all the shots in the bracketed series. If part of the progress indicator remains, you have not taken all the shots in the series. In a Continuous (CL or CH) release mode, all shots will fire in quick succession when you hold down the Shutter-release button.

Note: See the sidebar a few pages back called Using Bracketing Burst for instructions on how to override the way the camera captures the bracketed image series in step 4.

Settings Recommendation: You might use each of the bracketing types for different reasons as you shoot. Many landscape or scenic shooters use AE only (exposure) bracketing guite frequently, with the express purpose of having several images of the same scene shot at different exposures so they can later combine them in high dynamic range imaging (HDR or HDRI) software. If you haven't used bracketing before, I urge you to learn how. It is a powerful capability that seriously extends the camera's facility for capturing a greater range of light and variety of color.

e7 Bracketing Order

(User's Manual - Pages 241, 153)

The *e7 Bracketing order* setting allows you to choose the order of your exposure settings (normal, overexposed, and underexposed) during an exposure bracketing operation (see previous section, **e6 Auto Bracketing Set**).

There are two bracketing orders available in the D600. They allow you to control which images are taken first, second, and third in the bracketing series. The abbreviations used in this setting are as follows:

- MTR Metered value (normal exposure)
- Under Underexposed
- · Over Overexposed

Let's see what the settings are and how they're used during bracketing:

- MTR > under > over With this setting, the normal exposure is taken first, followed by the underexposed image, then the overexposed image. For WB bracketing the pattern is normal > amber > blue. This setting does not apply to ADL bracketing.
- Under > MTR > over A three-image bracket will be exposed in the following manner: underexposed, normal exposure, overexposed. For WB bracketing the pattern is amber > normal > blue. This does not apply to ADL bracketing.

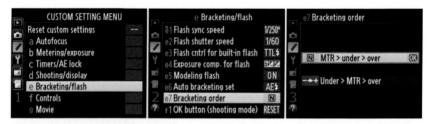

Figure 4.54 - Bracketing order choices

Finally, let's look at the steps to configure the e7 Bracketing order setting:

- 1. Select e Bracketing/flash from the Custom Setting Menu and scroll to the right (figure 4.54, screen 1).
- 2. Highlight e7 Bracketing order and scroll to the right (figure 4.54, screen 2).
- 3. Choose one of the bracketing orders from the list. In figure 4.54, screen 3, I selected MTR > under > over.
- 4. Press the OK button to lock in the setting.

Settings Recommendation: I leave Bracketing order set to MTR > under > over so that when the images are displayed in series on the Monitor I can see the

normal exposure (MTR) first and then watch how it varies as I scroll through the bracketed images. If that doesn't suit you, change it to the other direction, Under > MTR > over. The normal exposure will be in the middle of the bracket instead of at the beginning. Some photographers prefer the more natural flow of that bracketing order (underexposed to overexposed).

f Controls

Custom Settings f1-f9

Within the Controls menu you'll find nine settings:

- f1 OK button (shooting mode)
- · f2 Assign Fn button
- f3 Assign preview button
- · f4 Assign AE-L/AF-L button
- · f5 Customize command dials
- f6 Release button to use dial
- f7 Slot empty release lock
- · f8 Reverse indicators
- f9 Assign MB-D14 AE-L/AF-L button

f1 OK Button (Shooting Mode)

(User's Manual - Page 241)

The f1 OK button (shooting mode) setting determines how the OK button in the center of the Multi selector works. All three of the available settings affect the currently active AF point in the Viewfinder whenever the camera is not in Autoarea AF mode and is in Shooting mode (versus Playback mode).

When you use Auto-area AF the camera controls the AF points as it sees fit, so this function has no effect. When you use Playback mode to view a picture, pressing the OK button opens the Retouch Menu. Shooting mode simply means you are not viewing anything on the Monitor and are ready to take a picture.

There are three selections in OK button (shooting mode):

Select center focus point – When you are shooting, you often use the Multi selector with your thumb to navigate to an AF point in the Viewfinder. When you are done, unless you want to leave the AF point where it happens to be, you will have to scroll back to the center of the Viewfinder. Not anymore! If Select center focus point is chosen, the selected focus point resets to the center point when you press the OK button. This is the default action of the button.

- Highlight active focus point Sometimes when you are looking at a confusing subject through the Viewfinder it may be hard to see the small black AF point. When Highlight active focus point is selected and you press the OK button, the entire group of AF points lights up in red for easy viewing.
- Not used This does what it says: nothing happens when you press the OK button while in Shooting mode.

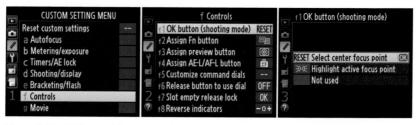

Figure 4.55 – OK button (shooting mode) choices

Use the following steps to choose one of the f1 OK button (shooting mode) settings:

- 1. Select f Controls from the Custom Setting Menu and scroll to the right (figure 4.55, screen 1).
- 2. Highlight f1 OK button (shooting mode) and scroll to the right (figure 4.55, screen 2).
- 3. Choose one of the options from the menu. In figure 4.55, screen 3, I chose Select center focus point.
- 4. Press the OK button to lock in the setting.

Note: When you have the camera set to Live view mode, pressing the OK button returns the square for the larger AF point back to the center, like the previously discussed Select center focus point setting. The Highlight active focus point setting has no effect in Live view. In fact, if you press the MENU button and open Custom setting f1 OK button (shooting mode) while you're in Live view, you'll find that it is grayed out. Live view mode defaults to Select center focus point.

Settings Recommendation: I have my camera set to Select center focus point so that when I press the OK button in Shooting mode the center AF point is selected. It saves time because I don't have to manually scroll. I don't find the Highlight active focus point setting all that useful since I can press the Shutter-release button halfway and the camera will highlight the active focus point. It seems like duplicate functionality to me, unless, of course, I am shooting in DX mode and have Custom setting a4 AF point illumination turned off so my Viewfinder DX view will be surrounded by a grayed-out area. In that situation, having an

additional way to highlight the current AF point is welcome. Frequent DX mode shooters, take notice of this setting!

If you would rather highlight the active focus point (area) with the OK button, simply choose the Highlight active focus point setting; then you can highlight the active AF point with both the OK button and the Shutter-release button (unless Custom setting a4 is disabled).

f2 Assign Fn Button, f3 Assign Preview Button, f4 Assign AE-L/AF-L Button

(User's Manual - Pages 242-244)

The f2 Assign Fn button, f3 Assign preview button, and f4 Assign AE-L/AF-L button settings are all discussed in this section because they work the same way.

When I refer to **Selected button**, I am talking about the camera button you want to configure—Fn button, Preview button, or AE-L/AF-L button. When you see **Selected button**, mentally replace it with the name of the button you want to configure. You can assign various camera functions to any of these three buttons.

After we consider each of the screens used to assign the various functions, we'll look at each function in detail in the list titled Assignable Function List. There are many different functions from which to choose. The screens, steps, and settings we are about to review are designed to let you customize the function of the **Selected button**.

The following figures show the **Selected buttons** with their default settings:

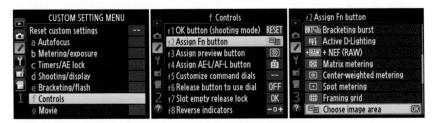

Figure 4.56 - Assign Fn button

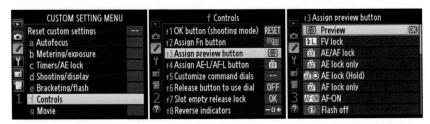

Figure 4.57 – Assign preview button

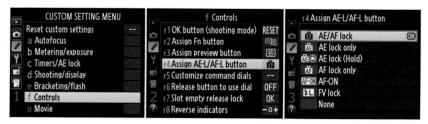

Figure 4.58 - Assign AE-L/AF-L button

Refer to figures 4.56 through 4.58 as you work through the following steps for each Selected button:

- 1. Select f Controls from the Custom Setting Menu and scroll to the right (figures 4.56, 4.57, or 4.58, screen 1).
- 2. Highlight Assign **Selected button** and scroll to the right (figures 4.56, 4.57, or 4.58, screen 2).
- 3. Select one of the functions from the list. The function you choose will be assigned to a single press of the Selected button (figures 4.56, 4.57, or 4.58, screen 3). See the upcoming section titled Assignable Function List for an explanation of each function.
- 4. Press the OK button to lock in your selection.

Now, let's look at the Assignable Function List to see what amazing powers we can give each of the assignable buttons on our cameras. The f4 Assign AE-L/AF-L button setting uses a subset of the functions that are available to the other two buttons. In other words, not all of the functions are available for assignment to all three of the buttons.

The following list will not match the order shown on the menu screens for the various buttons. Instead, they are presented alphabetically to make it easier for future reference.

Assignable Function List

- 1 step spd/aperture Normally the exposure value (EV) steps (1/3 step or 1/2 step) for the shutter speed and aperture are controlled by Custom setting b2 EV steps for exposure cntrl. However, if you select 1 step spd/aperture you can hold down the Selected button while rotating the rear Main command dial to change the shutter speed in 1 EV steps, overriding the 1/3 step or 1/2 step values set in Custom setting b2 EV steps for exposure cntrl. You can also do the same for the aperture by holding down the Selected button and rotating the front Sub-command dial. This function is not available for Assign AE-L/AF-L button.
- · Access top item in My Menu You can press the Selected button to jump directly to the top item in My Menu. This allows you to quickly use or modify

- Active D-Lighting You can hold down the Selected button while turning the Main command dial to select an Active D-Lighting level. The Control panel will show these levels in its bottom-right corner: oFF for Off, L (Low), n (Normal), H (High), HP (Extra high), and Auto (Shooting Menu > Active D-Lighting). This function is not available for Assign AE-L/AF-L button.
- AE/AF lock Enabling this function causes AE (exposure) and AF (focus) to lock on the last meter and autofocus system reading while the Selected button is held down.
- AE lock (Hold) Enabling this function causes AE (exposure) to lock on the
 last meter reading when the Selected button is pressed once. It stays locked
 until you press the Selected button again. In other words, the Selected button
 toggles AE lock.
- AE lock only This function allows you to lock AE (exposure) on the last meter reading when you hold down the Selected button.
- **AF lock only** When it is set, this function locks the AF (focus) system on the last autofocus reading while you hold down the **Selected button**.
- AF-ON This causes the camera to initiate autofocus when you press the Selected button. The more expensive Nikon DSLRs have a dedicated AF-ON button in addition to the assignable buttons. Not to be left out, the D600 gives you a similar assignable functionality. When AF-ON is active the Shutter-release button cannot be used to focus.
- Bracketing burst Normally, during a bracketing sequence with the shutter release set to Single frame release mode (S on the Release mode dial) or Quiet shutter-release mode (Q on the Release mode dial), you have to press the Shutter-release button once for each of the images in the bracket. The only way to shoot all the images in the bracketed series without letting up the Shutter-release button is to set the Release mode dial to CL or CH. If you select Bracketing burst, you can hold down the **Selected button** while holding down the Shutter-release button, and the camera will take all the images in the bracket in quick succession. In addition, any time you are using one of the Continuous release modes (CL or CH), the camera will fire the bracketed image series over and over—instead of stopping at the end of the series when you hold down the **Selected button**. This applies to AE, Flash, and ADL bracketing, which take one image for each release of the shutter. WB bracketing takes the entire bracket in one shutter press by creating three images with varying white balances. Multiple shutter releases will capture numerous multi-image WB brackets. If you use this function for WB bracketing and hold

- Center-weighted metering If you normally use Matrix metering or Spot metering as your primary metering system, you can temporarily use Center-weighted area metering by holding down the Selected button. When you release the button, the camera returns to your customary meter type, such as Spot metering or Matrix metering. This function is not available for Assign AE-L/AF-L button.
- Choose image area When you press the Selected button and rotate either Command dial you may choose an Image area setting. The camera will display 36–24 for FX and 24–16 for DX on the top Control panel. This function is not available for Assign AE-L/AF-L button.
- Choose non-CPU lens number This function allows you to shoot with older Al or Al-S Nikkor lenses that do not have a CPU chip in them. You must first register the lens in the Setup Menu > Non-CPU lens data function. After you have registered one or more lenses, you can select them by assigning Choose non-CPU lens number to the Selected button. Simply hold down the Selected button while rotating either of the Command dials to scroll through up to nine registered non-CPU lenses. You'll see n-1 to n-9 appear on the lower right corner of the Control panel on top of the camera as you scroll. Above that you'll see the current focal length and aperture. This function is not available for Assign AE-L/AF-L button.
- Flash off This is a temporary way to disable the flash for when you want to leave your flash turned on and still be able to take a picture without flash. While you hold down the **Selected button**, the flash is disabled. This function is not available for Assign AE-L/AF-L button.
- Framing grid If you don't have the gridlines enabled under Custom setting d2 Viewfinder grid display, you can temporarily enable the gridlines by pressing the Selected button, turning the Main command dial one click, and releasing the Selected button. This function is not available for Assign AE-L/AF-L button.
- FV lock If you set Selected button to FV lock, the button will cause the builtin Speedlight or the external Speedlight to emit a monitor preflash and then lock the flash output to the level determined by the preflash until you press the Selected button a second time.
- Matrix metering If you do not use Matrix metering as your primary metering system but want to use it occasionally, this setting allows you to turn it on while you hold down the Selected button. When you release the Selected button, the camera returns to your customary meter type, such as Spot

- metering or Center-weighted area metering. This function is not available for Assign AE-L/AF-L button.
- MY MENU Pressing the Selected button displays My Menu, with the first item in the menu highlighted. This function is not available for Assign AE-L/ AF-L button.
- +NEF (RAW) When you are using one of the JPEG modes (JPEG fine, JPEG normal, or JPEG basic), you can also get an additional NEF (RAW) image by pressing the Selected button before you press the Shutter-release button. The Selected button toggles +NEF (RAW). If you keep the Shutter-release button pressed halfway between shots, the camera will take a series of RAW and JPEG images. When +NEF (RAW) is active, RAW+ will display above the other image format setting on the Control panel. This function is not available for Assign AE-L/AF-L button.
- *None* Pressing the *Selected button* does nothing.
- Playback This function causes the Selected button to act as if you had pressed the Playback button. Nikon included this so you can play back images when you use a big telephoto lens that requires two hands to use. This function is not available for Assign AE-L/AF-L button.
- Preview This function shows you an actual view of what the camera sees with the aperture closed down to the selected aperture setting. Although it darkens the Viewfinder when you press the Selected button, you can see the depth of field (zone of sharp focus) that will be captured in the image. Normally, viewing the depth of field is controlled by the Depth-of-field preview button. Some people may not like the location of the Depth-of-field preview button and may decide to switch the Fn button (for instance) with the Depth-of-field preview button. This function is not available for the Assign AE-L/AF-L button.
- **Spot metering** If you normally use a metering system other than Spot metering, you can temporarily switch to Spot metering by holding down the **Selected button**. When you release the button, the camera returns to your customary meter type, such as Center-weighted area metering or Matrix metering. This function is not available for Assign AE-L/AF-L button.
- Viewfinder virtual horizon If you are concerned about keeping the camera level and the gridline display is insufficient for you, Nikon offers the Viewfinder virtual horizon. Press the Selected button once and the Viewfinder will display an indicator at the bottom. When you tilt the camera left or right, you'll see a series of dots moving to the left or right. When the dots disappear, the camera is level. When you press the Selected button this function remains active until you take a picture or until the meter goes off. Be careful about tilting the camera forward or backward too much or it may skew the results of the left to right leveling action. This function does not work for forward

and backwards tilt, only for left to right. If you need a true virtual horizon that works in all four axes, use Setup Menu > Virtual horizon instead. This function is not available for Assign AE-L/AF-L button.

Settings Recommendation: There are so many functions here that I'm loathe to recommend anything. People shoot in many different ways, and there are so many choices in this list that it's hard to pin down just a few. However, you can experiment with the settings I use and see if they suit your style. If not, you have a lot of choices! Here are my favorite button assignments:

- Assign Fn button Spot metering (my normal meter is Matrix metering)
- Assign preview button Preview (depth-of-field preview)
- Assign AE-L/AF-L button AE lock only

Using the Information Display to Change Button Assignments

You can assign the **Selected button** by using the Information display instead of the Custom Setting Menu selections. In figure 4.58.1 there are three screens shown. Each of them represents one of the assignable buttons we have discussed in this section.

If you prefer to use the Information display edit screen to access these buttons, instead of the camera's normal menu, you can.

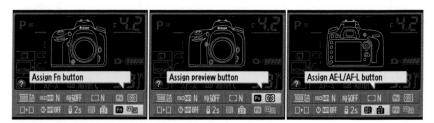

Figure 4.58.1 - Assigning buttons using the Information edit screen

Use these steps to assign the button of choice instead using of the Custom Setting Menu selections (f2–f4):

- 1. Open the Information display screen by pressing the Info button.
- 2. Press the Info button again to open the Information display edit screen, as shown in figure 4.58.1.
- 3. Scroll around with the Multi selector until you find the button you want to assign. The Screen tips will guide you if they are enabled in Custom setting d4. Highlight the button you want to assign.
- 4. Press the OK button to enter the configuration screen for that particular button, as shown in screen 3 of figures 4.56, 4.57, and 4.58.

The Nikon D600 is quite flexible in how it can be configured, isn't it?

f5 Customize Command Dials

(User's Manual – Page 245)

The f5 Customize command dials setting lets you change how the two Command dials operate. There are several operations you can modify:

- · Reverse rotation
- · Change main/sub
- Aperture setting
- Menus and playback

Reverse Rotation

This setting allows you to change which direction things increment when you rotate the Command dials. There are two selections: Exposure compensation and Shutter speed/aperture. If either of these is checked, both Command dials increment their settings in the opposite direction; they are reversed. Here are descriptions of how the two subfunctions work:

- **Exposure compensation** Normally, when you hold down the Exposure compensation button and rotate the Main command dial in a counterclockwise direction, the camera's Exposure compensation increases toward the plus side (e.g., +0.3, +0.7, +1.0). However, when you put a check mark in the Exposure compensation box, the same counterclockwise rotation of the Main command dial results in negative Exposure compensation (e.g., -0.3, -0.7, -1.0).
- **Shutter speed/aperture** When the D600 is set to Aperture-priority auto (A) and you rotate the Sub-command dial to the right, the aperture normally decreases (e.g., f/5.6, f/6.3, f/7.1). If you put a check mark in the Shutter speed/aperture box, the direction of the aperture changes will be reversed when you turn the Sub-command dial to the right (e.g., f/5.6, f/5, f/4.5). This applies to the front and rear Command dials.

Use the following steps to reverse the rotation of the Command dials:

- Select f Controls from the Custom Setting Menu and scroll to the right (figure 4.59, screen 1).
- 2. Highlight f5 Customize command dials and scroll to the right (figure 4.59, screen 2).
- 3. Choose Reverse rotation and scroll to the right (figure 4.59, screen 3).
- 4. Put a check mark in the Exposure compensation or Shutter speed/aperture box (or both) by highlighting the line and scrolling to the right with the Multi selector, and then select Done from the menu (figure 4.59, screen 4).
- 5. Press the OK button to lock in the setting(s).

CUSTOM SETTING MENU

Settings Recommendation: I leave the Command dials rotation set to the factory default. I find life confusing enough without my camera working backwards! Of course, you may have previously used a different brand of camera that worked in the opposite direction, so you might prefer to reverse the Command dial rotation.

f Controls

Change Main/Sub

This setting allows you to swap the functionality of the two Command dials. The rear Main command dial will take on the functions of the front Sub-command dial and vice versa. Here are the three settings:

- On The Main command dial controls the aperture in exposure modes A and M (on the Mode dial). The Sub-command dial controls the shutter speed in exposure modes S and M.
- **On (Mode A)** The Main command dial controls the aperture in exposure mode A. The rest of the modes work like Off (the next setting).
- Off The Main command dial controls the shutter speed, and the Subcommand dial controls the aperture (default).

Shooting mode P on the Mode dial is unaffected by Change main/sub.

Use the following steps to swap the functionality of the Command dials:

- 1. Select f Controls from the Custom Setting Menu and scroll to the right (figure 4.60, screen 1).
- 2. Highlight f5 Customize command dials and scroll to the right (figure 4.60, screen 2).

- 3. Choose Change main/sub from the menu and scroll to the right (figure 4.60, screen 3).
- 4. Select On, On (Mode A), or Off from the menu (figure 4.60, screen 4).
- 5. Press the OK button to lock in the setting.

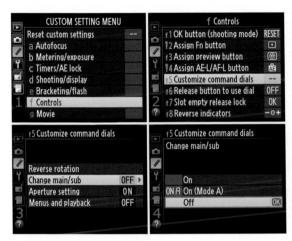

Figure 4.60 - Change main/sub

Settings Recommendation: I leave the Command dials set to the factory default (Off). I've been using Nikon cameras for too many years to change the Command dial functionality now. If you have other needs, you can set the controls however you want to. Nikon gives us a lot of flexibility with this camera.

Aperture Setting

There are two selections that allow you to modify how the camera treats CPU lenses that have aperture rings (non-G lenses). There are many excellent older, preowned AF Nikkor D lenses in eBay land, and your D600 can use them, in addition to the newer AF-S style G lenses. The two settings are as follows:

- Sub-command dial This is the factory default setting. The aperture is set using the Sub-command dial.
- Aperture ring This setting allows you to use the aperture ring of non-G lenses with a CPU to adjust the aperture instead of using the Sub-command dial. The EV increments will display only in 1 EV steps when this is active.
 Use the following steps to change the style of Aperture setting:
- 1. Select f Controls from the Custom Setting Menu and scroll to the right (figure 4.61, screen 1).
- 2. Highlight f5 Customize command dials and scroll to the right (figure 4.61, screen 2).

- 3. Choose Aperture setting from the menu and scroll to the right (figure 4.61, screen 3).
- 4. Select Sub-command dial or Aperture ring (figure 4.61, screen 4).
- 5. Press the OK button to lock in the setting.

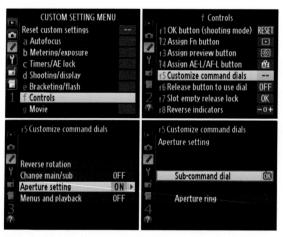

Figure 4.61 – Aperture setting (Sub-command dial versus Aperture ring)

Note: When you use a non-CPU lens, the aperture ring must always be used to set the aperture. If you are using a G lens with no aperture ring, you clearly can't set the aperture with an aperture ring, so the camera ignores this setting. You can even use older non-CPU lenses and adjust the aperture with the lens aperture ring when you have the camera in Live view mode. I used a 1970s Al Nikkor 35mm f/2 (non-CPU) lens to test this. It worked great!

Settings Recommendation: For shooting still images, I leave Aperture setting set to Sub-command dial. I have some older AF Nikkor lenses that I like to use, so I keep them locked at their smallest aperture settings and use the Sub-command dial to change their apertures. I usually don't adjust apertures with the old aperture ring on the lens unless I'm using older non-CPU manual-focus AI or AI-S lenses.

For shooting movies, the Aperture ring setting has gained quite a bit of importance. The Nikon D600 does not allow you to control the aperture with the Sub-command dial while you're shooting a movie—a bad and shortsighted decision by Nikon for a camera in this class—therefore, you can control the aperture by using an older Al/Al-S-type or D-type lens that has an aperture ring. Fortunately, the camera will respond correctly when you use a manual aperture ring to adjust the aperture. Remember this setting! We will discuss this further in the chapter called **Movie Live View**.

Using an older Nikkor lens with an aperture ring opens up some possibilities for depth-of-field control during a movie, whether it is a CPU or a non-CPU lens. Moviemakers take note!

Menus and Playback

This setting is designed for people who do not like to use the Multi selector for viewing image Playback or Info screens. It also allows you to use the Command dials for scrolling through menus.

The following selections change how the menus and image playback displays work when you would rather not use the Multi selector:

- On While you are viewing images during playback, turning the Main command dial to the left or right scrolls through the displayed images. Turning the Sub-command dial left or right scrolls through the data and histogram screens for each image. While you are viewing menus, turning the Main command dial left or right scrolls up or down in the screens. Turning the Subcommand dial left or right scrolls left or right in the menus. This setting simply gives you two ways to view your images and menus.
- On (image review excluded) The Command dials will scroll around in the camera menus, as described in the On setting. However, you must use only the Multi selector to scroll through your pictures during image review (just after taking a picture).
- Off This is the default action. The Multi selector is used to scroll through images, thumbnails, and menus.

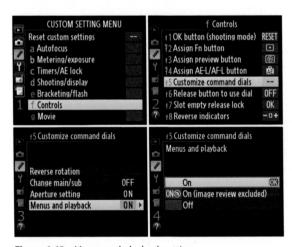

Figure 4.62 – Menus and playback setting

Use the following steps to configure Menus and playback:

- 1. Select f Controls from the Custom Setting Menu and scroll to the right (figure 4.62, screen 1).
- 2. Highlight f5 Customize command dials and scroll to the right (figure 4.62, screen 2).
- 3. Choose Menus and playback from the menu and scroll to the right (figure 4.62, screen 3).
- 4. Select one of the settings from the menu (figure 4.62, screen 4).
- 5. Press the OK button to lock in the setting.

Settings Recommendation: I leave Menus and playback set to On. I've heard others say how much they like this function, and now I use it myself. I like the fact that I can use either the Multi selector or the Command dials to move around in my camera's menus and images. Try this one out; you may like it too!

f6 Release Button to Use Dial

(User's Manual - Page 246)

The f6 Release button to use dial setting allows people who dislike holding down various buttons and turning Command dials at the same time to change the settings. This setting could be very useful to a person with limited hand strength because the camera would be easier to operate.

There are two settings under Release button to use dial:

- Yes (On) This setting changes a two-step operation into a three-step operation. Normally, you would press and hold down a button while rotating a Command dial. When you select Yes under Release button to use dial, the camera allows you to press and release a button, rotate the Command dial, then press and release the button again. In other words, the normal (No) actions are to press and hold a button and then turn a Command dial. The Yes actions are to press and release a button, turn a Command dial, and press and release the button again. The initial button press locks the button so you do not have to hold your finger on it while turning the Command dial. After you have changed whatever you are adjusting, you must press the button a second time to unlock it. If the exposure meter turns off, or you press the Shutterrelease button halfway down, you must start over.
- No (Off) This is the default setting. You must press and hold a button while rotating the Command dials to change the camera function.

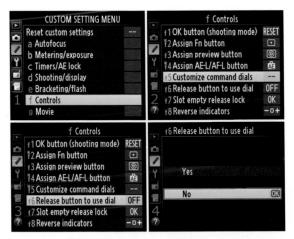

Figure 4.63 - Release button to use dial

Use the following steps to configure f6 Release button to use dial:

- 1. Select f Controls from the Custom Setting Menu and scroll to the right (figure 4.63, screen 1).
- 2. Highlight f5 Customize command dials and scroll to the right (figure 4.63, screen 2).
- 3. Highlight f6 Release button to use dial and scroll to the right (figure 4.63, screen 3).
- 4. Choose Yes or No from the list. In figure 4.63, screen 4, I selected No.
- 5. Press the OK button to lock in the setting.

Settings Recommendation: I haven't found this function to be useful because it merely adds extra steps to changing settings. However, a person with limited hand dexterity or strength may find this to be a very useful function.

f7 Slot Empty Release Lock

(User's Manual - Page 246)

The f7 Slot empty release lock setting is primarily designed for people who work with their camera tethered to a computer. If a memory card is not present, the camera will not normally let you take a picture.

However, when you enable Slot empty release lock, the camera will let you take quite a few pictures as it fills up the internal buffer memory. If the camera is not attached to a computer—with software designed to intercept the images—the pictures have nowhere to go, so you'll lose them. You can't insert a memory card after the fact and save them.

There are two settings available under f7 Slot empty release lock:

- **Release locked** The camera simply refuses to take a picture unless a memory card with available storage space is inserted in the camera.
- Enable release If your D600 is tethered to a computer and you know how
 to use the software, this setting is a great choice. Anytime you want to take
 pictures without a memory card, you'll need to select this setting. Be careful,
 though; if the camera is not hooked up to a computer and you don't have a
 memory card in the camera and then accidentally take an important picture,
 you can't save it.

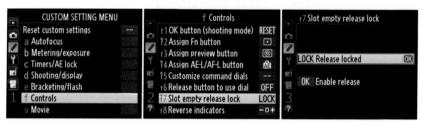

Figure 4.64 - Slot empty release lock

Use the following steps to choose one of the f7 Slot empty release lock settings:

- 1. Select f Controls from the Custom Setting Menu and scroll to the right (figure 4.64, screen 1).
- 2. Highlight f7 Slot empty release lock and scroll to the right (figure 4.64, screen 2).
- 3. Choose Release locked or Enable release from the list. In figure 4.64, screen 3, I selected Release locked.
- 4. Press the OK button to lock in the setting.

Settings Recommendation: I don't often shoot in-studio with my camera tethered to a computer, but I'm glad the D600 provides the ability to do so. I don't suggest leaving this setting on Enable release unless you know exactly why you are doing it. Otherwise you could lose your images if no card is in the camera. I'd much rather have the camera refuse to take a picture if I've inadvertently left out a memory card. Don't you agree?

f8 Reverse Indicators

(User's Manual – Page 246)

The f8 Reverse indicators setting lets you change the direction of your camera's exposure displays. Normally, any time you see the exposure indicators in the Viewfinder or Information display, the + is on the right and the – is on the left.

This is backwards from Nikon cameras from only a couple of years ago, and some people do not like this reversal of directions.

In figure 4.65, screen 3, you can see both directions displayed. Notice how +/- becomes -/+ when they are reversed. You'll see the same thing in any exposure indicators. Choose the style that makes you most comfortable. Most people leave this setting alone.

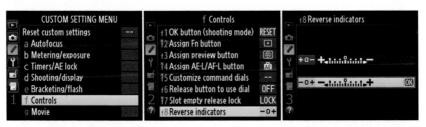

Figure 4.65 - Reverse indicators

Use the following steps to set the f8 Reverse indicators:

- 1. Select f Controls from the Custom Setting Menu and scroll to the right (figure 4.65, screen 1).
- 2. Highlight f8 Reverse indicators and scroll to the right (figure 4.65, screen 2).
- 3. Choose one of the selections from the list. In figure 4.65, screen 3, it is set to the factory default -/+ direction.
- 4. Press the OK button to lock in the setting.

Settings Recommendation: I like the exposure indicators with + on the left and on the right. However, if you are used to a camera where it works the opposite way, or you would just prefer it the other way, it's easy to change. Select your favorite indicator direction for maximum ease!

f9 Assign MB-D14 AE-L/AF-L Button

(User's Manual – Page 247)

The f9 Assign MB-D14 AE-L/AF-L button setting lets you use the AE-L/AF-L button built into the optional MB-D14 battery pack in the same manner as the one on the camera body. There are seven distinct functions, similar to the ones used by Custom setting f4 Assign AE-L/AF-L button:

- AE/AF lock Enabling this function causes AE (exposure) and AF (focus) to lock on the last meter and autofocus system reading while the AE-L/AF-L button on the MB-D14 is held down.
- AE lock only This allows you to lock AE (exposure) on the last meter reading when you hold down the AE-L/AF-L button on the MB-D14.

- AE lock (Hold) Enabling this function causes AE (exposure) to lock on the last meter reading when the AE-L/AF-L button on the MB-D14 is pressed once. It stays locked until you press the AE-L/AF-L button again. In other words, the AE-L/AF-L button on the MB-D14 toggles AE lock.
- AF lock only This function locks the AF (focus) system on the last autofocus reading while you hold down the AE-L/AF-L button on the MB-D14.
- AF-ON This causes the camera to initiate autofocus when you press the AE-L/AF-L button on the MB-D14. The Shutter-release button cannot be used to focus.
- FV lock If you set the AE-L/AF-L button on the MB-D14 to FV lock, the button will cause the built-in Speedlight or an external Speedlight to emit a monitor preflash. It will lock the flash output to the level determined by the preflash until you press the AE-L/AF-L button on the MB-D14 a second time.
- Same as Fn button This setting allows you to configure the AE-L/AF-L button on the MB-D14 so it executes whatever function you assigned to the camera's Fn button in Custom setting f2 Assign Fn button.

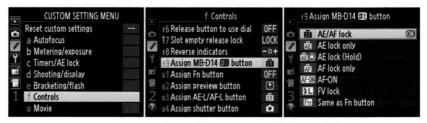

Figure 4.66 - Assign MB-D14 AE-L/AF-L button

Use the following steps to select an f9 Assign MB-D14 AE-L/AF-L button setting:

- 1. Select f Controls from the Custom Setting Menu and scroll to the right (figure 4.66, screen 1).
- 2. Highlight f9 Assign MB-D14 AE-L/AF-L button and scroll to the right (figure 4.66, screen 2).
- 3. Choose one of the selections from the list. In figure 4.66, screen 3, I selected AE/AF lock.
- 4. Press the OK button to lock in the setting.

Settings Recommendation: I generally use AE lock only for this button. You can assign one of the seven functions to this button as a separate assignment from any other button. If you don't like AE lock only, you can assign your favorite instead.

Custom Settings g1-g4

Within the g Movie menu you'll find four settings in the D600:

- g1 Assign Fn button
- · g2 Assign preview button
- · g3 Assign AE-L/AF-L button
- · q4 Assign shutter button

g1 Assign Fn Button, g2 Assign Preview Button, g3 Assign AE-L/AF-L Button

(User's Manual - Pages 247-248)

The g Movie section has identical settings to the Assign Fn button, Assign preview button, and Assign AE-L/AF-L button in the f Controls section of the camera, so the three sections are combined here. Once again, I'll use **Selected button** as a substitute for the actual button being assigned. When you see **Selected button**, mentally replace it with the name of the button you want to configure under the g Movie section. You can assign various camera functions to any of these three buttons. A list of functions is provided after the step-by-step method.

Here are the screens and steps to choose a function for all three assignable buttons.

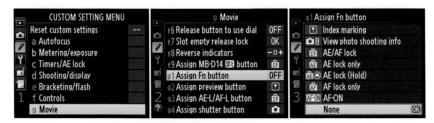

Figure 4.67 - Assign Fn button for Movie live view mode

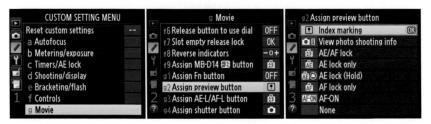

Figure 4.68 - Assign preview button for Movie live view mode

Figure 4.69 - Assign AE-L/AF-L button for Movie live view mode

Use these steps to assign the previously mentioned functions to the **Selected button** (figures 4.67, 4.68, and 4.69):

- 1. Select g Movie from the Custom Setting Menu and scroll to the right (figure 4.67, 4.68, or 4.69, screen 1).
- Highlight Selected button and scroll to the right (figure 4.67, 4.68, or 4.69, screen 2).
- 3. Choose one of the assignment selections from the list. In figures 4.67, 4.68, and 4.69, screen 3, the default for each is selected.
- 4. Press the OK button to lock in the setting.

The following are detailed descriptions of what each of these button assignments allows you to do in g Movie mode. The list is in alphabetical order for easy reference:

- AE/AF lock Enabling this function causes AE (exposure) and AF (focus) to lock on the last meter and autofocus system reading while the Selected button is held down.
- AE lock (Hold) This function causes AE (exposure) to lock on the last meter reading when the Selected button is pressed and released once. It stays locked until you press the Selected button again or the exposure meter goes off.
- AE lock only This allows you to lock AE (exposure) on the last meter reading when you hold down the Selected button.
- AF lock only This function locks the AF (focus) system on the last autofocus reading while you hold down the Selected button.
- AF-ON This causes the camera to initiate autofocus when you press the Selected button. The Shutter-release button cannot be used to focus.
- Index marking If you have Index marking enabled while you are recording
 a movie, you can set an index mark at the current frame position by pressing
 the Selected button. This index mark does not appear in the movie itself. It is,
 however, available when you are viewing and editing movies.
- None Pressing the Selected button in Movie live view mode does nothing.
- View photo shooting info This function allows you to view shooting information for still images when you are using Movie live view mode. The

resulting still images have a slightly reduced image size and a different ratio, which I will discuss in a moment. Normally, in Movie live view mode the camera displays the shutter speed, aperture, and ISO sensitivity (recording information) for a potential movie at the bottom of the Monitor. When you press the **Selected button**, the camera displays the shutter speed, aperture, and ISO sensitivity (shooting information) for still image creation instead. The camera will happily take still images when you are using Movie live view mode. However, note that there are some image size and ratio differences when you take a still image using Movie live view instead of Live view photography mode. When you are using Live view photography mode, a normal Large FX image is 6016×4016 (24.2 MP); however, in Movie live view, a Large still image is 6016×3376 (20.3 MP). When you use Movie live view, the camera enters the HD world, which is one of the reasons this camera is called an HD-SLR, not just a DSLR. Instead of the 3:2 aspect ratio used by Live view photography mode, the still image from Movie live view uses a 16:9 ratio. It is still a fully usable image at 20.3 MP. The ratio matches the look of an HDTV (16:9) instead of a normal picture format. You could use this mode for still images when you know the pictures will be displayed on an HDTV because it will match the HD ratio without the blank space on the sides that you see when you display a normal 3:2 image on a modern monitor. Test this for yourself on a newer LCD or LED computer monitor, and you will see how much more closely the 16:9 format matches the monitor's display size. See the section Image Area in the chapter **Shooting Menu** for more detail on image aspect ratios.

Settings Recommendation: The Index marking function is very useful if you want to mark certain locations in a movie for future editing.

The View photo shooting info setting is very useful if you like to shoot 16:9 ratio 20.3 MP still images in Movie live view mode. You can toggle movie and still exposure information with the **Selected button**.

Sometimes when you are making movies the light suddenly changes when the subject moves near a window or a bright lamp in the room. The surroundings and the subject go dark while the camera adjusts to the much brighter light source. To prevent that from happening, it is a good idea to use AE lock (Hold). With a single touch of the **Selected button**, I can lock the camera at a correct exposure for the subject. If the subject walks in front of a bright window, the details outside the window will be blown out, but the subject will still be properly exposed. The camera does not change exposure levels when a sudden bright light is temporarily introduced.

However, what if I need to walk from a darker room into a bright room, or even go outside with my subject? I simply press the **Selected button** again, allow the camera to adjust to the new light source, and then press it once more to

lock the exposure again. Many moviemakers use a similar method. I find AE lock (Hold) to be the most useful function to assign to the **Selected button** when I am shooting movies.

AF lock only is an excellent function to assign to the Selected button when you need to lock the focus and not have it update automatically, for whatever reason you may have.

I often use AE lock only when I want to lock the exposure but not the focus, such as when I meter the sky away from the sun during a colorful sunset, so the sun won't excessively influence the light meter. Then I can recompose while holding the **Selected button** and take the picture.

If you are a high-speed sports shooter who needs to wring out every last drop of frame rate (frames per second, or fps) performance, you might want to use zone focusing to get the focus within acceptable range and not have autofocus slow down the camera. In that case you may want to assign the AF-ON function to the **Selected button** when you are shooting stills in Movie live view mode.

Of course, since there are eight functions, you should read about each one and experiment to find out when and why you might use it. You will likely need all of them at one time or another.

q4 Assign Shutter Button

(User's Manual - Page 248)

The g4 Assign shutter button setting lets you choose how the Shutter-release button works in Movie live view mode only. You have two choices:

- Take photos If you are in the middle of recording a movie and you absolutely must have a Large FX still image of something going on in the frame, you can acquire a 16:9 aspect ratio image by pressing the Shutter-release button all the way down. The camera will stop recording the movie and take a still image with a pixel ratio of 6016×3376 (20.3 MP). This image will closely match the format of an HDTV and a modern computer monitor because it is shorter and wider than a normal 3:2 aspect ratio FX image.
- Record movies If you are going to shoot movies for a while instead of taking still images, you can select this setting and the camera will enter Movie live view mode whenever you press the Shutter-release button halfway down. When you are in Movie live view mode, you can focus by pressing the Shutterrelease button halfway down again. Then press the Shutter-release button all the way down to start recording the movie. To stop recording the movie, simply press the Shutter-release button all the way down again. To stop Movie live view mode, press the Lv button. When you have this function selected, the camera behaves more like a true movie camera than a still camera. You

cannot, of course, take still images when using this function because the Shutter-release button is set to enter, focus, start, and stop movie recording.

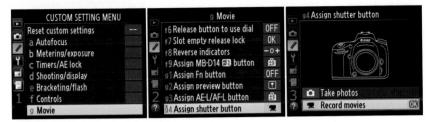

Figure 4.70 – Assign shutter button for Movie live view mode

Use these steps to assign the previously mentioned functions to the Shutter-release button:

- 1. Select g Movie from the Custom Setting Menu and scroll to the right (figure 4.70, screen 1).
- 2. Choose g4 Assign shutter button and scroll to the right (figure 4.70, screen 2).
- 3. Choose one of the two selections from the list. In figure 4.70, screen 3, Record movies is selected.
- 4. Press the OK button to lock in the setting.

Settings Recommendation: If you use the Record movies function, the camera focuses on recording a movie and turns off almost everything that has to do with still image creation. You can't take pictures, measure preset white balance, take dust off reference photos, do interval timer photography, or do most other things related to still imagery in Movie live view mode.

If you think you might need to stop a movie and take a picture, don't use Record movies; use Take photos instead. You can still shoot a movie, but you can stop the movie and get a quick 16:9 still image.

If you bought the Nikon D600 to take advantage of its superior video, you will most likely set the Record movies function and never look back. That's what I did!

If you want the D600 for both movies and 16:9 still images, Take photos may be the best setting. You have the Live view photography mode for taking still images in normal FX format. Therefore, you might want to leave the camera set to Record movies for convenience. Then, when you flip the camera to Movie live view, you can do it all with the Shutter-release button instead of searching for the tiny red Movie record button.

One thing to note is that whenever you have modified one of the Custom settings so it is no longer set to its factory default, a small asterisk will appear above the letter in the Custom setting name.

If you look carefully at Custom setting g4 Assign shutter button (figure 4.71, red arrow), you can see the small asterisk that shows it's a modified function.

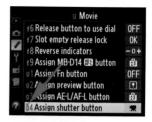

Figure 4.71 - Custom setting with modification

Author's Conclusions

We've reached the end of the biggest chapter in the book. I'm glad you stayed with me all the way through this incredibly dense series of 50 functions.

Keep in mind that all of these settings can be modified in three different ways: with user settings U1 and U2 and the non-user setting (any other Mode dial position). Your Nikon D600, like a chameleon, can change to a different style of shooting with a mere turn of the Mode dial.

We will now move on to the Setup Menu and learn about the camera's most basic settings. You won't change these settings often, but they are very important, especially for initial camera configuration. The Setup Menu configuration is not stored in the user settings like the Shooting Menu and Custom Settings Menu. Whatever you change in the Setup Menu affects the camera at all times. Let's see what more we can learn!

Setup Menu

Twenty-Seven Cents Per Gallon – Jim Hammond (hamjam)

This is likely the first menu you'll use when you prepare your new D600. Right away you'll have to set the time and date, format a memory card, and set the Monitor brightness.

The symbol for the Setup Menu is a wrench. It is about midway down the menu tree on the left (figure 5.1).

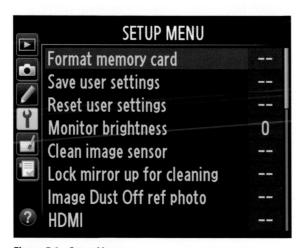

Figure 5.1 - Setup Menu

The following is a list of the 22 functions available in the Setup Menu of the D600:

- **Format memory card** This function allows you to delete all images from your memory card(s).
- Save user settings You can configure the camera under the individual user settings U1 and U2 on the Mode dial and save the settings to internal memory. The D600 will remember the settings and use them when you select U1 or U2.
- Reset user settings If you decide to return one of your user settings (U1 or U2) back to the factory default, this function will do it for you.
- *Monitor brightness* Choose the brightness level for the Monitor.
- **Clean image sensor** This function allows immediate cleaning of the imaging sensor to remove dust, or you can configure the camera to clean the sensor at startup and shutdown.
- Lock mirror up for cleaning You can safely lock the mirror up and open the shutter so you can clean the sensor with a brush, blower, or chemicals and swabs.

- Image Dust Off ref photo You can create a dust off reference photo to help remove a dust spot from images that were accidentally taken with dust on the sensor. You must use the reference photo as a guide in Nikon Capture NX2 software to remove the dust.
- HDMI You can select various HDMI sync rates for interfacing with an HDTV or monitor.
- **Flicker reduction** If you often shoot under fluorescent or mercury-vapor lights while making a movie, this function allows you to choose a frequency that matches the local electrical power supply to reduce flicker.
- *Time zone and date* Set the Time zone, Date and time, Date format, and Daylight saving time in your camera.
- Language Choose the language you would like your camera to use from a list of 28 languages. It will use the chosen language when displaying menus and screens.
- Image comment Add a comment (up to 36 characters) that embeds itself
 in the internal metadata of each image. This can help protect you from image
 theft or simply add pertinent information to each image.
- Auto image rotation This function adds camera orientation information to each image so it will display correctly on the Monitor and later on your computer monitor.
- **Battery info** This function provides information about the battery's current charge, how many pictures were taken with the battery on the current charge, and the useful life left in the battery before you should dispose of it.
- **Copyright information** You can add two items of information, including Artist (36 characters) and Copyright (54 characters). This function is designed for people who use their images commercially. It allows you to embed specific identity information in the picture's internal metadata.
- Save/load settings This function allows you to save the current menu configuration of most internal camera settings to a memory card for transfer to a computer. You can back up complex configurations and restore them to the camera when needed.
- GPS If you own a GPS that can be connected to the Nikon D600—such as
 the Accessory shoe-mounted Nikon GP-1 or another GPS unit—you can record Latitude, Longitude, Altitude, Heading, and UTC (Coordinated Universal
 Time) into the metadata of each image.
- Virtual horizon This function displays a virtual horizon on the Monitor. This
 display shows tilt to the left or right and forward or backward.
- Non-CPU lens data This function lets you select from a series of nine non-CPU lenses, such as Al and Al-S Nikkor lenses from the 1970s and 1980s. Each lens is registered within the camera with its own number so you can select it and use it later, when you mount the lens.

- AF fine-tune You can fine-tune the autofocus for up to 12 of your AF and AF-S lenses. The camera will detect which lens you have mounted and correct for front or back focus, according to your settings.
- Eye-Fi upload You can use an Eye-Fi Express or Pro wireless SD card to transmit images from your D600 to your home computer and 25 online services (e.g., Flickr). Or you can use Eye-Fi Pro X2 cards to transmit images directly to your Wi-Fi enabled computer using Ad Hoc transfer. You'll have menu access to enable or disable uploading, along with connectivity information.
- Firmware version Discover the current firmware version installed in your camera. Firmware is the camera's operating system software that is embedded on in-camera memory chips. You can upgrade it when Nikon releases new firmware that is specific to your camera.

Let's examine each of these settings in detail.

Format Memory Card

(User's Manual - Page 250)

Format memory card allows you to prepare your memory card(s) for use in your camera. This is the best way to prepare the memory card, and it should be done before you use a new one.

Interestingly, formatting a memory card doesn't actually remove any images from the card. Instead, it removes their entries from the memory card's file allocation table (FAT) so they can no longer be seen or found by the camera. Therefore, you can use card recovery software to rescue the images if you do not write anything new to the card after you format it. That is a good thing to remember in case you accidentally format a card with images you want to keep.

The D600 has two memory card slots: Slot 1 (top) and Slot 2 (bottom). You have to format each of them separately. There are two ways to format a memory card. First, you can use the Setup Menu > Format memory card function; second, you can use external camera controls. We'll look at both methods in this section.

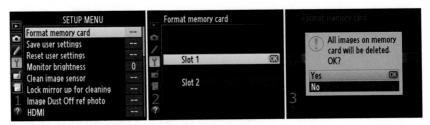

Figure 5.2 – Format memory card with Setup Menu screens

- 1. Select Format memory card from the Setup Menu and scroll to the right (figure 5.2, screen 1).
- 2. Select the card you want to format (figure 5.2, screen 2). You have a choice of Slot 1 or Slot 2. Make your selection and scroll to the right. You'll need to repeat this action to format the card in the other slot.
- 3. Select Yes from the final screen with the big red exclamation point and warning that all images will be deleted (figure 5.2, screen 3).
- 4. Press the OK button to start formatting the card. You'll see two screens in quick succession. The first will say *Formatting memory card*. A few seconds later—when the card has been successfully formatted—you'll briefly see a final screen that says *Formatting complete*. Then the camera switches back to the first screen of the Setup Menu. The card is now formatted and you can take lots of pictures.

Camera Button Format Method

This is the fastest way to format the memory card, and it is not very difficult. The camera defaults to formatting the card in the primary slot, not the secondary slot. You can select the secondary slot instead, as I'll describe in the upcoming steps. Figure 5.3 shows the buttons and Control panel screens used to format the card. Notice that these two buttons are marked with the red FORMAT symbol.

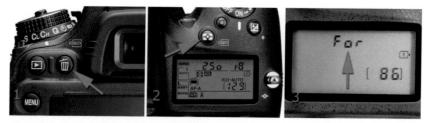

Figure 5.3 – Format memory card with camera controls

To format a memory card with external controls, follow these steps:

- 1. Hold down the Delete/format button and Metering/format button at the same time (figure 5.3, images 1 and 2) until *For* starts flashing on the Control panel (figure 5.3, image 3, red arrow).
- 2. While For is still flashing, you can rotate the Main command dial with your thumb to select either Slot 1 or Slot 2. You can see in figure 5.3, image 3, that I selected Slot 1 (the SD card symbol on the far right of the screen has a 1 in it).
- 3. While For is still flashing on the Control panel, as shown in figure 5.3, image 3 (red arrow), quickly release and instantly re-press the Delete/format button

and Metering/format button together. You'll see the screen change so For is flashing where the image count normally appears on the Control panel, which means the format operation is in process. Do not turn your camera off during formatting. When the flashing For changes back to the image count, the format operation is done.

Settings Recommendation: You can repeat the operation for the other slot on the D600 if needed. Both the Setup Menu > Format memory card and the camera button format methods are easy to use. Most people learn to use the button method since it's so fast. However, I sometimes use the Setup Menu > Format memory card method immediately after I view images on the Monitor for verification of previous transfer to my computer. If it's safe to format the card, I quickly switch to the Setup Menu to format since I'm already looking at the Monitor. It's a good idea to learn how to use both methods.

Save User Settings

(User's Manual - Page 81)

Save user settings allows you to save up to two user settings. Later you can recall those settings by selecting U1 or U2 from the Mode dial. Each user setting can save certain configuration preferences, but they can't save others. The following lists include items that can and cannot be saved:

Items that can be saved

- · Adjustments to one exposure mode (P, S, A, M, or SCENE) per user setting, including aperture (modes A and M), shutter speed (modes S and M), and flexible program mode (mode P*)
- Exposure and flash compensation (+/– EV settings)
- · Flash mode (Fill flash, Rear-curtain sync, Slow sync, Red-eye reduction, no flash, etc.)
- Focus point (currently active AF point)
- Metering mode (Matrix meter, Center-weighted area meter, Spot meter)
- · Autofocus modes (Single-servo autofocus, Continuous-servo autofocus, Auto-servo, etc.) in both Viewfinder and Live view photography modes
- AF-area modes (Single-point AF, Dynamic-area AF, Auto-area AF, etc.) in both Viewfinder and Live view photography modes
- Bracketing (Exposure, Flash, White balance, Active D-Lighting)
- Shooting Menu (19 of 25 settings can be saved; six settings cannot be saved)
- Custom Setting Menu (all 50 settings)
- · Live view photography mode and Movie live view mode settings controlled by the Custom Setting Menu or Shooting Menu (Shooting Menu > Movie settings)

- Release modes (S, CL, CH, Q, MUP)
- Storage folder (100ND600)
- File naming (DSC_1234)
- Image area (FX or DX)
- · Manage Picture Control settings
- · Multiple exposure settings
- Interval timer shooting settings
- Settings on other menus (Playback Menu, Setup Menu, Retouch Menu, My Menu, or Recent Settings menu)

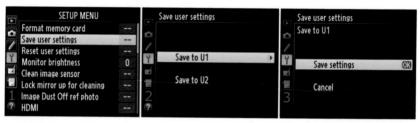

Figure 5.4 – Saving a user setting (U1 or U2)

Now, let's examine how to save a user setting. Use the following steps to save one of the two user settings (U1 and U2). This must be repeated for each of the settings:

- 1. Configure your camera's settings exactly how you want them to be saved for one user setting. Be sure to configure all the items in the *Items that can be saved* list that you want to save. When you are finished, set the Mode dial to whatever mode you want to use for the user setting (such as P, S, A, M, Auto, or SCENE), then save it. Do not select U1 or U2 on the Mode dial before you save the setting; instead, leave it set to one of the shooting modes.
- 2. Press the MENU button and select Save user settings from the Setup Menu, then scroll to the right (figure 5.4, screen 1).
- 3. Choose either Save to U1 or Save to U2 from the menu and scroll to the right (figure 5.4, screen 2).
- 4. Select Save settings from the menu (figure 5.4, screen 3).
- 5. Press the OK button to save the selected setting.

Settings Recommendation: Any time you make a modification to the Shooting Menu or Custom Setting Menu that you want to reuse, be sure to save it under one of the user settings. If you are making a temporary change, it isn't important to save it. The user settings will not change unless you resave them. However, if you want to save a particular configuration for future reuse, just set the camera

up the way you want to shoot and save the configuration under one of the user settings. Later, you can retrieve that configuration by simply selecting U1 or U2 on the Mode dial.

Reset User Settings

(User's Manual - Page 82)

Reset user settings allows you to reset one of the camera's user settings back to the factory defaults. The two user settings, U1 and U2, are independent of each other and must be reset individually. If you have a preowned D600 it is a good idea to reset both of the user settings. That way, the user settings are fresh and ready to be configured for your styles of shooting. The two choices on the Reset user settings menu are Reset or Cancel.

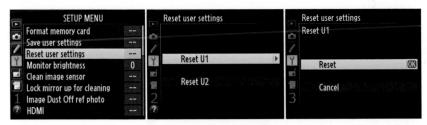

Figure 5.5 – Resetting a user setting (U1 or U2)

Here's how to reset one of your camera's user settings, either U1 or U2. Repeat these steps for each user setting:

- 1. Select Reset user settings from the Setup Menu and scroll to the right (figure 5.5, screen 1).
- 2. Select either Reset U1 or Reset U2. Scroll to the right (figure 5.5, screen 2).
- 3. Choose Reset or Cancel (figure 5.5, screen 3).
- 4. Press the OK button to lock in your setting. If you chose Reset, the selected user setting will be reset immediately.

Settings Recommendation: If I were to buy a used Nikon D600 I would definitely reset the user settings. That way I could reconfigure the camera to my own styles of shooting. It is a good idea to reset the settings on a new Nikon as well, just in case someone at the factory was fiddling around with the camera for some reason, or just to start fresh.

(User's Manual - Page 250)

Monitor brightness is more important than many people realize. If the Monitor is too dim, you'll have trouble seeing your images in bright light. If it is too bright, you might allow some images to be underexposed because they look fine on the Monitor. Even a seriously underexposed image may look okay on a screen that is too bright.

There are two selections under Monitor brightness (figure 5.6):

- Auto When the monitor is on, the camera senses the ambient light level and
 adjusts the monitor brightness accordingly. This works the same way as auto
 brightness on a smart phone or tablet. When the ambient light is bright, the
 camera will make the monitor brighter, and when the ambient light is dim,
 the camera will reduce the brightness of the monitor.
- Manual You must manually select the brightness from five steps below to five steps above zero (-5 to +5). Use the Multi selector to select the brightness you prefer by scrolling up or down.

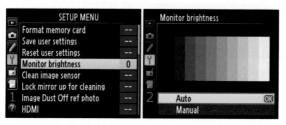

Figure 5.6 - Auto Monitor brightness level adjustment

Use the following steps to automatically adjust your Monitor brightness:

- 1. Select Monitor brightness from the Setup Menu and scroll to the right (figure 5.6, screen 1).
- 2. Choose Auto from the menu (figure 5.6, screen 2).
- 3. Press the OK Button to select your setting. The camera will now automatically adjust the screen brightness according to the ambient light level.

Next, let's see how to manually choose a brightness setting. You can select from ten levels of brightness, from -5 to +5.

Use the following steps to manually adjust your camera's Monitor brightness:

- 1. Select Monitor brightness from the Setup Menu and scroll to the right (figure 5.6.1, screen 1).
- 2. Choose Manual from the menu and scroll to the right (figure 5.6.1, screen 2).

- 3. Use the Multi selector to scroll up or down through the ten values from -5 to +5 (figure 5.6.1, screen 3). You will see the brightness of the Monitor change with each incremented step.
- 4. Press the OK button when you find the value you like best.

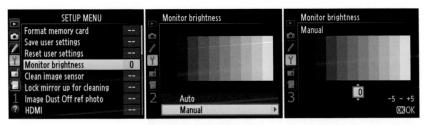

Figure 5.6.1 - Manual Monitor brightness level adjustment

Settings Recommendation: At first I used the Auto setting, but the Monitor always seemed too dim. Set the Monitor brightness to Auto and walk around under various ambient light levels while watching the Monitor brightness change. The Auto setting may work well for you.

If you decide to manually adjust the Monitor brightness, you should adjust it until you can barely make out a distinction between the last two dark bars on the left. That may be the best setting for that particular ambient light level. The camera defaults to 0 (zero), which is right in the middle, yet this setting is about right for most people.

If you choose to set your camera to a level higher than 0, be sure to check the histogram frequently to validate your exposures. Otherwise you may find that your images are slightly underexposed. The bright screen can fool you.

Clean Image Sensor

(User's Manual – Page 301)

Clean image sensor is Nikon's helpful answer to dust spots on your images caused by a dirty sensor. Dust is everywhere and will eventually get on your camera's sensor. In some cases there may be a little dust on the sensor from the factory.

Dust doesn't really get on the sensor itself because there are filters in front of it, such as the low-pass filter. The D600 cleans the sensor by vibrating the entire sensor unit, which includes the filters in front of the sensor. These highfrequency vibrations will make dust fall off the low-pass filter so you won't see it as spots on your pictures.

The vibration cleaning method seems to work pretty well. Of course, if any pollen or other sticky dust gets into the camera, the vibration system won't be able to remove it. Then it may be time for a brush or wet cleaning.

This option allows you to clean the sensor at any time. If you detect a dust spot, or just get nervous because you are in a dusty environment with your D600, you can simply select Clean now, and the camera will execute a cleaning cycle.

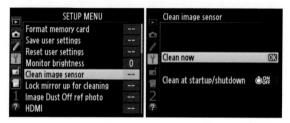

Figure 5.7 - Clean now screens

Use the following steps to immediately clean the camera's sensor:

- 1. Select Clean image sensor from the Setup Menu and scroll to the right (figure 5.7, screen 1).
- 2. Select Clean now from the menu and press the OK button (figure 5.7, screen 2).
- 3. The automatic cleaning process will begin. A screen will appear that says Cleaning image sensor. When the process is complete another screen will appear that says Done. Then the camera switches back to the Setup Menu.

Now, let's look at how to select a method for regular sensor cleaning.

Clean at Startup/Shutdown

For preventive dust control, many people set their cameras to clean the sensor at startup, shutdown, or both. There are four selections for startup/shutdown cleaning:

- Clean at startup
- Clean at shutdown
- Clean at startup & shutdown
- Cleaning off

These settings are self-explanatory. I find it interesting that I don't detect any startup or shutdown delay when using the startup/shutdown cleaning modes. I can turn my camera on and immediately take a picture. The cleaning cycle seems to be very brief in this mode.

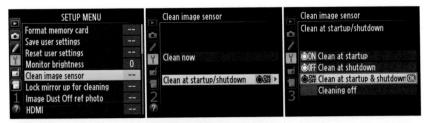

Figure 5.8 - Clean at startup/shutdown screens

Use the following steps to choose a Clean at startup/shutdown method:

- 1. Select Clean image sensor from the Setup Menu and then scroll to the right (figure 5.8, screen 1).
- 2. Choose Clean at startup/shutdown from the menu and scroll to the right (figure 5.8, screen 2).
- 3. Select one of the four methods shown in figure 5.8, screen 3. I chose Clean at startup & shutdown.
- 4. Press the OK button to lock in your choice.

Settings Recommendation: Nikon suggests that you hold the camera at the same angle as when you are taking pictures (with the bottom down) when you use these modes to clean the sensor.

I leave my camera set to Clean at startup & shutdown. If I am in a dusty environment, I usually turn my camera off and back on from time to time so it cleans the sensor.

I rarely use the Clean now method but like knowing it's there when I need it. I suspect that Clean now may have a longer cleaning cycle since it seems to take at least two or three seconds. I don't detect a several-second delay when I use the Clean at startup & shutdown method. I can shoot immediately when I turn on the camera. Of course, taking a picture may just cancel the startup cleaning.

Lock Mirror Up for Cleaning

(User's Manual - Page 303)

Lock mirror up for cleaning is for those times when the high-frequency vibration method of cleaning your D600 sensor does not dislodge some stickier-than-normal dust. You may have to clean your sensor more aggressively.

In many cases all that's needed is to remove the dust with a puff of air from a dust blower. I remember doing this to my Nikon D100 in 2002, and I was afraid I might ruin the shutter if I did it incorrectly. With the D100, I had to hold the shutter open in bulb mode with one hand while I blew off the sensor with the other hand.

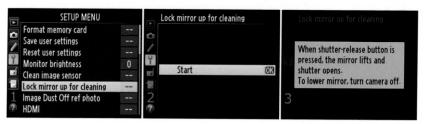

Figure 5.9 - Lock mirror up for cleaning

Use the following steps to select this mode for manual sensor cleaning:

- 1. Select Lock mirror up for cleaning from the Setup Menu and scroll to the right (figure 5.9, screen 1).
- 2. Press the OK button on Start (figure 5.9, screen 2).
- 3. A message will say that as soon as you press the Shutter-release button the camera will raise the mirror and open the shutter (figure 5.9, screen 3).
- 4. Remove the lens and press the Shutter-release button once. The sensor will now be exposed and ready for cleaning. Be careful not to let new dirt in while the sensor is exposed to air.
- 5. Clean the sensor by using a blower bulb to blow dust off (figure 5.10), or use proper cleaning fluids and pads (i.e., Eclipse fluid and Pec Pads).
- 6. Turn the camera off and put the lens back on.

Make sure you have a fresh battery in the camera because that's what holds the shutter open for cleaning. The battery must have at least a 60 percent charge or the camera won't start the process. If the battery has less than a 60 percent charge, the Lock mirror up for cleaning selection will be grayed out. If you try to force the issue and use it anyway, the camera will display a window that says, This option is not available at current settings or in the camera's current state. Use a fresh battery!

Settings Recommendation: You'll need a good professional sensor-cleaning blower, such as my favorite, the Giotto's Rocket-air blower, with a long tip for easy insertion (figure 5.10). This deluxe blower pulls air in from an opening in the bulb end of the blower instead of from the red tip of the blower. This prevents you from blowing dust you have removed back onto the low-pass filter. I bought mine from the Nikonians PhotoProShop at this website:

http://www.PhotoProShop.com

Figure 5.10 - Giotto's Rocket-air blower

If even an air blower fails to remove stubborn dust or pollen, you will need to either have your sensor professionally cleaned or do it yourself. Nikon says you'll void your warranty if you touch the low-pass filter in front of the sensor. However, many people wet or brush clean their sensor. I've done it myself, although I'll never admit it! (Oops!) If all of this makes you nervous, then send your camera off to Nikon for approved cleaning, or use a professional service.

Image Dust Off Ref Photo

(User's Manual – Page 251)

You may go out and do an expensive shoot only to return and find that some dust spots have appeared in the worst possible places in your images. If you immediately create an Image Dust Off ref photo, you can use it to remove the dust spots from your images. Then you can clean the sensor for your next shooting session.

When you use the following instructions to create the Image Dust Off ref photo, you'll be shooting a blank, unfocused picture of a pure white or gray background. The dust spots in the image will then be readily apparent to Nikon Capture NX2 software. Yes, you must use Nikon's software to automatically batchremove dust spots from a large number of images.

When you load the image to be cleaned into Capture NX2, along with the dust-off image, the software will use that image to remove the spots in your production image.

The position and amount of dust on the low-pass filter may change. You should take Image Dust Off ref photos regularly and use one that was taken within one day of the photographs you wish to clean up.

Finding a Subject for the Dust-Off Reference Photo

First, you'll need to select a featureless subject to make a photograph for the Image Dust Off ref photo. The key is to use an object that has no graininess, such as a bright white or slick plastic card. I tried using plain sheets of white paper held up to a bright window, but the resulting reference photo was unsatisfactory to

After some experimentation, I finally settled on three different subjects that seem to work well:

- · A slide-viewing light table with the light turned on
- A computer monitor with a blank white word processor document open
- · A plain white card in the same bright light in which the subject resides

All these subjects provided enough light and few enough features to satisfy both my camera and Capture NX2. The key is to photograph something fairly bright, but not too bright. You may need to experiment with different subjects if you don't have a light table or computer.

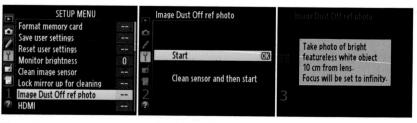

Figure 5.11 – Image Dust Off ref photo settings

Now, let's prepare the camera to take the reference photo:

- Select Image Dust Off ref photo from the Setup Menu and scroll to the right (figure 5.11, screen 1). In addition to Start, there is a Clean sensor and then start selection. Since you want to remove dust on current pictures, don't clean your sensor first. It might remove the dust bunny that is imprinted on the last 500 images you shot! Clean your sensor after you get a good Image Dust Off ref photo.
- 2. Choose Start and press the OK button (figure 5.11, screen 2). Afterward, you'll see the characters *rEF* in the Viewfinder and on the Control panel. This simply means that the camera is ready to create the image.
- 3. When the camera is ready, hold the lens about 4 inches (10 cm) away from the blank subject (figure 5.11, screen 3). The camera will not try to autofocus during the process, which is good because you want the lens at infinity. You are not trying to take a viewable picture; you're creating an image that shows where the dust is on the sensor. Focus is not important, and neither is minor camera shake. If you try to take

Figure 5.11.1 – Image Dust Off ref photo failure

- the picture and the subject is not bright enough, or if it's too bright, you will see the screen shown in figure 5.11.1. If you are having problems with too much brightness, use a gray surface instead of a white one. Most of the time this error is caused by insufficient light.
- 4. If you don't see the screen in figure 5.11.1 and the shutter fires, you have successfully created an Image Dust Off ref photo. You will find the image shown in figure 5.11.2 on your Monitor. An approximately 5.75 MB file will be created on your memory card, in the current folder, with a file extension of NDF instead of the normal NEF, TIF, or JPG (an example file name is DSC_1234.NDF). This NDF file is basically a picture of the millions of clean pixels on your im-

Figure 5.11.2 - Successful Image Dust Off ref photo

aging sensor and a few dirty ones. When displaying the NDF file on the computer or camera Monitor, you will not see an actual picture of the sensor. Instead, you will see a pleasant-looking checkerboard with the labels NDF and *Image Dust Off Ref photo* (figure 5.11.2).

You cannot display the Image Dust Off ref photo on your computer. It will not open in Nikon Capture NX2 or any other graphics program that I tried. It is used only as a reference by Capture NX2 when it's time to clean images.

Where to Store the Reference Photo

Copy the NDF file from your memory card to the computer folder that contains the images that have dust spots on them. You can now use Nikon Capture NX2 to remove the dust spots from all the images that correspond to the Image Dust Off ref photo. That process is beyond the scope of this book, but there are many good Nikon Capture NX2 books on the market that will explain it well.

White Card Tips

Remember, all your camera needs to create an Image Dust Off ref photo is a good, bright light on the imaging sensor so it can map the dust in an NDF file. If you see the warning screen in figure 5.11.1 that says Exposure settings are not appropriate, change the exposure settings and try again. Shoot another Image Dust Off ref photo with a bright and clean white surface. Put the lens very close to the surface— Nikon recommends less than 4 inches (10 cm)—and make sure it is not in focus. You might even want to manually set the lens to infinity if you are having problems with this. When you find your favorite white or gray surface for Image Dust Off ref photos, keep it safe and use it consistently.

HDMI

(User's Manual - Page 205)

HDMI (high-definition multimedia interface) allows you to display your images and movies on a high-definition TV or monitor.

If you enable Device control, the camera allows itself to be controlled by an external HDMI device using the HDMI-CEC (Consumer Electronics Control) standard.

You'll need an HDMI type A to type C cable, which is not included with the camera but is available from many electronics stores. This cable is also known as a mini-HDMI to HDMI A/V HD cable.

Figure 5.12 gives you a closeup look at both ends of the cable. The smaller end (mini-HDMI, type C) goes into the HDMI port under the HDMI/ USB cover on your camera, and the other end (HDMI, type A) plugs into your HD device. The HDMI setting has two options, Output resolution and Device control, which we'll discuss next.

Figure 5.12 – HDMI connectors

Output Resolution

You can select one of the following formats for output to your HDMI device:

- Auto (default) Allows the camera to select the most appropriate format for displaying your image on the currently connected device
- 480p (progressive) 640 x 480 progressive format
- *576p (progressive)* 720 x 576 progressive format
- 720p (progressive) 1280 x 720 progressive format
- 1080i (interlaced) 1920 x 1080 interlaced format

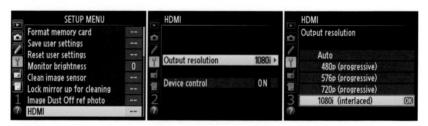

Figure 5.13 - Selecting an HDMI Output resolution

Use the following steps to select an Output resolution:

- 1. Select HDMI from the Setup Menu and scroll to the right (figure 5.13, screen 1).
- 2. Choose Output resolution from the menu and scroll to the right (figure 5.13, screen 2).

- 3. Select one of the five output resolutions (figure 5.13, screen 3).
- 4. Press the OK button to lock in your selection.

Check the user's manual for your HDMI device to find its appropriate format, or use Auto.

Device Control

Select one of the two settings that affect how you will control your HDMI device:

- On When you connect your camera to a television that supports HDMI-CEC, a simple display will appear on your TV screen. There will be two choices: Play and Slide show. When you see this display you can use your TV remote to control the camera during full-frame playback and slide shows.
- Off You must use the Multi selector to control the image display on the TV.

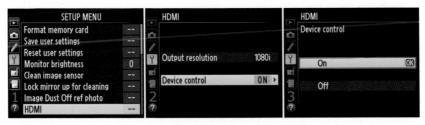

Figure 5.14 - Enable or disable Device control for HDMI-CEC

Use the following steps to enable or disable Device control:

- 1. Select HDMI from the Setup Menu and scroll to the right (figure 5.14, screen 1).
- 2. Choose Device control from the menu and scroll to the right (figure 5.14, screen 2).
- 3. Select On or Off from the menu (figure 5.14, screen 3).
- 4. Press the OK button to lock in your selection.

Settings Recommendation: These modes will be discussed in more detail in the chapter titled Movie Live view. Here we've examined only how to select the modes. Leave the HDMI mode set to Auto until you learn more about HDMI. The D600 can interface with both progressive and interlaced devices.

Flicker Reduction

(User's Manual – Page 252)

Flicker reduction allows you to attempt to match the camera's recording frequency to that of the local AC power supply so when you use Live view or shoot a movie under fluorescent or mercury-vapor lighting you can minimize flickering.

Figure 5.15 - Selecting Flicker reduction frequencies

Use the following steps to select a setting in hopes of reducing flicker:

- 1. Select Flicker reduction from the Setup Menu and scroll to the right (figure 5.15, screen 1).
- 2. Choose Auto, 50 Hz, or 60 Hz from the menu (figure 5.15, screen 2). Auto will always be used for Movie live view playback or recording.
- 3. Press the OK button to lock in your setting.

Settings Recommendation: This function is somewhat limited since there are really only two flicker settings: 50 Hz and 60 Hz. Auto just selects one of them automatically.

However, it could help to control the flickering that looks like dark horizontal bands moving through the movie. Experiment to see if it helps to switch between the two settings when you detect flicker under fluorescent or mercury-vapor lighting.

Time Zone and Date

(User's Manual - Page 253)

Time zone and date allows you to configure the Time zone, Date and time, Date format, and Daylight saving time for your camera.

If you haven't set the time and date you'll see the word CLOCK flashing on the Control panel. In addition to the main lithium ion (li-ion) battery pack, the camera has a built-in clock battery that is not user replaceable. The built-in battery charges itself from the main camera battery pack. When CLOCK blinks on the Control panel, it can also mean that the internal battery is exhausted and the clock has been reset.

It takes about two days of having a charged battery in the camera to fully charge the separate built-in clock battery. When the clock battery is fully charged, the clock will remain active without a main camera battery for up to two months.

Time Zone

Figure 5.16 shows the Time zone configuration screens. The screen used to set the time zone displays a familiar world map from which you will select the area of the world where you are using the camera.

As an example, New York is in the Eastern Time (ET) zone. I hope you remember your geography lessons! Fortunately, the camera displays some major city names below the time zone map in case you don't recognize your location.

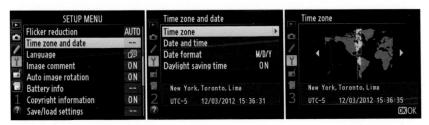

Figure 5.16 - Time zone settings

Use the following steps to set the Time zone:

- 1. Select Time zone and date from the Setup Menu and scroll to the right (figure 5.16, screen 1).
- 2. Choose Time zone from the menu and scroll to the right (figure 5.16, screen 2).
- 3. To set the Time zone, use the Multi selector to scroll left or right until your location is under the vertical yellow bar or when you see the nearest city marked with a small red dot (figure 5.16, screen 3).
- 4. Press the OK button to lock in the Time zone.

Date and Time

Figure 5.17 shows the three Date and time configuration screens. The final screen in the series allows you to select the year, month, and day (Y, M, D) and the hour, minute, and second (H, M, S).

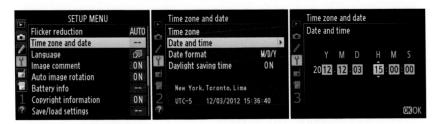

Figure 5.17 - Date and time settings

- 1. Select Time zone and date from the Setup Menu and scroll to the right (figure 5.17, screen 1).
- 2. Choose Date and time from the menu and scroll to the right (figure 5.17, screen 2).
- 3. Use the Multi selector to scroll left or right until you've selected the value you want to change. Then scroll up or down to change the value. The first set of numbers shown in figure 5.17, screen 3, includes the year, month, and day (Y, M, D). The second set of numbers includes the hour, minute, and second (H, M, S).
- 4. Press the OK button to lock in the Date and time.

Note: The time setting uses the 24-hour military-style clock. To set the clock to 3 p.m., you would set the H and M settings to 15:00. Please refer to the following 12 – to 24-Hour Time Conversion Chart.

Settings for a.m.		
12:00 a.m. = 00:00 (midnight)	06:00 a.m. = 06:00	
01:00 a.m. = 01:00	07:00 a.m. = 07:00	
02:00 a.m. = 02:00	08:00 a.m. = 08:00	
03:00 a.m. = 03:00	09:00 a.m. = 09:00	
04:00 a.m. = 04:00	10:00 a.m. = 10:00	
05:00 a.m. = 05:00	11:00 a.m. = 11:00	
Settings for p.m.		
12:00 p.m. = 12:00 (noon)	06:00 p.m. = 18:00	
01:00 p.m. = 13:00	07:00 p.m. = 19:00	
02:00 p.m. = 14:00	08:00 p.m. = 20:00	
03:00 p.m. = 15:00	09:00 p.m. = 21:00	
04:00 p.m. = 16:00	10:00 p.m. = 22:00	
05:00 p.m. = 17:00	11:00 p.m. = 23:00	

Note: There is no 24:00 (midnight). After 23:59 comes 00:00.

Date Format

The camera gives you three different ways to format its internal date:

- Y/M/D Year/Month/Day (2011/12/31)
- M/D/Y Month/Day/Year (12/31/2011)
- D/M/Y Day/Month/Year (31/12/2011)

U.S. camera owners will probably use the second setting, which matches the format used in the United States. People in other parts of the world can select their favorite date format from the two additional choices.

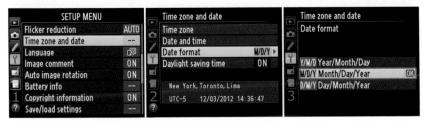

Figure 5.18 – Date format settings

Here are the steps to set the Date format:

- 1. Select Time zone and date from the Setup Menu and scroll to the right (figure 5.18, screen 1).
- 2. Choose Date format from the menu and scroll to the right (figure 5.18, screen 2).
- 3. Choose your favorite Date format from the menu (figure 5.18, screen 3). I selected M/D/Y Month/Day/Year.
- 4. Press the OK button to lock in the Date format.

Daylight Saving Time

Many areas of the world observe daylight saving time. On a specified day in spring of each year, people set their clocks forward by one hour. Then in the fall they set their clocks back, leading to the clever saying, "spring forward, fall back."

If you live in a part of the world that observes daylight saving time, turn this setting on or off as a reference only. Then adjust the camera's time to reflect your current time. The function does not automatically adjust the time for you.

Here are the steps to enable or disable the Daylight saving time reference:

- 1. Select Time zone and date from the Setup Menu and scroll to the right (figure 5.19, screen 1).
- 2. Choose Daylight saving time and scroll to the right (figure 5.19, screen 2).
- 3. Figure 5.19, screen 3, shows you the two choices for Daylight saving time: On and Off. If daylight saving time is in effect in your area (spring and summer in most areas of the United States), select On. When daylight saving time ends, you will need to change this setting to Off to adjust the clock back by one hour.
- 4. Press the OK button to lock in the setting.

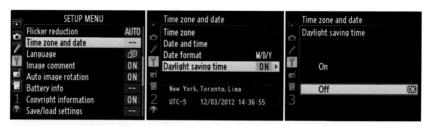

Figure 5.19 - Daylight saving time settings

Settings Recommendation: This is a relatively useless function except for helping you remember whether daylight saving time is in effect. When you set the time forward or back on your wristwatch and clocks, you will need to set it for your camera too, otherwise your images will have metadata reflecting a time that is off by one hour for half the year.

A reference I found on the support.nikonusa.com website makes this very clear: "Nikon cameras have an option for 'Daylight Saving Time,' but this will NOT automatically change your cameras time when Daylight Saving Time changes. This option is used only to reflect the correct time display, (whether you are recognizing Daylight Saving time or not). Nikon users will need to manually correct the cameras clock and change the Daylight Saving Time setting to recognize the change."

Language

(User's Manual - Pages 253, 330)

Language is a function that lets the camera know what language you prefer for the camera's menus, screens, and messages. Nikon is an international company that sells cameras and lenses around the world. For that reason, the D600 can display its screens and menus in up to 28 languages.

The D600 includes the following languages on its Setup Menu > Language screen (in alphabetic order):

Arabic

Greek

Portuguese (Portugal)

- Chinese (simplified)
- Hindi

Romanian

- · Chinese (traditional)
- Hungarian
- Russian

Czech

- Indonesian

- Danish
- Italian

Spanish

Dutch

Swedish

- Japanese
- Thai

- English
- Korean

- Finnish

Norwegian

Turkish

- French
- Polish

Ukrainian

- German
- Portuguese (Brazil)

This list of languages does not match the order found in the camera because the list was created for easy reference so you can see if your language is available. You will need to be able to read the language in order to recognize it on the menu (figure 5.20, screen 2).

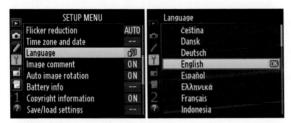

Figure 5.20 - Language selection

Use the following steps to select your preferred Language:

- 1. Select Language from the Setup Menu and scroll to the right (figure 5.20, screen 1).
- 2. Choose your preferred Language from the list shown in figure 5.20, screen 2.
- 3. Press the OK button to lock in your choice.

Settings Recommendation: The camera should come preconfigured for the main language that is spoken where you live. If you prefer a different one, use this setting to select it.

Image Comment

(User's Manual - Page 253)

Image comment is a useful setting that allows you to attach a 36-character comment to each image you shoot. The comment is embedded in the picture's internal metadata and does not show up on the image itself. I include an e-mail address in this field.

In older Nikon cameras, I place a copyright notice in Image comments; however, the Nikon D600 provides Artist and Copyright fields under the Setup Menu > Copyright information selection. We will consider Copyright information in an upcoming section.

Adding your e-mail address allows someone who is interested in your image to contact you instead of claiming it is orphaned and doing whatever they want with it. If you upload your images to a social media site or image sharing site and care about who uses the images, please add your e-mail address or other identifying information, such as a short web address, in the Image comment field.

Figure 5.21 - Attaching an Image comment

Use the following steps to create an Image comment:

- 1. Select Image comment from the Setup Menu and scroll to the right (figure 5.21, screen 1).
- 2. Select Input comment from the menu and scroll to the right (figure 5.21, screen 2).
- 3. In figure 5.21, screen 3, you'll see a series of symbols, numbers, and letters on top and a rectangle with lines at the bottom. The lines are where you will put the text of the comment you want to attach to the image. There is a blank spot just after the lowercase z, which represents a blank space that you can insert in the line of text. This can be used for separating words. Notice that the lowercase letters follow the uppercase letters.
- 4. Use the Multi selector to scroll through the numbers and letters to find the characters you want to use.
- 5. Press the OK button to insert a character. Keep inserting new characters until you have the entire comment typed into the rectangle at the bottom of the screen. I added "sample@email.com" to represent your e-mail address.
- 6. If you make a mistake, hold down the Playback zoom out/thumbnails button while using the Multi selector to move to the position of the error. Press the Delete button and the character will disappear.
- 7. Press the Playback zoom in button when you are finished entering the comment.
- 8. The camera will switch back to the screen shown in figure 5.21, screen 4. Put a check mark in the Attach comment check box so the comment will be attached to each image. To check the box, highlight the Attach comment line and scroll to the right, or press the OK button to add the check mark to the

- box. You'll see a check mark appear as soon as you scroll to the right (figure 5.21, screen 5).
- 9. Scroll up to Done and press the OK button to save the new comment (figure 5.21, screen 6).

Settings Recommendation: I add my e-mail address to Image comment because I am worried about image theft. In today's world, with so little respect for image copyright (everything on the Internet is free, right?), it's a really good idea to add identity information to the internal metadata of your images so they cannot accidentally become orphaned and revert to the public domain.

Auto Image Rotation

(User's Manual - Page 254)

Auto image rotation is concerned with how vertical images are displayed on your camera's Monitor and later on your computer. Horizontal images are not affected by this setting. The camera has a direction-sensing device, so it knows how the camera was oriented when a picture was taken.

Depending on how you have Auto image rotation set, how the Playback Menu > Rotate tall setting is configured, and the direction you hold your camera, the camera will display a vertical image either in a portrait orientation (with the top of the image at the top of the Monitor) or lying on its side in a landscape orientation (with the top of the image to the left or right side of the Monitor). The two selections are as follows:

- On With Auto image rotation turned On, the camera stores orientation information within each image, primarily so the image will display correctly in computer software. The metadata will indicate whether you were holding the camera horizontally or vertically (hand grip down), or even upside down and vertically (hand grip up). The image will display in the correct orientation on the Monitor only if you have Playback Menu > Rotate tall set to On. Auto image rotation lets the image speak for itself as to orientation, while Rotate tall lets the camera listen to the image and display it in the proper orientation.
- Off If Auto image rotation is turned Off, the vertical image will be displayed horizontally, on its side, in computer software. The top of the image will be on the left or right depending on how you held the hand grip (up or down) when you took the picture. The camera does not record orientation information in the image metadata. It will display images horizontally, even if you have the Playback Menu > Rotate tall function set to On.

Figure 5.22 - Auto image rotation settings

Use the following steps to set the Auto image rotation function:

- 1. Select Auto image rotation from the Setup Menu and scroll to the right (figure 5.22, screen 1).
- 2. Choose On or Off from the menu (figure 5.22, screen 2).
- 3. Press the OK button to lock in your selection.

If you're shooting in one of the Continuous frame advance modes (CL or CH), the position of your camera for the first shot sets the direction the images are displayed.

Settings Recommendation: If you want your images to be displayed correctly on your camera Monitor and in your computer, you'll need to be sure that Auto image rotation is set to On. I always keep mine set that way.

Battery Info

(User's Manual - Page 255)

The *Battery info* screens will let you know how much battery charge has been used (Charge), how many images have been taken with this battery since the last charge (No. of shots), and how much life the battery has before it will no longer hold a good charge (Battery age) and should be replaced.

Here are the steps to examine the Battery info:

- 1. Select Battery info from the Setup Menu and scroll to the right (figure 5.23, screen 1).
- 2. The next screen is the Battery info screen. It is just for information, so there's nothing to set (figure 5.23, screen 2).
- 3. When you've finished examining your camera's Battery info, press the OK button to exit.

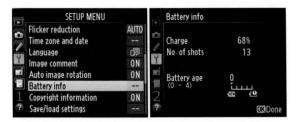

Figure 5.23 - Battery info screen

The D600 goes a step further than most cameras. Not only does it inform you of the amount of charge left in your battery, it also lets you know how much life is left. After some period of time, all batteries weaken and won't hold a full charge. The Battery age meter will tell you when the battery needs to be completely replaced. It shows five stages of battery life, from 0-4, so you'll be prepared to replace the battery before it gets too old to take many more shots.

Settings Recommendation: It's important to use Nikon brand batteries in your D600 so they will work properly with the camera. Aftermarket batteries may not charge correctly in the D600 battery charger. In addition, they may not report correct Battery age information. There may be an aftermarket brand that works correctly, but I haven't found it. Instead, I use the batteries designed by Nikon to work with this camera. I am afraid to trust a camera that costs this much to a cheap aftermarket battery of unknown origin.

Battery Info with an MB-D14 Battery Pack

If you are using the MB-D14 battery pack with an EN-EL15 battery, the Battery info screen will display a split screen. The left side of the screen shows information for the battery in the camera, and the right side shows information for the battery in the MB-D14 battery pack.

Copyright Information

(User's Manual - Page 256)

Copyright information allows you enter Artist and Copyright information. The camera will then write that information into the metadata of each image.

Here are the steps to enter your Artist and Copyright information:

- 1. Select Copyright information from the Setup Menu and scroll to the right (figure 5.24, screen 1).
- 2. Select Done from the menu and scroll to the right (figure 5.24, screen 2).
- 3. Scroll down to Artist then scroll to the right (figure 5.24, screen 3).

- 4. You'll now see the Artist screen with all the available characters (figure 5.24, screen 4). Add your name here, to a maximum of 36 characters. Use the Multi selector to scroll around within the characters. Lowercase letters follow uppercase letters. Select a character by pressing the OK button. Correct errors within the text you've already entered by holding down the Playback zoom out/thumbnails button and scrolling left or right with the Multi selector. Remove a character that's already in the name area by scrolling to it and pressing the Delete button. Press the Playback zoom in button when you have entered your name.
- 5. Now scroll down to the Copyright line on the Copyright information screen, and then scroll to the right (figure 5.24, screen 5).
- 6. Add your name using the method and controls described in step 4 (figure 5.24, screen 6).
- 7. Scroll down to the Attach copyright information line (figure 5.24, screen 7). Notice that there is no check mark in the box.
- 8. Now scroll to the right to place a check mark in the box (figure 5.24, screen 8).
- 9. Finally, scroll up to Done on the Copyright information screen (figure 5.24, screen 9).
- 10. Press the OK button to save your Artist and Copyright information.

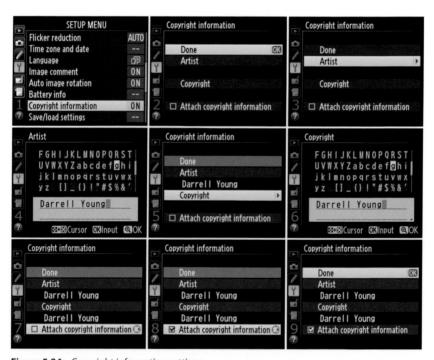

Figure 5.24 – Copyright information settings

Settings Recommendation: Be sure to add your name in both the Artist and Copyright sections of this function. With so much intellectual property theft going on these days, it's a good idea to identify each of your images as your own. Otherwise you may post an image on Flickr or Facebook to share with friends and later find it on a billboard along the highway. With the Artist and Copyright information embedded in the image metadata, you will be able to prove that the image is yours and charge the infringer.

Embedding your personal information is not a foolproof way to identify your images since unscrupulous people may steal them and strip the metadata out of them. However, if you do find one of your images on the front page of a magazine, or on someone else's website, you can at least prove that you took the image and have some legal recourse under the Digital Millennium Copyright Act (DMCA). When you take a picture, you immediately own the copyright to that image. However, you must be able to prove you took it. This is one convenient way to do so.

You'll have even more power to protect yourself if you register your images with the United States Copyright Office at the following website:

http://www.copyright.gov/

Save/Load Settings

(User's Manual - Page 257)

Do you have your D600 set up exactly the way you like it? Have you spent hours and hours reading this book and the User's Manual, or simply exploring menus, and finally have all the settings in place? Are you worried that you might accidentally reset your camera or that it could lose its settings somehow? Well, worry no more!

Save/load settings works a little like the Save user settings function we examined at the beginning of this chapter, except that Save/load settings writes configuration settings to the removable memory card—instead of storing them in the camera's internal memory (i.e., it doesn't use U1 or U2)—so you can back them up to your computer.

When you have your camera configured to your liking, or at any time, simply use the Save/load settings function to save the camera configuration to your memory card. It creates a 2 KB file named NCSETUPA.BIN in the root directory of your memory card. You can then save that file to your computer hard drive.

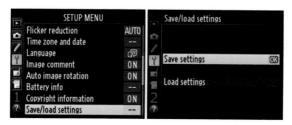

Figure 5.25 - Save/load settings

Here are the steps to save or load the camera settings:

- Choose Save/load settings from the Setup Menu and scroll to the right (figure 5.25, screen 1).
- 2. Select Save settings or Load settings from the Save/load settings screen, and then follow one of these easy procedures (figure 5.25, screen 2):
 - a) Save settings Select Save settings and press the OK button. Your most important camera settings will be saved to your memory card. Then copy the settings file (NCSETUPA.BIN) to your computer for safekeeping. Warning: You may notice that the Load settings selection on your screen in figure 5.25, screen 2, is grayed out. That simply means there are no saved settings on the card. If Load settings is not grayed out when you get ready to Save settings, be careful—you are about to overwrite previously saved settings that are currently on the memory card. The only time you'll see Load settings not grayed out is when an NCSETUPA.BIN file already exists on the memory card.
 - b) **Load settings** Insert a memory card with a previously saved NCSETUPA. BIN file on it, select Load settings, and press the OK button. The settings you previously saved will be reloaded into the D600 and will overwrite your current settings without prompting you for permission, so be sure that you are ready to have the settings overwritten. If you change the name of the NCSETUPA.BIN file, the D600 will not be able to reload your settings.

Here is a list of settings that are saved or loaded when you use Save/load settings. It doesn't save or load every setting in the D600, only the ones listed here:

Playback Menu

- Playback display options
- Image review
- After delete
- · Rotate tall

Shooting Menu

- File naming
- Role played by card in Slot 2

- Image quality
- Image size
- · Image area
- JPEG compression
- NEF (RAW) recording
- White balance (includes fine-tuning adjustments and presets d-1 to d-4)
- Set Picture Control
- · Auto distortion control
- Color space
- Active D-Lighting
- · Long exposure NR
- · High ISO NR
- ISO sensitivity settings
- Movie settings
- Remote control mode
- Movie settings

Custom Setting Menu

Custom settings (includes all configurable settings)

Setup Menu

- · Clean image sensor
- HDMI
- Flicker reduction
- Time zone and date (except date and time)
- Language
- Image comment
- Auto image rotation
- Copyright information
- GPS
- Non-CPU lens data
- · Eye-Fi upload

My Menu and Recent Settings

- My Menu (includes all items you've entered)
- Recent Settings
- Choose tab

Settings Recommendation: The Save/load settings function is a great idea. After I use my new camera for a few days and get it set up just right, I save the settings file to my computer for safekeeping. Later, if I change things extensively and want to reload my original settings, I just put the backed-up settings file on a memory card, pop it into the camera, use Load settings, and I'm back in business.

Save User Settings versus Save/Load Settings

Early in the chapter we discussed Save user settings and how you can use it to configure your camera in custom ways and save the customizations under U1 or U2 for quick access on the Mode dial. Now we have another similar-sounding function called Save/load settings. How is it different? Save/load settings does not save the camera's settings to the camera's internal memory; instead, it saves them to a removable memory card. By placing the camera's settings on a memory card, you can back them up to your computer or share them with a friend who has a D600. The Save/load settings function is completely separate from and does not affect the user settings you saved to U1 and U2.

GPS

(User's Manual – Page 175)

Nikon has wisely included the ability to geotag your images with global positioning system (GPS) location data. Now when you shoot a spectacular travel image, you can rest assured that you'll be able to find that exact spot next year. With the Nikon GP-1 GPS unit (or an aftermarket brand), the D600 will record the following GPS information about your location into the metadata of each image:

- Latitude
- Longitude
- · Altitude
- Heading
- UTC (time)

Using a GPS Unit with Your D600

The GPS unit you choose must be compatible with the National Marine Electronics Association (NMEA) 0183 version 3.01 ASCII data format.

As shown in figure 5.26, I use a Nikon GP-1 GPS unit on my D600. It's small, easy to carry and store, and works very well. The GP-1 attaches to the Accessory shoe (you can also mount it on the camera strap with the included GP1-CL1 strap adapter). You can see that the included GP1-CA90 cable is plugged into the GPS

connector on the side of the camera (look for the letters GPS on the outside of the lower Accessory terminal cover). I deliberately put the curl in the cable to keep it from sticking out awkwardly. The figure also shows the optional MC-DC2 remote release cable.

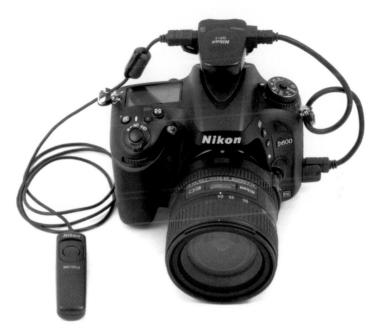

Figure 5.26 - Nikon D600 with a Nikon GP-1 GPS unit, GP1- CA90 cable, and MC-DC2 remote release cable

The GP1-CA90 cable that comes with the GP-1 also works with the Nikon D7000 and D90, and it includes a GP1-CA10 cable for Nikon cameras with a 10-pin port on the body, such as the D200, D300, D300S, D700, D2X, D3, D3S, D3X, and D4. You can also get an optional Nikon MC-DC2 remote release cable that plugs directly into the GP-1 for hands-off, vibration-free photography. This cable will fire the shutter through the GPS on any Nikon camera that is compatible with the GP-1 unit.

One thing to note about the Nikon GP-1 GPS unit is that it doesn't have a built-in digital compass, so it will not report Heading information to the camera.

Preparing the Camera for GPS Use

There are several screens to set up the D600 for GPS use. First, you have to make a decision about the exposure meter when a GPS unit is plugged into the camera. While the GPS unit is mounted (figure 5.27), the camera's exposure meter must be active to record GPS data to the image. You'll have to do one of two things:

Figure 5.27 - Nikon GP-1 mounted on the Accessory shoe

- Set the exposure meter to stay on for the entire time that a GPS is plugged in, which, of course, will increase battery drain, but it keeps the GPS locked to the satellites (no seeking time).
- Press the Shutter-release button halfway down to activate the exposure meter before you take the picture. If you press the Shutter-release button quickly and the GPS is not active and locked (indicated by a solid green light), it won't record GPS data to the image. The meter must be on before the GPS will seek satellites.

Standby Timer

Figure 5.28 shows the screens used to set the meter to stay on the entire time the GPS is connected or to shut down after the *Custom Setting Menu > c Timers/AE lock > c2 Standby timer* expires. You can select either Enable to use the c2 Standby timer or Disable to not use it (the Standby timer is called Auto meter-off in older Nikons). Here's what each setting does:

• **Enable (default)** – The meter turns off one minute after the Custom setting c2 Standby timer expires (the default is six seconds). GPS data will be recorded only when the exposure meter is active, so allow some time for the GPS unit to reacquire a satellite signal before taking a picture. This is hard to do when Standby timer is set to Enable. You just about have to stand around with your finger on the Shutter-release button to keep the meter active. I suggest using Disable, described next.

Disable – The exposure meter stays on the entire time a GPS unit is connected. As long as you have a good GPS signal, you will be able to record GPS data at any time. This is the preferred setting for using the GPS for continuous shooting. It does use extra battery life, so you may want to carry more than one battery if you're going to shoot all day. Turn the camera off between locations to conserve your battery.

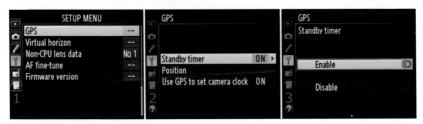

Figure 5.28 - Setting the Standby timer

Here are the steps to configure the Standby timer:

- 1. Choose GPS from the Setup Menu and scroll to the right (figure 5.28, screen 1).
- 2. Select Standby timer and scroll to the right (figure 5.28, screen 2).
- 3. Select Enable or Disable (figure 5.28, screen 3).
- 4. Press the OK button to lock in the setting.

Position

The Position setting is shown in figure 5.29, screen 2. If your GPS unit is not attached to the camera, the Position selection is grayed out.

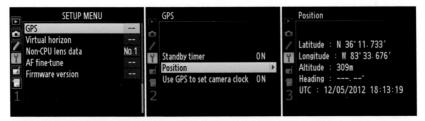

Figure 5.29 - GPS Position setting

When a GPS is attached, the screen shown in figure 5.29, screen 3, shows the actual GPS location data that is being detected by the D600. When the camera establishes communication with your GPS unit, three things will happen:

- 1. Position information appears on the GPS Position screen (figure 5.29, screen 3).
- 2. A GPS symbol will appear on the Information display (red arrow in figure 5.30). It will blink when it is acquiring a GPS signal lock, and it will stop blinking when at least three global positioning satellites have been acquired.

Figure 4.0.1 – U1 and U2 user settings

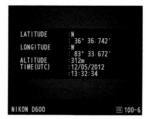

Figure 5.31 – GPS Information display screen (Playback)

3. An additional information screen will be displayed when you use the Playback button to review your images (figure 5.31). You can press up or down with the Multi selector to scroll through the image data screens on the Monitor. One of them will be the screen shown in figure 5.31, which is a picture of the GPS data screen with a dark background so you can see the numbers with no distractions. Normally the information is overlaid on top of an image.

Note: The rear LED light on the Nikon GP-1 will blink red while acquiring satellites, blink green when locked onto two satellites, and shine solid green when locked onto at least three satellites. Allow a few seconds for the GPS to acquire satellites when the camera has been turned off. If you are a great distance from where you last used the GP-1, it may require up to a minute or two to acquire a satellite lock. After the GP-1 has a local satellite lock and you turn the camera off, the GPS unit will reacquire the signal in just a few seconds when the camera is turned back on.

Use GPS to Set Camera Clock

The D600 has a cool feature designed to let the GPS satellite keep your camera's time accurate. It can query the satellite to set the clock. If you use GPS a lot, you might want to leave this on.

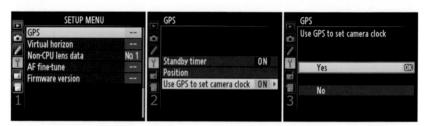

Figure 5.32 - Use GPS to set camera clock

Here are the steps to enable Use GPS to set camera clock:

- 1. Choose GPS from the Setup Menu and scroll to the right (figure 5.32, screen 1).
- 2. Select Use GPS to set camera clock and scroll to the right (figure 5.32, screen 2).
- 3. Select Yes to enable the setting or No to disable it (figure 5.32, screen 3).
- 4. Press the OK button to save the setting.

Using the GPS

If the GPS icon is flashing on the Control panel and Information display, it means that the GPS is searching for a signal (figure 5.30). If you take a picture with the GPS icon flashing, no GPS data will be recorded. If the GPS icon is not flashing, it means that the D600 is receiving good GPS data and is ready to record data to a picture. If the D600 loses communication with the GPS unit for more than two seconds, the GPS icon will disappear. Make sure the icon is displayed and isn't flashing red before you take pictures!

If you want the GPS Heading information to be accurate, keep your GPS unit pointing in the same direction as the lens. Some aftermarket GPS units contain a digital compass, unlike the Nikon GP-1. Point the GPS in the direction of your subject and give it enough time to stabilize before you take the picture, or the Heading information will not be accurate. This does not apply to the Nikon GP-1 GPS unit; it records only Latitude, Longitude, Altitude, and UTC time, not the Heading.

Settings Recommendation: Get the Nikon GP-1 GPS unit! It's easy to use, foolproof, and has all the cables you need for using it with your camera. You can also buy the optional MC-DC2 remote release cable (coiled on the left in figure 5.26). I constantly use the GP-1 when I'm shooting nature images so I can remember where to return in the future. After you start using a GPS unit, you'll find it hard to stop.

Virtual Horizon

(User's Manual - Page 258)

Virtual horizon is a function that allows you to level your camera when it's on a tripod. It's not for live picture-taking use. All it does is bring up the Virtual horizon indicator on the Monitor.

The Live view and Movie modes have a similar version of the Virtual horizon that you can see through for live usage.

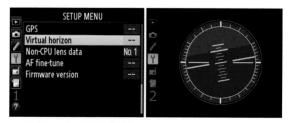

Figure 5.33 - Virtual horizon

Here are the steps to use the Virtual horizon:

- Choose Virtual horizon from the Setup Menu and scroll to the right (figure 5.33, screen 1).
- 2. The next screen shows the Virtual horizon indicator. You can use it to level the camera on your tripod (figure 5.33, screen 2). This indicator shows left or right tilts and forward or backward tilts. The Virtual horizon in screen 2 shows that the camera is tilted to the left (white and yellow bars) and the lens is tilted down (the horizon, where the brown and blue fields meet, is too high).

Settings Recommendation: In addition to Custom setting d2 Viewfinder grid display, I use the Virtual horizon when I initially set my camera up on a tripod for scenic shots. This extra discipline helps me keep the horizon level in my images. Plus, I find it easier to use than a small bubble level that is included on some tripods.

I suggest that you put Virtual horizon in My Menu (see the chapter called My Menu and Recent Settings) so you can find it easily.

Non-CPU Lens Data

(User's Manual – Page 173)

Non-CPU lens data helps you use older non-CPU Nikkor lenses with your camera. Do you still have several older AI or AI-S Nikkor lenses? I do! The image quality from the older lenses is simply outstanding with the D600 because they match the format of the FX sensor.

Since the D600 is positioned as an advanced camera, it must have the necessary controls to use both auto focus (AF) and manual focus (MF) lenses. Many photographers on a budget use the older MF lenses to obtain professional-level image quality without having to break the bank on expensive lens purchases. You can buy excellent AI and AI-S Nikkor lenses on eBay for US\$100–\$300 and have image quality that only the most expensive zoom lenses can produce.

Lens manufacturers like Zeiss and Nikkor are still making MF lenses, and because some of them do not have a CPU (electronic chip) that communicates with

the camera, it's important to have a way to let the D600 know something about the lens in use. The Non-CPU lens data function allows you to do exactly that. You can store information for up to nine separate non-CPU lenses in the D600.

Here is a detailed analysis of the Non-CPU lens data screen selections (figure 5.34, screen 2):

- Done When you have completed the setup of a particular lens, or several lenses, simply scroll to this selection and press the OK button. Your lens data will be saved in the D600. Later, you can put a non-CPU lens on your camera and select it from the list of nine lenses (1-9). You can use external camera controls or the Non-CPU lens data menu to change to your current lens.
- Lens number Using the Multi selector, you can scroll left or right to select one of your lenses. There are nine lens records available. When you select a Lens number here, the focal length and maximum aperture of that lens will show up in the Focal length and Maximum aperture fields. If you haven't stored information for a particular Lens number, you'll see double dashes (--) in the Focal length and Maximum aperture fields.
- Focal length (mm) This field contains the focal length in millimeters (mm) of the Lens number in use. You can select focal lengths from 6mm to 4000mm. Hmm, I didn't know they even made a 4000mm lens. I want one!
- Maximum aperture This field is for the Maximum aperture of the lens. You can enter an f-stop number from F1.2 to F22. Remember, this is for the maximum aperture only (largest opening or f-stop). When you've entered a maximum aperture, the camera can determine the other apertures by your use of the aperture ring on the lens (remember those?).

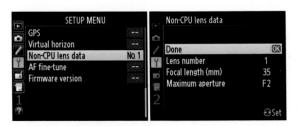

Figure 5.34 - Non-CPU lens data

Use the following steps to configure each of your non-CPU lenses for use with your D600:

- 1. Select Non-CPU lens data from the Setup Menu and scroll to the right (figure 5.34, screen 1).
- 2. Scroll down to Lens number and scroll left or right until you find the number you want to use for this particular lens, from 1–9 (figure 5.34, screen 2).

- 3. Scroll down to Focal length (mm) and scroll left or right to select the focal length (mm) of the lens. If you are configuring a zoom lens, select the widest setting (e.g., on a 24–85mm lens, select 24mm). This works because the meter will adjust for any light falloff that may occur as the lens is zoomed out.
- 4. Scroll down to Maximum aperture and then scroll left or right to select the maximum aperture of the lens. If you are configuring a variable-aperture zoom lens, select the largest aperture the lens is capable of. This works because the meter will adjust for the variation in the aperture.
- 5. Scroll to Done and press the OK button to store the setting.

The settings in figure 5.34, screen 2, are for my Al Nikkor 35mm f/2 lens, which I set to the Lens number 1 position. When you're done entering data for your nine lenses, don't forget to use the Done selection to save your work! It serves double duty by allowing you to either select a lens or save changes for the current lens. You can use the set of screens in figure 5.34 to either input data for or select an already configured non-CPU lens.

When you have selected a lens for use, the *Setup Menu > Non-CPU lens data* selection will show the number of the lens you've selected. It will be in the format of No. 1 to No. 9. Notice that in figure 5.34, screen 1, you can see the lens selection (No. 1) at the end of the Non-CPU lens data line.

Selecting a Non-CPU Lens with the Non-CPU Lens Data Menu

You can select a non-CPU lens by following these steps:

- 1. Open the Non-CPU lens data screen (figure 5.34, screen 2).
- Select a lens by scrolling left or right on the Lens number field (figure 5.35). I selected the No. 2 position, which is my Al Nikkor 105mm f/2.5 lens.
- Scroll up to the Done selection and press the OK button.

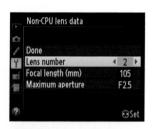

Figure 5.35 – Lens No. 2 selected

Selecting a Non-CPU Lens with External Camera Controls

The D600 allows you to customize the buttons to do things the way you want them to be done. You may have only one or two non-CPU lenses, so it may be sufficient to use the Non-CPU lens data menu to select a lens. However, if you have a large selection of non-CPU lenses, you may wish Nikon had provided more than nine lens selections in the Non-CPU lens data menu.

Since I use several older manual-focus Al Nikkor lenses, I use the assign button functions in the Custom Setting Menu so I can use the camera's Fn button to select non-CPU lenses on the fly.

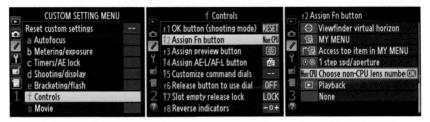

Figure 5.36 - Assign Fn button to Non-CPU lens data screens

Here are the steps to assign your camera's Fn button for this purpose (you could assign the Preview button instead):

- 1. Notice that we've left the Setup Menu briefly and switched to the Custom Setting Menu to make the button assignment.
- 2. Select f Controls from the Custom Setting Menu and scroll to the right (figure 5.36, screen 1).
- 3. Highlight Assign Fn button (or Assign preview button if you would prefer to use the Preview button) and scroll to the right (figure 5.36, screen 2).
- 4. Select Choose non-CPU lens number from the menu (figure 5.36, screen 3).
- 5. Press the OK button to lock in the assignment.

Now you can choose a non-CPU lens by holding down the Fn button (figure 5.37, image 1) while turning the Main command dial (figure 5.37, image 2) and choosing one of the nine lens selections on the Control panel (figure 5.37, image 3, bottom red arrow). You'll see n-1 to n-9 scroll by as you rotate the Main command dial. In figure 5.37, image 3, the top red arrow points to the focal length and maximum aperture of the currently selected non-CPU lens. You can see that lens n-1 is selected, which is a 35mm f/2 lens.

This is a really quick way to change the lens selection after you mount a different non-CPU lens.

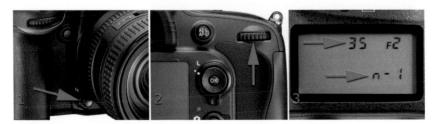

Figure 5.37 – Using the Fn button and Main command dial to select non-CPU lenses

Settings Recommendation: I like using the Fn button in combination with the Main command dial to select my non-CPU lenses, particularly when I switch non-CPU lenses often. I leave the Preview button assigned to depth of field preview. You cannot assign the AE-L/AF-L button to this function.

AF Fine-Tune

(User's Manual - Page 259)

One thing that really impresses me about the D600 is its ability to be fine-tuned in critical areas like metering and autofocus. With many older cameras, if an AF lens had a back focus problem, you either had to tolerate it or send it off to be fixed by Nikon. Now, with *AF fine-tune* controls, you can adjust your camera so the lens focuses where you want it to focus.

Nikon has made provisions for keeping a table of up to 12 lenses that you've fine-tuned. It recommends that you use the fine-tuning system only if you know what you are doing and only when required. The idea behind fine-tuning is that you can push the focus forward or backward in small increments, with up to 20 increments in each direction.

When the green AF indicator comes on in your Viewfinder and AF fine-tune is enabled for a lens you've already configured, the actual focus is moved from its default position forward or backward by the amount you've specified. If your lens has a back focus problem and you move the focus a little forward, the problem is solved. There are four selections on the AF fine-tune menu:

- AF fine-tune (On/Off)
- · Saved value
- Default
- · List saved values

Figure 5.38 - Fine-tuning the focus of a lens

Use the following steps to start the process of fine-tuning a lens:

 Choose AF fine-tune from the Setup Menu and scroll to the right (figure 5.38, screen 1).

- 2. Select AF fine-tune (On/Off) and scroll to the right (figure 5.38, screen 2).
- 3. The next four subsections show the screens to configure AF fine-tune. Each of the figures continues where figure 5.38, screen 2, leaves off.

AF Fine-Tune (On/Off)

Figure 5.39 shows the AF fine-tune (On/Off) screen and its selections. The two values you can select are as follows:

- On This setting turns on the AF fine-tune (On/Off) system. Without this setting enabled, the D600 focuses like a factory-default D600. Set AF fine-tune (On/Off) to On if you are planning to fine-tune a lens now.
- Off This default setting disables the AF fine-tune (On/Off) system.

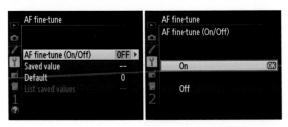

Figure 5.39 - Enabling AF fine-tune

Saved Value

With an autofocus lens mounted, Saved value allows you to control the amount of front or back focus you'd like to input for the listed lens. At the top left of figure 5.40, screen 2, just under the words Saved value, you can see the focal length of the lens that is mounted on your camera (24-85mm), the aperture range (F3.5-4.5 VR), and the number assigned to the lens. If you're configuring a lens for the first time, you'll see NO. --. You can fine-tune a maximum of 12 lenses. After you save a lens configuration, a number will appear in place of the dashes (NO. 00 to NO. 99). Remember, you can save values for only 12 lenses, but you can number the lenses from 00 to 99.

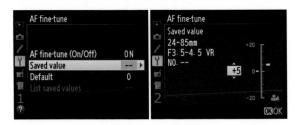

Figure 5.40 - Fine-tuning a lens with a Saved value

Default

The Default configuration screen looks a lot like the Saved value screen, except no lens information is listed. The Default value will be applied to all AF lenses you mount on your camera. If you are convinced that your particular camera always has a back or front focus problem and you are not able or ready to ship it off to Nikon for repair, you can use the Default value to push the autofocus in one direction or the other until you are satisfied that your camera is focusing the way you'd like. Again, this will affect all autofocus lenses you mount on your camera.

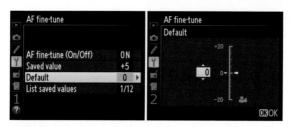

Figure 5.41 - Setting a Default fine-tuning value

As shown in figure 5.41, screen 2, to set a Default value, use the scale that runs from +20 on the top to -20 on the bottom. The yellow pointer starts at 0. You can move this yellow pointer up or down to change the amount of focus fine-tuning you want for all lenses you mount on the camera, if no value already exists in the Saved value for the lens. Moving the pointer up on the scale pushes the focal point away from the camera (front focus), and moving it down pulls the focal point toward the camera (back focus). When you are done, press the OK button.

List Saved Values

Notice in figure 5.42 that there are several screens to configure the list of saved values. List saved values helps you remember which lenses you've fine-tuned, with a camera-controlled number from 1–12. From screen 1 it is apparent that my camera has three (of 12) lenses registered for fine-tuning (3/12).

Figure 5.42 - List saved values

The camera also allows you to set an identification number of your choice for each lens numbered from 00–99. Some people use the last two digits of the lens serial number as an identification number for that lens. In figure 5.42, screen 2, you can see a list of lenses with the last two digits of their serial numbers entered as identification numbers (44, 71, and 30). If you do not like this method, simply use whatever two-digit numbers make sense to you.

Notice in figure 5.42, screen 3, that there is a yellow box in the middle after NO. This box is where you set the identification number you want to use for each particular lens. The number in the box scrolls from 00 to 99. Use the Multi selector to scroll up or down until the number of your choice is shown in the box. Press the OK button to connect the identification number to the lens.

Notice at the bottom of figure 5.42, screen 2, that you can delete any of the lenses you have registered. Simply press the Delete button and answer Yes to the screen that pops up asking for permission to delete.

Settings Recommendation: AF fine-tune is good to have! If I buy a new lens and it has focus problems, I don't keep it. Back it goes to the manufacturer for a replacement. However, if I buy a used lens or have had one long enough that it's out of warranty and it later develops front or back focus problems, the camera allows me to fine-tune the autofocus for that lens. An advanced camera has these little necessities to keep you out of trouble when you shoot commercially.

Eye-Fi Upload

(User's Manual - Page 260)

Eye-Fi upload appears on the Setup Menu of your D600 only when you have an Eye-Fi card inserted.

Eye-Fi makes several SD/SDHC cards with builtin Wi-Fi transmitters. Figure 5.43 shows my Eye-Fi Pro X2 16 GB high-speed Class 10 SDHC card.

With an Eye-Fi card inserted into your camera and Eye-Fi software installed on a computer with a wireless network connection, you can take

Figure 5.43 - Eye-Fi Pro X2 16 GB Wi-Fi card

pictures and they are automatically transferred to your computer. You can also simultaneously transfer images to file-sharing and social-media websites like Flickr and Facebook (plus several more).

Most lower-cost Eye-Fi cards require a wireless network to transfer the images. However, Eye-Fi recently came out with a card that will do Ad Hoc transfers, meaning that they don't need a wireless network connection and will send pictures directly to a computer with wireless capability. In effect, the Eye-Fi card becomes a Wi-Fi transmitter that can communicate directly with a Wi-Fi-enabled computer—without an intervening network.

At the time of this writing, only two cards—the Eye-Fi Pro X2 8 GB and Eye-Fi Pro X2 16 GB—can transfer images directly to a computer without a wireless network. Other cards cost less but require a wireless network to move images.

Eye-Fi designates cards that are capable of Ad Hoc transfer as Pro cards. Current Eye-Fi cards are named Pro X2, Mobile X2, and Connect X2. Older Eye-Fi cards have names like Geo X2 and Explore X2. Only the Pro X2 cards are capable of Ad Hoc file transfers. Since memory card prices are extremely volatile, I'm sure that the capacities and names will change quickly.

Enabling Eye-Fi Uploads on the D600

An Eye-Fi card does not use any more battery life than a normal SD card until you enable Wi-Fi. Unless you are currently shooting images for transfer, I don't recommend leaving the Eye-Fi upload feature enabled. Why waste battery life where there are no wireless networks? To make it really convenient to access the Eye-Fi upload function—when needed—I simply added it to My Menu. We'll examine how to do that in the chapter titled **My Menu and Recent Settings**.

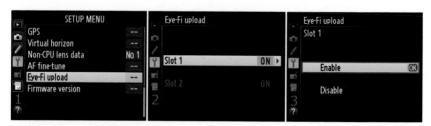

Figure 5.44 - Enabling Eye-Fi upload

Here are the steps to Enable or Disable Eye-Fi upload:

- Choose Eye-Fi upload from the Setup Menu and scroll to the right (figure 5.44, screen 1).
- Select which slot you want to enable or disable (Slot 1 or Slot 2). The camera will detect which slot has an Eye-Fi card in it (figure 5.44, screen 2). My D600 has an Eye-Fi card in Slot 1 only, so Slot 2 is grayed out. I suppose you could

use an Eye-Fi card in both slots, so Nikon provides the ability to Enable or Disable the card in either slot.

- 3. Select Enable or Disable from the Eye-Fi upload screen (figure 5.44, screen 3).
- 4. Press the OK button to lock in the setting.

Note: You can download additional information about using an Eye-Fi card, called Eye-Fi Card Information, from this book's downloadable resources at these websites:

http://www.nikonians.org/NikonD600 http://rockynook.com/NikonD600

Settings Recommendation: I wanted to buy a nice Nikon WT-4 wireless transmitter until I saw the price. Whew! I think I'd rather buy that Nikkor lens I have my eye on. Instead, I bought an Eye-Fi card for about one-eighth the price of the WT-4. It doesn't give me the large wireless range and multiple modes the powerful WT-4 transmitter offers, but I can shoot an event within 50-90 feet of my notebook computer and have reasonably fast, wireless, Ad Hoc file transfer capability.

Since even the low-priced Eye-Fi cards have the ability to use an existing Wi-Fi connection to transfer images through the Internet to a home computer, you could do a photographic walkabout, stop at your favorite café, and use their wireless connection to transfer images to your home computer while you eat. I really like this little Eye-Fi card!

Firmware Version

(User's Manual - Page 260)

Firmware version is a simple informational screen, like the Battery info screen. It informs you which version of the camera's operating system (firmware) your camera is running. My camera is currently running version A1.00, B1.00, and L1.002.

Here are the steps to see the Firmware version of your camera:

- 1. Choose Firmware version from the Setup Menu and scroll to the right (figure 5.45, screen 1).
- 2. Examine the Firmware version (figure 5.45, screen 2).
- 3. Select Done and press the OK button.

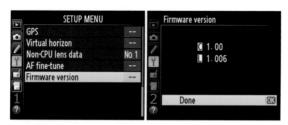

Figure 5.45 – Viewing the camera's Firmware version

Upgrading Your Camera's Firmware

From time to time Nikon releases firmware upgrades for their cameras. You may want to install the upgrades for the D600 because they often fix bugs, speed things up, and even add features to your camera.

When you are ready to upgrade your camera's firmware, you can go to the downloadable resources websites for this book and download a document called **Firmware Upgrade**:

http://www.nikonians.org/NikonD600 http://rockynook.com/NikonD600

Author's Conclusions

Whew! The D600 may seem like a complicated little beast, but that's what you get when you fold advanced-level functionality into a relatively compact HD-DSLR body. For as complex as it is, I'm certainly delighted with it.

Next, we'll consider how to use the camera's Retouch Menu to adjust images without using a computer. If you are in the field shooting RAW files and you need a quick JPEG or black-and-white version of a file, the Retouch Menu has you covered.

You can even do things like Red-eye correction, Color balance changes, filtration, cropping, and image resizing—all without touching a computer. Let's see how!

Retouch Menu

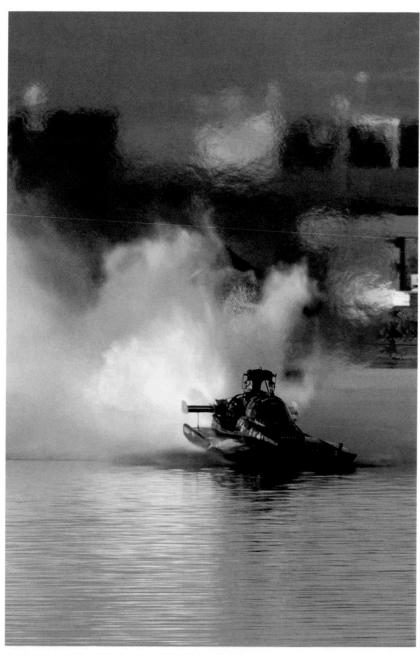

Spirit of Texas in Semi Finals – Donald Heldoorn (TakeTwo)

Retouching allows you to modify your images in-camera. If you like to do digital photography but don't particularly like to adjust images on a computer, these functions are for you. Obviously, the camera Monitor is not large enough to allow you to make extensive creative changes to an image, as you can with Nikon Capture NX2 or Photoshop on a computer. However, it is surprising what you can accomplish with the Retouch Menu.

The D600 has 20 Retouch Menu selections. The following is a list of each function and what it does:

- D-Lighting This feature opens up detail in the shadows and tends to protect highlight details from blowing out. This is similar to the Shooting Menu > Active D-Lighting function, but it's applied after the image is taken.
- **Red-eye correction** This removes the unwanted red-eye effect caused by light from a flash reflecting back from the eyes of human subjects.
- **Trim** This feature creates a trimmed (cropped) copy of a selected photograph. You can crop the image to several aspect ratios, including 1:1, 3:2, 4:3, 5:4, and 16:9.
- Monochrome You can convert your color images to monochrome. There
 are three tints available, including Black-and-white (grays), Sepia (reddish),
 and Cyanotype (bluish).
- **Filter effects** Seven filter effects are available that can be applied to the image to change its appearance. The seven filters are Skylight, Warm filter, Red intensifier, Green intensifier, Blue intensifier, Cross screen, and Soft.
- **Color balance** To change the color balance of your image, you can increase or decrease the amount of Green, Blue, Amber, and Magenta.
- Image overlay This creates a new image by overlaying two existing NEF (RAW) files. Basically, you can combine two RAW images to create special effects—like adding an image of the Moon into a separate landscape picture.
- **NEF (RAW) processing** You can create highly specialized JPEG images from your NEF (RAW) files without using your computer.
- Resize You can take a full-size image and convert it to several smaller sizes.
 This is useful if you would like to send an image via e-mail or if you need a smaller image for other reasons.
- Quick retouch The camera automatically tweaks the image with enhancements to saturation and contrast. In addition, when a subject is dark or backlit, the camera applies D-Lighting to open up shadow detail.
- **Straighten** You can straighten an image with a crooked horizon by rotating it in-camera until it looks good. The camera will trim (crop) the edges of the image to create a normal perspective without the tilt.
- **Distortion control** You can remove barrel and pincushion distortion that affects the edges of the image. You can cause the camera to make automatic

6 Theory

- adjustments, or you can do it manually. The camera automatically trims (crops) the edges of the image after adjustment.
- Fisheye This feature allows you to incrementally bulge images from their centers in an often hilarious way to get that strange fisheye effect you can often see while looking through a door peephole. It provides a very distorted image that will make your friends either laugh or chase you. Warning: This effect can be dangerous to use on wives, sisters, and girlfriends! (Don't ask me how I know!)
- Color outline This creates an outline effect, as if you had traced an underlying image on paper with a pencil. The effect is monochrome, contrary to the name of the function. Nikon provides this effect to "create an outline of a photograph to use as a base for painting." If you are a painter, this may be useful to you.
- Color sketch This effect is very similar to Color outline; the main difference is that the result is in pastel color. The edges of the subjects in your image are sketched and colorized, similar to using colored pencils or crayon. You can control the vividness of the color and the contrast of the line edges.
- Perspective control This is a useful control that helps adjust perspective distortion out of an image. It's useful for pictures of things like buildings, which can have a falling-over-backward effect when shot with a wide-angle lens. You can adjust the building so it looks more natural. The camera automatically crops the edges of the image to allow the distortion to be removed.
- Miniature effect This effect allows you to create a reverse diorama (an image with a very limited band of sharpness that is taken from a high vantage point) to make the image look fake. The image may be of a real subject, like a city shot from the top of a tall building; however, the Miniature effect causes the scene to look artificial, as if small models of reality were used.
- Selective color You can use this function to create photographs with certain elements in color and the rest in black-and-white. Imagine a bright red rose with no color in the image except the rose petals. You can selectively choose a color with an eyedropper icon, and only that color will appear in the image.
- Edit movie You can shorten a movie by cropping out a small section from a large movie file.
- Side-by-side comparison You can compare a retouched image—created via the Retouch Menu—with the original image. The images are presented side by side so you can see the before and after versions.

The Retouch Menu of the D600 is shown in figure 6.1. It is the fifth menu down the menu selection bar, just below the Setup Menu. Its icon resembles a palette and paintbrush.

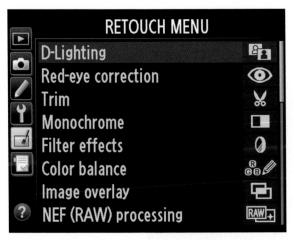

Figure 6.1 - Retouch Menu

Retouched File Numbering

When you use Retouch Menu items, the D600 does not overwrite your original file. It always creates a JPEG file with the next available image number. The retouched image will be numbered as the last image on the memory card. If you have 100 images on your card and you are retouching image number DSC_0047, the new JPEG image will be number DSC_0101 (it will be the 101st image).

Accessing the Retouch Functions – Two Methods

There are two methods for accessing the Retouch Menu. You can use the main Retouch Menu—under the MENU button—to choose an image to work with, or you can display an image in Playback mode and press the OK button to open the Retouch Menu. They work basically the same way, except the Playback Retouch Menu leaves out the step of choosing the image (since there is already an image on the screen), and it has fewer retouch selections. The most comprehensive retouch selections are available under the Retouch Menu.

Since both the Playback Retouch Menu and Retouch Menu methods have the same functions, we'll discuss them as if you were using the Retouch Menu. However, in case you decide to use the Playback method, let's discuss it briefly.

Playback Retouching

Use the following steps if you want to work with an image that you are viewing on the Monitor—what I call Playback retouching.

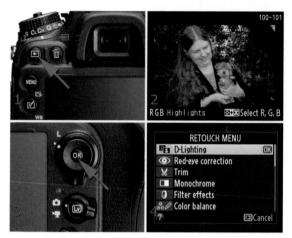

Figure 6.2 - Playback Retouch Menu

To use the Retouch Menu options, follow four basic steps:

- 1. Press the Playback button and choose a picture by displaying it on the Monitor (figure 6.2, images 1 and 2). You now have a picture ready for retouching.
- 2. Press the OK button to open an abbreviated Retouch Menu (figure 6.2, image 3).
- 3. Select one of the Playback Retouch Menu items (figure 6.2, screen 4).
- 4. Press the OK button when you have a Playback Retouch Menu item selected. You will then see the settings that you can apply to your picture.

Some of the Retouch Menu options are not available under the Playback Retouch Menu. Remember that Playback retouching is available by simply pressing the OK button when an image is displayed on the Monitor.

Limitations on Previously Retouched Images

Sometimes there are limitations imposed when you are working on an image that has already been retouched. You may not be able to retouch a previously retouched image with another retouch function. When you use the Playback retouch method, the items will be grayed out on the menu. If you use the Retouch Menu directly, any images that are overlaid with a box containing a yellow X cannot be retouched again with the current retouch function.

Using Retouch Menu Items Directly

The following functions work backwards from the Playback Retouch Menu just described. Instead of selecting an image first, you must select a Retouch Menu function first and then select an image to which you want to apply the effect. Let's consider each Retouch Menu function.

D-Lighting

(User's Manual - Page 264)

D-Lighting allows you to reduce the shadows in an image and maybe even rein in the highlights a bit. It lowers the overall image contrast, so it should be used sparingly. The D600 is not aggressive with its D-Lighting, so you can use it quickly if needed. Also, remember that Retouch Menu effects are applied to a copy of the image, so your original is safe.

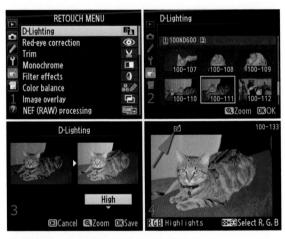

Figure 6.3 - D-Lighting Retouch Menu

Use the following steps to apply D-Lighting to an image:

- 1. Select D-Lighting from the Retouch Menu and scroll to the right (figure 6.3, screen 1).
- 2. Select the image you want to modify and press the OK button (figure 6.3, screen 2). You'll see the image surrounded by a yellow box.
- 3. Choose the amount of D-Lighting you want for the chosen image by using the Multi selector to scroll up or down. You'll choose from Low, Normal (or medium), and High D-Lighting (figure 6.3, screen 3). When the image on the right of the side-by-side comparison looks the way you want it to, press the OK button to save the new file.

4. The D600 will display a brief *Image saved* notice and then display the new file on the Monitor. The retouched image will have a small palette-and-paint-brush icon to show that it has been retouched (figure 6.3, screen 4, red arrow). The original image is still available for future retouching.

Settings Recommendation: There is no one setting that is correct for all images. I often use Normal (medium) to see if an image needs more or less D-Lighting, then I change it to High or Low if needed. Remember that any amount of D-Lighting has the potential to introduce noise in the darker areas of the image, so the less D-Lighting you use, the better.

Red-Eye Correction

(User's Manual - Page 264)

Red-eye correction attempts to change bright red pupils—caused by reflected light from the flash—back to their normal dark color. Red eye makes a person look like one of those aliens with glowing eyes from a science fiction show. If you've used flash to create a picture, the Red-eye correction function will work on the image if it can detect any red eye. If it can't detect red eye in the image, it will not open the red-eye system and will briefly display a screen that says *Unable to detect red-eye in selected image*.

If you try to select Red-eye correction for an image in which flash was not used, the camera will display a screen that says *Cannot select this file*.

Use the following steps to execute the Red-eye correction function:

- 1. Select Red-eye correction from the Retouch Menu and scroll to the right (figure 6.4, screen 1).
- 2. Select the image you want to modify and press the OK button (figure 6.4, screen 2).
- 3. You'll see an hourglass on the Monitor for several seconds (figure 6.4, screen 3) while the Red-eye correction process takes place.
- 4. After Red-eye correction is complete, you can use the Playback zoom in button to zoom in on the image to see how well it worked. Zoom back out with the Playback zoom out/thumbnails button. Press the OK button to save the file with a new file name (figure 6.4, screen 4, red arrow) or press the Playback button to cancel.
- 5. You'll see an *Image saved* message screen (figure 6.4, screen 5) and then the saved image will appear on the Monitor (figure 6.4, screen 6). Again, you can tell it is a retouched image because of the palette-and-paintbrush symbol above the top left corner of the image. This newly retouched image will have its own new file number.

Figure 6.4 - Red-eye correction

Settings Recommendation: I've found that the Red-eye correction function works pretty well as long as the subject is fairly large in the frame. The image of the lovely young lady in figure 6.4, screen 4, had only minor red eye. That gives you an idea of how large in the frame the subject has to be for this function to work well. With small subjects, I've had it correct one eye that was closer to the camera (and therefore larger in the image) and not the other. I have also tried Red-eye correction for larger groups of people. Sometimes it works and other times it doesn't.

I would rate this function as quite helpful but not always effective. However, it's a good function for quick Red-eye correction on critical images you need to use immediately.

Trim

(User's Manual - Page 265)

The *Trim* function allows you to crop an image in-camera, change its aspect ratio, and save the file as a new image. Your original image is not modified.

This is a useful function if you need to cut out, or trim, the most useful area of an image to remove distracting elements from the background.

Use the following steps to Trim an image in-camera:

- 1. Select the Trim function from the Retouch Menu and scroll to the right (figure 6.5, screen 1).
- 2. Select the image you want to modify (figure 6.5, screen 2). Press the OK button when you have selected your target image.

- 3. You'll see a screen that has a crop outlined in yellow (figure 6.5, screen 3). Use the Playback zoom out/thumbnails button to crop or trim more of the image or the Playback zoom in button to crop less. Use the Multi selector to move the yellow selection rectangle in any direction within the frame until you find the best trim.
- 4. Select the Aspect ratio of the crop by rotating the Main command dial. Your choices are 3:2, 4:3, 5:4, 1:1 (square), or 16:9. Figure 6.5, screen 3 (red arrow), shows that the 1:1 Aspect ratio is selected.
- 5. When you have the crop correctly sized and the Aspect ratio set, press the OK button to save the image with a new file name, the results of which are seen in figure 6.5, screen 4. Before the retouched image is displayed you will see an *Image saved* message screen appear briefly.

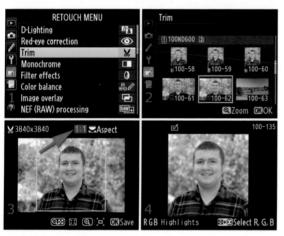

Figure 6.5 - Trim function

Settings Recommendation: This is a very useful function for cropping images without a computer. The fact that you have multiple Aspect ratios available is just icing on the cake. The D600 has some useful Aspect ratios, including a square (1:1) and an HD format (16:9).

Monochrome

(User's Manual – Page 266)

The *Monochrome* function in the D600 is fun to play with and can make some nice images. Converting the images to one of the three monochrome tones is a good starting point for creative manipulation. The three different types of Monochrome are as follows: Black-and-white (grays), Sepia (golden tone), and Cyanotype (blue tone).

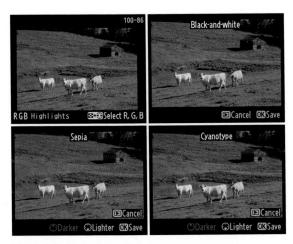

Figure 6.6 - Monochrome images

Figure 6.6 shows a sample of a normal color image and the three monochrome tones you can use. I chose the Darker setting on the Sepia and Cyanotype versions to show their maximum effects. Notice that the Black-and-white version has no darkness or lightness setting because the D600 provides only one level. However, for Sepia and Cyanotype, you can fine-tune the tint from light to very saturated in three levels.

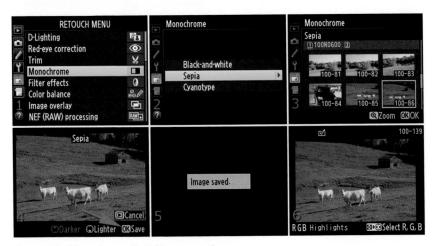

Figure 6.7 – Monochrome (Sepia) image creation

Use the following steps to create a Monochrome image from a color image:

1. Select Monochrome from the Retouch Menu and scroll to the right (figure 6.7, screen 1).

- 2. Select a Monochrome tone—Black-and-white, Sepia, or Cyanotype (figure 6.7, screen 2). I selected Sepia.
- 3. Select the image you want to modify (figure 6.7, screen 3).
- 4. For a Black-and-white image, you cannot adjust the level of lightness or darkness. For Sepia and Cyanotype, you can use the Multi selector to saturate or desaturate the tone (figure 6.7, screen 4). Scroll up or down and watch the screen until the tint is as dark or light as you want it to be. You can cancel the operation by pressing the Playback button.
- 5. Press the OK button to save the image with a new file name (figure 6.7, screen 4, red arrow).
- 6. A screen that says Image saved will briefly appear, then the final image will be displayed with a retouch icon in the top left of the Monitor (figure 6.7, screens 5 and 6).

Settings Recommendation: I normally use the Black-and-white conversion when I need an immediate Monochrome image. However, it's a lot of fun to make a new image look old-fashioned with either Sepia or Cyanotype. Figure 6.8 is a Sepia creation of three lovely ladies, with a border added in Photoshop.

Figure 6.8 - Sample Sepia image conversion (border from Photoshop manipulation)

Filter Effects

(User's Manual – Page 267)

The D600 allows you to add one of seven Filter effects to an image. You can intensify the image colors in various ways, add starburst effects to points of light, and add a softening effect for a dreamy look.

Here is a list of the effects:

- Skylight
- · Warm filter
- · Red intensifier
- · Green intensifier
- Blue intensifier
- Cross screen (starburst filter)
- Soft

Skylight Filter Effect

This effect is rather mild and removes the blue effect caused by atmospheric diffraction in distant scenes. This effect makes an image slightly less blue.

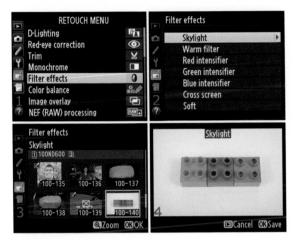

Figure 6.9 - Skylight filter effect

Use the following steps to choose the Skylight filter effect:

- 1. Select Filter effects from the Retouch Menu and scroll to the right (figure 6.9, screen 1).
- 2. Select Skylight and scroll to the right (figure 6.9, screen 2).
- Choose an image and press the OK button (figure 6.9, screen 3). You can zoom in by pressing the Playback zoom in button if you want to examine the image first.
- 4. You will see the image with the Skylight effect added (figure 6.9, screen 4). Press the OK button to save the image with a new file name, or press the Playback button to cancel.

Warm Filter Effect

The Warm filter effect adds a mild red cast to the image to make it appear a little warmer.

Here's how to set the Warm filter effect:

- 1. Select Filter effects from the Retouch Menu and scroll to the right (figure 6.10, screen 1).
- 2. Select Warm filter and scroll to the right (figure 6.10, screen 2).
- 3. Choose an image and press the OK button (figure 6.10, screen 3). You can zoom in by pressing the Playback zoom in button if you want to examine the image first.

4. You will see the image with the Warm filter effect added (figure 6.10, screen 4). Press the OK button to save the image with a new file name, or press the Playback button to cancel.

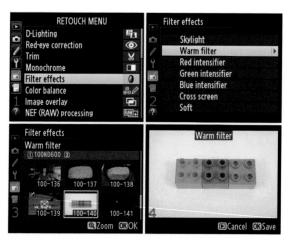

Figure 6.10 - Warm filter effect

Red Intensifier Filter Effect

The Red intensifier filter effect intensifies the reds in an image and adds a red cast. This effect can be controlled by making an initial selection then increasing or decreasing the effect by using the Multi selector to scroll up or down when the image is on-screen. Even though it doesn't tell you, there are three levels of intensity. The default level is applied first. You can scroll up with the Multi selector for the maximum effect and scroll down for the minimum effect.

Here's how to set the Red intensifier filter effect:

- 1. Select Filter effects from the Retouch Menu and scroll to the right (figure 6.11, screen 1).
- 2. Select Red intensifier and scroll to the right (figure 6.11, screen 2).
- 3. Choose an image and press the OK button (figure 6.11, screen 3). You can zoom in by pressing the Playback zoom in button if you want to examine the image first.
- 4. You will see a new image with the Red intensifier effect added (figure 6.11, screen 4). Press the OK button to save the image with a new file name, or press the Playback button to cancel.

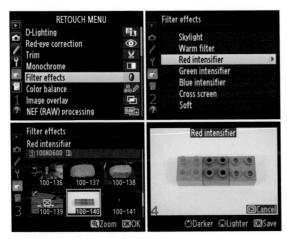

Figure 6.11 - Red intensifier filter effect

Green Intensifier Filter Effect

The Green intensifier filter effect intensifies the greens in an image and adds a green cast. This effect can be controlled by making an initial selection and then increasing or decreasing the effect by using the Multi selector to scroll up or down when the image is on-screen. Even though it doesn't tell you, there are three levels of intensity. The default level is applied first. You can scroll up with the Multi selector for the maximum effect and scroll down for the minimum effect.

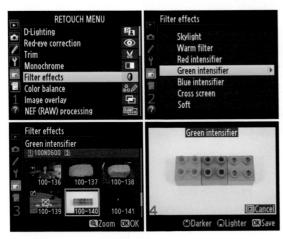

Figure 6.12 - Green intensifier filter effect

- 1. Select Filter effects from the Retouch Menu and scroll to the right (figure 6.12, screen 1).
- 2. Select Green intensifier and scroll to the right (figure 6.12, screen 2).
- 3. Choose an image and press the OK button (figure 6.12, screen 3). You can zoom in by pressing the Playback zoom in button if you want to examine the image first.
- 4. You will see a new image with the Green intensifier effect added (figure 6.12, screen 4). Press the OK button to save the image with a new file name, or press the Playback button to cancel.

Blue Intensifier Filter Effect

The Blue intensifier filter effect intensifies the blues in an image and adds a blue cast. This effect can be controlled by making an initial selection then increasing or decreasing the effect by using the Multi selector to scroll up or down when the image is on-screen. Even though it doesn't tell you, there are three levels of intensity. The default level is applied first. You can scroll up for the maximum effect and scroll down for the minimum effect.

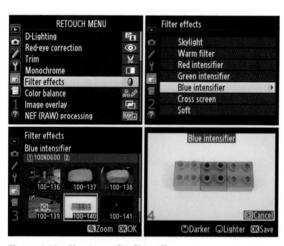

Figure 6.13 - Blue intensifier filter effect

Here's how to set the Blue intensifier effect:

- 1. Select Filter effects from the Retouch Menu and scroll to the right (figure 6.13, screen 1).
- 2. Select Blue intensifier and scroll to the right (figure 6.13, screen 2).

- 3. Choose an image and press the OK button (figure 6.13, screen 3). You can zoom in by pressing the Playback zoom in button if you want to examine the image first.
- 4. You will see a new image with the Blue intensifier effect added (figure 6.13, screen 4). Press the OK button to save the image with a new file name, or press the Playback button to cancel.

Cross Screen Filter Effect

The Cross screen filter effect adds a starburst to any points of light. There are four adjustments for this effect, along with Confirm and Save commands. My subject for this test is two candle flames at a distance, shot from above.

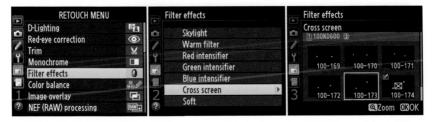

Figure 6.14 - Cross screen filter effect

To create the Cross screen filter effect, use the following steps:

- 1. Select Filter effects from the Retouch Menu and scroll to the right (figure 6.14, screen 1).
- 2. Select Cross screen and scroll to the right (figure 6.14, screen 2).
- 3. Choose an image with the Multi selector and press the OK button (figure 6.14, screen 3). You can zoom in by pressing the Playback zoom in button if you want to examine the image first.
- 4. Now follow steps 5 through 10. Step 5 and figure 6.15 start where figure 6.14, screen 3, leaves off.
- 5. The first adjustment is the Number of points (4, 6, or 8) in the starburst. Scroll to the right to select the Number of points (figure 6.15, screen 1). In figure 6.15, screen 2, you can see that an icon with the number of rays in the starburst is provided along with a numeral. I selected 8 points. Press the OK button to lock in your selection. You can zoom in by pressing the Playback zoom in button if you want to examine the image first. You will follow the same procedure for the next three adjustments, which are Filter amount, Filter angle, and Length of points on the starburst.

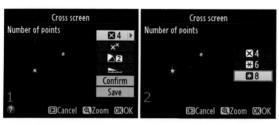

Figure 6.15 - Cross screen filter effect - Number of points

6. The second adjustment is the Filter amount (figure 6.16, screen 1). This adjustment affects the brightness of the light source(s). The more Xs, the brighter the light source. I selected the maximum level in figure 6.16, screen 2.

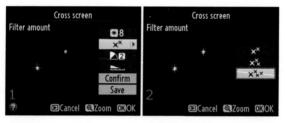

Figure 6.16 - Cross screen filter effect - Filter amount

7. Select the angle of the starburst rays with the Filter angle adjustment. You can rotate the rays in a clockwise direction until the starburst is at the angle you prefer (figure 6.17, screen 1). Notice that the rays are rotated clockwise by a few degrees in figure 6.17, screen 2. This is not a strong effect, but you can rotate the rays a few degrees in either the clockwise (3) or counterclockwise (1) direction.

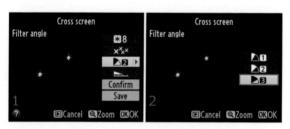

Figure 6.17 - Cross screen filter effect - Filter angle

8. Select the length of the starburst rays with the Length of points adjustment (figure 6.18, screen 1). I wanted the longest rays, so I selected the bottom setting in figure 6.18, screen 2. If you look closely, you can see that the rays are slightly longer in figure 6.18, screen 2.

Figure 6.18 - Cross screen filter effect - Length of points

9. Select Confirm to see the effect applied to your image (figure 6.19). This is like an update button. You can change the adjustments in steps 5 through 8 multiple times and Confirm them each time to see the updated image until the effect is the way you want it. You must do the Confirm step after each change or you will not see a difference.

Figure 6.19 - Cross screen filter effect - Confirm

10. Select Save and press the OK button (figure 6.20, screen 1). After a moment you'll see a screen that says *Image saved* (figure 6.20, screen 2). Then you'll see the full-size image in normal Playback mode (figure 6.20, screen 3).

Figure 6.20 - Cross screen filter effect - Save

Settings Recommendation: As previously mentioned, the subject for the Cross screen filter test is two candles on a black background, looking down from above the candles. The D600 is more sensitive to the size of the points of light than previous Nikon cameras I've worked with. The size of the points of light had to be significantly smaller to have the starburst effect show up.

If you are testing this effect and can't get the rays to appear, you may need to make the points of light smaller, but not too small. Try shooting a candle in a darkened area as an experiment. You will soon learn how small the point of light must be. The length of the candle flame can also make a difference.

In figure 6.16, screen 1, you can see that only one of the candles displayed a burst of rays until I selected a stronger, brighter effect. Small, round points of light work best with this effect.

Soft Filter Effect

The Soft filter effect is designed to give your subject that dreamy look popularized by old movies, where the beautiful woman looks soft and sweet. You can select from three levels of softness: Low, Normal, and High.

Figure 6.21, screens 1–4, show small versions of the original image and the three softness settings: screen 1 = Original, screen 2 = Low, screen 3 = Normal, screen 4 = High.

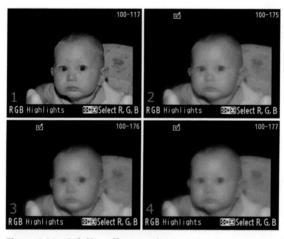

Figure 6.21 - Soft filter effect samples

This is an interesting effect. Even though the overall image has a softness to it after the effect has been applied, the subject is still somewhat sharp. It doesn't look like the image is soft because of poor focus or camera movement. It's like a softness has been overlaid on the image, and the original image is still sharp. You would have to see this misty look in a full-size image to understand what I mean.

Here are the steps to select one of the Soft filter levels:

- 1. Select Filter effects from the Retouch Menu and scroll to the right (figure 6.22, screen 1).
- 2. Choose Soft from the menu and scroll to the right (figure 6.22, screen 2).

- 3. Select the image to receive the Soft filter effect and press the OK button (figure 6.22, screen 3). You can zoom in if you want to examine the image first by pressing the Playback zoom in button.
- 4. You'll see the word Normal surrounded by a yellow rectangle (figure 6.22, screen 4, red arrow). Use the Multi selector to scroll up or down and select one of the softness levels (Low, Normal, or High). The small image on the left is the original image, and the one on the right is the adjusted image. You can easily see the softness vary as you select different levels. Choose the level you want to use.
- 5. Press the OK button to save the new image and display it on the Monitor, as shown in figure 6.21.

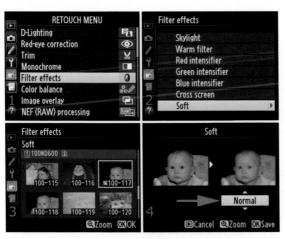

Figure 6.22 – Soft filter effect settings

Settings Recommendation: In comparing the levels of softness, I tend to like the Normal setting best. The Low setting looks like I made a mistake, and the High setting is too soft. Compare the three levels and see which one works best for you.

Color Balance

(User's Manual - Page 268)

Color balance lets you deliberately add various tones to your pictures. You can visually add a light or strong color cast.

You might want to warm things up a bit by adding a touch of red, or cool things down with a touch of blue. Or you could get creative and add various

- Green
- Blue
- Amber
- Magenta

Figure 6.23 shows four samples of the tints. Notice that the red arrow in the first screen points to the color box. You move the little black square around in the color box to add tints to the image. In all four images, you can see that I moved the black square into a different area of the color box. The small picture above the color box shows how the final saved image will look. You can return the square to the center of the color box to neutralize any tints.

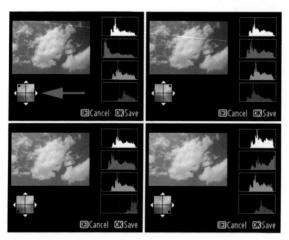

Figure 6.23 – Color balance samples

On the right side of each screen you can see the RGB histogram for the image. As you make color changes you will see the color shift in the histograms. Be careful not to overdo any particular color (clip it off on the right) or you will blow out the color channel, which removes all detail from that color. We'll discuss the histogram in the chapter titled **Metering, Exposure Modes, and Histogram**.

Use the following steps to modify the Color balance in your image:

- 1. Select Color balance from the Retouch Menu and scroll to the right (figure 6.24, screen 1).
- 2. Select the image you want to modify and press the OK button (figure 6.24, screen 2). You can zoom in by pressing the Playback zoom in button if you want to examine the image first.

- 3. Use the Multi selector to move the black indicator square in the color box toward whatever color makes you happy (figure 6.24, screen 3). Watch the histograms as they display the changing color relationships in the red, green, and blue color channels. You can see the color changes as they are applied to the small version of your image in the upper-left corner of the screen.
- 4. Press the Playback button to cancel, or press the OK button to save the image with a new file name. The new image will then be displayed on the Monitor (figure 6.24, screen 4). You can tell it is a retouched image by the inclusion of the palette-and-paintbrush symbol in the top left corner of the screen.

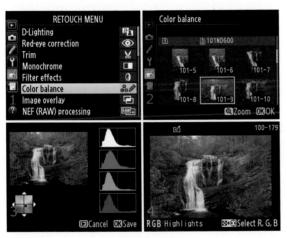

Figure 6.24 - Color balance settings

Settings Recommendation: This is a cool function for persnickety people, and I'm one of them! If you like to fine-tune the color of your pictures—but hate using the computer—here's your control. You can introduce almost any color tint to an image by moving the black square in any direction within the color box, using combinations of colors to arrive at one that pleases you. This also allows you to offset existing color casts that were caused by the color temperatures of various light sources.

Image Overlay

(User's Manual - Page 269)

The Image overlay function is a nice way to combine two RAW images as if they were taken as a multiple exposure. You can select two NEF (RAW) shots and combine them into a single new overlaid image.

The results can be a lot like what you get when you use Shooting Menu > Multiple exposure, but Image overlay gives you a visual way to overlay two

Image Overlay Ideas

You can set up all sorts of special effects with Image overlay, from duplicating a person in a picture to making another person look transparent. Here's how:

- Overlay idea # 1: Shoot two separate pictures of the same person against a solid colored background. Have the person stand on the right side in one picture and on the left side in the other picture. Have the person extend a hand, as if to shake hands. Overlay the two images and adjust the density to match. See if you can make people believe that long-lost twins just met.
- Overlay idea # 2: With your camera on a tripod, take a picture of someone sitting on the left side of a couch. Without moving the camera, shoot another person sitting on the right side of the same couch. Overlay the two images and lower the density of the second image so it is partially transparent, or ghosted.

Use the following steps to do an Image overlay:

- 1. Select Image overlay from the Retouch Menu and scroll to the right (figure 6.25, screen 1).
- 2. Insert the first RAW image in the Image 1 box (outlined in yellow) by pressing the OK button and selecting an image (figure 6.25, screen 3). Press the OK button again to return to the combination screen (figure 6.25, screen 4). You can vary the gain (density) of the first image by using the Multi selector to scroll up or down in the X1.0 field (figure 6.25, screen 4). The X1.0 setting is variable from X0.1 to X2.0. It lets you control how bright (transparent) or dark (dense) an image is so it can more closely match the density of the other image in the overlay. X1.0 is normal image density.
- 3. Use the Multi selector to move the yellow box to the Image 2 position (figure 6.25, screen 5). Press the OK button, select the second picture (figure 6.25, screen 6), then press the OK button again to insert the image (figure 6.25, screen 7). Use the X1.0 field to vary the density of the second image. Try to match the density as much as possible to provide a realistic overlay, unless you are trying to create a special effect, such as ghosting.
- 4. Use the Multi selector to move the yellow box to the Preview area. You'll see two selections below it: Overlay and Save. Choose one of them and press the OK button (figure 6.25, screen 8).
- 5. If you select Overlay, the D600 will temporarily combine the images, and you'll see a preview screen that displays a larger view of the new image. You can

- press the OK button to save the image with a new file name, or you can press the Playback zoom out/thumbnails button to return to the previous screen.
- 6. If you choose Save instead of Overlay and press the OK button, the D600 immediately combines the two images and saves the new image with a new file name without letting you preview the image first. Basically, the Save selection saves now, and Overlay gives you a preview of the combination so you can modify or save it.

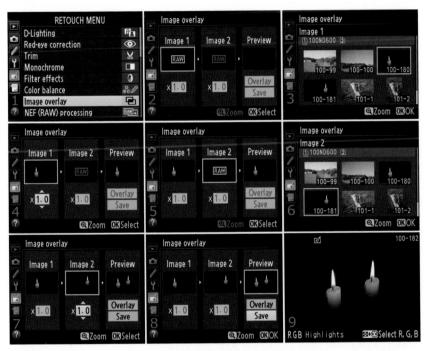

Figure 6.25 – Image overlay (combining two images into one)

Settings Recommendation: This is an easy way to overlay images without a computer. There are some drawbacks, though. One image may have a strong background that is impossible to remove, no matter how much you fiddle with the image density (X0.1 to X2.0). This is a situation in which a computer excels, since you can use software tools, like masking in Capture NX2 or Photoshop, to remove parts of the background and make a more realistic overlay. However, if you must combine two simple images in the field, you have a way to do it in-camera.

NEF (RAW) Processing

(User's Manual - Page 271)

NEF (RAW) processing is a function that allows you to convert a RAW image to a JPEG inside the camera. If you normally shoot in RAW but need a JPEG quickly, this is a great function. It works only on images taken with the D600, so you can't insert a card from a different Nikon camera and expect to process those images.

There are a lot of things you can do to an image during NEF (RAW) processing. A RAW file is not yet an image, so the camera settings you used when you took the picture are not permanently applied. In effect, when you use NEF (RAW) processing you are applying the camera settings to the JPEG image after the fact, and you can change the settings you used when you originally took the picture.

You can apply settings when you take a picture through the Shooting Menu or by using external camera controls. However, with NEF (RAW) processing, the settings are applied to the image after the fact, instead of while shooting. See the chapter titled **Shooting Menu** for a thorough explanation of each setting.

Let's see how to convert a RAW image to JPEG—in the camera. If you don't like working with computers but like to shoot RAW images, this is an important function!

Here's a list of post-shooting adjustments you can make with in-camera NEF (RAW) processing, with basic explanations of each function:

- Image quality With NEF (RAW) processing, you are converting a RAW file to
 a JPEG file, so the camera gives you a choice of FINE, NORM, or BASIC. These
 are equivalent to the Shooting Menu > Image quality settings called JPEG fine,
 JPEG normal, or JPEG basic.
- Image size This lets you select how large the JPEG file will be. Your choices are L, M, or S, which are equivalent to the Large (24.2 MP), Medium (13.6 MP), and Small (6.0 MP) settings in Shooting Menu > Image size.
- White balance This lets you change the White balance of the image after you've already taken the picture. You can select from a series of symbols that represent various types of White balance color temperatures. As you scroll up or down in the list of symbols, notice that the name of the corresponding White balance type appears just above the small picture. You can see the effect of each setting as it is applied.
- **Exposure comp.** This function allows you to brighten or darken the image by applying +/– Exposure compensation to it. You can apply exposure compensation up to 2 EV in either direction (+2.0 to -2.0 EV).
- Picture Control With this setting you can apply a different Picture Control
 than the one with which you took the image. It shows abbreviations—such

- as SD, NL, VI, MC, PT, or LS—for each Picture Control, plus any Custom Picture Controls you might have created with the designation of C-1, C-2, C-3, and so forth.
- High ISO NR You can change the amount of High ISO NR applied to the image. The camera has H, N, L, or Off settings, which are equivalent to the Shooting Menu > High ISO NR settings called High, Normal, Low, and Off.
- Color space You can choose from the camera's two Color space settings: sRGB or Adobe RGB. Adobe RGB is abbreviated as AdobeRGB in this setting. This is equivalent to the Shooting Menu > Color space setting.
- Vignette control This setting allows you to control how much automatic vignette (dark corner) removal you want to use. If a particular lens regularly causes light falloff in the corners of your pictures, this function can be useful. You can select from H, N, L, or Off.
- **D-Lighting** This lets you manage the level of contrast in the image by brightening the shadows and protecting the highlights. You have four choices: Low (L), Normal (N), High (H), and Off.
- **EXE** This simply means execute. When you select EXE and press the OK button, all your new settings will be applied to a new JPEG image, and it will be saved to the memory card with a separate file name.

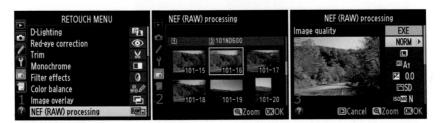

Figure 6.26 - NEF (RAW) processing

Now, let's look at the steps you can use to convert a file from NEF (RAW) to JPEG in-camera:

- 1. Select NEF (RAW) processing from the Retouch Menu and scroll to the right (figure 6.26, screen 1).
- 2. Select a RAW image with the Multi selector and then press the OK button (figure 6.26, screen 2). Only NEF (RAW) images will be displayed. Now we'll look at each setting shown in figure 6.26, screen 3. The following steps, and figures 6.27 through 6.39, begin where figure 6.26, screen 3, leaves off.
- 3. Select one of the Image quality settings—FINE, NORM, or BASIC—from the Image quality menu (figure 6.27). FINE gives you the best possible quality in a JPEG image. After you select the setting you want to use, press the OK button to return to the main NEF (RAW) processing configuration screen. You can

cancel the operation with the Playback button. You can zoom in to check the image quality with the Playback zoom in button.

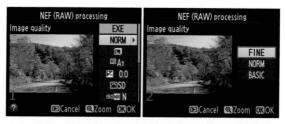

Figure 6.27 - NEF (RAW) processing - Image quality

4. Select one of the Image size settings from the Image size menu (figure 6.28). Your choices are L (24.2 MP), M (13.6 MP), and S (6.0 MP).

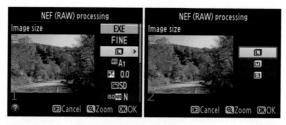

Figure 6.28 - NEF (RAW) processing - Image size

- Select the setting you want to use then press the OK button to return to the main NEF (RAW) processing configuration screen. You can cancel the operation with the Playback button.
- 6. Select one of the White balance settings for your new JPEG (figures 6.29 to 6.32). You can choose from AUTO, Incandescent, Fluorescent, Direct sunlight, Flash, Cloudy, Shade, K-Choose color temp., or PRE Preset manual (figure 6.29, screen 2). A1 and A2 (figure 6.29, screen 3) refer to normal and slightly warmer White balance settings. The tint of the White balance can be fine-tuned in figure 6.29, screen 4. Please review the chapter titled **White Balance** for information on each of these items. The Fluorescent, K, and PRE settings have additional screens with choices that you must select. Let's examine the extra screens in those three settings.

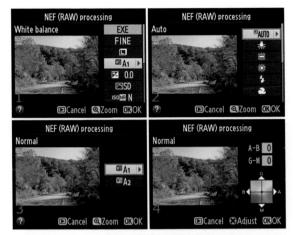

Figure 6.29 - NEF (RAW) processing - White balance

a) Fluorescent – You must choose a type of fluorescent light. There are seven choices, with names like Sodium-vapor, Warm-white, Cool-white, and so forth. Each choice has a number assigned to it. Figure 6.30, screen 3, shows Cool-white fluorescent, which is number 4 on the list. Scroll to the right to move to the fine-tuning screen, where you can adjust the color tint of the image by moving the black dot in the color box with the Multi selector (figure 6.30, screen 4). You can immediately press the OK button for no changes, or you can make fine-tuning changes and press the OK Button to save the setting, or you can press the Playback button to cancel.

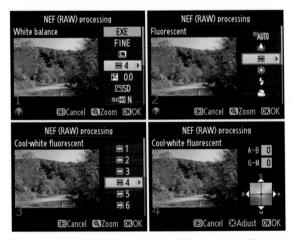

Figure 6.30 - NEF (RAW) processing - White balance - Fluorescent

b) **K-Choose color temp.** – You can choose a color temperature from the list shown in figure 6.31, screen 3. Remember that color temperatures change how the image color looks by warming it (red) or cooling it (blue). The list ranges from 2500K (cool) to 10000K (warm). You can also use the fine-tuning screen to modify the color's base (figure 6.31, screen 4). Press the OK button to save the setting, or press the Playback button to cancel.

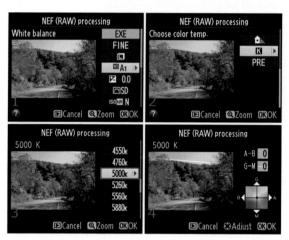

Figure 6.31 - NEF (RAW) processing - White balance - K-Choose color temp.

c) PRE-Preset manual – With this setting you can choose a saved White balance while letting the camera measure the ambient light reflected from a gray or white card (the PRE method). See the chapter titled White Balance for information on doing ambient light (PRE) readings. You can choose from up to four previous PRE readings that are stored in memory locations d-1 to d-4 (figure 6.32, screen 3). As you scroll through the list of settings, you'll see the color temperature of the image change. My current d-1 setting contains a White balance in the 5K area—the color of the foliage looks about right for a sunny autumn day, which is about 5500K. Select the setting you want to use and press the OK button to return to the main NEF (RAW) processing configuration screen, or you can scroll to the right and fine-tune the colors of the individual White balance (figure 6.32, screen 4). You can see your fine-tuning adjustment change the color temperature of the image. If you decide you don't want to fine-tune the White balance, simply press the OK button when you get to the fine-tuning screen. The camera will return to the main NEF (RAW) processing configuration screen. You can cancel the operation by pressing the Playback button.

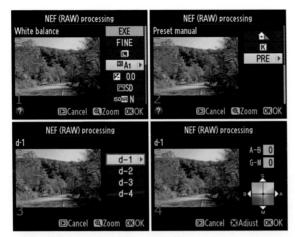

Figure 6.32 - NEF (RAW) processing - White balance - PRE-Preset manual

7. Now you can lighten or darken the image by selecting an Exposure comp. value from -2.0 - +2.0 EV steps (figure 6.33, screen 2). When the image looks right, press the OK button to return to the main NEF (RAW) processing configuration screen. You can cancel the operation by pressing the Playback button.

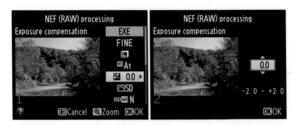

Figure 6.33 - NEF (RAW) processing - Exposure comp.

8. Next you can apply a Nikon Picture Control or one of your own Custom Picture Controls, if you've created any (figure 6.34, screen 2). These controls change how the image looks. You can make it sharper and give it more contrast, give it more or less color saturation, or change it to monochrome. In fact, you can even modify the settings of the current Picture Control by using the finetuning screen (figure 6.34, screen 3). Choose from SD (Standard), NL (Neutral), VI (Vivid), MC (Monochrome), PT (Portrait), LS (Landscape), or C-1 to C-9 (Custom Picture Controls), which appear farther down the list than shown in figure 6.34, screen 2. You can scroll to the right with the Multi selector if you want to fine-tune the image (figure 6.34, screen 3). Scroll up or down to select one of the settings—Sharpening, Contrast, Brightness, and so forth—and scroll left or right to modify the selected setting. If you make a mistake and want to start over, press the Delete button. The camera will display a screen

that says Selected Picture Control will be reset to default settings. OK? Choose Yes or No and press the OK button. If a Picture Control is different than the factory default, an asterisk will appear next to its name in all menus. The Monochrome (MC) Picture Control lets you adjust not only things like Sharpening, Contrast, and Brightness in the fine-tuning screen, but it also gives you toning (tint) controls like the Shooting Menu > Set Picture Control function. When the image looks right, press the OK button to return to the main NEF (RAW) processing configuration screen. You can cancel the operation by pressing the Playback button.

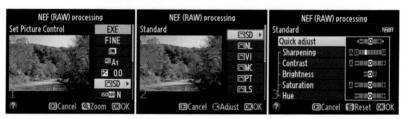

Figure 6.34 - NEF (RAW) processing - Picture Control

9. If the image needs high ISO noise reduction, you can apply it now (figure 6.35, screen 1). You have a choice of four settings: High (H), Normal (N), Low (L), or Off (figure 6.35, screen 2). Choose one and press the OK button to return to the main NEF (RAW) processing configuration screen. You can cancel the operation by pressing the Playback button. You can zoom in and check the image by pressing the Playback zoom in button.

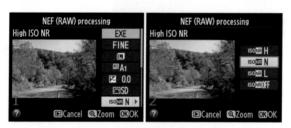

Figure 6.35 - NEF (RAW) processing - High ISO NR

10. Color space lets you choose one of the camera's two color space settings: sRGB or Adobe RGB (figure 6.36, screen 2). Choose one and press the OK button to return to the main NEF (RAW) processing configuration screen. You can cancel the operation with the Playback button. You can zoom in and check the image first by pressing the Playback zoom in button.

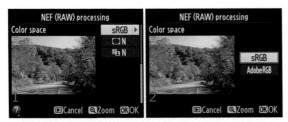

Figure 6.36 - NEF (RAW) processing - Color space

11. Vignette control allows you to lighten the corners of your images automatically. One minor problem with a full-frame sensor is that the extra bending of light that reaches to the corners of the frame can cause a small amount of light falloff, or darkening of the corners and edges. This is called vignetting. The camera has four settings to control vignetting: high (H), normal (N), low (L), or Off. The default is normal (N), which is generally the setting I use.

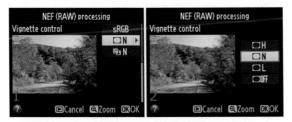

Figure 6.37 - NEF (RAW) processing - Vignette control

12. D-lighting (figure 6.38) is very similar to Shooting Menu > Active D-Lighting in that it restores shadow detail and protects highlights in your images. However, D-Lighting is applied after the fact, and Active D-Lighting is applied at the time the image is taken. Otherwise they are basically the same thing. You can select from high (H), normal (N), low (L), or Off (figure 6.38, screen 2). Press the OK button to set the D-Lighting level, or press the Playback button to cancel.

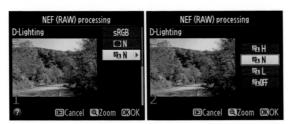

Figure 6.38 – NEF (RAW) processing – D-Lighting

Figure 6.39 - NEF (RAW) processing - EXE (execute)

This is a nice way to create specialized JPEG images from NEF (RAW) files without using a computer. How much longer will it be until our cameras come with a keyboard, monitor, and mouse ports? They are computerized, after all!

Settings Recommendation: NEF (RAW) processing is a complex, multistep process because you're doing a major conversion from NEF (RAW) to JPEG incamera, without using your computer. You're in complete control of each level of the conversion and can even replace the camera settings you originally used when you took the picture. If you want to simply convert the image without going through all these steps, just choose the EXE selection and press the OK button. That will convert the image with the camera settings you used to do the previous conversion, or it will use the factory default settings if you have never converted an image.

Resize

(User's Manual - Page 272)

The *Resize* function allows you to convert an image from a full-size 24.2 MP picture (6016 x 4016) to a smaller one, with four extra-small sizes. This function appears to be designed so you can create images that can easily be e-mailed or used on a website or blog.

There are three selections:

 Select image – This selection allows you to choose one or more images for resizing

- Choose destination This selection allows you to choose a destination for
- Choose size You can choose from four sizes:
 - a) 1920×1280 2.5 M
 - b) 1280×856 1.1 M
 - c) 960×640 0.6 M
 - d) 640×424 0.3 M

Let's examine the steps for resizing images:

1. Select Resize from the Retouch Menu and scroll to the right (figure 6.40, screen 1). Although it seems out of order, select Choose destination and scroll to the right (figure 6.40, screen 2). Select one of the card slots to be the destination for the resized images and press the OK button (figure 6.40, screen 3). This selection will be grayed out if one of the memory card slots is empty. In that case the destination will be the card slot that contains a card. Skip this step if you are using only one memory card.

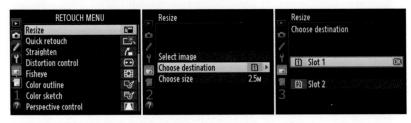

Figure 6.40 - Resize - Choose destination

2. Next, select Choose size and scroll to the right (figure 6.41, screen 2). You'll see four sizes, from 2.5 M to 0.3 M (figure 6.41, screen 3). These are the actual megapixel sizes available for images after you save them. Select a size and press the OK button.

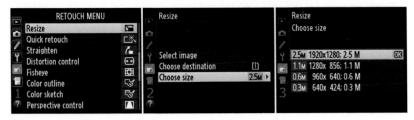

Figure 6.41 – Resize – Choose size

3. Next, choose Select image and scroll to the right (figure 6.42, screen 2). You'll see six image thumbnails. Use the Multi selector to scroll around in this group of thumbnails. When you see an image you want to resize, press the Playback

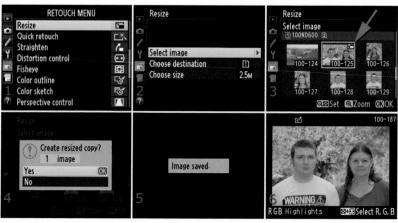

Figure 6.42 - Resize - Select image

Settings Recommendation: I use this function when I'm in the field and want to make a small image to send via e-mail. The full-size JPEG file is often too large to send through some e-mail systems. It's nice to have a way to reduce the image size without having to find a computer. Please notice that this function does not reduce the image size by cropping, like the Trim function we studied earlier. Instead, it simply reduces the image in the same aspect ratio as the original, and it has a smaller megapixel size.

Quick Retouch

(User's Manual – Page 273)

If you want to simply adjust an image so that all parameters are within viewable range, use the Quick retouch function. It creates a new copy of an existing image with "enhanced saturation and contrast," according to the User's Manual.

D-Lighting is automatically applied to your old image, and the new image is supposed to look better. You can scroll up and down in the preview screen to see the range of enhancements that can be applied when the new image is created.

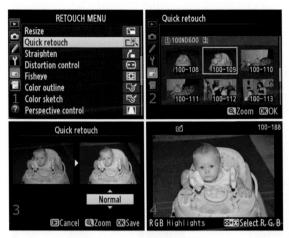

Figure 6.43 - Quick retouch of a cute baby image

Here are the steps to Quick retouch an image:

- 1. Select Quick retouch from the Retouch Menu and scroll to the right (figure 6.43, screen 1).
- 2. You'll see the images that are eligible for Quick retouch. Use the Multi selector to scroll to an image you want to retouch, and press the OK button to select it (figure 6.43, screen 2).
- 3. Use the Multi selector to scroll up or down, and select High, Normal, or Low (figure 6.43, screen 3). I chose Normal. You can preview the effect of your changes by looking at the before and after images.
- 4. Press the OK button when you're satisfied. The new image will be created and displayed on the Monitor (figure 6.43, screen 4).

Settings Recommendation: This function can help some images have a little more snap. I use Quick retouch only if I am going to give someone a JPEG image directly out of the camera and want to enhance it a little first.

Straighten

(User's Manual - Page 274)

Straighten is another really cool function. Often, when I shoot a landscape or ocean view handheld, I forget to level the horizon. With Straighten I can level the image before anyone else sees it.

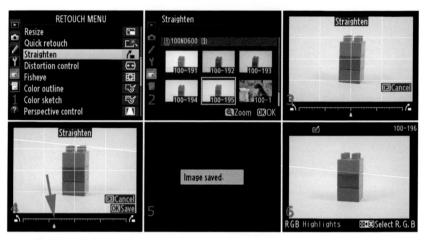

Figure 6.44 - Straighten an image

Here are the steps to Straighten or level an image:

- 1. Select Straighten from the Retouch Menu and scroll to the right (figure 6.44, screen 1).
- 2. With the Multi selector, scroll to the image you want to Straighten and press the OK button to select it (figure 6.44, screen 2).
- 3. Rotate the image to the right (clockwise) or the left (counterclockwise) in 0.25 degree increments with the Multi selector (figure 6.44, screen 3). Notice that there is a yellow pointer in the middle of the scale below the image in figure 6.44, screen 3. This image needs to be rotated to the left, so in figure 6.44, screen 4 (red arrow), you can see that I pushed the yellow pointer toward the left, which rotated the image counterclockwise. When you are happy with the new image, press the OK button to save it, or press the Playback button to cancel.
- 4. A screen that says *Image saved* will briefly appear (figure 6.44, screen 5).
- 5. You'll see the newly straightened and saved image on the Monitor (figure 6.44, screen 6).

Settings Recommendation: This is a handy function to level an image—as long as it is not tilted more than 5 degrees—without using a computer.

Distortion Control

(User's Manual - Page 274)

The Distortion control function is a companion to the Straighten function. The Straighten function levels the image from left to right, and the Distortion control function addresses barrel and pincushion distortion. Barrel distortion causes the edges of a subject to bow outward, like a barrel. Pincushion distortion is the opposite; the edges bow inward, like an hourglass. Using this control will remove some of the image edges as distortion compensation takes place. There are two settings in the Distortion control function: Auto and Manual.

Auto Distortion Control

You can use this setting only if you have a D or G lens on your D600. Select Auto when you want the camera to automatically make rough distortion adjustments, and then you can fine-tune the adjustments yourself if you think the new image needs it.

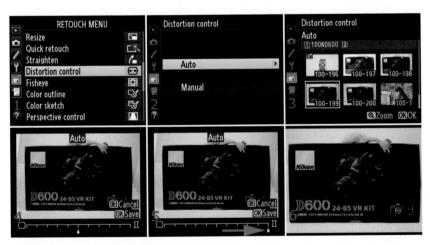

Figure 6.45 - Auto Distortion control

Here are the steps to let the camera make an Auto distortion adjustment:

- 1. Select Distortion control from the Retouch Menu and scroll to the right (figure 6.45, screen 1).
- 2. Choose Auto from the menu (figure 6.45, screen 2).
- 3. With the Multi selector, select the image you want to fix and press the OK button (figure 6.45, screen 3).
- 4. The camera will automatically make its best adjustment and then display the adjusted image (figure 6.45, screen 4). The yellow adjustment pointer

will be centered along the scale at the bottom of the screen. You can move the pointer between barrel and pincushion distortion adjustments, as represented by the small icons on either end of the scale (the barrel is on the left, and the pincushion is on the right).

- 5. If you are not satisfied with the camera's Auto adjustment, use the Multi selector to move the yellow pointer to the left to remove pincushion distortion (add barrel) or to the right to remove barrel distortion (add pincushion). I chose full barrel distortion correction (figure 6.45, screen 5, red arrow).
- 6. When you are happy with the appearance of the image, press the OK button to save it, or press the Playback button to cancel.
- 7. You'll see the new adjusted image on the Monitor (figure 6.45, screen 6).

The effect is not easy to see in these small images or on the Monitor of the camera. However, if you look closely at figure 6.45, screen 4, and compare it to screen 5, you can see a slight difference. Images that need greater adjustments should be corrected on a computer with full-sized images.

Manual distortion adjustments work the same way, except the camera does not make an Auto adjustment before displaying an image that you can manually adjust.

Manual Distortion Control

You are in control of this operation. You can adjust the image until you think it looks good, without interference from the camera.

Here are the steps to manually correct distortion:

- 1. Select Distortion control from the Retouch Menu and scroll to the right (figure 6.46, screen 1).
- 2. Choose Manual from the menu and scroll to the right (figure 6.46, screen 2).
- 3. Use the Multi selector to scroll to the image you want to fix, and press the OK button to select it (figure 6.46, screen 3). You can zoom in to check the image by pressing the Playback zoom in button.
- 4. The image will be displayed with the yellow pointer centered under the scale on the bottom of the screen (figure 6.46, screen 4). No adjustment has been made yet.
- 5. Move the yellow pointer along the scale to the left to remove pincushion distortion (add barrel) or to the right to remove barrel distortion (add pincushion). I chose full barrel distortion correction (figure 6.46, screen 5, red arrow).
- 6. When you are happy with the appearance of the image, press the OK button to save it, or press the Playback button to cancel.
- 7. You'll see the new adjusted image on the Monitor.

Figure 6.46 - Manual Distortion control

As with the Auto distortion adjustment, the Manual distortion adjustment is rather minor. If you look closely at figure 6.46, screen 4, and compare it to screen 5, you'll see that the User's Manual appears slightly less distorted.

Settings Recommendation: These functions are not overly useful because they do not allow for larger corrections. However, they do allow minor distortion correction. Use a program on your computer, such as Photoshop or Nikon Capture NX2, for greater distortion corrections.

Fisheye

(User's Manual - Page 274)

The Fisheye function is quite fun! You can distort your friends and make hilarious pictures that will make everyone laugh (well, maybe not everyone). Although the results are not true circular fisheye images, they do have a similar distorted appearance.

Figure 6.47 shows four samples of the Fisheye setting. Notice the small yellow pointer at the bottom under the scale. The farther toward the right you move it, the more distorted the image. The first image is normal, the second and third images are more distorted, and the fourth image is fully fisheyed! (Can you detect trouble brewing with wives and girlfriends? I used a picture of my son to stay out of trouble!)

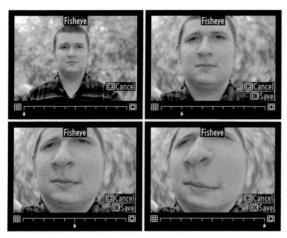

Figure 6.47 - Fisheye distortion samples

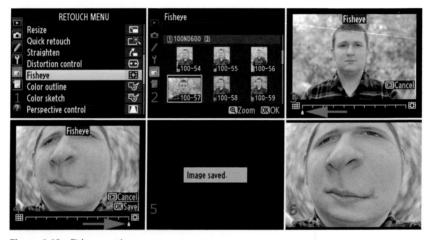

Figure 6.48 - Fisheye settings

Here are the steps to use Fisheye to distort one of your images:

- 1. Select Fisheye from the Retouch Menu and scroll to the right (figure 6.48, screen 1).
- 2. Scroll to the image you want to distort and press the OK button to select it (figure 6.48, screen 2).
- 3. Now press the Multi selector to the right and watch the yellow pointer move and the distortion grow (figure 6.48, images 3 and 4).
- 4. When you've found the perfect distortion amount (to the max, right?), simply press the OK button to save the image, or press the Playback button to cancel. An *Image saved* screen will appear briefly, and the finished product will appear on the Monitor (figure 6.48, screens 5 and 6).

Settings Recommendation: Be careful with this one! If you publish many pictures of your friends with this effect, I'm afraid they'll start running when they see you with your camera.

Color Outline

(User's Manual – Page 275)

Have you ever wanted to convert one of your images to a cartoon or a line drawing? Color outline will do it for you! This retouch setting creates an interesting outline effect on the distinct lines or color changes in your image.

Figure 6.49 shows an original image and the image after Color outline was applied. The final image is not actually in color.

Figure 6.49 - Color outline sample

You can convert an image to a color outline by opening it in Photoshop and using the fill functions to add cartoon colors between the lines (like the Color sketch function, coming up next). Or you can post-process the image into a fineart line tracing. This is an unusual functionality and shows the direction that our highly computerized cameras are going. They have computer power built in, so why not make use of it in new and fun ways?

Figure 6.50 - Color outline settings

Here are the steps to create a Color outline:

- 1. Choose Color outline from the Retouch Menu (figure 6.50, screen 1).
- 2. Select an image from the list of thumbnails. You can either press the OK button to start the conversion to outline form, or press the Playback zoom in

button to check the image first (figure 6.50, screen 2). After conversion, press the OK button to save the new image, or press the Playback button to cancel.

3. The new image will display on the Monitor (figure 6.50, screen 3).

Settings Recommendation: The Color outline setting gives you the opportunity to be creative and have some fun with your images. It makes a very sparse image that resembles a line drawing. You could use this as a basis for a painting, hand coloring, or just to have a cool-looking image that most cameras won't make.

Color Sketch

(User's Manual – Page 275)

With the Color sketch setting you can create a copy of your image that looks like a sketch made with colored pencils or crayons. This function is similar to Color outline, except it uses pastel colors instead of grayscale. Figure 6.51 shows an image before and after Color sketch was applied.

Figure 6.51 - Color sketch sample

You can convert an image to a Color sketch and change the Vividness (pastel color saturation) and Outlines (line and color contrast) until it meets your needs. Use the following steps to create a Color sketch:

- 1. Choose Color sketch from the Retouch Menu (figure 6.52, screen 1).
- 2. Select an image and press the OK button (figure 6.52, screen 2).
- 3. You can now set the Vividness, or color saturation, of the pastel colors. Change the Vividness until you like the look (figure 6.52, screen 3).
- 4. Next, you'll choose an Outlines setting, which will change the contrast of the lines and colors (figure 6.52, screen 4).
- 5. I set both Vividness and Outlines to the plus side, or maximum (figure 6.52, screen 5, red arrow). Press the OK button to make the new image, or press the Playback button to cancel. You can zoom in with the Playback zoom in button to check the image before you save it.
- 6. The new image will display on the Monitor (figure 6.52, screen 6).

Figure 6.52 - Color sketch settings

Settings Recommendation: Like Color outline, the Color sketch function lets you play around with the post-processing computer in your camera. Occasionally I like to play with these functions. Are they really useful? Well, I guess it depends on how often you need a Color outline or Color sketch. Maybe you have a great use for them in mind.

Perspective Control

(User's Manual - Page 275)

Perspective control gives you control over some forms of perspective distortion in your images. When you take a picture from the base of a tall object, like a building, with a wide-angle lens, the building looks like it's falling over backwards. With large-format view cameras, you can correct the problem by using their rise, fall, shift, tilt, and swing controls.

Nikon makes perspective-control lenses that perform some of the functions of a view camera, namely tilt and shift. However, good view cameras and perspective-controls lenses cost significantly more than the D600 camera.

Nikon has given D600 users some image correction capability with the Straighten, Distortion control, and Perspective control functions. We discussed the first two functions earlier in this chapter. Now let's see how to use Perspective control.

Perspective control allows you to stretch the left, right, top, or bottom of an image to tilt leaning objects so they appear straighter in the corrected image. Figure 6.53, screen 3, shows the yellow pointers (red arrows) you can move to change the perspective of an image by tilting the top toward you or away from

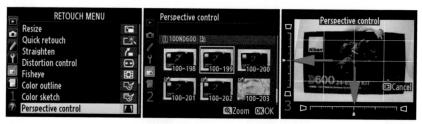

Figure 6.53 – Adjusting an image with Perspective control

Use the following steps to configure Perspective control:

- Select Perspective control from the Retouch Menu and scroll to the right (figure 6.53, screen 1).
- Choose an image from the list of thumbnails and press the OK button (figure 6.53, screen 2).
- 3. You'll see gridlines for edge comparison and two slider controls that are operated by the Multi selector (figure 6.53, screen 3, red arrows). You can move the yellow pointer on the vertical scale up or down to tilt the top of the image toward you or away from you. Or you can slide the yellow pointer on the horizontal scale to the left or right to turn the edges toward you or away from you.
- 4. When the image looks the way you want it, press the OK button to save the image, or press the Playback button to cancel.

The images in figure 6.54 show what happens to the subject when you use the vertical slider (red arrows). Notice how the top of the subject leans either toward you or away from you (forward-to-backward tilt) depending on how the slider is positioned.

Figure 6.54 - Tilting the top of the image

Figure 6.55 shows how the image swings to the left or right as you move the yellow sliders along the horizontal scale (red arrows). Can you see how powerful this function is for controlling perspective? The camera automatically crops off the top and bottom of the stretched ends to keep the image looking like a normal rectangle, so the final image will be smaller.

Figure 6.55 - Rotating the sides of the image

Settings Recommendation: Learn to use this powerful function! You now have excellent Perspective control, with no additional lens purchases! Add Straighten for leveling horizons (rotating the image), then Distortion control for removing barrel and pincushion distortion. You have the basics of a graphics program built right into your camera.

Miniature Effect

(User's Manual - Page 276)

Miniature effect is unusual because it allows you to create a reverse diorama. A diorama is a small 3-D model that looks like the real thing. You may have seen a city diorama, where there are tiny detailed houses and cars and even figures of people. A diorama is often used to make a movie when the cost would be too high to use real scenes.

I call the Miniature effect a reverse diorama because the camera takes an image that you have shot and uses a very narrow band of sharpness with a very shallow depth of field to make it look like a diorama, but it is actually real.

Figure 6.56 is a sample Miniature effect image I took while overlooking a train depot from a bridge over the tracks. It's best to shoot this type of image from a high vantage point so it looks like a real miniature.

The camera added extra saturation to the image to make the train cars look unreal. Notice that there is a band of sharpness running horizontally across the middle of the image. That very shallow depth of field in a full-sized image makes it look fake. The depth of field is usually that narrow only in closeup and macro shots

Figure 6.56 - Miniature effect reverse diorama

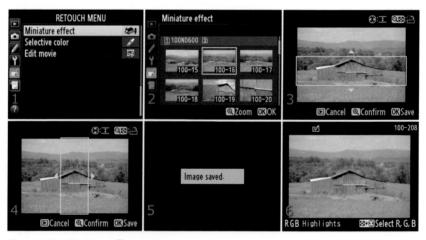

Figure 6.57 - Miniature effect settings

Here are the steps to create your own Miniature effect reverse diorama:

- 1. Select Miniature effect from the Retouch menu and scroll to the right (figure 6.57, screen 1).
- 2. Choose an image shot from a high vantage point that would make a good reverse diorama and press the OK button (figure 6.57, screen 2).

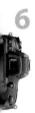

- 3. Notice the narrow yellow rectangle in figure 6.57, screen 3. This band represents a horizontal, movable band of sharpness. You can move it up or down on the screen until you find the optimum place to put the sharpness. Everything in front of and behind the band is blurry. If you are working with a vertical image, the band will be vertical instead of horizontal (figure 6.57, screen 4). After you position the band where you want it, press the OK button (Save).
- 4. You will now see an Image saved screen briefly, then the new Miniature effect image will be displayed on the Monitor (figure 6.57, screens 5 and 6). It is saved with a new file name on your memory card.

Settings Recommendation: You can get good effects when you are looking down on your subject, such as from a bridge, the top of a building, or an airplane. It's a lot of fun to make these images, although it's difficult to make one look realistic. Next time you are high above a real scene with lots of detail, try shooting a Miniature effect image for fun.

Selective Color

(User's Manual - Page 277)

Selective color allows you to create black-and-white still images with selective colors left in. We have all seen pictures of a lovely red rose with only the petals in color while the rest of the image is black-and-white. Well, the Nikon D600 goes a step further and allows you to create black-and-white images with up to three selective colors. Let's see how to do it.

Figure 6.58 - Using Selective color

- 1. Select Selective color from the Retouch Menu and scroll to the right (figure 6.58, screen 1).
- 2. Choose an image to use as a base and press the OK button (figure 6.58, screen 2).
- 3. Turn the Main command dial to select one of the color boxes (figure 6.58, screen 3, top red arrow) where you will store the colors you want to retain in your image. Turn the Main command dial multiple times in either direction to make it skip over a color box and move to the next box.
- 4. Use the Multi selector to scroll the yellow selection box to the location in the image from which you want to choose a color, then press the AE-L/AF-L button to select it (figure 6.58, screen 3, bottom red arrow). You can zoom in with the Playback zoom in button to select a color more precisely from a small section of the subject, and you can zoom back out with the Playback zoom out/thumbnails button. You can see that I chose the color of my son's shirt for one of the color choices. In figure 6.58, screen 4, you can see that I chose his skin as the second color to keep. I pressed the AE-L/AF-L button to capture the color and store it in the second color box (red arrows). Figure 6.58, screen 5, shows that I chose the color of my wife's blouse and stored it in the third color box (red arrows).
- 5. You can adjust the range of colors that will be retained by highlighting the up/down selector next to a color box with the Main command dial and then using the Multi selector to raise or lower the number from 1 to 7 (figure 6.58, screen 6, red arrow). The higher the number, the more colors, similar to the selected color in the color box, will be retained. The interface for moving around the color boxes needs improvement. It is slow and clunky.
- 6. After you have finished configuring the Selective color system, you can press the OK button to save the image. An hourglass will stay on the screen for a few seconds while the camera removes the colors you have disallowed, and an *Image saved* screen will appear briefly. The final image will then appear on the Monitor and will be saved under a new file name. Figure 6.58.1 shows before and after images.

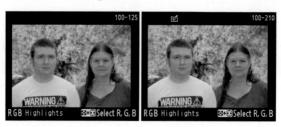

Figure 6.58.1 - Before and after Selective color

Settings Recommendation: Selective color images are a lot of fun. You can shoot images and later remove most of the colors for fine art black-and-white images. Other than the clunky interface surrounding the color boxes, this function is a useful one. You may want to spend a few minutes learning to use it and then see if you can make some art.

Edit Movie

(User's Manual - Page 69)

Edit movie gives you a two-step process to cut a section out of the middle of a movie created with your D600, or you can remove a beginning or ending segment. In addition, you can save an individual frame as a still image from anywhere in the movie.

There are two individual parts to the process of editing a movie—Choose start point and Choose end point—and you use them one at a time. When you complete one of the start point or end point choices, the camera saves the file as a new movie with a new file name. This tends to create a bunch of smaller movies on your memory card that you'll need to delete—take care that you don't delete the wrong one!

There are three parts to Edit movie:

- Choose start point This allows you to delete frames from the beginning of your movie and choose a new starting point
- Choose end point This allows you to delete frames from the end of your movie and choose a new ending point
- Save selected frame You can take a low-resolution snapshot of any frame in the movie

Since Choose start point and Choose end point use exactly the same screens and steps, the two functions are combined in the next section. Do one function, then, if needed, do the other by repeating the steps.

Choose Start Point and Choose End Point

Let's examine the steps to remove a movie segment:

- 1. Press the Playback button to display movies and pictures on your Monitor. Scroll back and forth with the Multi selector and find the movie you would like to trim.
- 2. Press the OK button to start playing the movie (figure 6.59, screen 1). Watch the progress bar in the bottom left corner of the movie until it gets close to the point where you want to trim it (figure 6.59, screen 2, left red arrow), then

Figure 6.59 - Edit movie

press the Multi selector to pause the movie (figure 6.59, screen 2, right red arrow). While the movie is playing, you can jump back or ahead by 10 seconds at a time by turning the Main command dial. You can also scroll left or right to examine individual frames. If you use the Main command dial while the movie is playing, it will automatically pause the movie when it jumps 10 seconds. You can start the movie again by pressing the OK button. You can make the movie display faster or slower (2x, 4x, 8x, and 16x) by tapping left or right on the Multi selector while the movie is playing. This can save time when you are dealing with a long movie. Basically, you want to get to the point in the movie where you plan to make the change, then move to the next step.

- 3. With the movie paused, press the Retouch/Picture Control button (figure 6.59, image 3), and the information shown in figure 6.59, screen 4, will appear. Highlight Choose start/end point and press the OK button.
- 4. Another message will appear, as shown in figure 6.59, screen 5, which gives you the choice of choosing the Start point or End point. Decide whether you are cutting off the beginning of the movie (Start point) or the end of the movie (End point), and press the OK button to execute the command.

- 5. Press up on the Multi selector (figure 6.59, screen 6, red arrow, which indicates a scissors symbol) and a new window will open and allow you to save the trimmed movie (figure 6.59, screen 7). From this screen you can choose Save as new file, Overwrite existing file (be careful, this destroys the original file), Cancel, or Preview. Cancel is self-explanatory. Preview plays the shortened movie without actually trimming it, and then it jumps back to the screen shown in figure 6.59, screen 7.
- 6. Press the OK button when you have highlighted your choice. If you selected Save as new file, the camera will save the new trimmed movie under a new file name and display it on the Monitor, ready for playing (figure 6.59, screens 8 and 9).
- 7. Repeat these steps for trimming the other end of the movie, if you would like to, and select the other choice in step 4.

This process will leave several trimmed versions of the movie on your memory card—the final of which is the fully trimmed version—unless you choose Overwrite existing file. If you decide to use the overwrite method, back up the movie first in case you make a mistake.

Note: Your movie must be at least two seconds long when you're done or the camera will refuse to cut any more frames; it will give you the terse message *Cannot edit movie*.

Save Selected Frame

You can save an individual low-resolution frame from anywhere in the movie. The frame size is based on the *Shooting Menu > Movie settings > Frame size/frame rate* setting:

- A 1920×1080 movie contains single still images of just over 2 MP
- A 1280 \times 720 movie contains single still images of just under 1 MP

Let's examine how it's done using the Retouch Menu:

- 1. Choose Edit movie from the Retouch Menu and scroll to the right (figure 6.60, screen 1).
- 2. Select Save selected frame and scroll to the right (figure 6.60, screen 2).
- 3. Choose one of the available movies and press the OK button (figure 6.60, screen 3).
- 4. Press the OK button to start playing the movie, and when it gets to the point where you want to cut out a frame, press the Multi selector to pause the movie (figure 6.60, screen 4). While the movie is playing, you can press left or right on the Multi selector to move through it a frame at a time until you find your favorite frame. You can jump 10 seconds forward or backward in the movie

- 5. Press up on the Multi selector when you have located the frame you want, and a small box will appear that says Proceed? Yes/No (figure 6.60, screen 5). Choose Yes from the menu, and the camera will make a copy of the frame as a separate image. While the selected frame is being saved you will see an hourglass then a screen that says Done.
- 6. The new image will be displayed on the Monitor (figure 6.60, screen 6). It is in the format of the movie, with a 16:9 ratio, even though it is now a still image. The icon at the top of the screen, which looks like a pair of scissors over a film frame, indicates that the image has been cut out of a movie (figure 6.60, screen 6, red arrow).

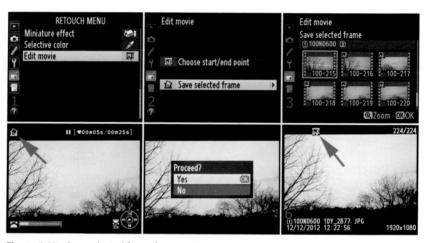

Figure 6.60 - Save selected frame from movie

Settings Recommendation: This series of steps becomes easier when you do it a few times. Practice it once or twice, and you'll remember it later.

Side-by-Side Comparison

(User's Manual – Page 279)

Side-by-side comparison allows you to compare an image you've retouched with the original source image. Interestingly, this function is not available from the Retouch Menu. You'll find it on the Playback Retouch Menu, which you access by pressing the OK button when a picture is displayed on the Monitor.

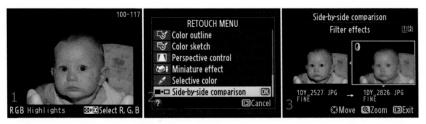

Figure 6.61 - Side-by-side comparison

Here are the steps to compare the original and retouched images side by side on the Monitor:

- 1. Press the Playback button to bring an image up on the Monitor. Find an original image that you know has been retouched (figure 6.61, screen 1) or any image marked with the retouched symbol. If you try to use an image that has not been retouched, the following steps will fail.
- 2. Press the OK button to access the Playback Retouch Menu. Scroll all the way to the bottom of the menu, select Side-by-side comparison, and press the OK button (figure 6.61, screen 2).
- 3. The original image will appear on the left, and one of the retouched versions will appear on the right (figure 6.61, image 3). If you retouched an original image more than once, a yellow arrow will appear above or below the retouched image. This means you can scroll up or down to see the other retouched versions. The retouched picture of the baby in figure 6.61, screen 3, shows the Soft filter effect. There is at least one more retouched image, which can be accessed with the Multi selector, as indicated by the yellow arrow on the bottom of the retouched image.

Settings Recommendation: I often use this function when I want to compare images to which I've added a color cast so I can see how they compare to the original. It's very convenient since you can choose the original image or one of the retouched images and the camera is smart enough to place them in the proper position in the Side-by-side comparison. You can tell an image is retouched by looking for the retouch icon in the upper-left corner of the image when it's displayed on the Monitor.

Author's Conclusions

Nikon has given camera users who dislike computers a way to work with their images in-camera. Although the Retouch Menu is not as fully featured as a computer graphics program, it does allow you to do quick and convenient conversions.

At first I didn't think this group of Retouch Menu functions would be all that useful to me. However, I find myself using them more in the field than I expected. Whether you use them often or not, it's good to know they are there for emergencies.

Next we'll move into the final menu system in the camera. It's called My Menu, and it may become very valuable to you as you learn how it works. It's a place to put your often-used, favorite settings so you can get to them very quickly. In the next chapter, we'll see how My Menu and its cousin, Recent Settings, work.

My Menu and Recent Settings

As you have read through this book and experimented with your camera, you've probably exclaimed, "My goodness, this camera has a lot of settings!" The D600 does have a large number of menus, screens, functions, and settings. When I was done taking pictures of the camera's menus and screens for this book, I had more than 1,000 images. That many screens can be somewhat complex to navigate. We need a shortcut menu for our most-used settings—a place to keep the functions we're constantly changing.

Nikon has given us two specialty menus in the D600: My Menu and Recent Settings. These are both designed to give us exactly what we need—a menu that can be customized with only the most-used functions or a menu of recent changes to often-used functions.

For instance, I often turn Exposure delay mode on and off. Instead of having to search through all the Custom settings, trying to remember exactly where Exposure delay mode lives, I simply added that Custom setting to My Menu. Now, whenever I want to add a one- to three-second exposure delay after pressing the Shutter-release button so the mirror vibrations can settle down, I just go to My Menu and enable Exposure delay mode. I can do it quickly, without searching, since I added it to My Menu.

Settings Recommendation: I rarely use Recent Settings. I prefer the control I get with my own personally customizable menu—My Menu. The Recent Settings menu has very little flexibility since it's an automatically updated, cameracontrolled menu system. You really can't do much in the way of configuring it. You just select it and use it. On the other hand, My Menu is a personal collection of links to my most-used settings. It is completely configurable.

We'll consider both menus in this chapter, with heavy emphasis on My Menu. There is not much to configure for the Recent Settings menu; the camera maintains it by remembering the last 20 camera settings you have modified and listing them in a convenient place.

What's the Difference between My Menu and Recent Settings?

The most important difference between the two menus is the level of control you have over what appears on the menu. My Menu is completely customizable and does not change unless you change it. You can add up to 20 settings from the Playback Menu, Shooting Menu, Custom Settings Menu, Setup Menu, and Retouch Menu to My Menu. Recent Settings simply shows the last 20 changes you've made to your camera's settings, and it's not configurable. It changes every time you change a different setting in your camera. However, since it shows the last 20 changes, you ought to be able to find the ones you change most often somewhere in the list. My Menu and Recent Changes are mutually exclusive and cannot appear on the D600 at the same time. One takes the place of the other when you select the Choose tab setting at the end of each menu and choose your favorite.

My Menu

(User's Manual - Page 280)

My Menu is my menu! I can add virtually any camera setting from one of the primary menus to My Menu for convenient, quick access. When I use My Menu I don't have to spend time looking for a function buried in the main menus system. Since I often use each function on My Menu, I'm glad to have it immediately available.

In figure 7.1 you can see that My Menu is the last selection on the D600 menu system. Its icon looks like a file folder tab turned sideways, with a check mark on it. Press the MENU button and scroll down with the Multi selector until the yellow highlight looks like figure 7.1.

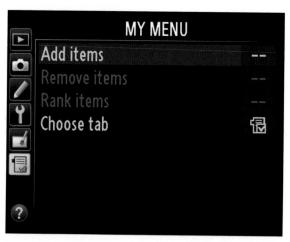

Figure 7.1 - My Menu

When you first look at My Menu you'll see nothing but the following selections:

- Add items
- Remove items
- Rank items
- Choose tab

Let's examine each of these menu choices in detail.

Add Items

To add an item to My Menu, you'll need to locate it first. Search through the menus until you find the setting you want to add, then make note of where it's located. You could do this from within the Add items menu, but I find that it's harder to locate what I'm looking for if I haven't already confirmed where it lives.

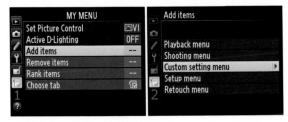

Figure 7.2 - Add items to My Menu

Find the item you want to add and make note of its location, then use the following steps:

- Select Add items from My Menu. Notice that I already have Set Picture Control and Active D-Lighting added to My Menu (figure 7.2, screen 1). I want to add something new.
- Use the Multi selector to scroll to the right, and you'll see a list of menus to choose from. The Add items screen shows all the menus in the D600 except My Menu and Recent Settings (figure 7.2, screen 2). Let's add one of my favorites, Exposure delay mode.
- 3. Figure 7.3 picks up where figure 7.2 left off. I already know that Exposure delay mode is under the Custom setting menu, so let's scroll down to it (figure 7.3, screen 1), then scroll to the right.

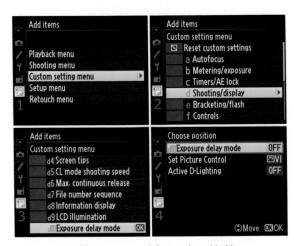

Figure 7.3 - Adding Exposure delay mode to My Menu

4. We now see the Custom setting menu and Custom settings a–g (figure 7.3, screen 2). Scroll down to d Shooting/display, and then scroll to the right.

- 5. Figure 7.3, screen 3, shows the d10 Exposure delay mode function that I want to add. All I have to do is highlight it and press the OK button. When I've done that, the D600 switches to the Choose position screen (figure 7.3, screen 4).
- 6. Figure 7.4 begins where figure 7.3 ends. Since I've already added a couple of other items to My Menu, I now have to decide the order in which I want them to be presented. The new d10 Exposure delay mode setting is on top because it is the newest entry (figure 7.4, screen 1). I think I'll move it down two rows and put Set Picture Control in the top position.

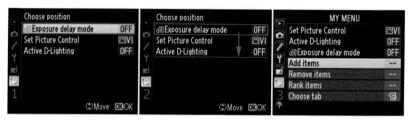

Figure 7.4 – Choosing a position for Custom setting d10 Exposure delay mode on My Menu

7. To move the position of the selected item, simply scroll down. The d10 Exposure delay mode setting has a yellow box around it (figure 7.4, screen 2). As you scroll down, a yellow underline moves to the last position (figure 7.4, screen 2, red arrow). This yellow underline represents the location where I want to move d10 Exposure delay mode. When I've decided on the position and have the yellow underline in place, I just press the OK button. The screen pops back to the first My Menu screen, with the My Menu items arranged the way I want them (figure 7.4, screen 3). Notice that d10 Exposure delay mode is now at the bottom of the list (it was originally at the top of the list).

Remove Items

Now that we've figured out how to Add items, let's examine how to Remove items. I've decided that Set Picture Control is redundant because the D600 has an external button for that item, so I'll remove it from My Menu.

Use the following steps to Remove items from My Menu:

- 1. Select Remove items from My Menu and scroll to the right (figure 7.5, screen 1).
- 2. The Remove items screen presents a series of selections with check boxes. Whichever boxes I check will be deleted when I select Done (figure 7.5, screen 2). You can check the boxes by highlighting the line item you want to delete and scrolling right with the Multi selector. You can also simply press the OK button to place a check mark in a setting's box. Pressing the OK button acts

- like a toggle and will check or uncheck a line item. In figure 7.5, screen 2, you can see that I've placed a check mark next to Set Picture Control.
- 3. When you've checked the settings you want to remove, simply scroll back up to Done and press the OK button (figure 7.5, screen 3). A message pops up and asks, Delete selected item? (figure 7.5, screen 4).
- 4. Press the OK button to remove the setting from My Menu. A message informs you that the item has been deleted, then the D600 switches back to the My Menu screen. You can press the MENU button to cancel if you decide you don't want to remove an item.

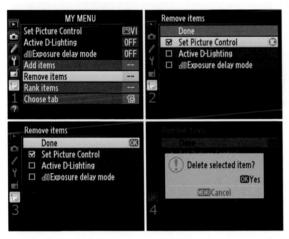

Figure 7.5 - Remove an item from My Menu

Rank Items

Ranking items works very similarly to positioning new additions in My Menu. All the Rank items selection does is move an item up or down in My Menu. You can switch your most-used My Menu items to the top of the list.

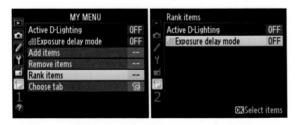

Figure 7.6 - Rank items in My Menu

Use the following steps to Rank items:

- 1. Select Rank items from My Menu and scroll to the right (figure 7.6, screen 1).
- 2. Now you'll see the Rank items screen and all the current My Menu items (figure 7.6, screen 2). I've decided that I use d10 Exposure delay mode more than Active D-Lighting, so I'll move it to the top.
- 3. Highlight d10 Exposure delay mode, press the OK button, and a yellow box will appear around that item. Move appears at the bottom of the screen (figure 7.7, screen 1).

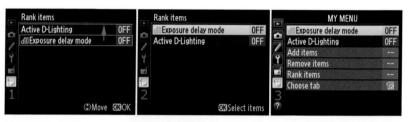

Figure 7.7 - Rank items in My Menu (continued)

- 4. Scroll up with the Multi selector. This action moves the yellow positioning underline to the top of the list (figure 7.7, screen 1, red arrow). Press the OK button to select the new position, and d10 Exposure delay mode will move to the top of the list (figure 7.7, screen 2).
- 5. This setting is now where we want it, so press the MENU button to return to the main My Menu screen (figure 7.7, screen 3).

Choose Tab

Choose tab allows you to switch between My Menu and Recent Settings. Both menus have the Choose tab selection as their last menu choice.

Use the following steps to switch between My Menu and Recent Settings:

- 1. At the bottom of My Menu, select Choose tab and scroll to the right (figure 7.8, screen 1).
- 2. You'll now have a choice between My Menu and Recent Settings. Choose Recent Settings and press the OK button (figure 7.8, screen 2).
- 3. The Recent Settings screen will now appear, completely replacing My Menu on the main menu screen (figure 7.8, screen 3).
- 4. Select Choose tab and press the OK button to return to My Menu (figure 7.8, screen 3).

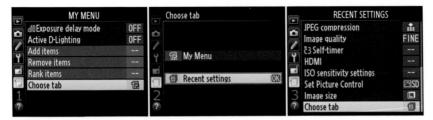

Figure 7.8 - Select My Menu or Recent Settings (Choose tab)

Notice that the Recent Settings menu has a Choose tab setting at the bottom, just like My Menu does (figure 7.8, screen 3). Clearly, this is a circular reference. You can use the Choose tab selection as a toggle between My Menu and Recent Settings to change which one appears as the last selection on the list of menus.

Settings Recommendation: My Menu gives you nice control over a customized menu that is entirely yours. Configure it however you want by choosing from selections in the primary menus. My Menu will save you a lot of time when you look for your 20 most-used selections.

If you're inclined to use Recent Settings, just remember that after you pass 20 camera setting adjustments, the next setting you use will jump to the top of the list and move everything down by one position. The last item on the list will simply disappear.

Now, let's take a look at Recent Settings in a little more detail.

Recent Settings

(User's Manual - Page 280)

Recent Settings is very simple. The camera remembers the last 20 items you have modified in your camera and lists them in Recent Settings (figure 7.9).

If you change something in your camera that's not already on the Recent Settings list, it will be added and will replace the oldest item. It will be added to the top of the list if there is no room left at the bottom (i.e., when you exceed 20 items).

This can be a convenient way to find something you've changed recently but can't remember where it is in the main menu systems.

As mentioned in the previous section, you can switch the camera to My Menu by highlighting Choose tab at the bottom of the Recent Settings menu and pressing the OK button.

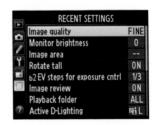

Figure 7.9 - Recent Settings menu

Author's Conclusions

This is the last of the text-based menus we'll cover in the D600. We've been through all of the menu screens!

Now it's time to move into the chapters that pull everything together. You have stepped through the internal setup of every part of your D600. Let's begin to see how best to use the controls we've configured. The next chapter takes up the subject of **Metering, Exposure Modes, and Histogram**. Please pay extra attention to the section on histograms if you want excellent exposures every time.

Metering, Exposure Modes, and Histogram

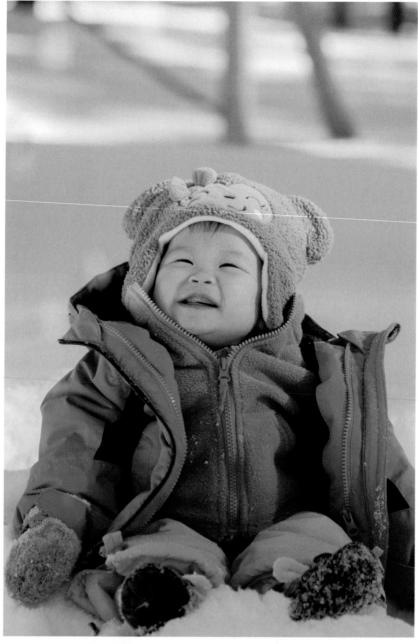

I've been using Nikon cameras since way back in 1980. It seems that with each camera released by Nikon there have been improvements in its metering and exposure modes. The Nikon D600 is no exception. With this camera, Nikon has designed metering and exposure to work not only with still images, but also with moving pictures and video.

In this chapter you'll learn how the exposure metering system and modes work. We'll look at how each of three different light meter types is best used. We'll examine the various modes you can use when taking pictures, including several exposure modes for when you want the camera to do most of the work while you enjoy shooting. Finally, we'll look in detail at how the histogram works on the Nikon D600.

The histogram is a new feature to those who are coming over to digital photography from film. This little readout gives you great control over metering and will help you make the most accurate exposures you've ever made. It is very important that you understand the histogram, so we'll look at it in detail.

This chapter is divided into three parts:

- Section 1 Metering The Nikon D600 provides three major light metering systems: Matrix, Center-weighted, and Spot.
- Section 2 Exposure Modes The camera's Mode dial is simply loaded with exposure modes, such as Auto exposure (AUTO), Programmed auto (P), Shutter-priority auto (S), Aperture-priority auto (A), Manual (M), and User settings U1 and U2. In addition, there are 19 Creative Photography SCENE modes that give inexperienced users command of a certain style of shooting.
- Section 3 Histogram The histogram is a digital bell-curve readout that shows how well an image is exposed and the dynamic range required for proper image capture. It is an important tool for advanced photographers. This chapter discusses how to read it and use it to better control your exposures.

Let's get started by looking into the three exposure metering systems.

Section 1 – Metering

(User's Manual – Page 109)

The basis for the Nikon D600's exposure meter is a 2,016-pixel RGB sensor that meters a wide area of the frame. Figure 8.1 shows a closeup of that sensor, which is used to meter the light and provide a correct exposure.

When it is used with a Nikkor G or D lens containing a CPU, the camera can set the exposure

Figure 8.1 - The D600's 2,016-pixel RGB sensor (light meter)

based on the distribution of brightness, color, distance, and composition. Most people leave their light meter set to matrix metering and enjoy excellent results.

Let's look more closely at each of the D600's exposure metering systems. Figure 8.2 shows the Metering button (red arrow in image 1), the Control panel readout set to Matrix metering (image 2), Spot metering (image 3), and Centerweighted metering (image 4).

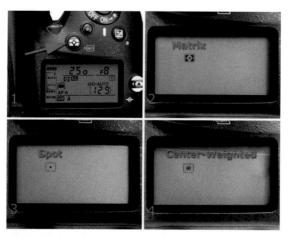

Figure 8.2 – Metering button and three meter types: Matrix, Spot, and Center-weighted

Here are the steps to change metering modes:

- 1. Hold down the Metering button with your index finger. You'll see the metering icon on the Control panel while you hold it down (figure 8.2).
- 2. While still holding down the Metering button, turn the Main command dial until the icon for the meter you prefer to use is displayed.
- 3. Release the Metering button.
- 4. Check the Control panel (or other displays, as shown in figure 8.3) to validate that you have selected the meter you want to use.

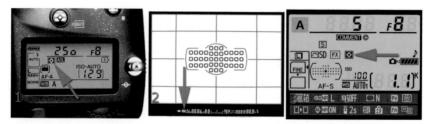

Figure 8.3 – Metering mode icons (matrix)

Figure 8.3 shows the Control panel (image 1), Viewfinder (screen 2), and Information display (screen 3) with the Metering icon and all the other icons you

normally see. I have Matrix metering selected on my camera, as indicated by the icons at the red arrows.

Now, let's examine the three meter types to see which you will use most often.

3D Color Matrix Metering II

The Nikon D600 contains a 3D Color Matrix Metering II system that's one of the most powerful and accurate automatic exposure meters in any camera today.

In figure 8.4 you can see a closeup of the matrix metering symbol from the Control panel. This meter will be set by default from the factory.

How does matrix metering work? Through complex mathematical formulas, there are characteristics for many thousands of images stored in the camera. These characteristics are used along with proprietary Nikon software and complex evaluative computations to analyze the image that appears in your Viewfinder. The meter is then

Figure 8.4 - Matrix metering symbol

set to provide accurate exposures for the majority of your images.

A simple example is when the horizon runs through the middle of an image. The sky above is bright, and the earth below is much dimmer. The metering system evaluates this image and compares it to hundreds of similar images in the camera's database and automatically selects and inputs a meter setting for you.

The meter examines four critical areas of each picture. It compares the levels of brightness in various parts of the scene to determine the total range of the exposure values (EVs). It then notices the color of the subject and surroundings. If you are using a G or D lens with a CPU chip, it also determines how far away your lens is focused so it can determine the distance to your subject. Finally, it looks at the compositional elements of the subject.

After it has all that information, it compares your image to tens of thousands of image characteristics in its image database, makes complex evaluations, and comes up with an exposure value that is usually right on the money, even in complex lighting situations.

Center-Weighted Metering

If you're a bit old-fashioned, having been raised on a classic center-weighted meter and still prefer that type, the D600's exposure meter can be transformed into a flexible center-weighted meter with a variable-sized weighting that you can control. Figure 8.5 shows the center-weighted metering symbol from the Control panel.

The center-weighted meter in the D600 evaluates the entire frame but concentrates 75 percent of the metering into an adjustable circle in the middle of the frame. The other 25 percent of the frame outside the circle provides the rest of the metering. You can make the circle as small as 8mm or as large as 20mm. You can even completely eliminate the circle and use the entire Viewfinder frame as a basic averaging meter.

Figure 8.5 – Center-weighted metering symbol

Let's examine the center-weighted meter more

closely. Using Custom setting b4, you can change the size of the circle the camera uses to concentrate the meter reading. (See **b4 Center-weighted area** in the chapter titled **Custom Setting Menu**.)

Figure 8.6 - Center-weighted metering circles

The default circle is 12mm in the center of your Viewfinder. However, by changing Custom setting b4 Center-weighted area, you can adjust this size to one of the following:

- 8mm (0.32 inch)
- 12mm (0.47 inch)
- 15mm (0.59 inch)
- 20mm (0.79 inch)
- Average (full frame)

The center-weighted meter is a pretty simple concept, really. Whatever part of your subject that is in the center of your Viewfinder influences the meter more than the edges of the frame, on a 75/25 basis. The circle gets 75 percent importance. Figure 8.6 shows a visual approximation of the full range of metering circles.

Note: If you are using a non-CPU lens, the center-weighted meter defaults to 12mm (0.47 inch) and cannot be changed. Even if you adjust *Custom Setting Menu* > *b Metering/exposure* > *b4 Center-weighted area*, it has no effect.

Where's the Circle?

You can't actually see any indication of circles in the viewfinder, so you'll have to imagine them, like I did in figure 8.6.

Locate your current autofocus (AF) sensor in the middle of your Viewfinder. Now imagine a 12mm circle, which at 0.47 inch is about one-half of an inch. The 15mm maximum size circle, at 0.59 inch, is a little bigger at just over one-half of an inch. This unseen circle in the center area of the viewfinder provides the most important 75 percent of the metering area.

Settings Recommendation: If I were to use the center-weighted meter often, I would stay with the default setting of 12 mm. That's a pretty small circle (almost in the spot metering range), so it should give you good readings. It's large enough to see more than a pure spot meter, though, so you have the best of both worlds. There is so little difference between 12mm and 15mm that it probably makes little difference which one you use. If you are concerned, experiment with the settings and see which works best for you.

Using the Averaging Meter

If you set your meter to Average (Avg) in Custom setting b4 Center-weighted area, the light values of the entire Viewfinder are averaged to arrive at an exposure value. No particular area of the frame is assigned any greater importance (figure 8.6, far right).

This is a little bit like Matrix metering, but without the extra smarts. In fact, on several test subjects, I got remarkably similar meter readings from Average and Matrix. However, Matrix metering should do better in difficult lighting situations because it has a database of image characteristics to compare with your current image, and it looks at color, distance, and where your subject is located in the frame.

Spot Metering

Often no other meter but a spot meter will do. In situations when you must get an accurate exposure for a very small section of the frame, or you must get several meter readings from various small areas, the D600 can, once again, be adjusted to fit your needs. Figure 8.7 shows the Spot metering symbol as displayed on the Control panel.

Figure 8.7 – Spot metering symbol

The D600's Spot meter consists of a 4mm circle (0.16 inch) surrounding the currently active autofocus (AF) point, if you are using single or continuous AF modes (AF-S or AF-C). To use the Spot meter effectively, you might want to set your D600 to AF-S or AF-C mode.

The spot meter evaluates only 1.5 percent of the frame, so it is indeed a spot meter. Since the spot surrounds the currently active AF sensor, you can move the Spot meter around the Viewfinder within the 39 AF points.

How big is the 4mm spot? Well, the Spot meter surrounds the currently selected AF point in your Viewfinder that is in use when you slightly press the Shutter-release button (figure 8.8). In fact, the spot meter follows the currently active AF point around the Viewfinder, so you can move the spot meter around the frame with the Multi selector.

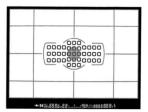

Figure 8.8 – Spot metering size

When your D600 is in Spot meter mode and you move the AF point to some small section of

your subject, you can rest assured that you're getting a true spot reading. In fact, you can use your Spot meter to determine an approximate EV range in the entire image by taking multiple manual spot readings and comparing the values. If the values exceed a range of 9 or 10 EV steps, you have to decide which part of your subject is most important to you and meter only for it.

On an overcast day, you can usually get by with no worries since the range of light values is often within the recording capability of the sensor. On a bright sunny day, the range of light exceeds what your sensor can record in some cases.

Don't let the numbers make you nervous. Just remember that spot metering is often a trade-off. You trade the highly specific ability to ensure that a certain portion of an image is spot-on for the camera's multiple averaging skills to generally get the correct exposure throughout the frame. The choice is yours, depending on the shooting situation.

If you spot meter a person's face while he or she is standing in the sun, the shadows around that person may contain little or no data. The shadows will be underexposed and be solid black. Then, if you spot meter from the shadows instead, the person's face is likely to blow out to solid white. We'll discuss this in more detail in section 3 of this chapter, about the histogram.

Settings Recommendation: Use your Spot meter to get specific readings of small areas on and around your subject. Then make some exposure decisions yourself, and your subject should be well exposed. Just remember that the Spot meter evaluates only for the small area that it sees, so it cannot adjust the camera for anything except that one tiny area. Spot metering requires some practice, but it is a very professional way to expose images.

Section 2 – Exposure Modes

(User's Manual - Pages 40, 73)

My first Nikon, back in 1980, was an FM. I remember it with fondness because that was when I first got serious about photography. It's hard for me to imagine that it has already been 33 years since I last used my FM! Things were simpler back then. When I say simple, I mean that the FM had a basic center-weighted light meter, a manual exposure dial, and manual aperture settings. I had to decide how to create the image in all aspects. It was a camera with only one mode: M, or manual.

Later I bought a Nikon FE and was amazed to use its A mode, or Aperturepriority auto. I could set the aperture manually and the camera would adjust the shutter speed for me. Luxury! The FE had two modes, Manual (M) and Aperture priority (A).

A few more years went by, and I bought a Nikon F4 that was loaded with features and was much more complex. It had four modes, including the two I was used to, M and A, and two new modes, Shutter-priority auto (S) and Programmed auto (P). I had to learn even more stuff! The F4 was my first P, S, A, M camera.

Does this sound anything like your progression? If you're over 50, maybe so; if not, you may just be getting into the digital photography realm with your D600, and I ought to stop reminiscing and get to the point.

Today's cameras are amazingly complex compared to cameras only a few years ago. Let's examine how we can use that flexibility for our benefit. The D600 is also a P, S, A, M camera. That's the abbreviated progression of primary shooting modes that allow you to control the shutter speed and aperture. In addition, the D600 has 19 SCENE modes and a fully AUTO mode for when you just want to take good pictures without thinking about exposure. Let's examine each in detail.

Figure 8.9 - Mode dial set to **AUTO**

There is just one control on the D600 to set the AUTO, SCENE, P, S, A, M, U1, and U2 modes. It is a convenient control called the Mode dial (figure 8.9). Let's discuss each exposure mode in detail.

Programmed Auto (P) Mode

Programmed auto (P) mode is designed for those times when you just want to shoot pictures and not think much about camera settings but still want emergency control when needed. The camera takes care of the shutter speed and aperture for you and uses your selected exposure meter to create the best pictures it can without human intervention. You can override the aperture by turning the Main command dial.

Figure 8.10 shows the Mode dial set to Programmed auto (P) mode. This mode is called Programmed auto because it uses an internal software program. It tries its best to create optimal images in most situations.

However, even the User's Manual calls this a "snapshot" mode. P mode can handle a wide variety of situations well, but I wouldn't depend on it for my important shooting. It can be great at a party, for example, where I want some nice snap-

Figure 8.10 - Mode dial set to Programmed auto (P)

shots. I don't have to think about the camera and I can just enjoy the party. To me, P mode is P for Party.

It's a good mode to use when you want to let the camera control the aperture and shutter while you control the flash. In a sense, it's like AUTO mode except that you, instead of the camera, decide when to use the popup Speedlight. It also lets you override the aperture in an emergency. You may need more depth of field and decide to use a smaller aperture, so you can take control by turning the Main command dial. When you do, the aperture is under your control, while the camera controls the shutter.

P mode comes in two parts: Programmed auto and Flexible program. Flexible program works similarly to Aperture-priority auto (A) mode. Why do I say that? Let me explain by giving an example.

Unexpected Group Shot!

You're shooting at a family party, taking a natural-light snapshot of cousin Jane. The camera, which is in P mode, has selected f/3.5 for the aperture. Suddenly cousin Bill, aunt Millie, and five more people run to get in the picture. Where you were shooting an individual portrait—using a shallow depth of field to emphasize your subject now you have a group with more than one row. You (being a well-trained photographer) glance down at your camera and realize that the f/3.5 aperture won't give you enough depth of field to focus on the front row and still have a sharp image of the back row. You pop open the flash (for extra light) and turn your Main command dial clockwise to reduce the aperture size for more depth of field. When the camera senses the Main command dial being turned, it realizes that it's being called upon to leave snapshot mode and give you some control. It displays a small P* on the Control panel (figure 8.10.1, screen 1) and Information display (figure 8.10.1, image 2) to let you know it realizes you are taking over control of the aperture. Since you are turning the dial clockwise, it obligingly starts cranking down the aperture. After a few clicks to the left, your aperture is now at f/8. You put the camera to your eye, yell "say cheeeeese!" and press the Shutter-release button. You've got the shot! A family memory, captured.

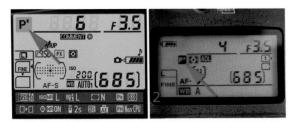

Figure 8.10.1 – P* mode on the Information display and Control panel

What you did in my imaginary scenario was invoke the Flexible program (P*) mode in your D600. How?

As soon as you turned the Main command dial, the D600 left normal P mode and switched to P* (Flexible program). Before you turned the Main command dial, the D600 was happily controlling both the shutter speed and the aperture for you. When you turned the dial, the D600 immediately switched to Flexible program mode and let you have control of the aperture. It then controlled only the shutter speed. In effect, the D600 allowed you to exercise your knowledge of photography very quickly and assisted you only from that point.

If you turn the Main command dial clockwise, the aperture gets smaller. If you turn it counterclockwise, the aperture gets larger. Nothing happens if you turn the Sub-command dial. You can take control of the aperture only in Flexible program mode. Can you see why I say Flexible program mode acts like Aperturepriority (A) mode?

Beware the Extra Clicks

If you turn the Main command dial counterclockwise until the aperture reaches its maximum size (usually f/3.5 on a kit lens), the camera starts counting clicks but does nothing else. To start making the aperture move again, you have to turn back the same number of clicks (up to 15). I have no idea why Nikon does it this way—maybe to allow for larger apertures—but it's been like this for many years.

It's confusing to have the camera stop letting you control the aperture just because you turned the Main command dial past wide open by several clicks until you turn it back the same number of clicks. It's no big deal, really. Just be aware that this will happen so you won't think the camera is not working right.

Shutter-Priority Auto (S) Mode

Shutter-priority auto (S) is for those who need to control the shutter speed while allowing the camera to maintain the correct aperture for the available light. You'll turn the Main command dial to adjust the shutter speed, while the camera controls the aperture. Figure 8.11 shows the Mode dial set to S for Shutterpriority auto mode.

If you find yourself shooting action, you'll want to keep the shutter speed high enough to capture an image without excessive blurring. Shooting sports, air shows, auto races, or any quickly moving subject requires careful control of the shutter. If you shoot a bird in flight, you'll want to use a fast shutter speed that allows for just a tiny bit of motion blur in its wings while stopping the body of the bird.

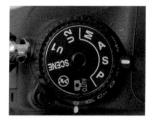

Figure 8.11 - Mode dial set to Shutter-priority auto (S)

Sometimes you'll want to set your shutter speed to slow settings for special effects or time exposures, such as a small waterfall in a beautiful autumn stream. See figure 8.12 for both effects.

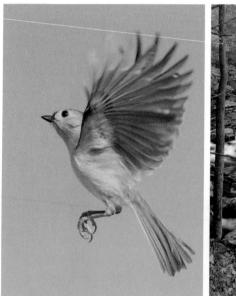

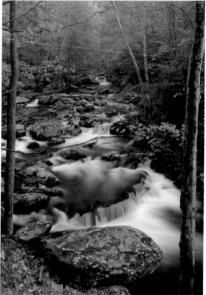

Figure 8.12 - Fast shutter speed to stop bird and slow shutter speed to blur water

If the light changes drastically and the camera cannot maintain a correct exposure with your current shutter speed setting, it will inform you by blinking the aperture setting and displaying an exposure indicator showing the amount (-/+) of under- or overexposure in the Viewfinder, Control panel, and Information display.

Figure 8.12.1 shows the Information display as an example. The aperture indicator (upper red arrow) and exposure indicator (lower red arrow) will blink when the exposure is incorrect.

To change the shutter speed, simply rotate the Main command dial to any value between 30 seconds and 1/4000 second. Turn the wheel counterclockwise for faster shutter speeds and clockwise for slower speeds. The camera will try to adjust the aperture to maintain a correct exposure; if it can't, it will warn you by blinking.

-Linidini

Figure 8.12.1 - Significant underexposure, items at points of arrows will blink

Watch Out for Camera Shake!

Be careful when the shutter speed is set below 1/125 second. Camera shake becomes a problem

for many people at 1/60 second and slower. If you are careful to stand still, brace your arms against your chest, and spread your feet apart with one in front of the other, you'll probably be able to make sharp images at 1/60 to 1/30 second.

Surprisingly, your heartbeat and breathing is reflected in your hands during slow shutter speed photography. If you are going to shoot at slow shutter speeds, buy yourself a nice solid tripod. You'll make much nicer pictures.

Figure 8.13 – Woman holding camera for steady shooting, and pro photographer using a tripod

Figure 8.13 shows the two main ways to steady a camera. Notice in the first picture how the young lady has her elbow tucked into her chest, her feet apart, and one foot in front of the other. She is squeezing the shutter release very slowly to prevent adding shake, and she is breathing out very slowly as she is firing the camera. This handholding technique provides maximum sharpness. In the other

The picture of the small waterfall in Great Smoky Mountains National Park (figure 8.12) was taken at a shutter speed of several seconds. It is virtually impossible for a person to hold a camera perfectly still for several seconds, so a shot like this is not possible without a tripod.

Aperture-Priority Auto (A) Mode

Nature and macro shooters, and anyone concerned with carefully controlling depth of field, often leave their cameras set to Aperture-priority auto (A) mode. Figure 8.14 shows the Mode dial set to Aperture-priority auto mode.

Aperture-priority auto mode, or A mode, allows you to control the aperture while the camera takes care of the shutter speed for optimal exposures. To select an aperture, you use the Sub-

Figure 8.14 – Mode dial set to Aperture-priority auto (A)

command dial. Turn the wheel clockwise for smaller apertures (stopping down) and counterclockwise for larger apertures (opening up).

The minimum and maximum aperture settings are limited by the minimum and maximum aperture openings on the lens you're using. Most consumer lenses run from f/3.5 to f/22. More expensive pro-style lenses may have apertures as large as f/1.2, but they generally start at f/2.8 and end at f/22-f/32.

Figure 8.15 – Large aperture to blur background and small aperture for deep focus

The aperture directly controls the amount of depth of field—or zone of sharpness—in an image. Depth of field is an extremely important concept for photographers to understand. Simply put, it allows you to control the range or depth of sharp focus in your images. In the bird image in figure 8.15, the depth of field is very shallow, and in the scenic shot it is very deep.

Suggested Reading for Depth of Field, Aperture, and Shutter Speed Basics

Many people who use the D600 are advanced photographers, reflecting the purpose of this feature-laden camera, and they fully understand things like depth of field, shutter speed, and aperture.

However, many newer photographers have decided to go for the D600 as their first entry into serious DSLR photography. The relationship between aperture, shutter speed, and ISO sensitivity are so important for new photographers that I wrote a book titled Beyond Point-and-Shoot, published by Rocky Nook, to clearly explain it (figure 8.15.1).

The book gives new DSLR users a way to fully understand how to use the more advanced features of their cameras and not depend so much on automatic modes. If that describes you, get the book. It will open your eyes to the best ways to control your new D600—for the best images you've ever taken.

Figure 8.15.1 - Beyond Pointand-Shoot (published by Rocky Nook)

Manual (M) Mode

Manual mode takes a big step backward to days of old. It gives you complete control of your shutter and aperture so you can make all the exposure decisions, with suggestions from the light meter. Figure 8.16, image 1, shows the Mode dial set to Manual.

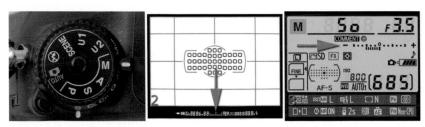

Figure 8.16 - Mode dial set to Manual (M); analog exposure display in Viewfinder and Information display screen

You can control how sensitive this scale is by changing Custom Setting Menu > b Metering/exposure > b2 EV steps for exposure cntrl. You can set Custom setting b2 to 1/3 EV step or 1/2 EV step. The camera defaults to 1/3 step.

When you are metering your subject, a dashed bar will show up underneath the analog exposure display and extend from the zero in the center toward the plus side to indicate overexposure, or toward the minus side to indicate underexposure. You can gauge the amount of over- or underexposure by the number of dots and lines the bar passes as it heads toward one side or the other. The goal in Manual mode is to make the bar disappear. As mentioned previously, in figure 8.16, screen 3, the bar is indicating underexposure of 1 EV step (or 1 stop).

You can adjust the aperture with the Sub-command dial and adjust the shutter speed with the Main command dial. In Manual mode you have control over the aperture (for depth of field) and the shutter speed (for motion control). If your subject needs a little more depth of field, just make the aperture is smaller, but be sure to slow down the shutter speed as well (or your image may be underexposed). If you suddenly need a faster shutter speed, then set it faster, but be sure to open the aperture to compensate for it. The camera will make suggestions with the meter, but you make the final decision about how the exposure will look.

Manual mode is for taking your time and enjoying your photography. It gives you the most control of how the image looks, but you need more knowledge to get correct exposures.

Settings Recommendation for Exposure Mode Selection

As a nature photographer, I am mostly concerned with getting a nice sharp image with a deep depth of field. About 90 percent of the time my camera is set to Aperture-priority auto (A) and f/8. I started using this mode back in about 1986 when I bought my Nikon FE, and I have stayed with it since. In A mode, you control the aperture and the camera controls the shutter speed.

However, if I were shooting sports or action, I would have my camera set to Shutter-priority auto (S) most often, which would allow me to control the speed of the shutter and capture those fast-moving subjects without a lot of blur. The

camera will control the aperture so I have to concentrate only on which shutter speed best fits my subject's movement.

I use the other two modes, Programmed auto (P) and Manual (M), only for special occasions.

When I want to control the camera absolutely, I use Manual. I've even been known to carry a small blanket with me so when I'm shooting in Manual mode I can toss it over the back of the camera and my head. That way I can feel like Ansel Adams or another view camera artist. I do admit that people (especially kids) seem to find that hilarious. Well, I bet they don't know how to use Manual mode!

I probably use Programmed auto (P) mode least of all. I might use it when I am at a party and just want to take nice pictures for my own use. I let the camera make most of the decisions in P mode, and I still have the ability to quickly jump into Flexible program (P*) mode when events call for a little more aperture control.

Why shouldn't you just use AUTO mode instead? (We'll explore it in the next section.) Well, AUTO mode controls everything, including when to use flash and which ISO sensitivity setting is best; therefore, it may not work well for maximum quality images in lower light levels. With P mode, the camera controls only the shutter speed and aperture, and you control the rest.

As mentioned, some people have recently switched from using a point-andshoot camera to the more powerful Nikon D600. Most point-and-shoot cameras have a completely automatic mode and some SCENE modes that represent common photographic opportunities. If you have come over from the pointand-shoot world, you might enjoy using the AUTO or SCENE modes at first while learning the more advanced P, S, A, and M modes. Let's look into how these extra modes work.

Auto Exposure (AUTO) Mode

The AUTO exposure mode (figure 8.17) is for those times when you want to get the picture with no thought as to how the camera works. All you need to be concerned about in AUTO mode is whether the battery is fully charged and how well the image is composed.

The D600 becomes a big point-and-shoot camera, like a heavy Nikon Coolpix. Many of its internal modes become automatic, which means you can't change them because the camera decides what is best for each setting:

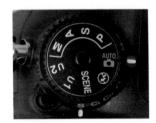

Figure 8.17 - Mode dial set to AUTO exposure mode

- White balance
- · Active D-Lighting
- ISO sensitivity
- Picture Control
- Built-in Speedlight flash

In addition, several of the Shooting Menu settings and Custom settings are disabled in AUTO. In effect, you relinquish control of the camera's functions for a "guarantee" that some sort of picture will be provided. In most cases, the D600 will provide its normal excellent images when you select AUTO. However, in difficult circumstances, the camera is free to turn up the ISO sensitivity and extend the Active D-Lighting range to get a picture, even at the expense of image quality.

If an alien spaceship lands in the local superstore parking lot, I might be convinced to use AUTO since I want to get a picture no matter what. I don't have to think about anything except framing the subject and pressing the Shutterrelease button. Or, if you want to loan your camera to your grandmother and she has no interest in how cameras work, the D600 will happily make nice images for her in AUTO mode. While you are learning to use the more advanced functions of the camera, you too might benefit from using this mode for a while. You'll usually get better pictures when you control the camera, but the D600 has some very efficient software that will help you if you're not ready to take control.

Settings Recommendation: I don't like to admit it, but I do use AUTO mode sometimes. The D600 is such a good camera that it will make some nice images without my help. If I have reasonably good light and am not shooting for commercial work, I will switch to AUTO mode just to enjoy taking pictures. Sometimes we need to take ourselves less seriously. AUTO mode lets me do that. Try it!

SCENE Modes

SCENE modes are considered "creative photography" modes by Nikon. In fact, they allow beginning photographers to emulate the camera settings they would be inclined to use if they had more experience. These modes allow them to make consistently good images, and later, as their experience grows, they can use the P, S, A, and M modes to get more creative control over the image.

Because the Nikon D600 has thousands of images stored in its Matrix metering system, I wouldn't be surprised if each of these SCENE modes uses a subset of stored image types that more closely match the selected subject matter. This might hold true in Matrix metering mode. I have no way to prove this, so don't quote me!

If you choose to use SCENE modes, do so with the understanding that you can eventually learn to control the image to a finer degree with the P, S, A, and

With the P, S, A, M, AUTO, and SCENE modes on the Mode dial, Nikon has given us the best of both worlds in one camera. Full or partial automation, or complete manual control. What flexibility!

The Nikon D600 provides no less than 19 distinct SCENE modes designed to give inexperienced users control over certain styles of photography. Let's look at a list of the various SCENE modes and then examine each of them in more detail:

- **Portrait**
- Landscape
- Child
- Sports
- Close up
- Night portrait
- Night landscape

- Party/indoor
- Beach/snow
- Sunset
- Dusk/dawn
- Pet portrait Candlelight
- Blossom

- Autumn colors
- Food
- Silhouette
- High key
- · Low key

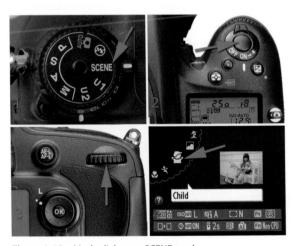

Figure 8.18 - Mode dial set to SCENE mode

Here are the steps to select a SCENE mode:

- 1. Set the Mode dial to SCENE (figure 8.18, image 1).
- 2. Make sure the light meter is active by pressing the Shutter-release button halfway, and then release the button (figure 8.18, image 2). (Nikon does not mention this step in the User's Manual on page 40; however, my camera does not display SCENE modes unless the meter is active.) If the light meter is already active, skip this step. Nikon suggests pressing the Info button, which also takes you to the SCENE modes.

- 3. Turn the Main command dial at least two clicks while examining the Monitor (figure 8.18, image 3). If you turn it only one click, the camera displays the Information display screen only for the current SCENE mode. Each click past the first one displays a different SCENE mode on the Monitor, with a small picture indicating the effect provided (figure 8.18, image 4). The SCENE mode display appears for only about two seconds before the Monitor changes to the Information display with the corresponding SCENE mode symbol displayed in the top left corner of the Monitor. Quickly turn the dial again to show more SCENE modes.
- 4. When you have selected the SCENE mode you want and the Monitor goes off, you are ready to shoot. If you don't want to wait, you can press the Shutterrelease button halfway to turn the Monitor off and get ready for shooting.

Settings Recommendation: It almost seems that Nikon added SCENE modes to the D600 as an afterthought. I often judge a user interface by how intuitively it works. The steps to set a SCENE mode are not intuitive at all. When I first got my D600 I noticed that nothing happens when you select SCENE from the Mode dial. I expected to see SCENE modes immediately appear on the monitor, but they don't. That's silly for an interface designed with inexperienced users in mind!

The following is an abbreviated version of how to get into the SCENE modes:

- 1. Set the Mode dial to SCENE.
- 2. Make sure the light meter is active.
- 3. Turn the rear Main command dial at least two clicks.

Now, let's take a detailed look at the SCENE modes. In each of the following 19 sections, I have included a figure that contains two screens: (left) the screen used to select the mode, with its sample picture; and (right) the Information display screen as it will appear after you've chosen a particular SCENE mode or if you press the Info button with a SCENE mode active.

Portrait Scene Mode

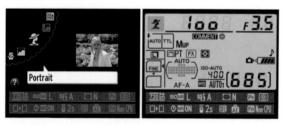

Figure 8.19 - Portrait SCENE mode

Portrait SCENE mode is best used when you are taking pictures of people or static subjects. Its sample image is a lady in a flower garden, and its icon resembles a proper lady wearing a big hat (figure 8.19). The camera tends to emphasize shallow depth of field (large apertures) so that only your subject is in sharp focus, which is a flattering way to focus attention on your subject while trying to blur out the background as much as possible. If you are taking pictures of friends (alone or in small groups), use this mode.

Landscape Scene Mode

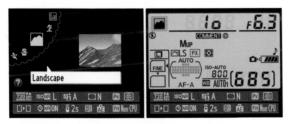

Figure 8.20 - Landscape SCENE mode

If you are spending a day in the mountains, you'll want to use the Landscape SCENE mode. It has a sample picture of a mountain, and its icon looks like a couple of mountain peaks (figure 8.20). Landscapes are usually best photographed on a tripod at small apertures so the entire scenic view is nice and sharp. Landscape mode will emphasize smaller apertures for more depth of field. This is sort of like using Aperture-priority auto (A) mode but with much less control over the aperture, since the camera decides on the setting.

Child Scene Mode

Figure 8.21 - Child SCENE mode

Child SCENE mode tries to balance the need for saturating the colors in the child's clothes and any colorful backgrounds while not overly saturating skin tones. It has a sample picture of a young girl tying her shoe, and its icon looks like a small child with raised arms (figure 8.21). The primary emphasis of this mode seems to be making skin tones look good while providing a fast enough shutter speed to capture a moving child and a small enough aperture to have some depth of field. It seems to be a balanced mode when it comes to shutter speed and aperture.

Sports Scene Mode

Figure 8.22 - Sports SCENE mode

Because sports usually have people or other subjects moving at a rapid pace, the Sports SCENE mode emphasizes faster shutter speeds to stop motion. It has a sample picture of a young boy shooting a basketball goal, and its icon is a person running (figure 8.22). Since you certainly don't want slow shutter speeds at a car race or air show, the camera will attempt to use the fastest shutter speed that the light will allow, and the camera will open the aperture to keep the exposure reasonable. Expect a shallow depth of field in Sports mode. This mode is similar to using Shutter-priority auto (S) mode with less control over specific shutter speeds. Autofocus is in Continuous-servo mode (focus never locks) because sports are constantly in motion.

Close Up Scene Mode

Figure 8.23 - Close up SCENE mode

Another name for Close up SCENE mode might be "flower mode," or even "macro mode." It has a sample picture of a beautiful yellow rose, and its icon is a flower (figure 8.23). It's designed to let you to take closeup pictures of flowers, insects, and other small items. The mode seems a bit neutral. It tries to balance a shutter speed that is fast enough to cut down on camera shake while providing enough depth of field to sharply focus your subject. It acts somewhat like Programmed auto (P) mode. The focus locks on your subject when it is acquired.

Night Portrait Scene Mode

Figure 8.24 - Night portrait SCENE mode

Night portrait SCENE mode acts somewhat similar to Close up SCENE mode in that it tends to use medium apertures and shutter speeds. It has a sample picture of a smiling woman in front of a well-lit carousel, and its icon is a small person with a star on the upper right (figure 8.24). The mode seems to balance the shutter speed and aperture for handheld shots so the shutter speed is fast enough to avoid camera shake while the aperture is open as much as possible to let in dim light. It seems to emphasize large apertures over faster shutter speeds.

Night Landscape Scene Mode

Figure 8.25 - Night landscape SCENE mode

Night landscape SCENE mode is designed to be used with a tripod for landscape exposures at night. It has a sample picture of a nighttime cityscape, and its icon is a building with a crescent moon (figure 8.25). If you want to shoot a cool moonlit landscape or a lighted city view at night, this is the mode for you.

When it's dark outside the camera uses longer exposures, higher ISO sensitivity, and noise reduction to keep noise from being a big problem. Since various light sources have different colors, the camera tries to "reduce ... unnatural colors," according to Nikon. The Built-in flash and the Built-in AF-assist illuminator are disabled. The camera will still fire an accessory shoe-mounted Speedlight in case you want to use flash for special effects or fill.

Party/Indoor Scene Mode

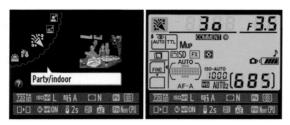

Figure 8.26 - Party/indoor SCENE mode

Party/indoor SCENE mode balances fill flash and ambient background lighting and adds red-eye reduction. Its sample picture is a family at a party meal, and its icon is a horn blowing with confetti and champagne bubbles (figure 8.26). This SCENE mode tries to overcome brightly lit people and dark backgrounds by allowing more background light to register on the sensor. It's great for shooting at events with people! Be careful if people are moving quickly because this mode uses slower shutter speeds, usually around 1/60 second. This can cause ghosting if the subject is moving too quickly.

Beach/Snow Scene Mode

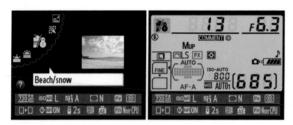

Figure 8.27 - Beach/snow SCENE mode

Beach/snow SCENE mode is optimized to work well with the often-bright expanses of water, sand, and snow. Its sample picture is a bright sandy beach scene, and its icon is a cloudy beach and snowman (figure 8.27). Use this mode when you shoot by the ocean or on a snowy day. It's a landscape mode, so it will intensify colors, if present, and sharpen the image a little. The popup flash and focus assist light are disabled.

Sunset Scene Mode

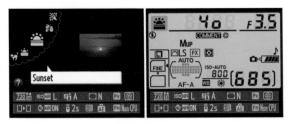

Figure 8.28 - Sunset SCENE mode

Sunsets often provide deep colors, so Sunset SCENE mode is designed to emphasize them. Its sample picture is a horizon with a setting sun, and its icon is a setting sun with rays (figure 8.28). This mode uses small apertures and slow shutter speeds, so it may be best to use a tripod to avoid blurry images. The popup flash and focus assist light are disabled. To provide nice sharp images, it increases sharpening.

Dusk/Dawn Scene Mode

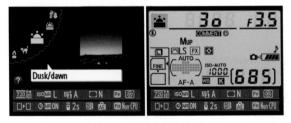

Figure 8.29 - Dusk/dawn SCENE mode

Dusk and dawn often have nice color in the sky and muted color elsewhere due to darkness, so Dusk/dawn SCENE mode saturates the color a bit. Its sample picture is a rim-lit urban area after sunset, and its icon looks like the Sunset SCENE mode icon except the sun has fewer rays (figure 8.29). This mode works like the Sunset mode, except it uses a cooler white balance of 4450K. Since the light is so low at dusk and dawn, you may want to use a tripod. The popup flash and focus assist light are disabled.

Pet Portrait Scene Mode

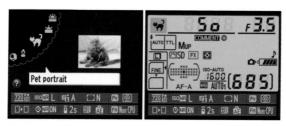

Figure 8.30 - Pet portrait SCENE mode

Pet portrait SCENE mode emphasizes faster shutter speeds to capture wiggling Fluffy and Spot. Its sample picture is a fuzzy kitten, and its icon is a proud cat with its tail raised (figure 8.30). The depth of field is shallow to better draw attention to your pet. The color saturation and contrast is normally set to medium so your pet won't have abnormally strong colors. However, the camera retains the ability to increase saturation when there are colorful backgrounds or pet clothing. It also increases sharpening a little to bring out your pet's lovely fur and eyes (or beak, feathers, gills, claws, scales, etc.). Autofocus continually updates to keep up with a moving pet (i.e., AF never locks). The AF-assist illuminator is disabled.

Candlelight Scene Mode

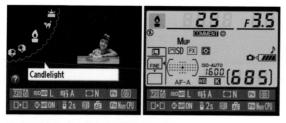

Figure 8.31 - Candlelight SCENE mode

Candlelight SCENE mode is designed to get those delightful candlelight pictures at parties and for special effects shots. Its sample picture is of a little girl about to blow out the candles on her cake, and its icon is a candle with a flame (figure 8.31). If you can, use a tripod because the shutter speeds will be low by candlelight. The camera uses a medium-cool white balance of 4350K to balance against the warmer color of candlelight. A little extra sharpening is provided in case you shake the camera a little while shooting in the dark ambient light. The popup flash and focus assist light are disabled. The focus locks on your subject when it is acquired.

Blossom Scene Mode

Figure 8.32 - Blossom SCENE mode

If you are a gardener or visit places with lots of flowers, you'll enjoy Blossom SCENE mode. It tends to emphasize color saturation. The sample picture is of a field of daffodils with blossoming springtime trees in the background, and its icon is a tree with a blossom on the left side (figure 8.32). Since you need a deeper depth of field when taking pictures of landscape flower blossom shots (not closeups), the camera uses smaller apertures. Use a tripod if the ambient light is low. The popup flash and focus assist light are disabled.

Autumn Colors Scene Mode

Figure 8.33 - Autumn colors SCENE mode

Who doesn't love the beautiful reds, yellows, and oranges of autumn? Autumn colors SCENE mode tends to saturate the deep colors for lots of colorful snap. This mode's sample picture is a beautiful red-leaved tree branch, and its icon is a tree with a leaf on the right (figure 8.33). This mode uses smaller apertures to get deeper focus for those colorful landscape shots. If the light gets low, please use a tripod because the shutter speeds will be slow. The popup flash and focus assist light are disabled.

Food Scene Mode

Figure 8.34 - Food SCENE mode

Food images should have nice color but not be overly saturated. Food SCENE mode uses medium color saturation and contrast to provide a natural look to food images. Its sample image is several platters of delicious-looking food, and its icon is a fork and knife (figure 8.34). This mode emphasizes smaller apertures to provide enough depth of field to get most of the food in focus. You'll need to use a tripod if you are shooting food images in low light. The Built-in flash and the Built-in AF-assist illuminator are disabled.

Silhouette Scene Mode

Figure 8.35 - Silhouette SCENE mode

When you take a picture of a silhouette, your subject is dark and the background is well lit. Silhouette SCENE mode is not for taking pictures of someone standing in front of a window, since the camera disables the popup flash (use Portrait or Night portrait SCENE mode for that). Instead, use this mode to take pictures of interesting foreground objects—such as trees, buildings, or people—silhouetted against a beautiful sunset or sky. Its sample image is of a row of palm trees silhouetted against a bright sky, and its icon is a sunset with a palm tree (figure 8.35). The Built-in AF-assist illuminator is disabled. The focus locks on your subject when it is acquired.

High Key Scene Mode

Figure 8.36 - High key SCENE mode

High key imagery is deliberately overexposed slightly to give a very bright look to the image. The image almost seems to shine with extra light, to the point that some highlight detail is lost. Its sample image is of a bright seashell still life, and its icon is the word Hi (figure 8.36). High key SCENE mode is often used with white subjects on white backgrounds for a bright, dreamy effect. The contrast is lowered slightly to save some highlights, and the brightness is raised automatically. The Built-in flash and Built-in AF-assist illuminator are disabled. The focus locks on the subject when it is acquired.

Low Key Scene Mode

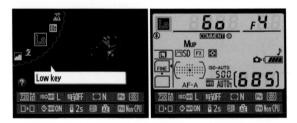

Figure 8.37 - Low key SCENE mode

Low-key photography is all about the highlights. Reflections from shiny subjects do well as low-key subjects. Its sample picture is a black Nikon FM2 camera, and the icon is the word Lo (figure 8.37). Use Low key SCENE mode when you want most of the subject to be dark and somber looking with the highlights preserved. The camera raises the contrast to deepen the shadows and automatically lowers the brightness. Since the light is low, it's a good idea to use a tripod when shooting in this mode. Color saturation is set to medium, since dark images often do not emphasize color. The Built-in flash and Built-in AF-assist illuminator are disabled. The focus locks on the subject when it is acquired.

Using the Help System in Scene Modes

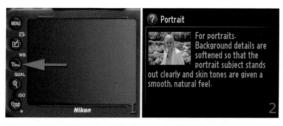

Figure 8.38 - Using the Help System in SCENE modes

If you find yourself unsure of what a certain SCENE mode does, you can use the help system to get a short tutorial. Simply select one of the SCENE modes, and when the SCENE mode selection screen or Information display is showing, press and hold the Help/protect button (figure 8.38, image 1, red arrow). A screen will display on the Monitor with information about the current SCENE mode (figure 8.38, screen 2). Portrait mode was selected when I pressed the Help/protect button, so the camera opened the help screen for that SCENE mode.

U1 and U2 User Settings

The user modes U1 and U2 on the Mode dial (figure 8.39) allow you to make adjustments to many of the camera's settings and then save them for later use. You'll need to configure your camera's settings and then use Setup Menu > Save user settings > U1 (or U2) to save the configuration for that specific User setting. Please refer to the chapter titled Setup Menu and the heading called **Save User Settings** for a thorough discussion of the U1 and U2 User settings, including the lists of items that can and cannot be saved to a user setting.

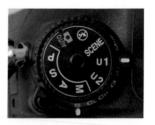

Figure 8.39 - U1 and U2 User Settings

After you have saved your configuration of settings into a User setting, you can recall them into use by simply selecting U1 or U2 from the Mode dial. This allows you to set your camera up for two very specific purposes and switch to them quickly. Very powerful!

Settings Recommendation: I set U1 for highest-quality NEF (RAW) shooting, and U2 for highest-quality JPEG shooting.

No Flash Mode

This setting, which I call the no flash mode, is basically the same as the AUTO setting we discussed earlier in this chapter (figure 8.40). All shooting functions are controlled by the camera, rendering the D600 a large, fully automatic point-and-shoot camera. The only difference between this setting and AUTO is that the flash is disabled. See the previously section named Auto Exposure (AUTO) Mode earlier in this chapter.

Figure 8.40 - No flash mode

Section 3 – Histogram

Back in the good old film days photographers didn't have histograms, so we had to depend on our experience and light meter to get a good exposure. Since we couldn't see the exposure until after we had left the scene, we measured our success by the number of correctly exposed images we created. With the exposure meter/histogram combination in the D600, and the ability to zoom in to an image with the high-resolution Monitor, our success rate is much higher than ever before.

The histogram can be as important, or even more so, than the exposure meter. The meter sets the camera up for the exposure, and the histogram verifies that the exposure is a good one.

If your exposure meter stopped working, you could still get perfect exposures using only the histogram. In fact, I gauge my efforts more by how the histogram looks than anything else. The exposure meter and histogram work together to make sure you get excellent results from your photographic efforts.

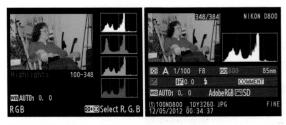

Figure 8.41 - The two histogram screens

Figure 8.41 shows the D600's two histogram screens, each representing the brightness and color values of the picture it is shown with. The screen on the left is called the RGB histogram screen (color channels), and it shows a series of histograms. On the top is a luminance histogram (weighted brightness, shown in

If your camera does not display the RGB histogram screen, put a check in the box found at *Playback Menu > Playback display options > RGB histogram*. This setting enables or disables the RGB histogram screen. The basic luminance histogram is one of the camera's main screens and can always be called into use. Both of these screens are available by scrolling up or down with the Multi selector when you have a picture displayed on the Monitor.

Now, let's discuss the use of a histogram in detail.

Understanding the Histogram

Using your histogram screens will guarantee you a much higher percentage of well-exposed images. It is well worth spending time to understand the histogram. It's not as complicated as it looks.

I'll try to cover this feature with enough detail to give you a working knowledge of how to use the histogram to make better pictures. If you are deeply interested in the histogram, there is a lot of research material available on the Internet. Although this overview is brief, it will present enough information to improve your technique immediately.

Light Range

The D600 sensor can record only a certain range of light values—up to 14.2 EV steps under the best of controlled conditions, according to DxO Labs. At the time of this writing, that is the third best dynamic range of a production camera in the world, bested only by the Nikon D800 and D800E.

Unfortunately, many high-contrast subjects contain more EV steps of light than even the D600 can handle in a single exposure. It is important to understand how your camera records light so you can better control how the image is captured.

The gray rectangular area in figure 8.42 represents an in-camera histogram. Examine it carefully! Think about it for a minute before reading on.

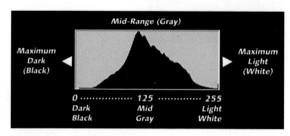

Figure 8.42 - A basic histogram

The histogram is basically a graph that represents the maximum range of light values your camera can capture, in 256 steps (0 = pure black, and 255 = pure white). In the middle of the histogram are the midrange values that represent middle colors like grays, light browns, and greens. The values from just above zero to just below 255 contain detail.

The graph often looks like a mountain peak, or a series of peaks, and the more there is of a particular color, the taller the peak is for that color (in an RGB histogram). In some cases the graph will be round on top, and in other cases it will be flat.

The left side of the histogram represents the maximum dark values that your camera can record. The right side represents the maximum bright values your camera can capture. On either end of the histogram the light values contain no detail. They are either completely black or completely white.

The height of the histogram (top of mountain peaks) represents the amount of individual colors. You cannot easily control this value in-camera, other than changing to a Picture Control with more or less saturated color, so it is for your information only. We are mostly concerned with the left- and right-side values of the histogram, since we do have much greater control over those (dark vs. light).

Simply put, the histogram's left and right directions are related to the darkness and lightness of the image, while the up and down directions (the valleys and peaks) pertain to the amount of color information (how many pixels for each color).

The left (dark) and right (light) directions are very important for your picture taking. If the image is too dark, the histogram will show that by clipping off the light values on the left; if it's too light, the values on the right will be clipped. This will be easier to understand when we look at well-exposed and poorly exposed images. Check out figure 8.43, and then we'll look at things in more detail.

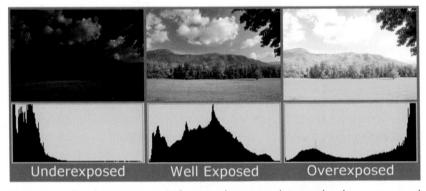

Figure 8.43 – Three histograms: one underexposed, one correctly exposed, and one overexposed

When you see the three histograms next to each other in figure 8.43, does it make more sense? The histograms on the bottom represent the images on top. Notice how the underexposed histogram is all the way to the left of the histogram window and is clipped midpeak, and there is a big gap on the right side. Then note how both edges of the well-exposed histogram just touch the edges of the histogram window on the left and right. Finally, notice how the overexposed histogram is clipped on the right. I hope this helps somewhat!

Now let's look at some histogram details.

Histogram Shape

Look at the image in figure 8.44. It is well exposed with no serious problems. The entire dynamic light range fits within the histogram window, which means that it's not too light or too dark and will take very little or no adjustment to view or print.

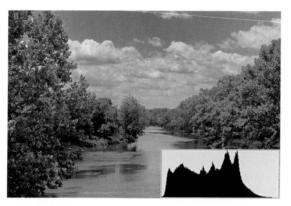

Figure 8.44 – Good image with normal histogram shape, no clipping

The image contains no more than 4 or 5 stops (EV steps) of light range. To finalize the image, I might increase the brightness in the trees a little, but otherwise it's a good image with potential for immediate use.

Compare the histogram in figure 8.44 to the histogram in figure 8.45. Notice that the histogram in figure 8.44 is not crammed against the dark value side, but the histogram in figure 8.45 is all the way to the left. In other words, the dark values in figure 8.44 are not clipped on the left. This means that the camera recorded all the dark values in figure 8.44 with no serious loss of shadow detail.

Now look at the right side of the histogram in figure 8.44 and note that it is not completely against the right side, although it is quite close. The image contains all the available light values. Everything between the two sides is exposed quite well, with full detail. A histogram does not have to cover the entire window for the exposure to be fine. When there is a very limited range of light, the histogram may be rather narrow.

The image in figure 8.44 is relatively bland, with smooth tonal gradations, so it makes a nice smooth mountain-shaped histogram. This shape will not occur every time, since images contain quite a bit of variation in color information (peaks). Each prominent color will be represented with its own peak on the histogram (in an RGB histogram). The most prominent colors will have higher peaks, and the less prominent colors will have lower or no peaks.

As we examine images with more color or light information, we'll see that the histogram looks quite different.

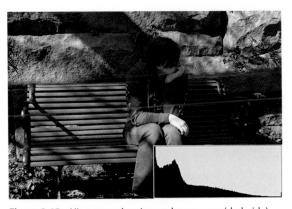

Figure 8.45 - Histogram showing underexposure (dark side)

Look at the image in figure 8.45. The dark values exceed the range of the sensor. The histogram is crammed to the left and is clipped. There are no gradual climbs like on a mountain range, from valley to peak and back to valley. Instead, the image shows up on the left side in midpeak. This is an underexposed image, and the histogram effectively reflects that.

The most important thing to understand when you see a histogram like the one in figure 8.45, with part of the peak clipped off on the left, is that some or all of the image is significantly underexposed.

Now look at the image in figure 8.46. A larger aperture was used and more light was allowed in. We can now see much more detail. But once again the range of light is too great for the sensor, so it is clipped off on the highlight side (right). The dark side (left) is clipped, too. This image simply has more light range than the camera can capture in one image.

The image in figure 8.46 shows plenty of detail but is not professional looking and will win no awards. The range of light is simply too great to be recorded fully. Most of the sky detail is overly light, which is indicated by the clipping on the right side. Also, there are very dark shadows in the trees, so the left side is

clipped. The most important thing to remember here is that when you see a histogram that is crammed all the way to the right and the left, there is a loss of detail in both the light and dark areas of the image. A good portion of the image in figure 8.46 is recorded as pure white or black and is permanently gone, or blown out

Figure 8.46 – Histogram showing excessive dynamic range

It is important that you try to center the histogram without clipping either edge, if you can. This is not always possible, as shown in figure 8.46, because the light range is often too great and the sensor can't contain it. If you center the histogram, your images will be better exposed. If you take a picture and see that the histogram is shifted way left or right, you can retake the photograph and expose in the opposite direction.

If there is so much light that you can't center the histogram, you must decide which part of the image is more important, the light or dark values, and expose for those values.

With an image like the one in figure 8.46 you will have to hold back some of the brightness in the sky with a graduated neutral density filter over the sky area. Or you could shoot multiple (bracketed) images at different exposures and later combine them in your computer. This is called high dynamic range (HDR) imaging.

The Nikon D600 can create a two-image HDR JPEG combination when you enable Shooting Menu > HDR (high dynamic range). You can create two JPEGS with 1 to 3 stops of exposure difference, and the camera will automatically combine them into a single HDR image.

This feature is nice for people who do not like to post-process images later in the computer. Try it out!

Note: If you are not experienced with shooting bracketed images and combining them in your computer for HDR imaging, you might want to read Practical HDRI and/or The HDRI Handbook 2.0 (figure 8.46.1).

Figure 8.46.1 - Practical HDRI by Jack Howard and The HDRI Handbook 2.0 by Christian Bloch

Both of these books are excellent for learning how to do HDR imaging. I own both of them and highly recommend them.

Luminance Histogram Differences

The luminance histogram (figure 8.41, right side) is, in a sense, a combined histogram of all three RGB channels. However, it is not a direct combination. It is a weighted brightness combination.

Human vision is heavily weighted toward green since most of nature is green. Therefore, the brightness of a luminance histogram is weighted this way: 59 percent green, 30 percent red, and 11 percent blue. This closely matches the way our eyes see.

We are much better at perceiving small changes in brightness than we are small changes in color shades. Therefore, a weighted brightness, or luminance histogram, more accurately reflects the way our brain perceives the world.

Note: If you would like more detailed information on how histograms work, I recommend the following website, which has more detail:

http://www.cambridgeincolour.com/tutorials/histograms2.htm

If you spend some time reading the technical document on histograms at this site, you will have a much deeper understanding of your camera's color system.

If you use the luminance histogram, you will generally get the best results. The only time most of us need to view the histogram from a single channel (RGB) is to see if a strong color, such as red, has blown out only that one color channel, leaving no detail in that particular color only.

The Nikon D600 offers us both RGB and luminance histograms. We have the best of both worlds!

The Histogram Represents a JPEG Image

Interestingly, the histograms presented by your Nikon D600 represent a cameracreated 8-bit JPEG file. When you take a picture, the camera takes RAW image information from the sensor, moves it into a 16-bit queue, and processes it. It then takes the 12 or 14 bits of color information your camera captures and compresses the color values into an 8-bit space, dumping extra color information. Since your eyes can see small changes in brightness much more easily than small changes in color shades, the removal of 4 to 6 bits of color information does not make a lot of difference in your picture, as long as the brightness is not affected.

However, since a RAW image from a Nikon D600 contains more color information than a JPEG, there is often a little more headroom in a RAW image. That is, if a histogram shows that the light or dark sides of the histogram are clipped (no detail), that clipping is based on a compressed JPEG created by the camera. If you shot the image in NEF (RAW) mode, there would actually be a little more detail in the dark and bright regions of the image than shown on the histogram.

This is a strong argument for shooting in RAW mode for very contrasty scenes. Your images will suffer less from loss of details in light and dark areas in RAW mode. Basically, the histogram is slightly conservative in how it represents the scene captured by the camera—if you are shooting in RAW mode, that is. If you shoot only JPEGs, the histogram will be accurate.

How Does the Eye React to Light Values?

The D600, with its imaging sensor and glass lenses, is only a weak imitation of our marvelously designed eye and brain combination. There are very few situations in which our eyes cannot adjust to the available light range. As photographers we are always seeking ways to record even a small portion of what our eye and mind can see.

Since our brain tends to know that shadows are black, and expect that, it is usually better to expose for the highlights. If you see dark shadows, that seems normal. We're simply not used to seeing light so bright that all detail is lost. An image exposed for the dark values will look very weird because most highlight detail will be blown out.

Your eyes can see a huge range of light in comparison to your digital sensor. The only time you will ever see light values so bright that detail is lost is when you are looking directly at an overwhelmingly bright light, like the sun. Therefore, in a worst-case scenario, expose the image so the right side of the histogram just touches the right side of the histogram window, and the image will look more normal.

Settings Recommendation: Since the beginning of photography, we have always fought with being able to record only a limited range of light. But with the digital camera and its histogram, we can now see a visual representation of the light values and can immediately review the image, reshoot it with emphasis on lighter or darker values, or see that we must use a filter or HDR imaging to capture it at all. Learn to use your histogram for consistently better exposures.

Computer Adjustment of Images

Looking at the image in figure 8.47, taken in midday with the sun overhead, we see an example of a range of light that is too great to be captured by a digital sensor, but the image is exposed in such a way that we can get a usable photo later.

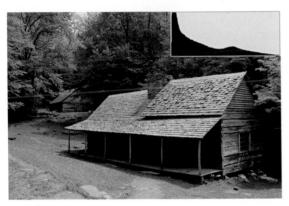

Figure 8.47 – Cabin picture with correct exposure but dark shadows, and its histogram

Notice in the histogram of the figure how the dark values are clipped and dark details appear to be lost. But on the right side of the histogram you can see that the light values are not clipped. The camera recorded all the light values but lost some dark values. This image was exposed for the light side, and the shadows remained dark.

Since our eyes see this as normal, the image looks okay. If we were standing there looking at the cabin ourselves, our eyes would be able to see much more detail in the front porch. But the camera just can't record that much light range.

If we wanted to get a bit more detail in the shadows than this image seems to contain, we can do it. Normally a camera does not give us enough control to add light values on the fly—except maybe with some in-camera Active D-Lighting—therefore, we use the histogram to get the best possible exposure and then adjust the image later in the computer.

We need a way to take all this light and compress it into a more usable range. We are now entering the realm of post-processing, or in-computer image manipulation. Look at the image in figure 8.48. This is the same image as in

figure 8.47, but it has been adjusted in Photoshop to add more shadow detail into the histogram by compressing the midrange values. Notice that the entire histogram seems to be farther right, toward the light side. We removed some of the midrange, but since there was already a lot of midrange there, our image did not suffer greatly.

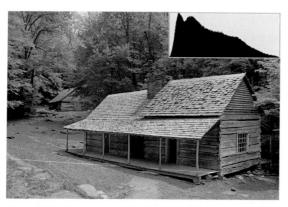

Figure 8.48 – Post-processed cabin picture and its histogram (in-computer manipulation)

How this computer post-processing was done is outside the scope of this book, but it is not very hard. Buy a program like Nikon Capture NX2, Adobe Photoshop, Adobe Photoshop Elements, Adobe Lightroom, Apple Aperture, or another fine graphics program designed for photographers.

Your digital camera and your computer are a powerful imaging combination—a digital darkroom, where you are in control from start to finish, from clicking the shutter to printing the image.

But, retreating from philosophy, let's continue with our histogram exploration. Notice in figure 8.48 how the histogram edge is just touching the highlight side of the histogram window.

What if, instead, a small amount of clipping on the light side was allowed to take place to allow more room for shadow values? Sometimes a very small amount of clipping does not seriously harm the image. The photographer must be the judge.

The greater apparent detail in this image is the result of compressing the midrange of the light values a bit in the computer. If you compress the midrange light values (remove color detail), that will tend to pull the dark values toward the light side and the light values toward the dark side, resulting in more apparent detail in your image.

It's like cutting a section out of the middle of a garden hose. If you pull both of the cut ends together, the other two ends of the hose will move toward the middle, and the hose will be shorter overall. If you compress or remove the midrange

of the histogram, both ends of the graph will move toward the middle. If one end of the graph is beyond the edge of the histogram window (clipped), it will be less so when the midrange is compressed.

We are simply trying to make the histogram fit into the frame of its window. If we have to cut out some of the middle to bring both ends into the window, well, there is usually plenty in the middle to cut out, so the image rarely suffers.

Remember, this is done outside of the camera in a computer. You can't really control the in-camera histogram to compress values, but you need to be aware that it can be done in the computer so you can expose accordingly with your camera's histogram. Then you will be prepared for later post-processing of the image.

In fact, now that we have compressed the midrange values, figure 8.48 more closely resembles what our eyes normally see, so it looks more normal to us.

In many cases your progression from the shooting site to your digital darkroom can benefit if you shoot NEF (RAW) images. A RAW digital image contains an adjustable range of light. With a RAW image you can use controls in your postprocessing software to select from the range of light within the big RAW image file. It's like moving the histogram window to the left or right over all that wide range of RAW image data. You select a final resting place for the histogram window, capture the underlying RAW data, and your image is ready for use.

This is a serious oversimplification of the process, but I hope it is more understandable. In reality, the digital sensor often records a wider range of light than you can use in one JPEG image. Although you can't get all of that range into the final image, it is there in the RAW file as a selectable range. I prefer to think of it as a built-in bracket, since it works the same way.

This bracketed light range within the image is present, to a very limited degree, in a JPEG image, but it is more pronounced in RAW images. That is why many people choose to shoot in RAW mode instead of JPEG.

Settings Recommendation: Use your camera meter only to get the initial exposure. Then look at the histogram to see if the light range is contained within the limited range of the sensor. If it is clipped to the right or the left, you may want to add or subtract light with your Exposure compensation button or shoot HDR images. For most images, you should expose for the light side of the histogram. Let your light meter get you close and then fine-tune the exposure with the histogram.

You can use other Monitor viewing modes along with the histogram, such as the Highlights (blink) mode so you can see blown-out highlights (put a check mark in the box next to *Playback Menu > Playback display options > Highlights*). This mode will cause your image to blink from light to dark in the highlight areas that are blown out. It is a rough representation of a histogram with clipped highlights, and it is quite useful for quick shooting. Using your light meter, histogram,

and Highlights (blink) mode together is a very powerful way to control your exposures.

If you master this method, you will have a very fine degree of control over where you place the light range of your image. It is sort of like using the famous Ansel Adams black-and-white Zone System, but it is represented visually on the Monitor of your D600.

The manipulation of the histogram levels in-computer is a detailed study in itself. It's part of having a digital darkroom. Learn to use your computer to tweak your images, and you'll be able to produce superior results most of the time. Even more importantly, learn to use your histogram to capture a nice image in the first place!

Your histogram is simply a graph that lets you see at a glance how well your image is contained by your camera. Too far left and the image is too dark; too far right and the image is too light; clipped on both ends and there is too much light range for a single image to contain. Learn to use the histogram well and your images are bound to improve!

Author's Conclusions

The D600 certainly gives you a lot of choices of light meters and exposure modes. You can start using this camera at whatever level of photographic knowledge you have. If you are a beginner, use the AUTO and SCENE modes. If you want to progress into partial automation, use one of the P, S, or A modes. And if you are a dyed-in-the-wool imaging fanatic, use the M mode for full manual control of the camera. You have a choice with the D600!

The next chapter is a subject of great importance to digital photographers: white balance. Understanding white balance gives you an edge over other photographers. When you have mastered those two subjects, and learned about color spaces, you will indeed be an advanced digital photographer. Let's proceed.

White Balance

Mandarin Duck on Golden Pond – Mike Goodman (mrginhop)

Back in the good old days, photographers bought special rolls of film or filters to meet the challenges of color casts that come from indoor lighting, overcast days, or special situations.

The D600 balances the camera to the available light with the White balance (WB) controls. Fortunately, the D600's Auto White balance setting does a great job for general shooting. However, discerning photographers should learn how to use the White balance controls so they can achieve color consistency in special situations.

How Does White Balance Work?

(User's Manual - Page 115)

Normally White balance is used to adjust the camera so that whites are truly white and other colors are accurate under whatever light source you are shooting. You can also use the White balance controls to deliberately introduce color casts into your image for interesting special effects.

Camera WB color temperatures are exactly the opposite of the Kelvin scale we learned in school for star temperatures. Remember that a red giant star is cool, and a blue/white star is hot. The WB color temperatures are opposite because the WB system adds color to make up for a deficit of color in the original light of the subject.

For instance, under a fluorescent light, there is a deficit of blue, which makes the subject appear greenish yellow. When blue is added, the image is balanced to a more normal appearance, with a WB in the 4200K range.

Another example is when you are shooting on a cloudy, overcast day. The cool ambient light could cause the image to look bluish if it's left unadjusted. The White balance control in your camera sees the cool color temperature and adds some red to warm the colors a bit. The normal camera White balance on a cloudy, overcast day might be about 6000K.

Just remember that we use the real kelvin temperature range in reverse and that red colors are considered warm and blue colors are cool. Even though this is the opposite of what we were taught in school, it fits our situation better. To photographers, blue seems cool and red seems warm! Just don't let your astronomer friends convince you otherwise.

Understanding WB in a fundamental way is simply realizing that light has a range of colors that go from cool to warm. We can adjust our cameras to use the available light in an accurate and neutral, balanced way that compensates for the actual light source. Or we can allow a color cast to enter the image by unbalancing the settings. In this chapter, we will discuss this from the standpoint of the D600's controls and how they deal with WB.

Color Temperature

(User's Manual - Page 120)

The D600 WB range can vary from a very cool 2500K to a very warm 10,000K. Figure 9.1 shows a picture adjusted in Photoshop, with the use of software filters, to three WB settings. Notice how the image in the center is about right; the image on the left is cooler (bluish cast), and the image on the right is warmer (reddish cast).

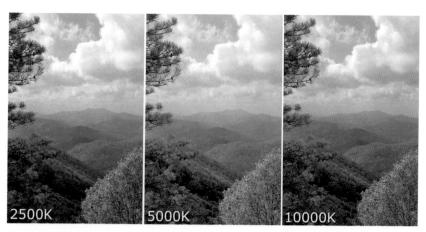

Figure 9.1 - Same image with three WB color temperature settings on the Kelvin scale

The same adjustments we made with film types and lens filters can now be achieved with the White balance settings built into the D600. To achieve the same effect as daylight film and a warming filter, simply select the Cloudy White balance setting while shooting in normal daylight. This sets the D600 to balance at about 6000K, which makes nice warm-looking images. If you want to really warm the image up, choose the White balance setting called Shade, which sets the camera to 8000K. Or you could set the White balance to AUTO2, which warms up the colors and automatically adjusts for current light sources.

On the other hand, if you want to make the image appear cool or bluish, try using the Fluorescent (4200K) or Incandescent (3000K) setting in normal daylight.

Remember, the color temperature shifts from cool values to warm values. The D600 can record your images with any color temperature from 2500K (very cool or bluish) to 10,000K (very warm or reddish) and any major value in between. There is no need to carry different films or lens filters to deal with light color ranges. The D600 has very easy-to-use color temperature controls and a full range of color temperatures available.

There are two methods for setting the White balance on the D600:

- Manual WB using the WB button and selecting options
- Manual WB using the Shooting Menu and selecting options

You may prefer to use different methods according to the amount of time you have to shoot and the color accuracy you want.

Camera Control Locations for WB Adjustment

In this chapter we will often use the WB button, Main and Sub-command dials, and Control panel when adjusting the White balance.

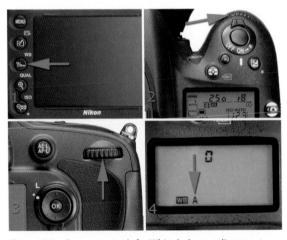

Figure 9.2 - Camera controls for White balance adjustment

Figure 9.2 provides a numbered illustration of the following controls:

- 1. WB button
- 2. Sub-command dial.
- 3. Main command dial
- 4. Control panel

More Information on Mired

Often in this chapter I will talk about adjusting White balance in mired increments. Mired stands for micro reciprocal degree, which is a unit of measure used to express differences in color temperature values. It is based on a just-noticeable difference where 1 mired equals just noticeable—between two light sources. It is founded on the difference of the reciprocal of Kelvin color temperatures (not the temperatures themselves). The use of mired values dates back to 1932 when Irwin G. Priest invented the method. The values are based on a mathematical formula, as follows: M = 1,000,000/T, where M is the desired mired value and T is the color temperature in kelvins. Most of us don't need to be concerned about understanding the term. Just realize that it means a visual difference between color values.

Manual White Balance Using the WB Button

(User's Manual – Page 115)

Sometimes you might want to control the WB manually. The methods in this section and the next one accomplish the same thing, except the first method configures the WB using a button and dial and the next method uses the camera's menu system.

Each of these methods will allow you to set a particular WB temperature. If you want your image to appear cool, medium, or warm, you can set the appropriate color temperature, take the picture, and then look at the image on the Monitor.

Here is how to manually choose a WB type using the WB button, Main command dial, and Control panel:

- 1. Press and hold the WB button
- 2. Rotate the Main command dial.
- 3. The symbols in the following list will appear one at a time on the Control panel (figure 9.3, red arrow). Each click of the dial will change the display to the next WB setting. These symbols, options, and their Kelvin values are as follows:

Incandescent – 3000K

Fluorescent - 2700K to 7200K

Direct sunlight - 5200K

Flash - 5400K

Cloudy - 6000K

Shade - 8000K

K – Choose a color temperature (2500K–10,000K)

PRE (Preset manual) – White balance measured from actual ambient light

Figure 9.3 – Manually selecting a WB value

Manual White Balance Using the Shooting Menu

(User's Manual – Page 116)

This method uses the Shooting Menu screens to select and fine-tune the appropriate White balance.

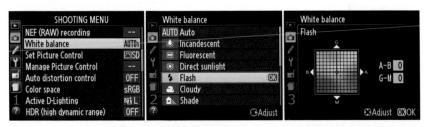

Figure 9.4 - Manual White balance with Shooting Menu screens

Here are the steps to select a White balance setting:

- 1. Select White balance from the Shooting Menu and scroll to the right (figure 9.4, screen 1).
- 2. Highlight one of the preset values, such as Flash or Cloudy, press the OK button to choose that White balance setting, and skip step 3 (figure 9.4, screen 2). Or, if you want to fine tune the White balance setting currently highlighted in screen 2, scroll to the right and use step 3 to make fine-tuning adjustments.

3. You can now fine-tune the White balance setting, if you want to, by including more amber or blue (A–B), and green or magenta (G–M), in six steps: A1–A6 or B1–B6, and G1–G6 or M1–M6. You simply press left or right, and up or down, with the Multi selector. Right adds amber (A) and left adds blue (B). Up adds green (G) and down adds magenta (M) (figure 9.4, screen 3). Each press of the Multi selector in a given direction is equal to one 5-mired step in that direction. To cancel the operation, simply return the little square to the center of the color box, if you have moved it, and press the OK button. The selected WB will be applied with no fine-tuning.

See the upcoming section called **Fine-Tuning White Balance** for more detailed information on fine-tuning.

Normally you'll use only the first two screens in figure 9.4 to select one of the preset WB values, such as Cloudy, Shade, or Direct sunlight. Then you'll press the OK button on the second screen, without changing anything in the third screen.

Note: When you have fine-tuned a WB setting an asterisk will appear next to its symbol in the Shooting Menu's main and secondary screens (figure 9.5). When the WB is set back to the factory defaults, the asterisk will disappear.

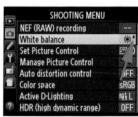

Figure 9.5 – A fine-tuned WB setting

Additional Screen for Auto and Fluorescent WB

If you choose Auto or Fluorescent, you will find an additional screen before you get to the final fine-tuning screen. It will appear between screens 2 and 3 in figure 9.4.

Auto White balance has two values from which to choose: AUTO1 Normal and AUTO2 Keep warm lighting colors (figure 9.6). AUTO2 can make a somewhat warmer image than AUTO1. If, back in the film days, you used an 81A warming filter, you may want to try AUTO2.

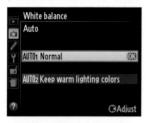

Figure 9.6 – Extra Auto WB screen before fine-tuning screen

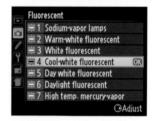

Figure 9.7 – Extra Fluorescent WB screen before fine-tuning screen

Fluorescent includes seven different types of Fluorescent lighting: Sodium-vapor lamps, Warm-white fluorescent, White fluorescent, Cool-white fluorescent, Day white fluorescent, Daylight fluorescent, and High temp. mercury-vapor (figure 9.7).

Manual Color Temperature (K) with the WB Button

(User's Manual - Page 120)

The K selection on the Control panel allows you to manually select a WB value between 2500K and 10,000K. This setting gives you the ability to use a very specific WB setting for those times when you need absolute consistency.

Here are the steps to select a specific Kelvin (K) White balance value using external camera controls:

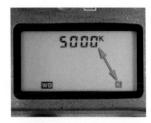

Figure 9.8 - Manual Color temperature (K) with external camera controls

- 1. Select the K symbol on the Control panel by holding down the WB button and rotating the Main command dial.
- 2. While still holding down the WB button, rotate the Sub-command dial to select the WB Kelvin temperature you desire, from 2500K to 10,000K. In figure 9.8, I selected 5000K.

Manual Color Temperature (K) with the Shooting Menu

(User's Manual – Page 117)

You can also manually select a color temperature and fine-tune it by using the Shooting Menu.

Here are the steps to select a specific Kelvin (K) White balance value using the Shooting Menu:

- 1. Choose White balance from the Shooting Menu and scroll to the right (figure 9.9, screen 1).
- 2. Select Choose color temp. from the White balance menu and scroll to the right (figure 9.9, screen 2).
- 3. Use the Multi selector to scroll up or down in the color temperature box and choose a number from 2500K to 10,000K. In figure 9.9, screen 3, I selected 5000K. Press the OK button to skip step 4 (fine-tuning), or scroll to the right to open the fine-tuning area (color box).

4. As shown in figure 9.9, screen 4, you can fine-tune the color temperature to include more amber or blue (A–B), and green or magenta (G–M), in six steps: A1–A6 or B1–B6, and G1–G6 or M1–M6. You simply press left or right, and up or down, with the Multi selector. Right adds amber (A) and left adds blue (B). Up adds green (G) and down adds magenta (M). Each press of the Multi selector in a given direction is equal to one 5-mired step in that direction. You can move the little black square to any position in the color box, which fine-tunes the tint of the color temperature you selected in screen 3. To cancel the operation, simply return the little square to the center of the color box, if you have moved it, and press the OK button. The selected WB will be applied with no fine-tuning. After you have fine-tuned the color temperature to your liking, press the OK button.

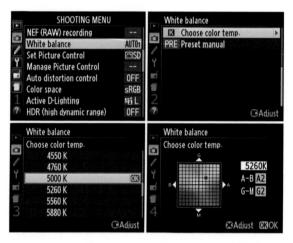

Figure 9.9 - Manual Color temperature (K) with Shooting Menu screens

See the upcoming section called **Fine-Tuning White Balance** for more detailed information on fine-tuning.

When you have selected an exact White balance, or fine-tuned one of them, all the images you shoot from that point forward—until you change to another WB—will have that setting. You can have very consistent White balance from image to image by using this method. For in-studio product shoots, or in any circumstance when you need a constant White balance, this is a desirable function.

Measuring Ambient Light by Using PRE

(User's Manual – Page 121)

This method allows you to measure ambient light values and set the WB. It's not hard to learn and is very accurate because it's an actual through-the-lens measurement of the source light's Kelvin temperature.

You'll need a white or gray card to accomplish this measurement. Figure 9.10 shows the popular WhiBal white balance reference card, which is available at http://michaeltapesdesign.com/whibal.html. The WhiBal card set is very convenient because it includes cards that will easily fit in your pocket or camera bag. I highly recommend these cards because of their durability, portability, and sizes for all occasions.

Figure 9.10 - WhiBal cards

Here's how to select the PRE White balance measurement method:

- 1. Press and hold the WB button.
- 2. Rotate the Main command dial until PRE appears in the lower-right corner of the Control panel (figure 9.11). You'll also see d-1 at the top of the Control panel.

Figure 9.11 – PRE White balance measurement method

3. While still pressing the WB button, turn the Sub-command dial and select one of the preset memory locations, d-1 to d-4. Your measured White balance reading will be stored in that location.

- 4 Release the WB button.
- 5. Press and hold the WB button again until PRE starts blinking (see the note after this list) in the lower-right corner of the Control panel (figure 9.12, red arrow). You will see the preset memory location number just above it (figure 9.12 shows that we are adjusting memory location d-1).

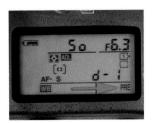

Figure 9.12 – PRE White balance measurement method

- 6. Point the camera at a white or neutral gray card in the light source under which you will be taking pictures. The camera does not have to focus on the card, but the card should fill the frame, so try to get close without making a shadow.
- 7. Press the Shutter-release button fully, as if you were photographing the card. The shutter will fire, but nothing will appear on the Monitor.
- 8. Check the Control panel to see if Good is flashing and PrE appears on the lower-right portion of the Control panel (above PRE). If Good is flashing, you have successfully measured for a correct White balance under the light in which you are shooting. If you see no Gd flashing (instead of Good), the operation was not successful. Your available light may not be bright enough to take an accurate reading.

Note: After PRE starts blinking on the Control panel, you must take the new White balance measurement (step 6) within about six seconds or you will have to repeat steps 4 and 5. If you have c2 Standby timer set to longer than six seconds, the PRE measurement time-out (how long PRE flashes) will match it. The PRE measurement time-out is tied directly to the length of time the light meter is active, which is controlled by *Custom Setting Menu* > c *Timers/AE lock* > c2 *Standby timer*.

The PRE measurement is very sensitive because it uses the light coming through the lens to set the WB. Unless you are measuring in extremely low light, it will virtually always be successful. If the lens aperture is set too small during the PRE reading, you may have trouble getting a good reading. If so, open the aperture.

Fine-Tuning White Balance

(User's Manual – Page 117)

You can fine-tune the White balance using the camera's external WB controls or the Shooting Menu. Fine-tuning with external controls allows for adjustment of only amber or blue. The Shooting Menu allows you to fine-tune not only amber and blue, but also green and magenta.

Fine-Tuning with External Controls

Only certain White balance values can be fine-tuned with external controls, including Auto, Incandescent, Fluorescent, Direct sunlight, Flash, Cloudy, and Shade. You cannot fine-tune K or PRE with the WB button.

To fine-tune with external controls, select one of the White balance values provided by the camera and add amber or blue in 5-mired increments. You can add or subtract amber or blue in up to six steps—A1 to A6 or b1 to b6. That means you can change the color from a minimum of 5 mired to a maximum of 30 mired. Remember, a 1-mired step is equivalent to a barely perceptible change in color.

Figure 9.13 – Fine-tuning White balance with external controls

Here is how to add or subtract amber or blue from a Nikon-provided White balance value using external camera controls:

- 1. Press and hold the WB button and turn the Main command dial until you select a White balance value you would like to fine-tune. In figure 9.13, you can see that I selected auto (A) White balance.
- 2. While still holding down the WB button, turn the Sub-command dial to the left (counterclockwise) for amber values (A1–A6) or to the right (clockwise) for blue values (b1-b6). Remember that each Sub-command dial click is a 5-mired value. In figure 9.13, there are two Control panel screens showing the two color types available (A1 and b1). Screen 1 is one 5-mired step of additional amber, and screen 2 is one 5-mired step of extra blue added to the current WB value.
- 3. Release the WB button.

Unfortunately, external control fine-tuning is not a visual process. You'll need to examine the images taken with your new WB value to determine if you like the results of your fine-tuning effort.

Fine-Tuning with the Shooting Menu

You can use the Shooting Menu to fine-tune even more effectively than you can with the camera's external controls. Instead of two colors (amber and blue), you can adjust four colors (amber, blue, green, and magenta).

If you want to fine-tune a previously saved White balance value, you can do it with the Shooting Menu screens. The value in any of the d-1 to d-4 memory locations can be manually fine-tuned. The color balance can be moved toward G (green), A (amber), M (magenta), or B (blue), or it can be moved toward intermediate combinations of those colors.

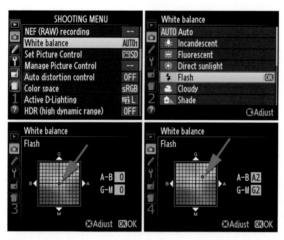

Figure 9.14 - Fine-tuning White balance with Shooting Menu screens

Here are the steps to fine-tune a White balance setting using the Shooting Menu:

- 1. Select White balance from the Shooting Menu and scroll to the right (figure 9.14, screen 1).
- 2. Choose one of the White balance types and scroll to the right (figure 9.14, screen 2). I chose Flash.

- 3. You will now see the fine-tuning screen with its color box. In the middle of the color box is a small black square (figure 9.14, screen 3, red arrow). When this square is in the middle, as shown in screen 3, nothing has been changed. Each press of the Multi selector in a given direction is equal to one 5-mired step in that direction—up is green (G), down is magenta (M), left is blue (B), and right is amber (A). You can see in figure 9.14, screen 4, that I have added both G and A by moving the square to a position in between those two values (red arrow). The A2 and G2 that appear next to A-B and G-M means that I have added 10 mired to amber (A) and 10 mired to green (G).
- 4. Press the OK button to save your changes. An asterisk will appear after the name of the fine-tuned White balance selection on the Shooting Menu screen and any other WB displays. To remove the fine-tuning adjustment, simply return to the screen with the color box and center the square, as in figure 9.14, screen 3.

Note: If you aren't familiar with adjusting the preset's default color temperature, or if you don't want to change it (most people don't), then simply press the OK button without moving the square from the center (figure 9.14, screen 3).

Fine-Tuning a PRE Measured White Balance

Previously we examined how to take a PRE measurement from a white or gray card to balance the camera to the available light. What if you want to fine-tune one of the already existing d-1 to d-4 Preset values? Let's do it!

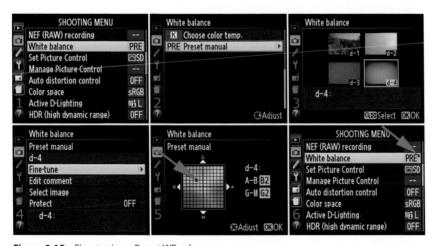

Figure 9.15 - Fine-tuning a Preset WB value

Use these steps to fine-tune a Preset White balance value:

- 1. Select White balance from the Shooting Menu and scroll to the right (figure 9.15, screen 1).
- 2. Choose Preset manual from the menu and scroll to the right (figure 9.15, screen 2).
- 3. Use the Multi selector to scroll to the memory location you want to fine-tune, from d-1 to d-4 (figure 9.15, screen 3). Press the Playback zoom out/thumbnails button to select it.
- 4. Choose Fine-tune from the Preset manual menu and scroll to the right (figure 9.15, screen 4).
- 5. Use the Multi selector to adjust the color balance (figure 9.15, screen 5). Scroll around in the color box toward whatever color you want to add to the currently stored White balance (red arrow). You'll see the color-mired values change on the right side of the screen in the fields next to A–B and G–M. Each increment (click) of the Multi selector is equal to about 5 mired.
- 6. Press the OK button to save your adjustments to the stored White balance. The camera will return to the main Shooting Menu screen, and PRE* will appear next to White balance (figure 9.15, screen 6, red arrow). The asterisk indicates that this particular Preset White balance has been fine-tuned.

Editing the PRE White Balance Comment Field

(User's Manual - Page 126)

You can add up to 36 characters of text to the comment field of a memory location (d-1 to d-4) for a stored White balance setting. Change the comment to something that will remind you of this measured WB setting's purpose.

Here are the steps to edit a comment field for a WB setting:

- 1. Select White balance from the Shooting Menu and scroll to the right (figure 9.16, screen 1).
- 2. Choose Preset manual from the menu and scroll to the right (figure 9.16, screen 2).
- 3. Select the memory location for which you want to edit the comment (d-1 to d-4) and press the Playback zoom out/thumbnails button (figure 9.16, screen 3). This will open the Preset manual menu.
- 4. Choose Edit comment from the menu and scroll to the right (figure 9.16, screen 4).
- 5. The character selection panel will now appear (figure 9.16, screen 5). Use the Multi selector to navigate among the letters and numbers. Press the OK button to add a character to the comment line at the bottom of the screen. To

- scroll through the characters you've already added, hold down the Playback zoom out/thumbnails button while navigating to the left or right with the Multi selector. Press the Delete button to delete the current character. Press the Playback zoom in button to save the memory location comment.
- 6. The White balance memory location screen will now appear with the new memory location comment displayed (figure 9.16, screen 6, red arrow). I filled in the comment field for memory location d-2 with the words Overcast day.

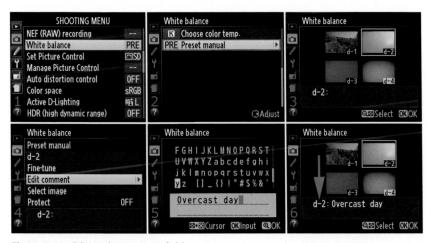

Figure 9.16 - Editing the comment field

Using the White Balance from a Previously Captured Image

(User's Manual - Page 124)

You can select a White balance setting from an image you have already taken. This WB value can then be applied to pictures you are about to take. If you are shooting pictures under a light source that you previously used for other photographs, this can be a time saver.

Here are the steps to recover the White balance setting from an image stored on your camera's memory card:

- 1. Select White balance from the Shooting Menu and scroll to the right (figure 9.17, screen 1).
- 2. Choose Preset manual from the menu and scroll to the right (figure 9.17, screen 2).
- 3. Choose a memory location to which you want to save the White balance setting from an existing picture. I chose d-4 (figure 9.17, screen 3). Press the Playback zoom out/thumbnails button to select the Preset memory location. This opens the Preset manual menu.

- 4. Choose Select image from the Preset manual menu and scroll to the right (figure 9.17, screen 4). Select image will be grayed out if there are no images on your current memory card.
- 5. You will now see the Select image screen (figure 9.17, screen 5). Navigate through the available images until you find the one you want to use for WB information. You can zoom in to look at a larger version of the image by pressing the Playback zoom in button. Press the OK button to select the image.
- 6. A small picture of the image will appear in your selected Preset White balance memory location and is saved there for future use (figure 9.17, screen 6). The White balance setting from that picture is now the White balance setting for the camera, until you change it.

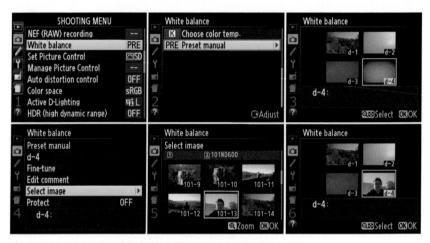

Figure 9.17 - Using the White balance from a previously taken image

Protecting a White Balance Preset

(User's Manual – Page 127)

You may have gone to great efforts to create a particular White balance Preset value that you will use frequently. Maybe you have a studio with a certain type of lighting that does not vary and you want to have a dependable Preset value available for it. Let's see how to protect a PRE (d-1 to d4) value.

Here are the steps to protect a White balance Preset value:

- 1. Select White balance from the Shooting Menu and scroll to the right (figure 9.18, screen 1).
- 2. Choose Preset manual from the menu and scroll to the right (figure 9.18, screen 2).

- 3. Choose the memory location you want to protect (d-1 to d-4). I chose d-3, which is where I stored my PRE reading called "My monolight strobes" (figure 9.18, screen 3). Press the Playback zoom out/thumbnails button to select the Preset memory location. This opens the Preset manual menu.
- 4. Choose Protect from the Preset manual menu and scroll to the right (figure 9.18, screen 4).
- 5. Choose On to protect or Off to remove protection from a White balance memory location. I am protecting d-3, so I chose On (figure 9.18, screen 5).
- 6. The camera will now display the White balance screen with a protection symbol displayed on the memory location you protected. The key symbol at the point of the red arrow in figure 9.18, screen 6, indicates that memory location d-3 is locked from deletion or change. You cannot modify the protected value in any way, including fine-tuning or editing the comment field, until you remove the protection.

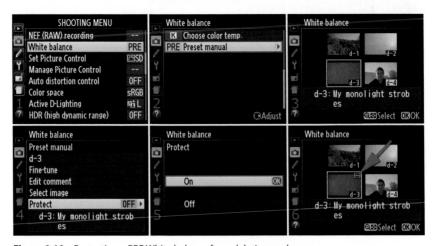

Figure 9.18 - Protecting a PRE White balance from deletion or change

Auto White Balance

(User's Manual - Page 115)

Auto White balance works pretty well in the D600. As the camera's RGB meter senses colors, it does its best to balance to any white or midrange grays it can find in the image. However, the color may vary a little on each shot. If you shoot only in Auto WB mode, your camera considers each image a new WB problem and solves it without reference to the last image taken.

The Auto WB setting also has the White balance fine-tuning screen, as discussed in the section called Fine-Tuning White Balance earlier in this chapter.

Using Auto WB (AUTO1 and AUTO2)

Auto White balance comes in two flavors: AUTO1 and AUTO2. The difference is that AUTO2 uses warmer colors than AUTO1.

For general shooting, AUTO1—or AUTO2, if you prefer warm colors—is all that's needed.

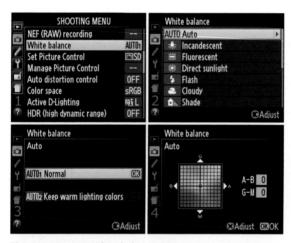

Figure 9.19 - Auto White balance choices

Here are the steps to select one of the Auto White balance options:

- 1. Choose White balance from the Shooting Menu and scroll to the right (figure 9.19, screen 1).
- 2. Select Auto from the menu and scroll to the right (figure 9.19, screen 2).
- 3. Choose AUTO1 Normal or AUTO2 Keep warm lighting colors (according to your color warmth preference) and scroll to the right (figure 9.19, screen 3).
- 4. Press the OK button to lock in the WB setting, or scroll to the right to fine-tune it if you'd like (figure 9.19, screen 4). See the section called **Fine-Tuning White Balance** earlier in this chapter.

Settings Recommendation: I often use AUTO1 White balance on my D600. The only time I use anything but AUTO1 is when I am shooting special types of

images. For instance, if I am shooting an event with flash and I want consistent color, I often choose the Flash White balance setting. Or, if I am shooting landscapes under direct sunlight, I often shoot with the Direct sunlight White balance setting. Other than special occasions, Auto White balance works very well for me. Give it a try, along with each of the others in their intended environments. This is all part of improving your digital photography. A few years back we carried different film emulsions and colored filters to get these same effects. Now it's all built in!

Should I Worry about White Balance If I Shoot in RAW Mode?

The quick answer is no, but that may not be the best answer. When you take a picture using NEF (RAW) mode, the sensor image data has no White balance, sharpening, or color saturation information applied. Instead, the information about your camera settings is stored as markers along with the RAW black-andwhite sensor data. Color information, including White balance, is applied permanently to the image only when you post-process and save the image in another format, like JPEG, TIFF, or EPS.

When you open the image in Nikon Capture NX2, or another RAW conversion program, the camera settings are applied to the sensor data in a temporary way so you can view the image on your computer screen. If you don't like the White balance, or almost any other setting you used in-camera, you can simply change it in the conversion software and the image looks as if you used the new setting when you took the picture.

Does that mean I am not concerned about my WB settings because I shoot RAW most of the time? No. The human brain can quickly adjust to the colors in an image and perceive them as normal, even when they are not. This is one of the dangers of not using the correct WB. Because an unbalanced image on your computer screen is not compared to another correctly balanced image side by side, there is some danger that your brain may accept the slightly incorrect WB as normal, and your image will be saved with a color cast.

As a rule of thumb, if you use your WB correctly at all times, you'll consistently produce better images. You'll do less post-processing if the WB is correct in the first place. As RAW shooters, we already have a lot of post-processing work to do. Why add WB corrections to the workflow? It's just more work, if you ask me!

Additionally, you might decide to switch to JPEG mode in the middle of a shoot, and if you are not accustomed to using your WB controls, you'll be in trouble. When you shoot JPEGs, your camera will apply the WB information directly to the image and save it on your memory card—permanently. Be safe; always use good WB technique!

White Balance Tips and Tricks

When measuring WB with a gray or white card, keep in mind that your camera does not need to focus on the card. In PRE mode, it will not focus anyway because it is only trying to read light values, not take a picture. The important thing is to put your lens close enough to the card to prevent it from seeing anything other than the card. Three or four inches (about 75mm to 100mm) away from the card is about right for most lenses.

Be careful that your lens does not cast a shadow onto the card in a way that lets your camera see some of the shadow. This will make the measurement less accurate. Also, be sure that your source light does not produce glare on the card. This problem is not common because most cards have a matte surface, but it can happen. You may want to hold the card at a slight angle to the source light if the light is particularly bright and might cause glare.

Finally, when the light is dim, use the white side of the card because it is more reflective. This may prevent a *no Gd* reading in low light. The gray card may be more accurate for color balancing, but it might be a little dark for a good measurement in dim light. If you are shooting in normal light, the gray card is best for balancing. You might want to experiment in normal light with your camera to see which you prefer.

Author's Conclusions

With these simple tips and some practice, you can become a D600 WB expert. Starting on page 115 of your D600 User's Manual you'll find extensive WB information, if you want another perspective.

Learn to use the color temperature features of your camera to make superior images. You'll be able to capture very accurate colors or make pictures with color casts to reflect how you feel about them. Practice a bit, and you'll find it easy to remember how to set your WB in the field.

Now, let's turn our attention to the autofocus (AF) system in the D600. Many people find the various modes hard to remember and even a bit confusing. In the upcoming chapter, we'll examine how the AF modes work and how they relate to other important camera functions, such as the AF-area and Release modes.

Autofocus, AF-Area, and Release Modes

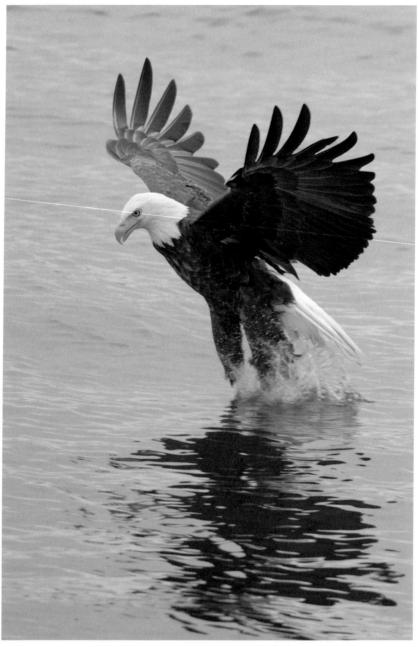

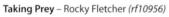

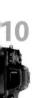

Autofocus (AF) and Release modes are active settings that you'll deal with each time you use your camera. Unlike adjusting settings in the menus, which you'll do from time to time, you'll use Autofocus and Release modes every time you make an image or movie. You will adjust AF-area modes less often; however, these critical functions affect how and where the camera focuses on your subject.

To take pictures and make movies, you need to be very familiar with these settings, so this is a very important chapter for your mastery of the Nikon D600. Grab your camera and let's get started!

This chapter is divided into three sections:

- Section 1 Autofocus in Viewfinder Photography
- · Section 2 Autofocus in Live View Photography
- Section 3 Release Modes

Section 1 - Autofocus in Viewfinder Photography

The Nikon D600 has two types of autofocus (AF) built in, with different parts of the camera controlling AF in different shooting modes (figure 10.1). When you take pictures through the Viewfinder, one type of autofocus is used, and when you shoot a picture or movie using Live view, a different type is used. They are as follows:

• TTL phase-detection autofocus – The Multi-CAM 4800 FX autofocus module provides through-the-lens (TTL) phase-detection autofocus, with 39 AF points in a grid-like array of AF points (white) in the central area of the Viewfinder (figure 10.1, image 1). This type of AF is known simply as phase-detection AF. It is a very fast type of autofocus and is used by the camera only when you are taking pictures through the Viewfinder. It does not use the CMOS sensor directly because focal-plane contrast AF uses it (next bullet). Instead, the Multi-CAM 4800 FX autofocus module is a separate internal device that controls AF directly. I used the CMOS sensor in figure 10.1, image 1, to show the area it overlays on the actual imaging sensor. This is basically what you will see when you look through the Viewfinder—a Viewfinder overlay on top of the CMOS imaging sensor.

Figure 10.1 - Actual CMOS FX sensor with phase-detection AF grid in center (image 1) and contrast-detection AF area (image 2)

What Is the Multi-CAM 4800 FX Autofocus Module?

The Multi-CAM 4800 FX autofocus module is a very accurate system that controls where and how your camera's AF and AF-S lenses achieve the sharpest focus on your subject.

The Nikon D600 offers a significant boost in the number of Viewfinder AF points over lesser cameras, with a total of 39 points. What do we gain from all these extra AF points and more powerful modes? As we progress through this chapter, I'll discuss these things in detail, along with how your photography will benefit most from using all the features of the Multi-CAM 4800 FX AF system.

Three Mode Groups

There are three specific mode groups that you should fully understand: *Autofocus modes, AF-area modes,* and *Release modes.*

Many people get these modes confused and incorrectly apply functions from one mode to a completely different mode. It is a bit confusing at times, but if you read this carefully and try to wrap your brain around the different functionalities provided, you'll have much greater control of your camera later.

First, let's consider how autofocus works when you use the Viewfinder. The three mode groups for Viewfinder shooting are as follows:

Autofocus modes (User's Manual – Page 97)

- Auto-servo AF (AF-A)
- Single-servo (AF-S)
- Continuous-servo (AF-C)

AF-area modes (User's Manual – Page 99)

- Single-point AF
- Dynamic-area AF (9, 21, and 39 AF points)
- 3D-Tracking
- · Auto-area AF

Release modes (User's Manual – Page 83)

- Single frame (S)
- Continuous low speed (CL)
- Continuous high speed (CH)
- Ouiet shutter-release (O)
- Self-timer
- Remote control
- Mirror-up (MUP)

What is the difference between these modes? Think of them like this: the AFarea modes are where the AF module focuses, the Autofocus modes are how it focuses, and the Release modes control when focus happens, or how often a picture is taken.

Although the Release modes are not technically Autofocus modes, it is a good idea to consider them at the same time because they control when autofocus functions.

In upcoming sections we'll look into all of these mode types and see how they work together to make the D600's autofocus and subject tracking system one of the world's best.

With the controls built into the D600 body, you'll be able to select whether the AF module uses one or many of its 39 AF points to find your subject. You'll also select whether the camera simply locks focus on a static subject or if it continuously seeks new focus if your subject is moving, and how fast (in frames per second) it captures the images.

Settings Recommendation: If you have trouble remembering what all these modes do—join the club! I've written multiple books about Nikon cameras and I still get confused about what each mode does. I often refer back to my own books to remember all the details.

You'll become familiar with the modes you use most often, and that is usually sufficient. Try to associate the type of mode with its name, and that will make it easier. Learn the difference between an AF-area mode (focus where), an Autofocus mode (focus how), and a Release mode (focus when).

Custom Settings for Viewfinder AF and Live View/Movie AF

The AF module has seven configurable Custom settings, a1-a7. We examined each of these Custom settings in the chapter titled Custom Setting Menu. You may want to review them.

Using Autofocus and AF-Area Modes for Viewfinder Photography

(User's Manual - Pages 97, 99, 328)

The D600 has distinct modes for how and where to focus. We'll examine each of those modes as a starting point in our understanding of autofocus with the Multi-CAM 4800 FX AF module. We'll tie together information about the AF-area modes, Autofocus modes, and Release modes since they work together to acquire and maintain good focus on your subject. Release modes are covered in the last section of this chapter because both Viewfinder and Live view photography use the same Release modes.

Figure 10.2 shows the controls we'll use in combination to change how the camera focuses and captures images.

Figure 10.2 - Image 1, AF-mode button; Image 2A, Main command dial; Image 2B, Sub-command dial; Image 3, Release mode dial; Image 4, Multi selector, with AF-lock switch below

Notice in figure 10.2, image 4, that the Multi selector has a lock switch below it. You can see a white dot and an L to the left side of the switch (at about the 10 o'clock position). Move the switch to the dot setting (as shown), which unlocks the internal AF point movement capability so you can move the AF point around the Viewfinder within the 39 available points.

Settings Recommendation: I leave my AF-lock switch unlocked all the time, but I check as the camera is focusing to make sure it is using the AF point I want in nonautomatic modes. I can use the Multi selector to move a single AF point around the array of 39 available points when I use Single-point AF or a group of points in Dynamic-area AF. We'll discuss this in more detail later.

Cross-Type AF Sensors at Various Apertures

Cross-type AF sensors will initiate autofocus in either a horizontal or a vertical direction, unlike standard AF sensors, which work only in a horizontal direction. The ability of the AF system to function properly is dependent on the maximum aperture of the lens in use (or of the lens and teleconverter combination). Lenses normally autofocus at maximum aperture and stop down to the aperture you have selected only when you press the Shutter-release button to take a picture. Most cameras are designed to autofocus with lenses that have a maximum aperture of f/5.6 or larger (e.g., f/1.4, f/2.8, f/4).

The Nikon D600 is in a special class of camera because its autofocus can work with lenses that have a maximum aperture smaller than f/5.6. The D600 can autofocus using lenses or teleconverter/lens combos that have maximum apertures from f/5.6 to f/8.

Figure 10.3 shows the various arrangements of cross-type and extra-sensitive AF sensors the camera can use when you are working with small maximum apertures. You must be sure to select one of the AF sensors shown in figure 10.3 if you are using a lens or teleconverter/lens combo that has a maximum aperture smaller than f/5.6. The camera will not warn you if you try to use an AF sensor that is not appropriate for a small maximum aperture, nor will it prevent you from using it.

You cannot select one of the overall patterns shown in figure 10.3. You simply move your active AF sensor into one of the locations in the pattern, according to how small the maximum aperture happens to be. Study this carefully if you regularly use teleconverters on telephoto lenses with autofocus.

Figure 10.3 - Image 1, 39 AF-point pattern for f/5.6 or larger maximum aperture; Image 2, 33 AF-point pattern for maximum apertures between f/5.6 and f/8; Image 3, 7 AF-point pattern for maximum aperture of f/8 only

- Figure 10.3, image 1 This shows the 39 AF points (horizontal only AF in black) that will work down to f/5.6; the 9 red points are cross-type AF points (horizontal and vertical AF)
- Figure 10.3, image 2 This shows the 33 AF points (horizontal only AF in black) that will work between f/5.6 and f/8; the 9 red points are cross-type AF points (horizontal and vertical AF). This is identical to image 1, except that it

does not have the outer three AF points on the far left or far right right of the AF point array (33 versus 39 AF points).

• Figure 10.3, image 3 – This shows the 7 AF points (horizontal only AF in black) that will work at f/8; the 1 red point is a cross-type AF point (horizontal and vertical AF).

You may be able to get the standard-sensitivity AF sensors to respond at an aperture smaller than f/8; however, you shouldn't depend on autofocus consistency when a standard AF sensor—not in the patterns in figure 10.3, images 2 or 3—is used at a maximum aperture smaller than f/5.6. You should test these sensors and learn the patterns.

In an emergency, just remember that the center AF point is always cross-type and will work at any aperture down to f/8. You can focus with the center AF point and recompose, if necessary, if you would rather not remember the patterns at apertures less than f/5.6 to f/8.

Autofocus Modes in Detail

(User's Manual – Page 97)

The Autofocus modes allow you to control how the autofocus works with static and moving subjects. They allow your camera to lock focus on a subject that is not moving or is moving very slowly. They also allow your camera to follow focus on an actively moving subject. Let's consider the three servo-based Autofocus modes to see when and how you might use them best.

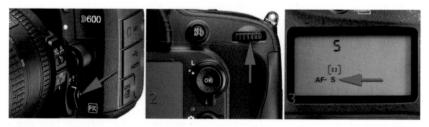

Figure 10.4 - Selecting an Autofocus mode

Here are the steps to select an Autofocus mode:

- 1. Hold in the AF-mode button (figure 10.4, image 1).
- 2. Turn the Main command dial (figure 10.4, image 2).
- 3. The Control panel will show each of the three modes (AF-A, AF-S, AF-C) as you turn the dial (figure 10.4, image 3).
- 4. Let go of the AF-mode button when the mode you want to use is displayed on the Control panel.

Auto-Servo AF (AF-A) Mode

Auto-servo AF (AF-A) is an automatic mode that pays attention to your subject's movement. It is rather simple to use because it senses whether your subject is static or moving.

- Subject is not moving If the subject is not moving, the camera automatically uses AF-S mode. In this mode the focus locks on the subject and does not update as long as the subject remains still. However, the focus can unlock if the camera detects subject movement, and it will switch to AF-C mode.
- **Subject is moving** If the subject is moving, the camera automatically sets itself to AF-C mode. It detects the movement across the AF sensors and automatically starts focus tracking the subject.

Single-Servo AF (AF-S) Mode

Single-servo AF (AF-S) works best when your subject is stationary—like a house or a landscape. You can use AF-S on slowly moving subjects if you'd like, but you must be careful. The two scenarios listed next may help you decide:

- Subject is not moving When you press the Shutter-release button halfway, the AF module quickly locks focus on your subject and waits for you to fire the shutter. If your subject starts moving and you don't release pressure on the Shutter-release button to refocus, the focus will be obsolete and useless. When you have focus lock, take the picture quickly. This mode is perfect for stationary subjects or, in some cases, very slowly moving subjects.
- Subject is regularly moving This will require a little more work on your part. Since the AF system locks focus on your subject, if the subject moves even slightly, the focus may no longer be good. You'll have to lift your finger off the Shutter-release button and reapply pressure halfway down to refocus. If the subject continues moving, you'll need to continue releasing and pressing the Shutter-release button halfway to keep the focus accurate. If your subject never stops moving, is moving erratically, or stops only briefly, AF-S is probably not the best mode to use. In this case, AF-C is better because it never locks focus and the camera tracks your subject's movement, keeping it in constant focus.

Continuous-Servo AF (AF-C) Mode

Using Continuous-servo AF (AF-C) is slightly more complex since it is a focus tracking function. The camera looks carefully at whether the subject is moving, and it even reacts differently if the subject is moving from left to right, up and down, or toward and away from you. Read these three scenarios carefully:

- Subject is not moving When the subject is standing still, Continuous-servo AF acts a lot like Single-servo AF, with the exception that the focus never locks. If your camera moves, you may hear your lens chattering a little as the autofocus motor makes small adjustments in the focus position. Since focus never locks in this mode, you'll need to be careful that you don't accidentally move the AF point off the subject because it may focus on something in the background instead.
- · Subject is moving across the Viewfinder If your subject moves from left to right, right to left, or up and down in the Viewfinder, you'll need to keep your AF point on the subject when you are using Single-point AF area mode. If you are using the Dynamic-area AF or Auto-area AF modes, your camera can track the subject across a few or all of the 39 AF points. We'll cover this in more detail in the upcoming section called AF-Area Modes in Detail.
- Subject is moving toward or away from the camera If your subject is coming toward you, another automatic function of the camera kicks in. It is called predictive focus tracking, and it figures out how far the subject will move before the shutter fires. After you've pressed the Shutter-release button all the way down, predictive focus tracking moves the lens elements slightly to correspond to where the subject should be when the shutter fires a few milliseconds later. In other words, if the subject is moving toward you, the lens focuses slightly in front of your subject so the camera has time to move the mirror up and get the shutter blades out of the way. It takes 52 milliseconds for the camera to respond to a press of the Shutter-release button.

Shutter Lag

Let's talk about the practical use of these Autofocus mode functions. If you are shooting an air show, for instance, in 52 milliseconds (0.052 second) a fastmoving airplane can move enough to slightly change the focus area by the time the shutter opens.

If you press the Shutter-release button all the way down until the shutter releases, first autofocus occurs and then the mirror moves up and the shutter starts opening. Those actions add up to about 52 milliseconds in the D600. In the time it takes for the camera to respond to your press of the Shutter-release button, the airplane has moved slightly, which just barely throws the autofocus off. With predictive focus tracking, the camera predicts where the airplane will be when the image is actually exposed, and it adjusts the focus accordingly.

Predictive Focus Tracking

How does predictive focus tracking work? Let's say you're playing a ballgame and you throw the ball to a running player. You would have to throw the ball slightly in front of the receiving player so the player and the ball arrive in the same place

at the same time. Predictive focus tracking does something similar for you. It saves you from trying to focus your camera in front of your subject and waiting 52 milliseconds for it to arrive. The timing would be a bit difficult!

Effect of Lens Movement

Lens movement (especially with long lenses) can be misinterpreted by the camera as subject movement. In that case, predictive focus tracking follows your camera movement while simultaneously trying to track your subject.

Attempting to handhold a long lens will drive your camera crazy. Use a vibration reduction (VR) lens or a tripod for the best results. Nikon says there are special algorithms in predictive focus tracking that allows it to notice sideways or up-and-down movement, and the camera shuts down the predictive focus tracking. Therefore, predictive focus tracking is not activated by the D600 for sideways or up-and-down subject movement or panning.

Settings Recommendation: I leave my Autofocus mode set to AF-A most of the time because it is capable of automatically changing to another mode as needed. If I am shooting sports, I switch to AF-C mode so there will be no autofocus delay if the subject moves very quickly. I rarely use AF-S mode since AF-A does the same thing when the subject is static, yet the camera can change modes if the subject moves.

AF-Area Modes in Detail

(User's Manual - Page 99)

The six AF-area modes are designed to let you control how many Viewfinder AF points are in use at any one time. Five of the six modes will track subject movement.

You can use 1 AF point in Single-point AF mode; you can use 9, 21, or 39 AF points in Dynamic-area AF mode. You can even use 3D-Tracking mode (39 AF points), which uses the color of the subject to help track it and keep it in focus while it moves around. If you don't want to think about the autofocus area, you can let the camera automatically control the AF-area mode by selecting the Auto AF-area mode setting.

Here are the steps to choose an AF-area mode:

- 1. Hold in the AF-mode button (figure 10.5, image 1).
- 2. Turn the Sub-command dial (figure 10.5, image 2) as you watch the four available modes scroll by on the Control panel.
- 3. Figure 10.5, image 3, shows the camera set to Single-point AF mode (red arrow). Release the AF-mode button when the mode you want to use is displayed on the Control panel.

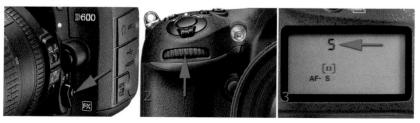

Figure 10.5 - Controls to set AF-area mode

Note: Some of the AF-area modes will not show up if you have your camera set to Single-servo autofocus (AF-S) mode, which allows only two of the six AF-area modes: Single-point AF mode and Auto-area AF mode.

You cannot use the following four AF-area modes unless you switch the Autofocus mode to Auto-servo AF (AF-A) or Continuous-servo AF (AF-C) mode: 9-point dynamic-area AF, 21-point dynamic-area AF, 39-point dynamic-area AF, and 3D-Tracking.

Remember, you adjust the autofocus mode with the rear Main command dial and the AF-area mode with the front Sub-command dial, while holding in the AF-mode button. Let's discuss each AF-area mode.

Single-Point AF

Single-point AF uses 1 AF point out of the array of 39 points to acquire good focus. Figure 10.6, screen 1 (red arrow), shows a big S on the Control panel, signifying that the camera is in Single-point AF-area mode. In figure 10.6, image 2, notice that the center AF point is selected. It is the only one that currently provides focus information. You can move the single AF point around the 39 points in the Viewfinder with the Multi selector if you would rather use a different AF point.

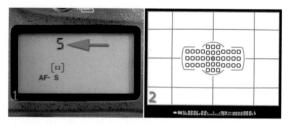

Figure 10.6 - Single-point AF-area mode

If two people are standing next to each other, with a gap in the middle, the single center AF point will examine the space between the two subjects. You can do one of two things to overcome this problem:

- You can get the focus first by moving the camera and pointing the center AF point at the face of one of the subjects, pressing the Shutter-release button halfway to focus, then holding it halfway down while recomposing the image. When you have recomposed the shot—without releasing the button you can press the Shutter-release button the rest of the way down to take the picture.
- You can compose the picture first by centering it however you'd like, then use the Multi selector to move the single AF point until it rests on the face of one of the subjects. With the AF point repositioned, press the Shutter-release button halfway down to get good focus, then the rest of the way down to take the picture.

Either of these methods will solve the bothersome autofocus problem of having a perfectly focused background with out-of-focus subjects, caused by the center AF point concentrating on the background between the subjects.

Single-Point AF Example

If a subject is not moving—like a tree or a standing person—then Single-point AF and Single frame (S) Release mode will allow you to acquire focus. When the focus is acquired, the AF module will lock focus on the subject and the focus will not change. If the subject moves, your focus may no longer be perfect and you'll need to recompose while releasing the Shutter-release button and pressing it halfway down again.

Often, if the subject is moving very slowly or sporadically, I don't use Continuous low speed (CL) Release mode on the Release mode dial. Instead I leave the camera in Single frame (S) Release mode. I tap the Shutter-release button halfway to acquire focus when the subject moves, and I tap it again as needed. When I'm ready, I simply press the Shutter-release button the rest of the way down, and I've got the shot!

Release Priority Settings

When you switch your D600 out of Single frame (S) Release mode, you must be aware of how Custom settings a1 and a2 are configured. These two Custom settings allow you to choose focus or release priority when shooting in AF-S and AF-C Autofocus modes. It's important that you understand these two priorities before you start using your camera on critical shoots or some of your images may not be in focus at all. I won't cover that information in this chapter, but we've looked at Custom settings a1 and a2 in detail in the chapter titled Custom Setting Menu. Please be sure that you understand what they do! (Hint: Use Focus priority.)

Dvnamic-Area AF

Dynamic-area AF is best used when your subject is moving. Instead of a single AF point used alone for autofocus, several sensors surrounding the one you have selected with the Multi selector are also active. The top row of figure 10.7 shows the Control panel with Dynamic-area AF selected in 9, 21, and 39 point modes. You must select one of the three AF point patterns using the controls shown in figure 10.5.

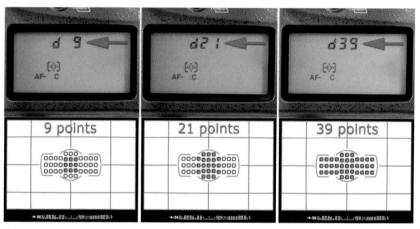

Figure 10.7 - Dynamic-area AF mode

The bottom row of figure 10.7 shows the three AF point patterns (9, 21, and 39) in the Viewfinder. While taking pictures, you normally will not see all these extra AF points light up except for when you first select a pattern (see the upcoming subsection, Viewing Autofocus Patterns). Instead, you will see only the AF point in the center of the pattern.

You can move the 9- and 21-point patterns around the Viewfinder with the Multi selector. If you hold in the AF-mode button while pressing the Multi selector, you will see the current pattern move around within the 39 points in the Viewfinder and on the Information display. If you do not hold in the AF-point button, you will see only the single AF point in the center of the pattern move around the displays.

The single AF point you can normally see in the Viewfinder provides the primary autofocus; however, the surrounding points in the pattern you've selected are also active. If the subject moves and the primary AF point loses focus, one of the surrounding points will quickly grab the focus.

If the subject is moving slowly or predictably, you can use a smaller pattern, such as the 9-point selection. If the subject's movement is more erratic or unpredictable, you might want to increase the number of AF points involved. Try 21 points, or even 39, for subjects that are very unpredictable and move quickly.

One caution is that the more AF points you use, the slower the initial autofocus may be, especially in low light. However, when the initial focus is acquired, the camera can track the subject quite well with all three patterns.

Can you see how flexible Dynamic-area AF could be for you, especially when you adjust the patterns? If your subject will move only a short distance—or is moving slowly—you can simply select a pattern of 9 points. Maybe you're doing some macro shots of a bee on a flower and the bee is moving around the blossom, where 9 points may be sufficient. Or you might be photographing a tennis game, in which case you could use 21 or 39 points to allow for more rapid sideto-side movement without losing focus. You'll have to decide which pattern best fits your needs for the current shooting situation.

Using Dynamic-area AF, you can more accurately track and photograph all sizes and speeds of moving subjects. The initial focus reaction speed of the AF system is somewhat slower when you use 39 points because the camera needs to process a lot more information. Take that into consideration when you are shooting events. I have used 39-point Dynamic-area AF in both weddings and graduation ceremonies with great success. The D600 is quite fast at acquiring the initial focus.

Viewing Autofocus Patterns

You can see the autofocus patterns if you use the camera's Viewfinder or Information display (Info button) while choosing the setting. Unlike with previous Nikon cameras, the pattern display on the top Control panel is not very detailed.

In the Viewfinder and on the Information display, the 9-, 21-, and 39-point patterns are accurately shown. However, the pattern for Auto-area AF is different. When viewed in the Viewfinder, the pattern shown for Auto-area AF does not actually reflect the pattern the camera uses. Instead, the camera shows an outline surrounding all 39 AF points (see upcoming figure 10.9, screen 2). In Auto-area AF, the camera chooses any combination of the 39 AF points it deems necessary to use.

When you select 3D-Tracking, which, like Auto-area AF, uses whatever AF point it needs to track the moving subject, the camera simply lights up all 39 AF points in a similar way as when 39-point AF is selected.

You may notice that the 9-, 21-, and 39-point AF-area patterns shown on the Information display have tiny + symbols on each active AF point in the pattern. The symbols represent the fact that each AF point in the pattern could actively seek focus on your subject and you can select which AF point(s) to use. On the other hand, the symbols are missing from the Auto AF-area shown on the Information display. This simply means the camera will choose which AF point(s) it likes best.

3D-Tracking AF

The mode called *3D-Tracking* adds color-detection capability to the tracking system (figure 10.8). The camera will not only track by subject area, it will also remember the color of the subject and use it to track even more accurately.

Figure 10.8 - 3D-Tracking AF

3D-Tracking works like the 39-point pattern except that it is more intelligent. Often your subject will be a different color than the background, and the D600's color-based system will provide more accuracy in difficult conditions. Be careful if the subject is a similar color to the background because this may reduce the autofocus tracking accuracy.

3D-Tracking is a good mode for things like action sports, air shows, races, and so on. It allows the camera to become a color-sensitive subject-tracking machine.

Note: You will see 3D in the Viewfinder only when you first select 3D-Tracking AF. After that, you will just see the AF point move around the Viewfinder as it tracks your subject.

Auto-Area AF

Auto-area AF turns the D600 into an expensive point-and-shoot camera. Use this mode when you simply have no time to think and would still like to get great images. The AF module decides what the subject is and selects the AF points it thinks will work best (figure 10.9).

Figure 10.9 – Auto-area AF

If you are using a D or G lens, there is human recognition technology built into Auto-area AF mode. The D600 can usually detect a human face and help you

avoid shots with perfectly focused backgrounds and blurry human subjects. In Live view mode the camera is downright amazing at finding and tracking multiple human faces, and I am even impressed with the camera's ability to find and focus on faces in Viewfinder mode. Surprisingly, I found little difference whether I used AF-A, AF-S, or AF-C Autofocus modes. However, some people may not agree. I have read on forums that some people prefer one Autofocus mode over another. Take time to try each Autofocus mode and see if you think the camera does better in one mode.

Prior to the D600, I rarely used Auto-area AF for anything except snapshots. However, I have been trying it when shooting quickly in events such as weddings and graduation ceremonies and am finding that the camera guite accurately locates and exposes people. This is a great people mode. Give it a try!

Now, let's talk about how the camera uses the mode groups in unison. See the sidebar Capturing a Bird in Flight for an example of how the camera uses the three mode groups—AF-area, Autofocus modes, and Release modes—to track a flying bird.

Capturing a Bird in Flight

Let's imagine that you are photographing a colorful bird perched in a tree but you want some shots of it in flight. You are patiently waiting for it to fly. Your camera is set to 3D-Tracking (39-point) AF-area mode and Continuous high speed (CH) Release mode. You are using Continuous-servo (AF-C) Autofocus mode so that autofocus never locks and will track the bird instantly when it starts flying. You've already established focus with the AF point you selected with the Multi selector, and you are holding the Shutter-release button halfway down to maintain focus. Since you've set the Release mode to CH (Continuous high), you can fire off rapid bursts of images (up to four per second). Suddenly, faster than you can react, the bird takes to flight. By the time you can get the camera moving, the bird has moved to the left in the Viewfinder, and the focus tracking system has adjusted by instantly switching away from the primary AF point you used to establish focus and is now using other AF points in the pattern of 39 points to maintain focus on the bird. You press the Shutter-release button all the way down, and the images start pouring into your memory card. You are panning with the bird, firing bursts until it moves out of range. You've got the shot!

Settings Recommendation: Many people use Single-point AF-area mode quite often. It works particularly well for static or slowly moving subjects. When I'm shooting beautiful nature images, I use Single-point AF-area mode along with Single frame (S) Release mode almost exclusively.

If I'm shooting a wedding where the bride and groom are walking slowly up the aisle, Single-servo autofocus (AF-S) mode, Single-point AF-area mode, and Continuous low speed (CL) Release mode seem to work well for me, although recently I have been successfully experimenting with Continuous-servo autofocus (AF-C) mode, Auto-area AF mode, and Continuous high speed (CH) Release mode. The D600 is uncannily accurate at finding and tracking human faces in Auto-area AF mode. You may be safest using AF-C Release mode along with Auto-area AF mode to let the camera track a face. If you use AF-S and Auto-area, the camera will quickly find the face but not track it. That's okay when you're taking a group shot, but it's not so good when you're tracking a moving face, such as a bride walking up the aisle.

I suggest experimenting with all these modes. You will need to use them all for different types of photography, so take time to learn how each mode functions for your styles of shooting.

Now, let's examine how the camera uses autofocus in Live view photography.

Section 2 - Autofocus in Live View Photography

(User's Manual – Page 49)

Live view (Lv) mode is a new feature that many old-timers may not fully appreciate. New DSLR users generally like to use it because they are accustomed to composing on the LCD screen of a point-and-shoot camera.

Both types of users should reconsider Live view. An old-timer who is used to using only the Viewfinder to compose images might find that some types of shooting are easier with Live view. Point-and-shoot graduates may want to see if they can improve the sharpness of their images by using the Viewfinder.

When Lv mode first came out, my initial thought was "gimmick." However, since I've been shooting macro shots with Lv mode, the ease of use has changed my thinking. When I need extreme, up-close focusing accuracy, Lv mode can be superior to using the Viewfinder. If you're an experienced DSLR photographer, try shooting some macros with Lv mode. I think you'll find that your work improves, and your back feels much better too.

If you've come over from the point-and-shoot world, use Lv mode if it makes you comfortable—at first. However, please realize that it is difficult to make sharp images when you are waving a heavy DSLR around at arm's length while composing a picture on the Monitor, especially with the 24-megapixel D600 having such massive image resolution. Also, the extra weight of a DSLR will tire your arms needlessly. Learn to use the Viewfinder for most work and Lv mode for specialized pictures. Both image composition tools are useful.

Using Autofocus and AF-Area Modes for Live View Photography

Live view mode is a little different than using the Viewfinder when it comes to autofocus. In some ways it is simpler, and in other ways it is more complex. The Autofocus modes have only two settings, and the AF-area modes have four.

The Release modes that we will discuss in **Section 3 – Release Modes** are the same whether you're using Lv mode or the Viewfinder.

The three mode groups available in Live view mode are as follows:

Autofocus modes (User's Manual – Page 51)

- Single-servo (AF-S)
- Full-time-servo AF (AF-F)

AF-area modes (User's Manual – Page 52)

- Face-priority AF
- · Wide-area AF
- Normal-area AF
- Subject-tracking AF

Release modes (User's Manual – Page 83)

- Single frame (S)
- Continuous low speed (CL)
- Continuous high speed (CH)
- Ouiet shutter-release (Q)
- Self-timer
- Remote control
- Mirror-up (MUP)

Autofocus in Live View Mode

In some instances a live view through the Monitor is quite useful. For instance, what if you want to take an image of a small flower growing very close to the ground? You could lie down on the ground and get your clothes dirty, or you could use Ly mode. Live view mode allows you to see what the lens sees without using the Viewfinder. Any time you need to take pictures up high or down low,

or even on a tripod, the D600 will happily give you that power with Lv mode.

To set your camera to Live view photography mode, simply flip the Live view selector switch to the top position so the white dot lines up with the small camera icon, as shown in figure 10.10 (red arrow).

Much of the Autofocus mode, AF-area mode, and Release mode information discussed in this

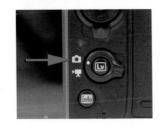

Figure 10.10 - Choosing Live view photography mode

chapter also applies to Movie live view mode (note the icon of the movie camera on a tripod in figure 10.10). We will discuss both Live view photography and Movie live view modes in later chapters.

After you have chosen Live view photography mode, press the Lv button. You are ready to start taking well-focused pictures.

Live View Mode Compared to Earlier Nikon Cameras

The Nikon D600 differs from previous Nikon cameras in Live view mode. Whereas previous semi-pro Nikon cameras had Handheld and Tripod modes, the D600 combines the two modes—sort of. In previous cameras, the reflex mirror would drop during an autofocus operation in Handheld mode so the camera could use standard phase-detection autofocus. The mirror stayed up in Tripod mode only with its contrast-detection autofocus.

The D600, however, raises the reflex mirror at the beginning of Live view mode and does not lower it for autofocus operations. Therefore, the Nikon D600 always uses mirror-up shooting in Live view. That means the camera cannot use the fast phase-detection autofocus provided for shooting with the Viewfinder. The primary problem is that contrast-detection AF is usually slower than phase-detection AF. However, the contrast-detection AF in the Nikon D600 is an improvement over previous Nikon cameras.

Many photographers were initially confused by the sounds coming from the D600 when taking a picture in Live view. It sounds like the mirror drops when you take a picture, but it doesn't. The Monitor blacks out briefly, as on previous Nikon cameras, while the camera fires the physical shutter. However, the Monitor blackout happens only while the shutter is firing. It has nothing to do with movement of the reflex mirror, even though it may sound like it.

Now, let's examine the two Autofocus modes. Remember, the Autofocus modes tell the camera *how* to focus.

Use the following steps to change the Autofocus mode:

- 1. Press and hold the AF-mode button (figure 10.10.1, image 1).
- 2. Rotate the Main command dial (figure 10.10.1, image 2).
- 3. AF-S and AF-F will appear on the Monitor as you turn the dial. Release the AF-mode button when your chosen mode appears. Singe-servo AF (AF-S) is selected in figure 10.10.1, image 3.

The two Autofocus mode selections are covered next. I photographed the screen with the lens cap on so you can clearly see the selections on a black background.

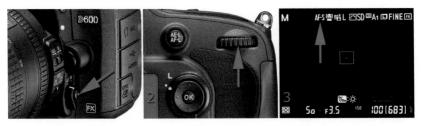

Figure 10.10.1 - Choosing an Autofocus mode in Live view photography

Single-Servo AF

Figure 10.11 has a red arrow pointing to the Single-servo AF (AF-S) mode symbol on the Live view screen. You control the focus by pressing the Shutter-release button halfway down. When focus is acquired, it locks and does not update unless you deliberately update it. You will have to refocus if you or your subject moves by releasing the Shutter-release button and reapplying pressure to refocus.

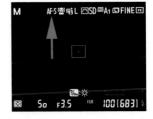

Figure 10.11 - Single-servo AF (AF-S) mode

A single red or green AF point square (with a dot) will appear in the middle of the Monitor. It will be red when the scene is not in focus and green when the scene is in good focus. You can move the square around the screen to select the area on which the camera will focus. If your subject doesn't move or moves very slowly, use this AF mode.

Full-Time-Servo AF

Figure 10.12 has a red arrow pointing to the Fulltime-servo AF (AF-F) mode symbol on the Live view screen. The red or green AF point square appears in the middle of the Monitor, as in Single-servo AF mode. It blinks on and off in red as the camera focuses, then it turns green and stops blinking when good focus is acquired. As the focus changes and is reacquired, you will see it blink green a few times. You can move the focus square around the Monitor to select a focus area.

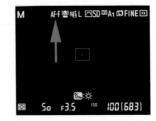

Figure 10.12 - Full-time-servo AF (AF-F) mode

This mode provides constantly updating autofocus that is tempered by the AF-area mode (discussed next) you have selected. The size and shape of the focus square changes with the AF-area mode you have selected.

The focus doesn't lock on the subject initially, which simply means it updates continuously (like AF-C) until you press the Shutter-release button halfway down, at which time the camera locks focus. If you release pressure from the Shutter-release button, the camera unlocks the focus and resumes continuous autofocus. The camera acts as if it is in AF-S mode when you have pressure on the Shutter-release button, and it acts as if it is in AF-C mode when you remove pressure.

Settings Recommendation: Unless I am going to do some very specialized macro shooting, I leave Live view mode's Autofocus mode set to AF-F, or Fulltime-servo AF. That way, the camera will automatically attempt to keep good focus on my subject.

If I am shooting a macro photo, I want to control exactly where the focus falls for depth of field control, so I use AF-S, or Single-servo AF.

Professional video shooters invariably use manual focus to prevent the frequent and noisy refocus operations of the camera when it detects changes in subject distance or contrast.

AF-Area Mode

The AF-area mode lets you choose where the camera senses your subject. Autofocus works differently for each of the four AF-area modes. You can cause the camera to look for people's faces, track a moving subject, widen out for landscapes, or pinpoint the focus on a small area of the subject.

Let's look at how to select one of the four AF-area modes, then examine what each one does.

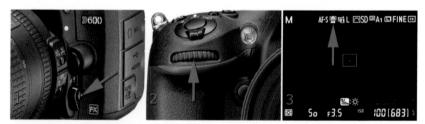

Figure 10.13 - Choosing an AF-area mode under Live view

Use the following steps to change the AF-area mode:

- 1. Press and hold the AF-mode button (figure 10.13, image 1).
- 2. Rotate the Sub-command dial (figure 10.13, image 2).
- 3. Various symbols will appear on the Monitor as you turn the dial. They represent four choices: Face-priority AF, Wide-area AF, Normal-area AF, and Subjecttracking AF. Release the AF-Mode button when your chosen mode appears. Face-priority AF is selected in figure 10.13, image 3 (red arrow).

Face-Priority AF

The red arrow in figure 10.14 points to the Facepriority AF symbol. When you are taking portraits in Live view mode or shooting movies with people in Movie mode, you may want to consider using Face-priority AF. The camera can track focus on the faces of several people at the same time. It is guite fun to watch as the little green and yellow AF point squares find faces and stay with them as they move—green squares are for focused faces and yellow squares are for faces that are being tracked but are not in the best focus.

Figure 10.14 - Face-priority AF

Nikon claims the camera can detect up to 35 faces at the same time. That's a lot of people! According to Nikon, "When multiple faces are detected, the camera will focus on the subject recognized to be the closest. Alternatively, you can also choose a different subject with the Multi selector."

Wide-Area AF

The red arrow in figure 10.15 points to the Widearea AF symbol. If you are a landscape shooter who likes to use Live view mode or shoot movies of beautiful scenic areas, this is your mode. The camera will display the AF point square on the Monitor, and it will be red when out of focus, green when in focus. You can move this AF point around until it rests exactly where you want the best focus to be. The camera will sense a wide area and determine the best focus, with priority on the area under the focus square.

Nikon says, "Suitable for hand-held shooting such as landscape."

Figure 10.15 - Wide-area AF

Normal-Area AF

The red arrow in figure 10.16 points to the Normalarea AF symbol. This mode is primarily for shooters who need to get very accurate focus on a small area of the frame.

If you are shooting a butterfly up close and want to focus on one of the antennae, use Normal-area AF. This is a great mode to use with a macro lens because it gives you a much smaller AF

Figure 10.16 - Normal-area AF

point square that you can move around the frame. Compare it to the AF point in Wide-area AF mode, and you'll see that it is about 25 percent of the size. You can pinpoint the exact area of the subject that you want to have the sharpest focus.

Nikon comments, "Suitable for tripod shooting with pinpoint focus such as close up."

Subject-Tracking AF

The red arrow in figure 10.17 points to the Subjecttracking AF symbol. When autofocus is locked in either by using the Shutter-release button in AF-S mode or automatically in AF-F mode (discussed previously)—this mode lets you start subject tracking with the OK button. When the subject is selected (after you press the OK button), the camera locks focus on the subject and tracks it when the subject or the camera moves.

Figure 10.17 - Subjecttracking AF

If you are making a movie of a black bear in the

Great Smoky Mountains, you just move the focus point to the bear, focus, and press the Multi selector center button to make the focus stay on the bear. It is amazing to watch the camera do this.

I suggest that you try AF-F, or Full-time-servo AF, with this mode. Full-time autofocus allows your camera to fully track the subject without you worrying about keeping it in focus yourself.

Nikon says, "Suitable for a moving subject."

Settings Recommendation: Why not leave the AF-area mode set to Facepriority AF if you often photograph people? If you are using Live view for macro shooting, Normal-area AF gives you the smallest, most accurate area for detailed, up-close focusing. Landscape shooters should use Wide-area AF, and wildlife or sports shooters should use Subject-tracking AF.

Now, let's carefully examine the Release modes, which affect the camera for Viewfinder and Live view shooting.

Using Focus Lock

Focus lock is a tool for those times when you need to lock the focus on a certain area of the subject and recompose. If the AE-L/AF-L button is configured correctly, you can lock focus on your subject whenever you want to. You can control the AE-L/AF-L button with Custom setting f4: Custom Setting Menu > f Controls > f4 Assign AE-L/ AF-L button. You can choose to lock both the exposure and autofocus with AE/AF lock, or choose AF lock only so you can lock just the autofocus at any time. This is convenient when you are using the AF-C Autofocus mode, which never locks focus on the subject but keeps updating. For a picture or two, you may want to lock the focus and recompose without the focus changing. Assign AE/AF lock or AF lock only to the AE-L/AF-L button so that whenever you press the button, the focus is locked until you release it.

Section 3 – Release Modes

(User's Manual - Page 83)

The D600 has several Release modes, which apply to both the Viewfinder and Live view photography.

You could also call them Shutterrelease modes because the Release modes pertain to when images will be taken and how fast you can take them. In figure 10.18, you can see the Release mode dial (right red arrow) and the lock release button (left red arrow). Press the lock release button and turn the Release mode dial to select a mode. CH is selected in figure 10.18.

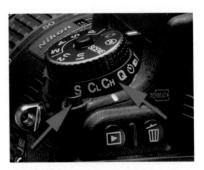

Figure 10.18 - Release mode dial and Release mode dial lock release button

Now, let's look at each of the Release modes in more detail. Here is a list of the seven modes:

- S Single frame
- CL Continuous low speed
- CH Continuous high speed
- O Ouiet shutter-release
- Self-timer
- · Remote control
- MUP Mirror-up

In the good old film days, the first three Release modes would have been called motor-drive settings because they are concerned with how fast the camera is allowed to take pictures.

We've already talked about these modes to some degree in the sections on the AF-area modes

Single Frame (S) Release Mode

Single-frame Release mode (figure 10.19) is the simplest frame rate because it takes a single picture each time you press the Shutter-release button fully. There is no speed here. This is for photographers who shoot a few frames at a time. Nature shooters often use this mode because they are more concerned with correct depth of field and excellent composition than blazing speed.

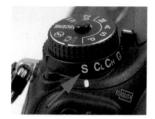

Figure 10.19 - Single frame (S) Release mode

Continuous Low Speed (CL) Release Mode

Continuous low speed Release mode allows you to select a frame rate between 1 and 5 frames per second (fps). When you hold down the Shutterrelease button, the camera will fire at the chosen frame rate continuously until you let up on the button or until the internal memory buffer gets full. Choose CL on the Release mode dial to select this mode (figure 10.20).

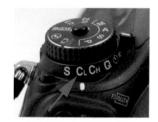

Figure 10.20 - Continuous low speed (CL) Release mode

The default CL frame rate from the factory is 3 fps. If you want more or less speed, simply open

Custom Setting Menu > d Shooting/display > d5 CL mode shooting speed and select your favorite frame rate (figure 10.21). Your camera cannot exceed 5 fps in CL mode.

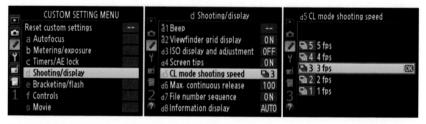

Figure 10.21 - Choosing a Continuous low speed Release mode frame rate

Continuous High Speed (CH) Release Mode

Continuous high speed Release mode is designed for when you want to shoot at the highest frame rate the camera can manage (figure 10.22). The D600 will attempt to capture 5.5 fps every time you hold down the Shutter-release button.

Figure 10.22 - Continuous high speed (CH) Release mode

Internal Memory Buffer

The camera's internal memory buffer limits how many frames you can take. When you shoot in JPEG mode, you may be able to record as many as 100 frames in one burst. You can control this maximum by adjusting Custom Setting Menu > d Shooting/Display > d6 Max. continuous release.

In Lossless compressed NEF (RAW) mode, you can shoot only 16 pictures at 14 bits, or 22 pictures at 12 bits, before the memory buffer is full. You'll have to wait for the camera to offload some buffered images to the memory card before you can shoot another long burst.

See the buffer capacity column in the Memory Card Capacity chart on page 335 of your Nikon User's Manual for a list of Image quality/Image size modes and buffer capacities.

When you are shooting in high-speed bursts, the areas of the Control panel and Viewfinder that are normally devoted to how many pictures are left changes to a new set of figures. Now you will see a letter r followed by a number (figure 10.22.1, screen 1, red arrow). The red arrow in figure 10.22.1, screen 2, points to where the r number will appear at the bottom right of the Viewfinder (not currently shown). This is the place where the remaining image count is usually shown.

Figure 10.22.1 - Buffer capacity's remaining images

The r stands for remaining. The number indicates how many frames you can shoot before the memory buffer is full. For instance, if you see r21, you would have only 21 frames left before the memory buffer will hold no more images. If the buffer gets full, the camera will drastically slow down as it writes images from the internal memory buffer to the memory card.

You can check the number of remaining images at any time by holding the Shutter-release button halfway down.

Requirements for Fast Frame Rates

All of the settings for fast frame rates (high fps) are based on the assumption that you are shooting with at least a 1/250 second shutter speed, have a fully charged battery, and have some buffer space left in your camera's memory.

Quiet Shutter-Release (Q) Release Mode

Quiet shutter-release Release mode is designed to silence the camera as much as possible when you fire the shutter (figure 10.23).

Viewfinder Mode

When using Q mode in Viewfinder mode, the D600 ties the raising and lowering of the mirror to the position of the Shutter-release button, instead of raising the reflex mirror, taking the picture, then lowering the mirror in one smooth step.

Figure 10.23 - Quiet shutterrelease (Q) Release mode

When you press the Shutter-release button and take a picture in Q mode, the mirror raises and the shutter fires. However, the mirror does not lower until you fully release the Shutter-release button.

If you want to reduce noise, you can hold the Shutter-release button down longer than normal and separate the raising and lowering of the mirror into two steps. This tends to draw out the length of the mirror/shutter action and reduces the perception of noise volume. In reality, the noise is not reduced much, but since it is broken into two parts, it seems guieter.

Live View Mode

In Live view mode the mirror is always raised; therefore, Q mode does nothing special for the mirror in Live view. However, in Live view mode the focal-plane shutter is always open for viewing and closes only long enough to time the image exposure. When you press the Shutter-release button in Q mode, the shutter closes, reopens for the exact length of the selected shutter speed, then closes again. It does not reopen for viewing until you release pressure from the Shutter-release button. That breaks the shutter action into four parts when you fully press the Shutter-release button: (1) shutter closes, (2) shutter opens for shutter speed time, (3) shutter closes at the end of shutter speed time, and (4) shutter reopens for Live view. The final step happens only after you release the Shutterrelease button. This quiets the shutter a tiny bit.

What makes this a little confusing is that the camera seems to act in a similar manner even when you are not using Q mode. In non-Q mode, the Monitor does not come back on when you are taking a Live view picture until you release pressure from the Shutter-release button, even though the shutter has already reopened. The only real difference between Q mode and non-Q modes is that the final click of the shutter reopening is delayed until you let go of the Shutterrelease button. You'll have to count the clicks in O mode and non-Q modes to see what I mean.

Self-Timer Release Mode

Use the Self-timer Release mode to take pictures a few seconds after you press the Shutter-release button (figure 10.24). The camera will autofocus when you press the Shutter-release button halfway down, and it will start the Self-timer when you press it all the way down.

You can use Custom Setting Menu > d Shooting/ display > c3 Self-timer to set the self-timer to 2, 5, 10, or 20 seconds.

Figure 10.24 - Self-timer Release mode

If you like to hear that little beep beep beep when the Self-timer is counting down the seconds before firing the shutter, you can control it with Custom Setting Menu > d Shooting/display > d1 Beep.

After you press the Shutter-release button in Self-timer mode, the AF-assist illuminator will blink about twice per second and the beeping will start. When the last two seconds arrive, the AF-assist illuminator will shine continuously and the beeping will double in speed. You are out of time when the beeping speeds up! The image is taken about the time the beeping stops.

If you want to stop the self-timer, all you have to do is press the MENU or Playback button.

Remote Control Release Mode

If you have the optional Nikon ML-L3 remote control, Remote control Release mode lets you fire the shutter remotely (figure 10.25). Three modes are available: Delayed remote (two-second delay), Quick-response remote (immediate shutter release), and Remote mirror-up (takes two button presses to release the shutter). These three modes are available under Shooting Menu > Remote control mode. Select a mode before you use Remote control Release mode.

Figure 10.25 - Remote control Release mode

Use the Remote control Release mode when you want to shoot pictures hands off. You can cut down on vibrations significantly by shooting with the remote control. The wireless ML-L3 remote is a very inexpensive item, and all D600 users should buy one (figure 10.25.1). Use it instead of the more expensive Nikon MC-DC2 electronic cable release, which is wired.

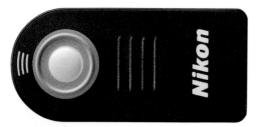

Figure 10.25.1 - Nikon ML-L3 infrared remote

Mirror-Up (MUP) Release Mode

Use Mirror-up Release mode to raise the mirror and allow vibrations to die down before you release the shutter (figure 10.26). In a three-step operation, the camera will first autofocus when you press the Shutter-release button halfway down. then raise the mirror when you press it all the way down. You can then use a remote release to fire the shutter, or even press the Shutter-release button again (not recommended because it cancels out the benefit of using MUP mode by introduc-

Figure 10.26 - Mirror-up (MUP) Release mode

ing new vibrations). If you do nothing after raising the mirror, the camera will fire by itself after about 30 seconds.

In Live view mode, the mirror is already raised. Therefore, the primary benefit of MUP mode is that the camera delays firing the shutter until you release the Shutter-release a second time with an MC-DC2 electronic cable release or ML-L3 wireless release (not your finger, please). That means you can allow camera vibrations to die down before the final shutter release occurs, even in Live view mode.

This mode is very simple and very effective. I use it constantly when I am shooting nature photos.

Don't Touch That Shutter Release!

Please buy a hands-off shutter release (Nikon MC-DC2 or ML-L3) so you don't have to manually press the Shutter-release button when the camera is on a tripod and in MUP mode. Touching the camera seems a bit silly after going to all

that trouble to stabilize it and raise the mirror. A finger press could shake the entire tripod!

If you do not have a wireless or cabled shutter release, simply wait 30 seconds after pressing the Shutter-release button in MUP mode and, as previously mentioned, the camera will fire on its own. This could be used as a slow but high-quality self-timer.

Custom Settings for Autofocus (a1-a7)

For a complete discussion of the autofocus-related Custom settings a1 through a7, please see the heading **Custom Settings a1–a7** in the chapter titled **Custom Setting Menu**. When you consider autofocus issues, it is especially important that you read the information in that chapter concerning Custom settings a1 and a2. If you don't read and understand that section, you may get quite a few out-of-focus images.

Also, consider using Focus tracking with lock-on when you use any mode that does focus tracking (9 point, 21 point, 39 point, or 3D-Tracking). This will prevent your camera from losing focus on the subject if something comes between the camera and the subject while the subject is moving. Otherwise the camera may switch the focus to the intruding object and lose the tracked subject. To enable Focus tracking with lock-on, go to Custom Setting Menu > a Autofocus > a3 Focus tracking with lock-on and choose a tracking delay time-out.

With lock-on enabled, the camera remembers the subject you are tracking for a few seconds after it loses contact with it. If the subject reappears, the camera will continue tracking it.

Author's Conclusions

I've followed the development of the Nikon autofocus systems since the late 1980s. Autofocus with the Nikon D600 is a real pleasure. It has a more powerful AF system than many cameras before it, and yet it is somewhat simplified in its operation. The system can still seem complex, but if you spend time with this chapter you should come away with a much greater understanding of the D600's AF module. You'll have a better understanding of how you can adapt your camera to work best for your style of photography. Enjoy your D600's excellent Multi-CAM 4800 FX autofocus system!

The next chapter will advance beyond our brief examination of Live view photography mode as it relates to autofocus by adding detailed information on how to best use the Live view photography mode controls for general photography.

Live View Photography Mode

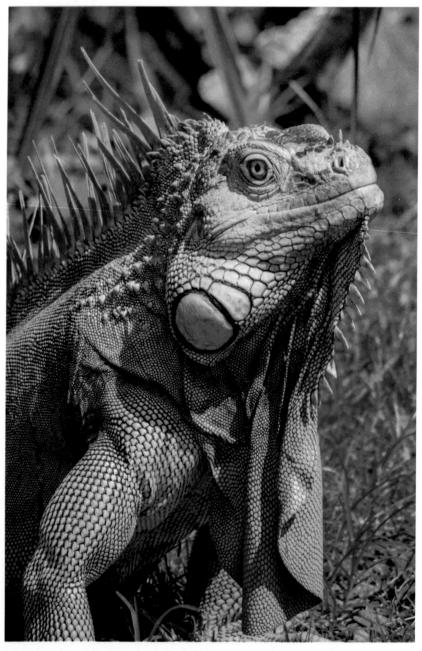

Iguana Invasion – Susan Braunhut (wife of dhmiller)

Live view photography mode in the Nikon D600 is a mature, full-featured still imaging system that's easy to use. It allows you to take your eye away from the camera and use the Monitor as a viewfinder. If you need to shoot with your camera at arm's length, such as in a crowd while taking pictures over the top of people's heads, the big 3.2-inch (8.13 cm) Monitor makes it easy to see your subject. If you need to take pictures that require you to bend over, such as when shooting closeups (macros) of plants or insects, the Live view mode will save your back from a lot of pain.

The contrast-detection autofocus used by Live view photography mode detects contrast at the pixel level, providing literally microscopic focus accuracy. Additionally, you can move the focus square to any point in the Monitor that will give you the most accurate autofocus.

Live view is divided into two parts in the Nikon D600: Live view photography mode and Movie live view mode. In this chapter we will examine Live view photography mode, which is used exclusively for shooting still images. You cannot shoot video in Live view photography mode; the Movie-record button will not respond.

In the next chapter we'll investigate Movie live view mode for special format (16:9) still images and broadcast-quality HD movies.

Using Live View Photography Mode

(User's Manual – Page 49)

To enter Live view photography mode, flip the Live view selector lever to the top position (figure 11.1, image 1) and press the Lv button. To exit Live view photography mode, simply press the Lv button again. Figure 11.1, screen 2, shows the Live view screen you'll see first. Normally this screen would show the subject you are about to photograph, but I left the lens cap on to provide maximum contrast for all the controls we will discuss.

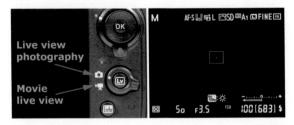

Figure 11.1 – Live view selector switch, Lv button, and Live view screen

As discussed in the previous chapter, Live view photography mode uses contrast-detection autofocus, which is activated by the Shutter-release button if you

are using Single-servo AF (AF-S) mode or automatically if you selected Full-time servo AF (AF-F) mode.

You can move the red focus square to any location on the screen to select off-center subjects. When you have good focus, the red square turns green. You are not limited to the central 39-point AF area as you are when you're looking through the Viewfinder.

Screen Blackout during Exposure

The screen doesn't black out while autofocus is active because the camera focuses by detecting contrast changes on the imaging sensor. When you fire the shutter, the Monitor will black out briefly while the picture is taken. The blackout is necessary to allow the camera to fire the shutter, which briefly blocks light from reaching the sensor. The reflex mirror does not drop when you are taking a picture in Live view photography mode, therefore the blackout period is brief.

Extreme Focusing Accuracy

Use Live view photography mode when you need extreme autofocus accuracy. Contrast-detection AF is slower than phase-detection AF, but it is very accurate. You can zoom in to pixel-peeping levels with the Playback zoom in button before starting autofocus. This is great for macro shooting because you can select very specific sections of the subject for focusing (figure 11.1.1).

Figure 11.1.1 – Pipevine Swallowtail (Battus philenor) captured in Great Smoky Mountains National Park with a mid-1970s Al Nikkor 200mm f/4 lens on a bellows for macro, from about 6 feet (2 meters) away

Taking Pictures in Live View Photography Mode

Hold the Shutter-release button down all the way and wait a moment for the camera to take the picture. It's usually slower than taking a picture with the Viewfinder because autofocus takes more time. When you take a picture in Live view photography mode, it appears on the Monitor. To return to Live view photography to take more pictures, just press the Shutter-release button halfway down.

According to Nikon, one important consideration in Live view photography mode is to cover the Viewfinder eyepiece when using Live view. Very bright external light coming into the eyepiece may negatively influence the exposure.

I experimented with this by shining an extremely bright LED flashlight directly into the Viewfinder eyepiece while I was metering a subject with Live view and saw absolutely no change in exposure. I then switched to standard Viewfinderbased photography mode and found that shining the flashlight into the Viewfinder eyepiece had an immediate and dramatic effect on exposure.

You may want to test this for yourself and see if your D600 reacts to light through the Viewfinder during Live view photography. Or you can play it safe and use the Eyepiece cover that comes with the camera.

Settings Recommendation: You can use Live view photography mode on or off your tripod. I normally use Live view for macro (closeup) images (figure 11.1.1), when I need the extra accuracy and focus positioning capability. With older Nikon cameras I was not all that interested in Live view photography because it didn't feel mature or complete. However, the Nikon D600 has a very refined Live view photography mode. It can be used in almost any situation when standard Viewfinder-based photography will work.

One exception is action shooting. Live view photography is not as good for many types of action shots because the autofocus method is slower and the shutter lag seems longer. If you prefocus the camera in Live view, maybe you could capture some action, but I wouldn't try it for action shots that require rapid autofocus.

Live view photography mode is for when you have the time and inclination to stand back from your camera and take excellent photos in a more contemplative manner. It's like using a small view camera instead of an HD-SLR. If you have not been in the habit of using Live view, you should seriously consider giving it a try. The D600 makes it a lot more effective and easier to use.

Live View Photography Mode Screens

(User's Manual - Pages 51-54)

There are four screen overlays available in Live view photography mode. You move between these screens by pressing the Info button repeatedly. Let's examine each of them.

Live View Photography - Screen 1

Figure 11.2 shows numerous symbols that allow you to see how various features are configured. To help us examine the symbols, I have numbered them and provided an explanation.

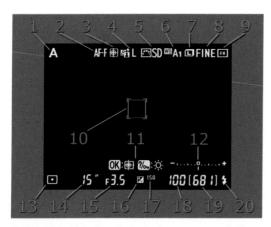

Figure 11.2 – Live view photography screen 1, symbols

- 1. **Exposure mode** Select a mode by turning the Mode dial. The available selections are P, S, A, M, U1, U2, SCENE, AUTO, and no flash mode.
- 2. **Autofocus mode** Set the mode with the AF-mode button and Main command dial. The available settings are AF-S and AF-F.
- 3. **AF-area mode** Set the mode with the AF-mode button and Sub-command dial. The settings are Face-priority AF, Wide-area AF, Normal-area AF, and Subject-tracking AF (uses symbols).
- 4. Active D-Lighting Control this setting with Shooting Menu > Active D-Lighting. The settings are Low to Extra High and Auto or Off (L = Low, N = Normal, H = High, H* = Extra high, A = Auto).
- 5. Picture Control Select a control with Shooting Menu > Set Picture Control. You can also control this setting by pressing the Retouch/Picture Control button and selecting a Picture Control from the Monitor with the Multi selector. See the upcoming section called Selecting a Picture Control in Live View for more detail.

- White balance Set the White balance by holding down the WB/Help/ protect button and rotating the Main command dial. Select from nine white balance settings, including Auto, Incandescent, Fluorescent, Direct sunlight, Flash, Cloudy, Shade, Choose color temp., and Preset manual (uses symbols).
- **Image size** Control the size with *Shooting Menu > Image size*. The settings are Large (L), Medium (M), and Small (S). You can also hold down the QUAL/ Playback zoom in button and rotate the Sub-command dial to select this value.
- Image quality Control the quality with Shooting Menu > Image quality. The settings are NEF (RAW) + JPEG; NEF (RAW); and JPEG fine, normal, or basic. You can also hold down the QUAL/Playback zoom in button and rotate the Main command dial to select this value. The abbreviations you'll see on the Monitor for these settings are FINE, NORM, BASIC, RAW+FINE, RAW+NORM, RAW+BASIC, and RAW.
- 9. **Image area** Control the area with Shooting Menu > Image area. You can select one of the two available image areas: FX or DX. The Monitor will display an image that is automatically cropped to the size selected in Image area. This value must be selected before you enter Live view photography mode. It cannot be changed during an active Live view photography session.
- 10. AF point (focus) Move the AF point around the screen with the Multi selector to select the subject for autofocus. This focus rectangle will vary in size and color according to the AF-area mode selected (item 3 in this list) and whether the subject is in focus.
- 11. Guide This control informs you of available Live view photography mode options. It shows that you can use the OK button—when in Subject-tracking AF mode only—to select the subject for tracking. It also shows that in any AF-area mode, if you press the Help/Protect/White balance button, the camera will display a Monitor brightness adjustment scale (sun symbol). See the upcoming section called Changing the Monitor Brightness.
- 12. **Exposure indicator** The light indicates whether the image will be over- or underexposed in Manual mode (M). It blinks on and off in the other exposure modes (P, A, and S) when the camera cannot make a good exposure using the current camera settings.
- 13. Metering mode Set the mode by pressing the Metering button and turning the Main command dial. The following choices are available: Matrix, Center-weighted, and Spot.
- 14. **Shutter speed** Set the speed by turning the Sub-command dial, with settings from 30 seconds to 1/4000 second (4000). You can change this manually only in Shutter-priority auto (S) and Manual (M) modes. The camera controls it in Aperture-priority auto (A) and Programmed auto (P) modes.

- 15. **Aperture** Set the aperture by turning the Main command dial. The aperture minimum and maximum varies according to the mounted lens. You can change it manually only in Aperture-priority auto (S), Flexible program (P*), and Manual (M) modes. The camera controls it in Shutter-priority auto (A) and Programmed-auto (P) modes.
- 16. **Exposure compensation** This symbol will appear only when +/– exposure compensation has been dialed into the camera. Adjust this value with the +/– Exposure compensation button.
- 17. **ISO mode** Control the mode with Shooting Menu > ISO sensitivity settings > Auto ISO sensitivity control. The choices are On and Off. You can also control this value by holding down the ISO/Playback zoom out/thumbnails button and turning the Sub-command dial to select from ISO or ISO AUTO on the Monitor. When you are not using the Auto ISO sensitivity control, it will say ISO. When the Auto ISO sensitivity control is enabled, it will say ISO AUTO.
- 18. ISO sensitivity Control the setting with Shooting Menu > ISO sensitivity settings. The choice of ISO values ranges from L 1.0 (ISO 50) to H 2.0 (ISO 25,600). You can also control this value by holding down the ISO/Playback zoom out/thumbnails button and turning the Main command dial. The ISO values will change on the Monitor.
- 19. *Frame count (remaining pictures)* The counter indicates approximately how many more pictures can be taken and stored on the currently selected memory card.
- 20. **Flash indicator** The light blinks when the camera suggests using flash or when underexposure may result. The indicator is solid (not blinking) when the flash is ready to be used.

Live View Photography – Screen 2

Figure 11.3 shows a much cleaner screen with a blank area at the top and a single line of information along the bottom, which matches some of the descriptions for figure 11.2. This is for users who prefer an uncluttered screen while shooting still pictures.

Figure 11.3 – Live view photography screen 2

Figure 11.4 – Live view photography screen 3

Mhoz

Live View Photography – Screen 3

Figure 11.4 shows a screen that is similar to the previous screen, except gridlines are added. Use these gridlines to level your subject in the Viewfinder, as is necessary when photographing things like a horizon in scenic photography or buildings, doors, or walls in architectural photography.

Live View Photography – Screen 4

The final screen, shown in figure 11.5, displays a Virtual horizon that allows you to level the camera in a dual-axis horizontal and vertical direction. If you are a pilot, you'll feel right at home with this new tool because it resembles the artificial horizon used to keep airplane wings and the nose level.

Figure 11.5 – Live view photography screen 4

Selecting a Picture Control in Live View

Picture Controls are easy to change in Live view photography mode. Interestingly, their effects on the subject are displayed on the Monitor as you select each Picture Control. You can see some samples applied to my Jeep hat in figure 11.6.

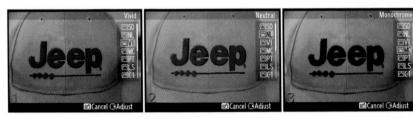

Figure 11.6 – Samples of Vivid (image 1), Neutral (image 2), and Monochrome (image 3) Picture Controls

To choose a Picture Control in Live view photography mode, you can press the MENU button and select *Shooting Menu > Set Picture Control* while a Live view session is active, or you can use external camera controls as described in the following steps.

The camera displays a special screen when you press the Protect/Picture Control/Help button, as seen in figure 11.6.1, screen 2.

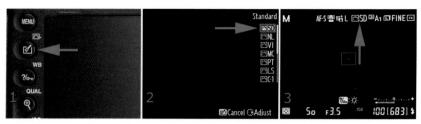

Figure 11.6.1 – Selecting a Picture Control in Live view photography mode

Use these steps to select a Picture Control during a Live view photography session:

- 1. With the camera already in Live view photography mode, press the Retouch/Picture Control button (figure 11.6.1, image 1, red arrow).
- 2. The Picture Control screen will appear while the camera is still in Live view photography mode (figure 11.6.1, screen 2). The current Picture Control in use will be highlighted in yellow. Select a different Picture Control by highlighting one of the others with the Multi selector, then press the OK button. Notice how the sharpness, contrast, brightness, saturation, and hue of the subject being viewed changes when you select different Picture Controls. (Note: You can even do a quick adjustment on the Picture Control by scrolling to the right when you have a Picture Control name highlighted, which opens the Quick adjust screen.)
- 3. The camera will switch back to the Live view photography screen with the new Picture Control active. It will be listed at the top of the screen (figure 11.6.1, screen 3, red arrow).

This is a very simple way to select a different Picture Control, not unlike how it is done with the same controls in normal Viewfinder-based photography.

Changing the Monitor Brightness

If you are shooting in a very bright or very dark area, you can change the brightness of the Monitor in Live view photography mode. This does nothing to the pictures you are taking and is only for your comfort while taking pictures.

Figure 11.7 shows examples of the maximum, middle, and minimum screen brightness settings. There is not a large difference between the maximum and middle settings shown in images 1 and 2. However, the difference between the middle and minimum settings, shown in images 2 and 3, is striking.

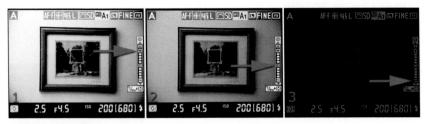

Figure 11.7 - Samples of Monitor brightness in Live view photography mode

Use the following screens and steps to adjust the Monitor brightness in Live view photography mode.

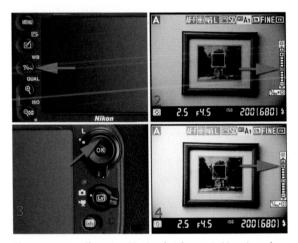

Figure 11.7.1 – Changing Monitor brightness in Live view photography mode

- 1. With the camera in Live view photography mode, press and hold the Help/ Protect/WB button (figure 11.7.1, image 1, red arrow) and the camera will display a Monitor brightness indicator scale on the right side of the Monitor (figure 11.7.1, image 2, red arrow).
- 2. Press up on the Multi selector to brighten the screen and press down to dim it (figure 11.7.1, image 3).
- 3. Release the Help/Protect/WB button to set the brightness level. Figure 11.7.1, image 4, shows the brightness set to maximum on the brightness control (red arrow).

Closing Notes on Live View Photography Mode

Movie Live View Still Images

When you first place your camera in Movie live view mode, before you press the Movie-record button, the camera can take 20.3 MP still pictures in a 16:9 format (6016×3376 pixels). The Movie live view still image size matches most HD devices, so if you are shooting stills for display on HD devices that closely match the 16:9 format, use Movie live view to take some pictures.

Figure 11.8 – Selecting Movie live view mode

Nearly all the information we have considered in this chapter applies to Movie live view still images. Just flip the Live view selector switch to the

ages. Just flip the Live view selector switch to the bottom position (figure 11.8), press the Lv button, and start taking excellent still images formatted for HD devices (e.g., tablets, HDTVs, and newer computer monitors). We will consider more about Movie live view in the next chapter.

Using Autofocus in Live View

Nikon strongly recommends using an AF-S lens when you are shooting in Live view modes. According to Nikon, "The desired results may not be achieved with other lenses or teleconverters."

You may see darkening or brightening in the Monitor as autofocus takes place, and autofocus will be slower than it is with Viewfinder-based photography. From time to time the focus indicator square may remain green (instead of red) when the camera is not actually in focus. Simply refocus when that occurs.

There are several things that may cause the camera to have difficulty focusing in Live view (according to Nikon):

- The subject contains lines that are parallel to the long edge of the frame
- · The subject lacks contrast
- The subject under the focus point contains areas of sharply contrasting brightness, or it includes spotlights, a neon sign, or another light source that changes in brightness
- There is flickering or banding under fluorescent, mercury-vapor, sodiumvapor, or similar lighting
- A cross-screen (star) filter or other special filter is being used
- · The subject appears smaller than the focus point
- The subject is dominated by regular geometric patterns (e.g., window blinds or a row of windows in a skyscraper)
- · The subject is moving

- The subject is moving too fast
- · Another object gets between the camera and the subject
- The subject size changes visibly
- The subject color changes
- · The subject gets brighter or dimmer
- The subject gets too small, too close, or too light or dark
- The subject is the same color as the background

Live View Camera Protection System

If conditions may harm the camera in Live view—such as using Live view for extended periods on a hot day, causing the camera to overheat—the D600 will protect itself by automatically shutting down Live view. A Time remaining countdown will display on the top right of the Monitor for 30 seconds before the Live view system shuts down (User's Manual page 53). If conditions warrant, the countdown timer may appear immediately upon entering or reentering Live view. This countdown allows your expensive camera to protect its internal circuits from overheating and causing damage.

Author's Conclusions

Live view photography mode in the D600 is a mature and very usable way to shoot still images. Using the Monitor is not just for point-and-shoot photographers anymore. There are several good reasons for using the Live view system, such as extreme focusing accuracy when shooting macro images and when composing the image on the Monitor will give you a better feel for the subject than the Viewfinder.

The next step in learning about the Nikon D600 is to examine Movie live view mode. This mode is used for special HD-format still images, but it's primarily designed for shooting excellent, broadcast-quality HD movies. Let's examine the powerful video subsystem in your D600 and see how it works.

Movie Live View Mode

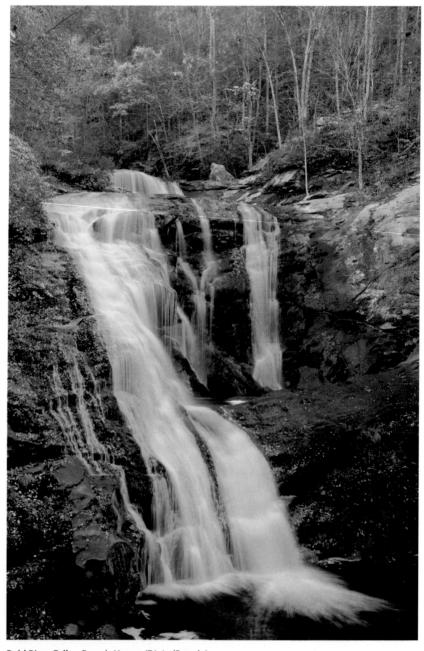

Bald River Falls – Brenda Young (DigitalBrenda)

With each new DSLR camera, Nikon has advanced the capability of the video recording system. The Nikon D600 is no exception. In fact, this camera has achieved a level of video capability that few other cameras can claim, even outside the 35mm form factor. Due to the power and flexibility of its Movie live view mode, Nikon has established a new type of camera, the HD-SLR. Where previous Nikon DSLR cameras were primarily still-image producers that happened to have video recording capability, the new HD-SLR D600 was constructed with a video system just as capable as the still-image system.

When you use the still-imaging side of the Nikon D600, you are taking extreme-resolution images that no other 35mm form-factor DSLR can match (at the time of this writing). And no other 35mm form-factor camera can match the videos taken by the D600. It can stream broadcast-quality, uncompressed HD (720p) or Full HD (1080p) video with no camera control overlays—called clean video—from its HDMI port. At the time of this writing, no other 35mm camera has that capability.

In a sense the Nikon D600 has two video subsystems. One is for recording high-quality, compressed home videos in MOV format, each up to 29 minutes, 59 seconds long, to the camera's SD memory cards. The second is for outputting an uncompressed 1080p video stream from the HDMI port with no time constraints. The second type also allows usage of the Nikon D600 for shooting Full HD video. You can use the video output from the Nikon D600 for basic (just press the button) or advanced (use an external recorder) D-Movie creation.

No Tripod and Handheld Modes

By separating Live view photography mode and Movie live view mode into separate chapters, I hope to make clear the differences and similarities between the two modes. I had gotten used to having a Tripod mode and a Hand-held mode in previous Nikon cameras.

You might think that switching between the two Live view modes, with icons that look similar to those on previous Nikon cameras, is simply switching between Tripod and Hand-held modes. However, the D600 works differently. In a sense, the Tripod and Hand-held modes have been combined in the D600, doing away with the ability to use phase-detection autofocus in a handheld mode and contrast-detection autofocus in a tripod mode.

The D600 raises (instead of lowers) its reflex mirror for pictures or video when you enter either of the new Live view modes. The shutter on the D600 is loud enough to make it sound like the mirror is being lowered, and the Monitor blackout when the picture is taken seems to imply that the mirror is being lowered, but it isn't. The camera simply blacks out briefly while the shutter is fired.

There is no way to use phase-detection autofocus in Live view photography or Movie live view modes. Autofocus for both modes is now based entirely on contrast-detection autofocus at pixel level on the imaging sensor.

Selecting Movie Live View Mode

(User's Manual - Page 57)

In case you are a new HD-SLR user and have never used Nikon's Live view modes, let's see how to switch the camera into Movie Live view mode. In figure 12.1 the camera is set to Movie live view mode, which is just below the setting for Live view photography mode on the Live view selector switch.

After you have entered Movie live view mode you can take still images and HD videos in the 16:9 aspect ratio *only*. No matter how you have the camera set in *Shooting Menu > Image area*, the still images and video are still in the 16:9 ratio.

Figure 12.1 – Selecting Movie live view mode

If you are shooting in DX mode or with a DX lens attached, the images and movies are in the 16:9 aspect ratio; however, the camera creates a cropped, DX-sized 16:9 ratio image or video that gives the appearance of pulling the subject in closer. It isn't really magnifying the image; it's just using less of the imaging sensor to capture the subject, so it appears larger in the image or video when it is displayed.

To take pictures or shoot videos you next have to press the Lv button and make sure an image appears on the Monitor. From that point on, there are some differences in how you either take a still image or shoot a video. First, let's briefly examine making still images, and then we will discuss making movies.

Movie Live View Still Images

As mentioned at the end of the previous chapter, the Nikon D600 provides a still-image capability in Movie live view mode that is very similar to Live view photography mode. In fact, most of what is written in the chapter **Live View Photography Mode** applies equally to Movie live view mode's 16:9 ratio still images.

For that reason, we will not discuss all the capabilities of the Movie live view still-imaging function. When you decide to take a picture (instead of a movie) using Movie live view mode, let the information in the previous chapter govern how you shoot, tempered by the differences discussed in this chapter.

I know this seems a little odd, and I wish Nikon had simply included a 16:9 aspect ratio format in Shooting Menu > Image area, along with FX and DX. If they had, the Movie live view mode could have been exclusively for shooting video, with no still image capability. However, we do have still-image capability in Movie live view mode, and some people may enjoy shooting in the 16:9 aspect ratio, so let's look at table 12.1 to see what is available for options and sizes.

Image area	Image size	Pixel size	Print size (in/cm)
FX	L	6016×3376	20.1 × 11.3/50.9 × 28.6
FX	М	4512×2528	15.0 × 8.4/38.2 × 21.4
FX	S	3008×1688	10.0 × 5.6/25.5 × 14.3
DX	L	3936×2224	13.1 × 7.4/33.3 × 18.8
DX	М	2944×1664	9.8 × 5.5/24.9 × 14.1
DX	S	1968×1112	6.6 × 3.7/16.7 × 9.4

Table 12.1 - Movie live view mode 16:9 still Image area and Image size with pixel and print dimensions

The Image area column in table 12.1 represents the values found in *Shooting* Menu > Image area > Choose image area, including values from FX and DX for the 16:9 aspect ratio of Movie live view mode. You must select the Image area before you enter Movie live view mode. The Image area choice is grayed out on the Shooting Menu when you are in Movie live view.

The Image size column in table 12.1 represents the values found in *Shooting* Menu > Image size. The table reflects the Large (L), Medium (M), and Small (S) Image sizes available in Movie live view mode. You can select these values from the Shooting Menu by pressing the MENU button while in Movie live view mode.

A still image taken in Movie live view with FX mode is approximately 91% of the width of a normal FX image, therefore the field of view from any lens will be slightly narrower than normal.

From this point forward, this chapter will focus primarily on shooting video because that is the primary purpose for Movie live view mode.

Figuring Print Sizes in Inches and Centimeters

The print sizes listed in table 12.1 are based on printing the image at 300 dpi (dots per inch). The print size will be different at various dpi settings. The formula to figure print sizes at various dpi settings is as follows (1 inch = approximately 2.54 cm):

Print size (inches) = Pixel size (one dimension)/dpi

Therefore, 6016 pixels/300 dpi = 20.1 inches (50.9 cm), as shown in table 12.1. That means the same pixels at 240 dpi would provide a larger image, as the formula shows: 6016 pixels/240 dpi = 25.06 inches (63.65 cm). For metric system users, the formula has one more step:

Print size (cm) = (Pixel size/dpi) \times 2.54

Therefore, $(6016 \text{ pixels/300 dpi}) \times 2.54 = 50.94 \text{ cm}$. Remember this useful formula, whether in inches or centimeters, if you use dpi as the standard for printing. This formula works for any pixel to print size (in dpi) conversion, not just in Movie live view mode. Use the pixel size for each dimension (height and width) of the image to determine an overall print size.

Movie Live View Screens

Let's start out by examining each of the four screen overlays you can use while taking stills or shooting movies in Movie live view mode. You can scroll through each of the five screens by pressing the Info button repeatedly.

Movie Live View - Screen 1

The Nikon D600 has two screens for each overlay in Movie live view. The first screen is available when you are shooting still images, and the second is available when you are recording video. I am using the first screen as a guide initially so we can examine each of the controls on the screen. When you start recording movies some of the controls in the overlay disappear. Figure 12.2 shows the first screen you should see when you enter Movie live view. Let's examine each of the controls displayed in the overlay.

Here is a list of controls shown on the first screen, with explanations for adjusting them. Each number in figure 12.2 has a corresponding entry in the list that follows:

 Exposure mode – You can select this by turning the Mode dial. The selections you will see appear on the Monitor are one of the P, S, A, M modes; SCENE mode; U1 or U2 mode along with its selected exposure mode (e.g., AU1); or AUTO mode. It cannot be changed while recording a movie.

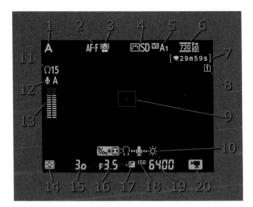

Figure 12.2 - Movie live view screen overlay 1, symbols

- 2. Autofocus mode Set this mode with the AF-mode button and Main command dial. The available settings are Single-servo AF (AF-S) or Full-time servo AF (AF-F). It can be changed while recording a movie.
- 3. AF-area mode Set this mode with the AF-mode button and the Sub-command dial. The settings are Face-priority AF, Wide-area AF, Normal-area AF, and Subject-tracking AF (uses graphical symbols). It can be changed while recording a movie.
- 4. *Picture Control* This is controlled by *Shooting Menu > Set Picture Control*. You can also control this setting by pressing the Retouch/Picture Control button and then selecting a Picture Control from the Monitor with the Multi selector. It cannot be changed while recording a movie.
- 5. White balance Set the White balance by holding down the WB button and rotating the Main command dial. Select from nine white balance settings, including Auto (A1 or A2 must be selected in advance), Incandescent, Fluorescent, Direct sunlight, Flash, Cloudy, Shade, Choose color temp., and Preset manual (uses graphical symbols). It can be changed while recording a movie.
- 6. Frame size/frame rate This is controlled by Shooting Menu > Movie settings > Frame size/frame rate, and it shows the current frame size and frame rate in Movie mode. You can choose 1080p at 30, 25, or 24 fps; or 720p at 60, 50, 30, or 25 fps. It cannot be changed while recording a movie.
- 7. **Time remaining** When you are recording a movie, this shows how much time is left before the camera automatically stops recording. Both 720p30 and 720p25 have maximum recording times of 29 minutes and 59 seconds, and 1080p30, 1080p25, 1080p24, 720p60, and 720p50 all have maximum recording times of 20 minutes. When you remove the memory cards from the camera and stream video through the HDMI port to an external video recording device, there is no limit on the recording time.

- 8. **Movie destination** This setting reflects the configuration stored in *Shooting Menu > Movie Settings > Destination*. You have a choice of SD card slots 1 or 2. A movie will record only to the selected destination card unless it has been removed from the camera, then the D600 will record video to the only available card. It cannot be changed while recording a movie.
- 9. AF point (focus) The point can be moved around the screen with the Multi selector to select the subject for autofocus. The focus rectangle will vary in size and color according to the selected AF-area mode (item 3 in this list) and whether the subject is in focus. The AF point can be moved during video recording to change focus to a different subject or area. You can force a refocus at any time by pressing the Shutter-release button halfway, even if you are using AF-F autofocus mode.
- 10. Guide This control informs you of available Movie live view mode options. It shows that you can use the Help/Protect/WB button and the Multi selector to change between the Headphone volume level (headphone symbol), Microphone sensitivity (mic symbol), and Monitor brightness adjustments (sun symbol). See the three subsections called Adjusting the Headphone Volume, Adjusting the Microphone Sensitivity and Changing the Monitor Brightness later in this chapter.
- 11. *Headphone volume* This setting lets you adjust the volume output to a set of headphones. You can adjust the volume anywhere between off (level 0) and level 30. You adjust the volume by holding down the Help/Protect/WB button and scrolling left or right with the Multi selector until you have selected Headphone volume. You then scroll up or down with the Multi selector until you have selected a comfortable volume. You must adjust the volume before starting a recording session. It cannot be changed while recording a movie.
- 12. *Microphone sensitivity* This setting allows you to adjust the current Microphone sensitivity setting. This setting is controlled by *Shooting Menu > Movie settings > Microphone*, or you can use the Help/Protect/WB button and Multi selector, with the choices of Auto sensitivity, Manual sensitivity (in 20 steps), and Microphone off. This value can be adjusted only before a recording session begins. It cannot be changed while recording a movie.
- 13. **Sound level** This indicator shows the current Sound level for audio recording. It is displayed with red at the top if the level is too high (may distort sound); yellow if it is approaching too high; and white if the sound is normal. Adjust the Microphone sensitivity (item 12 in this list) before you start recording a movie. Left (L) and right (R) channel indicators will appear when an optional Nikon ME-1 microphone or aftermarket-brand stereo microphone is used.

- 14. *Metering mode* Movie live view mode uses Matrix metering only. Unlike Live view photography mode, Spot and Center-weighted metering is not available. This icon is merely a label informing you that Matrix metering is active.
- 15. **Shutter speed** The shutter speed is limited to values from 1/30 to 1/4000 second while recording a video. Set the shutter speed with the Main command dial. Manual change is available only in Manual (M) mode. The camera controls this value in Aperture-priority auto (A), Shutter-priority auto (S), and Programmed auto (P) modes. Change the exposure modes as described in item 1 of this list. See the special note at the end of this list for information on how to best set the shutter speed with various recording frame rates in Manual (M) mode. The shutter speed can be changed while recording a movie in Manual (M) mode.
- 16. **Aperture** This value must be set before you enter Movie live view mode. The aperture cannot be changed when the camera is in Movie live view still image mode or while recording a movie. Set the aperture before entering Movie live view by turning the Sub-command dial, with aperture minimums and maximums that vary according to the mounted lens. Manual change is available only in Aperture-priority auto (S), Flexible Program (P*), and Manual (M) modes. The camera controls this value in Shutter-priority auto (A) and Programmed-auto (P) modes. After you have selected a shutter speed value, press the Lv button to enter Movie live view mode. If the camera is already in Movie live view mode, press the Lv button to leave Movie live view, change the Aperture value, and press the Lv button to reenter Movie live view. **Note:** At the time of this writing there was a rumor that Nikon would release a firmware upgrade that will allow you to set the aperture while in Movie live view mode. Only time will tell if that will become a reality. Watch the downloadable resources websites for any updates to this information: http://www.nikonians.org/NikonD600 or http://rockynook. com/NikonD600. The aperture cannot be changed while recording a movie.
- 17. **Exposure compensation** This symbol will appear only when +/– exposure compensation has been dialed in to the camera. Adjust this value with the +/- Exposure compensation button. Exposure compensation can be used only in P, S, and A modes. It can be changed while recording a movie.
- 18. ISO label In Live view photography mode (previous chapter), this value can reflect whether the camera is set to use the Auto ISO sensitivity control (ISO AUTO) or manual ISO sensitivity (ISO). However, in Movie live view, ISO is merely a label showing that the number to the right is an ISO value.
- 19. ISO sensitivity This is controlled by the camera's Auto ISO sensitivity control in three of the four shooting modes (P, S, and A). Movie live view uses the camera's Auto ISO sensitivity control in all shooting modes except Manual

12

(M), where the D600 relinquishes ISO control to the user for adjustment with the ISO button (Playback zoom out/thumbnails button) and Main command dial only. You can adjust the camera from ISO 100 to H2.0 (ISO 25,600). The ISO sensitivity settings menu selection is grayed out under the Shooting Menu. This can be changed while recording a movie in Manual (M) mode.

20. *Movie camera icon* – This cool movie camera icon reflects the fact that the camera is in Movie live view mode.

Note: When you adjust the shutter speed manually (item 15 in the previous list), follow the rule of setting the shutter speed to approximately twice the fps recording rate the camera is using. Otherwise you may have odd-looking motion-blurred or jumpy video. If you have the camera set to 1080p at 30 fps, use 1/60 second shutter speed. Using 720p at 24 fps means you should use 1/50 second shutter speed.

Screen Overlay and Controls Change When Recording a Movie

When you press the Movie-record button, the screen removes several of the controls in the overlay along the top of the screen, as shown in figure 12.3. You can tell the information is a screen shown during a video recording by the REC sym-

bol in the top left corner, next to the red dot. REC blinks the whole time you are making a recording.

Many of the controls disappear during a video recording to clean up the screen a bit so the overlay is less distracting while you are concentrating on your subject. You can change some of the control functions shown in figure 12.2, during the video recording, with the *exception* of these functions (the numbers correspond to the previous list):

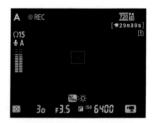

Figure 12.3 – Movie live view screen overlay 1 during a video recording

- · Exposure mode (1)
- Picture Control in use (4)
- Frame rate/frame size (6)
- Time remaining (7)
- Movie destination (8)
- Headphone volume (11)
- Microphone sensitivity (12)
- Metering mode (14)
- ISO label (18)
- Movie camera icon (20)

The MENU button has no effect during a video recording, so you are locked out of even attempting to make any serious camera adjustments that have no button/dial combinations on the camera. However, you can still adjust many of the control functions that are shown, or not shown.

For instance, if you press the AF-mode button while recording a video, the Autofocus and AF-area mode symbols will reappear, allowing you to turn the Main command dial to change the Autofocus mode or the Sub-command dial to change the AF-area mode. Try it.

Likewise, if you press the WB button during a recording, you can change White balance on the fly. If you are using Manual (M) mode, you can adjust the shutter speed and ISO sensitivity. Finally, you can always add or subtract exposure compensation with the \pm /– Exposure compensation button.

Shooting in Manual (M) mode gives you the greatest control over the camera during a video recording. In Manual mode you can adjust the following settings (the numbers correspond to the previous list):

- Autofocus mode (2)
- AF-area mode (3)
- White balance (5)
- AF point (focus) (9)
- Guide (10)
- Shutter speed (15)
- Exposure compensation (17)
- · ISO sensitivity (19)

Now, let's consider the other available screen overlays and their purposes. Press the Info button when you see screen 1 (figure 12.2 or 12.3) and the camera will switch to screen 2 (figure 12.4).

Movie Live View - Screen 2

Screen 2 in the overlay series is a very bare screen for those times when you want very little distraction while recording a still image or video. You can still see the most important controls at the bottom of the screen (aperture, shutter speed, and ISO sensitivity), but everything else is stripped out of the overlay.

Figure 12.4 - Movie live view screen overlay 2, for still images (screen 1) and video recording (screen 2)

12

Nikon calls the screen in figure 12.2 the *Information on* screen, and the screens in figure 12.4 are called the *Information off* screens.

Movie Live View - Screen 3

Most photographers have a tendency to tilt their camera to the left or right slightly. The *Framing guides* screen is designed to help keep things level in the viewfinder (figure 12.5). The gridlines are very useful for keeping the horizon level and architecture straight.

Figure 12.5 – Movie live view screen overlay 3, for still images (screen 1) and video recording (screen 2)

I leave these gridlines turned on in my Viewfinder-based photography all the time and use them in Live view photography mode when I need to level things in comparison to a feature in my subject, such as the horizon.

Movie Live View - Screen 4

The *Virtual horizon* screen (figure 12.6) displays roll and pitch from the camera's built-in tilt sensor. If the lines are green, the camera is level. The tilt sensor detects left and right tilts and forward and backward tilts. When the camera is not level in either direction, the line turns yellow and indicates the approximate degree of tilt.

Figure 12.6 – Movie live view screen overlay 5, for still images (screen 1) and video recording (screen 2)

This is a very useful screen overlay to use when you initially set up a camera on a tripod to shoot a video. You can start the video with the knowledge that the

camera is level both left to right and front to back. If you handhold the camera when shooting a video, this screen may be invaluable to prevent tilt in an otherwise excellent video.

Preparing to Make Movies

(User's Manual – Page 57)

The Movie mode in the D600 is one of Nikon's better HD-SLR video recording systems. It has automatic or manual focus; 1080p HD recording; stereo sound; 20-minute or 29-minute, 59-second recording segments according to frame size and rate; a 4 GB movie length maximum; and excellent rolling shutter correction.

Another excellent improvement is the fact that you can control the D600 in a mostly manual way while you record video, just like when you take still images. This is an important level of control for serious video mayens. If you want to buy all the cool attachments, like stabilization frames, bigger external video monitors, external streaming video recorders, a headphone set, and an external stereo mic, this camera has the ports and controls to support them.

Let's examine how to prepare for and record videos and then how to display them on various devices. Keep in mind that the D600 offers two levels of video recording: first, to the camera's memory card as a compressed (b-frame H.264/ MPEG-4 AVC) QuickTime MOV file; and second, as an HDMI uncompressed 4:2:2 video stream through the HDMI port to an external recording device—such as an Atomos Ninja-2—which will be discussed briefly later in this chapter and in an extensive document available on the downloadable resources websites.

Basic HD Video Information

Before you shoot your first movie, you'll need to configure the camera for your favorite video frame size and rate. We'll look into the actual configuration in a later section. For now, let's briefly discuss some basics.

A video frame is much smaller, in terms of pixels, than a normal still-image frame. Although your D600 can create beautiful 24 MP still images, its best HD video image is just above 2 MP (2,073,600 pixels).

Whoa! How can 2 MP be considered HD? Simply because it matches one of the HDTV broadcast resolutions. In the good old days of standard-definition television that we all grew up watching, there was even less resolution. Would you believe that the old TV you have stored in the garage displays only 345,600 pixels, or 0.3 MP?

I've been talking about the number of megapixels, but that's not normally how HD devices are rated. Instead of the number of pixels, most HD information talks about the number of lines of resolution. There are several HD standards for

lines of resolution. The most common standards are 720p, 1080i, and 1080p. The p and i after the numbers refer to progressive and interlaced. We'll talk about what that means in the next section.

The D600's best Movie mode captures video at 1080p, which is a displayquality HDTV standard. At the time of this writing, most over-the-air broadcastquality HD is 720p. I'm sure that will change now that TVs have gone digital. The 1080p designation simply means that your camera captures and displays HD images with 1,080 lines of vertical resolution. Each of those lines is 1,920 pixels long (wide), which allows the D600 to match the 16:9 aspect ratio in HDTV.

Progressive versus Interlaced

What's the difference between progressive and interlaced? Technically speaking, progressive video output displays the video frame starting with the top line and then draws the other lines until the entire frame is shown. The D600 displays 1,080 lines progressively from the top of what the imaging sensor captured to the bottom (lines 1, 2, 3, 4 ... 1,080).

Interlaced video output displays every even line from top to bottom, then it goes back to the top and displays every odd line (lines 2, 4, 6, 8 ... 1,080, then 1, 3, 5, 7 ... 1,079).

Progressive output provides a higher-quality image with less flicker and a more cinematic look. I'm sure that's why Nikon chose to make the D600 shoot progressive video. Now, let's set up our cameras and make some movies!

Camera Setup for Making Movies

The D600 is capable of creating movies at any time and with little thought, by simply using the following settings and actions:

- 1. Select Autofocus mode AF-F (Full-time-servo AF)
- 2. Set the Exposure mode to AUTO
- 3. Flip the Live view selector to Movie live view
- 4. Press the Ly button to enter Live view
- 5. Press the Movie-record button

Setting the camera this way makes it act like a standard video camera, where you give little consideration to camera settings and simply shoot the video.

However, you have purchased an advanced-level camera and you may want to do more than just take automatic movies. The D600 can do it either way. Let's discuss how to set up the camera for more professional movie creation. Before you make your first semipro movie, you'll need to configure several things on your D600:

- Choose a Picture Control with Shooting Menu > Set Picture Control
- Select a White balance with Shooting Menu > White balance
- Choose a Frame rate and size with Shooting Menu > Movie settings > Frame rate/frame size
- Select the Movie quality with Shooting Menu > Movie settings > Movie quality
- Set a Microphone level with Shooting Menu > Movie settings > Microphone sensitivity level
- · Adjust the Headphone output level with the Thumbnail/playback zoom out button and the Multi selector
- Set the brightness of the Monitor with the Thumbnail/playback zoom out button and the Multi selector
- Choose which memory card will save the video with Shooting Menu > Movie settings > Destination memory card
- · Set the Autofocus mode with the AF-mode button and the Main command dial
- · Set the AF-area mode with the AF-mode button and the Sub-command dial
- · Set the Shooting mode (P, S, A, M) with the MODE button and the Main command dial
- Adjust the aperture and the initial shutter speed setting (according to Exposure mode)
- Adjust the ISO sensitivity (according to Exposure mode)
- Flip the Live view selector lever to Movie live view
- Press the Lv button to enter Live view
- If streaming through HDMI to an external device, use Setup Menu > HDMI to set the Output resolution, and choose if you want to use Device control (HDMI-CFC)
- Press the Movie-record button

Let's examine each of these settings individually and prepare for recording premium-quality videos. Some of the settings are fully covered in previous chapters of this book, so we won't go into extreme detail about how to select the settings; only the screens are necessary. If you need more detail about a particular setting, refer to the chapter that covers it.

Choosing a Picture Control

Using different Picture Controls can give you powerful control over the look of your videos. Since videos are not still-image RAW files that can simply be adjusted to correct errors after the fact, it's a good idea to carefully choose a look based on a Picture Control you are comfortable with and that matches the current situation.

12

For instance, let's say you are shooting a video on an overcast, low-contrast day, and you want to add some snap to your movie. You can simply preselect the Vivid (VI) Picture Control, which will saturate the colors and darken the shadows.

Or you might be shooting on a very high-contrast, sunny day and want to tone down the contrast a bit. Simply preselect the Neutral (NL) Picture Control, which will open up the shadows and extend the dynamic range of the sensor for a lower-contrast look.

Maybe you are shooting a video of a lovely colorful autumn scene and want to maximize the colorful look. Simply preselect the Landscape (LS) Picture Control and your video will be optimized for beautiful scenery.

Just remember, you must select the Picture Control before you start recording the video. Here's how.

Figure 12.7 – Choosing a Picture Control for best movie look

Use the following steps to select a Picture Control:

- 1. In Movie live view mode press and release the Protect/Picture Control/Help button (figure 12.7, image 1, red arrow).
- 2. Press the Multi selector up or down to highlight a Picture Control (figure 12.7, screens 2 and 3, red arrows). I selected the Landscape (LS) Picture Control.
- 3. Press the OK button to select the control.

Fortunately, you can see the effect of each Picture Control. Use the Movie live view screen to select Picture Controls and see how they look by pointing the camera at your subject. When you have found a Picture Control that benefits the subject, use it for the video. You must set the Picture Control before you start recording the video.

Settings Recommendation: I like to shoot with the Neutral (NL) or Portrait (PT) Picture Control for most of my videos that include people because I like the skin colors better with those controls. However, when I am outdoors enjoying the beauty of nature, I often select the Landscape (LS) Picture Control, or if I am feeling a bit frisky in the autumn colors I might even use the Vivid (VI) Picture Control. The key thing is to use the Picture Controls enough to know what kind of results they produce. That way, you are in command of your camera.

White balance sets the color tint of the video. It is very important to use a White balance that matches where you will be shooting the video. Auto White balance works most of the time, but it can sometimes have problems with mixed lighting. You should be aware of the White balance and even experiment with it for your videos. Maybe you should switch to Shade White balance when you are in the shade, or Direct sunshine when you are in the sunlight. By paying careful attention to your camera's White balance your videos will have superior quality.

Figure 12.8 - Choosing a White balance

Use the following steps to select a White balance setting:

- 1. In Movie live view mode, press and hold the WB button (figure 12.8, image 1, red arrow).
- 2. Select a White balance by rotating the Main command dial (figure 12.8, image 2 and screen 3, red arrows). In screen 3, AUTO1 White balance is selected (WB A1).
- 3. Release the WB button to choose the White balance.

Watch carefully as you select the different White balance settings. You will see the color tint of the current White balance on your camera's Monitor. You can change the White balance during video recording. This shows how serious it is to use a correct White balance. Fortunately, the Nikon D600 makes it easy.

Settings Recommendation: I often use Auto White balance unless I am in tricky lighting situations, such as inside under fluorescent lighting with some outside light coming in the windows. In situations like that I try to match the camera to the most prevalent light source, in this case, fluorescent.

The camera does well outside in natural light, although at times I have seen a little blueness in the shade. In that case, I might use Shade White balance. The critical thing is if the color tint you are seeing on your Monitor looks like the scene as you see it with your own eyes. If not, try to make the camera match what you see.

Selecting a Frame Size and Frame Rate

(User's Manual – Page 65)

There are two Frame size settings available in *Shooting Menu > Movie settings > Frame size/frame rate,* and there are five *frame rates*. The frame sizes are both HD standards at 1920×1080 and 1280×720 . The frame rates are 60, 50, 30, 25, and 24 fps.

The camera records video using the progressive scanning method (sequential lines) and can output both progressive (p) and interlaced (i) standards through its HDMI port to external devices. Choose your favorite rate and size using the screens shown in figure 12.9. For more information on choosing a Frame size/frame rate, see the section called **Movie Settings** in the **Shooting Menu** chapter.

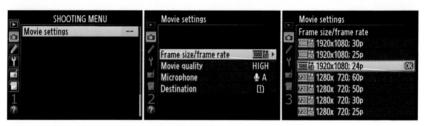

Figure 12.9 - Choosing a Frame size/frame rate

Use the following steps to select a frame size and frame rate:

- 1. Select Movie settings from the Shooting Menu and scroll to the right (figure 12.9, screen 1).
- 2. Choose Frame size/frame rate from the menu and scroll to the right (figure 12.9, screen 2).
- 3. Select one of the frame sizes and rates (figure 12.9, screen 3). I chose 1080p24 (1920×1080; 24p).
- 4. Press the OK button to lock in the size and rate.

Obviously, you must set the Frame size/frame rate before you start recording a video. The Frame size/frame rate setting changes how large the movie will be when it's stored on your memory card and computer hard drive. The maximum the camera will allow is 4 GB in any one movie segment. All frame sizes and rates are limited in length to 20 minutes, except for 720p30 and 720p25 (the last two settings in figure 12.9, screen 3), which allow recording for up to 29 minutes, 59 seconds.

Video File Format

The file format used by the D600 is the popular Apple QuickTime MOV format. This format is handled by virtually all computer movie players. The video

compression used inside the MOV file is H.264/MPEG-4 Advanced Video Coding (AVC).

A computer should display any of the Movie quality modes. Using a mini-HDMI (type c) to HDMI standard (type a) cable, you can play full HD videos on an HDTV. An HDMI cable is not included with the camera, but you can get one online and in many electronics stores. We'll talk more about how to display video in a later section, which includes pictures of the cables.

Settings Recommendation: There are three considerations when selecting a Movie quality setting: (1) How much storage capacity do I have on my memory cards?, (2) What type of display device will I show the movies on?, and (3) Am I a video fanatic?

If you are fanatical about video, you'll only shoot at the fastest rates and highest quality. Others may want to shoot a lot of family videos and hate storing the huge files that result from high frame sizes and rates. In that case, the normal quality setting and lower resolutions may be sufficient.

If you can't stand watching a non-HD video on YouTube, maybe you should stick to maximum quality. If standard YouTube videos are sufficient for your needs, nearly any quality setting from the D600 will look great on your computer.

This is a personal decision, and you'll need to experiment with video modes to balance quality and storage costs.

Why Different Frame Rates?

The NTSC encoding format, established in the 1940s, originally used two frame rates: 30 or 60 fps. In the 1960s a new German standard was created called PAL, which used 25 or 50 fps. Today frame rates of 24, 25, 30, 50, and 60 are common in HD-SLR cameras. These rates can also be expressed as hertz (Hz) on progressive scan monitors. The primary frame rate used in the movie industry is 24p.

We do not normally think of a video as a bunch of frames, but a video is many still pictures joined together and moved past your eye at a very fast rate. The human eye maintains an image at about 10 to 16 fps (1/10 to 1/16 second), so frame rates faster than that do not flicker for many people. However, some people's eyes are more sensitive and can see flicker in slower frame rates. I am afraid to say much more about this issue because it can rapidly degrade into an almost religious discussion, with people having very strong opinions about their favorite frame rates.

I'll just say that many people prefer 24 fps because that is normal for cinema movies. This rate is called a cinematic rate. Other people like the faster frame rate of 30 fps due to its lack of flicker. I suggest that you try all the frame rates and see which you like best. You might even want to shoot some 720p video at 60 fps and play it back at 30 fps for cool slow motion effects.

Movie Quality

The Movie quality setting has to do with the maximum bit rate (Mbps) that the camera can flow while making a movie. The higher the bit rate, the higher the quality. The bit rate can go as low as 8 Mbps in Normal quality mode and as high as 24 Mbps in High quality mode. Table 12.2 shows the Mbps flow in High and Normal quality modes, along with the maximum movie length. Note: Mbps stands for megabits per second, where a megabit is one million bits.

Frame size/frame rate	High quality	Normal quality	Maximum time at High quality/Normal quality
1920 × 1080/30 fps	24 Mbps	12 Mbps	20 min/29 min 59 sec
1920 × 1080/25 fps	24 Mbps	12 Mbps	20 min/29 min 59 sec
1920 × 1080/24 fps	24 Mbps	12 Mbps	20 min/29 min 59 sec
1280 × 720/60 fps	24 Mbps	12 Mbps	20 min/29 min 59 sec
1280 × 720/50 fps	24 Mbps	12 Mbps	20 min/29 min 59 sec
1280 × 720/30 fps	12 Mbps	8 Mbps	29 min 59 sec/29 min 59 sec
1280×720/20 fps	12 Mbps	8 Mbps	29 min 59 sec/29 min 59 sec

Table 12.2 - Bit rates at Movie quality settings

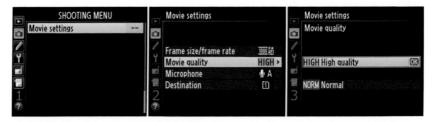

Figure 12.10 – Choosing a Movie quality (bit rate)

Use the following steps to select a Movie quality:

- 1. Choose Movie settings from the Shooting Menu and scroll to the right (figure 12.10, screen 1).
- 2. Select Movie quality from the menu and scroll to the right (figure 12.10, screen 2).
- 3. Choose High quality or Normal from the menu (figure 12.10, screen 3).
- 4. Press the OK button to lock in your choice.

Changing the bit rate is one way to control the amount of data the video contains. The higher the bit rate (24 Mbps versus 12 Mbps), the better the movie quality, just like the higher the bit depth (12 bit versus 14 bit), the better the still image quality. There is one drawback: the higher the bit rate, the larger the movie. You will need to decide which is more important, size or quality.

Settings Recommendation: Unless I am shooting a video for Internet only (Facebook or YouTube) and a subject with no commercial value, I shoot with the Maximum frame rate, frame size, bit rate, and whatever maximums I can max out. If a video has potential to make money or has an interesting subject that others will enjoy watching, I want the best quality I can wring out of those little 2 MP frames. However, that comes with a trade-off of much larger file sizes, so I have committed to buying larger and larger hard drives each year or two. The quality from this camera is amazing, and so are the file sizes!

Adjusting the Microphone Sensitivity

(User's Manual – Pages 61–62)

The Microphone sensitivity setting gives you the ability to set how sensitive the Microphone is to surrounding sound. This setting affects the built-in Microphone until you plug an external microphone into the camera's Microphone jack under the rubber Connector cover. Let's look at the best way to set the Microphone level just before recording a video.

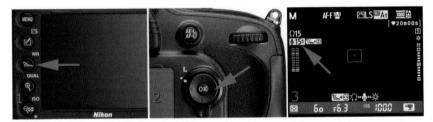

Figure 12.11 - Manually setting the Microphone sensitivity with camera controls

Use the following steps to adjust the Microphone sensitivity:

- 1. In Movie live view mode, press and hold the Help/Protect/WB button (figure 12.11, image 1, red arrow).
- 2. Press the Multi selector to the left or right to select the Microphone sensitivity icon (figure 12.11, image 2 and screen 3, red arrows).
- 3. Press up or down on the Multi selector to choose a sensitivity level. Your choices are Auto (A), Off, and 1 to 20 (figure 12.11, screen 3, red arrow).
- 4. Release the Help/Protect/WB button to set the level.

The D600 allows you to plug in an optional stereo microphone. It disables the built-in mono mic and overcomes some of its limitations. There are several microphones available for the D600, including a few that mount onto the camera's

Accessory shoe, like a flash unit. You can choose your favorite at online camera stores. I like Nikon's ME-1 microphone (figure 12.11.1).

The Microphone must be set before you start recording the video, so you may want to test the level to see if the sound gets into the yellow or red zones. The lower area of the mic indicator (figure 12.11, screen 3) is white. As the sound increases the indicator hits a yellow zone and finally a red zone, where clipping may occur. Keep the indicator in the mid- to upper white zone for normal sound and to give a little room for louder sounds.

Note: You can also set the Microphone sensitivity from the Shooting Menu, if you prefer. See the section called Movie Settings in the Shooting Menu chapter for more information on adjusting the Microphone level with the menus. Since it

Figure 12.11.1 - Nikon D600 with Nikon ME-1 microphone in Accessory shoe

is a very visual process to use the camera controls instead of the menus, it may be better to adjust the mic with the previously mentioned steps.

In figure 12.11.1 you can see where an external microphone plugs in to the camera. The microphone and headphone are side by side under the audio Connector cover (next section).

If you decide to simply use the built-in Microphone, be sure you don't accidentally cover it with your finger while you record a video.

The built-in Microphone is a series of two holes above the Nikon D600 logo near the BKT button on the front of the camera (figure 12.11.2, red arrow).

Figure 12.11.2 - Nikon D600 built-in Microphone

Sound Output from Camera

Sound from the video is output during camera playback through a small speaker on the back of the camera. There are four small holes below the Info button and Live view selector on the back of the camera (figure 12.11.3, red arrow). This little speaker can put out an amazing amount of volume.

You can control the volume output of the speaker with the Playback zoom in button (volume up) and the Playback zoom out/thumbnails button (volume down). The setting range is 1-30 and off. I find that level 20 is about right to hear well in a normal environment.

You can use headphones to listen to the sound from the video (next section). I find that 12 or 13 is about right for my headphones.

Figure 12.11.3 - Nikon D600 speaker

Settings Recommendation: First of all, I strongly suggest that you acquire the Nikon ME-1 external microphone. I bought mine when I got my camera and have really enjoyed using it. It vastly improves the quality of sound flowing into the camera during a video and isolates the camera's clicking and whirring noises more effectively than the built-in Microphone. The Nikon ME-1 is relatively inexpensive—well, compared to a lens, anyway.

I leave the Microphone sensitivity level set to Auto (A) most of the time. However, if I am in an especially loud environment, I manually set the sensitivity to about 15. When there are sudden loud sounds in Auto mode, the camera seems to struggle and often clips the sound because it overwhelms the camera's audio circuitry.

I suggest experimenting with this because normally it's not a problem. The problem occurs at something like a ball game when someone scores and the crowd yells and stomps with great happiness. Auto may not be the best setting under those kinds of circumstances.

Adjusting the Headphone Volume

(User's Manual – Pages 61–62)

The Headphone port under the rubber Connector cover (figure 12.12, red arrow) is an excellent addition to the Nikon D600. It allows you to plug in headphones to isolate yourself from surrounding sounds and focus on hearing what the camera is actually recording. This is important for those who are concerned about maximum sound quality.

Figure 12.12 - Headphone port under rubber Connector cover

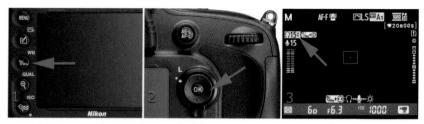

Figure 12.13 – Manually setting the Headphone output level with camera controls

Use the following steps to adjust the Headphone output level:

- 1. In Movie live view mode, press and hold in the Help/Protect/WB button (figure 12.13, image 1, red arrow).
- 2. Press the Multi selector to the left or right to move the yellow highlight around and select the Headphone sound level icon (figure 12.13, image 2 and screen 3, red arrows).
- 3. Press up or down on the Multi selector to choose a sensitivity level. You can select off or 1 to 30 (figure 12.13, screen 3). This adjustment will not appear on the Monitor unless you have a headset attached to the camera.
- 4. Release the Help/Protect/WB button to set the level.

Settings Recommendation: You don't have to use expensive headphones for them to be effective. I often use a set of normal isolation ear buds, like you would plug into your smart phone or iPod. Ear buds can be stored in a small pocket in your camera bag so they will always be with you. I like the type that have good bass response and actually can be inserted in your ear, instead of the type that hangs off your ear (like the ones that come with an iPhone).

I have found that output level 15 is about right for my ears during recording and playback. Be careful not to go too loud because sudden sound increases might damage your hearing. You may be more comfortable with the volume around 10 or 12.

The really cool thing is how people react when you have a set of ear buds connected to your camera. Invariably someone with a cheap point-and-shoot camera will ask me why, and I tell them, of course, that my camera has a built-in iPod so I can listen to music as I take pictures. The person is amazed and doesn't even realize that I am recording his or her face as we talk!

(User's Manual – Pages 61–62)

The Monitor brightness function is merely for your convenience when shooting in very light or dark environments. You can quickly turn the brightness up or down with the camera controls. The brightness setting in no way affects the video recording itself. It is just for your comfort while recording video.

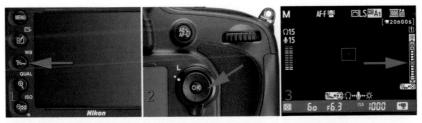

Figure 12.14 – Setting the Monitor brightness to a comfortable level for viewing

Use the following steps to adjust the Monitor brightness:

- 1. In Movie live view mode, press and hold the Help/Protect/WB button (figure 12.14, image 1, red arrow).
- 2. Press the Multi selector to the left or right to move the yellow highlight around and select the Monitor brightness indicator (figure 12.14, image 2 and screen 3, red arrows).
- 3. Press up or down on the Multi selector to choose a brightness level (figure 12.14, screen 3). You can adjust it in 12 steps or simply select A (Auto) at the top of the indicator for automatic adjustment. If you select A, the camera will use its ambient brightness sensor to detect the light level and adjust the Monitor accordingly.
- 4. Release the Help/Protect/WB button to set the level.

Note: You can also adjust the Monitor brightness with Setup Menu > Monitor brightness. However, by using the method in the previous steps you can adjust the brightness even while recording a video, which you cannot do from the menus because they are disabled during recording. If you want more information on adjusting the Monitor brightness with the menus, see the Monitor Brightness section in the Setup Menu chapter.

Settings Recommendation: I like to manually control the Monitor brightness. I find that it stays too dim for my liking in Auto (A) mode. However, you may enjoy the way it adjusts the brightness level like your smart phone does. Try it both ways and see which you prefer. I generally leave my camera set to the middle setting (0) unless I am out in bright sunshine, when I may crank it all the way up to the + sign (maximum) on top of the indicator.

(User's Manual - Page 65)

The D600 allows you to choose which of your camera's two SD cards slots will receive the video. It also gives you an estimate of available video recording time available for each card, based on the current Frame size/frame rate and Movie quality settings. The Destination must be chosen before you start shooting the movie

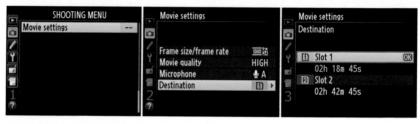

Figure 12.15 - Choosing a Destination for your movies

Use the following steps to select a Destination for your movies:

- 1. Select Movie settings from the Shooting Menu and scroll to the right (figure 12.15, screen 1).
- 2. Select Destination and scroll to the right (figure 12.15, screen 2).
- 3. Select one of the two memory card slots, paying attention to how much recording time is available on the cards at the current video frame size. The memory card in Slot 1 on my camera has 2 hours, 18 minutes, 45 seconds available (02h 18m 45s), and the memory card in Slot 2 has 2 hours, 42 minutes, 45 seconds available (figure 12.15, screen 3). I selected Slot 1.
- 4. Press the OK button to lock in your selection.

Settings Recommendation: Deciding which card to use is based on the speed and quality of your current cards. Use the fastest memory cards for video recording. I advise using large-capacity SD cards (32 GB minimum) or a bunch of smaller ones because the Nikon D600 can quickly fill up a memory card with video files.

I bought a handful of brand-name 16 GB SD cards (class 10) for about what a good hamburger costs for each one. Memory cards are getting cheaper every day. With a D600, it's a good thing!

Selecting an Autofocus Mode

(User's Manual - Page 51)

The Autofocus modes available in Movie live view are AF-S and AF-F. AF-S is Single-servo AF, and you control it. AF-F is camera-controlled autofocus (Fulltime-servo AF). These are the only two autofocus modes available for Movie live view. You can move the focus square to any point in the Monitor to focus on the best area of your subject in either autofocus mode. If you are using AF-S you can focus with either the Shutter-release button or the AF-ON button. You can even change Autofocus modes while recording a video. Here's how to select the AF mode with external camera controls.

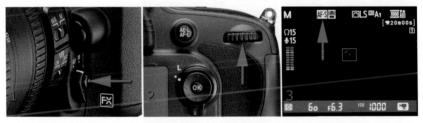

Figure 12.16 - Choosing an Autofocus mode

Use the following steps to select an Autofocus mode:

- 1. In Movie live view mode, press and hold the AF-mode button (figure 12.16, image 1, red arrow).
- 2. Rotate the Main command dial to the left or right to select AF-S or AF-F (figure 12.16, image 2 and screen 3, red arrows).
- 3. Release the AF-mode button to set the Autofocus mode.

Settings Recommendation: Many people use Full-time-servo AF (AF-F mode) for fun video shooting. However, for commercial purposes AF-F mode is lacking. It struggles to remain in focus in low light, and even in the best light it tends to rack in and out on a frequent basis, which is very distracting to viewers. That's why many serious videographers use manual focus lenses; they can control the focus with great smoothness—after much practice, of course.

I like shooting videos with my manual and autofocus prime lenses, such as my Al Nikkor 35mm f/2 or AF-S Nikkor 50mm f/1.4G in MF mode. I'm sure you already have, or will soon have, several favorite lenses that work well for video. Just be sure to try them in manual mode for the best focus results.

(User's Manual - Page 52)

The AF-area mode lets you choose *where* the camera will autofocus on your subject (see the **Autofocus**, **AF-Area**, **and Release Modes** chapter). The setting modifies the way autofocus decides what part of the subject is important for autofocus. You can change AF-area modes. Let's examine each screen and AF-point style and then see how to select one of the four AF-area modes.

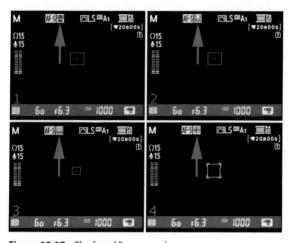

Figure 12.17 – The four AF-area modes

The following list explains the four available AF-area modes:

- Face-priority AF (figure 12.17, screen 1) The camera can track focus on the
 faces of several people at the same time. It is quite fun to watch as the green
 and yellow AF point squares find faces and stay with them as they move.
 Nikon claims the D600 can detect up to 35 faces at the same time.
- Wide-area AF (figure 12.17, screen 2) For the landscape shooters among us who like to use Live view mode or shoot movies of beautiful scenic areas, this is the mode to use. The camera will display a big red (out of focus) or green (in focus) AF point square on the Monitor. You can move this big AF point around until it rests exactly where you want the best focus to be. The camera will sense a wide area and determine the best focus, with priority on the area under the green square.
- Normal-area AF (figure 12.17, screen 3) This mode is primarily for shooters who need to get very accurate focus on a small area of the frame. This is a great mode to use with a macro lens because it gives you a much smaller AF point that you can move around the frame.

• Subject-tracking AF (figure 12.17, screen 4) – In this mode you have to autofocus first with the Shutter-release button or AF-ON button (AF-F mode does this automatically), and then you start subject tracking by pressing the center button of the Multi selector once. To stop subject tracking, press it again.

Now, let's see how to select one of the AF-area modes with external camera controls and the Monitor.

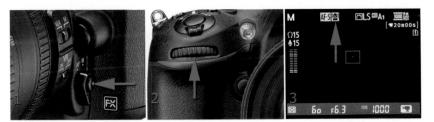

Figure 12.17.1 - Choosing an AF-area mode

- 1. In Movie live view mode, press and hold the AF-mode button (figure 12.17.1, image 1, red arrow).
- 2. Rotate the Sub-command dial to select one of the four AF-area modes (figure 12.17.1, image 2 and screen 3, red arrows).
- 3. Release the AF-mode button to set the AF-area mode.

Settings Recommendation: Why not leave the AF-area mode set to Face-priority AF if you photograph people a lot? If you are using Movie live view for macro shooting, Normal-area AF gives you the smallest, most accurate area mode for detailed, up-close focusing. Landscape shooters should use Wide-area AF, and wildlife or sports shooters should use Subject-tracking AF.

There is more detail available on this subject in the chapter titled Autofocus, AF-Area, and Release Modes in the section called AF-Area Mode.

Selecting an Exposure Mode

(User's Manual - Page 58)

Unlike in Live view photography mode, the Nikon D600 has some limitations on manually controlling exposure in Movie live view mode. When you are recording a video in Movie live view while using Programmed auto (P), Shutter-priority auto (S), or Aperture-priority auto (A) modes, the camera controls the aperture, shutter speed, and ISO sensitivity. Your only recourse to affect exposure is to use the +/- Exposure compensation button. That may not be a problem when you are shooting videos for recreational use. For fun videos, simply switch the Mode dial to AUTO and shoot your video (figure 12.18, image 1).

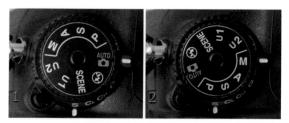

Figure 12.18 – Use AUTO for recreational video recordings and M for commercial recordings

However, if you want to shoot serious video you may want to consider using Manual (M) mode (figure 12.18, image 2). In M mode you have complete control over the shutter speed and ISO sensitivity while recording the movie. Controlling the aperture during a recording session is a problem with the D600, even in M mode.

- Aperture Unfortunately, you cannot control the aperture during a video, even in M mode. What was Nikon thinking? Instead, you must set the aperture before you start the recording session. In fact, you can't even have the camera set to Movie live view mode when you set the aperture. You must switch to Live view photography mode or drop out of Movie live view mode into regular Viewfinder mode. A work-around for this foolishness is to use an older Nikkor lens that has an aperture ring, which will restore your ability to control the aperture while recording a video. This is a serious limitation that has puzzled many people, myself included. I truly hope Nikon issues a firmware update to give us control of the aperture in M mode.
- Shutter speed In Manual (M) mode you have complete control of the shutter speed during the video recording session. This allows you to control the level of motion blur by simply rotating the Main command dial to change the shutter speed to any value between 1/30 and 1/4000 second. You cannot reduce the shutter speed to slower than 1/30 second in Movie live view mode.
- ISO sensitivity You have full control over the ISO sensitivity in Manual (M) mode. Control the ISO sensitivity by holding in the ISO button (Playback zoom out/thumbnails button) while rotating the Main command dial. Use this in conjunction with the shutter speed to make adjustments when conditions change. You can adjust the ISO sensitivity to anywhere between ISO 100 and H2.0 (ISO 25,600).

Note: If you use semiautomated Shooting modes (P, S, and A) or AUTO, the camera will change the ISO sensitivity to maintain a good exposure. The Nikon D600 uses ISO sensitivity as a fail-safe to make sure the video is usable. It will raise the ISO to noisy levels pretty quickly when the light starts falling, so be aware of that and use artificial light (e.g., LED) to prevent noisy videos.

If you are shooting in Manual mode and change the aperture or shutter speed quickly, the camera cannot adjust the ISO to compensate, so your video will get dark or too bright until you change the ISO or another control to match the new settings. Video is a little harder to shoot in Manual mode than still images because it is live, and everything you do to affect the exposure is immediately apparent to all viewers. Practice, practice, practice!

Settings Recommendation: The Nikon D600 is an excellent video camera. It can do things that even expensive pro video cameras cannot do because the large sensor creates such a shallow depth of field with wide-open apertures and the lens selection is so great. However, that puts a burden on you when you use the camera manually. You have the control you need for great videos, so practice until the controls are second nature so you can react well to changes.

I recommend shooting in AUTO mode most of the time until you are fully comfortable with operating a camera manually and understand what will happen. With the D600 you can make video masterpieces or really bad videos. Get some books on the subject and learn your new skills well.

I highly recommend these two books: How to Shoot Videos That Don't Suck: Advice to Make any Amateur Look Like a Pro by Steve Stockman (ISBN: 0761163239), and Mastering HD Video with Your DSLR by Helmut Krause and Uwe Steinmueller (ISBN: 1933952601). These books set me on the path to much better videos by discussing not only the formats and cameras involved, but also offering great advice on video technique.

Recording a Video with Your D600

Now let's look at the process of recording a video to your memory card. The following steps assume you've gone through the configuration process discussed in the first part of this chapter, which readies your camera to record video in the modes you prefer to use. Let's record a video!

- 1. Flip the Live view selector on the back of the camera to the bottom position to enable Movie live view (figure 12.19, image 1, red arrow).
- 2. Press the Live view (Lv) button to enter Movie live view (figure 12.19, image 2, red arrow).
- 3. Press the Movie-record button to start recording (figure 12.19, image 3, red arrow).
- 4. The video will now start recording with the REC icon blinking in the upper left corner (figure 12.19, screen 4, red arrow), the time-left counter counting down in the upper right corner, the Microphone sensitivity indicator moving as the camera records sound, and your new video being written to the memory card.
- 5. To end the recording, simply press the Movie-record button again.

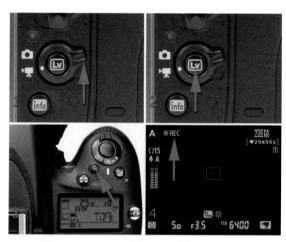

Figure 12.19 - Recording a video

Amazingly, that's all there is to it. You have a powerful video camera built in to your still camera. It is available with the flip of a switch and a press of a button.

Settings Recommendation: In most cases, unless you really want to control the camera manually, you can shoot your video in AUTO mode and enjoy what you have captured. The camera will make a good exposure in almost all circumstances. When you are ready to move into high-end video production, the Nikon D600 is ready to help you move up.

Recording Video from the HDMI Port

The Nikon D600 can stream uncompressed, broadcast-quality video from its HDMI port to an external recording device. Doing so is a relatively complex process, requiring knowledge of wrappers, containers, formats, and interfacing with recording equipment. However, it's a great deal of fun! The process of creating commercial video is beyond the scope of this book, unfortunately.

However, I have prepared a document that should get you started with the process. It is called Streaming Uncompressed HDMI Video from Your Nikon **D600**, and it is available at the following websites for readers of this book:

http://www.nikonians.org/NikonD600 http://rockynook.com/NikonD600

The document will give you the basics on working with the HDMI port along with format information to make your learning process easier. It also discusses the world's best external video recorder for your Nikon D600.

The Atomos Ninja-2 External Video Recorder

Figure 12.20 – The Atomos Ninja-2 external HDMI recorder on a Nikon D600 and the Ninja-2 kit from Atomos.com

I would like to make a strong recommendation to you. If you are serious about shooting video from the HDMI port to an external video recording device, run, don't walk, and get an Atomos Ninja-2 external recorder, which allows you to record uncompressed 4:2:2 video with no limitations on time. You can see my Ninia-2 on my D600 in figure 12.20, along with the Ninja-2 kit containing all the attachments and an excellent sealed case. Atomos offers this recorder as a full kit with everything you need, except an HDMI wire and an SSD or hard drive to store pictures. They provide two special cases to mount 2.5-inch hard drives internally. I use Sandisk 120 GB SSD drives with my recorder.

The Ninja-2 is a very easy-to-use device that is designed to work with your camera. It is one of the most popular recorders out there for the Nikon D600, for good reason. It lets you produce and record the best video your camera is able to make.

Check out the Atomos website (http://www.atomos.com) for information on the Ninja-2. The website presents information primarily about the Nikon D4 and D800; however, the Nikon D600 is also in the high-quality class of those professional cameras and deserves a great recorder.

I absolutely love my Ninja-2 and am using it to create videos with amazing quality. I am planning a commercial video for photographers who want to shoot the best places in the Great Smoky Mountains National Park. Visit my blog, www. MasterYourNikon.com, for information on availability. I will be using my Nikon D800 and D600 along with this marvelous Ninja-2 recorder to make the video.

The Streaming Uncompressed HDMI Video from Your Nikon D600 document I mentioned earlier will, of course, feature my Nikon D600 and how to interface with and use an Atomos Ninja-2. Be sure to download this document if you are a real video enthusiast.

HDMI Video Streams at 95 Percent Size Only!

There is an important problem that must be considered by those who plan to stream video via the Nikon D600's HDMI port. In its current form, the Nikon D600 cannot stream HDMI video at 100 percent size; instead, the size is limited to 95 percent. What this means is that videos streamed via the camera's HDMI port will have a black border all the way around the video. This applies only when streaming uncompressed, HDMI video to an external monitor or recorder, not when recording standard, compressed video to the memory cards. There has been a lot of discussion in the video industry about this problem because it limits the usefulness of the HDMI streaming video output for commercial purposes. Nikon was contacted about this issue and we were awaiting a reply at press time. This is a serious problem that, hopefully, was an oversight on Nikon's part and will be corrected in a firmware update. Please keep checking the Downloadable Resources websites for an update on this situation (http://www.nikonians.org/NikonD600 and http://rockynook. com/NikonD600). If you are unhappy that your camera streams uncompressed, HDMI video at only 95 percent size, please contact Nikon USA (or the Nikon branch in your country) and tell them how you feel! You can contact them at the following web address:

http://www.nikonusa.com/en/About-Nikon/Contact-Us.page

Displaying Movies

Now the fun begins! You have created a video on one of your memory cards. What next? You can simply transfer the video to your computer with Nikon ViewNX 2's Transfer button and view it there, or you can upload it to Facebook or YouTube directly, both of which can convert the QuickTime MOV file to display on their respective sites.

Let's also discuss how to enjoy one of your movies directly from the camera, either on the camera's LCD Monitor or on an HDTV.

The method used to view a movie on the D600 Monitor is simplicity itself, just like video capture. Videos are stored on the memory card, just like a still picture. All you have to do is find it and press the center button of the Multi selector to play the video.

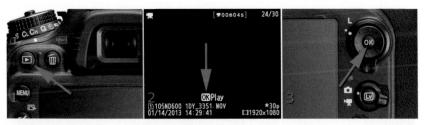

Figure 12.21 - Playing a movie on the Monitor

Use the following steps to play a movie on the Monitor:

- 1. Press the Playback button to display images on the Monitor (figure 12.21, image 1, red arrow).
- 2. Locate the video you want to play by scrolling through your images and videos with the Multi selector.
- 3. When the video appears on the Monitor you'll be able to identify it by three signs: a small Movie camera icon in the top left corner, a minutes-and-seconds counter at the top of the screen, and the word Play at the bottom of the screen. The image you see is the first frame of the video. Of course, I had the lens cap on so you can easily see the control overlays. Your camera will display the first frame of your video above the OK Play selection (figure 12.21, screen 2, red arrow).
- 4. Press the Multi selector center button to start playing the video (figure 12.21, image 3, red arrow).

Settings Recommendation: The Monitor on the D600 is big enough for several people to enjoy one of your videos. Don't be afraid to show off a bit since your camera creates excellent high-resolution videos. Set it up on the kitchen table, put a jar next to it for tips, and start a video. You'll find viewers!

Displaying a Movie on an HDTV

To display a video from your camera on an HDTV, you'll need an HDMI cable with a mini-HDMI (type c) end to insert into your D600, and the other end will have to match your HDTV's HDMI port, which is usually HDMI standard (type a). We'll talk more about the cable specs in a moment, but first let's discuss your camera's HDMI output frequencies.

Before you attempt to connect your Nikon D600 to your HDTV, be sure that you've correctly configured your HDMI output to match what your HDTV needs, or you won't get a picture. Use the *Setup Menu > HDMI* setting to select a specific Output resolution, or just select Auto so the camera and HDTV can figure it out for you. Here is a list of formats supported by your camera for video playback:

- Auto Allows the camera to select the most appropriate format for display on the currently connected device
- 480p 640 × 480 progressive format
- 576p 720 × 576 progressive format
- 720p 1280 × 720 progressive format
- 1080i 1920 × 1080 interlaced format

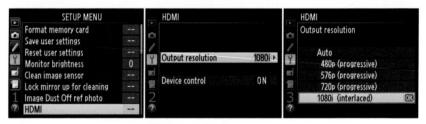

Figure 12.22 - Selecting an HDMI Output resolution

Use the following steps to select an Output resolution:

- 1. Select HDMI from the Setup Menu and scroll to the right (figure 12.22, screen 1).
- 2. Choose Output resolution from the menu and scroll to the right (figure 12.22, screen 2).
- 3. Select one of the five output resolutions (figure 12.22, screen 3). I chose 1080i (interlaced).
- 4. Press the OK button to lock in your selection.

Settings Recommendation: In my experience, when the camera is set to Auto and is plugged in to an HDTV, the video flows immediately.

If your HDTV has more than one HDMI port, make sure you have the correct HDMI port selected. Often there is a control on the TV's remote that lets you select a particular HDMI port. You won't see anything from the camera until that port is active.

Figure 12.23, image 1, shows what compatible HDMI cable ends look like. Unfortunately, you'll have to purchase an HDMI cable since one is not included with your D600. You'll need to use a mini-HDMI (type c) to HDMI standard (type a) cable. And, of course, you'll need to plug your HDMI cable into the correct port on the D600 (figure 12.23, image 2, red arrow).

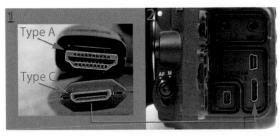

Figure 12.23 – HDMI connectors, types a and c, and camera HDMI type c port

Use the following steps to display a video on your HDTV:

- 1. Turn your camera off. Why take a chance of blowing up your camera from a static spark?
- 2. Open the rubber flap on the left side of your D600 and insert the mini-HDMI (type c) cable end into the HDMI port (figure 12.23, image 2, red arrow).
- 3. Insert the HDMI standard (type a) cable into one of your HDTV's HDMI ports. (Both video and sound are carried on this one cable.)
- 4. Your HDTV may have multiple HDMI ports, and you may have other devices connected, like a cable box or satellite receiver. When you plug the D600's HDMI cable into your HDTV, be sure to select that input or you won't see the video output. You may have to select the input from your TV remote or use another method. If in doubt, check your HDTV manual. (If your TV has only one HDMI port, please ignore this step.)
- 5. Turn on the camera, press the Playback button, and locate the video you want to show.
- 6. Press the OK button to play the video on your HDTV.

Settings Recommendation: Unless you are heavily into HDMI and understand the various formats, just leave the camera set to Auto. That allows the D600 to determine the proper format as soon as it's plugged into the display device and the HDMI input is selected.

Now, let's consider some information on rolling shutter effects. You need to know about this to avoid making wobbly videos.

Limitations in Movie Mode Video Capture

Let's look briefly at the limitations of the camera's video capture capabilities. No multiuse device can have all the features of a dedicated device, and the D600 has some limits on how it captures video.

The D600 uses a CMOS sensor to record video. This type of sensor uses a rolling shutter and has three potential issues that we need to discuss: skew, wobble, and partial exposure.

How the Rolling Shutter Works in Movie Mode

Since video is captured at 24 to 60 frames per second (fps), the D600 has an electronic shutter in addition to the normal mechanical shutter.

Have you ever used your D600 in Continuous release (CL or CH) mode when you are capturing up to 5.5 still images per second? The mechanical shutter activation combines with mirror movement to make the cool *chicka-chicka* sound that causes passersby—with their little point-and-shoot cameras—to look at you in awe.

You don't hear that sound in Movie mode because your D600 does not use the mechanical shutter when shooting movies. If it did you would wear the shutter out with only an hour or two of video capture. Remember, the camera captures video at a minimum of 24 fps. An hour of video requires 86,400 frames at that speed. You would quickly exceed the tested lifetime capacity—150,000 images—of the mechanical shutter.

Instead, the camera uses an electronic shutter and turns the sensor's rows of pixels on and off, as needed, in a scan from top to bottom. In other words, the camera records each video frame by scanning it—one line at a time—from top to bottom. This is called a rolling shutter. Not all parts of the image are recorded at exactly the same time! It can produce a skewed or wobbly video when you film rapidly moving subjects, like a race car or a flying bird.

Rolling shutters are used by video cameras that have CMOS sensors, like the Nikon D600. Most dedicated video cameras have CCD sensors, with global shutters that do not scan the image. They are mostly immune to the effects we are about to discuss.

Here is a list of the effects that can be experienced in extreme circumstances with a rolling shutter:

- Skew The image leans in one direction as the camera or subject moves. This
 is often seen at the edges of buildings and other static objects.
- Wobble This effect is harder to describe. The whole image wobbles in a strange way. It looks like the top of the image is out of sync with the middle and bottom of the image. Since video is a moving picture, the whole video can wobble back and forth in a very unnatural and dizzying way.
- Partial exposure If another camera's flash goes off during the shot, the
 burst of light may be present for only some of the rows of pixels in a particular frame. The top part of the frame may be brightly lit by the flash, while the
 bottom part appears dark. The partial exposure appears as a bright band in

one or a few frames, depending on the duration of the bright light. Some older fluorescent light bulbs have slow ballasts and can cause a video to have a series of moving bands as the light flickers. Our eyes can't see it, but the fast video captures it well. If you are shooting images of an ambulance with its lights flashing, it can also cause banding. Anything that has intense bursts of light for short periods may cause partially exposed bands to appear in a video.

To understand skew and wobble better, let's compare the D600 to a desktop scanner. It works in a similar way. If you place a paper document on a scanner and press the scan button, you'll see a band of light under the glass travel from the top of the document to the bottom as it records one line at a time. At the end of the scan, there is a copy of the document in your computer's memory that can be saved to the hard drive. You usually put the scanner's lid down on a paper document to hold it flat and keep it from moving.

Imagine that you're scanning a paper document on your desktop scanner, and halfway through the scan you move the paper a little. The top part of the scan would look normal, since it was already captured by the scanner's sensor, but the bottom part of the scan would be at a different angle than the top part. You could say that it is skewed from the original angle. This is an example of the skew that can result with a rolling shutter.

Now, what if you grab the paper during a scan and rotate it back and forth all the way through the entire scan? The final scanned document would look like a series of zigzags, with some parts at one angle and other parts at a different angle. This is an example of the wobble that can result with a rolling shutter.

The D600 records video in a similar manner, except it is much faster than a scanner. It records a frame of video in 1/24 second, or 24 fps, and can go as high as 60 fps. Since the Nikon D600 scans the image at this speed, there's not a problem in most cases. Most movement is too slow to be zigzagged (wobbled) or angled (skewed).

Skew and wobble become especially evident when a person is walking and recording a video at the same time. These combined movements can be enough to cause wobble in the video. I call this the "jellywobble effect." Like a bowl of Jell-O, your video looks like it is wobbling. What can you do to prevent it?

Avoiding the Jellywobble Effect

Primarily, you have to be careful not to allow too much camera movement. It truly is best to use the D600 on a nice fluid-head video tripod, or a stabilizing frame, if you want great results. I've found that Nikon's vibration reduction (VR) lenses help when you don't want to use a tripod, since they stabilize the camera a little. VR won't help much if you're walking while recording a video, since the camera movements are often too great for the VR system to overcome. If you're

standing quietly and doing your best to hold the camera still, it will help overcome small movements caused by your heartbeat and breathing.

This is one of the main differences between a dedicated video camera and a hybrid like the D600. Dedicated video cameras use a CCD sensor, which has a global shutter instead of a rolling shutter. A global shutter does not scan the image one line at a time. It uses the whole sensor at once to grab the image. There are some newer low-cost video cameras on the market that use a rolling shutter, but the better video cameras use a global shutter.

This is probably the worst problem with D600 video. True videophiles will turn up their noses at a rolling shutter. They'll buy a dedicated video camera with three separate CCD sensors—one for each RGB color—and a nice global shutter to avoid jellywobbles. And they'll pay several thousand dollars for the privilege of owning that equipment.

You, however, realize that the D600 is primarily a very high-quality still camera with added video capabilities. You might be standing in a superstore parking lot one day when an alien spacecraft lands. You'll get both still images and cool video from the same camera. So what if, in your excitement while running from the alien's heat ray, you get a few jellywobbles in your video? One of the rules for getting great video is having a video camera with you. With the D600, you have one at all times—with no extra effort. You do keep your camera with you just in case, right?

Settings Recommendation: Try to hold your camera still to greatly reduce any jellywobble effects. Use a tripod when you can, or even a VR lens. Anything that helps stabilize the camera will give you much higher-quality video.

Author's Conclusions

The video capability of the Nikon D600 is simply amazing. You will create some of the best videos of your life with this camera. When you are out shooting still images, why not grab some video too? Years from now actually hearing and seeing friends and family that are no longer with us will mean a lot.

Pictures are important, but so is video. Your camera does both, and either is available at a moment's notice. Carry your camera with you and record your life. Hard drives are cheap compared to the memories you will lose if you don't record them. Make good backups and give family videos to your family. Share the good qualities of your powerful camera with others, and the goodwill will come back to you later.

Now, let's look at the last chapter in the book, Speedlight Flash. Pop up the built-in Speedlight on your D600, or plug in your favorite external Nikon Speedlight, and let's see how to use a flash directly and control groups of Speedlights with Nikon's Creative Lighting System (CLS).

Speedlight Flash

Lyndia's Beautiful Smile – Jesse Martinez (*jesse101*)

Light Is a Photographer's Friend!

Controlling light is the primary thing that separates excellent from not-soexcellent photographers. On beautiful, balmy summer evenings, the light wraps around the land and gives us that so-called golden hour that we crave. However, some days are rainy, and some are dark and gloomy.

As photographers we want to take pictures. We don't want to stop just because the Sun won't cooperate. We need light that we can take with us, and we want it to be available quickly. We need a Speedlight!

Fortunately, your D600 has a built-in Speedlight (figure 13.1). That's Nikon's name for its flash units, large and small.

Figure 13.1 – Nikon D600 with popup Speedlight flash open

From the tiny popup flash on your camera to the flagship SB-910 flash, you have several choices. You can even create a wireless flash array using your camera, a commander unit, and several Speedlight flash units.

This type of setup is called the Nikon Creative Lighting System (CLS). We'll look at the CLS later in this chapter. First let's examine some general flash information and explore how the D600 uses flash. How can you determine which flash will work best for your style of shooting? Will the popup flash be enough with its range limitations, or do you need more power to reach out and light up more distant subjects? How is the power output of a flash unit rated?

First, we'll look at how to rate the power output of a flash by examining the quide number.

What Is a Guide Number?

The guide number (GN) for a flash unit measures how well it can light a subject at a specific ISO sensitivity and with a precise angle of view (wide angle versus telephoto). To put it simply, a higher GN means the flash is more powerful, all other things being equal.

Be careful when you are deciding on an external flash unit to use, whether it is a Nikon Speedlight or an aftermarket unit. Simply comparing the GN is not enough. You must understand the settings on which the GN is based. Many flash units have zoom capability and can light subjects farther away when they are zoomed out. Imagine buying a flash unit from a manufacturer who publishes the GN based on a longer zoom position and then comparing it to a different flash unit based on a shorter nonzoom position. The GN rating on the flash that is zoomed out would seem to be higher than the same unit not zoomed out. However, unless you are comparing flash unit GNs with exactly the same settings, it is truly like comparing apples to oranges. For instance, to get an exact comparison of GNs, you would have to know the following:

- Distance from flash head to the subject
- · Aperture in use on your camera
- · ISO sensitivity of your sensor
- Angle-of-view setting on the flash zoom head
- · Actual angle of view your lens provides (must match flash head)
- · Temperature of ambient air

In reality, the camera has little to do with figuring the GN, other than providing an f-stop number and ISO sensitivity. So how can you decide what GN is best without whipping out a scientific calculator? Just look at the flash unit specifications to see what the GN is based on. Here are the most important figures:

- Flash zoom angle-of-view setting (e.g., 24mm or 85mm)
- ISO sensitivity

If you see a flash unit advertised as GN 98, realize that this is not enough information to make a decision. In this instance, 98 is the GN. It represents the number of feet from the flash head to the subject (98 feet). In countries that use the metric system, an equivalent GN is 30, which is the number of meters from the flash head to the subject. That number by itself is simply incomplete. Don't buy a flash unit based solely on a GN like 98 or 100 or 111.

Let's think about this for a second. Let's say I'm a manufacturer who is desperate to sell you a flash unit. I might stretch things a little bit. I might say my Super-Duper flash unit has a GN of 98 (feet) or 30 (meters) and hope you won't ask about the settings I used to arrive at that number. Here is a comparison of two flash units with a so-called comparable GN:

Super-Duper flash unit GN information

- GN 98 (30)
- 80mm zoom-head setting
- ISO 200 sensitivity

Nikon SB-400 flash unit GN information (real values)

- GN 98 (30)
- 35mm zoom-head setting
- ISO 100 sensitivity

Both of the flash units have the same GN, so which one is really more powerful? The Nikon SB-400 will literally blow away the Super-Duper unit. Yet the Super-Duper manufacturer lists the same GN! The Super-Duper unit must have its zoom head set to 80mm, a much narrower beam, and have twice the camera ISO sensitivity to equal the Nikon SB-400 unit. Mr. Super-Duper is hoping you won't check the fine print at the bottom of the specifications so you'll think his much less powerful unit equals the Nikon SB-400. Surprisingly, there are flash unit manufacturers who do exactly this.

What can you learn from this example? The GN itself is not enough to make a decision on which flash unit to use. You must know what the GN is based on to make an informed decision. Take your time when buying a flash unit. You're safe in sticking with Nikon Speedlights, since the ratings are well known and they're designed to support all the features of your D600. There are also excellent aftermarket flash units available from manufacturers like Vivitar, Sigma, Sunpak, Metz, Braun/Leitz, and others. Examine the underlying settings and not just the GN. What the GN is based on is as important as the actual number.

For comparison purposes, the GN of the D600 popup Speedlight is 39 (feet) or 12 (meters) at ISO 100. Nikon's flagship Speedlight, the SB-910, is 111.5 (feet) or 34 (meters) at ISO 100 at the 35mm zoom head position. Obviously, the larger external flash unit has a lot more power and can light up subjects that are farther away.

Now, let's examine the various Flash modes found on the Nikon D600. Since I have no way of knowing which flash unit you'll be using, I'll write from the perspective of the popup flash. Almost everything mentioned next applies to the built-in flash and most Accessory shoe-mounted Nikon-brand Speedlight units, plus many Nikon-specific aftermarket flash units.

Page 293 in the Nikon D600 User's Manual has a listing of compatible Nikon Speedlight flash units, which include the following:

- SB-910
- SB-700

SB-R200

- SB-900
- SB-600
- SB-800
- SB-400

Technical GN Information

The GN is based on a specific formula: GN = distance × f-stop. It is based on the inverse-square law, which states that doubling the GN requires four times more flash power. A flash with a GN of 100 is four times more powerful than a flash with a GN of 50. The GN represents an exposure constant for a flash unit. For example, a GN of 80 feet at ISO 100 means that a subject 20 feet away can be completely illuminated with an aperture of f/4 (80 = 20×4) using a sensitivity of ISO 100. For the same GN and an aperture of f/8, the light source should be 10 feet from the subject (80 = 10×8). Fortunately, your camera and flash combination are capable of figuring the correct values for you when you use TTL mode.

Flash Modes

(User's Manual - Page 143)

The built-in popup flash has two types of flash metering:

- i-TTL balanced fill flash The flash fires in two stages. Nikon calls stage 1 monitor preflash. The built-in flash emits a series of almost invisible flashes (stage 1) before the main flash burst fires (stage 2). The preflashes allow the 2,016-pixel RGB sensor to examine all areas of the frame for reflectivity. The camera uses the Matrix meter and distance information from a D or G lens to calculate a flash output that is balanced between the main subject and the ambient lighting.
- Standard i-TTL When the Spot meter is used, the camera automatically switches to standard i-TTL. This mode ignores the background and concentrates on whatever the camera's selected AF point is focused on. For the most accurate flash output for a specific subject, set your camera to use its Spot meter and the flash will meter for the subject only.

In addition to the types of flash metering, the camera also has several Flash modes that affect how it controls light. We'll consider each of them shortly, but first let's talk about how the shutter blades work when the flash fires. This is basic information that will help you understand the Flash modes. To fully know what's happening when the flash fires, you must understand a little bit about the shutter curtains in your camera.

Your D600 exposes the sensor to light for specific periods of time. This is controlled by the camera's shutter speed. The actual exposure is handled by two moving objects called curtains. The D600 has two shutter curtains. You can see the front curtain in figure 13.2 (red arrow). It's composed of several narrow overlapping blades and is in the closed position.

Figure 13.2 – Nikon D600 shutter assembly and front shutter curtain (red arrow)

How do the curtains work? One curtain gets out of the way of the sensor to start the exposure, and the other curtain replaces it to stop the exposure. The first one is called the front curtain, and the second one is called the rear curtain. In this context, front and rear are not important as indicators of position but as indicators of which moves first and which moves second. The flash must fire when the first, or front, curtain is fully open and before the second, or rear, curtain starts closing. The time between the front curtain opening and the rear curtain closing is the actual shutter speed.

The whole sensor must be uncovered when the flash fires in normal Flash modes (non-Auto FP). If the shutter speed is too fast, the rear curtain will closely follow the front curtain and partially block the sensor when the flash fires. That's why the shutter speed is limited to a maximum of 1/200 second on the D600 when a flash is used. With faster shutter speeds, the sensor is always partially covered by one of the shutter curtains. If the flash fires while one of the curtains covers part of the sensor, that part of the sensor will not get a proper exposure from the flash and there will be an underexposed black band in your image.

The whole point of the Flash modes is to determine at what point during shutter curtain movement the flash fires and whether it's the main source of light or if some ambient light is mixed in. Keep this information in mind as we discuss the Flash modes.

Be sure to read the upcoming sidebar called **Auto FP High-Speed Sync** because Auto FP affects the maximum shutter sync speed and allows you to take it higher than 1/250 second. Also see the heading **e1 Flash Sync Speed** in the **Custom Setting Menu** chapter, where this mode is discussed in great detail.

Here are the steps to select one of the Flash modes:

- 1. Hold down the Flash mode button (figure 13.3, image 1).
- 2. Turn the Main command dial while watching the various modes change on the Control panel (figure 13.3, images 2 and 3).
- 3. Release the Flash mode button to lock in the Flash mode.

Figure 13.3 – Flash mode button (image 1), Main command dial (image 2), Control panel Flash mode readout (image 3)

Auto FP High-Speed Sync

The D600 has an additional mode that lets it exceed the normal flash sync speed of 1/200 second. It is called Auto FP high-speed sync mode. Remember how normally both the front and rear shutter curtains must be out of the way before the flash fires? Auto FP high-speed sync mode lets you use shutter speeds all the way up to 1/4000 second. At these speeds, the rear shutter curtain follows the front shutter curtain so closely that only a traveling narrow horizontal slit exposes the sensor at any given time.

When you select a sync speed faster than the normal 1/200 second, the camera fires the flash in a series of short pulses instead of one big flash. The pulses fire as the narrow shutter curtain slit moves across the face of the sensor. The faster the shutter speed, the less power the flash can manage. You must be able to depend on ambient light in addition to flash when using Auto FP high-speed sync mode, especially at higher shutter speeds. However, this lets you use your fast lenses (e.g., f/1.4, f/2.8) wide open in direct sunlight, due to the very fast shutter speed.

You can expose properly with a very shallow depth of field due to a large aperture, even though the light is very bright. We covered this mode in detail in the chapter titled **Custom Setting Menu**, under the heading **e1 Flash Sync Speed**.

The five basic Flash modes and how they work are described next. The camera will often combine these Flash modes as you use different shooting modes on the Mode dial. See the list of shooting modes at the end of this section.

Auto

Auto Flash mode is available only when you are using various SCENE modes (figure 13.4). It lets the camera decide when and what type of flash to use. You can select this mode if you are unsure about which mode to use in a certain situation, and the camera will do its best to give you a wellexposed picture. See the list at the end of this section to discover the other modes that are available when you are using the automatic SCENE modes.

Figure 13.4 - Auto flash in SCENE modes only

Fill Flash (Front-Curtain Sync)

In Fill flash (Front-curtain sync mode), the camera tries its best to balance the light if you're using a lens that has a CPU in it (figure 13.5). Older non-CPU lenses cause the camera to ignore the ambient light completely and use only the flash to expose the subject. A CPU lens, like an AF-S Nikkor G or D lens, balances ambient light and light from the flash and works to make the combined light look very natural. If you use this correctly outdoors, it will be hard to tell that you were us-

Figure 13.5 - Front-curtain

ing flash, except for the catch light in your subject's eyes and the lack of deep shadows. The flash simply fills in some extra light without overpowering the ambient light. In a situation where there is very little ambient light, the camera will use only the flash to get a correct exposure. It balances with ambient light only if there is enough ambient light.

There is a side effect to using this mode with slow shutter speeds. Fill flash simply causes the flash to fire as soon as the front shutter curtain is out of the way and before the rear shutter curtain starts closing. If there is some ambient light, the shutter speed is long (like 1/2 second), and the subject is moving, you'll see a well-exposed subject with a blurry trail in front of it. The flash correctly exposes the subject as soon as the front curtain gets out of the way, but the ambient light continues exposing the subject before the rear curtain closes. Since the subject was moving, you may see a ghostlike blur before or in front of the well-exposed moving subject in the picture. This can be seen at shutter speeds as fast as 1/60 second if the ambient light is strong enough and the subject is moving quickly enough.

Red-Eye Reduction

Red-eye reduction is not really a Flash mode (figure 13.6). It simply means that the AF-assist illuminator shines brightly in the face of your subject before the Fill flash fires. The intention is that the bright AF-assist illuminator will cause your subject's pupils to close somewhat and reduce the red-eye effect. It acts like you are using Fill flash (Front-curtain sync mode).

Figure 13.6 - Red-eye reduction

Slow Sync

Slow sync mode lets the camera use ambient light to make a good exposure and then fires the flash to add some extra light, rounding out the shadows or better exposing a foreground subject (figure 13.7). Use this mode in people shots outdoors or when you want ambient light to provide the primary exposure and the flash to add a sparkle to your subjects' eyes and remove dark shadows from their faces.

Figure 13.7 - Slow sync

This is closely related to Fill flash, except the ambient light is more important than the light from the flash. Be careful when using this mode indoors since it will expose for ambient light and only assist with some flash light. You can get some terrible ghosting and blurred handheld shots when using Slow sync indoors. Ambient light rules in this mode!

Rear-Curtain Sync

Rear-curtain sync (figure 13.8) is the opposite of Fill flash, or Front-curtain sync. The flash waits to fire until just before the rear curtain starts to close. The entire shutter speed time is just ending when the flash fires. This causes a ghosting effect for moving subjects in higher ambient light with slow shutter speeds.

When you press the Shutter-release button, the front curtain opens, ambient light starts hitting the sensor, and the sensor starts recording

Figure 13.8 - Rear-curtain sync

the subject. Just as the shutter's rear curtain is about to close, the flash fires, exposing the subject at its current position. The subject was fully exposed by the

flash at the end of the shutter speed time, so the ambient light had time to register the subject before the flash fired, thereby making a blurred ghost behind or after the well-exposed but moving subject.

List of Flash Modes by Shooting Mode

As mentioned previously, when you use the various shooting modes on the Mode dial, such as P, S, A, M, SCENE, and so forth, the camera will allow you to use certain Flash modes at certain times. Not all flash modes are available at all exposure settings.

The following list shows the shooting modes and available Flash modes:

SCENE modes – Portrait, Child, Close up, Party/indoor, Pet portrait, and AUTO

- Auto
- Auto + red-eye reduction

SCENE mode – Night portrait

- Auto + slow sync + red-eye reduction
- Auto + slow sync

SCENE mode - Food

Fill flash (front curtain sync)

Shooting mode – Programmed auto (P) and Aperture-priority auto (A)

- · Fill flash
- Red-eye reduction
- Slow sync + red-eye reduction
- Slow sync
- Rear curtain + slow sync

Shooting mode – Shutter-priority auto (S) and Manual (M)

- · Fill flash
- · Red-eye reduction
- Rear-curtain sync

No Flash Mode

There is a final Flash mode, if you want to call it that. It's Off, or no flash mode. Figure 13.9 shows it on the Mode dial and Control panel. When you use this mode, the flash is disabled. Obviously you cannot select the no flash mode when you use any of the other shooting mode selections on the Mode dial.

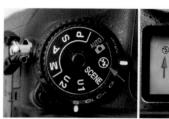

Figure 13.9 - No flash mode (Off)

Settings Recommendation: I use Fill flash for normal, everyday flash. It balances ambient light with flash light. Switch to Spot metering mode when you use Fill flash if you want extremely accurate exposures of a particular subject.

External Speedlight flash units offer modes like TTL BL, TTL BL FP, TTL FP, or just TTL. TTL stands for through the lens and represents an i-TTL mode (intelligent though the lens). BL stands for balanced. FP stands for Auto FP high-speed sync mode. Refer to the user's manual for your flash unit for exact details on how to switch modes on the flash unit.

When I'm shooting outside (only) and want a great exposure of my subject's surroundings, along with the subject, I often use Slow sync mode. The only caveat is that you must be aware that slow shutter speeds will cause ghosting and blurring as the light falls.

I don't use the Red-eye reduction mode often because it seems to confuse people. They think the initial shine of the AF-assist illuminator is the flash firing and then they look away just as the main flash fires. If you are going to use Redeye reduction mode, you might want to tell your subject to wait for the main flash.

Rear-curtain sync creates a cool effect if you want to show a ghosted image stretching out behind your subject when you use slow shutter speeds. It is sometimes used by sports shooters in situations when there may be some blurring from fast movement in low light. It is much more acceptable to have a ghosted blur after the subject since it implies motion. Front-curtain sync makes the blur show up in front of the subject, which just plain looks weird.

I suggest experimenting with all of these modes. You'll want to use each of them at various times.

Now let's look into the Nikon CLS, which allows your camera to control multiple flash units in a wireless array.

Flash Compensation

The Nikon D600 also offers a Flash compensation setting, as mentioned briefly in a previous chapter. You can add up to one EV step (overexposure) and subtract down to three EV steps (underexposure).

Use the following steps to dial in Flash compensation:

- 1. Hold in the Flash mode/Compensation button (figure 13.10, image 1).
- 2. Turn the Sub-command dial to select a Flash compensation amount (figure 13.10, image 2).
- 3. The Control panel will display the compensation in 1/3 or 1/2 EV steps, according to how you have Custom Setting Menu > b Metering/exposure > b2 EV steps for exposure cntrl set (1/3 step or 1/2 step). Figure 13.10, image 3 (red arrow), shows that I have selected +0.3 EV step overexposure.

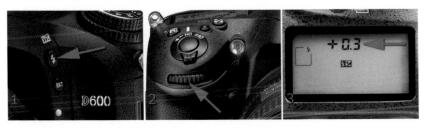

Figure 13.10 - 0.3 EV step Flash compensation (1/3 stop overexposure)

Nikon Creative Lighting System (CLS)

(User's Manual - Pages 293)

The CLS is an advanced wireless lighting technology that allows you to use your imagination in designing creative lighting arrangements. No wires are used since the CLS-compatible remote flash units are controlled by a commander device, or what Nikon refers to as a "master flash unit." You can use the Commander mode

built into the D600; an Accessory shoe-mounted commander, such as the SB-910, SB-900, SB-800, and SB-700 Speedlights; or the SU-800 Wireless Speedlight Commander unit.

The Nikon SB-600 and SB-R200 Speedlights have only a remote mode, so they cannot be used as a commander unit. The Nikon SB-400 is not compatible with the CLS at all; therefore, it can be used only as a standard i-TTL flash unit.

We'll consider only the camera's built-in Commander mode in this chapter. If you want to learn more about using a full-blown remote external flash unit, multiflash CLS system, I suggest buying a copy of The Nikon Creative Lighting System, 2nd Edition by Mike Hagen (published by Rocky Nook and NikoniansPress; figure 13.11). Mike's book

Figure 13.11 – The Nikon Creative Lighting System, 2nd Edition by Mike Hagen

goes into excellent detail on how to use the CLS with multiple banks of various external Nikon Speedlight flash units.

With the CLS you can easily experiment with setups and flash output. You can obtain a visual preview of how things will look by pressing the Depth-of-field preview button, which will fire the pulsed modeling capability within Nikon Speedlights.

There is no need to calculate complex lighting ratios when you can control your flash banks right from the camera and see the results immediately. The CLS simplifies the use of multiple flash unit setups for portraits, interiors, nature, or any situation where several Speedlights need to work in unison.

You can simply position the flash units where you'd like them to be and let the CLS automatically calculate the correct exposure, or you can change the lighting ratios directly from the *Custom Setting Menu* > *e3 Flash cntrl for built-in flash* > *Commander mode* menu of your D600.

Nikon's CLS is world class in power and not too difficult to use. The Nikon D600 contains everything you need to control a simple or complex CLS setup. Let's learn how to use it!

How Does the D600 Fit into the CLS Scheme?

In Commander mode, the camera functions as a controller for multiple Nikon Speedlight flash units. Although the professional-level Nikon D4, D3, D3S, and D3X cameras require the separate purchase of an Accessory shoe–mounted commander device, the D600 body has full Nikon CLS technology built right into the camera.

You can use normal i-TTL flash technology with the camera's built-in flash or use Commander mode and the built-in flash to control up to two groups of an unlimited number of external Nikon Speedlight flash units.

Nikon currently makes the powerful flagship SB-910 and SB-900 flash units, along with their only slightly less powerful SB-700 and SB-600 cousins, and other smaller Speedlight units, such as the SB-400 and SB-R200.

Many people who use the D600 have an external flash unit or two—usually the SB-910, SB-900, SB-800 (now discontinued), SB-700, SB-600, or SB-400. The SB-R200 flash is designed to be used on various brackets that are available from Nikon, and it will work in conjunction with the bigger Speedlight flash units. The Nikon D600 is happy to let you arrange professional lighting setups using these relatively inexpensive and very portable Speedlights.

The cool thing about the D600 is it can serve as a CLS flash commander device or use Nikon's other CLS flash commander devices at will. You have great control with this fine camera!

What Is Commander Mode and How Does It Work?

Commander mode is controlled through a menu on your D600. If you examine the Commander mode screen shown in figure 13.12, you'll see that there are controls for the built-in flash and two groups of external flash units (Group A and Group B). You'll also see that you can set exposure compensation for either of these groups.

If the main flash is too bright, you can either move it farther away or dial down its power by setting compensation (Comp.) to underexpose a

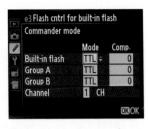

Figure 13.12 - Commander mode

little. You can set Comp. in 1/3-stop increments, so you have very fine control of each group's flash output. You can experiment until you get the image just the way you want it. Sure, you can do things the old way and use a flash meter or get your calculator and figure out complex fill ratios. Or you can simply use the CLS to vary your settings visually until the image is just right (figure 13.13).

Figure 13.13 - J. Ramón Palacios used a Commander device and two SB-800 Speedlights to take this CLS photo

Isn't it more fun to simply enter some initial settings into your Commander mode screen and then take a test shot? If it doesn't look right, change the settings and do it again. Within two or three tries you'll probably get it right, and you will have learned something about the performance of the CLS. In a short time you'll have a feel for how to set the camera and flash units, and you'll use your flash/camera combo with authority. Mike Hagen's CLS book, mentioned previously, will help you learn these techniques.

Note: If you leave Custom Setting Menu > e Bracketing/Flash > e5 Modeling flash set to the factory default of On, you can test fire the built-in modeling light of your single Speedlight—or all Speedlights in Groups A and B—by pressing and holding the camera's Depth-of-field preview button.

Using Commander Mode

Start by putting your camera into Commander mode. It will allow you to configure a CLS session using one or many external flash units.

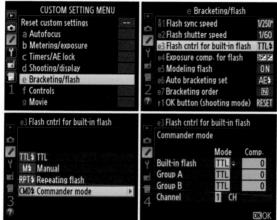

Figure 13.14 - Setting the camera to Commander mode

Use these steps to enter and adjust Commander mode in your D600:

- 1. Select e Bracketing/flash from the Custom Setting Menu (figure 13.14, screen 1).
- 2. Choose e3 Flash cntrl for built-in flash and scroll to the right (figure 13.14,
- 3. Select CMD Commander mode and scroll to the right (figure 13.14, screen 3).
- 4. Use the final screen to adjust the various Commander mode settings (Mode, Comp., and Channel) and then press the OK button to lock in the settings (figure 13.14, screen 4).

Since this section is about controlling multiple flash units, we'll have to change the settings in Commander mode, as shown in figure 13.14, screen 4. We'll examine each of the settings available in Commander mode.

First, we'll consider TTL (also known as i-TTL). It's the easiest to use since it allows you to set exposure compensation for the built-in flash and each of your flash groups. Second, we'll briefly look at AA mode, which is an old-fashioned mode that is not often used by new photographers. Third, we'll look at M mode, since that gives you fine control of your flash from full power (1/1) to 1/128 power. Finally, we'll consider the -- (double-dash) mode, which prevents the camera's built-in flash from firing the main flash output in whichever group is using -- mode.

When your camera is controlling external Speedlights using its built-in Commander mode, you must always raise the built-in flash on your D600. The camera communicates with the external flash units during the monitor preflash cycle.

Always position the sensor windows on the external Speedlights where they will pick up the monitor preflashes from the built-in flash.

Commander Mode Settings

Basically, the Mode fields on the Commander mode screen will display the selections in the following list. Use the Multi selector to change the values, as shown in figure 13.15.

Here are the four Commander mode settings:

- TTL, or i-TTL mode
- · AA, or Auto Aperture mode
- M, or Manual mode
- --, or double-dash mode (what else would one call it?)

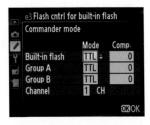

Figure 13.15 - Commander mode screen

You'll find each mode in the yellow highlighted Mode box in figure 13.15. Use the Multi selector to scroll up or down and select a mode. AA mode is not available for the Built-in flash, so you will see AA only in the Mode boxes following Group A and Group B. Now, let's examine each mode in more detail:

- TTL mode The TTL setting allows you to use the full power of i-TTL technology. By leaving Mode set to TTL (as shown in figure 13.15) for the Built-in flash or Group A or B, you derive maximum flexibility and accuracy from all your flash units. In this mode the Comp. setting will display exposure values from -3.0 EV to +3.0 EV, a full six-stop range of exposure compensation for each group of Speedlights. You can set the Comp. in 1/3 EV steps for very fine control.
- AA mode The AA mode is an older non-i-TTL technology included for people who are accustomed to using it. It is not available for the built-in Speedlight on the D600 or for the SB-600. You can safely ignore the AA mode, unless you want to experiment with it. It may not provide as accurate a flash exposure as TTL mode since it is not based on the amazing i-TTL technology. Otherwise it works pretty much the same as TTL mode.
- M mode This mode allows you to set different levels of flash output in 1/3 EV steps for the Built-in flash or the Speedlights in Group A or B. The settings you can put in the Comp. field are between 1/1 (full power) and 1/128. The intermediate 1/3-stop settings are presented as decimals within the fractions. For example, 1/1.3 and 1/1.7 are 1/3 and 2/3 stops below 1/1 (full).

Many people are used to working with flash units this way, so it seems more familiar to them. The CLS accommodates people who have experience working manually.

-- mode (double-dash mode) - The built-in Speedlight will not fire the main flash burst in this mode. It will fire the monitor preflashes, since it uses them to determine exposure and communicate with the external flash groups. Be sure you always raise the camera's built-in flash in any of the Commander modes; otherwise the external flash groups will not receive a signal and won't fire their flashes. When you set the mode for Group A or B to -- (double-dash mode), that entire group of flashes will not fire. You can use this mode to temporarily turn off one of the flash groups for testing purposes.

Since the preflashes of the built-in flash always fire, be careful that they do not influence the lighting of your image. Use a smaller aperture, or move the camera farther away from your subject if the preflashes add unwanted light. Alternatively, you could purchase the Nikon SG-3IR infrared panel, which fits in front of the Built-in flash and prevents light from influencing the exposure.

What Are Monitor Preflashes?

When you press the Shutter-release button with the popup flash open, the camera's built-in Speedlight fires several brief preflashes and then fires the main flash burst. These preflashes fire whenever your camera is set to TTL mode, even if your D600 is controlling multiple flash units through the CLS. The camera can determine a very accurate exposure by lighting your subject with a preflash, adjusting the exposure, and then firing the main flash burst.

Setting the Channel (CH) for Communication

Look at figure 13.16, or your camera's Commander mode screen, and you'll notice that just below Group B there is a Channel (CH) selection. The number 3 that I selected in the yellow box is the communication channel your D600 will use to talk to the external flash groups (the factory default is 1).

There are four channels available (1–4), in case you happen to be working in the vicinity of another Nikon photographer who is also using Commander mode. By using separate channels, you won't interfere with each other.

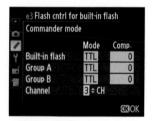

Figure 13.16 -Commander mode - Channel of communication

Note: It is important to realize that all external flashes in all groups must be on the same channel. This involves setting up your individual flash units to respond on a particular channel. They might be in separate groups, but they must be on the same channel. Each external Speedlight flash will have its own method for selecting a Group and a Channel. To learn how to configure each flash unit separately, you'll need to get Mike Hagen's book or read the user's manual for your flash unit.

Downloadable Resource on Flash Units

There is a downloadable PDF document accompanying this chapter called Selecting a Nikon Speedlight Flash Unit at either of these two websites:

http://www.nikonians.org/NikonD600 http://rockynook/NikonD600

The document discusses individual Nikon Speedlights that were available at the time this book was published.

Author's Conclusions

The Nikon D600 gives you control over the world-class Nikon Creative Lighting System. It is the envy of many other camera brand manufacturers and users.

I suggest that you find a good book on lighting techniques and study it well. You'll have to learn how to control shadows and reflections, plus you'll have to understand lighting ratios so you can recognize a good image when you see one.

Buy a couple of light stands and some cheap white flash umbrellas and set up some portrait sessions of your family, or even some product shots. With the Nikon D600 and just one extra Speedlight, you can create some very impressive images with much less work than ever before.

The really nice thing is that the Nikon CLS—executed by your camera's Commander mode and external Speedlight flashes—will allow you to shoot without worrying so much about detailed exposure issues. Instead, you can concentrate on creating a great-looking image (figure 13.17).

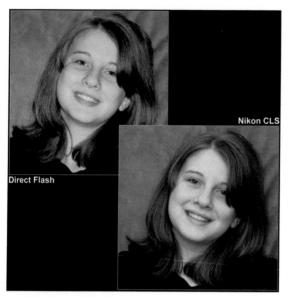

Figure 13.17 – Single-flash Nikon CLS compared to direct flash

Thank You!

I'd like to express my personal appreciation to you for buying this book and sticking with me all the way to the end of it. I sincerely hope that it has been useful to you and that you'll recommend my books to your Nikon-using friends.

Keep on capturing time...

Credits for Chapter Opening Images

Chapter 1 – Jesse Martinez (*jesse101*) — *Isabell and Her New Toys*

Nikon D600 with a Tamron 28–75mm f/2.8 XR Di lens at 62mm, 1/100s at f/2.8, ISO 640 One-year-old Isabell Rose Martinez is playing with her new toys that she got during the holidays in 2012. From the cute expression on her face, you can tell that she was really fascinated with her new toy dog.

Chapter 2 - Marcel Carey (mcpianoca) — Bountiful Harvest

Nikon D600 with an AI Nikkor 35mm manual focus lens, 1/100s at f/11, ISO 1100 I really enjoyed this combination because the 35 AI Nikkor is small and light. As you can see, it's also very sharp, and has a little glow quality to it. This is one of my favorite lenses. The picture was taken under a gazebo tent where producers were exhibiting their crops. There was a window to the left of the pumpkins and I really liked the light caressing them.

Chapter 3 – Philip Rice (pjr) — Rendezvous

Nikon D600 with an AF-S Nikkor 24–120mm f/4G ED VRII lens at 40mm, 1/20s at f/6.3, ISO $800\,$

I shot this image in what was an old train tunnel, now a passageway, in Ottawa, Ontario, Canada. I was with several other photographers at a photo meet up when a couple of them wandered ahead of us. I spotted them, liked the scene, framed the picture, and took the shot! I later made a B&W conversion from the minimally-processed-in-Lightroom image.

Chapter 4 – Eric Bowles (ericbowles) — Mesquite Flat Dunes in Death Valley

Nikon D600 with an AF-S Nikkor 24–70mm f/2.8 lens at 34mm, 1/40s at f/11, ISO 100 Death Valley is a fabulous place for landscape photography, and Mesquite Flat Dunes is one of the best locations. The strong wind of the previous day and night wiped away all the footprints on the dunes and provided us with clean, unblemished sand for sunrise images. Warm early morning light and a blue sky provide great color for the scene. By using a wide lens setting and emphasizing the foreground, the texture of the dunes made wonderful patterns and leading lines in the composition.

Chapter 5 – Jim Hammond (hamjam) — Twenty-Seven Cents Per Gallon

Nikon D600 with a Nikkor 28–300mm lens at 58mm, 1/200s at f/11, ISO 200

I took this image in early morning sunlight on our way back to Lincoln, CA from a trip to Reno, NV, USA. We drove down into Old Town Truckee, CA, to get a cup of coffee and to see if there might be an image waiting for us. Sure enough, we spotted this old Texaco Flying A Service Station, now a Sporting Goods Store. The old pumps brought back some nostalgic memories of when you could get a gallon of gas at 27 cents per gallon. That's the price that is still shown on the pumps, which is why I titled the image Twenty-Seven Cents Per Gallon.

Chapter 6 – Donald Heldoorn (*TakeTwo*) — Spirit of Texas in Semi Finals

Nikon D600 with a Nikon 300mm lens, 1/250s at f/13, ISO 200

I took this shot, up close and personal, at the Lucas Oil Drag Boat Racing Series (LODBRS) on Sunday, November 4, 2012. The Boat is the "Spirit of Texas," a Top fuel Hydro, 8000 horse power machine, which does 0–1000 feet in 3.4 seconds at a top speed of 250 mph.

Chapter 7 – Jackie Donaldson (bhpr) — Nature's Beauty

Nikon D600 with an AF-S Nikkor 28–300mm VR lens at 300mm, 1/500s at f/7.1, ISO 800

I took the butterfly photo under the New River Gorge Bridge in West Virginia, USA, on the railroad tracks. I was learning the D600 and it was proving to be an excellent camera. I was walking the tracks looking for a better shot of the bridge and I came across this beautiful butterfly. I had just bought my D600 a few days before my vacation so I was excited to come across this great subject. The original file was in landscape mode and I cropped it for better composition.

Chapter 8 – Anthony Do (*gudnuf4u*) — *Baby Big Bear*

Nikon D600 with an AF-S Nikkor 85mm f/1.8G lens, 1/250s at f/4, ISO 180

I took this picture of my baby girl in Big Bear Lake, California, USA. It was her first day in the snow and I wanted to capture the memory. I really love this picture of my baby, and now I have something to show her when she grows up.

Chapter 9 - Mike Goodman (mrginhop) — Mandarin Duck on Golden Pond

Nikon D600 with an AF-S Nikkor 200–400mm f/4.0 lens at 400mm, 1/250s at f/8, ISO 1400 This Mandarin duck resides at a pond in the Albuquerque Zoo. I was in the area to shoot at the Bosque del Apache sanctuary in late November, which is about an hour away. It was late afternoon and the low light was creating wonderful golden reflections on the pond. The challenge was to get the duck in the sunlight facing me. It took many shots before it all came together.

Chapter 10 – Rocky Fletcher (rf10956) — Taking Prey

Nikon D600 with a Nikkor 300mm f/4.0 lens and TC-14E II teleconverter, 1/1250s at f/5.6, **ISO 720**

A friend of mine is an avid eagle photographer and stimulated my interest in giving it a try. This was actually my first go at it, hoping that I would get a couple of keepers. The D600 made it possible to get many nice captures. I took this picture at Lock and Dam 14 on the Mississippi River. It is a well-known spot for eagle photography in January and February. I had literally received the camera the previous week as a replacement for my D300, which had recently been stolen.

Chapter 11 – Susan Braunhut (wife of *dhmiller*) — *Iguana Invasion*

Nikon D600 with an AF-S Nikkor 70-300mm f/4-5.6G VR lens at 300mm, 1/1250s at f/11, ISO 1100

I shot this image near Arenal Volcano in Cost Rica, outside the Iguana Restaurant, where the grounds were covered with iguanas of all shapes and sizes.

Chapter 12 – Brenda Young (DigitalBrenda) — Bald River Falls

Nikon D600 with an AF-S Nikkor 24–85mm f/3.5–4.5G VR lens at 46mm, 1.3s at f/16, ISO 100 Darrell and I were on an autumn trip to explore Cherohala Skyway in Tennessee and North Carolina, USA. We always stop at Bald River Falls in Tellico Plains, TN, for a few shots, I was using my new Nikon D600, a gift from Darrell, and I shot this vertical using my Manfrotto tripod. This is one of the highest waterfalls in Tennessee, at over 100 feet, and it is quite beautiful year round, but especially in the fall.

Chapter 13 – Jesse Martinez (jesse 101) — Lyndia's Beautiful Smile

Nikon D600 with a Tamron 28–75mm f/2.8 XR Di lens at 72mm, 1/160s at f/2.8, ISO 100 The beautiful model's name is Lyndia. I took this shot in Denver, Colorado, using Nikon CLS for lighting. I positioned the flash on a Manfrotto stand, set it to remote mode, and used the in-camera Commander mode to control the Speedlight. The flash was used as fill only, to remove shadows, thereby allowing ambient light to be the main light source.

Index

Symbols & Numbers

+/- Exposure compensation setting, 171 +/- versus -/+ (reverse indicators), 240-241 +NEF (RAW) (assignable function), 231 -- (Double dash flash Commander mode), 212-213, 528 0F, 2F, 3F (ADL bracketing), 222 0-4 (Battery info), 277 0001–9999 before counter rollover, 195 1 step spd/aperture (assignable function), 1 to 5 fps CL mode shooting speed, 192 1/3 or 1/2 step (ISO sensitivity step value), 169 1/3 or 1/2 step (Exposure cntrl), 170 1.0x FX Image area, 79 11 points (autofocus), 165 12-bit vs. 14-bit Bit depth, 85 12 Mbps bit-rate (Movie), 147 12- to 24-Hour Time Conversion Chart, 270 1280×720 (720p Movie), 147 1.5x DX Image area, 79 14.2 EV steps Dynamic range, 112, 396 15.4 megapixels (Large DX image area), 79 16:9 ratio (Movie mode still image), 245 1920×1280 frame size (1080p Movie), 147 20 min. (Movie length), 147 20.3 megapixels (Medium FX image area), 79

20.3 megapixels (Movie mode still image),

23.976 fps (Movie), 150

24 Mbps bit-rate (Movie), 147

24.2 megapixels (Movie mode still image), 245

256 steps in a histogram, 396 29 min. 59 sec. (Movie length), 147 24×16 Image area, 79 2400×1600 (Small DX image area), 79 3D Color Matrix Metering II, 369

3D-Tracking AF-area mode, 432, 444

3:2 image area, 79

3.8 megapixels (Small DX image area), 79 36.2 megapixels (Large FX image area), 79 36×24 Image area, 79 3600×2400 (Medium DX image area), 79 3680×2456 (Small FX image area), 79 39 points (autofocus), 165 480p (HDMI), 266, 506 4800×3200 (Large DX image area), 79 50Hz (HDMI), 268 5520×3680 (Medium FX image area), 79 576p (HDMI), 266, 506 59.94 fps (Movie), 150 60Hz (HDMI), 268 6016×3376 (Movie mode still image), 245 6016×4016 (Movie mode still image), 245 720p (HDMI), 266, 506 7360×4912 (Large FX Image area), 79 8 Mbps bit-rate (Movie), 147 8.6 megapixels (Medium DX image area), 79 9.0 megapixels (Small FX image area), 79 9, 21, and 39 AF points, 432 100 shot JPEG buffer, 193 1080i (HDMI), 266, 506 2,016 pixel RGB sensor, 367 2,500K-10,000K color temperature (K), 413 H.264/MPEG-4 Advanced Video Coding (AVC), 6

Α

a1 to a7. See Custom Setting Menu A exposure mode, 378-379 AA (Commander mode), 212, 527 AA batteries. See Batteries in MB-D14 Access top item in My Menu (assignable function), 228 Active D-Lighting (assignable function), Active D-Lighting (Live view), 464 Active D-Lighting (Shooting Menu), 13, 55, 112-115 Add items (My Menu), 358-360

Additional photo info (Playback display

options), 31

Autofocus ADL, 112-115, 218 all information, 157-168, 431-453 ADL bracketing, 218, 222 Adobe RGB Color space, 55, 57, 63, 110autofocus patterns, 443 Auto-area AF-area mode, 167, 432, 444 112, 325, 330 Auto-servo AF mode (AF-A), 432, 437 AE/AF lock (assignable function), 229, 241, AF-area modes, 432, 439-446, 464 244 Continuous-servo AF mode (AF-C), 432, AE & flash (Bracketing), 217, 218 AE lock (hold) (assignable function), 229, 437 Cross-type AF points, 435 242, 244 Dynamic-area AF-area mode, 432, AE lock only (assignable function), 229, 442-443 241, 244 AE only (Bracketing), 217, 218 Face-priority AF-area mode, 447, 451 AF11 vs. AF39, 165 Focal-plane contrast AF, 432 AF-area modes, 432, 439-446, 464, 477, Focus lock (sidebar), 453 Full-time servo AF mode (AF-F), 447, 498-499 AF-assist illuminator, 167 Live view photography mode AF, 446-AF-A autofocus mode, 167, 432 453, 447, 464 AF-C autofocus mode, 157, 432 Movie live view mode, 477, 497 AF-C priority selection (a1), 13, 157 AF fine-tune (Setup Menu), 252, 292–295 Normal-area AF-area mode, 447, 451 Single-point AF-area mode, 432, AF lock only (assignable function), 229, 242, 244 440-441 Single-servo AF mode (AF-S), 432, 437, AF-ON (assignable function), 229, 242, 244 AF points, 432, 435 447, 449 AF-S autofocus mode, 158, 167, 432 Subject-tracking AF-area mode, 447, AF-S priority selection (a2), 158 452 TTL phase-detection AF, 431 AF-S Nikkor 24-85mm f/3.5-5.6G ED VR Viewfinder autofocus, 431-453 lens, 119 Wide-area AF-area mode, 447, 451 After delete, 17, 44-45 All (Delete), 22-24 3D-Tracking AF-area mode, 432, 444 Auto Flash (Scene mode), 519 All (Playback folder), 25 Altitude (GPS), 282 Auto FP High-speed sync (flash), 204-207, Amber tint (Color balance), 320 518 Auto gain (Multiple exposure), 139, Aperture-priority auto mode (A), 378-379 140-141 Aperture setting (command dials), 235 Auto HDMI, 266, 268 Aperture ring (command dials), 235 Auto Information display color (dark or Artist (Copyright information), 278 Attach comment (Image comment), 274 light), 197 Attach copyright information, 278 Auto image rotation (Setup Menu), 12, 252, Atomos Ninja-2, v, 503-504 275-276 Auto image rotation vs. Rotate tall Auto (Active D-Lighting), 113 Auto-area AF-area mode, 167, 432, 444 (sidebar), 47 Auto distortion control (Shooting Menu), Auto ISO sensitivity control, 127–136 Auto Minimum shutter speed, 131 55, 108-109 Auto Monitor brightness, 258 Auto distortion control (Retouch Menu), autofocus patterns, 443 Auto sensitivity (Microphone), 148 Auto exposure mode (AUTO), 381–382

Auto-servo AF mode (AF-A), 432, 437

Auto White balance, 88, 412, 414, 425–427 Audio type (Movie), 150 Autumn colors scene mode, 391 AVC – H.264/MPEG-4 Advanced Video Coding, 6 Averaging meter. See Center-weighted metering

В

b1 to b5. See Custom Setting Menu Background only (Flash compensation), Backup (Role played by card in Slot 2), 65 Banks (User Settings U1 and U2), 57-58 barrel distortion, 108 basic camera setup, 6-11 Battery age (Battery info), 277 Battery info (Setup Menu), 252, 276-277 Basic photo info (Playback display options), 31 Battery order, 203 batteries in MB-D14 (LR6, HR6, FR6), 202 Beach/snow scene mode, 388 Beep alert, 185-187 Beyond Point-and-Shoot by Darrell Young, Bit-depth, 12- vs. 14-bit (NEF (RAW) recording), 85 Bit-depth tutorial, 86 Berger Bros Camera Exchange, v Black-and-white (Monochrome), 309 Black-frame subtraction noise reduction. 121 black to white blinking on Monitor, 33 Blink mode (Highlights), 33 Blossom scene mode, 391 Blue intensifier filter effect, 314 Blue tint (Color balance), 320 Bowles, Eric (ericbowles), 152 bracketing, 217-223 Bracketing burst (assignable function), 229 Braunhut, Susan (wife of dhmiller), 460 Brightness (Monitor), 258 buffer image capacity, 455 Buffer-What is it? (sidebar), 194

Built-in flash (Commander mode), 212, 526 Burst (Bracketing), 220, 229

C

c1 to c5. See Custom Setting Menu C-1 to C-9 (Manage Picture Control), 100-101 Camera Body Reference, xvi camera setup, 6-11 Candlelight scene mode, 390 camera settings recommendations, 14 Capture NX 2, 119 Carey, Marcel (mcpianoca) image, 16 Center-weighted area, 173-174 Center-weighted metering, 173-174, 175, 369-371 Center-weighted metering (assignable function), 230 CH mode (shooting speed), 192 Change main/sub (command dials), 234 Channel (CH—Commander mode), 213, 528-529 Charge (Battery info), 277 Child scene mode, 385 chimping images (sidebar), 44 Choose destination (Resize), 333 Choose end point (Edit movie), 349 Choose image area (assignable function), 230 Choose non-CPU lens number (assignable function), 230 Choose size (Resize), 333 Choose start point (Edit movie), 349 Choose tab (My Menu), 362-363 CIELAB color space, 110–112 Clean at startup/shutdown (image sensor), 260, 261 Clean image sensor (Setup Menu), 251, 259-261 Clean now (image sensor), 260 Cleaning off (image sensor), 261 CL mode (shooting speed), 192 CLS. See Creative Lighting System Close up scene mode, 386 Cloudy White balance, 88, 413 CMD. See Commander mode Codec (NEF files), 69

Color balance (Retouch Menu), 301, 319–231

Color of Information display, 196 Color outline (Retouch Menu), 302, 341–342

Color sketch (Retouch Menu), 302, 342–343

Color space (Shooting Menu), 13, 55, 63, 109–112, 325, 331

color space technical information, 112 Color temperature (White balance), 410–411

Commander mode (flash), 209, 211–215, 525–529

compression of images (sidebar), 74 compression of video (sidebar), 150 Compressed (NEF (RAW) recording), 83 Continue as before (After delete), 44

Continuous high-speed release mode (CH), 433, 455

Continuous low-speed release mode (CL), 433, 454

Continuous-servo AF mode (AF-C), 432, 437

contrast-detection autofocus, 432 control reference, xvi

Copy to camera (Manage Picture Control), 103, 104–105

Copy to card (Manage Picture Control), 104, 106–107

Copyright (Copyright information), 278 Copyright information (Setup Menu), 252, 277–279

Copy image(s), 17, 36-42

Creative Lighting System, 215, 523–529

Cross screen filter effect, 315

Cross-type AF points, 435

Current (Playback folder), 25, 26

CUSTOMPC folder on memory card, 108

Custom Settings. See Custom Setting

Menu

Custom Settings Menu (Save/load settings), 281

Cyanotype (Monochrome), 309

Custom Setting Menu

a Autofocus, 157-168, 459

a1 AF-C priority selection, 13, 157–158, 159

a2 AF-S priority selection, 13, 158–160

a3 Focus tracking with lock-on, 13, 160–162

a4 AF point illumination, 162-163

a5 Focus point wrap-around, 164-165

a6 Number of focus points, 165-166

a7 Built-in AF-assist illuminator,

b Metering/exposure, 168-176

b1 ISO sensitivity step value, 169–170

b2 EV steps for exposure cntrl, 170-171

b3 Easy exposure compensation, 171–172

b4 Center-weighted area, 172-174

b5 Fine-tune optimal exposure, 174–176

c Timers/AE lock, 176-185

c1 Shutter-release button AE-L, 176–177

c2 Standby timer, 177-178

c3 Self-timer, 179-182

c4 Monitor off delay, 13, 182-183

c5 Remote on duration, 184-185

d Shooting/display, 185-204

d1 Beep, 13, 185-187

d2 Viewfinder grid display, 13, 188-189

d3 ISO display and adjustment, 189–190

d4 Screen tips, 190-192

d5 CL mode shooting speed, 192-193

d6 Max. continuous release, 193-194

d7 File number sequence, 13, 194-196

d8 Information display, 196-198

d9 LCD illumination, 198-199

d10 Exposure delay mode, 199-200

d11 Flash warning, 200-201

d12 MB-D14 battery type, 201-202

d13 Battery order, 203-204

e Bracketing/flash, 204-225

e1 Flash sync speed, 13, 204–207

e2 Flash shutter speed, 208-209

e3 Flash cntrl for built-in flash, 209-215

e4 Exposure Comp. for flash, 215-216

e Bracketing/flash, continued...

e5 Modeling flash, 216–217 e6 Auto bracketing set, 217–223

e7 Bracketing order, 224-225

f Controls, 225-242

f1 OK button (shooting mode), 225-227

f2 Assign Fn button, 13, 227-232, 291

f3 Assign preview button, 13, 227–232

f4 Assign AE-L/AF-L button, 13, 227-232

f5 Customize command dials, 233-238

f6 Release button to use dial, 238–239

f7 Slot empty release lock, 239–240

f8 Reverse indicators, 240-241

f9 Assign MB-D14 AE-L/AF-L button, 241–242

g Movie, 243-248

g1 Assign Fn button, 243-246

g2 Assign preview button, 243–246

g3 Assign AE-L/AF-L button, 243-246

g4 Assign shutter button, 246–247

D

d1 to d13. See Custom Setting Menu

dark-frame subtraction noise reduction, 121

Dark on light (Information display), 198

Date and time, 10, 269

Date format, 9, 270

Daylight saving time, 10, 271

Default (AF fine-tune), 293-294

Delayed remote (Remote control mode), 136–137

Delete from card (Manage Picture Control), 103, 105–106

Delete (Manage Picture Control), 102-103

Delete (Playback Menu), 17, 18–24

Deselect all (Copy image(s)), 39

Deselect all? (Hide image), 29-30

Destination (Movie settings), 146, 147,

149-150

Device control (HDMI), 267, 506

Direct sunlight White balance, 88, 413

displaying a movie, 504-507

Distortion control (Retouch Menu), 301,

337–339

D-Lighting (Retouch Menu), 301, 305–306,

325, 331

D/M/Y (Date format), 270

Do, Anthony (qudnuf4u), 366

downloadable resources websites, 15, 529

DPOF print order, 18, 50-53

Dusk/dawn scene mode, 389

Dust off reference photo (Setup Menu),

247, 252, 263-265

Dynamic-area AF-area mode, 432, 442–443

dynamic range, 33, 396–398 DX (Image area), 78–79, 163

DX mode (image area) (Image size), 76, 163

E

e1 to e7. See Custom Setting Menu

Edit movie (Retouch Menu), 302, 349–352 Enable release (empty memory card slot),

240

EN-EL15 battery, 203

English language selection, 273

Entire frame (Flash compensation), 215

EV step values (1/3 or 1/2), 169, 170

Exposure comp. (NEF (RAW) processing),

324, 329 Exposure compensation setting (+/–), 171,

479
Exposure compensation (command dials),

233

Exposure delay, 199-200

Exposure differential (HDR), 116, 117

Extra high (Active D-Lighting), 113

Eye-Fi upload (Setup Menu), 252, 295–297

EXE (NEF (RAW) processing), 325

Exposure modes (P, S, A, M), 373-395, 464,

F

499-501

f1 to f9. See Custom Setting Menu

Face-priority AF-area mode, 447, 451, 498

File naming (Shooting Menu), 55, 63-64

File number sequence, 64, 194–196, 303

Fill flash (Flash mode), 519

Filter amount (Cross screen filter effect),

316

Filter angle (Cross screen filter effect), 316 Filter effects (MC Picture Control), 95–96 Filter effects (Retouch Menu), 301, 310–319

Fine-tune

Autofocus, 253, 292–295
Color balance, 319–321
Exposure, 175
Metering, 175
White balance, 416
Firmware version (Setup Menu), 252, 297–298
first use of camera, 6–11
Fisheve (Retouch Menu), 302, 339–341

Fisheye (Retouch Menu), 302, 339–341 Flash compensation, 522–523 flash information (Speedlight), 204–207, 513–530, 515

Flash modes, 208–209, 516–522 Flash off (assignable function), 230 Flash only (Bracketing), 217, 218 Flash White balance, 88, 413

Fletcher, Rocky (*rf10956*), 430 Flicker reduction (Setup Menu), 252,

267–268
Fluorescent White balance, 88, 412, 414
For bloom the (com) (Non-CPI Long data)

Focal length (mm) (Non-CPU lens data), 289 Focal-plane contrast AF, 432

Focus lock (sidebar), 453
Focus point (Playback display options), 32
Focus priority (AF-C), 157
Focus priority (AF-S), 159
FocusTune calibration tools, v

Food scene mode, 392

Format memory card (Setup Menu), 12, 251, 253–255

FR6 battery. See batteries in MB-D14 Frame interval (Slide show), 48 Framing grid (assignable function), 230 Frame size/frame rate (Movie settings), 146–147, 477, 488

Frequency (Repeating flash), 211 Front-curtain sync (flash), 208, 519, 520, 522

Full-time servo AF mode (AF-F), 447, 449 FV lock (assignable function), 230, 242 FX (image area), 75, 78–79 FX mode (image area) (Image size), 76

G

g1 to g4. See Custom Setting Menu Giotto's Rocket Air Blower, 263 Goodman, Mike (mrginhop), 408 GPS flashing or solid on displays, 287 GPS (Setup Menu), 252, 282–287 Green intensifier filter effect, 313 Green tint (Color balance), 320 Grid screen (Picture Control), 97 Grid display in Live view, 189, 466, 482 Grid display in Viewfinder, 188 Group A or B (Commander mode), 212 Guide number (GN), 514–516

н

H.264/MPEG-4 Advanced Video Coding (AVC), 6 Hammond, Jim (hamjam), 250 Handheld and Tripod modes, 473 HDMI (Movie live view), 502-504, 507 HDMI (Setup Menu), 252, 266-267 HDMI-CEC, 267 HDTV, 505-506 HD video information, 483 HDR flashing on displays, 118 HDR (high dynamic range) (Shooting Menu), 56, 115-119 HDR mode, 116, 117 Heading (GPS), 282 Headphone volume, 478, 493-494 Heldoorn, Donald (taketwo) image, 300 Help—D600's help system, 153-154 Help—Scene modes, 394 Hidden images (Playback folder), 26 Hide image, 17, 27-30 High ISO NR (Shooting Menu), 13, 56, 124-126, 325, 330 High key scene mode, 393 Highlights (Playback display options), 32 - 33Highlight active focus point (OK button), 225

Histogram

all information, 395–406 blink mode, 33 clipping, 33, 399–400

Histogram, continued...

luminance histogram differences, 401 main histogram screens, 395 represents a JPEG image, 402 RGB histogram, 34, 87, 395 shape of histogram, 398 visual tutorial, 397 H/M/S (Date and time), 269 HR6 battery. See Batteries in MB-D14

1

Image area (Live view), 465
Image area (Shooting Menu), 55, 77–80
image compression (sidebar), 74
Image comment (Setup Menu), 252, 273
Image dust off ref photo (Setup Menu), 251, 263–265
image format recommendations, 74–75
Image overlay (Retouch Menu), 301, 321–323
Image quality (Live view), 465
Image quality (Shooting Menu), 13, 55, 67–75, 324, 326
Image review, 13, 17, 43–44, 182

Image review, 13, 17, 43–44, 182 Image size (Live view), 465 Image size (Shooting Menu), 13, 55, 75–80, 324, 326

Image type (Slide show), 48 Index marking (assignable movie function), 244 Incandescent White balance, 88, 412

Information display

color (light or dark), 196 Shut-off delay, 182 Input comment (Image comment), 274 interlaced video, 266, 267, 484, 488, 506 Interval between shots (Self-timer), 180–181

Interval (Time-lapse photography), 144 Interval timer shooting (Shooting Menu), 56, 141–144

ISO range (ISO 50 to 25,600), 127 ISO sensitivity (Live view), 466, 479, 500 ISO sensitivity settings (Shooting Menu), 13, 56, 126–136 ISO sensitivity Auto setting, 128

ISO-What is it? (sidebar), 136

i-TTL balanced fill flash (Flash mode), 516

J

Job HDR flashing on displays, 118
JPEG compression (Shooting Menu), 13,
55, 81–82
JPEG fine, normal, basic (Image quality), 67,
71–75, 193
JPEG positives and negatives, 73
JPEG vs. RAW, 74, 193

K

K manual White balance, 415 Kelvin color temperature (White balance), 409–411

L

Landscape (LS) Picture Control, 90–95
Landscape scene mode, 385
Language (Setup Menu), 8, 252, 272
Latitude (GPS), 282
Length of points (Cross screen filter effect), 317
LensAlign calibration tools, v
Lens number (Non-CPU lens data), 289
light meter timeout, 177
Light on dark (Information display), 198
light on front of camera. See AF-assist illuminator
List saved values (AF fine-tune), 294–295
Live view movie mode. See Movie live view mode

Live view photography mode, 461-471

activating, 461
Active D-Lighting, 464
AF-area modes, 464
aperture, 466
autofocus, 446–453, 447, 465, 470–471
exposure compensation, 466
exposure modes, 464
grid display, 189, 466
Image area, 465
Image size, 465
Image quality, 465
ISO mode, 466

Maximum aperture (Non-CPU lens data), Live view photography mode, continued... ISO sensitivity, 466 Maximum sensitivity (ISO sensitivity Metering mode, 465 settings), 129 Monitor brightness, 468-469 MC Picture Control, 90-95 movies. See Movie live view mode M/D/Y (Date format), 270 Picture Controls, 467-468 Memory buffer-What is it? (sidebar), 194 screens, 464-467 memory cards missing (do what?), 240 shut-off delay, 182 Menus shutter speed, 465 Custom Setting Menu, 152–249 video. See Movie live view mode My Menu, 11, 12, 228, 231, 296, Virtual horizon, 467 356-363 White balance, 465 Playback Menu, 16-53, 256, 275, 280 Load/save (Manage Picture Control), Recent Settings, 256, 281, 357, 364-365 103-104 Retouch Menu, 300-355 Setup Menu, 251-298 Load settings (Save/load settings), 280 Lock mirror up for cleaning (Setup Menu), Shooting Menu, 54-151 Shut-off delay, 182 251, 261-263 Long exposure NR (Shooting Menu), 13, using the menus, 11 56, 121-124 Metering, 367-372, 465, 479 Longitude (GPS), 282 meter timeout, 177 Lossless compressed (NEF (RAW) record-Michael Tapes Design, v Microphone sensitivity, 146, 147, 148-149, ing), 83 Low key scene mode, 393 478, 491-493 LR6 battery. See Batteries in MB-D14 Miniature effect (Retouch Menu), 302, LS Picture Control, 90-95 345-347 Minimum shutter speed (ISO sensitivity M settings), 129-131 mired color adjustment, 217, 222, 412 M exposure mode, 379-381 Mirror-up release mode (MUP), 433 M flash mode, 209, 210, 212-213, 527 ML-L3 Infrared Remote, 458 MC-DC2 electronic cable release, 283, 287, Monochrome (MC) Picture Control, 90–95 458 Monochrome (Retouch Menu), 301, Magenta tint (Color balance), 320 308-310 Manage Picture Control (Shooting Menu), Monitor preflash, 528 55, 100-108 Monitor Brightness (Live view), 468-469, 495

Manual distortion control (Retouch Menu), 338
Manual flash (M), 209, 210, 212–213, 527
Manual Information display color (dark or light), 197
Manual mode (M), 379–381
Manual Monitor brightness, 258
Manual sensitivity (Microphone), 148
Martinez, Jesse (*jesse101*), 2, 512
Matrix metering, 175, 230, 369
Matrix metering (assignable function), 230

Brightness (Setup Menu), 12, 251, 258–259
Image review (shut-off delay), 182
Information display (shut-off delay), 182
Live view (shut-off delay), 182
Menus (shut-off delay), 182
Playback (shut-off delay), 182
technical information (sidebar), 18

Movie live view mode, 473–510
activating, 474, 484, 501

AF-Area modes, 477, 498-499

Movie live view mode, continued... aperture, 479, 500 autofocus, 477, 497 displaying a movie, 504-507 exposure compensation, 479 exposure modes, 499-501 file format, 488-489 Frame size/frame rate, 477, 488 Grid overlay, 482 Headphone volume, 478, 493-494 HDMI, 502-504, 507 HDTV, 505-506 HD video information, 483 ISO sensitivity, 479, 500 Metering mode, 479 Microphone sensitivity, 478, 491-493 Monitor brightness, 495 Movie destination, 478, 496 Movie quality, 490-491 Picture Controls, 477, 485-486 preparing to make a movie, 483-501 progressive versus interlaced, 484 recording a movie, 501-504 rolling shutter (skew, wobble, partial exposure), 508 screens, 476-483 selecting, 474 shutter speed, 479, 500 Sound level, 478 still images in Movie mode, 470, 474-476 time remaining, 477 Tripod and Handheld modes, 473 Virtual horizon, 482 White balance, 477, 487 Movie settings (Shooting Menu), 13, 56, 146-150 Movie quality (Movie settings), 146, 147-148 MPEG-4, (H.264/MPEG-4 Advanced Video Coding), 6 MTR > under > over (Bracketing order), 224

MULTI-CAM 4800 FX autofocus module,

Multiple exposure (Shooting Menu), 56,

My Menu, 11, 231, 281, 356-363

My Menu (assignable function), 231

432

138-141

N

NCP ending for Custom Picture Control files, 108 ND600 (Playback folder), 25 +NEF (RAW) (assignable function), 231 NEF file is not an image yet, 70 NEF file positives and negatives, 71 NEF (RAW) compressed (NEF (RAW) record-NEF (RAW) (Image quality), 67, 68, 193 NEF (RAW) + JPEG fine, normal, basic (Image quality), 67, 73 NEF (RAW) lossless compressed (NEF (RAW) recording), 83 NEF (RAW) recording (Shooting Menu), 13, 55, 83-87 NEF (RAW) processing (Retouch Menu), 301, 324-332 Neutral (NL) Picture Control, 90-95 Night landscape scene mode, 387 Night portrait scene mode, 387 Nikon Capture NX 2, 119 NIKON folder on memory card, 108 Ninia-2 (Atomos), v, 503-504 NL Picture Control, 90-95 No flash mode, 395 No (Off) (Release button to use dial), 238 No. of shots (Battery info), 277 noise—what is it? (sidebar), 126 Non-CPU lens data (Setup Menu), 252, 288-292 None (assignable function), 231 None (assignable movie function), 244 None (image only) (Playback display options), 31-32 Noise reduction High ISO NR, 13, 124-126 Long exposure NR, 13, 121-124 Normal-area AF-area mode, 447, 451, 498 Not used (OK button), 225 No wrap (a5 Focus point wrap-around), 164 Now (Interval timer shooting), 142 NR. See Noise reduction Number of points (Cross screen filter effect), 316 Number of shots (Multiple exposure), 139

0

On (Mode A), On, Off (command dials), 234, 237
On (image review excluded), 237
On (series) (Multiple exposure), 139
On (single photo) (Multiple exposure), 139
Optimal quality (JPEG compression), 81–82, 193
Output (Repeating flash), 211
Output resolution (HDMI), 266, 506
Overflow (Role played by card in Slot 2), 65

P

P exposure mode, 373–375 Party/indoor scene mode, 388 *Pause*

Slide show, 49
Interval timer shooting, 143
Perspective control (Retouch Menu), 302, 343–345
Pet portrait scene mode, 390
Phase-detection autofocus, 431
Photoshop, 98–99, 119, 403–406, 410
PictBridge printing, 53
Picture Control Fine-tuning, 91–92
Picture Control grid screen, 97
Picture Controls (Live view), 464, 467–468, 477, 485–486
Picture Control (NEF (RAW) processing), 324

Picture Control resetting, 98
pincushion distortion, 108
Pitch (Beep), 187
Playback (assignable function), 231
Playback display options, 13, 17, 30–36
Playback folder, 13, 17, 25–26
Playback menu, 11, 16–53, 280
Playback (Movie), 504–507
Playback (shut-off delay), 182
Portrait (PT) Picture Control, 90–95
Portrait scene mode, 384
Position (GPS), 285
post-processing images, 403–406

Practical HDRI by Jack Howard, 401

PRE (Preset manual) White balance, 413, 417–418, 421 predictive focus tracking, 438 preflash, 528 Preview (assignable function), 231 Programmed auto mode (P), 373–375 progressive video, 266, 484, 488–489, 506 protecting images from deletion, 23 PT Picture Control, 90–95

0

Quiet shutter-release mode (Q), 433, 456 Quick-response remote (Remote control mode), 136–137 Quick retouch (Retouch Menu), 301, 334–335

R

Rank items (My Menu), 361-362 RAW Slot 1-JPEG Slot 2 (Role played by card in Slot 2), 65-66 RAW file is not an image yet, 70 RAW file positives and negatives, 71 RAW vs. JPEG, 74 Rear-curtain sync (flash), 208, 520 Recent Settings (menu), 11, 281, 363-364 Record movies (assign shutter-release button), 246 recording a movie (Live view), 501-504 recovering deleted images (sidebar), 24 reciprocal of focal length shutter speed rule, 131 Red-eye correction (Retouch Menu), 301, 306-307 Red-eye reduction (flash), 208, 520 Red-eye reduction with slow sync (flash), 208, 520 Red intensifier filter effect, 312 Remote control mode (Shooting Menu), 56, 136-138 Remove items (My Menu), 360-361 reference, camera body and controls, xvi Release locked (empty memory card slot), 240

Release modes

Continuous high-speed release mode

(CH), 433, 455	RPT. See Repeating flash
Continuous low-speed release mode	
(CL), 433, 454	S
Live view mode, 456	
Mirror-up release mode (MUP), 433	S exposure mode, 375–378
Remote control release mode, 136-138,	Same as Fn button (MB-D14 assignable
433	button), 242
Self-timer release mode, 433, 457	Save/edit (Manage Picture Control), 100
Single frame release mode (S), 433, 454	Save/load settings (Setup Menu), 252,
Quiet shutter-release mode (Q), 433,	279–282
456	Save selected frame (Edit movie), 349, 351
Viewfinder mode, 456	Save to U1, Save to U2 (Save user settings),
Release priority (AF-C and AF-S), 157–158,	256
441	Save user settings (Setup Menu), 251,
Remote control mode (Release mode),	255–257
136–138, 433	Save User Settings versus Save/
Remote mirror-up (Remote control mode),	Load Settings, 282
136–137	Saved value (AF fine-tune), 293
Rename (Manage Picture Control), 101-	Scene modes, 382–394
102, 105	Screens
Repeating flash, 209, 210	Live view movie mode, 476–483
reset a Picture Control, 98	Live view photography mode, 464–467
Reset custom settings (Custom Setting	menus, 11
Menu), 156	shooting display, 34–36
Reset shooting menu (Shooting Menu), 55	Screen tips, 190
Reset U1, Reset U2 (Reset user settings),	SD Picture Control, 90–95
257	Select all images (Copy image(s)), 39
Reset user settings (Setup Menu), 251, 257	Selected (Delete), 19–20
Reset shooting menu (Shooting Menu),	Select center focus point (OK button), 225
59–60	Select date (Delete), 20–21
Resize (Retouch Menu), 301, 332–334	Select date (Hide image), 28–29
resources websites (downloads), 15	Select destination folder (Copy image(s)),
Retouch Menu, 11	40
Reverse indicators, 240–241	Select folder by number (Copy image(s)),
Reverse rotation (Command dials), 233	40
Review (image), 13, 17	Select folder by number (Storage folder),
RGB, 33	61, 62
RGB Channel and Bit-Depth Tutorial, 86	Select folder from list (Copy image(s)), 41
RGB histogram (Playback display options),	Select folder from list (Storage folder), 61
34	Selective color (Retouch Menu), 302,
Rice, Phillip (<i>pjr</i>) image, 54	347–349
Role played by card in Slot 2 (Shooting	SG-3IR infrared panel (flash), 214
Menu), 13, 55, 65–66	Show frame count (ISO display and adjust-
rolling shutter (skew, wobble, partial expo-	ment), 190
sure), 508–510	Select image (Resize), 332, 334
Rotate tall, 13, 18, 45–47	Select image(s) (Copy image(s)), 38

Rotate tall vs. Auto image rotation

(sidebar), 47

Select no. of times x no. of shots (Interval software included with camera, 70 timer), 142 NEF (RAW) conversion software, 69 Select protected images (Copy image(s)), Sound level (Movie live view), 478 Speedlight flash information, 204-207, Select/set (Hide image), 27–28 513-530, 515 Select source (Copy image(s)), 37 Sports scene mode, 386 Self-timer delay, 179 Spot metering, 175, 231, 371-372 Self-timer release mode, 433, 457 Spot metering (assignable function), 231 Sepia (Monochrome), 309 sRGB Color space, 35, 55, 57, 110-112 setup of camera, 6-11 Standard (SD) Picture Control, 90–95 Setup Menu, 11, 251-298, 281 Set Picture Control (Shooting Menu), 13, Standby timer (GPS), 284-286 55, 90-99, 330 Start settings (User Settings U1 and U2), 57–58 Lock mirror up for cleaning, 262 Slide show, 48 Shade White balance, 88, 413 Time-lapse photography, 144 Shooting data (Playback display options), Start time (Interval timer shooting), 142 34-36 Shooting Menu, 11, 54-151, 280 steps to set up camera, 7-11 still images in Movie mode, 470, 474-476 Shooting time (Time-lapse photography), Standard i-TTL (Flash mode), 516 144-145 Storage folder (Shooting Menu), 55, 60–62 Show ISO/Easy ISO (ISO display and adjust-Straighten (Retouch Menu), 301, 335–336 ment), 189 Show ISO sensitivity (ISO display and ad-SU-800 Wireless Speedlight Commander, justment), 189 Show next (After delete), 44 Sub-command dial (change functionality), Show previous (After delete), 44 235 Subject-tracking AF-area mode, 447, 452, shutter lag, 438 499 Shutter-priority auto mode (S), 375–378 Sunset scene mode, 389 Shutter speed/aperture (command dials), Sync speed (flash), 204-207 Side-by-side comparison (Retouch Menu), T 302.352-353 Silhouette scene mode, 392 Single frame release mode (S), 433, 454 Take photos (assign shutter-release button), 246 Single-point AF-area mode, 432, 440-441 The HDRI handbook by Christian Bloch, 401 Single-servo AF mode (AF-S), 432, 437, 447, 449 Thumbnails (NEF files), 69 Size priority (JPEG compression), 81, 193 Times (Repeating flash), 211 Time conversion chart (12- to 24-hour), 270 Skylight (Filter effect), 311 Time-lapse photography (Shooting Menu), Slide show, 18, 47-50 Slot 1 or Slot 2 (Movie Destination), 149 56, 144-146 Slot 1 or Slot 2 (Eye-Fi upload), 296 Time remaining (Movie live view), 477 Time zone (Setup Menu), 9, 252, 269 Slow rear-curtain sync (flash), 208, 520 Time zone and date (Setup Menu), 252, Slow sync (flash), 208, 520 268-272 Smoothing (HDR), 116, 117 Toning (MC Picture Control), 96-97 Soft filter effect, 317

> Tracking (3D-Tracking AF-area mode), 432 Trim (Retouch Menu), 301, 307–308

Tripod and Handheld modes, 473 TTL, TTL FP, or TTL BL FP (flash), 206, 209, 210, 212, 527 TTL phase-detection autofocus, 431 Type (NEF (RAW) recording), 83

U

U1 and U2. See User settings
Under > MTR> over (Bracketing order), 224
unhide image removes delete protection
 (sidebar), 30
Use camera battery first. See Battery order
Use GPS to set camera clock, 285, 286–287
use of camera, initial setup 6–11
Use MB-D14 batteries first. See Battery
 order
User settings (U1 and U2), 57–58, 154–155,
 394
UTC (time) (GPS), 282

٧

View photo shooting info (movie mode), 244
Viewfinder autofocus, 431–453
Viewfinder in DX mode, 79–80
Viewfinder grid display, 188
Viewfinder virtual horizon (assignable function), 231
Vignette control (Shooting Menu), 13, 56, 119–121, 325, 331
Virtual horizon (assignable function), 231
Virtual horizon in Live view, 467, 482
Virtual horizon (Setup Menu), 252, 287–288
Vivid (VI) Picture Control, 90–95

Volume

Beep, 187 Microphone, 491–493 Headphone, 493–494

VI Picture Control, 90-95

W

Warm filter effect, 311 WB bracketing, 217, 220

Websites mentioned in this book

downloadable resources, 15 support.nikonusa.com, 69 www.ardfry.com, 69 www.atomos.com, v www.berger-bros.com, v www.cambridgeincolour.com, 401 www.copyright.gov, 279 mtapesdesign.com, v www.photoproshop.com, 262 www.Nikonians.org, 15 www.RockyNook.com, 15

WhiBal cards, v White Balance

Auto1 and Auto2, 414, 425-427 Color temperature, 410, 415 control locations for adjustment, 411 editing PRE comment field, 422-423 Fine-tuning, 89, 416, 419-422 Fluorescent type's extra screen, 414 from a previously captured image, 423 fundamentals (sidebar), 410 how does it work?, 409-410 K manual White balance, 415 Live view, 465, 477, 487 Manual White balance (by controls), 412 Manual White balance (by menu), 413 NEF (RAW) processing, 324, 327–329 PRE measurement, 417-418, 421 protecting a WB preset value, 424 RAW mode, 427 Shooting Menu, 87–89 symbols, 412-413 tips and tricks, 428 White balance (Shooting Menu), 13, 55, 87-89 white to black blinking on monitor, 33 Wide-area AF-area mode, 447, 451, 498 Wrap (a5 Focus point wrap-around), 164 Write-locked memory card insertion (sidebar), 38

X

X + Flash sync speed, 207 X-Sync, 207

γ

Yes (On) (Release button to use dial), 238 Y M D (Date and time), 269 Y/M/D (Date format), 270 Young, Brenda (*DigitalBrenda*) image, 472

Nikonians Gold Membership

Nikonian Sue Kane (Sue A) took this picture suek.redbubble.com

Enter the following voucher code to obtain a 50% discount for a Nikonians Gold Membership: **G2**

With over 400,000 members, reaching out to over 58,000 photographers daily and 1.5 million monthly, Nikonians is the largest community for Nikon photographers.